Imagine Math 7

Michele Emmer • Marco Abate

Editors

Imagine Math 7

Between Culture and Mathematics

 Springer

Editors
Michele Emmer
Sapienza University of Rome (retired)
Rome, Italy
and
IVSLA – Istituto Veneto di Scienze
Lettere ed Arti
Roma, Italy

Marco Abate
Mathematics Department
University of Pisa
Pisa, Italy

ISBN 978-3-030-42655-2 ISBN 978-3-030-42653-8 (eBook)
https://doi.org/10.1007/978-3-030-42653-8

Cover illustration: From the catalogue of the exhibition by Mimmo Paladino, Sulla Mathematica, Palazzo Loredan, IVSLA, Venice, March-April, 2019, Centro Internazionale della Grafica, Venezia

This Springer imprint is published by the registered company Springer Nature Switzerland AG.
The registered company address is: Gewerbestrasse 11, 6330 Cham, Switzerland

To
Nanni Balestrini

Preface

Imagine building mathematical models that make it possible to manage our world better, imagine solving great problems, imagine new problems never before thought of or imagine combining music, art, poetry, literature, architecture, theatre and cinema with mathematics. Imagine the unpredictable and sometimes counterintuitive applications of mathematics in all areas of human endeavour.

Imagination and mathematics, imagination and culture, culture and mathematics. For some years now the world of mathematics has penetrated deeply into human culture, perhaps more deeply than ever before, even more than in the Renaissance. In theatre, stories of mathematicians are staged; in cinema Oscars are won by films about mathematicians; all over the world museums and science centres dedicated to mathematics are multiplying. Journals have been founded to explore the relationships between mathematics and contemporary art and architecture. Exhibitions are mounted to present mathematics, art and mathematics and images related to the world of mathematics.

The volumes in the series *Imagine Math* are intended to help readers grasp how much that is interesting and new is happening in the relationships between mathematics, imagination and culture.

This seventh volume is dedicated to the Italian poet, visual artist and writer Nanni Balestrini who died May 2019. He took part in the *2015 Venice Conference* with a presentation and an exhibition dedicated to his combinatorial book *Tristano* and his combinatorial film *Tristanoil* (Imagine Maths 5, 2016).

The volume starts with a homage to the Italian artist Mimmo Paladino who created exclusively for the *Venice Conference 2019* ten original and unique works of art paper dedicated to the themes of the meeting. An exhibition of the ten works together with the series of six etchings entitled *Mathematica* opened for 1 month in Palazzo Loredan in Venice, the other venue of the *Istituto Veneto di Scienze, Lettere ed Arti*, where many conferences on *Mathematics and Culture* have taken place in recent years.

After the Homage to the Anniversary of the Bauhaus (1 April 1919), a large section is dedicated to the most recent Fields Medals including a Homage to Maryam Mirzakhani and the story of soap bubbles in mathematics including a presentation of the international exhibition on soap bubbles in art and science with works of art from many Museums of the world that took place in the *Galleria Nazionale dell'Umbria* in Perugia, March–June 2019. A section of the conference was dedicated to cinema and theatre including two living performances by Claire Bardainne and Adrien Mondot and the Portuguese mathematician Telma Joao Santos. A part of the conference focused on the community of mathematicians and their role in literature and even in politics with the extraordinary example of Antanas Mockus Major of Bogotá, presented by Carlo Tognato of the *Universidad Nacional de Colombia*. Mathematics in the constructions of bridges, in particular in Italy in the 1960s, was presented by Tullia Iori. A very particular contribution on *Origami* by a mathematician, Marco Abate, and an artist, Alessandro Beber. And many other topics.

As usual the topics are treated in a way that is rigorous but captivating, detailed and full of evocations. This is an all-embracing look at the world of mathematics and culture.[1]

Rome, Italy Michele Emmer

[1]P.S. The world, life, culture, everything has changed in a few weeks with the Coronavirus. Culture, science are the main ways to safeguard people's physical and social life. Trust in humanity's creativity and ability. The motto today in Italy is *Everything will be fine*.

Acknowledgement

We thank Mimmo Paladino for his permission to reuse the images published in the catalogue of the exhibition Mimmo Paladino, *Sulla Mathematica*, Palazzo Loredan, IVSLA, Venice, March–April, 2019, Centro Internazionale della Grafica, Venezia.

Contents

Part I Homage to Bauhaus

Homage to Bauhaus, April 1, 1919 .. 3
Michele Emmer

**Paul Klee's "Honey-Writing" Some Reflections on the Relation
of Automatism, Automation, Machines and Mathematics**................... 5
Michael Rottmann

Part II Fields Medals

Maryam Mirzakhani: A Mathematical Polyglot 33
Elisabetta Strickland

From Soap Bubbles to Fields Medals: An Exhibition 45
Michele Emmer

Part III Mathematics and Cinema

Alternative Methods for Digital Contrast Restoration...................... 73
Alice Plutino and Alessandro Rizzi

Mathematically Based Algorithms for Film Digital Restoration 89
Serena Bellotti, Giulia Bottaro, Alice Plutino, and Michele Valsesia

Homage to Octavia Spencer.. 105
Michele Emmer

Part IV Mathematics and Origami

Geometric Origami ... 117
Marco Abate

Origami Tessellations: Designing Paperfolded Geometric Patterns........ 135
Alessandro Beber

Part V Mathematics and Art

Geometric Concept of a Smooth Staircase: Sinus Stairs.................... 151
Cornelie Leopold

**Sublime Experience: New Strategies for Measuring the Aesthetic
Impact of the Sublime** ... 167
Maddalena Mazzocut-Mis, Andrea Visconti, Hooman Tahayori,
and Michela Ceria

Mathematics in Disney Comics ... 189
Alberto Saracco

Part VI Mathematics and Applications

The Language of Structures ... 213
Tullia Iori

Mathematical Aspects of Leonardo's Production in Milan 231
Elena Marchetti and Luisa Rossi Costa

A Mathematical Improvement of the Skate Curves 247
Enrico Perano and Marco Codegone

Part VII Mathematics and Physics

Infinity in Physics .. 265
Jean-Marc Lévy-Leblond

Part VIII Mathematics and . . .

Hyperbolic Honeycomb .. 279
Gian Marco Todesco

Explaining Cybersecurity with Films and the Arts 297
Luca Viganò

Part IX Mathematicians

A Portrait of the Mathematical Tribe.. 313
Marco LiCalzi

**Creation/Representation/Transmission: Culture
and/of Mathematicians' Autobiographies** 333
Odile Chatirichvili

**Mathematical Imagination and the Preparation of the Child
for Science: Sparks from Mary Everest Boole** 347
Paola Magrone and Ana Millán Gasca

Antanas Mockus and the Civil Role of a Mathematician.................... 363
Carlo Tognato

Part X Mathematics and Literature

François Le Lionnais and the Oulipo ... 383
Elena Toscano and Maria Alessandra Vaccaro

Part XI Visual Mathematics

**Local Estimates for Minimizers, Embodied Techniques and (Self)
Re-presentations Within Performance Art** 411
Telma João Santos

Acqua Alta .. 423
Claire Bardainne and Adrien Mondot

A Supposedly Fun Thing We Would Do Again 435

Imagine Math ... 471

Editors and Contributors

About the Editors

Michele Emmer is a member of the Istituto Veneto di Lettere, Scienze e Arti in Venice, founded by Napoleon. Former Professor of Mathematics at La Sapienza University in Rome (until 2015), since 1997 he has organized the Mathematics and Culture conferences in Venice. He has organized several exhibitions, cooperating with the Biennale of Art of Venice and the Prada Foundation among others. He is a member of the board of the journal *Leonardo: Art, Science and Technology*, MIT Press; a filmmaker, including a film on M.C. Escher; and author of the series *Art and Math*. He is also editor of the series *Mathematics and Culture* and *Imagine Math* by Springer, as well as the series *The Visual Mind* by MIT Press. His most recent books include *Flatlandia di E. Abbott*, with DVD, music by Ennio Morricone, 2008; *Bolle di sapone tra arte e matematica*, Bollati Boringhieri, 2010, which won the best Italian essay award at Viareggio 2010; *Numeri immaginari: cinema e matematica*, Bollati Boringhieri, 2012; *Il mio Harry's bar*, Archinto ed., 2012; *Imagine Math 3*, Springer, 2013; *Imagine Math 4*, Springer, 2015, *Imagine Math 5*, Springer, 2016, *Imagine Math 6*, Springer, 2018; and *Racconto matematico: memorie impersonali con divagazioni*, 2019, Bollati Boringhieri.

Marco Abate is a Full Professor of Geometry at the University of Pisa. He has written more than 100 scientific papers and textbooks, as well as several papers on the popularization of mathematics. His interests include holomorphic dynamics, geometric function theory, differential geometry, writing (comic books and more), photography, origami and travelling (having already visited Antarctica, his next destination is the Moon).

Contributors

Marco Abate Dipartimento di Matematica, Università di Pisa, Pisa, Italy

Claire Bardainne Adrien M & Claire B, Lyon, France

Alessandro Beber Vignola-Falesina, Trento, Italy

Serena Bellotti MIPS Lab, Computer Science Department, Università degli Studi di Milano, Milano, Italy

Giulia Bottaro MIPS Lab, Computer Science Department, Università degli Studi di Milano, Milano, Italy

Michela Ceria Dipartimento di Informatica "Giovanni Degli Antoni", Università degli Studi di Milano, Milano, Italy

Odile Chatirichvili Université Grenoble Alpes, UMR Litt&Arts – ISA, Grenoble, France

Rodolfo Clerico Rudi Matematici, Torino, Italy

Marco Codegone Dipartimento di Scienze Matematiche, Dipartimento di Eccellenza 2018–2022, Politecnico di Torino, Torino, Italy

Luisa Rossi Costa Dipartimento di Matematica, Politecnico di Milano, Milano, Italy

Michele Emmer Sapienza University of Rome (retired), Rome, Italy; IVSLA – Istituto Veneto di Scienze, Lettere ed Arti, Venice, Italy

Piero Fabbri Rudi Matematici, Torino, Italy

Ana Millán Gasca Department of Education, Roma Tre University, Rome, Italy

Tullia Iori Università di Roma Tor Vergata, Rome, Italy

Cornelie Leopold Descriptive Geometry, FATUK [Faculty of Architecture], TU Kaiserslautern, Kaiserslautern, Germany

Jean-Marc Lévy-Leblond University of Nice-Côte d'Azur, Nice, France

Marco LiCalzi Department of Management, Università Ca' Foscari, Venezia, Italy

Paola Magrone Department of Architecture, Roma Tre University, Rome, Italy

Elena Marchetti Dipartimento di Matematica, Politecnico di Milano, Milano, Italy

Maddalena Mazzocut-Mis Dipartimento di Beni Culturali e Ambientali, Università degli Studi di Milano, Milano, Italy

Adrien Mondot Adrien M & Claire B, Lyon, France

Francesca Ortenzio Rudi Matematici, Torino, Italy

Enrico Perano Federal Executive FISR under the auspices of CONI, Milano, Italy

Alice Plutino MIPS Lab, Computer Science Department, Università degli Studi di Milano, Milano, Italy

Alessandro Rizzi MIPS Lab, Computer Science Department, Università degli Studi di Milano, Milano, Italy

Michael Rottmann Academy of Art and Design FHNW Basel, IXDM – Institute of Experimental Design and Media Cultures, Basel, Switzerland

Telma João Santos Lisboa, Portugal

Alberto Saracco Dipartimento di Scienze Matematiche, Fisiche e Informatiche, Università di Parma, Parma, Italy

Elisabetta Strickland Dipartimento di Matematica, University of Rome "Tor Vergata", Rome, Italy; Gender Interuniversity Observatory, University of Roma TRE, Rome, Italy

Hooman Tahayori Department of Computer Science, Engineering and IT, School of Electrical and Computer Engineering, Shiraz University, Shiraz, Iran

Giam Marco Todesco Digital Video, Rome, Italy

Carlo Tognato Center for Cultural Sociology, Yale University, New Haven, CT, USA; Center for the Study of Social Change, Institutions, and Policy (SCIP), Schar School of Policy and Government, George Mason University, Arlington, VA, USA; Center for Holocaust and Genocide Studies, University of Minnesota, Minneapolis, MN, USA; Department of Sociology, National University of Colombia, Bogotá, Colombia

Elena Toscano Università di Palermo, Palermo, Italy

Maria Alessandra Vaccaro Università di Palermo, Palermo, Italy

Michele Valsesia MIPS Lab, Computer Science Department, Università degli Studi di Milano, Milano, Italy

Luca Viganò Department of Informatics, King's College London, London, UK

Andrea Visconti Dipartimento di Informatica "Giovanni Degli Antoni", Università degli Studi di Milano, Milano, Italy

Homage to Mimmo Paladino

Dreams and Numbers

Tout est nombre.
Le nombre est dans tout.
Le nombre est dans l'individu.
L'ivresse est un nombre.

Baudelaire, *Journaux Intimes*, Œuvres posthumes, 1908.

It was inevitable that the universes of Mimmo Paladino and of the *Imagine Math* conferences would meet again in this imaginary and geometric city which is Venice. Earlier I had written about the *Mathematica* series:

Paladino has always been attracted by numbers, geometric shapes. He depicts shapes and numbers everywhere, on faces, on objects. Numbers that are disturbing and reassuring presences, which are human and divine, eternal and contemporary. The numbers and geometric shapes which attract the artist, with their timeless, immutable and imaginative charm.

It is worth remembering what D'Arcy Thompson wrote in 1917 in his book *On Growth and Form*:

We find more and more our knowledge expressed and our needs satisfied through the concept of number, as in the dreams and visions of Plato and Pythagoras. Dreams apart, numerical precision is the very soul of science.

And even mathematicians dream, as the famous mathematician Ennio De Giorgi repeatedly emphasized:

I think there is a generally indistinct capacity to dream as generally indistinct is the feeling which the ancients called philosophy, or love of wisdom ... I have developed over the years the idea that all sciences and arts share a common foundation.

The famous English mathematician G. H. Hardy stated: "the mathematician's patterns, like the painter's or the poet's must be beautiful; the ideas, like the colours or the words, must fit together in a harmonious way. Beauty is the first test: there is no permanent place in the world for ugly mathematics".

In 1868, Isidore Lucien Ducasse under the pseudonym of Conte de Lautréamont celebrated the fascination of mathematics in a visionary and terrible book, the *Chants de Maldoror*:

> O mathématiques sévères, je ne vous ai pas oubliées, depuis que vos savantes leçons, plus douces que le miel, filtrèrent dans mon coeur, comme une onde rafraîchissante... Arithmétique ! algèbre ! géométrie ! trinité grandiose ! triangle lumineux !... Aux époques antiques et dans les temps modernes, plus d'une grande imagination humaine vit son génie, à la contemplation de vos figures symboliques tracées sur le papier brûlant, comme autant de signes mystérieux, vivants d'une haleine latente, que ne comprend pas le vulgaire profane et qui n'étaient que la révélation éclatante d'axiomes et d'hyéroglyphes éternels, qui ont existé avant l'univers et qui se maintiendront après lui.

And not by chance the historian of mathematics, Morris Kline, wrote:

> Mathematics has determined the direction and content of much philosophic thought, has destroyed and rebuilt religious doctrines, has supplied substance to economic and political theories, has fashioned major painting, musical, architectural, and literary styles, has fathered our logic, and has furnished the best answers we have to fundamental questions about the nature of man and his universe.

This new encounter was inevitable. Paladino's *Manifestos* for the 2019 *Mathematics and Culture Conference*.

Venice, Italy Michele Emmer
March 2019

From the catalogue of the exhibition Mimmo Paladino, *Sulla Mathematica*, Palazzo Loredan, IVSLA, Venice, March–April, 2019, Centro Internazionale della Grafica, Venezia. Reproduced with permission.

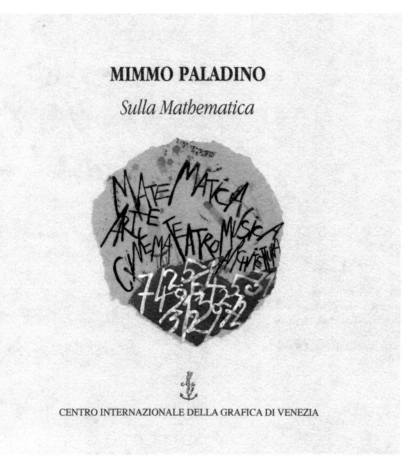

Fig. 1 Cover of the catalogue *Mimmo Paladino, Sulla Mathematica* © Centro Internazionale della Grafica, Venezia, 2019

Fig. 2 Sketch for the
conference *Mathematics and
culture*, 2018. Work on paper,
mixed media.
1000 × 800 mm. Private
collection

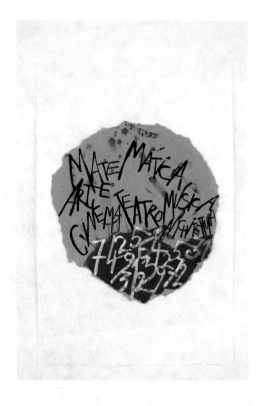

Fig. 3 Sketch for the
conference *Mathematics and
culture*, 2018. Work on paper,
mixed media.
1000 × 800 mm. © Mimmo
Paladino

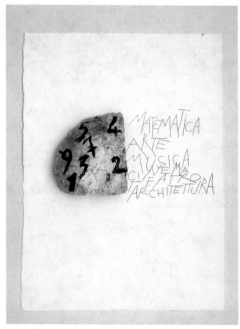

Fig. 4 Sketch for the
conference *Mathematics and
culture*, 2018. Work on paper,
mixed media.
1000 × 800 mm. © Mimmo
Paladino

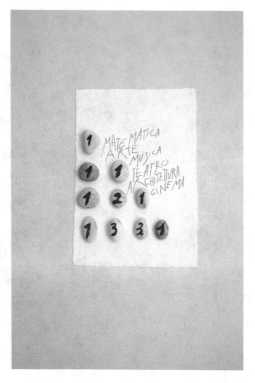

Fig. 5 Sketch for the conference *Mathematics and culture*, 2018. Work on paper, mixed media. 1000 × 800 mm. © Mimmo Paladino

Fig. 6 Sketch for the
conference *Mathematics and
culture*, 2018. Work on paper,
mixed media.
1000 × 800 mm. © Mimmo
Paladino

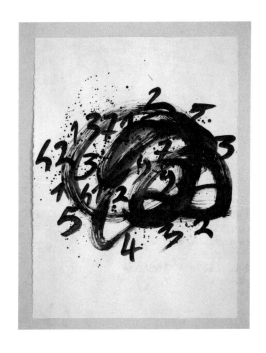

Fig. 7 Sketch for the
conference *Mathematics and
culture*, 2018. Work on paper,
mixed media.
1000 × 800 mm. © Mimmo
Paladino

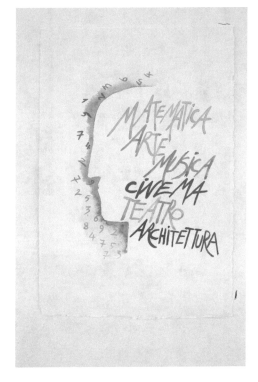

Fig. 8 Sketch for the
conference *Mathematics and
culture*, 2018. Work on paper,
mixed media.
1000 × 800 mm. © Mimmo
Paladino

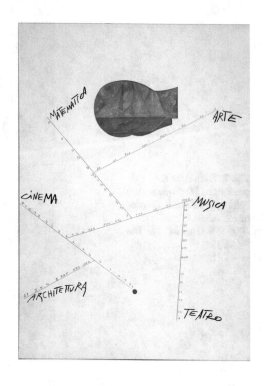

Fig. 9 Sketch for the
conference *Mathematics and
culture*, 2018. Work on paper,
mixed media.
1000 × 800 mm. © Mimmo
Paladino

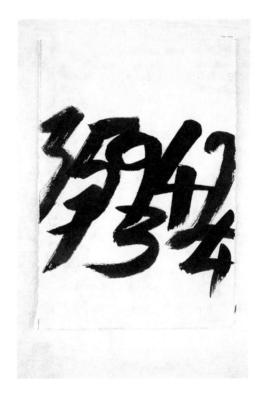

Fig. 10 Sketch for the
conference *Mathematics and
culture*, 2018. Work on paper,
mixed media.
1000 × 800 mm. © Mimmo
Paladino

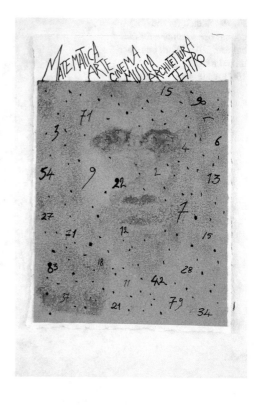

Fig. 11 Sketch for the conference *Mathematics and culture*, 2018. Work on paper, mixed media. 1000 × 800 mm. © Mimmo Paladino

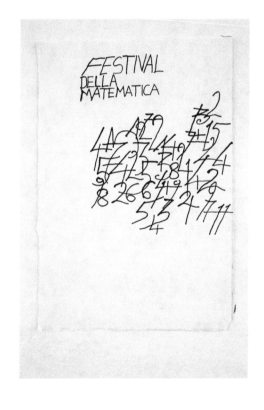

Paladino's Matematici

Immobile, silent, solemn indecipherable, mysterious even impenetrable in their sacred stillness, these six figures have a great deal to do with the hieratic "white sculptures" of the 1990s disseminated among the olive trees of Paduli, near Benevento in the south of Italy. Though they have been called "witness", Paladino says that they are thinkers, philosophers, perhaps shamans or "mathematicians".

In some way it is one and the same because, in the end, the philosophy of numbers can coincide with that of forms. If a great Greek mathematician could declare that "everything is number", a great philosopher, he too Greek, later clarified that "everything (in the visible world) is form". One can, therefore, say that number and form make up "the real immutable essence of reality".

Paladino's absorbed and motionless figures—surrounded by symbols, numbers and geometric forms—appear indifferent to our gaze. Perhaps because they have already "calculated the number of particles in the 3000 worlds" beyond which as has been said "what cannot be calculated begins".

The unreasonable "philosophy of numbers" ends, and perhaps the illogical "theory of forms" begins; both nonetheless capable of interrogating and unveiling the memory of the world. Thus, the "mathematicians" come into play, those creatures Paladino depicts as "thinkers of numbers and forms", of which they are, in fact, adorned in ineffable representation.

Perhaps they possess the power of magic, a word so often misunderstood because the magician was once a "wise man", the one who knew what to do and how to do it. Or perhaps they are shamans, endowed with extraordinary powers, trustees and custodians of a community's "conscience and knowledge". If, then, we speak of forms, number and figures, attention must also be given to alchemy, a wisdom that is mysterious, timorous and at times even victim of persecution, of apparent meanings.

These figures by Paladino could even represent medieval alchemists, those thinkers who said they possessed the "stone of madness", the mythical "philosophers' stone". Yet it is essentially the numbers and the geometric forms that attract and "condition" the artist because they are essential tools of his imaginative alchemy.

In our culture, the concept of perfection is entrusted to number; it is the only instrument we have to define the incommensurable, the infinite. Aesthetic expression and the golden section have, moreover, always had something to do with "measure", that is, geometry.

Surely Paladino's six "mathematicians" manipulate Fibonacci's magic numbers and already know "zero and fire", but they also have the aura of unspeakable seduction, dressed in sumptuous clothes. The forms and the numbers that adorn their figures appear clearly symbolic, like the decoration of a priestly vestment.

These figures pose continuous questions without worrying much about giving credible or comprehensive answers. Perhaps this is because—as Duchamp once said of the alchemic artist and even himself—Paladino and his mathematicians think in the dream of art and as such "know not what they do".

Venice, Italy Enzo di Martino
March 2019

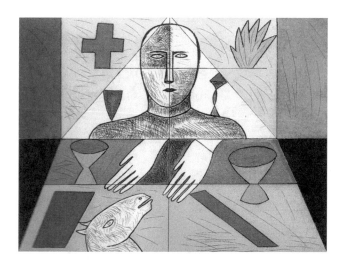

Fig. 1 *Matematico 1*, 2001 etching, 8-colour aquatint, 300 × 408 mm slab, © Mimmo Paladino & Art of this Century, New York—Paris

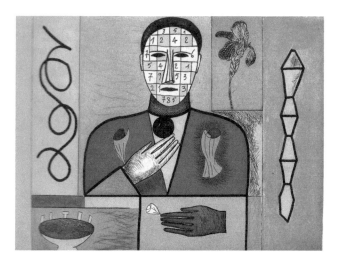

Fig. 2 *Matematico 2*, 2001 etching, 8-colour aquatint, 300 × 408 mm slab, © Mimmo Paladino & Art of this Century, New York—Paris

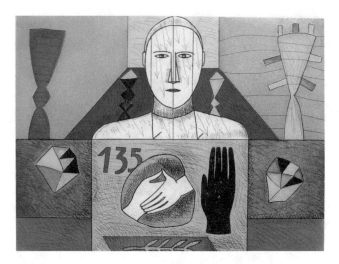

Fig. 3 *Matematico 3*, 2001 etching, 8-colour aquatint, 300 × 408 mm slab, © Mimmo Paladino & Art of this Century, New York—Paris

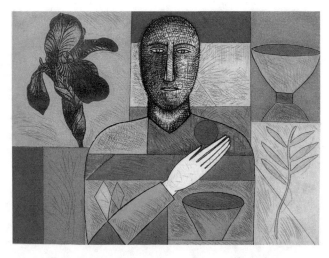

Fig. 4 *Matematico 4*, 2001 etching, 8-colour aquatint, 300 × 408 mm slab, © Mimmo Paladino & Art of this Century, New York—Paris

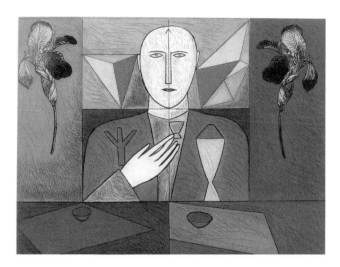

Fig. 5 *Matematico 5*, 2001 etching, 8-colour aquatint, 300 × 408 mm slab, © Mimmo Paladino & Art of this Century, New York—Paris

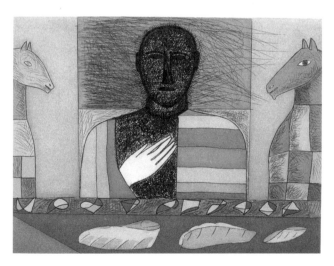

Fig. 6 *Matematico 6*, 2001 etching, 8-colour aquatint, 300 × 408 mm slab, © Mimmo Paladino & Art of this Century, New York—Paris

Part I
Homage to Bauhaus

Homage to Bauhaus, April 1, 1919

Michele Emmer

The *Staatliches Bauhaus* or simply *Bauhaus* (building house) was founded by Walter Gropius in Weimar, Germany, in 1919. The opening date is considered April 1, 1919. One hundred years later the meeting of *Mathematics and Culture*, *Imagine math 7*, took place in Venice with the opening dedicated to the Bauhaus anniversary. In April 1919 Gropius wrote a text that is usually called *Bauhaus Manifesto* (Programs Staatlichen Bauhauses in Weimar) in which he traced the guidelines of the *Bauhaus*: Charles W. Haxthausen wrote in the catalogue of the important exhibition *Workshops for Modernity: Bauhaus 1919–1933,* at *the MoMa, The Museum of Modern Art*, in New York, November 8, 2009–January, 25, 2010 [1]:

> The *Manifesto* is the founding proclamation of an institution that has become synonymous with visual modernity, exerting a profound influence on design, artistic practice, and art education that extends down to our own day . . . The text is a fervently utopian one-page mission statement and two-page program outlining the principles and pedagogical organization of the school. The text precedes from the premise that painting, sculpture and architecture, once integrated in a *great building* have become mutually isolated, to the detriment of all three. The goal of the *Bauhaus* is to reunite them . . . Gropius concludes his *Manifesto* with a heady exhortation:
>
> Let us collectively desire, conceive, and create the new building of the future, which will be everything in one structure: architecture and sculpture and painting, which . . . will one day rise together towards heaven as the crystalline symbol of a new and coming faith.

The school started in Weimar from 1919 to 1925, then in Dessau from 1925 to 1932 and in Berlin from 1932 to 1933. Gropius was the director from 1919 till 1928. Hannes Meyer from 1928 till 1930, and Ludwig Mies van der Rohe from 1930 until 1933 when the school was closed under the pressure of the Nazi regime.

M. Emmer (✉)
Sapienza University of Rome (retired), Rome, Italy

IVSLA – Istituto Veneto di Scienze, Lettere ed Arti, Venice, Italy
e-mail: emmer@mat.uniroma1.it

© Springer Nature Switzerland AG 2020
M. Emmer, M. Abate (eds.), *Imagine Math 7*,
https://doi.org/10.1007/978-3-030-42653-8_1

Mathematics, Geometry had an important role in the years of the Bauhaus. In the volumes of the series *Mathematics and Culture* and *Imagine math* several papers were dedicated to geometry, mathematics and the Bauhaus, in particular in connection with Paul Klee, Wassily Kandinsky and Max Bill [2–7]. It was Gropius who asked Paul Klee to become one of the teachers at the Bauhaus in 1920. Kandinsky was at the Bauhaus between 1922 and 1933. Bill was a student at the Bauhaus. After learning that a new Bauhaus was to open in Dessau, Bill applied and was accepted in April 1927 aged 18. Bill left the Bauhaus after 2 years without a diploma "but with a lot of energy and ideas" wrote Angela Thomas Schmid *(The Max Bill Georges Vantongerloo Stiftung and Hauser & Wirth)*, the curator for the centenary of Bauhaus of a major exhibition in Zurich devoted to Max Bill.

References

1. C.W. Haxthausen, Walter Gropius and Lyonel Feininger Bauhaus Manifesto, in *Workshops for Modernity: Bauhaus 1919–1933*, ed. by B. Bergdoll, L. Dickerman, catalogue; *MoMa, The Museum of Modern Art*, New York, November 8, 2009–January 25 2010, pp. 64–67
2. D. Guderian, Mathematics in contemporary arts – finite and infinity, in *Mathematics and Culture II*, ed. by M. Emmer, (Springer, Heidelberg, 2005), pp. 23–37
3. M. Emmer, Abstraction, in *Mathematics and Culture VI*, ed. by M. Emmer, (Springer, Heidelberg, 2009), pp. 173–182
4. R. Giunti, Strands of complexity in art: Klee, Duchamp and Escher, in *Mathematics and Culture III*, ed. by M. Emmer, (Springer, Heidelberg, 2012), pp. 97–107
5. A.C. Quintavalle, Max Bill at the Bauhaus between Klee and Kandinsky, in *Imagine Maths 4*, ed. by M. Emmer, M. Abate, M. Villarreal, (UMI & IVSLA publisher, Bologna, 2015), pp. 5–14
6. C. Leopold, The mathematical approach at Ulm School of Design, in *Imagine Maths 4*, ed. by M. Emmer, M. Abate, M. Villarreal, (UMI & IVSLA publisher, Bologna, 2015), pp. 15–27
7. M. Emmer, Max Bill: a journey through memories, in *Imagine Maths 4*, ed. by M. Emmer, M. Abate, M. Villarreal, (UMI & IVSLA publisher, Bologna, 2015), pp. 29–43

Paul Klee's "Honey-Writing" Some Reflections on the Relation of Automatism, Automation, Machines and Mathematics

Michael Rottmann

> *Being capable to recognize a clear structure, I will get more from this as from a lively, imaginary construction, and something typical will result of series of examples automatically.*[1]
>
> Paul Klee 1902/1903 (23-years old)

Introduction

It may sound like a disenchantment: Paul Klee (1879–1940) devoted himself to mathematics. Among other things he dealt with perspective, arithmetics (golden section), topology and combinatorics (see [2], p. 133–135, 231–232, 252–253, [3], p. 338). He owned books like *Mathematisches Unterrichtswerk für höhere Schulen* (1929) [*Textbook Mathematics for Secondary Schools*] by Reinhard Zeisberg, *Lebendige Mathematik* (1929) [*Vivid Mathematics*] by Felix Auerbach and *Geometrisches Zeichnen* (1920) [*Geometrical Drawing*] by Hugo Becker; The latter served, marked up with pink notes, for preparation of lessons at the Bauhaus (see [4], p. 38). If necessary, for example to gain "objectification and utmost precision" in "pure geometric constructions", the artist used for his artworks a "technical equipment" like "drawing pen, pair of compasses, level, angular measure [and] stencil" (see [5], p. 22) (Fig. 1). Taking "mathematical-abstract means of artistic expression" and "geometric-constructive design principles" into consideration, Christian Geelhaar even spoke of a "mathematization of the creative process" with a view to Klee´s drawings around 1930 (see [6], p. 22, 63) (Fig. 2). This corresponds with a "technological-rational objective" of the Bauhaus, which had begun with

[1] Here quoted after [1], p. 10 (All quotations translated by myself).

M. Rottmann (✉)
Academy of Art and Design FHNW Basel, IXDM – Institute of Experimental Design and Media Cultures, Basel, Switzerland

© Springer Nature Switzerland AG 2020
M. Emmer, M. Abate (eds.), *Imagine Math 7*,
https://doi.org/10.1007/978-3-030-42653-8_2

Fig. 1 Paul Klee, Studio with rulers (Castle Suresnes, Werneck-street 1, Munich, 1920), in [1], p. 15

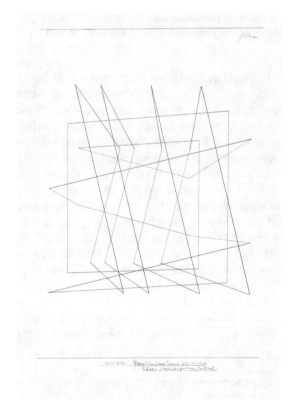

Fig. 2 Paul Klee, *Spiegellauf eines Thema über 4 kubische Flächen (centralperspectivische Grundconstr.)* (1931), 220, pen on paper on cardboard, 47.9 × 31.4 cm, Zentrum Paul Klee, Bern. Photo: Zentrum Paul Klee, Bern

its movement from Weimar to Dessau in 1925 (see [5], p. 22). A "scientific-rational thinking" predominated especially since 1928 with the headship of architect Hannes Meyer (see [7], p. 33).

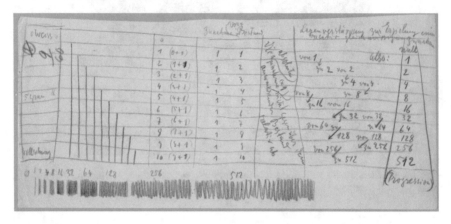

Fig. 3 Paul Klee, *Bildnerische Gestaltungslehre: I.2 Principielle Ordnung* (undated), crayon on paper (recto), 15/14.3 × 33 cm, Zentrum Paul Klee, Bern, Inv. Nr. BG I.2/175. Photo: Zentrum Paul Klee, Bern

Mathematics was linked by Klee to his artistic subjects like dynamics, movement or vibration (see [5], p. 8, [1], p. 18–21). So a huge amount of mathematical notes can be found in his graphical sheets and (pedagogical) writings: They are criss-crossed by series of numbers, geometrical design drawings, "examples of shaping and diagrams" as well as charts with numerical entries ([5], p. 7). One has to consider: Klee was rooted in drawing: since he was a child he did drawings, which led him to painting ([5], p. 7). In particular he described issues of creation with numerical orders.[2] For example exists a sheet of his *Principielle Ordnung* (*Bildnerische Gestaltungslehre*), on which he described the principle of a gradual overlay of colours for transitions from "white" via "grey" to "black" graphically, diagrammatically in a chart and last but not least numerically with a geometrical "progression" (Fig. 3).[3] Klee noted once: "The artificial measurement allows a numerical exact control of steps and with it a synthetic way of proceeding in the representation of scales from brightness to darkness" (see [1], p. 10).

In such a way Klee worked in his watercolour *Zwei Gänge* (1932) (Fig. 4) and before in his *black-watercolours* (*Schwarzaquarelle*) like *Uhr auf der Kredenz, bei Kerzenlicht* (1908) and *Blick in eine Schlafkammer* (1908) (see [5], p. 12) (Fig. 5).

[2]Several publications in Klee's estate like *Farbennormung auf mathematischer Grundlage* by K. Koelsch Munich (undated) show his interest in an arithmetical treatment of artistic issues. See [8].

[3]Something comparable can be found in colour theory (earlier in Michel Eugène Chevreul, later in Josef Albers).

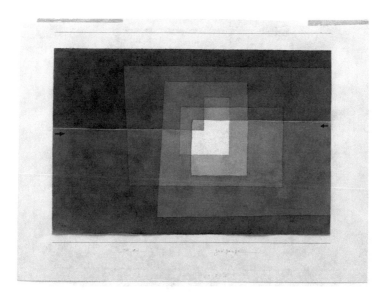

Fig. 4 Paul Klee, *Zwei Gänge* [*Two Ways*] (1932), watercolour on paper, mounted to paper, 31.3 × 48.4 cm, mount: 44.3 × 61 cm, Solomon R. Guggenheim Museum, New York, Estate of Karl Nierendorf, by purchase. Photo: © Solomon R. Guggenheim Museum

Geelhaar explained: "he summarized layer by layer of diluted black watercolour, to move stepwise into a shady darkness". In doing so he kept "the steps of tones from white to black pure" ([5], p. 12, [6], p. 21). Following Geelhaar a "mathematical light-dark-proportion" arose of it, whereat Klee had remarked that the "structured arrangement" reminds of "gamuts" and "musical scales" ([5], p. 12–13). There is talk about a "light-dark-procedure of time measurement" (see [6], p. 23). Music played for Klee in his whole life an important role. His father was a music teacher, his mother a singer (see [6], p. 14, [5], p. 9). Klee himself played excellently violin and wrote reviews; music, he once explained, would be a "lover", but painting an "oil-smelling brush-goddes, which I only embrace, because of being my wife" (see [3], p. 336).

Music anyhow can explain why Klee worked in fine arts with notations (see [3]), what will be discussed later in more detail, and as a time-based artform it offers a reference to problems like "movement" as well as "space and time", which were so important for the artist (see [6], p. 10). It was one of his central tasks to mediate movement or chronological sequence in a static image (see [5], p. 8–9). One solution was colour gradients. Like in *Scheidung Abends* (1922) and in *Statisch-Dynamische Steigerung* (1923) they evoke dynamics and direct the gaze of the viewer—here in

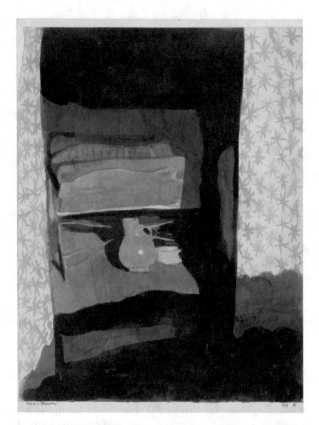

Fig. 5 Paul Klee, *Blick in eine Schlafkammer* (1908), watercolour on paper, mounted to cardboard, 30 × 23.6 cm, Kunstmuseum Basel. Photo: Kunstmuseum Basel, public domain: http://sammlungonline.kunstmuseumbasel.ch/eMuseumPlus (20.09.2019)

a vertical or spiral way (Figs. 6 and 7).[4] Klee took the view that media of fine arts are time-based and that was why he criticised Lessing's *Laokoon* (see [9], p. 78).

With a view to the foregoing the following description about Paul Klee is quite well understandable: in the case of Klee we have a "highly reflected, technical subtle art" ([10], p. 100). This was said to distinguish his creative activity from "the surrealist practice of loss of control", because Klee's one was treated again and again by the surrealist's automatic writing (*écriture automatique*).[5] One thing is for certain, Klee knew the surrealists and in 1925 they had a common exhibition in Paris (see [5], p. 29). But even the first French review disagreed the view of Louis Aragon that Klee got his artworks "dictated automatically" by his subconscious, because his art is about planned spontaneity (here quoted after [11], p. 12). Since

[4]On the theorisation by Klee see [1], p. 10.

[5]Recently the exhibition *Paul Klee und die Surrealisten* at Zentrum Paul Klee, Bern was dealing with that connex (see [10]).

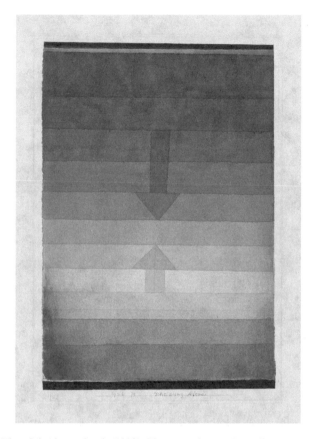

Fig. 6 Paul Klee, *Scheidung Abends* (1922), 79, watercolour and pencil on paper on cardboard, 33.5 × 23.2 cm, Zentrum Paul Klee, Bern, Gift Livia Klee. Photo: Zentrum Paul Klee, Bern

then the connex is rated in the research debate as ambivalent.[6] While Uwe M. Schneede saw the issue as purely "superficial", Michael Baumgartner pled for a relativisation of this view, he asked to consider that the "psychic automatism" has been an important aspect in Klee's "artistic self-discovery"—but that has happened earlier than the surrealists (see [11], p. 12); drawing had been described by Klee as a "primordial territory of psychological improvisation", the related drawings as "psychograms" (here quoted after [10], p. 100). In this sense Christian Geelhaar saw in such drawings, "in which inner feelings and the unconscious tell themselves suddenly to the seismographically registering hand" a counterpart to the objective ones of the Dessau period mentioned before, which are "cleaned from subjective movement" (see [5], p. 22). As an example the art historian gave *bewölktes Gebirg*

[6]Concerning the discourse see [11], footnote 31.

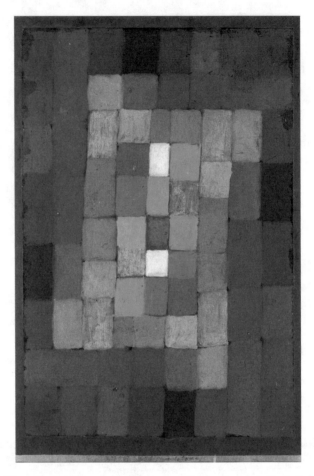

Fig. 7 Paul Klee, *Statisch-Dynamische Steigerung* [*Static Dynamic Gradation*] (1923), oil and gouache on paper bordered with gouache, watercolour, and ink, mounted on cardboard, 38.1 × 26.1 cm, The Met, The Berggruen Klee Collection, 1987. Photo: bpk | The Metropolitan Museum of Art

(1932) with its mellifluous pencil lines, which are drawn through, what goes also for *die Bucht* (1930) (Fig. 8) and *Baumschlag* (1931). Geelhaar explained: "The intellectual control in the creative process is turned off as far as possible and the invention is given over to the automatically gliding inkstand" ([5], p. 22). But a closed line could become (with regard to Ludwig Klages' physiognomy of movement) also an "expression of ratio", at any rate when it appears as a zig-zag band with sudden changes of direction like in *Der Wille* (1933) (Fig. 9), how Régine Bonnefoit suggested (see [12], p. 56–57). Anyway, Klee called his procedure of a

Fig. 8 Paul Klee, *die Bucht* (1930), 96, pencil on paper on cardboard, 32.9 × 41.9 cm, Zentrum Paul Klee, Bern

mellifluous graphical expression laconically and perhaps as a replica to the *écriture automatique*: "honey-writing" ("Honigschrift") (here quoted after [5], p. 22).[7]

It is hardly surprising that a tension was made out in research literature: On the one hand exists the "painter of enchanted fairytales and dreamworlds, which he showed off to advantage in his pictures out of a highly imaginative internalization as it were a psychic automatism, like postulated by the surrealists" [8] On the other hand becomes clear, "that he made his pictures often in a calculating and planned manner" (see [13], p. 7, [14], p. 9).[9] An explanation for this phenomenon can be deduced from the coupled terms "intuition" and "construction" as they were used by Klee.[10]

[7]We have to consider that he did not speak about "honey-graphics" ("Honiggrafik").

[8]Klee himself backed up this view in his dairies and notes (see [13], p. 7).

[9]Very similarly Itten said in retrospect: "The creative automatism was recognized by myself as one of the most important factors of artistic production. I worked myself with geometrical-abstract images, which were based on careful constructions" ([15], p. 9).

[10]Which was subject of an exhibition of Mannheimer Kunsthalle in 1990 (see [13]). Here it becomes clear that art history also reproduces a dualistic thinking, which postructuralism would like to know as overcomed (see [16]).

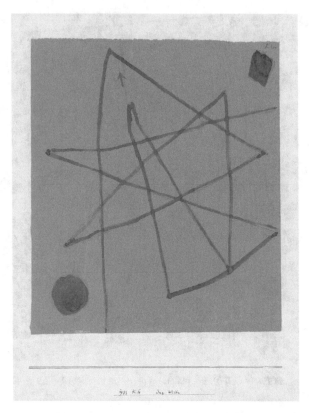

Fig. 9 Paul Klee, *Der Wille* (1933), 11, brush on grounding on paper on cardboard, 31.5 × 27.8 cm, private collection Switzerland, permanent loan Zentrum Paul Klee, Bern

"Intuition" was understood in general language usage of the 1920s in Germany according to Henri Bergson as an "intuitive, immediately imagined insight, without intellectual operation" (see [17], p. 498). It is remarkable that "intuition" and "construction" were also treated in the 1920s in mathematics—within so-called Intuitionism of Dutch mathematician Luitzen Egbertus Jan Brouwer (see [18], p. 191).[11]

In our context the coupled terms are also of interest, because Klee in his text *Exakte Versuche im Bereich der Kunst* (1928) connected them with art and sciences and said in the course of this something about the role of mathematics. While art

[11] An examination of the relation of these terms would be interesting, but cannot be done here.

works with intuition, following Klee, sciences are exact and "logical".[12] But also
in arts "exact research" would be possible and: "Mathematics and physics provide
for it a way of handling in sort of rules for backpedalling and for difference" ([19],
p. 69). At Bauhaus such an approach of receiving scientific procedures in fine arts
could find favour: for architects this was daily business and Klee's colleague and
compatriot Johannes Itten had even studied mathematics (see [20], p. 12). Klee
praised the advantages of this approach, but he was also warning that intuition and
genius would be indispensable in fine arts (see [19], p. 69–70).

 Against this background hereafter the role of mathematics in the creative process
and its conception will be examined in a perspective of production aesthetics. (There
shall be no proof of the reception of certain mathematical issues or its reconstruction
in artworks.) This will be done with a view to Klee's drawings[13] as well as his other
graphical and written output. A focus is on his Bauhaus years—Klee had begun
to teach in 1920 at Weimar as a master and changed in 1931 to the Academy of
Fine Arts in Düsseldorf.[14] On the one hand the development of his pedagogy was
accompanied by a reflection of his own creative work; for him practice, theory and
teaching should "go together" (see [1], p. 9, 21, 30). On the other hand during his
"Bauhaus-decade" Klee dedicated himself increasingly to "principles" whereby the
tension of "schematism" and "phantasy" appeared (see [5], p. 19–20).

 In a first part Klee's theory of creation (Schöpfungstheorie) will be reconstructed
together with his terms "intuition" and "construction" and the role of mathematics
demonstrated. This enables a clarification of the relation to surrealist automatism.
In a second part shall be examined in which way Klee's graphisms—notations and
operative images like diagrams, which he used in a very different manner—were
useful for his creative process (see [21]). This examination is also about questions of
finding an image or an artwork (Bild- bzw. Werkfindung). With respect to this I will
refer to theories of design, draft, notation, diagrammatics and notational iconicity.
One hypothesis is that in the work of Klee, who had a pronounced interest in
machines, mathematics and his machine thinking are connected and with regard
to the concept of "symbolic machines" (see [22], p. 3) by Sybille Krämer, that
especially the mathematical plays together with his graphical machines to realise
a kind of automation—the already mentioned adjective "automatic" also relates
to this meaning—and in this way an oblivion of sense. Thus the mathematical
mediates between construction and intuition. That is why the approach here is to
think automatism, automation, machines and mathematics together.

[12]In sciences intuition would be helpful and speeds up, but not absolutely necessary (see [19], p.
69).

[13]Here will be focused on drawings, because the work processes in Klee are in principle extending
over longer periods up to years (see [12], p. 11).

[14]He had almost a vocation at the Academy of Fine Arts in Stuttgart as a successor of Adolf
Hoelzel (see [1], p. 17).

Klee's Theory of Creation: Construction/Intuition

Construction and intuition seem to be in a tension, especially with regard to "Klee's demand for [...] freedom of the artist" (see [14], p. 9). In contrast to this Hans-Jürgen Buderer demonstrated an explanatory model, which mediates.[15] According to him the relation could not be resolved by a replacement of construction by intuition, rather exists an interplay of opposites, a "necessary dipolarity of two basically interdependent moments of creative labor [...]" (see [14], p. 10), which was also pointed by Klee. In *Exakte Versuche* the artist had explained: "We construct and construct, but intuition is still a good thing. Without it one can do considerable things, but not all" ([19], p. 69). On the basis of a reconstruction of his writings Buderer described intuition as an "area", "in which the artist creates, independent from the forms of appearance of nature and its inner structures, a new autonomous order of image-effective relations" (see [14], p. 19).[16] In doing so he would be obliged to the "laws of creation" ("Gesetze[n] des Bildnerischen", [14], p. 19), which he could not determine himself, because they would be "immanent to the means of creation" ("bildnerischen Mittel[n]").

This and in particular Klee's "demand for an exact analysis of the means of creation" (see [14], p. 14) becomes better understandable with a more exact consideration of his theory of creation (Schöpfungstheorie). (In the 1920/30s one speaks in German language about "creation" ("Schöpfung", see [23], p. 780) in the sense of a "creative act" ("Schaffensakt") instead of "creativity".) This is also instructive, because his thinking about nature and machines appears in it. An essential precondition for artistic work Klee saw in the knowledge of "visual basic elements" ("bildnerischen Grundelemente", [14], p. 9) like line, light–dark tone and colour, on which he focused firstly in his teaching. He analysed extensively the appearance, the kinesic behaviour as well as the ways of expressions of lines and areas (see [14], p. 11). The course of his teaching programme shows that his examinations went on successively from "single visual basic elements" (see [14], p. 12) via its "relational dependences" to "a regularity [in the sense of a principle], which determines the unity of appearance". Dealing with mathematics and physics could be helpful for this purpose, at first with functions then with forms, how he advised in *Exakte Versuche* (see [19], p. 69). Furthermore he explained:

> Algebraic, geometric tasks are moments of training towards the essential and the functional in opposite to the impressive. One learns to see behind the curtain, seizing a thing by its root. One learns to recognize what pours underneath, learns the prehistory of the visible. Learns digging into depth, learns to uncover. Learns to give reasons, learns to analyse ([19], p. 69).

[15]Related reflections on transcendental, religious and metaphysical aspects cannot be considered here (see [7]).

[16]With this concept raises the discussable question: Does not the artist become a creator, who overcomes the regularities and constraints of the world?

Klee was especially interested in the relational interplay of visual basic elements. Long before structuralist thinking of the 1960s (and its reception in fine arts) he used the term "structure" (see [2], p. 217) and was speaking about the image as a "set of structures" (here quoted after [14], p. 13), when a pictorial unit repeats regularly or rhythmically. Klee pursued the essential, procedural and functional. In nature— which he called an "original area of creation" (see [6], p. 54–55)—structures as well as processes could be studied and transformed into regularities.

In his lecture *Organismus als Bewegungsmaschine* Klee discussed the interplay of bones, bands and muscles of man, in another lecture that one of water, drive belts and wheels with the example of a watermill (Fig. 10) (see [24], p. 345). Following Buderer they are metaphors for universal or cosmic laws, its restrictions and interactions (see [14], p. 13).

In this context Klee himself explained an important aim: "The artistic is about creating movement on the basis of the law and differences with reference to the lawful" (see [2], p. 152). At the same time he warned: "Taking the lawful too seriously will lead into a droughty area" (see [2], p. 152).[17] With the consideration of mathematics and physics one would not only learn "logic", but also "to organize movement by logical relationships" ([19], p. 69). According to Buderer in Klee the image could be seen as an "organism of movement" ("Bewegungsorganismus", see [14], p. 12–13)—to understand this one needs the analysis of the basic elements as mentioned before. Movement can be regarded in every respect as central in Klee: In the process of production and reception (the hand, which draws, the eye, which observes) and finally in the "creative process" (see [14], p. 19, [5], p. 8–9) itself. Buderer explained:

> On the one hand, by requesting the artist to interrupt his action after a first "initial movement" ("Initialbewegung") and to check his arrangement in a receptive manner, and to control, if the way of the eye conclusively follows the parts of the image. On the other hand he sees movement between production and reception, but also as an process of actuating the stepwise developed regularities (see [14], p. 19).

A decisive aspect here is, in a synopsis of the examples mentioned by Klee not only man and machine were brought together, but one can get also with respect to Buderer a characterisation of "intution" and the artist´s conception of "creation": Nature and image behave analogue (see [14], p. 13–14). In each case elements and motion sequences are determined by inner (genetics/ways of expression) and outer conditions (clima/receptive impact). But the example of the watermill shows that its appearance is determined also by its function—"the driving of the hammer" (see [14], p. 13–14)—so the "creative acting gains freedom for an order, which is going beyond the specific means, and which results from the will of the artist to act and shape". And the "freedom of developing an image structure, as much it has to follow its inner law-structure", characterises "the image as creative act, which is in the end

[17]Klee also said "that laws should be only a basis, so it is blooming on them . . . That laws are only common basis for nature and art" (here quoted after [5], p. 20).

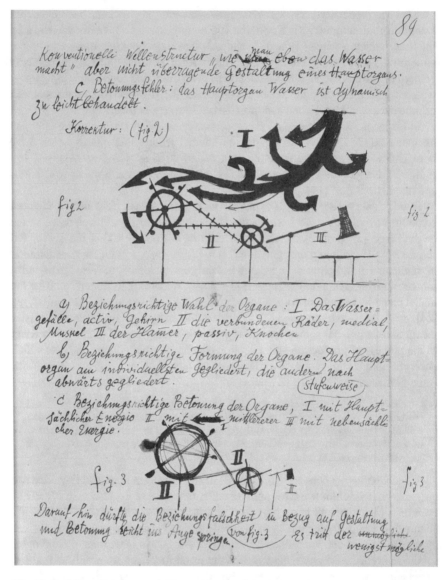

Fig. 10 Paul Klee, *Beiträge zur bildnerischen Formlehre* [water mill] (undated), pen and crayon on paper, 20.2 × 16.3 cm, Zentrum Paul Klee, Bern, Inv. Nr. BF/92. Photo: Zentrum Paul Klee, Bern

independent from nature and forms of appearance of the empiric world" (see [14], p. 13–14). Buderer summarised:

> To uncover the possibilities of a process of creation, which are lying safe in its origin and which can be developed in the course of the complex process of artistic acting, is the benefit of intuition (see [14], p. 21).

In other words, "intuition" is a "mental potential", which serves in the act of creation, "to use the insights concerning the laws of the means of creation like line, light-dark and colour, which were made understandable, in such a way, that the possibilities of creation, hidden in that means, can flower" ([7], p. 34).

At this point a more exact differentiation of Klee and surrealism can be made with Buderer: It seems that surrealism had monopolised Klee, because of his examination of pictorial representation in arts and his anti-academicism, but a closer look shows, while surrealism was aimed at a negation of art, Klee in contrast pursued a "change of traditional forms of appearance and the aesthetic canon of norms" (see [14], p. 22–23). Something comparable goes also for automatism: André Breton diagnosed in his first *Manifest of Surrealism* (1924) the drawing of Klee as "partial automatism" (Breton, here quoted after [14], p. 22) and as statements "from the depths of human mind". According to Breton automatism serves to overcome "positivism, which determines art and sciences with its clarity on the verge of stupidity'" (see [14], p. 23). Infantile fantasy, intuition, emotion and chance would aim at the elimination of "planning mental control" and thus of any "logical structuring" (see [14], p. 23). In this way only the "psychic-physiological state of the artist" should be included in the image (see [14], p. 23). In Klee, on the other hand, the image would be a reification of a "pictorial regularity, an inner logic and conclusiveness", which has to be checked in the process of creation and which shall be fulfilled while observing (see [14], p. 23). Thus it can be said: "Freedom and intuition are means for dealing with the laws of effect concerning the pictorial, but do not question its validity" (see [14], p. 23).[18]

Insofar it is quite fitting that Klee's relationship with mathematics is quite different to that one of the surrealists. For Klee dealing with mathematics was as fruitful as it was with nature and machines, whereas the surrealists pointed out the lack of the mathematical language and did "work on the myth", to legitimise their anti-rationalistic art (see [25], in particular p. 13–14, see also [26], p. 38).

Although one can talk about a general principle of creation in Klee, in which intuition plays an important role, the introduced spectrum of case examples— from geometrical design drawings via prearranged watercolours to drawings in the mode of "honey-writing"—shows that his processes of creation were actually quite different. So we will have now a closer look to his graphical practices.

Painted, Built and Mathematical–Graphical Machines

Already with Klee's watermill metaphor was indications that he owned an interest for mechanical machines. He made them even a subject in his pictures

[18] Klee's conception would be closer to cubism than surrealism.

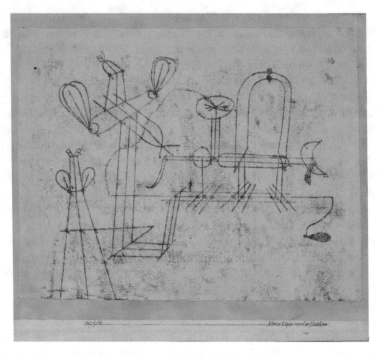

Fig. 11 Paul Klee, *Kleine Experimentier Maschine* (1921), 11, oil transfer drawing and water-colour on paper on cardboard, 23.5 × 31.2 cm, location unknown. Photo: Zentrum Paul Klee, Bern

Zwitscher-Maschine (1922)[19] and *Kleine Experimentier Maschine* (1921) (Fig. 11). We have to consider, in the 1920s machines usually were still understood in Germany as devices, which transmitted forces in a mechanical or electrical manner, but not yet information; this applied to "working machines" in industry, as well as automobiles and airplanes (see [30], p. 205–206). In this direction Klee once said: "The swimmer in the kingdom of heaven (the aviator or sailor) must identify with its machine and unified with it, he can indulge in new possibilities of movement" [31].

In this respect at the Bauhaus machines were not only subjects of paintings, but also built and usable objects. The latter were used as applied machines and as artist's machines. In the sense of the modern spirit design objects were fabricated with machines (in workshops). Lazlo Moholy-Nagy developed 1930 his *Light-Space-Modulator* (*Licht-Raum-Modulator*), which was introduced at an exhibition of German design in the same year as a generator for lighting and motion effects on

[19]The work was interpreted as a satire of labour sciences (see [27], p. 79), as a questioning of the purpose of machines (see [28], p. 84) and as a proof for Klee's general interest in the relations of animal and machine as well as organism and mechanism (see [29], p. 240–241).

a stage—dynamics was an important parameter of modernity from which futurism bears witness.[20] From a today's point of view this machine creates ephemeral moving images. Klee himself, who understood the image of a traditional panel painting as a "moving machine" ("Bewegungsmaschine", [4], p. 123), reworked around 1940 a commercial projector (see [32, 33]).

A closer look shows that Klee's relationship to machines was ambivalent. When he once in 1921 said that "music without dynamics sounds machine-like and inexpressive", this seems in a certain manner pejorative (see [2], p. 285). There was already a talk in society about a "machine age" (see [30], p. 214). The growing penetration of the world of work was discussed critically in the 1920s, the substitution of man was perceived also as threatening. In this context a statement of Klee appears like a positioning: "How the machine functions, is not bad, how life functions is more. Life fathers and gives birth. When will the worn machine have children?" (see [34], p. 59). Machines were seen as useful, but in comparison with man they were seen as in deficit. An examination of the social dimension was made out in Klee's interest in puppets like in his watercolour *Puppentheater* (1923): "The assault of the machine-world on the body is represented by the puppet, which is in truth, although it shows human features, a pure mechanical being" ([10], p. 210). With a view to its title Klee's watercolour *Analÿse verschiedener Perversitäten* [*Analysis of different perversities*] (1922) can be understood as a critique when the natural, the technical and the human interact in a mechanical manner (Fig. 12). It is remarkable that the watercolour was created in the same year 1922 when Oskar Schlemmer's *Triadisches Ballett* was premiered and early literary treatments of the machine age like Karel Čapek's *W.U.R.—Werstands Universal Robots* (first German translation), which produces our today's term "Robot", and Ernst Toller's *The Machine Wreckers* (*Die Maschinenstürmer*) were published. Both made the man–machine relation an issue. Fritz Lang's film *Metropolis* (1927) and Charlie Chaplin's *Modern Times* (1937) should follow.

Against this background shall be now taken a closer look at Klee's graphisms and his graphical practices. One has to consider quit different contexts and functions: Graphisms can be find in notes, in his theoretical and in his teaching material (for visualisation) as well as in sketches or artwork-like drawings. It is a crucial aspect that the artist did not only work with sketches, to record or prepare ideas in a pictorial manner, but also with graphical means like the list, the chart and the diagram, to develop works on paper. The latter exist also as very complex ones, often filled with extensive calculations—how it could be already seen in the example at the beginning of this text (Fig. 3). Just the notation of the mathematical calculus, which is equipped with a system of rules, was described by media philosopher Sybille Krämer as a "symbolic machine" ([22]), because with it could be operated quasi-mechanically and achieved results, without knowing the meaning of the symbols (to a certain degree). This concept shall serve in the following as a figure of thought, even when Klee worked not with the calculus itself and not only with notations.

[20]For the relationship of futurism, Klee and the machine see [14], p. 22.

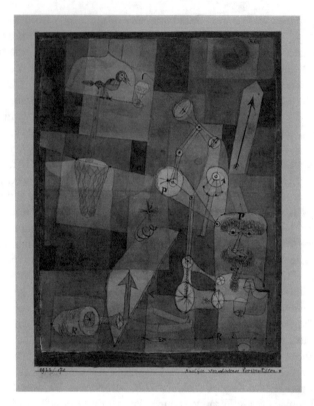

Fig. 12 Paul Klee, *Analÿse verschiedener Perversitäten* (1922), China chalk and watercolour on paper on cardboard, 47 × 31.4 cm, Centre Georges Pompidou, Paris. Photo: Philippe Migeat—Centre Pompidou, MNAM-CCI/Dist. RMN-GP, public domain: https://www.centrepompidou.fr/cpv/resource/cbqL49o/rajyr4g

Rather he made single mathematical procedures his own (Anverwandlung). On a sheet of his *Bildnerische Gestaltungslehre/Specielle Ordnung* he applied geometrical transformations like translation ("Schiebung"), reflection ("Spiegelung") and rotation ("Drehung") on graphical elements (Fig. 13).[21] In particular he did so to generate patterns or formal configurations. Often Klee puts forms of the same kind on a sheet, among them geometrical ones like the triangle or the rectangle, which he subdivided (regularly), so that fields came into being, which could be filled with colours as well as with words, letters or numbers. Well comprehensible Birgit Schneider pointed out: In such a manner issues like colour configurations could not

[21] For the aspect of axis of reflection see [6], p. 82–83. Very similar Klee works in other sheets (see [35], p. 274–275).

Fig. 13 Paul Klee, page of *Bildnerische Gestaltungslehre: I.3 Specielle Ordnung* (undated), pencil and crayon on paper (leaflet, 3d. page), 33 × 21 cm, Zentrum Paul Klee, Bern, Inv. Nr. BG I.3/004. Photo: Zentrum Paul Klee, Bern

only be represented ("Darstellen"), but also be found and tested ("Herstelllen") (see [35], p. 269). Another sheet attests such a work on paper (Fig. 14). It appears like a scientific experiment, when configurations of the four colours red, yellow, blue and black, which were also represented by the letters a, b, c, and d in a 2 × 2-grid, were arranged or let us better say produced in a systematic manner. For it the places of the letters were swapped from top to bottom in line and column and the resulting configurations were subjected to translations and reflections. It fits well that Christian Geelhaar in Klee diagnosed a "wealth of formal inventions" and once identified: "*Experiments* with unusual painting supports and ingenious technical procedures lead to new artistic solutions" (see [6], p. 65, 59). The assignment of letters to colours owns a historico-cultural tradition and can be found also in Klee's

Fig. 14 Paul Klee, page of *Bildnerische Gestaltungslehre: I.3 Specielle Ordnung*, pencil and crayon on paper, 33 × 21 cm, Zentrum Paul Klee, Bern, Inv. Nr. BG I.3/901. Photo: Zentrum Paul Klee, Bern

Fig. 15 Paul Klee, Formungsbeispiel und irreguläre Projektion durch bewegte Veränderung der Grundverhältnisse, in [2], p. 255

Skizzenbuch Bürgi (*sketchbook Bürgi*) of the years 1922–1925 (see [36], p. 197). According to Wolfgang Kersten the "numbered listing of colours and form-motifs" can be read in some cases "like a working instruction for creating a certain image" (see [36], p. 198).

Formation happened in Klee not only in his interplay with combinatorial-arithmetical procedures of mathematics. For instance (deformed) grids served as road systems for potential line structures and controlled the drawer by the layout of the line (Figs. 15 and 16) how it appeared again in the 1960/1970s in conjunction with Frank Stella's *shaped canvas*-paintings and Mel Bochner's *Wittgenstein Illustrations* (see [37], p. 6, [24], p. 301, 307).[22]

The combinatorial moment in Klee—he talked once about "combination of fixed and loosed rhythms" ([39], p. 34)—could be stimulated like in his colleagues Wassily Kandinsky and Josef Albers by chemist Wilhelm Ostwald, who had used his "combinatorial method" ([40], p. 296, [41], p. 325) as a means for creative and interdisciplinary thinking. Also Ostwald started with elementary forms to find new

[22]Klee treated also topics like *Der subjektive Weg* (see [2], p. 175). For the number as a means of formation and arithmetics as a bridge between Europe and America see [38], in particular p. 261.

Fig. 16 Paul Klee, page of *Beiträge zur bildnerischen Formlehre* (undated), pen and pencil on paper, 20.2 × 16.3 cm, Zentrum Paul Klee, Bern, Inv. Nr. BF/92. Photo: Zentrum Paul Klee, Bern

ones, which he developed further to more complex ones by translation, rotation and reflection (see [40], p. 297).

All things considered I want to claim that in Klee graphical machines could be made out. Here are addressed the graphical systems, which often unite pictorial and notational elements and contain conventional mathematical operators or other graphisms tied with rules. An "operative iconicity" ("operative Bildlichkeit" ([42])

with inherent rules found application. With recourse to its "mechanics" Klee could work "mechanical" or rather semi-automatically: in the sense of today's Actor–Network Theory (ANT) the graphical systems take over decisions and actions of the artist to a certain extent (see [35], p. 269, 274–275). This goes together with Klee's theory of creation. It was mechanically connoted and machine-like, especially movement (translations and rotations) and forces played a role. Klee talked for example of "mechanics of subjective elevation" (see [2], p. 165) and "mechanics of latitude". The scale and the mill (with "water wheel", "wheelwork" and "hammer", see [24], p. 346) served for him as didactical media. His lecture notes remind to "technical-physical educational books" ([35], p. 271). With the "generative dimension" (see [35], p. 269) of his graphisms he could be familiar not least by musical notations (see [2], p. 285–286), which serve as operative notations for composing, interpretation and performing. But Klee's graphical systems need not to be necessarily notational systems in the strict sense of Nelson Goodman (see [43], p. 125–127). Finally, just Klee's machine sujets like *Zwitscher-Maschine* (1922), which calls the relationship of fine art and music (see [6], p. 45–46), and *Kleine Experimentier Maschine* (1921), whose title becomes here mission, show that the machine-like was not only a subject, but also a method: in each case served the technique of "oil transfer drawing" as a "mechanical production process", namely by "pushing through, tracing", to "produce an automatic image" (see [44], p. 49)—casually speaking: drawing with "machine oil".

Conclusion

Let us summarise: Klee was not only working with automatism, but also with a kind of automation in the sense of a guiding or even taking over control to a certain degree by rule-based media, one could talk about semi-automation—or to put it in other words: He was working with honey-writing and "machine-writing". The work with graphical machines (on the paper) could become a life of its own in a twofold sense: On the one hand such a practice leads to a growing consideration of the appearance and the properties of the graphism itself (see [45], p. 344); when reached states are reflected and "built-in spontaneous in the further process of form finding", "logical and intuitive actions [...] are interlaced"[23]—thus it appears the same tension like in Klee's theory of creation. On the other hand the graphical practice could reduce the artists thinking and let him even work—in the sense of a symbolic machine—mechanically and with reduced control by consciousness.[24] This leads

[23]The work oscillates between "logical-rational" and "intuitive-experimental" (see [45], p. 344).

[24]Concerning the metaphors of the working process one has to consider: Honey can "flow", but also "slow down". In the latter sense drawing has been described as a productive procedure, because it slows down and thus provides time for rethinking (see [46], p. 48). In that way Klee's term would be a "false friend", because his "honey-writing" is intended to turn off thinking.

to a surprising turn: automatism and automatisation, which are basically different, show similar effects, move closer and stand even in a dialectical relationship.

Against this background it is insightful to include Klee's drawing *Psychoreg-istrierapparat* (1920) in the discussion. The drawing can be understood as a satire of the many graphical recording instruments, which were invented in science of the nineteenth century (see [12], p. 116). The latter were plotting the inner state of a proband in scientific graphics, visualisations, which could be read in turn. Similarly Klee transferred with the method of psychic automatism his inner— direct, but without any technical instrument—in graphics, which were interpreted as described at the beginning of this text in a graphologic manner (namely as honey-writing). Thus one can argue that Klee dealt with this issue not only via the subject of this drawing, but also via the method he used. This applies all the more, when he worked with graphical machines, whereby he touches on the problem of objectivity of scientific procedures based on apparatus and furthermore the resulting artworks could be interpreted no more in a graphologic manner as "psychograms".

Although Klee appreciated the use of scientific procedures in fine arts, he pointed out, that they could not substitute the genius: "One was hard-working; but genius is not diligence, how a wrong slogan means" ([19], p. 70). And he added: "Genius is genius, is grace, is without beginning and end. Is fathering. Genius cannot be trained, because it is not a norm, but a special case" ([19], p. 70). And also his further statements appear like a contribution to the (current) discourse of creativity:

> It is difficult to count on the unexpected. Nevertheless as a guide in person is avant-garde. It blows ahead in the same direction or another direction. Perhaps it is already today in an area, one was thinking little about. Because genius is often heretic for dogma. Has no principle except itself ([19], p. 70).

Acknowledgements This chapter was written in the context of the research project *Automated Innovations. Machine Arts in the 20th and 21st Century in the Tension of Subject, Medium and Process and Its Contributions to the Discourse of Creativity* granted by Swiss National Science Foundation (SNSF). I also want to thank the Zentrum Paul Klee, Bern and The Guggenheim Museum, New York for providing digital images in a generous manner.

References

1. J. Spiller, Einführung. Entstehung der pädagogischen Schriften, in *Paul Klee, Das bildnerische Denken* [1956], ed. by J. Spiller, 3rd edn., (Schwabe & Co., Basel, 1971), pp. 9–31
2. P. Klee, Beiträge zur bildnerischen Formlehre. II. Wege zur Form, wie Form wird, Wege zu den Grundformen. [. . .] [1921/22], in *Paul Klee, Das bildnerische Denken* [1956], ed. by J. Spiller, 3rd edn., (Schwabe & Co., Basel, 1971), pp. 101–292
3. M. Baumgartner, Aspekte der Notation bei Paul Klee, in *Notation. Kalkül und Form in den Künsten, Catalogue* Akademie der Künste Berlin, ed. by H. Amelunxen, D. Appelt, P. Weibel, (Akademie der Künste Berlin, Berlin, 2008), pp. 336–342
4. F. Eggelhöfer, *Paul Klees Lehre vom Schöpferischen*, Dissertation, Universität Bern, Bern, 2012
5. C. Geelhaar, Die Zeichnungen Paul Klees, in *Klee-Zeichnungen: Reise ins Land der besseren Erkenntnis*, ed. by C. Geelhaar, (DuMont Buchverlag, Köln, 1981), pp. 7–27

6. C. Geelhaar, *Paul Klee. Leben und Werk* (DuMont Buchverlag, Köln, 1977)
7. D. Teuber, Intuition und Genie. Aspekte des Transzendenten bei Paul Klee, in *Paul Klee: Konstruktion – Intuition, Catalogue* Kunsthalle Mannheim, ed. by Kunsthalle Mannheim, (Verlag Gerd Hatje, Stuttgart, 1990), pp. 33–43
8. P. Klee, *Bildnerische Gestaltungslehre*, I.2 *Principielle Ordnung*, BG I.2/185, Archive Zentrum Paul Klee, Bern
9. P. Klee, Schöpferische Konfession [1920], in *Paul Klee, Das bildnerische Denken* [1956], ed. by J. Spiller, 3rd edn., (Schwabe & Co., Basel, 1971), pp. 76–80
10. M. Baumgartner, N. Zimmer (ed.), *Paul Klee und die Surrealisten*, *Catalogue* Zentrum Paul Klee Bern, (Hatje Cantz Verlag, Berlin, 2016)
11. M. Baumgartner, Paul Klee und die Surrealisten, in *Paul Klee und die Surrealisten*, *Catalogue* Zentrum Paul Klee Bern, ed. by M. Baumgartner, N. Zimmer (Hatje Cantz Verlag, Berlin, 2016), pp. 8-39
12. R. Bonnefoit, *Die Linientheorie von Paul Klee* (Michael Imhof Verlag, Petersberg, 2009)
13. M. Fath, Vorwort, in *Paul Klee: Konstruktion – Intuition, Catalogue* Kunsthalle Mannheim, ed. by Kunsthalle Mannheim (Verlag Gerd Hatje, Stuttgart, 1990), p. 7
14. H.-J. Buderer, Konstruktion – Intuition, in *Paul Klee: Konstruktion – Intuition, Catalogue* Kunsthalle Mannheim, ed. by Kunsthalle Mannheim, (Verlag Gerd Hatje, Stuttgart, 1990), pp. 9–24
15. J. Itten, *Mein Vorkurs am Bauhaus, Gestaltungs- und Formenlehre* (Verlag Otto Maier, Ravensburg, 1963)
16. G. Deleuze, *Differenz und Wiederholung*, transl. by J. Vogl (Fink Verlag, München, 1992)
17. Brockhaus. Handbuch des Wissens in vier Bänden, vol. 2: F-K, 6. gänzlich umgearbeitete und wesentlich vermehrte Auflage von Brockhaus kleinem Konversationslexikon (F. A. Brockhaus, Leipzig, 1926)
18. K. Mainzer, *Geschichte der Geometrie* (Bibliographisches Institut, Mannheim, 1980)
19. P. Klee, Exakte Versuche im Bereiche der Kunst [1928], in *Paul Klee, Das bildnerische Denken* [1956], ed. by J. Spiller, 3rd edn., (Schwabe & Co., Basel, 1971), pp. 69–71
20. P. Klee, Beiträge zur bildnerischen Formlehre. III. Die Grundbegriffe des Werdens [...], in *Paul Klee, Das bildnerische Denken* [1956], ed. by J. Spiller, 3rd edn., (Schwabe & Co., Basel, 1971), pp. 293–430
21. *Johannes Itten: das Frühwerk 1907–1919*, Catalogue Kunstmuseum Bern, ed. by J. Helfenstein, H. Mentha (Kunstmuseum Bern, Bern, 1992)
22. *Notationen in kreativen Prozessen*, ed. by F. Czolbe, D. Magnus (Königshausen & Neumann, Würzburg, 2015)
23. S. Krämer, *Symbolische Maschinen. Die Idee der Formalisierung im geschichtlichen Abriss* (Wissenschaftliche Buchgesellschaft, Darmstadt, 1988)
24. Der Große Brockhaus, Handbuch des Wissens in zwanzig Bänden, 15. völlig neubearbeitete Auflage von Brockhaus Konversations-Lexikon, vol. 16: Roc-Schq (F. A. Brockhaus, Leipzig, 1935)
25. G. Werner, *Mathematik im Surrealismus* (Jonas Verlag, Marburg, 2002)
26. M. Rottmann, Ausgerechnet...Mathematik und konkrete Kunst, in GDM-Mitteilungen, 83/2007, Berlin, pp. 36–46
27. D. Kenney, D. Wheye, *Humans, Nature, and Birds: Science Art from Cave Walls to Computer Screens* (Yale University Press, New Haven, CT, 2008)
28. A.C. Danto, *Encounters & Reflections: Art in the Historical Present* (University of California Press, Berkeley et al., CA, 1997)
29. O. Werckmeister, *The Making of Paul Klee's Career. 1914-1920* (University of Chicago Press, Chicago/London, 1989)
30. Der Große Brockhaus, Handbuch des Wissens in zwanzig Bänden, 15. völlig neubearbeitete Auflage von Brockhaus Konversations-Lexikon, vol. 12: Mai-Mud (F. A. Brockhaus, Leipzig, 1932)
31. P. Klee, *Bildnerische Formlehre*, BF/68, Archive Zentrum Paul Klce, Bern

32. W. Fuchs, »Ein lang gehegter Wunsch«, der Projektionsapparat von Paul Klee, in Zwitscher-Maschine, No. 2 (Summer 2016), pp. 96–98

33. W. Fuchs, »Ein lang gehegter Wunsch«, der Projektionsapparat von Paul Klee [Fortsetzung], in Zwitscher-Maschine, No. 5 (Spring 2018), pp. 128–129

34. P. Klee, Die Dinge in der Natur, auf ihr Inneres untersucht. Wesen und Erscheinung, in *Paul Klee, Das bildnerische Denken [1956]*, ed. by J. Spiller, 3rd edn., (Schwabe & Co., Basel, 1971), pp. 59–62

35. B. Schneider, Mit bildnerischen Elementen operieren. Paul Klee und die Struktur der Weberei, in *Notation. Kalkül und Form in den Künsten*, ed. by H. Amelunxen, D. Appelt, P. Weibel, (Akademie der Künste Berlin, Berlin, 2008), pp. 269–278

36. W. Kersten, Kunst als Arbeit: Vinvent van Gogh – Paul Klee – Franz Gertsch, in *Entwerfen und Entwurf. Praxis und Theorie des künstlerischen Schaffensprozesses*, ed. by G. Mattenklott, F. Weltzien, (Reimer Verlag, Berlin, 2003), pp. 191–210

37. M. Rottmann, Kalkulierte Innovationen. Zur Kritik der Systematisierung von Entwurfs- und Innovationsprozessen in der Kunst um 1960, in *Entwerfen mit System, Reihe: Studienhefte Problemorientiertes Design: 10*, by M. Rottmann, C. Mareis, ed. by J. Fezer, O. Gemballa, M. Görlich, (Adocs Verlag, Hamburg, 2020), pp. 123–221

38. R. Crone, Zahlen und Zeichen: Arithmetische Systeme von Paul Klee bis zu Sol LeWitt, in *Europa/Amerika. Die Geschichte einer künstlerischen Faszination seit 1940, Catalogue Museum Ludwig Köln*, ed. by S. Gohr, R. Jablonka, (Museum Ludwig Köln, Köln, 1986), pp. 256–275

39. P. Klee, Gestaltung ist mit der Bewegung verbunden. Triebkräfte und Grenzen, in *Paul Klee, Das bildnerische Denken [1956]*, ed. by J. Spiller, 3rd edn., (Schwabe & Co., Basel, 1971), pp. 24–38

40. T. Hapke, Wilhelm Ostwald's Combinatorics as a link between in-formation and form. Library Trends 61(2), (2012), pp. 286–303

41. L. Barrière, Combinatorics in the art of the 20th century, in *Conference Proceedings Bridges Waterloo 2017: Mathematics, Art, Music, Architecture, Education, Culture*, ed. by D. Swart, C. Séquin, K. Fenyvesi, (Tesselations Publishing, Phoenix, AZ, 2017), pp. 321–328

42. S. Krämer, Operative Bildlichkeit. Von der ›Grammatologie‹ zu einer ›Diagrammatologie‹? Reflexionen über erkennendes ›Sehen‹, in *Logik des Bildlichen. Zur Kritik der ikonischen Vernunft*, M. Hessler, D. Mersch (transcript Verlag, Bielefeld, 2008), pp. 94–122

43. N. Goodman, *Sprachen der Kunst. Entwurf einer Symboltheorie*, 2nd edn. (Suhrkamp Verlag, Frankfurt am Main, 1998)

44. E. Seibert, Klees Kleine Experimentier Maschine und prähistorische Malereien im Museum of Modern Art (1937), in Zwitscher-Maschine, No. 2 (Summer 2016), pp. 44–54

45. G. Hasenhütl, Zeichnerisches Wissen, in *Kulturtechnik Entwerfen. Praktiken, Konzepte und Medien in Architektur und Design Science*, ed. by D. Gethmann, S. Hauser, (transcript Verlag, Bielefeld, 2009), pp. 341–358

46. M. Reason, Drawing, in *Routledge Handbook of Interdisciplinary Research Methods*, ed. by A. Heller-Nicholas et al., (London, Routledge, 2018), pp. 47–52

Part II
Fields Medals

Maryam Mirzakhani: A Mathematical Polyglot

Elisabetta Strickland

The atmosphere was absolutely electric in the main hall of the COEX, a huge conference centre in Seoul, South Korea, on that unforgettable 13 August 2014: the Opening Ceremony of the 27th ICM (International Congress of Mathematicians) was about to start and 5000 people were sitting there waiting for the names of the four Fields Medalists to be announced.

A large portion of the audience was represented by female mathematicians, for the very simple reason that rumours had been circulating that for the first time a woman would be among the winners and that woman would be Maryam Mirzakhani. She was sitting in the front seats with her blue silk shirt, calm, smiling.

Then her name was officially announced with those of the other three winners: Arthur Avila, Manjul Bhargava and Martin Hairer (see Fig. 1). A novel feature of the ceremony was short films about the winners, produced by Jim Simmons, the American mathematician, hedge fund manager and philanthropist, who, through his foundation, supports projects in mathematics and in research in general.

We could all see on the screen Maryam in her home in Palo Alto, California, kneeling with a felt-tip pen in her hand, doodling on vast white sheets of drawing paper unrolled on the floor of her room, to the amusement of her toddler Anahita, who believed she was painting instead of drawing Riemann surfaces (see Fig. 2).

When her name was announced, an incredible roar went up in the hall, tears came to the eyes of all the women who attended the ceremony and they all stood up screaming in joy because, all of a sudden, it was true: for the first time after so many editions of the ICM since 1897, a woman had received the Fields Medal, the most coveted award in mathematics since 1936. The citation by the IMU Fields Medal

E. Strickland (✉)
Dipartimento di Matematica, University of Rome "Tor Vergata", Rome, Italy

Gender Interuniversity Observatory, University of Roma TRE, Rome, Italy
e-mail: strickla@mat.uniroma2.it

© Springer Nature Switzerland AG 2020
M. Emmer, M. Abate (eds.), *Imagine Math 7*,
https://doi.org/10.1007/978-3-030-42653-8_3

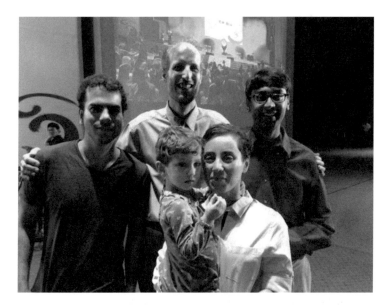

Fig. 1 Maryam Mirzakhani in Seoul, together with the other 2014 Fields Medal winners: Arthur Avila, Manjul Bhargava and Martin Hairer. Author: Gert-Martin Greuel. Source: Archives of the Mathematisches Forschunginstitut Oberwolfach. Permission granted by the author

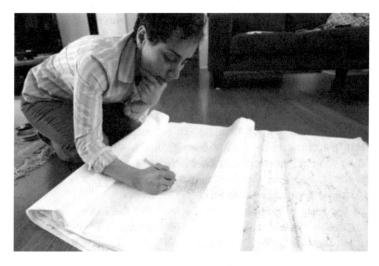

Fig. 2 Maryam in her home in Palo alto, kneeling with a felt-tip pen in her hand drawing Riemann surfaces. Courtesy of Seoul 2014 ICM Press Office

Committee was "for her outstanding contributions to the dynamics and geometry of Riemann surfaces and their moduli spaces".

Maryam was 37 years old at that time. Even if it was known that she was undergoing therapy for breast cancer, people dismissed the thought from their

Fig. 3 Maryam when she was a little girl dreamed to become a novelist. Wikipedia Commons

minds, that was a time for optimism. Unfortunately, 3 years later on July 2017 she died, her body had not succeeded in remission from the disease and the cancer had spread to her bones.

Since that magic day in Seoul, she did some fantastic work in the world of billiards, a profound and modern mathematical subject. She developed this work together with Alex Eskin and partly in collaboration with Amir Mohammadi. The crowning result of this work, by some considered one of the most important of the decade, is now known as the "Magic Wand Theorem".

Before getting briefly into some details about her work, we would like to say something of her biography.

Until mathematics attracted her, she planned to become a novelist. It was only later in her school career in Tehran that she discovered that she possessed a special understanding of mathematics, thanks to an encouraging teacher, so she switched her interest to science. In the Iran of her childhood, (see Fig. 3), books cost very little and so she read so many that later her maths had a literary tinge, as if the problems she studied were the characters of a fascinating plot. She just had to do her best to know them and work them out.

Maybe her early passion for literature was also the reason for being, by her own admission, a "slow" mathematician. Her husband Jan Vondrak, an electrical engineer and theoretical computer scientist at IBM Almaden Research Center in San José, California, joked about her steady approach to all areas of life.

She was so smart in school that she entered the Tehran Farzanegan School, an institution for educationally gifted girls. Then, she was the first girl, together with her friend and schoolmate Roya Beheshti, to represent her country in the Mathematics Olympic Games, winning gold medals for two successive years, in 1994 in Hong Kong and in 1995 in Toronto. She had a sister and two brothers; about her parents she said in an interview that they were always very supportive

and encouraging. It was important for them that their children had meaningful and satisfying professions, but they did not care as much about success and achievement.

After graduating from Sharif University in Tehran, she followed a path taken by many Iranian students, as she left for the United States for postgraduate studies and in 2004 obtained her PhD at Harvard, under the doctoral supervision of Curtis McMullen, a fellow Fields Medal winner in 1998. Maryam background before she went to Harvard was more in combinatorics and algebra. She was also familiar with complex analysis. Her initial perception of McMullen's lectures was that she did not understand much, but could appreciate the way he brought alive topics and the way he could convey their simplicity and elegance.

Later McMullen said in an interview about Maryam: "She had a sort of daring imagination. She would formulate in her mind an imaginary picture of what must be going on, then come to my office and describe it [1]". The results of her thesis were astonishing for everybody, including her doctoral advisor: Maryam had discovered beautiful ties between seemingly very different geometric counting problems. The 130-page thesis was titled "Simple geodesics on hyperbolic surfaces and volume of the moduli space of curves".

Of her breakthroughs, perhaps the most easily explained involves hyperbolic surfaces: roughly, doughnuts with two or more holes, but where each point on the surface curves upwards, like a saddle. These exist, in theory, in infinite varieties. A big puzzle involves "geodesic" lines: the shortest distance between two surface points. Some may be infinitely long; others are "closed", forming loops with no endpoints.

A fascinating and tiny handful, known as "simple", never cross themselves. Her thesis revealed a formula for how the number of simple closed geodesics of a given length rose as the length increased. As an application, Maryam had found an alternative proof of Edward Witten's celebrated conjecture first proved by Maxim Kontsevich in 1992, for which he was awarded the Fields Medal in 1998. Witten conjectured a certain recursive formula for the so-called intersection numbers and interpreted this recursion in the form of KdV (Korteweg de Vries) differential equations satisfied by the generating function. This conjecture caused an explosion of interest in the mathematical community, because a single formula interlaced quantum gravity, enumerative algebraic geometry, combinatorics, topology and integrable systems. Maryam Mirzakhani suggested an alternative proof to the one given by M. Kontsevich, ingeniously applying techniques of symplectic geometry to the moduli spaces of bordered Riemann surfaces.

In all Maryam's papers one always realizes that they are full of beautiful ideas that are still at the stage of being absorbed by the mathematical community.

Having defended her PhD thesis, which represented more or less an academic earthquake, Maryam Mirzakhani chose to take up an assistant professorship at Princeton University equipped with a prestigious Clay Mathematics Institute Research Fellowship, which allowed her to think about harder problems, travel freely and talk to other mathematicians. In 3 years, during the Fellowship, Maryam produced several profound papers on curved surfaces. These were published in leading journals in mathematics, like the Annals of Mathematics, Inventiones

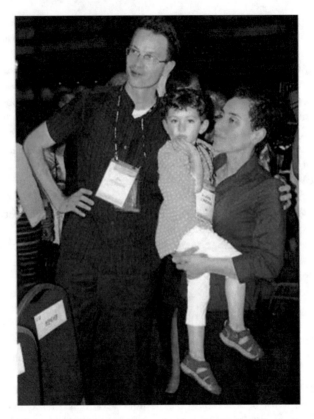

Fig. 4 Maryam married in 2005 Jan Vondrak, a Czech national who had a doctorate in computer science and also a Ph.D. in applied mathematics from the MIT. They had a daughter, Anahita, in 2011. Wikipedia Commons

Mathematicae and the Journal of the American Mathematical Society [2–4]. After she completed the Fellowship in 2008, she moved to Stanford as a full professor.

While at Princeton, Maryam met Jan Vondrak, a Czech national who had a doctorate in computer science and also a PhD in applied mathematics from the Massachusetts Institute of Technology. Jan was a post-doctoral teaching fellow at Princeton; they married in 2005 and had a daughter, Anahita, in 2011 (see Fig. 4).

Maryam was an invited speaker at the International Congress of Mathematicians of 2010, held in Hyderabad, India. The first International Conference of Women Mathematicians (ICWM), immediately preceded the Congress, and Maryam was one of the eight women who delivered lectures in the event. Her talks were a treat, visually and mathematically, and left a lasting impression on the audience.

Being not only the first woman to win the Fields Medal but the first Iranian, she became a celebrity in her country, so much that, after her death, the media gave up portraying her with a headscarf, showing instead an Iranian woman with short hair, her head uncovered. She remained a heroine for many of her countrymen, including

Fig. 5 The original drawings of Maryam on her work on simple closed geodesics. Wikipedia Commons

President Hassan Rouhani, who released a condolence message about her "unique brilliance and contribution to scientific progress of Iranian women".

While Maryam was not easily disappointed and was always confident in herself, when she was told by email that she had been awarded the Fields Medal, she ignored the message, even if it was signed by Ingrid Daubechies, at that time President of IMU, assuming it was a joke.

She resisted pressure to be a role model because she believed that many other women were also doing great things in mathematics. But she believed that discouragement is a real problem for female mathematicians, as the peak years of mathematical productivity often coincide with the time in life that women give birth and care for small children. So, when she won the medal, she expressed the hope that her award would encourage female mathematicians.

Let us now try to explain briefly why her work has been so important. The main theme of her research was understanding the geometry and dynamics on hyperbolic surfaces (see Fig. 5). A "hyperbolic surface" is a surface with constant negative curvature. The simplest model of a hyperbolic surface in three dimensions is a hyperboloid, which is obtained by rotating a hyperbola around one of its principal axes. The genus of a torus (viz. the surface of a doughnut) is one, and a genus two surface can be visualized as attaching two tori side by side.

Any surface with genus at least two is a hyperbolic surface. A "geodesic" on a surface generalizes the notion of a straight line in a plane and is a path on the surface joining two points that is made up of segments each of which is the shortest one joining its endpoints. A "simple" geodesic is one which does not intersect itself. One of the results Maryam proved in her thesis relates to counting the simple closed geodesics on a complete hyperbolic surface of finite area.

Stanford University had to work hard on press releases in order to explain her specialization in the geometry and dynamics of complex curved surfaces, an abstract field that reads like an obscure foreign language to non-mathematicians. The official

Fig. 6 Mathematicians were always astonished by Maryam's deep ideas. Author: Francois Labourie. Permission granted by the author

Stanford press release states that she worked on "moduli spaces, Teichmüller theory, hyperbolic geometry, ergodic theory and symplectic geometry", that is to say an astonishing variety of fields. This is like stating that she was a mathematical polyglot. In addition to their beauty and complexity, her results in these fields will help physicists and cosmologists to investigate the fundamental nature of the universe.

It is really interesting to read what outstanding mathematicians thought about Maryam when they first met her (see Fig. 6).

For instance, Terence Tao, commenting on her death in his blog in 2017 [5], said:

> My first encounter with Maryam was in 2010, when I was giving some lectures in Stanford, one on Perelman's proof of the Poincarè conjecture and another on random matrix theory. I remember a young woman sitting in the front who asked perceptive questions at the end of both talks; it was only afterwards that I learned that it was Mirzakhani. I really wish I could remember exactly what the questions were, but I vaguely recall that she managed to put a nice dynamical interpretation on both the topics of my talks.

Now let us say something about the Magic Wand Theorem [6]. From a dynamical point of view, it has been a long-standing and vague conjecture that the moduli space of holomorphic differentials on Riemann surfaces of arbitrary genus resembles that of a "homogeneous space with difficulties", citing her co-author Alex Eskin. Indeed, for several decades, it was not clear to what extent the dynamics of the action of the group of 2×2 matrices with real coefficients and unit determinant on such moduli space of Abelian and quadratic differentials resembles homogeneous dynamics. For Alex Eskin, who came to dynamics in the moduli space from homogeneous dynamics, it was, probably, the main challenge for 15 years. Maryam Mirzakhani joined him in working on this problem around 2006. She was challenged by the

result of her scientific advisor Curt McMullen, who had solved the problem in the particular case of genus 2 surfaces, ingeniously reducing it to the homogeneous case of genus 1.

But his techniques did not extend to higher genera. After several years of collaboration, the first major part of the theorem, namely the classification and properties of the group of all 2×2 matrices with unit determinant orbits closures was proved. In the following years, basically every paper in that area of interest used the Magic Wand Theorem in one way or the other.

However, it took Alex Eskin and Maryam Mirzakhani several more years to extend their result, proving the rigidity properties not only for the group of all 2×2 matrices with unit determinant, but also for its subgroup of upper-triangular 2×2 matrices. Eskin and Mirzakhani proved this result for higher genus surfaces, integrating ideas from topology, geometry and dynamical systems.

Their result in higher genus has an immediate application to the famous billiards problem, which is to understand the geometry of the initial billiard using the geometry of the orbit of any trajectory on the billiard.

Suppose, for example that you have to study billiards in a rational polygon (that is, in a polygon with angles that are rational multiples of π). What mathematical object can be more simple-minded than a rational triangle? However, the only known efficient approach to the study of billiards in rational polygons consists of the following.

One has to keep in mind that mathematical billiards are idealized. No friction will slow them down. Instead of a ball with some large area, a single point travels in a straight line until it hits the side of the table, at which point it has a perfectly elastic collision with the side and continues along its way in another direction. All that bouncing around and changing directions make it complicated to keep track of the trajectory, so mathematicians employ a clever trick to make their question easier: they unfold the table (see Fig. 7).

When the ball hits the side, instead of the ball's trajectory being reflected, we reflect the table, and the ball continues unhindered. That way the direction stays the same forever.

The proof of the Magic Wand Theorem is a titanic work, which absorbed numerous recent fundamental developments in dynamical systems.

Among the array of fascinating uses of the Magic Wand Theorem one which is particularly intriguing is called the wind–tree model.

More than a century ago, physicist involved in describing the process of diffusion imagined an infinite forest of regularly spaced identical and rectangular trees. The wind blows through this peculiar forest, bouncing off the trees as light reflects off a mirror. Mathematicians following the steps of Maryam Mirzakhani and Alex Eskin proved using their theorem that a broad universality exists in these forests: once the number of sides to each tree is fixed, the wind will blow through the forest at the same fundamental rate, independently from the shape of the tree.

Another amazing application is related to the so-called illumination problem (understanding the sight-lines of a security guard in a complex of mirrored rooms) [7].

Fig. 7 A polygon with paired sides glued up

Mirzakhani has left researchers with plenty of ideas and thoughts to build upon. Her contributions, directly and indirectly to several areas of mathematics, are still unfolding.

This is the reason for justifying the following extraordinary initiative which involved the mathematical community worldwide.

May 12 is the birthdate of Maryam Mirzakhani, so on 31 July 2018, at the ICM of Rio de Janeiro, the Women's Committee of the Iranian Mathematical Society proposed to the participants of the World Meeting for Women in Mathematics, that May 12th be adopted to celebrate women in mathematics, which was approved by a vast majority of participants of the meeting. To disseminate the initiative, an independent Coordination Group has been formed with the collaboration of EWM, the European Women in Mathematics, AWM, the Association for Women in Mathematics, the African Women in Mathematics Association, Indian Women in Mathematics, Colectivo de Mujeres Matematicas de Chile and of course the Women's Committee of the Iranian Mathematical Society. More than 100 events have been organized, announced by the website http://may12.womeninmathematics.org/#, taking place in the following countries: Argentina, Australia, Belgium, Benin, Brazil, Canada, Chile, Congo, Denmark, Egypt, Ethiopia, France, Germany, India, Indonesia, Iran, Israel, Italy, Mexico, Nepal, Panama, Peru, Philippines, Portugal, Russia, Senegal, Slovakia, South Africa, Spain, Sweden, Thailand, Tunisia, the United Kingdom, Ukraine and the United States. Local events were varied: films, exhibitions, panel discussions, lectures, lunches, dinners and so on (see Fig. 8).

The success of this initiative proved once more that Maryam Mirzakhani, even if she is gone far too soon, represents a strong inspiration for the thousands of women who pursue math and science in their lives (see Fig. 9).

Fig. 8 The official poster of the May12 worldwide initiative. Courtesy of https://may12. womeninmaths.org

Fig. 9 Maryam Mirzakhani's papers are full of beautiful ideas that are still at the stage of being absorbed by the mathematical community. Author: Francois Labourie. Permission grated by the author

Therefore, we can agree with Firouz Naderi, the Iranian-American scientist at NASA, who announced Maryam's death stating: "A light was turned off today. Both Maryam's work and her personality inspired and encouraged many people all over the world, women and men".

References

1. C. McMullen, *The Mathematical Work of Maryam Mirzakhani*, Proceedings of the ICM, Seoul 2014, vol. 1 (Kyung Moon SA. Co. Ltd., Seoul, 2014), pp. 73–79
2. M. Mirzakhani, Weil-Petersson volumes and intersection theory on the moduli space of curves. J. Am. Math. Soc. **20**(1), 1–23 (2007)
3. M. Mirzakhani, Simple geodesics and Weil-Petersson volumes of moduli spaces of bordered Riemann surfaces. Invent. Math. **167**(1), 179–222 (2007)
4. M. Mirzakhani, Growth of the number of simple closed geodesics on hyperbolic surfaces. Ann. Math. **168**(1), 97125 (2008)
5. T. Tao. https://terrytao.worldpress.com/2017/07/15/maryam-mirzakhani/
6. A. Zorich, Le théorème de la baguette magique de A. Eskin et M. Mirzakhani. Gazette des Mathématiciens **142**, 39–54 (2014)
7. A. Wright, From rational billiards to dynamics on moduli space. Bull. AMS **53**, 41–56 (2016)

From Soap Bubbles to Fields Medals: An Exhibition

Michele Emmer

> *It is perhaps something serious? No, it's nothing serious. They are soap bubbles, pure chimeras...*
>
> Fyodor Dostoyevsky, Crime and Punishment

On March 16, 2019, a large exhibition on soap bubbles in art and science opened in *Palazzo dei Priori,* home of the *National Gallery of Umbria* in Perugia, Italy. Marco Pierini, the director of the *Galleria Nazionale dell'Umbria,* curator together with Michele Emmer of the exhibition, wrote in the Introduction to the catalogue [1, p. 7]:

> *Soap Bubbles. Forms of Utopia Between Vanitas, Art and Science* was inspired by an idea that Michele Emmer had and by his beautiful and popular book that won the Premio Viareggio in 2010*: Bolle di sapone. Tra arte e matematica* [2]. The exhibition was initially intended to be a kind of *mise en scène* of the volume, physically bringing together the images accompanying the text. However, as organization and research efforts progressed, variations, additions, and deviations to the framework were implemented, modifying the guidelines and rendering the initial catalogue, which was already abundantly vast and well structured, even richer. The plunge into the iconographic universe of soap bubbles was, in fact, full of surprises and continuous discoveries, to the extent that the team involved in the project was genuinely surprised that a thematic exhibition on the subject had not yet been created. While the presence of soap bubbles seems like it would be a unique and sporadic occurrence in the panorama of art history, they actually appear with an unexpected frequency and an uninterrupted continuity. The fragile sphere of soap film was introduced into art at the end of the sixteenth century by Hendrick Goltzius (*or perhaps by Agostino Carracci in the same years, at the end of the Cinquecento* [3]). It has arrived to the present without ever losing popularity, having been adapted to the changing times and iconographic needs.

M. Emmer (✉)
Sapienza University of Rome (retired), Rome, Italy

IVSLA – Istituto Veneto di Scienze, Lettere ed Arti, Venice, Italy
e-mail: emmer@mat.uniroma1.it

Fig. 1 Man Ray, *Ce qui manque à nous tous*, 1935. Copy of 1963, glass bubble, glue, ceramic tube with inscription, East Sussex, Lee Miller Archives Farleys House, Farley Farm, Muddles Green © photo Marco Giugliarelli. Catalogue [1] n. 35. Reproduced with permission

Pierini ends his introduction reaching the twenty-first century:

As part of an unremitting tradition, the intriguing and silent bubble has managed to arrive at the other end of the twentieth century through the works of the young Max Beckmann (Fig. 2) and Cagnaccio di San Pietro. It was at the centre of Man Ray's (Fig. 1) and Naum Gabo's experimental research, and has appeared at the end of the avant-garde period in the works of Joseph Cornell and Enrico Prampolini. A fascination with bubbles has pervaded even the second half of the twentieth century and the beginning of the twenty-first (Giulio Paolini, Mariko Mori, Jiri Georg Dokoupil). They are now not only depicted but even physically part of the work, like in *Nothing* (1999), Pipilotti Rist's soap bubble-making device.

A significant part of the exhibition was devoted to links with science, in particular physics, chemistry, biology and of course mathematics. Many references to contemporary architecture and even cinema were not missing, since the beginning of the history of cinema, with the screening at the exhibition of some silent films of the early twentieth century. An exhibition that touched all these aspects, not exhausting the topic, it would have been absolutely impossible, due to the extraordinary history of soap bubbles between art and science.

Fig. 2 Max Beckmann, *Soap Bubbles*, 1900, mixed media on cardboard, private collection. C. n. 28. Reproduced with permission

The Fantastic Story of Soap Bubbles: Science

Have fun on sea and land
Unhappy it is to become famous
Riches, honours, false glitters of this world,
All is but soap bubbles.

On December 9, 1992, the French physicist Pierre-Gilles de Gennes (1932–2007), professor at the Collège de France, after being awarded the Nobel Prize in Physics, concluded his conference in Stockholm with this poem, adding that no conclusion seemed more appropriate [4]. The poem appears as a comment on a

1758 engraving by Jean Daullé of François Boucher's lost painting *La souffleuse de savon*. His lecture was entirely devoted to *Soft Matter*, and one of the topics was precisely soap bubbles, which he referred to as "the delight of our children". But is such interest in these beautiful, colourful, and fragile objects, as ethereal as a breath, justified? Have soap bubbles always existed? Do they have a history between art, literature, architecture and science? Have many people studied bubbles and soap films? As I wrote in the catalogue of the exhibition [1, p. 14]:

> The history of soap bubbles most likely begins with the slow diffusion of soap in Europe; soap bubbles were a side effect of this diffusion. They fascinated children in the northern regions of Europe, especially Holland and Germany. In the sixteenth and even more in the seventeenth century, playing with soap bubbles was likely a popular pastime among children. This is suggested by the hundreds of paintings and engravings on the topic of bubbles. That which has inspired artists, however, has been the fragility and vanity of human ambition that the bubble symbolizes.

At the end of the 1660s, Isaac Newton (1643–1727) began to study optics. In 1666, he wrote *Of Colours*, followed by *Optical Lectures* from 1669 to 1671, which were not published until 1728, and *New Theory of Light and Colours* in 1672. During this period, he studied the refraction of light and showed that a prism can break down white light into a spectrum of colours, and that a lens and a second prism can recompose the spectrum into white light. In 1671, the *Royal Society* asked him to demonstrate his reflecting telescope. The interest it generated encouraged him to publish his notes on the theory of colours, which he later further developed in his 1704 work *Opticks* [5]. It is probable that the widespread pastime of blowing soap bubbles, on the one hand, and artists' fascination with them, on the other, was what prompted even scientists to ask questions about soap film. Colour was certainly one of the main reasons fueling interest in the game and artists' fascination with soap bubbles at the time, even though recreating the curious effect that manifested itself on the soapy surface was so complicated that the soap bubbles appear almost transparent in nearly every painting. The same reason, colour, generated the interest of scientists and Isaac Newton was the first:

> Newton, busy at the table working on his discoveries in optics, turns around and by chance sees a child making soap bubbles. In that image, unsurprisingly, a phenomenon of colors created from the refraction of rays appears. A woman whom we might assume to be Newton's sister is with the young man, holding the water container and smiling at the child.

These words were written by Count Paolo Tosio of Brescia in a letter dated September 13, 1824. He was explaining to the painter Pelagio Palagi (1775–1860) what the exact theme and characters of the painting he had commissioned should be: Newton discovering the phenomenon of colour on soap films. Though he was writing many years after Newton's research, the scene he describes is highly plausible (Fig. 3).

Fig. 3 M. Pierini and M. Emmer in front of the painting of Pelagio Pelagi, *Newton scopre la teroria della diffrazione della luce*, oil on canvas, 1827, Palazzo Tosio, property of Musei Civici, Brescia. © Photo Marco Giugliarelli, c.n. 23. Reproduced with permission

In *Opticks*, Isaac Newton describes the phenomena observed on the surface of the soap films in detail. In the second volume, he notes his observations on soap bubbles:

> *Obs.* 17. If a Bubble be blown with Water first made tenacious by dissolving a little Soap in it, 'tis a common Observation, that after a while it will appear tinged with a great variety of Colours. To defend these Bubbles from being agitated by the external Air (whereby their Colours are irregularly moved one among another, so that no accurate Observation can be made of them,) as soon as I had blown any of them I cover'd it with a clear Glass, and by that means its Colours emerged in a very regular order, like so many concentrick Rings encompassing the top of the Bubble.

The phenomenon that Newton had observed is known as interference and occurs when the thickness of the film is comparable to the wavelength of visible light. In soapy liquid, the different colours that make up sunlight move at different speeds.

The Fantastic Story of Soap Bubbles: Art

A series of engravings by Hendrick Goltzius (1558–1617) is considered to be the beginning of the bubble's thereafter frequent appearance in Dutch art in the sixteenth and seventeenth centuries. Goltzius's most recognized and well-known work is called *Quis evadet?* ("Who will be spared?") and is dated 1594 (Fig. 4, right). As already remarked, a similar engraving was made by Agostino Carracci (1557–1602), even with the same title, in the same years (Fig. 4, left).

For artists the sixteenth and the seventeenth centuries were the period of greatest interest in soap bubbles; bubbles started to appear constantly in depictions of the broader theme of human frailty and, more in general, in the theme of games for children.

One of the most famous works was created in different versions by Jean Siméon Chardin (1699–1779) in the early eighteenth century and is called *Les bulles de savon*. In another famous painting, *La Blanchisseuse* (Fig. 5), Chardin depicted a child playing with soap bubbles. It was a real emotion when the painting arrived from the Rome Fiumicino airport, flying from the *Hermitage Museum* in Saint Petersburg, arriving around midnight in Perugia.

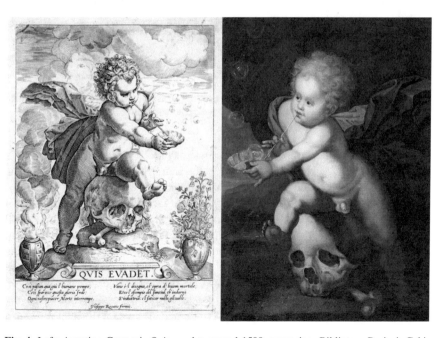

Fig. 4 Left: Agostino Carracci, *Quis evadet*, around 1590, engraving, Biblioteca Panizzi, Gabinetto delle stampe "A. Davoli", Reggio Emilia, c.n. 1°. Right: Follower of Jacob de Witt, *Quis evadet*, first half XVIII c., oil on canvas, private collection, c. n. 1b. Probably a copy of a lost painting of H. Goltzius. Reproduced with permission

Fig. 5 Jean Siméon Chardin, *La Blanchisseuse,* oil on canvas, around 1733–1734, The State Hermitage Museum, Saint Petersburg, c. n. 20. Reproduced with permission

The opening of the exhibition was the next day at 10 in the morning! Manet's painting from 1867 is also quite famous. In the same years Bizet composed music by the title of *Bulles de savon* in the series for piano *Jeux d'enfants.*

It is interesting to note that in those years the fact that soap films are natural phenomena related to schemes of maximization and minimization was not at all clear to scientists. Only in the nineteenth century it became understood that soap films provide an experimental model for math and physics problems, thus fully inserting soap films in the mathematical field of *Calculus of Variations.* Joseph Antoine Ferdinand Plateau (1801–1883) was not the first to study soap bubbles and films, as we have seen. However, it was his experimental observations that decisively influenced the work of mathematicians, even though, as an experimenter, Plateau's work was mainly directed at physicists and chemists. The Belgian researcher exposed his eyes to sunlight for too long, which caused irreversible damage to his sight. In 1843, he became completely blind. It was in these years that he began to take an interest in the nature of molecular forces present in fluids, eventually

discovering forms that soap films contained in particular metal wires take when immersed in soapy water take.

In 1873 he published the result of 15 years of research in two volumes of the treatise *Statique expérimentale et théorique des liquides soumis aux seules forces moléculaires*. The central part of Plateau's treatise is titled *Systèmes laminaires. Lois aux quelles ils sont soumis; comment ils se developpent; principe général qui régit leur constitution. Démonstration théorique de leurs lois* [6].

Returning to Plateau's experiments, it was possible to create surfaces of mean curvature zero, i.e. minimal surfaces, of which either the equations or the geometric generator are known. The idea is to draw a closed contour with the only condition that it contains a limited portion of the surface and that it is compatible with the surface itself; if then a wire identical to the previous contour is constructed, immersed entirely in soapy liquid and then pulled out, a set of soapy films is generated representing the portion of the area under consideration. Plateau could not but note that these surfaces, most of which are highly intriguing, are obtained *as though by magic*. It is clear that the procedure can be applied to solve the most complex problems in which the surface being studied is not known. In this case, the experimental solution to the problem is obtained with soap films.

Plateau himself talked about the reliability of his experiments on the structure of soap films, keen to reassure those reading his treatise. While painters like Couture and Manet painted soap bubbles on their canvases in those years, Plateau was not satisfied with their spherical shape and experimented with the physical and chemical properties of soapy water to find completely new forms.

All these experiments are very unusual; it is incredibly fascinating (*charme*) to contemplate these light forms, which, in essence, are reduced to mathematical surfaces. Plateau examined the shape blowing into a soapy liquid with a straw. It is the same phenomenon that occurs when soapy water foam is formed by pouring detergent into water to wash dishes; as everyone knows, what you get is not detached spherical soap bubbles, but a system of soapy surfaces, none of which is perfectly spherical. You can then add more bubbles and build a very complex agglomeration. It is clear that the more you blow, the more complex the agglomeration of films becomes. You may think that the way in which the different films meet can give rise to infinite configurations. And therein lies Plateau's incredible discovery: *however high the number of soap films that come into contact with each other, there can be only two types of configurations*. More precisely, the three experimental rules that Plateau discovered about soap films are as follows:

1. A system of bubbles or a system of soap films attached to a supporting metallic wire consists of surfaces flat or curved that intersect with each other along lines with very regular curvature.
2. Surfaces meet only in two ways: either three surfaces meet along a line or six surfaces that give rise to four curves meet in a vertex.
3. The angles of intersection of three surfaces along a line or of the curves generated by six surfaces in a vertex are always equal in the first case to 120° (Fig. 6), in the second to 109° 28′.

Fig. 6 Bradley Miller, *Without title*, 1975, Photographic technique, © B. Miller, c. n. 45. Reproduced with permission

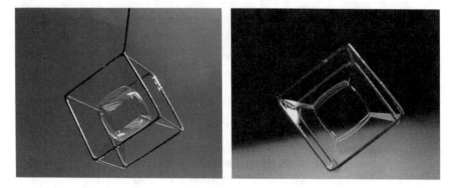

Fig. 7 Michele Emmer and Elio Bisignani, *Soapy Hypercube*, 1984, Photograph, c. n. 46 © M. Emmer

In this way, it is possible to have a precise idea of the experimental solutions to mathematical problems for which no explicit solutions are known. Moreover, it has been verified that in each case, Plateau's rules regarding angles hold true. The experiment is fascinating for those who perform it, given the incredible precision of the compositions obtained. One of the first wires Plateau considered was the skeleton of a cube. The soap films became stable within a few moments of extracting the wire. Films meet at the centre in a square film, which is always parallel to one of the faces of the cube frame. If, then, the obtained soapy structure is immersed again in soapy water and taken out from the liquid but not entirely, so that the films catch a small volume of air and then the entire wire is extracted, the air bubble is immediately captured in perfect symmetry in the middle of the laminar structure. A picture of the cube structure was shown at the *Biennale Internazionale d'Arte di Venezia* in 1986, by the title *Soapy Hypercube* (Fig. 7) [7].

The Role of Mathematicians

With his experiments, Plateau had posed two problems to mathematicians: one that is known as Plateau's problem and the other on the geometry of soap films. The mathematician Euler was the first to ask himself the question of how to find the minimal surface bounded by a closed contour, in the eighteenth century. The official birth date of minimal surfaces is considered 1760, the year when a work of Joseph-Louis Lagrange (1736–1813) was published [8].

For many years the only explicit solution to the Plateau problem was the one obtained by Hermann Schwarz (1843–1921) for a non-planar quadrilateral contour. In 1931, the mathematician Jesse Douglas (1897–1965) published a work entitled *Solution of the problem of Plateau*. For his work on minimal surfaces, in 1936 Douglas received the Fields Medal, the highest recognition for a mathematician less than 40 years old, awarded every 4 years at the International Congress of Mathematicians. In the early 1960s, Ennio De Giorgi (1928–1996) and Ernst Robert Reifenberg (1928–1964) introduced a completely new approach to solving Plateau's problem. The idea is to generalize the concept of surface, of area and boundary, looking for a more general solution. By using De Giorgi's method (the so-called *Perimeter Theory*) and the *Geometric Measure Theory* (Integral Currents) introduced by Herbert Federer (1920–2010) and Wendell H. Fleming, *Plateau's problem* could be solved. The problem of the study of singularity remained, and was addressed and solved by several scholars, including Mario Miranda (1937–2017), Enrico Giusti, and Enrico Bombieri in Italy and Federer, Fleming, and Fred J. Almgren, Jr. (1933–1997) in the United States. Bombieri received the Fields Medal in 1974 also for his contributions to the theory of minimal surfaces. Another question remained: were the laws on the geometry of soap films that Plateau discovered experimentally correct or not?

> Water, soap, forms, shapes, experiments, art: few concepts bearing great relevance. All these are elements to which Bradley Miller has added his capacity to create images. And in this way the world of soap film shapes, of the millions of soap films that are created even when we wash dishes, becomes a universe of essential and perfect geometrical shapes, pure mathematical shapes, abstract and yet gripping and mesmeric. A new universe that takes shape in front of our amazed eyes.

These words can be read in the preface to the collection of images by Bradley Miller, a soap film photographer [9]. In 1976, when Jean Taylor showed that the laws Plateau had experimentally found to explain the geometry of soap films were correct [10], Bradley Miller, an art student, had the idea of using photography to capture the image of soap films and went to Princeton University where Taylor worked with her husband Fred Almgren. In 1976 they wrote a well-known article on their research, published in *Scientific American* in 1976, including many beautiful colour pictures of soap bubbles and soap films [11].

D'Arcy Wentworth Thompson (1860–1948) in his extensive essay *On Growth and Form* [12], which was one of the first attempts to make mathematics and

mathematical models the basis for the morphology of living beings (the first edition dates back to 1917), writes:

> Cell and tissue, shell and bone, leaf and flower, are so many portions of matter, and it is in obedience to the laws of physics that their particles have been moved, moulded and conformed. They are no exceptions to the rule that God always geometrizes. Their problems of form are in the first instance mathematical problems.

Many pages are dedicated to soap bubbles and films as models for living structures in nature. In Chap. 7 on *The Forms of Tissues or Cell-Aggregates*, Thompson recalls a problem that always concerns soap films:

> A few years after the publication of Plateau's book, Lord Kelvin showed that we must not hastily assume that the close-packed assemblage of rhombic dodecahedra will be the true and general solution of the problem of dividing space with a minimum partitional area. Or will be present in a liquid *foam* in which the general problem is completely and automatically solved. Lord Kelvin made a remarkable discovery that by means of an assemblage of fourteen-sided figures or *tetrakaidekahedra*, space is filled and homogeneously partitioned into equal, similar and similarly situated cells, with an economy of surface in relation to volume even greater than in assemblage of rhombic dodechadrea.

In 1994, Denis Weaire and Robert Phelan of *Trinity College* in Dublin found a better solution than the one proposed by Lord Kelvin (William Thomson 1st Baron Kelvin) using two cells of equal volume: an irregular dodecahedron and a tetradecahedron which Kelvin had used, both with curved faces (Fig. 8).

The polyhedrons proposed by Weaire and Phelan were in turn the source of inspiration for the creation of the *Water Cube*, the *Olympic swimming stadium* at the Beijing Olympics in 2008. The project was carried out by a team of Australian, German, and Chinese architects, PTW Architest, ARUP and China Construction Design International (Figs. 9 and 10).

In 2008, Frank Morgan demonstrated that a minimum for the configuration of the problem posed by Lord Kelvin exists, but an explicit solution has not yet been found. After Weaire and Phelan, John Sullivan had proved that there are families of polyhedra of different types with a surface area smaller than that proposed by Lord Kelvin.

Fig. 8 The model of Weaire and Phelan

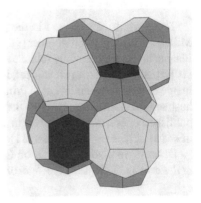

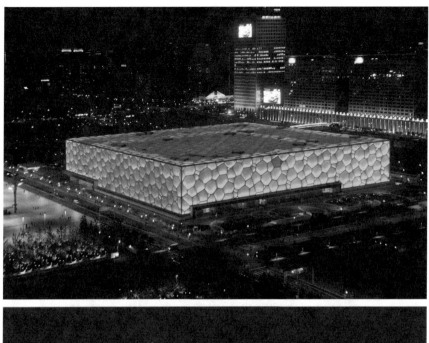

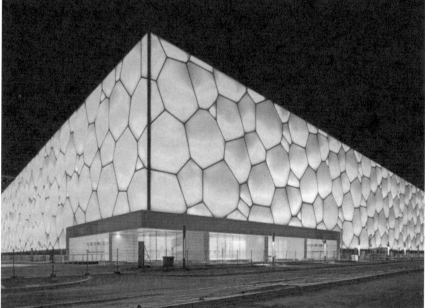

Fig. 9 PTW Architest, ARUP and China Construction Design International, *Beijing National Aquatic Center (Water Cube)*, project, 2008. © PTW- ARUP. Reproduced with permission

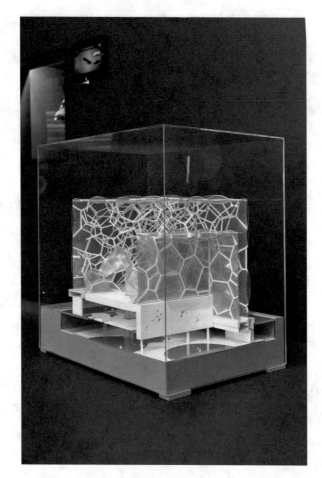

Fig. 10 PTW Architest, ARUP and China Construction Design International, *Beijing National Aquatic Center (Water Cube)* maquette, scale 1.125, 2008. © PTW- ARUP, C. n. 44. Reproduced with permission

Years earlier, in 1972, the large tent suspended over the Olympic Stadium in Munich became famous. It was built by the German architect Frei Otto (1925–2015) based on models of soap films.

My Personal Dream

In 1970 I started my work as a mathematician at the university of Ferrara with Mario Miranda, part of the group of mathematicians (others were Ennio De Giorgi, Enrico

Giusti and Enrico Bombieri) working on Minimal Surfaces, Soap Bubbles. As I already recalled Bombieri received the Fields Medal in 1974.

In 1976 I met Jean Taylor and Fred Almgren and we decided to make one of my films in the series *Art and Mathematics* on Soap Bubbles, partially filming at the *University of Princeton* [13]. In 1984 with Elio Bisignani we made a series of pictures of the Plateau' solution for the cube, calling it *Soapy Hypercube*. Both the film and the pictures were included in the 1986 *Biennale Internazionale d'Arte di Venezia* dedicated to the theme of *Art and Science*.

One of my dreams was the idea of making a big exhibition on the theme of soap bubbles. I first spoke with Maurizio Calvesi on the occasion of the Venice Biennale of 1986, devoted to art and science. He was the curator of the Biennale and I curated a small section.

The same year I published a paper *Soap Bubbles in Art and Science: from the Past to the Future of Math Art*, in the journal *Leonardo*, MIT Press. Reprinted in *The Visual Mind: Art and Mathematics* in 1991 [14].

In 1991 I wrote the first book dedicated to soap bubbles in art and science *Bolle di sapone* and I also started with Valeria Marchiafava to make theatre shows on soap bubbles.

In 2009 I wrote my final book on soap bubbles *Bolle di sapone tra arte e matematica* [2]; the book received the important *Viareggio Award* for the best Italian essay in 2010. In 2013, at the *Carnevale of the Biennale di Venezia* I organized a 2-days event on soap bubbles with films, music, plays, workshops.

Two Fantastic Events

While we were preparing the exhibition in Perugia to open in March 2019, on August 1, 2018, the Fields medals for mathematics were announced at the International Congress of Mathematicians in Rio de Janeiro: Peter Scholze, German, Akshay Venkatesh, Indian, Caucher Birkar, Iranian Kurd and naturalized British, and, finally, after so many years, a second Fields Medal was awarded to an Italian, Alessio Figalli.

The Italian mathematician works on *Calculus of Variations*, optimization principles, and partial differential equations. All details of his research can be found on the Fields Medal website, or on the Zurich Polytechnic website. One law that nature seems to respect (at least we think so) is that nature tends to find the best possible solution, the one that involves the least energy and thus the least amount of effort. The goal is to find the minima of the functions that describe a mathematical or physical phenomenon. This area of research in mathematics is called *Calculus of Variations*. Soap bubbles and soap films are models for three dimensional problems in *Calculus of Variations*.

On March 19, 2019 the mathematician Karen Uhlenbeck received, the first woman ever, the Abel Prize 2019 for her works including results on soap bubbles

Fig. 11 Palazzo dei Priori, Galleria Nazionale dell'Umbria, Perugia, location of the exhibition. Reproduced with permission

and soap films. *The New York Times* dedicated to her a full page in its International edition (April 10, 2019) by the title *A Mathematical Universe in a Bubble*.

A few days before, March 16, 2019, finally the exhibition on Soap Bubbles opened in Perugia (Fig. 11).

All photos (except the last one) of the exhibition by Marco Giugliarelli ©. Courtesy of *The Galleria Nazionale dell'Umbria*, Perugia.

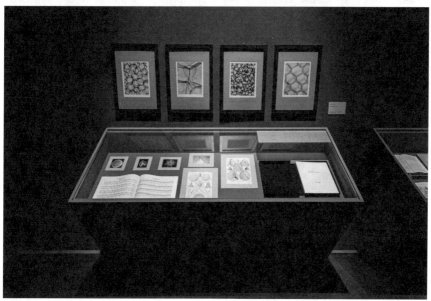

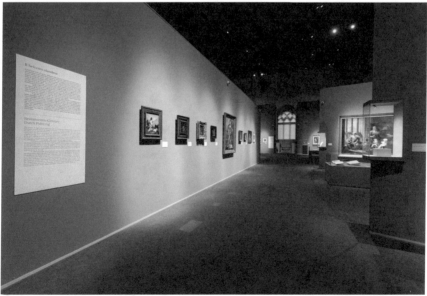

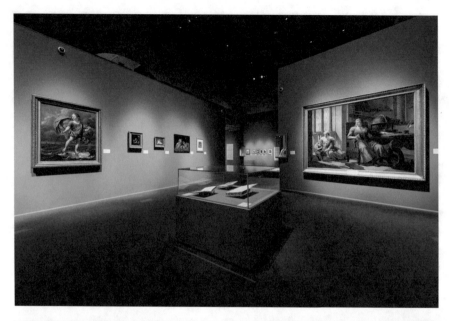

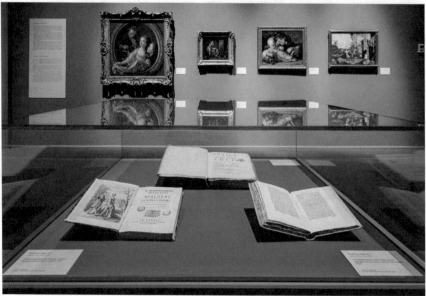

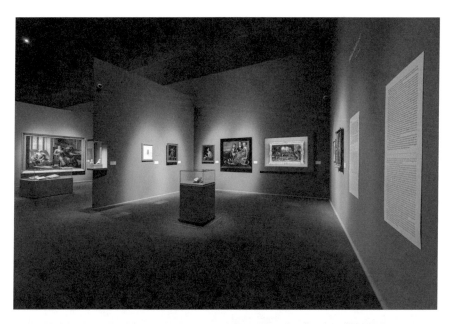

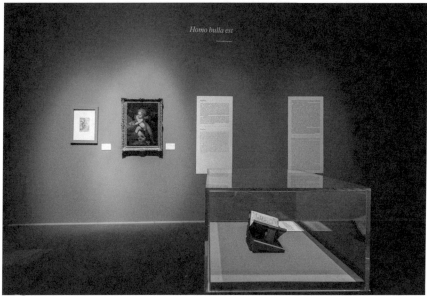

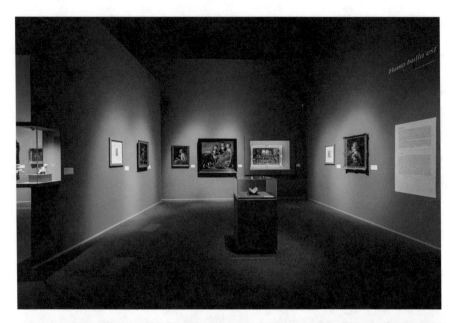

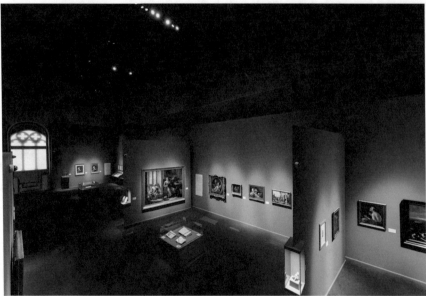

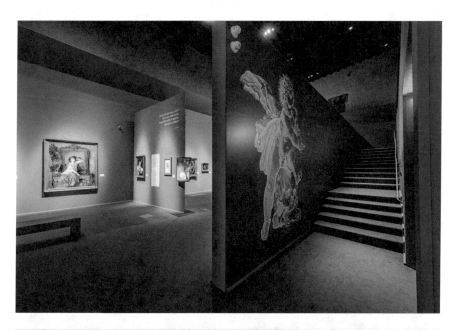

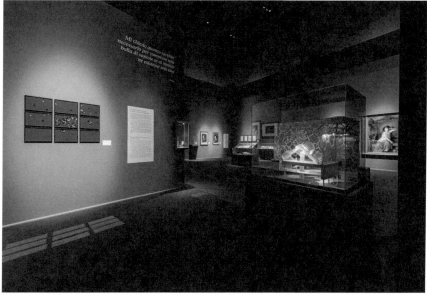

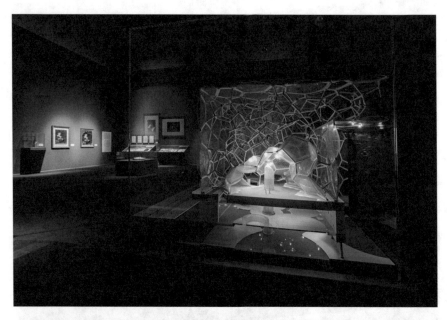

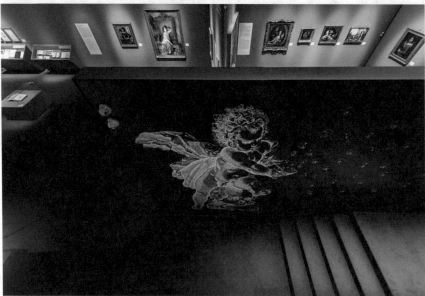

This last photo is by Paolo Ballerani ©. Courtesy of *The Galleria Nazionale dell'Umbria*, Perugia to have a look at the exhibition: https://youtu.be/fFHh9hi5fwM

Cover of the catalogue of the exhibition. © Silvana Editoriale and *The Galleria Nazionale dell'Umbria*

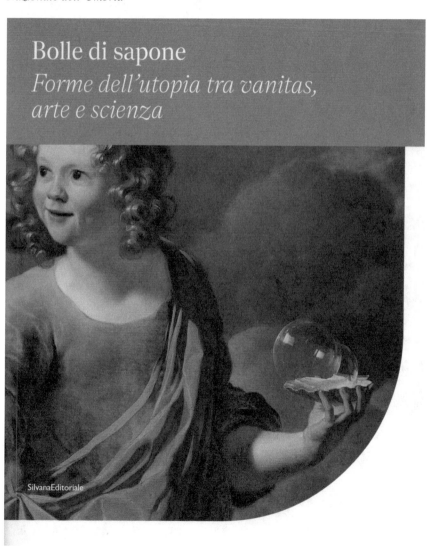

Cover of the book for children *Bubbles Bubbles Bubbles*, © M. Emmer and F. Greco, Aguaplano Publisher and *The Galleria Nazionale dell'Umbria*

The story of soap bubbles is a never ending story
.

All the world's a tiny bubble Floating inside

Those of us who notice are Expected to hide

All the world's a tiny bubble Floating inside, the truth
Paul McCartney

References

1. M. Emmer, M. Pierini (eds.), *Bolle di sapone. Forme dell'utopia tra vanitas arte e scienza,* catalogue exhibition, 16 March–9 June 2019, Galleria Nazionale dell'Umbria, Perugia, Silvana Editoriale, Milano (2019). English edition *Soap Bubbles: Forms of Utopia Between Vanitas, Art and Science*, Silvana Editoriale (2019), ebook, Kindle ed.
2. R. Ascott, D. Foresta, T. Sherman, T. Trini (eds.), *Tecnologia e Informatica*, catalogue of the section, Biennale Internazionale d'Arte di Venezia, M. Calvesi (ed.), *Arte e Scienza* (Electa, Milano, 1986), p. 83
3. M. Emmer, *Bolle di sapone. Tra arte e matematica* (Bollati Boringhieri, Torino, 2009) Viareggio Award, Best Italian Essay 2010
4. C. Scagliosi, *PICTURA BULLA EST, Soap Bubbles in Dutch (and Flemish) Golden Age Painting*, [1], p. 44.
5. P.G. de Gennes, Soft matter. Science **256**, 495–497 (1992)
6. M. Emmer, Soap bubbles in art and science: from the past to the future of math art, in *The Visual Mind, Art and Mathematics*, ed. by M. Emmer, (The MIT Press, Cambridge, MA, 1993), pp. 135–142
7. I. Newton, *Opticks*, printed for Sam Smith, and Benj (Walford, London, 1704)
8. J. Plateau, *Statique expérimentale et théorique des liquides soumis aux seules forces moléculaires* (Gauthier-Villars, Paris, 1873)
9. J. De Lagrange, *Essai d'une nouvelle méthode pour déterminer les maxima et le minima des formules intégrales indéfinies* (1760). Reprint: *Oeuvres de Lagrange,* vol. 1 (Gauthiers-Villars, Paris, 1873), p. 389
10. B. Miller, *Bubbles Shadows* (Anderson Ranch Arts Center, Colorado (USA), 2006)
11. J.E. Taylor, The structure of singularities in soap-bubbles-like and soap-film-like minimal surfaces. Ann. Math. **103**, 489–539 (1976)
12. F. Algren, J. Taylor, *The Geometry of Soap Bubbles and Soap Films* (Scientific American, July 1965), pp. 82–93
13. D.W. Thompson, *On Growth and Form* (Cambridge University Press, Cambridge, 1917). second extended edition 1942
14. M. Emmer, film maker, *Soap Bubbles,* series *Art and Math*, 25 m., DVD, (1984) M. Emmer & Film 7, Rome prod.

Part III
Mathematics and Cinema

Alternative Methods for Digital Contrast Restoration

Alice Plutino and Alessandro Rizzi

Introduction

Film restoration is a complex process that usually involves experts from different fields, from historians and philologists to physicists and computer scientists. This is because the common restoration workflow is composed by different steps: the historical research about film origin, the manual restoration of the analog film reel, its digitization, the digital restoration and the conservation of different supports (analog and digital) [3, 4, 22]. So far, progress in the field of digital restoration has been left to private software developers, regardless of its big potential [2, 6]. Digital restoration used to be divided in two main threads: color restoration (i.e., correction of colors and color grading) and digital restoration per se (i.e., image reconstruction through specific algorithms). The advent of digital technologies gave an important contribution to digital restoration, but the greatest one is in color restoration. This is because in the analog intermediate color correction was made through the use of negative copies analyzed by a Color Analyzer, that allowed to simulate the chemical printing process at different exposures in the whole film base [2]. This process was very expensive in time and was often inaccurate and imprecise. With the advent of the digital intermediate, the color grading process works in a completely different way: the software that controls the digital image can work on each primary color independently, and consent to modify the colors of just certain areas or elements in the framing. Furthermore, those methods are precise and reversible. The potential of color restoration today is infinite, raising the issue about an excessive intervention on old film frames that, after the restoration, looked completely different from the original. Due to this issue the main laboratories defined different guidelines for the

A. Plutino (✉) · A. Rizzi
Università degli Studi di Milano, Computer Science Department, MIPS Lab, Milan, Italy
e-mail: alice.plutino@unimi.it; alessandro.rizzi@unimi.it

© Springer Nature Switzerland AG 2020
M. Emmer, M. Abate (eds.), *Imagine Math 7*,
https://doi.org/10.1007/978-3-030-42653-8_5

contrast restoration assessments, left to the film owner or to the curator, who has the task of evaluating the results of a contrast and digital restoration [5]. In this work, we focus on film color restoration and we present some algorithms that permit to obtain an automatic and unsupervised frames restoration, reducing the costs in time and resources. We compare the results between automatic and manual restoration and we define the pros and cons of each method.

Restoration Approaches

Nowadays many digital restoration techniques use two main approaches: conservative and innovative. The conservative approach includes all the techniques and methods that aim to archive and preserve the film in proper conditions, without making any correction on the frames, and being as much faithful as possible to the original. This approach includes all the techniques that permit the translation from an instable film-base (e.g., nitrate) to more stable ones (e.g., PVC). The innovative approach concerns all the methods that focus on valorization, fruition, or new redistribution of films. This group includes all the techniques that employ the modern advantages and technologies to increase the quality of old films (e.g., improvement of resolution, correction of faded colors, removal of alterations, . . .). In this context a solution can suggest to restore a film being faithful to the original copy, but in many cases the physical analysis of the color dyes and the colorimetric reconstruction are not sufficient to obtain a satisfying result [18]. This is due to the optical and physical complexity of the restoration pipeline in which the major part of the involved gamuts are unknown [8] and, moreover, the correct contrast and color acquisition has been proven to be practically irrecoverable [9].

It follows that all the uncontrolled changes of features like contrast, gamma, gamut, spatial arrangements of colors influence the final frame appearance. Furthermore, those characters can be affected also by the devices used to produce an image or a color used at the time of the movie production, that can affect the approach to film restoration. In this work we propose an alternative approach based on the idea of restoring the colors as they perceptually appeared originally, preserving the ratio [7]. The idea of restoring the color appearance can be achieved through algorithms simulating the mechanisms of the Human Visual System (HSV). The algorithms of this family, called Spatial Color Algorithms (SCAs) [15], are unsupervised and have already been tested for film restoration providing promising results [14, 19].

Spatial Color Algorithms: SCA

As already mentioned, the idea of SCAs is to simulate the behavior of the human visual system, starting in particular from the idea that a color is not only a physical stimulus, but also depends on the spatial arrangement of the scene. To reproduce this

behavior the SCAs work comparing all the pixels in a scene, in a two-phase process. At first, each pixel is recomputed from scratch according to the spatial distribution of the other pixels in the scene. In the second phase, the matrix of values generated in the previous step is recomputed and scaled onto the available dynamic range, according to global anchoring principles and to the model goal. Here the output image is generated. In addition, non-linear adjustments, gamma or LUT (Look-Up Table) can be added in the second phase due to the SCA goal. This characteristic makes the SCAs suitable for High Dynamic Range (HDR) tone rendering, for conversions derived to the changes of support, like gamut mapping, analog-to-digital dynamic range adjustments, etc. In [10, 11, 20] we have demonstrated that the SCAs follow people's visual preference.

ACE: Automatic Color Equalization

For this restoration project we have chosen the ACE algorithm. This algorithm, as SCA, works by comparing every pixel p_t in the image I to every other pixel p_j separately for each RGB channel, and summing all the differences to compute the final value:

$$p_{new} = \frac{1}{k_t} \sum_{p_j \in I, p_j \neq p_t} r(p_t - p_j) d(t, j) \tag{1}$$

$$k_t = \sum_{p_j \in I, p_j \neq p_t} d(t, j) \tag{2}$$

Before the sum, each difference is modified by a non-linear function $r(\cdot)$ and weighted by $d(\cdot)$, the inverse of the Euclidean distance among the pixels p_t and p_j. The normalizing factor k_t is used to make the weighting meaningful. The factor $r(\cdot)$ is the truncated gain function:

$$r(p_t - p_j) = \begin{cases} -1 & \text{if } p_t - p_j \leq -thr, \\ \frac{p_t - p_j}{thr} & \text{if } -thr < p_t - p_j < thr, \\ 1 & \text{if } p_t - p_j \geq thr. \end{cases} \tag{3}$$

This last function is a non-linear amplification of the normalized difference between pixel values, responsible for the final spatial rearrangements [16]. It causes different spatial re-arrangements of pixel values according to $r(\cdot)$ and to the point of threshold thr. The contrast tuning effect of ACE depends on the slope of $r(\cdot)$, whose growth rate is in fact proportional to the increment of contrast (see Figs. 3, 4, 5, 6, and 7).

Restoration Workflow

The ACE algorithm [16] works on single frames, as described in section "ACE: Automatic Color Equalization", and to obtain the best result the parameter $r(\cdot)$ needs to be set according to the frames characteristics. To this aim, the whole film has to be divided in scenes and for each one the proper $r(\cdot)$ parameter can be chosen. After that, since the frame content is not supposed to change remarkably in the same shot, the same parameter can be applied. Thus, the restoration workflow based on the application of ACE is divided into the following steps:

- Scene detection
- Key-frames extraction
- ACE parameter tuning on the key-frames
- Filtering of the whole scene
- Results Assessment
- Final corrections and harmonization

The scene detection is the first step of the applied restoration workflow and involves the subdivision of the film in shots (i.e., a sequence of frames filmed constantly). Automatic techniques for scene detection are based on the detection of difference between frames in histograms or texture, work reasonably well, but a visual assessment is always needed. The scene detection can also be performed manually, and this is preferable when in a movie there are transitions like fade-in and fade-out effects. The result of scene detection is the subdivision of the film in video shots or groups of frames of different lengths characterized by visual similarities. The following step concerns the extraction of relevant frames that summarize the content of each scene. These frames are called key-frames and are the input of the parameter tuning step. This stage is performed manually. As presented in section "Spatial Color Algorithms: SCA" all the SCAs have a set of parameters that must be tuned; in the ACE algorithm it is $r(\cdot)$. In general the parameter tuning is not a critical step [14], and often different parameters values could lead to acceptable results. Then, the restoration expert or curator decides which is the best value for the enhancement of each scene according to its restoration aim. After the parameter tuning on the key-frames, the whole scene is filtered with the same parameters. During the years different methods for the assessments of the SCAs filtering results have been made, but an absolute metric does not exist [13]. Due to this, it is the curator who makes the final judgment about the restoration results of each scene. In this step it is possible to make further adjustments and corrections on the scenes. In conclusion, all the adjusted frames are rejoined in the same sequence. Since the filtering is tuned on the key-frames it can happen that between scenes filtering produces changes in lightness, so it is important to smooth and harmonize the final movie.

Results

Scene Detection and Key-Frames Extraction

The restored film is a black and white documentary directed by Luciano Emmer and Enrico Gras: "Isole della Laguna" (1948). To have a trustworthy evaluation of the performances of the ACE filtering on a movie, the restoration was made semi-automatically using the ACE algorithm and manually using the software Da Vinci Resolve [1]. The scene detection was performed at first manually, dividing all the film frames in scenes, and then automatically through Da Vinci Resolve. Manually we identified 89 scenes, while the 86 recognized by the software. The scene detection through the software is semi-automatic; in fact, it requires constant supervision of the operator. In Fig. 1, it is possible to see an example of a scene cut that was not automatically identified by the detection software and was performed manually.

In this application the key-frame extraction is performed manually and each key-frame was selected in order to be representative for the whole scene. To better understand what does it mean for a frame to be "representative" we report some examples in Fig. 2. Here we give an idea of the scene detection reporting the first and the last frame of some scenes, and in addition we show the selected key-frame. The film under restoration is a black and white documentary, so in this case it is fundamental to choose the key-frame of each scene that better represents the medium contrast in the scene and the highest dynamic range. For example, in Fig. 2 the scene 6 is characterized by a big variance in the scene content and in luminance. The first frame of the scene comes from a fade-in and -out effect, it is really dark; at the opposite, the last frame is brighter. In this case, we selected a key-frame that represented the average lightness in the scene. Furthermore, scene 6 starts with the film framing of an old woman with a goat and ends with an overview of the landscape. The key-frame must represent the whole scene, so we selected a frame that included both the subjects.

Fig. 1 Example of scene cut that is not identified by the automatic detection software

Scene 6

Scene 7

Scene 8

Scene 20

Scene 27

Scene 39

Scene 78

First Frame Last Frame Key - Frame

Fig. 2 Example of scene detection and key-frame extraction

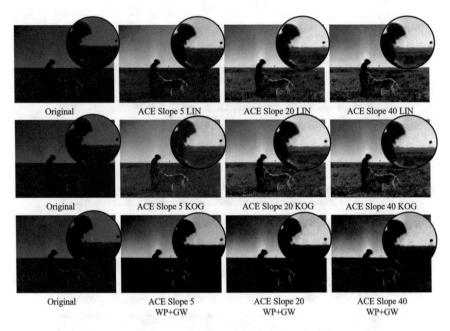

Fig. 3 First frame of "Isole della Laguna" scene 6 restored through different ACE parameters

ACE Parameter Tuning and Scene Filtering

The ACE parameter tuning is performed on the key-frame extracted from each scene. The analyzed film was in good conservation conditions and for this reason we set as starting parameter a very low value of $r(\cdot)$. Some example of parameters tuning are reported in Fig. 3. Here we can see the comparison between the original frame and the ones restored through different ACE parameters.

As we have already mentioned the first frame of scene 6 comes from a fade-in and -out effect introduced by the director. This is an example of an artistic feature that must not be removed by the application of the SCAs. Due to this, in the SCAs implementation specific functions are taken into account for the implementation. These functions are introduced in the second phase of the filtering and were presented in [19]. The main functions are: Keep Original Gray (KOG), Keep Original Color Cast (KOC), and Keep Original Dynamic Range (KODR). The KOG function preserves the original average values of each RGB channel, instead of re-computing the medium gray. This option is useful to preserve the tonal characteristics of a low or high key image. The KOC function is useful when the director introduces unnatural colors in a sequence for artistic purpose, so, in this case, the SCAs compute the original color cast and re-introduce it in the second phase. Finally, the KODR function is used when the director uses only a part of the dynamic range to obtain specific visual effects. In this case the SCAs apply the new enhanced scaling on the limited original dynamic range. In this application

Table 1 Statistics of ACE filtering

	Number of scenes	Average slope	Variance of slope
LIN	8	3.6	5.4
KOG	7	3	2.6
WP+GW	7	5.6	30.8

the most interesting function to be applied is KOG. It was used especially for the fade-in and -out effects. In Fig. 3 we present an application of different dynamic range computation on the first frame of scene 6. Here, LIN denotes that the computation fills the available dynamic range linearly using the computed values. WP+GW denotes the White Patch+Gray World function, where the mean gray value is computed and set as middle value of the dynamic range. In this example it is clear that for the frames involved in the fade-in and -out effect the KOG function gives better results, because the frame dissolve is preserved. Considering the scene content, the WP+GW filtering gives the worst result because the scene details are completely lost. For what concerns the tuning of the $r(\cdot)$ parameter it is possible to see in Fig. 3 that a growth of slope corresponds to a growth of contrast. In this scene we applied a value of $r(\cdot)$ of 5, 20, and 40. Here, the best parameter to use is 5, because in the LIN and KOG application enhances the scenes details. On the other hand, a big value of slope like 20 or 40 can produce artifacts in the frames, as is clearly visible when $r(\cdot)$ is 40. This example is useful to understand the potentials and the limits of ACE and of the slopes in general, that can produce great increase in the image details and contrast equalization, but can also produce alteration if not took under control. At the end of the parameter tuning and scene filtering process, in this study we enhanced 20 scenes through the ACE filtering; the statistics of the enhancement are reported in Table 1.

Results Assessment

Figures 4 and 6 report some examples of original frames, enhancement through ACE using different parameters, and the result of the manual correction made with Da Vinci Resolve. The manual enhancement was performed through the Da Vinci Resolve software and concerned mostly the white balancing of the frames. This operation was made equalizing the RGB channels of the image. Also in this case, the manual enhancement was made on the key-frame and then applied to the whole scene. Normally, the quality control is made by the curator, who defines which is the best parameter for the restoration project, due to his experience, but in many cases it is done subjectively by the operator. In this work we propose a quality control based on different objective measures, assessing image features, to support the work of the experts in evaluating the performance of different restoration methods. The use of many basic measures to estimate the quality of a frame, instead of a unique

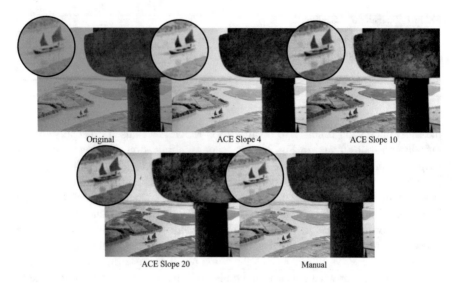

<div align="center">Original ACE Slope 4 ACE Slope 10</div>

<div align="center">ACE Slope 20 Manual</div>

Fig. 4 Key-Frame of "Isole della Laguna" scene 8 restored through different ACE parameters and manually. For each frame an enlargement of the details is provided

overall image quality index, attempts to preserve all the main characteristics of the restoration pipeline. This method is a valuable tool to estimate the enhancement that different methods made on film key-frame and so to evaluate which are the parameters that are improved through a specific restoration algorithm. The first intuitive method to assess the enhancement made by an algorithm on a frame is the analysis of the image histogram [21].

The image histogram is a graphical representation of the tonal distribution in the digital image. The horizontal axis of the graph represents the tonal variations (from 0 to 255), while the vertical axis represents the number of pixels for each tone. The image histogram is typically made for the image luminance (the L* channel in the CIE L*a*b* color space). When working with old film and in the field of film restoration, the image is often subject to decay and aging and can be affected by fading, losing information in the lighter area. Due to this, in the digital image the lighter point (pure white) is no more represented by the maximum value, 255, but is lowered proportionally with the fading [23]. In Figs. 5 and 7 the histograms of the images in Figs. 4 and 6 are reported. The effect of silver fading in the original film is clearly visible in the histogram of the original frame. Here the maximum value for white is around 160 and the aging affected also the black, whose lower value is around 10. The two considered enhancement methods provided different histograms, shown in Figs. 5 and 7. Both the methods increase the contrast in the image (i.e., ratio between the brightest and darkest value of luminance), but the manual restoration didn't set the black point at 0 and the white one at 255, at the opposite of ACE that extended the luminance values using all the possible dynamic range. Considering just the ACE parameter applied to the scenes, the difference

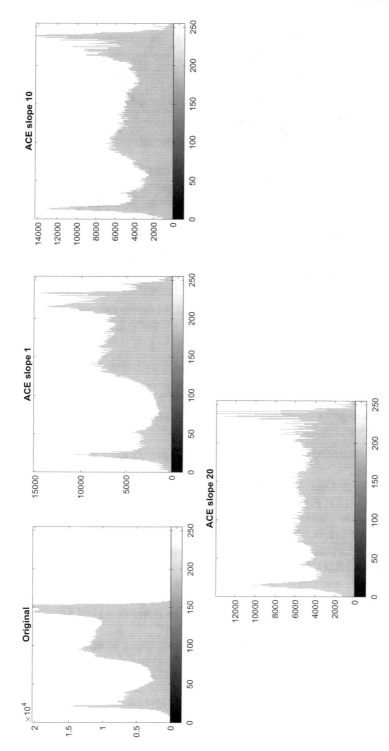

Fig. 5 Image histograms of the frame in Fig. 4

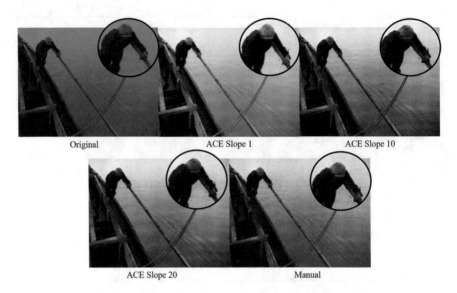

Fig. 6 Key-Frame of "Isole della Laguna" scene 29 restored through different ACE parameters and manually. For each frame an enlargement of the details is provided

between the restoration methods can be seen also in Tables 2 and 4, where the average and variance of the histograms are reported.

To give a more specific idea of the enhancement that ACE and Da Vinci made on the original image we computed also some statistical measures on the frames [12]. In particular we measured:

- **L***: Mean intensity of the pixels in the Luminance channel of the CIEL*a*b* color space.
- **MRContrast**: Multi-Resolution Contrast of the pixels in the L* channel [17]. It is computed at first measuring the L^1 distance between the pixel $L^*(x)$ and the eight pixels surrounding x in a 3×3 window centered in x, for all the pixels in the image. The average of this value is called *average local contrast*. The Multi-Resolution Contrast is obtained computing the *average local contrast* for a set of images, obtained scaling the L* image under analysis (i.e., obtained progressively reducing the resolution of the image).
- **HF**: is the Histogram Flatness and measures the entropy of the distribution of L* as L^1 distance between the histogram of the image (see Figs. 5 and 7) and a uniform PDF over the range of the image [0,255].
- **CLV**: is the Coefficient of Local Variation and is the mean value of the relative standard deviation computed at each pixel x of the image in the L* channel in a 9×9 window centered in x.

The statistical measures applied at Fig. 4 are reported in Table 3. At first, we can notice that the enhancement, manual and with ACE, increases the mean value of luminance L*. The enhancement with ACE Slope 4 presents the higher increase

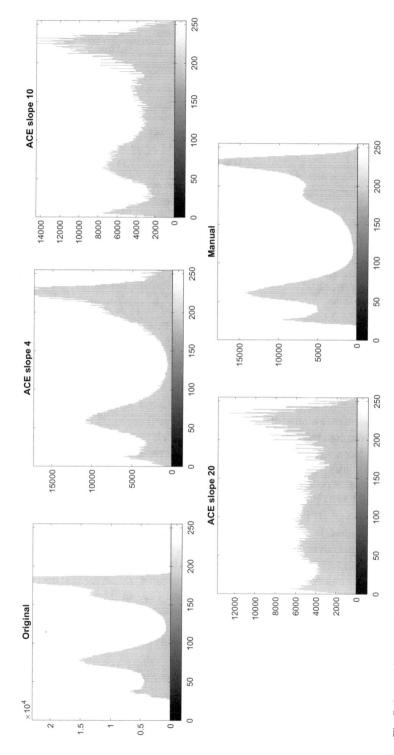

Fig. 7 Image histograms of the frames in Fig. 6

Table 2 Values of average and variance of the histograms of the frames in Fig. 4

	Original	ACE slope 4	Manual
Average	6912	5184	5184
Variance	7.8183e+08	1.1421e+07	1.9347e+07

Table 3 Some general No-Reference Image Quality Measures applied to the frames in Fig. 4

Frame	L*	MRContrast	HF	CLV
Original	42.42	1.11	0.007	0.05
Manual	53.08	1.78	0.007	0.072
ACE slope 1	61.32	1.89	0.007	0.07
ACE slope 10	54.48	2.11	0.007	0.10
ACE slope 20	53.38	2.24	0.007	0.10

Table 4 Values of average and variance of the histograms of the frames in Fig. 6

	Original	ACE slope 1	Manual
Average	5184	5184	5184
Variance	3.9182e+07	9.9295e+06	9.5896e+06

Table 5 Some general no-reference image quality measures applied to the frames in Fig. 6

Frame	L*	MRContrast	HF	CLV
Original	52.89	1.13	0.007	0.03
Manual	57.96	1.74	0.007	0.05
ACE slope 1	57.91	1.83	0.007	0.07
ACE slope 10	56.04	2.29	0.007	0.09
ACE slope 20	54.27	2.48	0.007	0.09

of luminance in the frame, instead of manual, ACE slope 10 and ACE slope 20 that maintain a luminance around 50. An interesting value is the MRContrast, that shows numerically the concept already explained for which an increase of slope in ACE produces an increase in contrast. Here, the manual enhancement and ACE slope 4 maintain the contrast around 1.7–1.8, whereas ACE slopes 10 and 20 increase the contrast to a value over 2. Considering the values of L* and MRContrast, manual restoration and ACE slope 4 produces a satisfiable enhancement, at the opposite of ACE slope 10 and 20 that, increasing more the contrast and luminance, produce an increase of noise in the image (see Fig. 4). The histogram flatness is exactly the same for all the analyzed frames. The CLV value is useful to determinate the local variation in the image, so to define if the details in the image are visible and if the enhancement introduces an increase of noise. In the table we can see that the manual and ACE slope 4 restoration increase the original CLV of 0.02 points, and ACE slope 10 and 20 of 0.05 points. Considering those values in relation with the value of contrast and the resulting image, we can assess that ACE 10 and 20 increase the perceived noise in the image, whereas manual and ACE slope 4 increase the details in the image without raising the noise in the image (Table 4).

The statistical measures applied to the frames in Fig. 6 are reported in Table 5. Also in this example the luminance channel is equalized in all the enhancements, and we can see that the Manual enhancement and ACE slope 1 provided the same increase of L*. This value is really significant, because it shows that the

restoration through an automatic unsupervised algorithms provided the same results as a manual enhancement but in a shorter time. The main difference between Manual and ACE slope 1 restoration lays in the values of contrast and CLV, in fact the manual enhancement keeps those values lower than ACE slope 1, even though in the restored image the noise and details are really similar between those two methods. ACE slopes 10 and 20 increase the luminance of 2 points, the contrast over 1.00 points and the CLV is tripled. This increase translates into higher noise in the resulting image.

Thanks to the application of image histograms and statistical measures for the assessment of the quality of restored frames, it was possible to underline and objectively define the advantages of a restoration through unsupervised SCAs. In those applications the best results were archived by Manual restoration and ACE with the lowest slope values (1 and 4). Furthermore, the strong correlation between the manual and ACE restoration demonstrates that the obtained results are not just faithful to the original frame, but also perceptually preferred.

Conclusion

The documentary directed by Luciano Emmer and Enrico Gras "Isole della Laguna" (1948) has been a test-bed for an alternative method to restore the contrast of aged films. In this work we showed the potentials of the ACE algorithm and the possibilities that offer to support the work of experts as kick-off step in the restoration pipeline or for a direct enhancement. This method provides not only a contrast enhancement based on the original ratio between pixel in an image, but also a restoration that is perceptually preferable by users. In this way, the color correction is no longer dependent by the colorist professionalism and prone to times and costs relatives to a long-term restoration project, but can be made in wider economic terms and is faithful to the human visual system. Furthermore, in this application, we have assessed the quality of different restoration methods, comparing the ACE unsupervised enhancement with a manual restoration. Results showed that, for the contrast correction of "Isole della Laguna" a restoration through ACE with low slope values is preferable and permit to reach results close to a manual restoration in shorter time.

Acknowledgments This work was made by "I've Seen Things – Ho visto cose" Research Group (MIPS Lab) at the University of Milan, Computer Science Department. We thank Michele Emmer who provided us his father's documentary "Le Isole nella Laguna" to improve the research in the field of film digital restoration. Furthermore, we would like to thank Arianna Brivio for the work in filtering and making experiments on the frames.

References

1. *Da Vinci Resolve 16* (2019). https://www.blackmagicdesign.com/it/products/davinciresolve/ (visited on 07/11/2019)
2. R. Catanese, *Lacune Binarie. Il restauro dei film e le tecnologie digitali* (Bulzoni, Rome, 2013)
3. A. Cornwell-Clyne, *Colour Cinematography* (Chapman and Hall, London, 1936)
4. L. Enticknap, *The Culture and Science of Audiovisual Heritage* (Palgrave MacMillan, New York, 2013)
5. N. Fairbairn, M.A. Pimpinelli, T. Ross, in *The FIAF Moving Image Cataloguing Manual*, ed. by Linda Todic for the FIAF Cataloguing and Documentation Commission (2016)
6. G. Fossati, *From Grain to Pixel* (Amsterdam University Press, Amsterdam, 2009)
7. E.H. Gombrich, *Art and Illusion: A Study in the Psychology of Pictorial Representation* (Phaidon Inc Ltd., London, 2002)
8. N. Mazzanti, Ciname colors, now and then, in *ICA-Belgium Color Symposium* (2019)
9. J.J. McCann, V. Vonikakis, A. Rizzi, *HDR Scene Capture and Appearance* (SPIE, Bellingham, 2017)
10. C. Parraman, A. Rizzi, Searching user preferences in printing: a proposal for an automatic solution, in *Printing Technology SpB06* (2006)
11. C. Parraman, A. Rizzi, User preferences in colour enhancement for unsupervised printing methods, vol. 6493 (2007). https://doi.org/10.1117/12.704144
12. A. Plutino, M. Lecca, A. Rizzi, A cockpit of measures for image quality assessment in digital film restoration, in *New Trends in Image Analysis and Processing – ICIAP 2019* (2019). https://doi.org/10.1007/978-3-030-30754-7
13. A. Plutino et al., Work memories in Super 8: searching a frame quality metric for movie restoration assessment. J. Cult. Herit. (2019). ISSN: 1296-2074. https://doi.org/10.1016/j.culher.2019.06.008
14. A. Rizzi, M. Chambah, Perceptual color film restoration. SMPTE Motion Imaging J. **119**(8), 33–41 (2010). ISSN: 1545-0279. https://doi.org/10.5594/J17295
15. A. Rizzi, J.J. McCann, On the behavior of spatial models of color, vol. 6493 (2007), pp. 6493–6493–14. https://doi.org/10.1117/12.708905
16. A. Rizzi, C. Gatta, D. Marini, A new algorithm for unsupervised global and local color correction. Pattern Recogn. Lett. **24**(11), 1663–1677 (2003)
17. A. Rizzi et al., A proposal for contrast measure in digital images, in *Conference on Colour in Graphics, Imaging, and Vision*, vol. 2004.1 (2004), pp. 187–192. ISSN: 2158–6330. https://www.ingentaconnect.com/content/ist/cgiv/2004/00002004/00000001/art00039
18. A. Rizzi et al., A mixed perceptual and physical-chemical approach for the restoration of faded positive films, in *Conference on Colour in Graphics, Imaging, and Vision*, vol. 2008.1 (2008), pp. 292–295. ISSN: 2158–6330. https://www.ingentaconnect.com/content/ist/cgiv/2008/00002008/00000001/art00063
19. A. Rizzi et al., Unsupervised digital movie restoration with spatial models of color. Multimed. Tools Appl. **75**(7), 3747–3765 (2016). ISSN: 1573–7721. https://doi.org/10.1007/s11042-014-2064-5
20. A. Rizzi, D. Fogli, B. Barricelli, A new approach to perceptual assessment of human-computer interfaces. Multimed. Tools Appl. **76**(5), 7381–7399 (2017)
21. A. Rizzi et al., Designing a cockpit for image quality evaluation, in *Transactions: Imaging/Art/Science – Image Quality, Content and Aesthetics* (University of Westminster, London, 2019), 26th April
22. P. Uccello, *Cinema. Tecnica e Linguaggio* (San Paolo, Milan, 1997)
23. S. Zuffi, R. Cereda, A. Rizzi, Valutazione automatica di interventi di restauro del colore in opere cinematografiche, in *Terza Conferenza nazionale del Gruppo del Colore (SIOF)* (2007)

Mathematically Based Algorithms
for Film Digital Restoration

Serena Bellotti, Giulia Bottaro, Alice Plutino, and Michele Valsesia

Introduction

Since its invention in the nineteenth century, cinema has become one of the most important media of popular culture, becoming a fundamental part of our historical memory [4, 13]. Even with the advent of the digital, many directors prefer to shoot movies on the analog support and in many festivals films are still projected using the traditional instruments [10]. Unfortunately, the frequent projection of the film and the contact with dirt or worn rollers in the film path can cause film deterioration. Furthermore, damages can occur also outside the projector, if film is wound too tightly or loosely and stored in wrong conservation conditions, or also during the editing or restoration processes. Furthermore, films are subject to the aging of dyes contained in the emulsion and a fast decay of the support itself especially when the conservation conditions of temperature and humidity are not appropriated and controlled. The decay is an irreversible natural process that usually introduces a color dominant, loss of contrast and/or color desaturation [7, 14]. Dealing with the risks of losing the cinematographic heritage, the need to preserve moving images becomes more and more important, even though conservative practices are not yet defined or jointly approved by the film restoration community [2, 5]. Generally, the workflow consists on the following parts:

1. Historical/artistic research: it is the census of the existence of copies in the archives of the film object of restoration.
2. Analogic or photochemical restoration: it provides a first phase of reparation of damage on the material film (e.g., fixing tears and lacerations of the support, repairing broken perforations and reducing dirt, dust and oil stains) to reinstate its

S. Bellotti · G. Bottaro (✉) · A. Plutino · M. Valsesia
Università degli Studi di Milano, Computer Science Department, MIPS Lab, Milan, Italy
e-mail: giulia.bottaro@studenti.unimi.it

© Springer Nature Switzerland AG 2020
M. Emmer, M. Abate (eds.), *Imagine Math 7*,
https://doi.org/10.1007/978-3-030-42653-8_6

functionality. It allows the film to properly run into the machine used to generate a first element of conservation by analogically printing a new copy. Base-side scratches, for example, can be minimized during the duplication process using the wet gate method, in which the damaged film passes through a liquid solution that temporarily fills the scratches, so they appear significantly reduced in the resulting copy. Then, this one could be scanned to obtain a digital copy of the film.

3. Digital Restoration: this operation is made after the film scanning. From a theoretical point of view based on the definitions proposed by the director of the Cinémathèque Royale de Belgique Nicola Mazzanti, it *is an intervention of duplication that involves the correction and reintegration of compromised aspects in the starting copies*. The programs used in this process are software that work in manual, automatic, and interactive mode, based on sophisticated algorithms able to identify and remove the anomalous elements present in the image. It usually includes also the color correction operations.

One advantage of digital restoration with respect to the analog one is the possibility to study and test the effect of restoration algorithms without directly intervening on the analog support, so without risking to damage the original film [6]. Nevertheless, the most used restoration software involves a significant human intervention and an accurate work of supervision frame-by-frame controlled by qualified operators. In fact, if the automatic filters do not work properly, a further phase of manual cleaning is required. Moreover, the licenses for restoration software have a high cost that makes the digital restoration process expensive in terms of money as well as in terms of time. The first consequence of this high cost is that the majority of small audiovisual archives cannot afford the whole restoration process. In recent years, different works concerning the automatic and unsupervised color and contrast correction have been done [8, 9], but it is still fundamental to improve the research in the field. In the context of digital restoration, the kind of deterioration can be different, but among them, scratches, dust, and sparkles, are the most common. Scratches appear as vertical lines of different lengths and thickness, usually dark or white. They are identified as *principal* if they cover more than the 95% of the image height, or *secondary* in all other cases. Dust or sparkles may settle and stick on the emulsion side during the winding of the film and they will appear in random positions and variable forms from one frame to another during the projection. To remove scratches, dust, and sparkles, the main digital restoration interventions are:

- Dirt and sparkles removal: it uses an algorithmic process for the recognition, the elimination and the replacement of dirt residues. It is usually performed through the identification of difference in brightness between consecutive frames.
- Scratch removal: it uses an algorithmic calculation based on spatial filters, built on micro-interpolations between the pixel neighboring to the scratch. It recognizes the interruption in the photographic harmony in the frame, and reconstructs the scratched information starting from the pixels adjacent to it.
- Noise reduction: it uses a temporal algorithm based on the comparison between consecutive frames to reduce the noise in the image.

Starting from the need to improve digital restoration and make available to the archives tools to support the work of the restorers, in this work we present an open source software which reduces the human intervention and that could be easily used even by non-pro users: DustRemover. Here, we tested our software on the documentary *Isole nella Laguna* (1948) by Luciano Emmer and Enrico Gras. In section "Digital Restoration" we explain the main operations used in digital restorations software and in section "DustRemover" we present our innovative software. In section "Digital Restoration of *Isole nella Laguna*" we show the results of the application of DustScratch on the documentary *Isole nella Laguna* and in section "Conclusions" the conclusions are presented.

Digital Restoration

The Digital restoration (DR) is the operation that follows the film scanning in the restoration pipeline and concerns the film digital reconstruction. The tools performing DR are software-based systems that work in manual, automatic, and interactive mode. Usually, those tools are based on sophisticated algorithms able to identify and remove anomalous elements contained in film frames, apparently impossible to be restored through the photochemical methods. The typical defects corrected by those tools are instability dirt, cracks, deformations, transparencies, graininess, scratches, sparkles, etc. Despite the DR algorithms can be extremely performing, it is fundamental to be faithful to the original information and to define, in the restoration project, the invasiveness of the intervention of digital restoration. In fact, following the recent developments in cinematographic philology, reconstructing an entire scene of a film or substituting damaged frames can disagree with the aim of preserving the history of a film, and not just of its content [3]. Due to this, also if the potential of DR is infinite, we focused on the operation mainly used, in particular on the algorithms for dirt, sparkle, scratches, and dust removal. Those operations, in fact, are the most used, because they permit a partial or total removal of some of the most common problems in film, providing a reconstruction of some damaged pixels in the frames, and not altering the entire image content.

Dirt and Sparkles Removal

Since dirt and sparkles vary a lot between frames, they can be detected by comparing adjacent frames that differ just for a few amounts of details, except for the ones at the beginning and at the end of a scene. This similarity between nearby frames is known as temporal coherence. Commonly, to find dirt and sparkles, each frame is divided into blocks of pixel of the same size. Then, each block is compared to the one in the same position in the next frame. To define the similarity between frame blocks and frames different metric can be used. In this work we applied the Sum of

Absolute Differences (SAD). It computes the absolute difference between the pixels in each block, then, the values of each block are summed to obtain the measure. This method is equivalent to the calculation of the Manhattan distance. SAD is defined as

$$SAD(b_1, b_2) = \sum |b_1 - b_2| \tag{1}$$

where b_1 represents a block in the current frame, b_2 a block in the next one, and n is the block size. If SAD between two blocks is 0, the blocks are equal. As the SAD value increases, the blocks are more different. Once the dirt and sparkles have been identified, the missing pixel are repaired using a technique called *inpainting* (See section "Inpainting").

Scratches Removal

In an image, scratches are lines of different lengths that can be dark or white. They are identified as *principal* if they cover more than the 95% of the image height, or *secondary* in all other cases. Usually, their width can go from 3 to 10 pixel [1]. Scratches are identified and restored through a local algorithm that compare the pixels in the considered frames. In contrast to dirt and sparkles removal, scratches usually affect subsequent frames, so a comparison between consecutive frames is not sufficient to detect them. Scratches are identified comparing the intensity of each pixel in a frame with the intensity of its neighbors. Frames are scanned from left to right and when a sudden change of intensity is detected, the pixel that caused it is copied on an intermediate binary image called mask. The mask is used to represent the position of the scratches in the original image. After the mask creation, the group of pixels which value is over a defined threshold are reconstructed in the restored frames, and the ones which value is below the threshold are discarded. The scratches restoration is usually made through the *inpainting* technique.

Inpainting

The term inpainting refers to a series of algorithms that restore regions of an image completely destroyed or irremediably ruined, where it is impossible to use image enhancement algorithms. It is applicable when the region to be inpainted is not static compared to the background and the content from the other frames provides new information. It could work in two different ways:

- A Model Based Inpainting: it estimates missing data using mathematical models (like Bayesian predictors) and differential equations to retrieve the lost content. The frame issue (dirt/sparkle or scratch) is converted through a minimization process in the best prediction possible for the missing pixel of an image.

- An Exemplar Based Inpainting: it attempts at filling the holes present in an image looking for similar patches in the neighborhood of the ruined regions. Through the analysis of the texture and the geometric structure of an image, this method scans a series of patches and finds those that fit better with the adjacent pixel of a hole. At the end of the process, missing pixels are replaced with the ones contained in the best patch found previously. This method does not introduce the blurring artifacts that affect the Model Based Inpainting [12].

Dust Removal

Dust can be reduced considerably with the application of denoising filters that can be implemented using different methods. Firstly, it is possible to apply a low-pass filter on an image, in an operation called *smoothing*. Here, each pixel is replaced with the average value calculated between itself and a defined number of its neighbors. The *smoothing* can be performed also through a weighted average; in this way, it is possible to consider only specific areas of an image. The smoothing filtering removes the high frequencies and pass only the lower ones. For this reason, the filtered image tends to be blurred and its content is flattened because most of its details are deleted. A second common method is a *non-linear median filter*, known to be very good in preserving image details. For each pixel, it considers a set of its neighbors, the elements from that set are sorted out according to their intensities and form an ordered list. The value of the original pixel value is replaced with the median obtained from that list. The median filter is particularly good at removing salt and pepper noise, but partially blurs the edges of the image.

DustRemover

In this work we present DustRemover, an open source software which reduces the human intervention and that could be easily used even by non-pro users. DustRemover is made of a series of different filters. Each filter is a plug-in of a video manipulation framework called Vapoursynth, which consists of a core library written in C++ and a Python module to allow video scripts to be created. We have chosen this kind of framework because on one hand it is extremely fast and optimized for a great variety of machine architectures and on the other hand the use of a Python module simplifies the filter chain extension so that it is much easier to update and modify the underlying code. DustRemover supports only YV12 and planar YUY2 color spaces and the format of the videos used as input must be progressive. If a video is interlaced or has a different color space, it needs to be converted before being filtered. The output of this filter is a video in which dust, dirt, sparkles, and little scratches are repaired. DustRemover consists of three main

Fig. 1 Graphical description of DustRemover pipeline

phases: motion detection, noise detection, and restore (see Fig. 1). Every phase has different parameters that can be set by the user due to the specific frames properties.

Motion Detection

The Motion Detection is an automatic process that detects scene changes comparing the current frame with the previous and next ones. This step is fundamental to split a film in scenes and detect the movement in it. This is done with the *dfactor* parameter. A preprocessing phase creates three clips filtered using different methods:

- Firstly, a denoiser filter replaces each pixel with the median calculated between the current pixel and its counterparts in the previous and subsequent frames. It considerably reduces the noise present in the clip and maintains its temporal coherence, but it introduces new defects, especially on scene changes. This new clip is named *cleansed*.
- The second filter replaces every pixel of a frame with the median value calculated between the current pixel and its counterpart in the next frame. *sbegin* is the name of the output clip.

 This method avoids introducing artifacts to the first frame of a scene.
- The third clip, called send, replaces every pixel of a frame with the median calculated between the current pixel and its counterpart in the previous one.

 This method avoids introducing artifacts to the last frame of a scene.

The motion detection phase identifies the scene changes and the global motion in the source clip using a filter called SCSelect. The resulting clip is *scenechange*. SCSelect chooses the frames for its output clip from the other input clips using the following criteria:

- If $SAD(n - 1) > dfactor \cdot SAD(n)$, then frame n represents the beginning of a scene and hence the corresponding output frame is taken from *sbegin*.
- If $SAD(n) > dfactor \cdot SAD(n - 1)$, then frame n represents the end of a scene and hence the corresponding output frame is taken from *send*.
- If $SAD(n) \leq dfactor \cdot SAD(n - 1)$ and $SAD(n - 1) \leq dfactor \cdot SAD(n)$, then frame n contains global motion and hence the corresponding output frame is taken from *cleansed*.

Here, *dfactor* is a parameter that sets the scene change sensitivity. If the *dfactor* value is too high, SCSelect focuses its research on frames containing global motion,

on the other hand, if the value is low, the filter focuses its research on scene changes frames. The above algorithm is optimized so that only one SAD per frame is calculated.

Noise Detection

Noise Detection computes the SAD distance between frames sub-sampled in 8x8 pixels blocks. If the content of a block is different between two adjacent frames, a movement is detected. A block whose content differs of a certain amount between its adjacent frames is called motion block. Here SAD is computed between 8×8 pixel blocks (p_i and q_i) of the current and previous/subsequent frames:

$$SAD(|p_i - q_i|) = \sum |p_i - q_i| \qquad (2)$$

This phase is controlled by the following parameters:

- noise: specifies the amount of noise ignored by the algorithm.
- noisy: represents the number of noisy pixels of a block that should be exceeded in order to consider that block as a motion block.
- As alternative to noisy is possible to use *gmthreshold*: an alternative to the noisy parameter for the identification of a block as motion block due to its SAD value.

Since noisy blocks can be detected as motion blocks because their content varies a lot from one frame to another, it is important to identify them before the restore phase. The spatial filter Repair works on the clips *scene change* and *cleansed* in 18 different modes. It can be set to consider only the motion areas of a frame, leaving the static ones unrepaired, thus creating the corresponding filtered clips named *alt* and *restore*. Then, filter RestoreMotionBlocks restores motion blocks affected by noise working in two phases:

- The first phase detects noisy motion blocks through a comparison with a series of thresholds. Motion blocks without noise are called phase-one motion blocks because they are found during the phase one of RestoreMotionBlocks.
- The second phase restores damaged blocks replacing them with the ones taken from other input clips, but this procedure will be addressed in the Restore phase.

A motion block is detected starting from the source clip. If RestoreMotionBlocks identifies a motion block in *cleansed*, it replaces this block with the one contained in *restore*, unless, in that case, the percentage of motion blocks exceeds the percentage specified in gmthreshold when the entire frame is replaced with the one contained in *alt*: in this way, scene changes and global motion are correctly handled. If *alt* is not given, *restore* is used in its place. The gmthreshold value represents both the global percentage of motion blocks allowed in a frame and a threshold that must be exceeded to decree a block as a motion block. So, this parameter determines how different are the two frames one from the other. The noise threshold specifies the

amount of noise ignored by the algorithm, while noisy represents the number of noisy pixel of a block that should be exceeded to consider it as a motion block.

Restore

Restore is the last phase of the workflow and is the core of frames restoration: it repairs the motion blocks identified as damaged replacing them with the pixel taken from the input clips previously created. For this reason, during the noise detection phase we have identified noise-free motion blocks, so the remaining ones can be only static or noisy. This step is controlled by the following thresholds:

- dist: evaluates the differences between blocks identified as motion blocks.
- dmode: the higher is the value, the most accurate is the selection of the motion blocks.
- gmthreshold: is the same threshold of the previous phase, but here it figures out which frame must be replaced.
- repmode: allows to choose between 24 different methods to restore frames.
- pthreshold: verifies how many blocks need to be restored working only on the Luma plane.
- cthreshold: verifies how many blocks need to be restored working only on the Chroma planes.

The last filter adopted by DustRemover is RemoveGrain: a spatial denoising filter that cleans grain and dirt that a temporal cleaner cannot remove because of the excessive amount of grain contained in frames. To do that, it considers the 3×3-pixel square neighborhood centered on the pixel that needs to be replaced. The top and bottom rows in addition to the leftmost and rightmost columns of a frame are not processed.

Digital Restoration of *Isole nella Laguna*

Isole nella Laguna

The digital restoration was made on the documentary *Isole nella Laguna*, that we received by Michele Emmer already digitalized. It is a documentary directed by Luciano Emmer and Enrico Gras in 1948, part of the series *Giornate senza tramonto* produced by Universalia. In the short film, the directors capture the melancholy of the Venetian Lagoon, preferring long shots in which the lagoon landscape is the true protagonist, giving the film a disturbing atmosphere that evokes a marked feeling of solitude. Gino Cervi's voice reads a text by Diego Fabbri describing the images of the isles of Venice, of small boats with sailors and of working men and women. The

soundtrack is present but does not obscure the narration [11]. Isole nella Laguna is a black and white film of 12:47 minutes, reproduced with a speed of 24 fps, for a total of 19.199 frames. It has been scanned with a pixel resolution of 1080 × 1920.

Results Assessment

For the results assessment we used the PSNR (Peak signal-to-noise-ratio) metric. It is an objective measure chosen to compare the filtered frame with its original. It is defined as the ratio between the maximum possible power of a signal and the power of the corrupting noise that affects the fidelity of its representation [8]. Since a signal can have a wide dynamic range, PSNR is usually expressed in decibel (dB). Let I be the image under analysis:

$$PSNR = 10 \cdot \log_{10} \left(\frac{MAX(I)}{\sqrt{MSE}} \right) \tag{3}$$

where $MAX(I)$ is the maximum possible pixel value of the image, and MSE (Mean Squared Error) is computed as follows:

$$MSE = \frac{1}{mn} \sum_{i=0}^{m-1} \sum_{j=0}^{n-1} [I(i, j) - K(i, j)]^2 \tag{4}$$

where I is a noise-free $m \times n$ monochrome image with pixels at $I(i, j)$ coordinates, and K its noisy approximation. For color images with three RGB values per pixel, MSE is calculated for each color channel independently. In fact, a channel could have a different dimension according to the sampling rate adopted to represent the chrominance information, hence a diverse mn value. We call these three values MSE_r, MSE_g, MSE_b. The MSE is then obtained as:

$$MSE = \frac{MSE_r + MSE_g + MSE_b}{3} \tag{5}$$

When an image has a color space different from RGB, PSNR is computed for each channel of that color space independently. Typical values for PSNR are between 30 and 50 dB (when the bitdepth is 8 bits). Higher values are considered better values. If the noise is absent, I and K are identical, then MSE is zero and the PSNR is infinite. If the PSNR is infinite, its value has been set to 60 dB by convention. PSNR is a stable and a simple measure, and although it does not consider the content of a frame, it provides a good and simple representation of the quality of a filtered frame.

Results

Isole nella Laguna presents a great variety of different types of frames to be tested and this allowed us to evaluate in a simple way how DustRemover performed on different content types. For our tests, we have chosen frames that contain some of the most common film defects: dust, dirt, sparkles, and scratches. After some test, we applied DustRemover using the default parameters in Table 1.

Nevertheless, to test the performance of the tool we provide examples of two different restoration approaches, one *Moderate* and one *Brutal*, increasing the values of noise and noisy (see Table 2).

The first test considered a frame full of noise and containing some sparkles on the right side (Fig. 2). First, we applied the Moderate parameters and, since the image is extremely noisy, we have increased noise and noisy parameters to a higher value. We have decided to consider only the noisy parameter to test if there could be a significant speed and quality variation. The algorithm runs a bit faster, but the filtered frame maintains approximately the same quality (see Table 3).

For the second test, we have focused on the removal of a great amount of dirt. It was not possible to remove it completely using Moderate parameters, so we have decided to apply a Brutal filtering increasing the parameter noisy, since it is faster than noise. We have also set gmthreshold to the maximum value (100). In this way, DustRemover is more restrictive on motion blocks detection, so it is easier to identify the noisy blocks. However, this kind of approach reduces considerably the details present in a frame, as we can see from the PSNR value (see Fig. 3 and Table 3).

The third test aimed to reduce the big scratch present on the right side of the frame (Fig. 4). Moderate parameters have attenuated it quite a lot, but the scratch is totally disappeared only after having increased noisy to 20. In this case, the quality of the frame is improved even from an objective point of view (Table 3).

In the fourth test, we have tested how DustRemover performs on a scene change that presents a fade in-out effect. Moderate parameters reduce dust and sparkles quite enough, but only after having increased the noisy value to 30 we have managed

Table 1 DustRemover default parameters

d factor	4
dist	1
gmthreshold	80
pthreshold	10
dmode	2

Table 2 Parameters of noise and noisy for the test images

		Test 1	Test 2	Test 3	Test 4
Moderate	Noise	10	10	10	10
	Noisy	12	12	12	12
Brutal	Noise	38	10	10	10
	Noisy	34	64	20	64

Fig. 2 Test 1: The first frame is the original, the second one is filtered using Moderate parameters, and the last frame is filtered using Brutal parameters

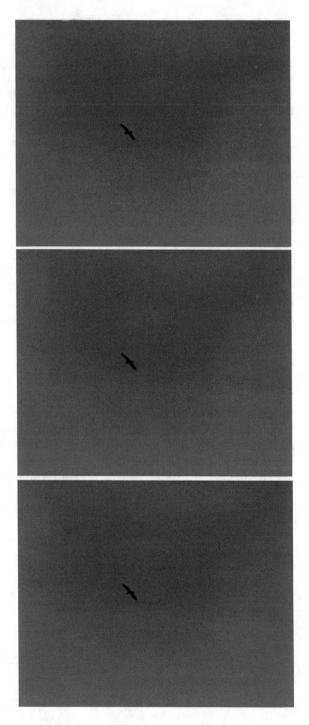

Table 3 Results assessment

	Test 1		Test 2		Test 3		Test 4	
	Moderate	Brutal	Moderate	Brutal	Moderate	Brutal	Moderate	Brutal
PSNR (dB)	39.96	39.65	38.90	36.45	45.31	45.64	43.73	41.06
Runtime (ms)	32	13	10	10	10	10	10	10

to completely clean the frame, leaving its quality practically intact (Fig. 5). The PSNR value did not change much compared to the frame filtered with Moderate parameters (Table 3).

Conclusions

A downside of DustScratch algorithm is given by the fact that, if a scene is extremely noisy, it destroys some of the frame details. For this reason, noise and noisy parameters should be used moderately, because an excessive increase can create loss of details, loss of edges, and blur, so a supervision of the results is needed. The gmthreshold determines the number of motion blocks present in a frame and identifies the noisy ones. A high value allows to detect blocks full of noise and that are more different from the previous and the next frame, while a low value is a good choice for scenes affected by a small amount of noise. Other parameters produce only small variations of the frame content and slightly modify PSNR values. For instance, the dfactor parameter does not improve the quality of a single frame, but the smoothness of the entire clip; or the pthreshold parameter handles how blocks fit one to another within a frame avoiding the macro blocking effect during the clip playback. The main limit of DustRemover is in the identification of scene changes because when two following scenes, respectively, end and begin with a global motion frame, it cannot identify the scene change. Generally, it determines a satisfying removal of dust, a partial elimination of vertical scratches and an extensive cleaning of the images. In addition, the filter execution is fast with a runtime around 6–8 ms. On *Isole nella Laguna*, DustRemover performs quite well on frames affected by noise, dirt, and little scratches and after a general evaluation it is possible to assert that DustRemover ensures an improvement of the visual quality: it is possible to estimate a 70% removal of vertical scratches and dust. When applied on large scratches, it considerably reduces their thickness, but it does not remove them completely. In general, it needs a minor human intervention, shortening restoration time, even if user supervision is required since parameters, for example noise and noisy, must be set case-by-case. Since it is open source and free, one of its advantages is that even small audiovisual archives could afford it. One aspect of the algorithm that could be improved is its ability to identify scene changes even when they occur between two scenes that, respectively, end and start with a motion block.

Fig. 3 Test 2: The first frame is the original, the second one is filtered using Moderate parameters, and the last frame is filtered using Brutal parameters

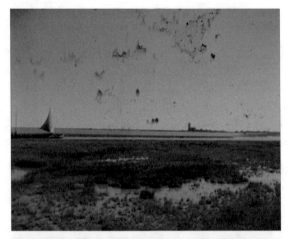

Fig. 4 Test 3: The first frame is the original, the second one is filtered using Moderate parameters, and the last frame is filtered using Brutal parameters

Fig. 5 Test 4: The first frame is the original, the second one is filtered using Moderate parameters, and the last frame is filtered using Brutal parameters

Acknowledgments This work was made by "I've Seen Things—Ho visto cose" Research Group (MIPS Lab) headed by professor Alessandro Rizzi at the University of Milan, Computer Science Department. We would like to thank Michele Emmer that provided us his father's documentary *Isole nella Laguna* to improve the research in the field of film digital restoration. We would like to thank Chiara Arpiani and Matteo Rebuzzini for helping us in testing and developing the DustScratch software.

References

1. S. Bhuvaneswari, T.S. Subashini, N. Thillaigovindan, Detection and removal of scratches in images, in *Mining Intelligence and Knowledge Exploration* (Springer, Cham, 2013), pp. 212–223
2. V. Boarini, V. Opela, Charter of film restoration. J. Film Preserv. **83**, 37–39 (2010)
3. R. Catanese, *Lacune Binarie. Il restauro dei film e le tecnologie digitali* (Bulzoni, Rome, 2013)
4. L. Enticknap, *The Culture and Science of Audiovisual Heritage* (Palgrave MacMillan, New York, 2013)
5. N. Fairbairn, M.A. Pimpinelli, T. Ross, in *The FIAF Moving Image Cataloguing Manual*, ed. by Linda Todic. FIAF Cataloguing and Documentation Commission (2016)
6. G. Fossati, *From Grain to Pixel* (Amsterdam University Press, Amsterdam, 2009)
7. Institute, RIT Image Permanence, *Visual Decay Guide* (2019). https://filmcare.org/ (visited on 09/26/2019)
8. A. Plutino et al., Work memories in Super 8: searching a frame quality metric for movie restoration assessment. J. Cult. Herit. ISSN: 1296–2074. https://doi.org/10.1016/j.culher.2019.06.008
9. A. Rizzi et al., Unsupervised digital movie restoration with spatial models of color. Multimed. Tools Appl. **75**(7), 3747–3765 (2016). ISSN: 1573–7721. https://doi.org/10.1007/s11042-014-2064-5
10. T. Saetervadet, *FIAF Digital Projection Guide* (Fiaf, Brussels, 2012)
11. P. Scremin, *Parole dipinte: il cinema sull'arte di Luciano Emmer* (Cineteca di Bologna, Bologna, 2010)
12. A. Telea, An image inpainting technique based on the fast marching method. J. Graph. Tools **9**, 23–34 (2004)
13. P. Uccello, *Cinema. Tecnica e Linguaggio* (San Paolo Edizioni, Milan, 1982)
14. UNESCO, Recommendation for the Safeguarding and Preservation of Moving Images (1980) http://portal.unesco.org/en/ev.php-URL_ID=13139&URL_DO=DO_TOPIC&URL_SECTION=201.html (visited on 09/26/2019)

Homage to Octavia Spencer

Michele Emmer

In a 2016 article I wrote a short history of the recent films on mathematicians until 2015. The paper was published by the title *Cinema and Mathematics: Recent Developments* [1]. Since then there have been interesting developments.

The Oscars Academy Awards for 2015

Before 2015 only two films with mathematicians in leading roles had won Oscars:

Will Hunting [2], Oscar for original screenplay to Matt Damon and Ben Affleck and best supporting actor Robin Williams, the only one in the film not to impersonate a mathematician.

A Beautiful Mind [3], Oscar for best film, best director, best supporting actress, not as a mathematician, best non-original screenplay Akiva Goldsman. No Oscar to *Gladiator* Russell Crowe, the protagonist.

At the Academy Awards 2015 two mathematician-related films were nominated, although for the second one the protagonist was a mathematical physicist and astrophysicist more than a mathematician:

The Imitation Game [4], nominated for best film, best director, leading actor Benedict Cumberbatch, best supporting actress Keira Knightley, non-original screenplay.

The Theory of Everything [5], best film, best actor Eddie Redmayne, best actress, non-original screenplay.

The Oscar winners were, in the following categories:

M. Emmer (✉)
Sapienza University of Rome (retired), Rome, Italy

IVSLA – Istituto Veneto di Scienze, Lettere ed Arti, Venice, Italy
e-mail: emmer@mat.uniroma1.it

© Springer Nature Switzerland AG 2020
M. Emmer, M. Abate (eds.), *Imagine Math 7*,
https://doi.org/10.1007/978-3-030-42653-8_7

Best actor: Eddie Redmayne, for *The Theory of Everything.*
Best non-original screenplay: Graham Moore, for *The Imitation Game.*
In my paper I wrote that

We could draw the conclusion that in movies it is better to write a story involving mathematicians than to play the role of a mathematician. It is interesting to note that in almost all 2015 Academy Awards winning movies the real protagonist was, leaving aside the profession of the protagonists, the representation of various serious diseases, with Julianne Moore and Eddie Redmayne earning best actress and best actor. Surely the film on Turing was much more interesting than the one on Hawkings, and it is no coincidence that the first was nominated for best director and best film, while the other only for best film.

In light of the many films in which mathematicians appear, there is no doubt that the range of possible stories has expanded greatly. Cinema in general has advanced in fantasy, in emotions, sometimes in genius, showing perhaps how unified the underlying culture can be. If the two 2015 Oscar winning films are certainly those that have been talked about more, numerous movies and books have been published in recent years in which mathematics appears sometimes unexpectedly. See my book on math and cinema [6]. In 2011 for the category Best Foreign Language film, one of the nominees for then Oscar was:

Incendies, Director Denis Villeneuve, Cast: Lubna Azabal, Melissa Désormeaux-Poulin, Maxim Gaudette, Rémy Girard, Screenplay: Denis Villeneuve and Valérie Beaugrand-Champagne, Play by Wajdi Mouawad, Canada.

In 2012 Octavia Spencer won the Oscar as Best Supporting Actress for the film *The Help*, directed by Tate Taylor. No mathematicians, no mathematics were involved in the film but for the Oscar 2017 another film received four nominations for the Oscar [7]:

Best picture: *Hidden Figures*, Best director: Theodore Melfi, Best adapted screenplay: Theodore Melfi and Allison Schroeder and Best supporting actress: Octavia Spencer (Fig. 1).

The role of Octavia Spencer is that of a black woman mathematician in a movie where almost all of the characters are mathematicians in a forgotten story of the 1960s.

Fig. 1 Poster of the movie "Hidden Figures"

Also in this case mathematicians are the heroes of the situation, managing to do their job even in conditions of great suffering. "I feel like a mathematician," says the protagonist of the film. This is nothing new, since films on mathematicians have become so many. But who pronounces that sentence is a woman. And very few of them have been seen in *math* movies cinema, mostly in marginal or nonexistent roles, as in *The Imitation Game* (apart from the unimpressive *Agora*, in which the tragic story of Greek mathematician Ipazia, played by Rachel Weisz, is treated with the stylistic features of a *sword-and-sandal* or *peplum* film). Here she is the protagonist. Or rather one of three.

Three black mathematician women are the protagonists. A woman mathematician, all the more so if she is black is an absolute novelty in movies. If the story takes place in the United States at the start of the space race, it is even more amazing. It turns out that the black women who were involved in mathematics were not only three, like the protagonists of the film *Hidden Figures,* but dozens and dozens. Many women and men worked at NASA. In the 1970s black engineers were 1%, a percentage that rises to 8.4% in 1984. Margot Lee Shetterly, the author of the book that originated the title of the film, [8], was also involved in the script and was the daughter of two black engineers at the *National Aeronautics and Space Administration's Langley Research Center* in Hampton, Virginia, at that time a segregationist state.

As a child, Shetterly thought that the vast majority of black Americans, men and women, dealt with science, mathematics, engineering. "I can mention the names of at least 50 black women who worked as computers (making calculations by hand), mathematicians and engineers at Langley from 1943 to 1980, and at least another 20 names could be added." She met in person the extraordinary Katherine Johnson (in the film Taraji P. Henson), who controlled the trajectory of reentry from the space of the astronaut John Glenn. She is one of the protagonists of the film. The other two are Dorothy Vaughan (Octavia Spencer) and Mary Jackson (Janelle Monae). Their story a really amazing story.

On the official site of NASA there is a special page, which answers the questions raised by the book and the film, first of all: how was it possible to forget this story and who was responsible for this? The official position of NASA is that they never forgot this story. On the IBM website there are pages dedicated to the famous *Data Processing System 7090*, first installed at NASA in 1959. Any student of mathematics in these years remembers well the first courses of Fortran to program those enormous computers with piles of punched cards. The big computer is one of the protagonists of the movie. One of three black young women had the idea of learning Fortran, the programming language, and of teaching it to the other dozens of young women to ensure that they would not be caught unprepared for the arrival of the big computer. It is the role of Octavia Spencer, the only one who understands how the computer works while almost all the others (men) do not even know how to operate it.

The first Sputnik was launched by the Soviets on October 4, 1957. Juri Gagarin was the first man to fly in space on April 12, 1961. The United States tried to catch up, also suffering military implications in the middle of the Cold War (the Cuba crisis, after the failed American invasion of the *Bay of Pigs* in April 1961, and Soviet nuclear missiles installed on the island's bases, took place in October 1962). The American response was the Mercury space project, the first to include human space missions. It was active from 1958 to 1963. The story of the three black mathematicians is part of an equally amazing story. Among them, the most brilliant is Katherine. At the beginning of the film, she is a child and scans positive integers indicating the prime numbers (always very photogenic in cinema and literature). Then the geometric figures, the Platonic solids. And solves the system of two second degree algebraic equations. She is the theorist, the one who "feels like a mathematician."

The mathematics that appears in the film is accurate and not trivial: for example Frenet's formulas, which allow, with differential techniques, to study the geometry of curves, their qualitative properties. It is Katherine who performs the calculations, even in the humiliating conditions reserved for blacks: the bathroom is in another building, almost a kilometer away, the coffee machine is different from that of colleagues. A white mathematician, as soon as he sees her, says he never worked with a black woman. Computers had appeared very recently, and the gigantic IBM was not yet usable for this purpose. It was therefore necessary to calculate by hand the orbits, in particular the parameters for putting the Mercury capsule into orbit (with the first American astronaut, John Glenn, on board), so that it would take an elliptical orbit around the Earth.

It was necessary to calculate by hand the transformation of the elliptic orbit to a parabolic curve descending on Earth: it must have the right inclination, to make the capsule fall into the ocean, where the recovery ships would be present (otherwise, it would sink). To do this calculation, Katherine had the idea of using the Euler method, which allows to treat in a numerically approximate way differential equations whose solutions are not known, and which is the basis of some of the most widely used methods in applied mathematics. The final scene of the film, in which John Glenn, shortly before getting on the spacecraft, asks that *the Girl* verify the data of the orbits and the return to Earth, is invented. As stated on the NASA website, the calculations had been controlled by Katherine, but about 10 days before the launch. And she says in the movie: "Mathematics is only numerical." It is not so, but the real Katherine knows it for sure. She is still alive, a hundred years old. Of her two companions, Dorothy Vaughan, who later headed an IBM software sector, died in 2008, 3 years after Mary Jackson, the first black woman engineer in NASA.

Kevin Costner plays Al Harrison, chief engineer, tough on the surface but intelligent, capable and ultimately friendly, a role built on several real characters from NASA at that time. He immediately declares to newspapers his dislike: "I never understood our obsession with mathematics. Few of us use negative equations or numbers in everyday life. Yet in high school we were judged for that." The film is a

comedy, sometimes brilliant, with very little tension, there are no negative characters and the racial tension is left much in the background. The three mathematicians are witty and they love to be courted. Despite the dominant tone, less serious than typical American civil cinema, the film is destined to leave a mark.

In 2017 the film received three Academy Award nominations, including one for Best Film, Octavia Spencer was nominated for Best Supporting Actress. One observation: an American black mathematician, Rudy Horne Jr, of the University of Boulder, Colorado, was drafted as a consultant, teaching Katherine to remember the formulas to be written in the right order. For some mathematicians, acting as film consultants, collaborating with scripts and scenes has become a profession. Not to mention their role in animation cinema. Because mathematics, as Wiener claims, "is unreasonably useful," even in the cinema.

> *Film is one of three universal languages,*
> *the other two: mathematics and music.*
> Frank Capra, *The name above the title.*
> *Autobiography*, 1971

Octavia Spencer had won, as already mentioned, an Oscar in 2012, always as supporting actress, with the film *The Help*. She is again a supporting actress in another 2017 film, *Gifted* [9], a story of three mathematicians: Mary, a very gifted 7-year-old girl, her mother Diane and her grandmother Evelyn. Mary has the (hereditary) gift of mathematical ability. Spencer is her good friend and watches over her. Little Mary does not have the trivial calculation skills of the child in love with Bardot in *Dear Brigitte* (1956) or the multiple talents of Fred Tate, the child-prodigy of *My little Tate* (1991), first movie directed by Jodie Foster. Mary is interested in differential equations and integrals, not multiplication tables. Her teacher immediately realizes that she has nothing to teach her, and that she should attend a school for gifted children. She lives with her maternal uncle, who occasionally repairs boat engines.

Evelyn, also a mathematician, gave up her career to marry an older, very wealthy man, and placed her unsatisfied ambitions on Mary after her daughter's suicide, when Mary was still in her infancy. The film is punctuated by references to other films that feature mathematicians. The ending is reminiscent of *Will Hunting* or π (1998), one of the first, almost experimental, films by Darren Aronofsky. The story of the solution of a great mathematical problem, the rivalry and complicity between parents and mathematical children recalls the movie *Proof*, and so on. And the mathematics, as already happened in *Hidden Figures*, begins to be more sophisticated. Nothing to do with the π and the golden section of the movie *Oxford Murders*! (Fig. 2).

The problem that the grandmother and the child's mother tried to solve is the analytical solution of the famous differential equations that govern the movement of fluids, known as *Navier–Stokes equations*, from the name of two mathematicians

Fig. 2 Poster of the movie "Gifted"

of the nineteenth century, the Anglo-Irish George Gabriel Stokes, and the French Claude-Louis Navier.

In 1900 David Hilbert presented 23 problems to the mathematical community at the World Congress in Paris, the most famous of which was the Poincaré conjecture. Almost all of them were later resolved, although some only partially. In 1998, an American industrialist, Landon T. Clay, created with the Harvard University mathematician Arthur Jaffe the CMI (Clay Mathematics Institute), a private nonprofit foundation dedicated to increasing and spreading mathematical knowledge, based in Cambridge, Massachusetts, home of the MIT. On May 24, 2000, Clay set up seven prizes of 1 million dollars each for those who could solve one of the seven unresolved problems (Millennium Prize Problems), including the solution of the Navier–Stokes equations and the Riemann conjecture. It is to the Clay Institute where Evelyn goes, toward the end of the film, with the unpublished manuscript of her daughter, to understand if she was able to solve the famous problem.

Giving up the love of her granddaughter, favoring glory over affections. Like the mathematician woman in the movie *Antonia's tree* (1995), by the filmmaker Marleen Gorris, Oscar winner in 1996 as best foreign film, who chooses the passion for math rather than her daughter. One of the seven problems of the Millennium Prize, the only one solved so far, was the Poincaré conjecture, whose solution is due to the Russian mathematician Perelman. The photo of Perelman is in fact the only one in one of the seven message boards—each with the text of one of the famous problem—that Evelyn shows to her granddaughter at the entrance of the Clay Institute. In the film, egoism and the desire for an imperishable glory transform the mathematician into a bad subject. And the child, admitted to the university a decade too earlier, finds that studying math is boring and lifeless: in the end she runs out to play with her peers.

Octavia Spencer, the child's protector, is the only non-mathematical character in the movie while all the other protagonists are mathematicians. Spencer aside from supporting actress, evidently comes to mind to those involved in casting when a film addresses mathematicians. In 2018 Spencer is still supporting actress *in The Shape of Water* and is again nominated for an Oscar. Interestingly, Sally Hawkins, nominated for an Oscar for the same film as best actress, was also the co-star of the small British production $X + Y$ [10], a film presented at the 2014 *Toronto Film Festival*, released in the United Kingdom in 2015, focused on the story of a young English student who is very good in mathematics, who is autistic and has to attend the Mathematics Olympiad. Sally Hawkins in the role of the boy's mother, was nominated for *Best Supporting Actress* at the 2014 BIFA (*British Independent Film Award*). The young mathematician was nominated for Best Actor.

It begins to become interesting to follow *Arianna's threads* concerning mathematicians in cinema (Fig. 3).

Fig. 3 Poster of the movie "$X + Y$"

References

1. M. Emmer, Cinema, literature and mathematics: recent developments, in *Imagine Math 5*, ed. by M. Emmer, M. Abate, M. Falcone, M. Villarreal, (IVSLA & UMI, Unione Matematica Italiana, Bologna, 2016), pp. 75–90
2. *Will Hunting*, director Gus van Sant, with Matt Damon, Ben Affleck, Robin Williams, Stellan Skargard, subject & script Matt Damon and Ben Affleck, USA (1998)
3. *A Beautiful Mind*, director Ron Howard, with Russel Crowe, Ed Harris, Jennifer Connelly, script Akiwa Goldsman, USA (2001)
4. *The Imitation Game*, director M. Tyldum, with Benedict Cumberbatch, Keira Knightley, Matthew Goode, subject Andrew Hodges, script Graham Moore, UK and USA (2014)
5. *The Theory of Everything*, director James Marsh, with Eddie Redmayne, Felicity Jones, Emily Watson, subject Jane Wild Hawking, script Anthony McCarten, UK (2014)
6. M. Emmer, *Numeri immaginari: cinema e matematica* (Bollati Boringhieri, Torino, 2013)
7. *Hidden Figures*, director, Theodore Melfi, with Taraji P. Henson, Octavia Spencer, Janelle Monae, Kevin Costner, Kirsten Dunst, subject Margot Lee Shetterly, USA (2016)
8. M.L. Shetterly, *Hidden Figures, The Untold True Story of Four African-American Women who Helped Launch Our Nation Into Space*, HarperCollins, USA (2016)
9. *Gifted*, director, Marc Web, with Chris Evans, McKenna grace, Lindsay Duncan, Octavia Spencer, script Tom Flynn, USA (2017)
10. *X + Y*, director Morgan Matthews, with Asa Butterfield, Rafe Spall, Sallt Hawkins, Eddie Marsanm Jo Wang, script James Graham, UK (2015)

Part IV
Mathematics and Origami

Geometric Origami

Marco Abate

Introduction

What is origami? The standard answer is "paper folding"; and this immediately brings to mind paper hats, maybe paper cranes, or possibly (after having seen *Blade Runner* too many times) paper unicorns. But origami is much more than that. A better answer might be "the art of paper folding"; but after the impetuous development of origami in the last 25 years or so an even better answer is "the art and science of paper folding." Indeed, while the aim still is to realize beautiful objects (and thus it is an art), the techniques and methods required for planning the folds needed for reaching the desired goal have evolved so much to give rise to a (mostly mathematical) theory, up to the point that now congresses on the theory of origami are regularly held (see, e.g., [1] for the proceedings of a recent one).

A typical way (though not the only one) for creating a complex origami model starts with choosing the subject of the piece: an insect, a man reading a newspaper, a biplane, a heart with wings, a fractal... contemporary origami techniques allow the folding of practically any subject. Then the creator puts on the scientist hat and, using the theories and techniques available, plans (sometimes even using computer programs) the sequence of folds needed to get a suitable *base*, i.e., a still mostly abstract form close enough to the subject of the piece, with the right number and relative dimensions of flaps, appendices, points, etc. Then the artist hat comes on. First, there is the very important step of choosing the right paper: the color, the strength, the thinness are all elements that will greatly change the final appearance of the piece (and sometimes even the possibility of actually folding it). After having chosen the paper, the true folding starts; it might last a few minutes, or a few

M. Abate (✉)
Dipartimento di Matematica, Università di Pisa, Pisa, Italy
e-mail: marco.abate@unipi.it

© Springer Nature Switzerland AG 2020
M. Emmer, M. Abate (eds.), *Imagine Math 7*,
https://doi.org/10.1007/978-3-030-42653-8_8

hours, or sometimes even days or months, depending on the difficulty of the model. The origamist follows the plan laid out in the preliminary theoretical step, and if everything goes well (which does not always happen: the paper might tear, or it might be too thick, or the theoretical folds turn out to be impossible to perform in practice) she/he gets to a good approximation of the desired aim: arms, legs, and heads are all in the right place and of the right length, the wings (of insects, planes, or hearts) are open, and so on. A last step remains, and the artist hat comes handy again: the modeling. The series of folds, nudges, and delicate creasing transforming the approximation in a real work of art—and it is at this stage that one can tell apart an (even proficient) origami practitioner from a origami artist: the model folded by the first one is right, the same model folded by the second one is beautiful. The pictures in this article will give you a very vague idea of how beautiful a origami model can be; a good web site where one can find amazing pictures of incredible models is [2].

A Very Brief History of Origami

Origami consists in obtaining beautiful objects folding pieces of paper. The piece of paper usually is a square; but there are exceptions. Usually the model is folded starting from one piece of paper, but again there are exceptions, and actually we shall later discuss a particular form of origami where models are composed by tenths (and sometimes hundreds) of pieces of paper all folded in the same way. But the rule that every contemporary origamist respects is: no cuts.[1] The paper should be folded with respect, and cutting it would be disrespectful.

While it is known that paper was invented in China around 100 BC, and that paper making arrived in Japan via Korea around 550 AD, in the Arab world around 750 AD and in Europe via the Arabs around 1000 AD, it is not known where and when recreational paper folding first started. There are references to the use of folded paper for ceremonial or official use in Japan in the Heian era (794–1185 AD), but apparently the earliest sure references to recreational paper folding dates from the 1600 AD, both in Japan and in Europe. The famous Japanese book *Senbazuru Orikata* (How to fold one thousand cranes) published in 1797 seems at present to be the oldest known book about recreational paper folding, but it is very plausible that other books or printed material on the subject were available before.

The use of the word "origami" (from the Japanese words "oru," meaning "to fold," and "kami," meaning "paper") to refer to recreational (as opposed to ceremonial) paper folding is relatively recent, replacing at the end of the nineteenth century the less specific word "orikata" ("folded shapes"). The word "origami"

[1]Traditional models sometimes require cuts; but they were already rare 50 years ago, and have disappeared from contemporary origami. If you like to cut paper, you might try *kirigami*, the Japanese art of cutting the paper to get tridimensional models, like the ones in pop-up books.

became commonly used in the Western world around the end of the 1950s, when modern origami books started to be published in English, but it should be remarked that Spanish countries refer to origami using the word "papiroflexia," proposed by Vicente Solorzano Sagredo in Argentina in the 1930s.

The permanence of a different word in the Spanish world probably is due to the influence of a precursor of modern origami, the philosopher and poet Miguel Unamuno (1864–1936), that went beyond the traditional models introducing new techniques and devising his own style of folding, inspiring many followers in Spain and Argentina. But the man that actually gave birth to modern origami is Akira Yoshizawa (1911–2005), not only because he devoted his entire life to origami devising many new techniques and creating hundreds of new models, but because he invented writing in the 1950s. Until then, the instructions for making origami models were mostly passed on by oral tradition, accompanied by just a few sketches, and this greatly limited the diffusion and sharing of models. Yoshizawa instead created a standard set of symbols for recording the sequence of folds needed to reproduce a model. His system was promptly adopted in the West with just a few modifications due to Robert Harbin and Samuel Randlett in the 1960s, and it is now the standard in all origami publications around the world. The adoption of a standardized method of recording the folding of origami models allowed for a much easier sharing of models and techniques among origami artists, and possibly as a consequence many new talents appeared (Fred Rohm, Neal Elias, Patricia Crawford in the USA, Adolfo Cerceda and Ligia Montoya in Argentina, Kunihiko Kasahara and Toshie Takahama in Japan, to name just a few), the number of available origami models passed from about one hundred to thousands in a few years, and a tradition of sharing ideas, techniques, and instructions among origami folders with no limitations due to nationality or language (or race, gender, religion, or anything else) took hold and it is still very much alive nowadays.

But even with writing one can go so far on intuition only; most of the models created in the 1960s and 1970s were relatively simple, stylized pieces, that can be folded in no more than 30–40 steps. To go beyond that one needs a more systematic approach; one needs a theory. After some initial innovations introduced in the 1980s by John Montroll in the USA and Jun Maekawa in Japan (and others: for the sake of brevity I unfortunately have to leave out many worthwhile names), in the 1990s a breakthrough occurred. A new technique (the *circle/river packing* method) was independently developed by Robert J. Lang in the USA and Toshiyuki Meguro in Japan, giving a general theoretical and practical framework for producing bases with the desired shape. At more or less the same time, the "bug wars" took place. A group of brilliant Japanese origamists (besides Maekawa and Meguro there were at least Issei Yoshino, Sejji Nishikawa, Fumiaki Kawahata, and Satoshi Kamiya, founding members of the Tanteidan origami group which has become one of the more influential in the world of origami—"Tanteidan" means "Detective group," by the way) and one American (Robert J. Lang) started challenging each other to create insects and arachnids as realistic as possible, with many legs, wings, antennas... and at the same time as beautiful as possible. This allowed to show that the theory that was being developed could actually be used to create amazing origami models with

Fig. 1 *Allomyrina dichotoma. Opus 655*. Model created and folded by Robert J. Lang. (From www.langorigami.com. Reproduced with permission)

an incredible amount of detail and harmony. A selection of the models created in the bug wars can be found in [3–5]; see also Fig. 1 for one example.

In the following years other powerful general theories and techniques were developed, and the net result of this theoretical revolution is that now it is possible to model in origami essentially anything, from a space station to a Kraken assaulting a full-rigged ship, from all kinds of animals to all kinds of human figures; see, e.g., Fig. 2 for a spectacular example. There are hundreds of active origami creators, and tens of thousands of available models (the site [6] lists more than 50,000 models, considering only models published with instructions) ranging from one fold (the famous one-crease elephant [7]) to hundreds of folds.

The main ideas of modern origami design are described in the highly influential book *Origami design secrets* by Robert J. Lang, so successful that it recently had a second updated edition [7]. On the other hand, it is not that easy to find reliable information about the history of origami, at least in English; a starting point are the sites [8, 9] collecting notes by David Lister, one of the main Western origami historian.

Geometric Origami

The vast majority of origami models are figurative: they represent something. But there is an increasing minority of models which are abstract—mostly geometrical in nature. There were some geometrical models in traditional origami (typically stars or decorations) but in the last 15 years or so we have seen a strong increase of the interest in this kind of origami (and in particular in *kusudama* and tessellations; see

Fig. 2 *Il Capitan*. Model
created and folded by Eric
Joisel. (From *Eric Joisel –
The Magician of Origami*, M.
Yamaguchi ed., Origami
House, Tokyo, 2010.
Reproduced with permission)

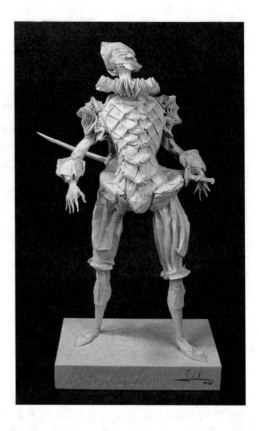

below), possibly spurred by the mathematical approach to origami described in the previous section. In 2018 a new book by Robert J. Lang appeared [10], laying out the theory behind the design of geometric origami (mostly tessellations), and this probably will start a new wave of geometric models.

Geometric origami can be two-dimensional or three-dimensional. Typical subjects for two-dimensional geometric origami are stars (see, e.g., [11]) and spirals (see, e.g., [12]); typical subjects for three-dimensional geometric origami are polyhedra. Platonic solids have been folded by many authors, but a particular mention goes to John Montroll that not only designed all Platonic solids and many Archimedean and not Archimedean polyhedra (Fig. 3 is a 9-sided bipyramid, for instance), but he also published a book [13] explaining in detail how to design origami polyhedra (and including instructions for more than 50 different models). He also published a book called *Origami and Math* [14], containing the instructions for his famous 8 × 8 chess board folded starting from a single square (see Fig. 4).

Fig. 3 *9-sided bipyramid.*
Model created by John
Montroll and folded by the
author

Fig. 4 8×8 *chess board.*
Model created by John
Montroll and folded by the
author

A different approach to polyhedra-like models is provided by another flavor of
origami: *kusudama* (or *modular*[2]) origami. Kusudama origami models, instead of
being made with a single piece of paper folded hundreds of times, are made by
many (usually tenths, in a few cases hundreds) of small pieces of paper called *units*,
usually all folded in the same way and joined together without glue inserting flaps
into pockets created by the folding. The positions of the units often follow the
geometry of a polyhedron, usually Archimedean or Platonic; the appearance and
the beauty of the model mostly depend on the shape of the free (that is, not used for
the joining) parts of the units and the color of the chosen paper—which in kusudama
origami is even more important than usual. A good introductory book to kusudama
origami is [15] by Ekaterina Lukasheva; Fig. 5 is one of her kusudama polyhedra.

Another flavor of geometric origami is *fractal origami*. A fractal origami model
has a structure that can be repeated to smaller and larger scales, in principle ab
infinitum; like a fractal, it is invariant under change of scale. Fractal origami are
relatively rare; Fig. 6 shows a typical 3-D example by Jun Maekawa, and Fig. 7
a typical 2-D example by Shuzo Fujimoto. A somewhat atypical but exceptional
example of modular 3-D fractal origami is the 4-level Menger sponge created by

[2]Actually, modular origami is more general than kusudama, because a modular origami model can
be formed with several different kinds of units and can be even figurative. Figure 8 is an example
of a (non-figurative) modular origami which is not kusudama.

Fig. 5 *Tiara variation.*
Model created and folded by
Ekaterina Pavlovic
(Lukasheva) (From www.
kusudama.me. Reproduced
with permission)

Fig. 6 *Pyramid.* Model
created by Jun Maekawa and
folded by the author

Fig. 7 *Hydrangea.* Model
created by Shuzo Fujimoto
and folded by Ed Sprake.
(Reproduced with
permission)

Fig. 8 *4-level Menger sponge*. Model created and folded by Serena Cicalò; photo by Francesco Finarolli. (From www.flickr.com/people/162102357@N06/. Reproduced with permission)

Serena Cicalò, larger than 1 m and with a weight of about 25 kg, composed by hundred of thousands of different units of nine different kinds; see Fig. 8 and [16].

A Geometric Interlude

In geometric origami it is often useful to fold a preliminary square grid on the paper (see, e.g., Fig. 16 where a 26×26 square grid is used). To fold a 2×2 square grid on a square of paper is easy: it suffices to fold in half the paper both in the horizontal and in the vertical directions. If on the paper we have two parallel lines, folding one line over the other produces a new line parallel to the previous two and exactly in the middle; using this trick one easily folds 4×4, 8×8, and in general $2^n \times 2^n$ square grids. What about $d \times d$ grids where d is not a power of 2? Taking measurements is (not precise and) not allowed; it should be achieved by folding only.

The answer (see, e.g., [13] where also other techniques are described) is surprisingly simple. Let us start by writing $d = 2^n + b$, where 2^n is the largest power of 2 less than d, and $0 \leq b < 2^n$. Assume for simplicity that the square of paper has length 1. Then:

(a) fold the diagonal from the upper left to the lower right corner;
(b) dividing by 2 horizontally enough times find the point distant $b/2^n$ from the lower right corner on the right side of the paper;

(c) trace the fold from the lower left corner to the point $b/2^n$ on the right side;

(d) fold vertically the paper across the intersection of the diagonal with the line created in the previous step;

(e) this vertical fold intersects the lower side in a point distant $2^n/d$ from the lower left corner; by dividing by 2 vertically one traces the lines whose distance from the vertical left side are $2^{n-1}/d$, $2^{n-2}/d$, and so on until one gets $1/d$;

(f) by repeatedly dividing by 2 one gets all the vertical lines of the $d \times d$ grid on the left of the line traced in step (d); to get the vertical lines on the right it suffices to fold the right rectangle to the left along the $2^n/d$ vertical line and then fold it along the vertical lines already present in the left rectangle;

(g) to complete the grid it suffices to fold horizontal lines across the intersections between the diagonal and the vertical lines.

Figure 9 shows the procedure for $d = 11 = 2^3 + 3$.

It is not difficult to prove that this procedure is exact. Choose a system of coordinates with origin in the lower left vertex of the square. The segment going from the origin to the point of coordinates $(1, b/2^n)$ identified in step (b) is parameterized by $(t, tb/2^n)$ for $0 \leq t \leq 1$. The diagonal folded in step (a) is parameterized by $(s, 1 - s)$ for $0 \leq s \leq 1$. The intersection point should satisfy $(t, tb/2^n) = (s, 1 - s)$, that is $t = s$ and

$$t\frac{b}{2^n} = 1 - t \quad \Longrightarrow \quad t = \frac{2^n}{b + 2^n} = \frac{2^n}{d}.$$

Since t is the x-coordinate of the intersection point, the vertical line folded in (d) passes through the point $(2^n/d, 0)$, as claimed.

Tessellations

In the last 20 years or so another form of geometric origami has developed extensively: *tessellations*. The definition of origami tessellation in [10] is the following: an origami representation of a dissection of the plane into geometric patterns where the borders are formed by folded edges and/or variations in the number of layers. Usually, a tessellation is a periodic pattern that in principle can cover the entire plane, limited only by the dimension of the piece of paper (but there are also examples of aperiodic tessellations). Tessellations can be 2-dimensional (see, e.g., Fig. 10) or 3-dimensional (see, e.g., Fig. 11).

The study of tessellations in origami started in the 1970s with the work of Shuzo Fujimoto (Fig. 7 can be repeated to form a tessellation) and Yoshihide Momotani (see Fig. 13), but it developed in earnest in the 1990s thanks to the explorations conducted by Paulo Taborda Barreto and Chris K. Palmer. Nowadays there are many origami artists creating new beautiful tessellations (e.g., Alex Bateman, Joel Cooper, Ilan Garibi, Eric Gjerde, Ekaterina Lukasheva, Robin Scholz, and many

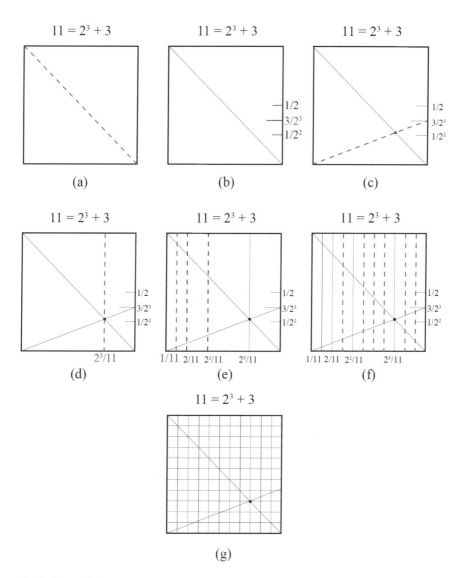

Fig. 9 How to fold an 11×11 grid

others; among them I am pleased to mention the Italian origamist Alessandro Beber, who has an article in this volume with more about tessellations).

Tessellations differ from ordinary origami also in the way they are folded. Ordinary origami mostly uses an approach to folding that I will call *local*: any given fold affects only the paper close to it and can be done by itself, or at worst involving a handful of other folds to be performed together—and this property is important for the diagramming system introduced by Yoshizawa. On the other hand origami

Fig. 10 *3.4.6.4 flagstone tessellation.* Model created and folded by Robert J. Lang. (From *Twists, Tilings, and Tessellations: Mathematical Methods for Geometric Origami,* CRC Press, Boca Raton, 2018. Reproduced with permission)

Fig. 11 *Red flower.* Model created by Ilan Garibi and folded by the author

tessellations very often require *global* foldings: each fold affects the whole sheet of paper and all folds should be done at the same time for the model to form.

As a consequence, instructions for tessellations are almost always presented not as a sequence of steps but as a *crease pattern*: a diagram showing in one picture all the creases needed to fold the model. Crease patterns are also used to present complex figurative origami, but in that case the crease pattern usually contains the most important creases only; the crease pattern of a tessellation contains instead all

Fig. 12 Crease pattern for
Red flower on a 16 × 16 grid

creases needed to fold the model. For instance, Fig. 12 contains the crease pattern[3] for the model shown in Fig. 11.

Besides being useful for folding origami, crease patterns are important because they show the underlying geometrical structure of the model, and they are suitable for a mathematical treatment of origami (see, e.g., [10]). For instance, a much studied problem, with several applications to tessellations, is the following: when a crease pattern can be folded so that the final model is flat (in short: when a crease pattern can be flat folded)?

It turns out that there is a complete theoretical answer to this question. A *vertex* in a crease pattern is a point where several creases meet. For the whole crease pattern to be flat foldable, at the very least it should be flat foldable near any of its vertices. There is a necessarily and sufficient condition for a vertex to be flat foldable:

Theorem 1 (Kawasaki–Justin–Robertson Theorem) *An interior vertex of a crease pattern is flat foldable if and only if the alternate sum of the angles between the creases meeting at the vertex vanishes.*

This theorem has been first proved by S.A. Robertson in 1978 [17], and then it has been independently rediscovered by J. Justin [18] and T. Kawasaki [19] in the 1980s. Figure 13 is an example of a flat foldable tessellation; indeed its crease pattern (Fig. 14) satisfies the Kawasaki–Justin–Robertson condition at each internal vertex.

The proof of Theorem 1 is not difficult; it essentially boils down to the remark that if the vertex is flat-folded then walking along a circle around the vertex when we cross a fold the paper changes orientation: if before the fold one side is up, after the

[3]Green lines represent mountain folds and red lines represent valley folds. This is not Yoshizawa's convention but it makes the crease pattern more readable.

Fig. 13 *Momotani's wall.*
Model created by Yoshihide
Momotani and folded by the
author

Fig. 14 Crease pattern for
Momotani's wall on a
32 × 32 grid. It satisfies the
Kawasaki–Justin–Robertson
condition, and indeed the
model is flat

fold that side is down. This change of orientation can be recorded by changing the
sign of the angle between two consecutive creases, because the change of orientation
corresponds to a change in the direction of the walk. Since completing the walk
around the vertex we come back to the starting point, necessarily the alternate sum
of the angles should be zero.

Somewhat surprisingly, if all internal vertices are flat-foldable, that is if they
satisfy the condition described by Kawasaki–Justin–Robertson theorem, then
the whole crease pattern is *theoretically* flat foldable. This has been proved by
Dacorogna, Marcellini, and Paolini in 2008 (see [20–22]) by using techniques
coming from the study of partial differential equations. However, I have emphasized
"theoretically" because there are a few *caveat* to be considered.

Fig. 15 *Childhood*. Model
created by Ilan Garibi and
folded by the author

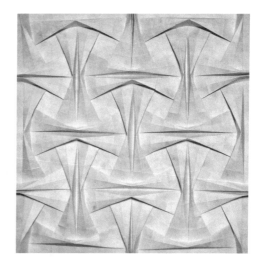

First of all, a real piece of paper is finite, and so a real crease pattern contains also
boundary vertices, points where the creases intersect the boundary of the paper. Flat
foldable boundary vertices do not necessarily satisfy Kawasaki–Justin–Robertson
theorem, and so they have to be treated differently (and indeed Dacorogna,
Marcellini, and Paolini spend some time discussing suitable boundary conditions).

But the main reason why this is only a theoretical result is that it does not take
into account the fact that, during folding, the paper cannot self-intersect. The map
produced by Dacorogna, Marcellini, and Paolini might not be actually realizable
because folding it might require for the paper to cross itself. Understanding for
which crease patterns this does not happen is a global problem, very delicate, very
complex, and not yet completely solved (see, e.g., [10] for a discussion).

The third reason why this is only theoretical is that actual paper has thickness,
and elasticity, and memory, and thus it does not always behave like an abstract plane
figure. From an artistic point of view, this can be an advantage, as shown for instance
in a sub-class of tessellations called *corrugations,* where the pattern is obtained
without overlapping paper but playing with 3D effects created by not flattening the
folds; see, e.g., Fig. 15, whose crease pattern is in Fig. 16.

A good introductory book on tessellations and corrugations is [23].

And More...

In this short note we have only scratched the surface of contemporary geometric
origami. Putting together mathematics and art has led (and it is still leading) to
the creation of models that are both artistically and mathematically beautiful and
that could not even be imagined before. Figures 17 and 18 are just two particularly
striking examples among many of what can be obtained putting together techniques

Fig. 16 Crease pattern for *Childhood* on a 26 × 26 grid. It does not satisfy the Kawasaki–Justin–Robertson condition, and indeed the model is not flat

Fig. 17 *Double diagonal shift vase 2*. Model created and folded by Rebecca Gieseking (From www.flickr. com/people/rgieseking/ Reproduced with permission)

coming from geometric origami with techniques coming from figurative origami. As already mentioned, much more information, both mathematical and otherwise, can be found in [7, 10]; I hope that this short introduction will entice you toward this beautiful subject. Art is just a fold away...

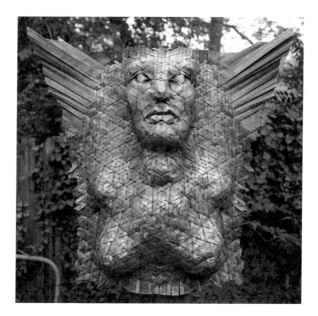

Fig. 18 *Oread*. Model created and folded by Joel Cooper (From www.flickr.com/people/ origamijoel/ Reproduced with permission)

References

1. R.J. Lang, M. Bolitho, Z. You (eds.), *Origami*[7] (Tarquin, St. Albans, 2018)
2. http://www.origami.me
3. R.J. Lang, *Origami Insects and their Kin* (Dover, New York, 1995)
4. F. Kawahata, S. Nishikawa, *Origami Insects I* (Origami House, Tokyo, 2000)
5. R.J. Lang, *Origami Insects II* (Origami House, Tokyo, 2003)
6. http://www.giladorigami.com
7. R.J. Lang, *Origami Design Secrets*, 1st edn. (A.K. Peters, Natick, 2003). Second edition: CRC Press, Boca Raton, 2011
8. http://www.paperfolding.com/history
9. http://www.britishorigami.info/academic/lister/index.php
10. R.J. Lang, *Twists, Tilings and Tessellations: Mathematical Methods for Geometric Origami* (CRC Press, Boca Raton, 2018)
11. J. Montroll, *Galaxy of Origami Stars* (CreateSpace, Leipzig, 2012)
12. T. Fuse, *Spirals* (Viereck Verlag, Berlin, 2012)
13. J. Montroll, *Origami Polyhedra Design* (A.K. Peters, Natick, 2009)
14. J. Montroll, *Origami and Math* (Dover, New York, 2012)
15. E. Lukasheva, *Modern Kusudama Origami* (Amazon, Charleston, 2016)
16. S. Cicalò, The PJS technique and the construction of the first origami level-4 Menger sponge, in *Origami*[7], ed. by R.J. Lang, M. Bolitho, Z. You, vol. 2 (Tarquin, St. Albans, 2018), pp. 653–668
17. S.A. Robertson, Isometric folding of Riemannian manifolds. Proc. R. Soc. Edinb. **79**, 275–284 (1978)
18. J. Justin, Mathematics of origami, part 9, in *British Origami*, June (1986), pp. 28–30

19. T. Kawasaki, On the relation between mountain-creases and valley-creases of a flat origami, in *Proceedings of the First International Meeting of Origami Science and Technology*, ed. by H. Huzita (Università di Padova, Padova, 1989), pp. 229–237
20. B. Dacorogna, P. Marcellini, E. Paolini, Lipschitz-continuous local isometric immersions: rigid maps and origami. J. Math. Pures Appl. **90**, 66–81 (2008)
21. B. Dacorogna, P. Marcellini, E. Paolini, Origami and partial differential equations. Notices Am. Math. Soc. **57**, 598–606 (2010)
22. P. Marcellini, E. Paolini, Origami and partial differential equations, in *Imagine Math*, ed. by M. Emmer (Springer, Berlin, 2012), pp. 241–250
23. I. Garibi, *Origami Tessellations for Everyone* (Amazon, Wrocław, 2018)

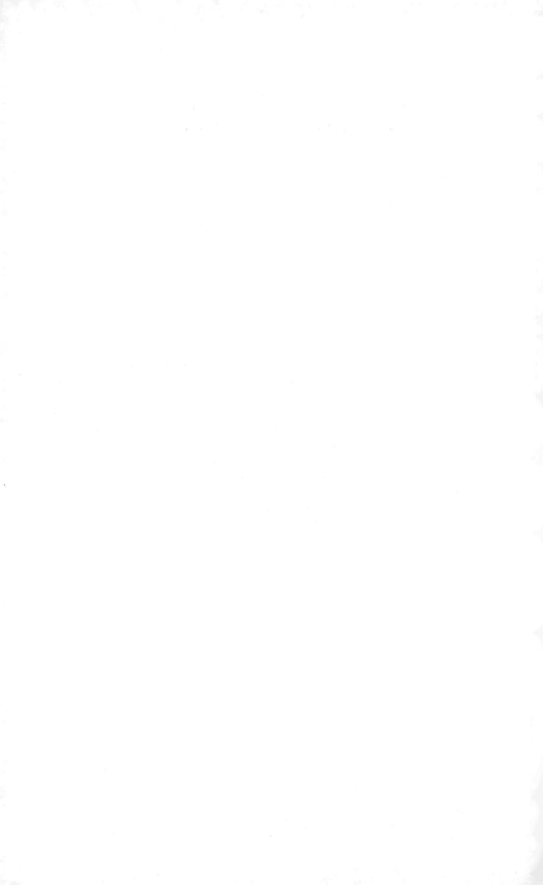

Origami Tessellations: Designing Paperfolded Geometric Patterns

Alessandro Beber

Overview

Origami, or the folding techniques used to obtain animals and objects from paper, developed during centuries especially in Japan. However, the current status of modern origami as a real creative art form is far more recent, beginning its evolution only around the mid-twentieth century, thanks to a few pioneers such as Akira Yoshizawa. He began creating unique paperfolded sculptures, so different from the usual pointy flat silhouettes of traditional origami. He also invented a graphic language to describe a folding sequence, allowing people to learn new folds from diagrams, breaking the prior language and distance barriers. At that point, a worldwide community of enthusiasts and several new styles appeared, mathematicians studied the underlying rules of paperfolding and scientists began applying folding techniques to many different fields.

Origami Tessellations

Origami *tessellations* are one kind of geometric abstract origami, creating repeating folded patterns on a single sheet of paper. Tiles are sets of creases forming a foldable molecule, and they can be placed one next to each other, completely filling a plane (the sheet of paper), no matter how large it is, and the result is still foldable, i.e., the

A. Beber (✉)
Trento, Italy
e-mail: ale.beber.92@gmail.com

© Springer Nature Switzerland AG 2020
M. Emmer, M. Abate (eds.), *Imagine Math 7*,
https://doi.org/10.1007/978-3-030-42653-8_9

molecule is compatible with copies of itself. Being the sheet continuous (with no cuts or holes), the paper area of a tile will shrink while folding, creating pleats and other kinds of overlapping.

This genre of paperfolding had been first explored by Japanese paperfolders Shuzo Fujimoto and Yoshihide Momotani in the 1970s (see [4]). Prior to them, in the 1960s, several examples of the same kind were studied by American scientists David Huffman (1925–1999) and Ron Resch (1939–2009), who apparently worked independently, without contact with the growing origami community until some decades later.

Moving further from paper and origami, folded patterns were developed using fabric since the Middle Ages through embroidery techniques such as *smocking*. In this case the material is much softer and more flexible than paper, not suitable for proper folding. Nevertheless, when some points on the fabric surface are brought together by stitching, pleats and other kinds of overlapping will form, and the result may look like folded. Curiously, some fabric smocking patterns were independently rediscovered centuries later in folded paper by people exploring the possibilities of origami tessellations.

Some technical advancements in this kind of origami were made during the 1990s by Chris Palmer, Thomas Hull and a few others, but it was in the early 2000s that this field suddenly started to grow in popularity, with many new artists exploring the possibilities of these techniques (see [5] for some examples).

Computational origami also received growing interest from scientists, and a few authors such as Alex Bateman, Robert J. Lang, Jun Mitani and others wrote their own software tools in order to design increasingly complex tessellations (see [6]). As it often happens with computational origami, these results are usually not foldable without using any tool other than hands, and require printing or scoring the pattern of creases (the so-called *crease pattern*, or *CP*) onto the paper before folding it. (Note: any point or line could be obtained solely by folding with extremely good precision if not exactly, but construction lines may often be confusing and undesirable). Apart from computational origami tessellations and a few other examples, most origami tessellations are based on either square or triangular grids. This means that such a grid is pre-creased (or pre-scored) on the sheet of paper, and all other creases are obtained from points on the grid, i.e., crease intersections.

Personal Approach

I have always been interested in mathematics and constructions, and origami is a sort of puzzle to be solved, giving joy and pleasure by constructing objects solely from a sheet of paper and your own hands, even when just folding designs by other authors from instructions. Designing your own origami can give a greater

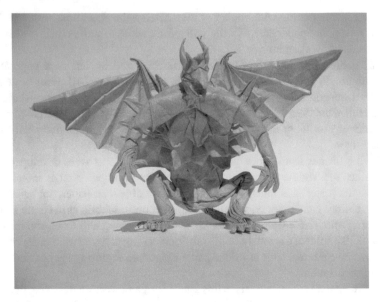

Fig. 1 Gargoyle 2.1, designed and folded by Alessandro Beber in 2011

satisfaction, combining the joy of creating something original, never seen before, with problem solving and mathematical challenges (not all origami designs rely on mathematics but many do, especially geometric origami). Therefore, I find quite natural to have developed a strong passion for this craft and art form after discovering it as a young child. I soon started to learn and study the mathematics of origami, in order to understand how other authors designed their creations and eventually creating my own ones. For a number of years I had been mainly focused on complex representational origami, which is still a trend in the origami community, especially for younger enthusiasts. It means designing natural subjects (mostly animals), characters and fantastic creatures with a high degree of details and realism, trying to obtain a paper sculpture as accurate and life-like as possible (see Fig. 1).

At the same time, my interest for understanding the underlying rules and structures of complex origami was growing, and at some point I began to enjoy the elegance and geometric beauty of their inner structures of creases even more than the completed folded pieces (see Fig. 2). Probably this is the reason why I suddenly switched to geometric tessellations, complex origami in which the underlying structures of creases are not hidden inside a representational sculpture, but still visible in the folded result as well.

Fig. 2 Crease pattern for
Gargoyle 2.1

Origami Tessellation Design

Since origami tessellations are tilings of repeating molecules made of creases on
a single sheet of paper, and since the paper is usually a continuous flat sheet (i.e.,
a portion of a plane flat surface), such molecules should follow the rules of flat
folding in order to shrink the paper surface evenly. (Note: origami tessellations can
include 3D elements, protruding from the plane in circumscribed areas. A particular
kind of folded patterns called *corrugations* can avoid obeying flat-foldability rules,
resulting in 3D structures, but they still have a 2D nature in order to preserve the
possibility of extending the pattern onto a larger sheet surface.)

Origami tessellations are essentially made of pleats and various kinds of pleat
intersections. A *pleat* is a pair of folds, one *valley* fold and one *mountain* fold, often
parallel to each other. Pleats shrink the surface in one direction creating a strip of 3
overlapped layers (see Fig. 3).

In order to shrink the paper surface evenly, it is necessary to fold pleats running
in different directions, and they will necessarily intersect each other; the paper at
their intersection can be released and arranged in different ways (see Figs. 4 and 5).

Fig. 3 One pleat fold, made
of parallel mountain and
valley creases

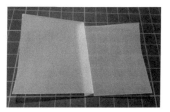

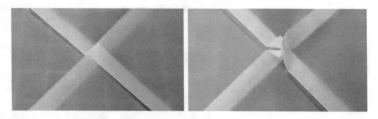

Fig. 4 Intersection of two perpendicular pleats

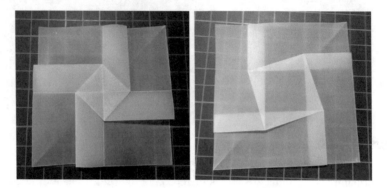

Fig. 5 Square twist folds, obtain by the intersection of four semi-pleats

Flat Folding

Crease patterns (CPs) must obey a few rules in order to fold flat. Local flat-foldability is simple to check, while global flat-foldability can raise some difficulties. First, creases must all be segments of straight lines in order to fold flat (a curved crease will necessarily result in curved surfaces and hence 3D results). A crease line cannot be placed anywhere onto a sheet of paper: its two endpoints must lie either on the paper edge, or at a *vertex*, i.e., where other crease segments start/end. Local flat-foldability then applies on any single vertex inside the sheet of paper, i.e., not at those vertices placed along the edges of the sheet. Being n the number of folds at a given vertex, M and V the number of mountain and valley folds ($n = M + V$, construction creases are not considered as they will not be folded) and δ_i, $1 \le i \le n$ the angles between two consecutive creases ($\sum_{i=1}^{n} \delta_i = 2\pi$), three simple conditions must be satisfied.

The *Kawasaki–Justin* theorem states that a vertex is flat-foldable if and only if $\delta_1 - \delta_2 + \delta_3 - \cdots - \delta_n = 0$, and hence n must be an even number. This does not specify mountain/valley parity of the folds, but it means that if the latter condition is satisfied, then there exists (at least) one possible crease assignment to flat fold the given vertex.

The *Maekawa–Justin* theorem deals with M/V parity of folds at vertices, stating that for any flat-foldable vertex $M - V = \pm 2$. Again, n must be even as a

consequence, and since a vertex with $n = 2$ is trivial ($\delta_1 = \delta_2 = \pi$) being just a point on a single crease segment and not a proper vertex, we can say that any vertex in a flat-foldable CP must have $n \geq 4$, with n even.

The last condition deals with the stacking order of layers while folding, and it is known as the *Big-Little-Big* theorem. It states that whenever an angle δ_i is smaller than both adjacent ones, the twofold surrounding δ_i must have opposite crease assignment, in order to prevent self-crossing of layers while folding (this applies also to vertices at the edges). By applying the latter condition recursively onto a vertex (by removing twice the smallest angle at each step, and applying it again on the resulting cone), it is possible to obtain a valid crease assignment for any vertex and for the complete CP, if there exists one. Anyway, this is still a *local* flat folding condition, and other problems may occur elsewhere, by the interactions of multiple vertices and layers in the complete CP. It is now known that determining the *global* flat-foldability of a given CP requires satisfying all the previous conditions and avoiding self-crossing globally, which is known to be an NP-complete problem. However, regarding origami tessellations, if a single tile is flat-foldable and tiles are connected in a simple way (without creating new vertices or causing self-crossing issues at their borders), flat-foldability is preserved along the entire tessellation.

Twist Fold Tessellations

An interesting kind of pleat intersection often used in origami tessellations is the *twist fold*. Figure 6 depicts a pentagonal one as an example. It consists of a folded polygon, with a pleat extending outward from each of its sides. A simple construction is illustrated in Fig. 7 and it consists of constructing a pleat on each edge of the polygon, perpendicularly to the edge and with each pleat having the same relative width and position with respect to its edge. By extending all pleats inward and connecting their intersections, another polygon appears in the middle. If the two creases forming a pleat are not placed on different halves of their relative edge (avoiding placing one on the left half and the other on the right half), then this construction results in a flat-foldable CP for any regular polygon and any triangle.

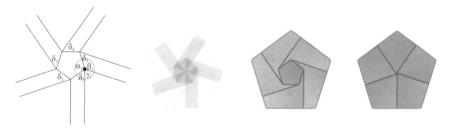

Fig. 6 One pentagonal twist fold, displaying its crease pattern and folded results (layers, front and back)

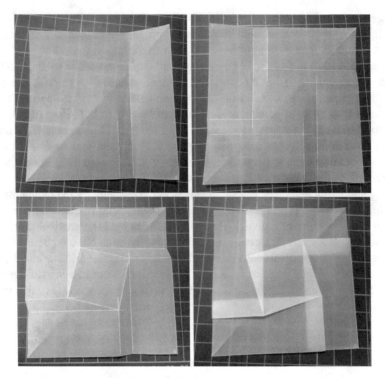

Fig. 7 Construction of a polygonal twist fold

Figure 8 shows various polygonal twist folds based on regular polygons, having one crease placed on the perpendicular bisectors of the polygon edges (such twist folds are often called *closed back* ones, as their folded edges meet at a single point on their back).

Being the pleat folds perpendicular to the polygonal molecule edges, it is simple to connect them together with their mirror copies (see Fig. 9) and fold a larger tessellation from a single sheet of paper. Designing an origami tessellation can then be reduced to finding a tiling of the plane consisting of suitable polygons, and constructing a twist fold inside each of them (see Fig. 10).

This process would require having an even number of molecules at each vertex of the tiling (because of alternating rotational direction of adjacent twist folds), but origami design is not just applying an algorithm blindly. Knowing the rules of the game, it may be possible to find simple solutions for solving such issues, or to fill in the pattern with irregular molecules as well, still preserving its global flat-foldability (see Figs. 11 and 12). I personally enjoyed exploring this technique for a few years as there were not many similar origami designs around, since they are usually not foldable from the classic square and triangular grids alone, and eventually published my results in [1].

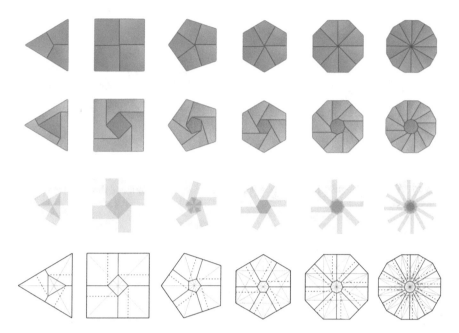

Fig. 8 Various closed-back polygonal twist folds

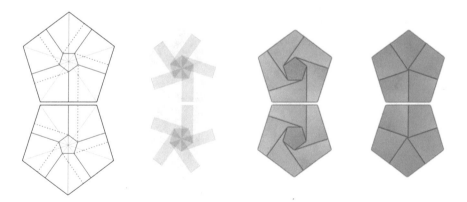

Fig. 9 Connecting two twist folds

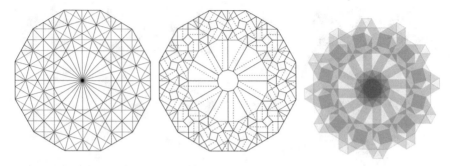

Fig. 10 A tiling of regular polygons in a dodecagon, its crease pattern and the computed folded object (© A. Beber, 2012)

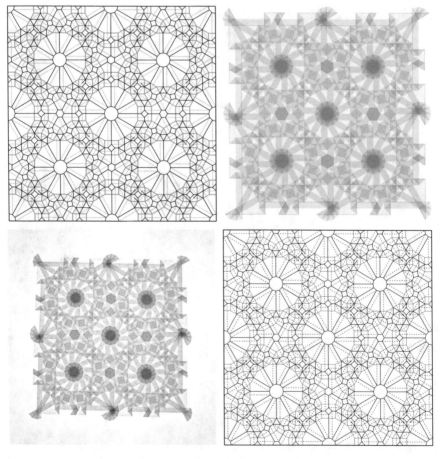

Fig. 11 A periodic tiling of regular polygons, computed and real folded object, and foldable CP (© A. Beber, 2012)

Fig. 12 A 4.6.12 tiling, crease pattern, and a larger folded model (© A. Beber, 2012)

Fig. 13 Some examples of perspective illusions designed using flagstone tessellations

Fig. 14 Three different flagstone tiles

Fig. 15 A Reutesvärd/Penrose triangle obtained by combining flagstone tiles with a flat background. Part of the process, crease pattern and folded result (© A. Beber, 2013)

Fig. 16 JOAS sign represented with flagstone tiles (© A. Beber, 2014)

Fig. 17 A more elaborate design using flagstone tiles (© A. Beber, 2015)

Flagstone Tessellations

Origami tessellations are usually abstract geometric tilings or decorative patterns of flowers, stars or other simple shapes. At some point I began wondering whether this style could be used to represent objects, in particular 3D and impossible objects through perspective illusions (see Fig. 13). Therefore I started exploring the possibilities of *flagstone* tessellations in order to achieve this goal. Flagstone tessellations are origami patterns in which the result displays solid polygonal blocks, not covered by the neighbouring ones and hence resembling stone blocks. Therefore, I looked for flat-foldable tiles having this property, and compatible with another flat pattern to be used as background. I developed one rhombic 60°–120° tile which can be arranged in threefold symmetry and other configurations, and two different triangular tiles (see Fig. 14), combining those with a classic origami tessellation (a triangular twist fold pattern discovered by Shuzo Fujimoto back in the 1970s) for the background.

It turned out that these elements can be used for constructing any design made of equilateral rhombi and triangles (and a few different shapes) arranged on a grid of triangles, as shown in Figs. 15, 16, and 17. The technique is described in details in [2] and [3].

References

1. A. Beber, *Fold, Twist, Repeat* (Centro Diffusione Origami, New York, 2013)
2. A. Beber, *Origami New Worlds* (Self-published, 2017)
3. A. Beber, Representing 3-D objects through flat tessellations, in *Origami 7: The Proceedings from the 7th International Meeting on Origami in Science, Mathematics and Education*, ed. by R.J. Lang, M. Bolitho, Z. You. Design, Education, History, and Science, vol. 1 (Tarquin, St Albans, 2018), pp. 63–72
4. S. Fujimoto, M. Nishiwaki, souzu suru origami asobi he no shoutai (in Japanese) (1982)
5. E. Gjerde, *Origami Tessellations: Awe-Inspiring Geometric Designs* (A K Peters, Natick, 2009)
6. R.J. Lang, *Twists, Tilings, and Tessellations: Mathematical Methods for Geometric Origami* (CRC Press, Boca Raton, 2018)

Part V
Mathematics and Art

Geometric Concept of a Smooth Staircase: Sinus Stairs

Cornelie Leopold

Introduction

Stairs are fascinating elements of architecture, especially from a geometric point of view. The geometry of stairs is in the focus of this research combined with an educational project in architecture, where a sinus staircase as a walk-in project had been realized. The artist Werner Bäumler—Laurin developed the idea to create stairs similar to a smooth hill in the 1990s. Only the experience to walk on such stairs can verify the concept. Therefore, a 1:1 realization had been an important part of this study.

The geometries of stairs can be related to their typologies and the resulted movements in space. They are always related to the human movements. Stairs have mainly the function to overcome height differences, but became independent spatial elements in architecture with stay qualities. The "Scalinata di Trinità dei Monti" in Rome illustrates particularly those stay qualities of stairs in the urban space, hence it is now no longer allowed to sit on them in order to regulate the masses of visitors.

Stairways facilitate relationships between movements in space and therefore organize the spatial concepts in architecture, for example in the Elbphilharmonie Hamburg by Herzog and de Meuron, 2016, shown in Fig. 1. The idea of human movements and explorations of proven design rules for stairs influenced the development of the idea of the sinus staircase.

C. Leopold (✉)
Descriptive Geometry, FATUK [Faculty of Architecture], TU Kaiserslautern, Kaiserslautern, Germany
e-mail: cornelie.leopold@architektur.uni-kl.de

© Springer Nature Switzerland AG 2020
M. Emmer, M. Abate (eds.), *Imagine Math 7*,
https://doi.org/10.1007/978-3-030-42653-8_10

Fig. 1 Stairs as part of the spatial concept of Elbphilharmonie Hamburg by Herzog and de Meuron, 2016. © Photo by C. Leopold

Design Rules of Stairs

Rules for the construction of staircases go back to Vitruvius. In his *Ten Books of Architecture* [1] he described rules for stairs of temples and theaters. Measurements for the rise and tread of steps of a temple had been suggested in order to achieve a comfortable going up:

> The steps in front must be arranged so that there shall always be an odd number of them; for thus the right foot, with which one mounts the first step, will also be the first to reach the level of the temple itself. The rise of such steps should, I think, be limited to not more than ten nor less than nine inches; for then the ascent will not be difficult. The treads of the steps ought to be made not less than a foot and a half and not more than two feet deep. [1]

He suggested for the rise of steps for a temple between 22.8 and 25.4 cm, for the treads between 45.7 and 61.0 cm.

These relationships between riser and tread of a staircase had been resumed by Alberti, 1452, in *De re aedificatoria* [2] and Palladio, 1570, in *I quattro libri dell'architettura* [3]. The French architect and engineer François Blondel referred in his book *Cours d'architecture* [4], 1675, to the historical examples of stairs rules by Vitruv, Alberti, and especially the drawings of Palladio. There Blondel introduced in Book 3 a formula for the measurements of stairs, which he based on measures

Fig. 2 Stairs notions: rise or riser, tread or run, and inclination angle

of the human step. He postulated that two rises and one tread should make together the length of 65 cm (Fig. 2). The step measurement rule—as basis for staircase dimensions—is one of the most important planning principles for staircase builders till today. The step measurement rule is based on the insight that human step length on slopes is reduced by twice the height, therefore two rises.

Today we take usually the rule that the step length for the calculation of stairs with normal inclination of 30° (degree) should be around 63 cm, although there are differences. In the Netherlands the stairs are very steep with a smaller step length due to historical house tax, lack of wood and stone as well as traditional ship construction with steep stairs and ladders.

Scalalogy as Staircase Science

It had been the merit of Friedrich Mielke (1921–2018), German building conservator and stairs researcher, to bring together studies on stairs to a proper staircase science, called *scalalogy*. Friedrich Mielke collected and explored stairs over six decades. He measured stairs, recorded them in drawings, photos, and models. In his *Handbuch der Treppenkunde* [5], published 1993, he established a nomenclature and typology with over 60 variants of staircases. Parts of the work of Friedrich Mielke, also a lot of his models and the books, around 30, had been shown at the Architecture Biennale in Venice 2014 in the central pavilion as part of the exhibition *Elements of Architecture* [6], curated by Rem Koolhaas.

The staircase typologies form the basis for scalalogy, the staircase science. But until now the extensive work of Mielke and his collection is not fully worked up yet. We visited with our students the Friedrich-Mielke-Institute for Scalalogy of OTH Regensburg [7], directed by Joachim Wienbreyer in November 2017, now directed by Dr. Ulrike Fauerbach. He and now she is still reappraising the comprehensive work of Friedrich Mielke on stairs. Joachim Wienbreyer showed us the collection. Mielke analyzed around 10,000 staircases and collected associated material. We studied some of his works and of the Friedrich-Mielke-Institute for Scalalogy [8].

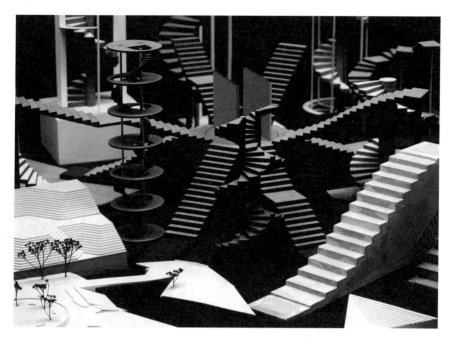

Fig. 3 Models by our students related to their respective focus on stairs, photo by Benedikt Blumenröder [9]

These studies stimulated our students for their own research on staircases. Figure 3 illustrates models by the participants related to their respective focus on stairs, including the Sinus Stairs project [9].

Humans and Stairs

Studies on the relationships between humans and stairs is integrated in scalalogy. There are relationships between the human leg and the stairs: the length of the leg influences the step length and the length of the foot determines the measure of the tread. Mielke analyzed empirical studies on human behavior on stairs in order to get further background for the stairs' conditions [10]. He criticized that stairs are built according traditional measures instead of results of empirical studies of the users of stairs. He studied stepping paths on worn stairs, looked for notations of traces on each step with a graphical documentation, which marks the most frequented path common to all users. The stepping path is an exact documentation of the preferred path of a number of anonymous people of different genders and ages. The studies showed that people mainly do not choose the direct ascending line. There are individual differences, but the stepping paths on a stair do not follow in most cases the ascending or descending line with a constant slope ratio. So, people

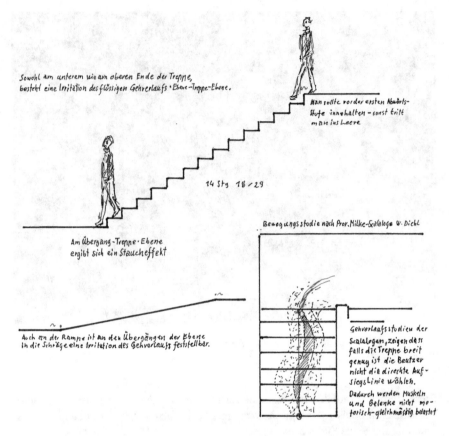

Sowohl am unterem wie am oberen Ende der Treppe,
besteht eine Irritation des flüssigen Gehverlaufs «Ebene-Treppe-Ebene».

Man sollte vor der ersten Abwärts-
Stufe innehalten – sonst tritt
man ins Leere

14 Stg 18 / 29

Am Übergang-Treppe·Ebene
ergibt sich ein Staucheffekt

Bewegungsstudie nach Prof. Milke-Skalaloga W. Dichl

Auch an der Rampe ist an den Übergängen der Ebene
in die Schräge eine Irritation des Gehverlaufs festtellbar.

Gehverlaufsstudien der
Skalalogen, zeigen dass
falls die Treppe breit
genug ist die Beutzer
nicht die direkte Auf-
siegslinie wählen.
Dadurch werden Muskeln
und Gelenke nicht mo-
torisch-gleichmässig belastet

Fig. 4 Irritations by transition from the horizontal plane to the stairs and to the horizontal plane again. Stepping paths studies according Friedrich Mielke. Sketches and notes © Werner Bäumler—Laurin. Reproduced with permission

choose variations in slope ratios. In his opinion, the standards and regulations for stairs are based on those wrong assumptions.

Therefore, one consequence is that a stair must not have always the same slope. According to the thoughts on a smooth staircase by Werner Bäumler—Laurin [11], German artist, living and working in Venice, documented in sketches and notes around 1991, shown in Fig. 4, there is an irritation when stepping on a stair or ending. The idea arose that there should be a better transition from the horizontal plane to the stairs and to the horizontal plane again. He refers to the mentioned studies of Friedrich Mielke, that people mainly do not choose the direct ascending line. From this fact, he concludes that the stairs users do not wish to have always the same muscle and joint strains.

Concept of the Sinus Stairs

These stepping paths studies with the result that people do not prefer to take a way on the stairs with constant slope had been one background for Laurin's idea of the sinus stairs. He derived his idea from the vision that walking on a staircase should be like walking up or down a smooth hill [12].

The section profile of a terrain starts from the horizontal plane rising slowly and flattening again from half height up to the upper level—such as the shape of the half of the period of a sinus or cosine line. Starting from the horizontal plane with a slight rise continuously to the steeper part and again the transition to the horizontal plane.

As a consequence, each step has another rise. But a second condition of the sinus stairs is that the slope ratio of the steps is always related to the step length, which is a constant measure. These two conditions determine changing riser heights and tread depths. The drawings in Fig. 5 show the scheme of increasing—then decreasing step heights and decreasing, then increasing depths of treads, so that the step length is constant (Fig. 5).

Laurin developed the characteristics of the sinus staircase with the following ideas:

If one goes to the stairs, also in a hurry, the kinetic energy can be taken on the stairs. By the first gentle, then steeper course, the flow coming from the plane is not disturbed. The horizontal path is therefore not kinked as in the normal staircase, but bent. Due to the increasing—then decreasing risers and the thus changing depths of tread, the muscle tension and the joint position are a bit changed. The effort of overcoming the height is first increasing then decreasing again. These characteristics of changing muscle and joint strain correspond with the empiric results of users' chosen paths on a staircase. The transition from the horizontal plane to the slope of the stairs is formed continuously. By walking downstairs, you are slowly transferred to the horizontal plane again at the bottom of the stairs (Fig. 6).

Laurin created a sculptural sinus staircase, exhibited at Bauhaus Dessau in 1991 (Fig. 7) and later in Bonn in front of the ministry of building. He realized another sinus staircase in steel (1994) for the administration building of a company in Landshut, Germany, and many models.

His research and experiments on sinus stairs include variants also as spiral sinus staircases, shown in the exhibition at the Imagine Maths 7 conference in Venice 2019 (Fig. 8).

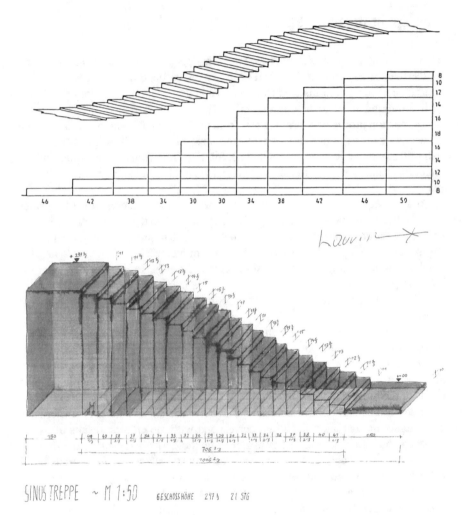

Fig. 5 Sinus stairs concept with increasing then decreasing risers and decreasing treads then increasing treads to achieve a constant step length. © Werner Bäumler—Laurin. Reproduced with permission

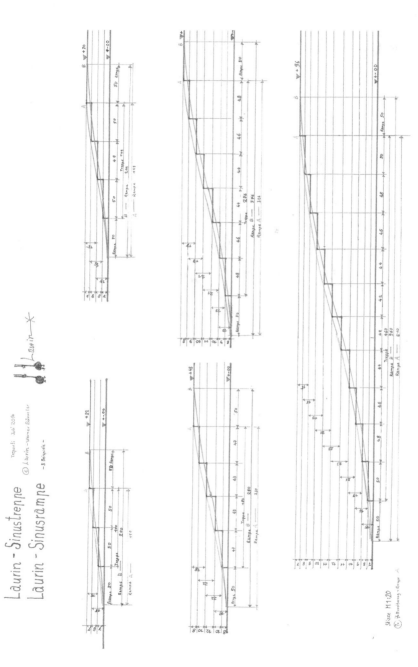

Fig. 6 Examples of Sinus Stairs and ramps by Laurin, 2014. © Werner Bäumler—Laurin. Reproduced with permission

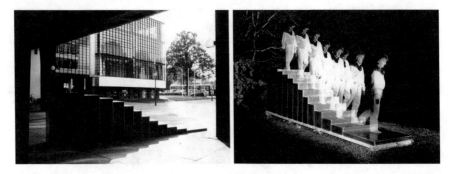

Fig. 7 Laurin's Sinus Stairs in front of Bauhaus Dessau, 1991. © Werner Bäumler—Laurin. Reproduced with permission

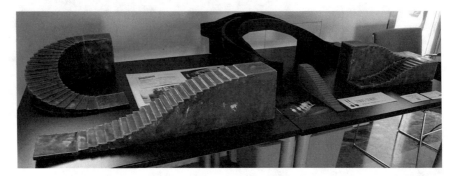

Fig. 8 Variants of sinus stairs in models at the exhibition in Venice 2019. © Werner Bäumler—Laurin, photo: C. Leopold. Reproduced with permission

Sinus Stairs Project

In 2018 we picked up the idea of the sinus stairs as a project with students of architecture at TU Kaiserslautern. In the frame of studies on the geometry of stairs in the course "Design Geometry"—"Gestaltungsgeometrie" [13], the students created and realized a sinus staircase in our faculty building as a walk-in example in order to have the chance for experiencing the presumed effect walking on such a staircase.

Werner Bäumler—Laurin provided us his material on the creation processes of the sinus stairs.

The changing heights and depths of the sinus staircase can be calculated according to a chosen version of a sinus curve which determines the maximal slope of the resulted stairs. The students Benedikt Blumenröder and Moritz Brucker generated a graphical method for developing the sinus stairs. We took in our example the step length of 63 cm. From the Blondel's formula:

$$2 \text{ risers} + 1 \text{ tread} = 63 \text{ cm}$$

Fig. 9 Graphical method with results of variants of sinus stairs by students Moritz Brucker and Benedikt Blumenröder [13]

The linear function based on the slope triangle can be derived by transformation:

$$f(x) = -0.5x + 31.5 \text{ cm.}$$

This linear function creates a family of lines by translation. The graph of the linear function $f(x)$ must be moved at its slope triangle as shown in Fig. 9. This group of parallel lines have to be superimposed then with the respective sinus curve. The steps of the sinus stairway are located at the intersections of the graph of the sinus function

$$g(x) = \sin(x)$$

with the family of the parallel lines.

Figure 10 shows in detail the graphical method to develop the steps of the sinus stairs. The graph of the linear function $f(x)$ in blue must be moved at its slope triangle in red. The resulted group of parallel lines is then superimposed with the graph of the sinus function. The steps are located at the intersections marked with a green dot and one step drawn in green.

The normal sinus function creates a relatively steep staircase. Therefore, other variants with stretched sinus functions had been tried out. The stretched sinus functions lead to more comfortable staircases. The sinus staircase in the middle in Fig. 9 is probably the most comfortable staircase, as it is not too steep and not too flat.

At the Biennale in Venice in 2014, a sinus staircase had been also realized. But the exhibited version did not follow the concept of Laurin. Friedrich Mielke designed this sinus stairs with increasing and decreasing risers, but with treads remaining at a constant depth. This leads to changing slopes and changing step lengths, when walking on the staircase. Therefore, there had been no smooth

Fig. 10 Detail of the graphical method to develop the increasing and decreasing risers and treads with constant step length

walking on this stair in the exhibition—there was an irritation—an experience of stumbling.

The concepts of Friedrich Mielke and Werner Bäumler related to the idea of the sinus stairs are different. In his book "Treppen im Modell" [14], already before published in 1992 [15], Friedrich Mielke stated:

> Bei der Sicherheit des Steigens spielt die Tiefe der horizontalen Trittflächen eine geringere Rolle als die vertikalen Abstände der Stufen voneinander. Die menschlichen Schrittlängen sind variabel. [14, p.18]

> In the safety of climbing, the depth of the horizontal treads plays a minor role than the vertical distances of the steps, the risers. The human step lengths are variable (my trans.).

In the publication "Element of Architecture. Stair" [6] catalogue to the Biennale in Venice 2014, a text by Mielke from 1992 [15] had been published, where Mielke explained his reason to modify the idea of Laurin:

> However, once the tread is of sufficient depth, and in order to achieve the stair user stepping pro- and regressively, without falling into a potentially endangering monotony, it is appropriate to modify Bäumler's idea. A first variant is proposed by the Centre of Stair Research. It maintains all treads of one flight at the same depth. This, combined with differential riser heights, results in challenging the stair user with changing lengths of step, which activates their reactions. [6]

We decided to follow the concept of Werner Bäumler—Laurin with changing tread depth in order to have constant step lengths. Figure 11 shows the concrete model of our planned sinus stair with increasing and decreasing risers and changing tread lengths resulting constant step lengths. The measures had been taken from the real situation at the entrance hall of our faculty building, so that the sinus stairs go from the entrance level to the first platform of the existing staircase. The parameter storey height is normally the first parameter influencing the staircase.

Figure 12 shows the existing entrance situation in our faculty building and the rendering of the planned sinus stairs installation. Only by walking on the sinus

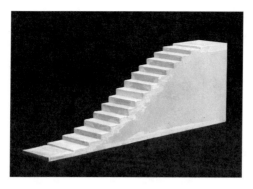

Fig. 11 Concrete model of our chosen sinus stairs with increasing and decreasing risers, changing tread lengths, and constant step length, by students Jana Gretz and Angelika Walz [9]

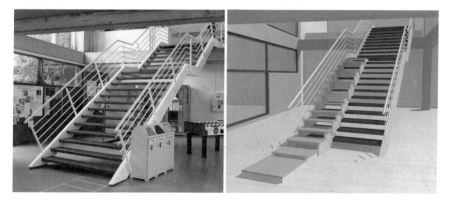

Fig. 12 Existing entrance staircase in the faculty building and rendering of the planned sinus stairs installation

staircase it is possible to experience the claimed pleasant increasing and decreasing stairs slope. Therefore, we decided to realize the walk-in project in the main entrance hall on the existing staircase in our faculty building. In this way, we have the normal stairs and the sinus stairs directly comparable side by side. It gets obvious that the sinus stairs need more space for achieving the smooth walking. The concept of the sinus staircase is illustrated in top view, section and perspective in Fig. 13.

In the further planning process, the students tried to find a way to build the sinus staircase by themselves out of wood. They could use the faculty's lab and the material of an old staircase. The old wood had been carefully planned, nails removed and glued together for the various treads of the sinus stairs. The stairs stringers had been cut out of blockboard panels (Fig. 14).

Finally, we realized the walkable sinus stairs on the entrance staircase (Fig. 15). The difference between the normal and the sinus stair could be directly experienced. Each of us had been surprised, how smooth, supple and fluid it appears, while walking on the sinus stairs. In a public exhibition the visitors confirmed the surprising comfortable experience with the sinus stairs (Fig. 16).

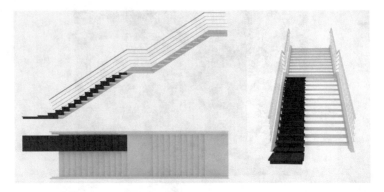

Fig. 13 Top view, section, and perspective of the sinus stairs walk-in project

Fig. 14 Construction work for the sinus staircase by our students, treads made of wood of an old staircase, the stairs stringers out of blockboard panels

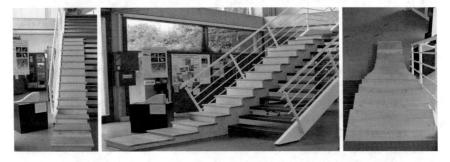

Fig. 15 Installation of the walk-in sinus staircase in the faculty building, view from below, from the side and from above

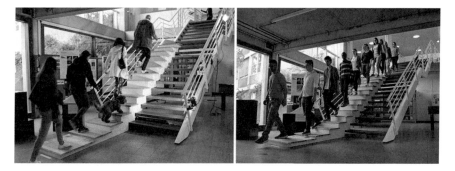

Fig. 16 Smooth and supple walking on the installed sinus stairs

Conclusions

The concept of the sinus stairs is the result of the research on human movements related to geometry. The human movement gets interrelated with geometric designs. The development of the sinus stairs according the changing inclinations of the sinus curve showed the relationship between mathematics and ideas for the cultural element stairs created after the results of scalalogy, the science of stairs, and the studies of movements. It had been an interesting experience to analyze the background, design, build, and walk on the sinus stairs as well as finally to confirm the comfortable walking on it.

Acknowledgments Special thanks to Werner Bäumler—Laurin for sharing his idea of the Sinus Stairs with us, to provide his drawings, writings, and photos as well as to come to the Imagine Maths 7 conference with his models. The figures are reproduced with courtesy of Werner Bäumler.

Thanks to Prof. Joachim Wienbreyer, University of Applied Sciences, Friedrich-Mielke-Institute, Regensburg, to provide us insight in the Friedrich-Mielke-Institute with details of the research. And last but not least many thanks to my engaged and motivated students: Benedikt Blumenröder, Yuliana Brehmer, Moritz Brucker, Marian Buchheiser, Sabrina Funk, Jana Gretz, Jonas Heuser, Sarah Lutgen, Emmanuel Niyodusenga, Ernst-Markus Rauska, Anna Specchio, Angelika Walz, and Philipp Weber.

References

1. P. Vitruvius, *De architectura* (transl. by M.H. Morgan), *The Ten Books on Architecture* (Harvard University Press, Cambridge, 1914), Book III, 4, p. 88. https://archive.org/details/vitruviustenbook00vitruoft. Accessed 28 Aug 2019
2. L.B. Alberti, *De re aedificatoria. On the Art of Building in Ten Books* (transl. by J. Rykwert, R. Tavernor, N. Leach) (MIT Press, Cambridge, MA, 1988). Book 1, Chapter 13
3. A. Palladio, *I quattro libri dell'architettura.* (Dominico de' Francheschi, Venice, 1570), Book 1, Chapter XXVIII
4. F. Blondel, *Cours d'architecture.* Cinquième Partie, Livre Troisième, Des Escaliers (Enseigné dans L'Academie Royale D'Architecture, Paris, 1698). http://digi.ub.uni-heidelberg.de/diglit/blondel1698c/0335. Accessed 28 Aug 2019

5. F. Mielke, *Handbuch der Treppenkunde* (Verlag Th. Schäfer, Hannover, 1993)
6. S. Trüby, R. Koolhaas, I. Boom, Friedrich-Mielke-Institut für Scalalogie, *Elements of Architecture. Stair* (Marsilio, Venezia, 2014), pp. 194–195
7. Friedrich-Mielke-Institut für Scalalogie Regensburg, https://www.oth-regensburg.de/fakultaeten/architektur/aktuelles/aktuelles-dateilansicht/news/regensburger-treppen-auf-der-architektur-biennale-in-venedig.html. Accessed 17 Sept 2019
8. P. Morsbach, T. Schulz, J. Wienbreyer, *Die Treppe. Leiter der Sinne, Ausstellungskatalog* (Dr. Peter Morsbach Verlag, Regensburg, 2012)
9. C. Leopold (ed.), *Scalalogie* (Technische Universität Kaiserslautern, Kaiserslautern, 2018)
10. F. Mielke, *Mensch und Treppe. Scalalogia. Schriften zur internationalen Treppenforschung.* Band XVI (Knotenpunkt Verlag, Potsdam, 2008)
11. W. Bäumler—Laurin, Homepage, http://www.laurinonline.de/installationen.en.html. Accessed 17 Sept 2019
12. C. Wiget, Treppe mit weichem Übergang. Hochparterre: Zeitschrift für Architektur und Design **5**(1–2), 69 (1992)
13. C. Leopold, Geometric aspects of scalalogy. J. Geom. Graph. **23**, 2 (2019)
14. F. Mielke, *Treppen im Modell. Schriften zur internationalen Treppenforschung.* Band XIV (Verlag Klaus Hupfauf, Edelshausen, 2007), pp. 18–21
15. F. Mielke (ed.), *Collectaneen 3. Scalalogia. Schriften zur internationalen Treppenforschung.* Band VI (Jacob-Gilardi-Verlag, Allersberg, 1992), pp. 88–91

Sublime Experience: New Strategies for Measuring the Aesthetic Impact of the Sublime

Maddalena Mazzocut-Mis, Andrea Visconti, Hooman Tahayori, and Michela Ceria

Introduction

The sublime, the mixed feeling of pleasure and displeasure, is by far one of the most discussed categories in the history of Aesthetics. However, the research on the topic has been altered by a lack of agreement between scholars on its nature and effects. The recently revived research programmes of empirical Aesthetics could benefit the sublime's theoretical history; but empirical studies of this topic have been very limited in number and scale. The conducted researches were marred by a limited understanding of the philosophical debate.

The sublime in theatre is supposed to be a systemic superordinate outcome: the expression in the subject of the creation of a particular kind of relationship between spectator(s) and performance. Our theoretical approach has several precursors. In 2001 Mayne and Bonanno [25] edited the volume "Emotions. Current Issues and Future Directions", a structured set of contributions aimed at mathematically patterning emotions through the use of Ordinary Differential Equations (ODEs) and at describing them as emerging properties of interpersonal and intrapersonal systems. Although Mayne and Bonanno do not discuss aesthetics-related topics, they show

M. Mazzocut-Mis
Dipartimento di Beni Culturali e Ambientali, Università degli Studi di Milano, Milan, Italy
e-mail: maddalena.mazzocut-mis@unimi.it

A. Visconti (✉) · M. Ceria
Dipartimento di Informatica "Giovanni Degli Antoni", Università degli Studi di Milano, Milan, Italy
e-mail: andrea.visconti@unimi.it

H. Tahayori
Department of Computer Science and Engineering and IT, School of Electrical and Computer Engineering, Shiraz University, Shiraz, Iran
e-mail: tahayori@shirazu.ac.ir

© Springer Nature Switzerland AG 2020
M. Emmer, M. Abate (eds.), *Imagine Math 7*,
https://doi.org/10.1007/978-3-030-42653-8_11

that emotions and feelings may be formalized through mathematical tools. On the same theoretical line many models have been developed to investigate, respectively: population dynamics [33], conflict escalation processes (Richardson), predator–prey interactions [5], behaviour and opinion dynamics in social networks [52]. In [14], Philip Galanter adopts a different set of mathematical tools to formalize art: he refers to algorithmic methods in the context of systems and complexity theory in order to understand creative processes, defining generative art as the use of a system (a set of rules) to (contribute to) creating works of art. In 2009, in the framework of the "Generative Art" conferences held in Milan, Galanter delivered the paper entitled "Complexity, Neuroasthenics, and Computational Aesthetic Evaluation" [15], in which he explored formalized processes that could allow computers to make aesthetic evaluations (also about the sublime) and to be creative. In [15], Galanter stated that such models should include a balance of order and disorder and should be predisposed to recognize the "effective complexity" (the mix between order and disorder) characteristic of living systems. In Galanter's hypothesis, aesthetic pleasure in human beings derives from a tuning between our nervous system and objects of effective complexity (such as those typically found in living or ecological systems). A different computational approach comes from computer science and is based on the adoption of artificial intelligence to search specific relational and procedural patterns in experimental data. Several naturally inspired models, in particular those that mimic biological immune systems, are widely used in pattern recognition [1, 11, 36, 48] and [47]. Biological immune systems draw up lines of defence to protect living organisms from all kinds of unwanted invaders. The lines of defence are grouped in chemical and physical barriers, innate immune system and adaptive immune system. In this respect one of the main tasks which a biological immune system has to perform is to recognize what is exogenous or endogenous in the organism's internal environment; the immune system carries out this task by mapping isomorphic or not isomorphic patterns in an organism's tissues and apparatuses. Similarly, Artificial Immune Systems (AISs) are able to recognize elementary self-components/patterns and elementary non-self-components/patterns in chaotic environments [17–19, 24, 50], and [51]. Developed in the 1990s, AISs proposed in the last decade were mainly studied and implemented for individuating specific patterns in real-world problematic fields such as road traffic anomalies, hardware fault detection, intrusion detection systems, etc. [11, 23, 50]. All these issues have a common factor: the need to find specific patterns by using a set of experimental data collected in a noisy environment.

In this context, to ease pattern recognition by AISs, fuzzy logic proceedings are widely applied to reduce the complexity of relational environments and to deal with situations where no sharply defined criteria exist. Models as these have never yet been applied to the study of the arousal and evolution of a feeling like the sublime in an audience during a theatrical performance.

In this paper, we investigate the nature of the sublime, defining a methodology to measure its impact on theatre consumption, and to harness the whole creative process, from page to stage. To do so, a number of topics should be investigated: (1) A new definition of this aesthetic category; (2) The development of an innovative

"affective theatrical stimuli system" designed so as to obtain normative ratings of the sublime; (3) A cognitive analysis to be conducted in the laboratory and during the live performances of the custom-made pieces—for example, realized in theatres—in order to identify specific patterns of activation reflecting the "sublime" experience; (4) The application of an agent-based software framework—i.e., an Artificial Immune System based on fuzzy logic—to model the sublime. The innovative interaction between several disciplines—philosophy, theatre practice, cognitive and computer science—should to be conducted by a team of philosophers, playwrights, computer and cognitive scientists working in synergy.

The paper is structured as follows. Section "The Sublime" is devoted to the definition of the sublime emotion. Section "An Introduction to the Biological Immune System" introduces the biological immune system while in section "Fuzzy Sets" Fuzzy logic is briefly described. Section "Designing a Methodology to Identify and Measure the Sublime" presents a methodology used to measure the sublime emotion on theatre consumption. Finally, conclusions are drawn in section "Conclusions".

The Sublime

Starting from the reformulation of the eighteenth century category of the sublime as it emerges in the Du Bos-Burke-Mendelssohn axis (all of whom emphasized the physiological dimension of the sublime), we proceed along a unexplored pathway: the emotion of the sublime will be analysed by deploying the most recent mathematical models for the iteration between agents, in particular through the use of differential equations for the study of the dynamics of opinions and conflicts.

Emotions are complex phenomena. We all have an intuitive understanding of what they are because we experience them in everyday life. They happen in response to a triggering situation in the external environment and play a major role in our perception, cognition and motivation. Despite their paramount importance in our lives, attempts to provide a general definition of emotions or a complete taxonomy of what counts as an emotion have been unsuccessful [37].

Not only is the general essence of emotions poorly understood, several affective properties are also still a matter of debate. Among these, a central and still much discussed feature is the valence of emotions, i.e., their positive or negative character [8]. Today, the discussion on whether and how we should differentiate between positive and negative emotions is no longer the exclusive domain of philosophical inquiry, but has become the subject of a multidisciplinary analysis. However, such enquiry has not produced satisfactory results to date [34]. There is a lack of general consensus on how positivity or negativity is mirrored by the multitude of theories that have attempted to solve this puzzle with no definitive conclusions [41, 46].

The D-B-M axis (Du Bos, Burke and Mendelssohn) [22, 26] develops an idea that is clearly compatible with the activation of the emotional element. An emotional element that is particularly interesting because it is complex and twofold. The duplicity component is supported by pleasure and displeasure. The pleasure for

the representation of the suffering of others and the displeasure for the object of the representation are added to and overlap with regret for the other—other than myself but with whom I mirror myself, thus empathizing with them. This is when the sympathetic (emphatic) element comes into action.

But what emotion are we talking about?

The D-B-M Axis: D-Du Bos

As Du Bos wrote: "They flocked to see one of the most horrific events that men can ever look at, I mean the torture of another man suffering the penalty of the law on the scaffold and dying from the horrible torments: it should nevertheless provide, assuming that you already know from experience, that the circumstances of torture and groans of your fellow creature cause the viewer, despite himself, a lasting impression that will torment him for a long time before being completely forgotten; but the attraction of emotion for many people is stronger than the reflections and advice caused by the experience."[1] The moments of enjoyment that we can experience in the face of a real calamity are in fact "followed by days so sad" that art should find a way to separate the pleasantness of the passion from the unpleasantness of consequences. Therefore, could not art "create, so to speak, creatures of a new nature? Could it not produce objects that arouse artificial passions in us, able to keep us busy when we feel them and unable to cause real pain and genuine sorrow?" [12, pp. 25–26].

Real passions, therefore, have only one negative effect: they leave a "bad taste" in the mouth, they tend to prolong pain and to overwhelm the soul, which needs to be excited without bad consequences. Art creates beings of a "new nature"—that is to say—fantastic creatures from the world of "as if", creatures that know how to make us weep without making us suffer. The excitement generated by illusion is of no consequence. It is an impression of "second nature" rather than an impression caused directly by the object and, because it does not reach the "reason" but "strikes only the sensitive soul vividly, it fades quickly" [12, p. 10] and has no lasting negative consequences.

The artists have no other task than to rouse the same passions that the most violent and most moving events produce in real life, but without backlashes, without side-effects. Even if the object of art only lives an "artificial life", that object must have the same force as reality. That is the secret of art [12, p.10]. This is the source of pleasure, or, rather, of "pure pleasure" without those "inconveniences" linked to the "serious" emotions provoked by the reality.

[1][12, p. 5]. See also the Italian critical edition: [13].

B-Burke

As stated in Edmund Burke's *Philosophical Enquiry into Our Ideas on the Sublime and Beautiful* (1757), without moderation, or, better, without moderation grounded in common sense, and without the good admonitions of the French moralists, the enjoyment of horror intensifies and extends the problem of enjoying what, in reality, stirs strong passions and pain to their very limit.[2]

Anything can instil "ideas of pain and danger, that is to say whatever is in any sort terrible or is conversant about terrible objects, or operates in a manner analogous to terror, is a source of the sublime" [7, cit., p. 39]. The pleasure of the sublime is quite specific: stimulated by a shock, it gives rise to what might be called "negative pleasure".

In Burke's thought, the term delight indicates a middle ground, whether we take it as a passage, as in the cessation of pleasure or pain—a kind of ambiguous experience, languishment—and whether we take it as the midpoint of tension between opposing forces, a thin boundary that is likely to be crossed, as in terror. In the first part of the enquiry, delight corresponds to the relief given by the cessation of pain, the languishment that comes from indulging in some pain that is more pleasant than its lack. In the fourth part of the text, delight, mingling with terror, takes on the traits of violence, spasm, and tension pushed to the limit. Terror delights because it excites: however it must be bearable.

For Burke, a necessary condition to experience the sublime is the development, within the viewer, of a feeling of "self-preservation". It is an essential condition to the experience, but it is not a cause of the feeling of the sublime. "When danger or pain press too nearly, they are incapable of giving any delight, and are simply terrible; but at certain distances, and with certain modifications, they may be, and they are, delightful, as we everyday experience" [7, p. 40]. However, although being at distance is an indispensable pre-requisite for the spectator, the sense of immunity does not rouse any delight.[3]

One should not set a qualitative difference between the sublime in real life and the artificial (artistic) sublime, claiming that people would leave a theatre empty if there was an execution in a square nearby. This is also one of the limits in Burke's research and, therefore, the reason why his thought should be integrated with Du Bos and, as we will see, Mendelssohn.

[2]Cp. [7]. On the relationship between Du Bos and Burke see [10, pp. 141–160]. Although Burke makes explicit reference to Du Bos only once, the influence of Du Bos's *Reflections* is evident. As Doran says: "by asserting that sublime poetry affects by the obscurity of the images it conjures [...], Burke offers a competing view to Dubos's claim that painting affect us through their clarity" (p. 165). See [20, chap. II, paragraph "From mimesis to process"] and [49].

[3]It is important to remember, as Shusterman pointed out, that the somatic value of Burke's sublime has been often underestimated. Although Burke's sublime can be seen as "reductionistic" or "mechanistic", it is nonetheless extremely useful in this context [39, pp. 145 etc.] and [38].

M-Mendelssohn

Mendelssohn was directly inspired by French thought, and he especially appreci-
ated the issues discussed by Du Bos—whose ideas, however, Mendelssohn often
betrayed or misunderstood. The influence of Burke's thought on Mendelssohn
is well-known, as much as the debate that Burke's theories roused between
Mendelssohn and Lessing.

> Lisbon's demise in the earthquake attracted countless people to take in the sight of this
> terrible devastation with their own eyes. After the bloodbath at [Mendelssohn does not
> mention the place] all our citizens hurried over to the field of slaughter, strewn as it was
> with corpses. After the deed was done, the sage himself, who would have taken pleasure in
> preventing this evil by offering up his own life, waded through the human blood and felt a
> frightful fascination at the sight of this terrible place" [31, pp.131–132].

Anyone who enjoys the pain of misfortune should have no direct responsibility
for what happened; the audience is not responsible. Once the mishap has occurred,
nobody can intervene to make things right. They are, in all respects, "spectators".
Reality becomes their representation, and they create a drift between themselves
and the object represented; the object per se draws the spectator's disapproval,
but its enjoying rouses pleasure. When something evil occurs and we are neither
responsible for it nor could have we prevented it in any way (hence we are devoid
of any moral involvement), then—only then—can our soul turn to spectacles that
would have been otherwise unbearable. We wish that the object per se did not exist,
but, at the same time, we desire its representation. Since the representation engages
our faculty to know and desire, it is pleasant, and it enhances the "reality" of the
human soul.

Each representation is related both to the thing, "as its object", of which it
bears the "imprint", and to the "soul", i.e., with the subject of which it is "a
determination". This distinction can also lead us to find pleasure in what, in reality,
we abhor (as Aristotle put it, why do we find pleasant, in art, what we find repugnant
in life? [3]). "We disapprove of the evil that has occurred; we wish that it had not
happened or that it stood in our power to make things right again. Once, however,
the evil has occurred, and if it has occurred without our being in any way responsible
for it and without our being able to prevent it, then we are powerfully attracted to
the representation of it and long to acquire that representation" [31, p.131].

Main Topics

Given the definition of the D-B-M axis that we have just illustrated in its historical
components, we would like to highlight some of the elements that constitute the
sublime and that makes it a unique emotion:

- The essential "spectatorial state" in the enjoyment of other people's pain, when
 this takes place in real life. This can be divided into four elements:

- those who enjoy other people's pain must be in a condition of self-preservation (a pre-requisite, according to Burke, and something that per se never rouses pleasure);
- they must not be directly responsible for the event (moral element and pre-requisite according to Mendelssohn);
- they cannot help make the event better (moral element and pre-requisite according to Mendelssohn);
- they must have no personal involvement—sentimental, economical, etc.—in the event.

- The nature of the "mixed feeling" (which, according to Burke generates delight, and which, according to Mendelssohn, has a double emotional and cognitive identity). The mixed feeling is extremely interesting in the moment in which the pathetic component of the sublime is triggered—for example, in the pleasure of weeping. The mixed feeling must be investigated both in the context of fiction and in that of reality, and it is necessary to highlight its physiological, psychological and cognitive characteristics. We must investigate the nature of an essential double component: the pleasant and the unpleasant.
- The origin and nature of the paradoxical element that characterizes the pleasure of weeping and that we can describe as the paradox of painful art.

We would like to focus on this last topic.

Paradoxes

The D-B-M axis highlights what Smuts defines as "the paradox of painful art". This paradox can be summarized as follows:

"1. People avoid things that provide painful experiences and only pursue things that provide pleasurable experiences.
2. People have painful experiences in response to putatively painful art (e.g. tragedies, melodramas, religious works, sad songs, and horror).
3. People pursue putatively painful art.

 The paradox boils down to a simple question: If people avoid pain then why do people want to experience art that is painful?" [40, p. 43].

 Brady stressed that, in the history of aesthetics, there are at least two main ways to solve this paradox: the meta-response theory and the conversion theory (Cp. [6]). The first states that terror and fear are negative experiences which are effectively painful for the subject experiencing them, while pleasure is a meta-response to them. "[...] [T]he meta-response is a recognition of our capacity to feel emotions appropriately—to pity someone in a tragic situation" [6, p. 153], stimulating our sense of humanity. This fact arouses in us a meta-reaction: a gratification because we discover ourselves as moral.

According to the second solution (the conversion theory), there is a distinction between the perceived emotions (pleasure) and the objects which arouse them (pain, for which a feeling of disapproval might be felt); such a solution is also compatible with Mendelssohn's views that defines the sublime as a mixed feeling, composed of dissatisfaction with the object and satisfaction for its representation [31, Rhapsody, cit., p. 134]. However, if the object touches us too closely, or if subject and object intermingle, the pleasure diminishes or disappears altogether, and pain takes over.

To sum up, the sublime is certainly the most common feeling experienced by human beings. The D-B-M axis can help to provide the basis of such pleasure, especially for what are regarded as artificial passions. If researchers do not draw this distinction and do not identify the pleasure of someone else's weeping in the fictional or in the real context, there can be no experimentation possible. Furthermore, we need to properly identify the moral interference in order to fully recognize this emotion: we are dealing with a complex emotion, a mix of different components that need to be separated before attempting any analysis. As Mendelssohn pointed out, we need to look at both the object (the moral element) and its representation (aesthetic element). An investigation into the sublime, then, can be successfully undertaken by science only if the relevant theoretical framework is used as a starting point.

An Introduction to the Biological Immune System

We call *biological immune system* [2, 9] a set of organs and specific cells aimed to protect a living organism from infections caused by external agents (such as germs, bacteria or viruses) or internally produced ones. The components of a biological immune system are distributed in the organism and they can communicate via lymphatic vases, which connect organs and allow the circulation of the cells.

One of the main tasks of the immune system is to guarantee *correct recognition*. Indeed, it should be able to carefully distinguish between *self-molecules* and *non-self-molecules* [35]. Self-molecules are internally produced by the organism or, at least, do not present any kind of danger for it. On the other hand, non-self-molecules are externally produced and/or pathogens (responsible of diseases), so they may cause damages to the organism and need to be blocked or destroyed as soon as possible. Serious problems for the organism may arise in the case the immune system is less active than needed (i.e. it cannot defeat attacks), which is the case of *immunodeficiencies*. Also the opposite problem may cause severe damages to the organism. This is the case of *autoimmunity* [35], that is actually a failure in recognition, giving "false negatives". Indeed, in this case, self-molecules, i.e., same parts of the organism, are attacked as they were pathogens by the immune system. Finally, *hypersensitivity* concerns an exaggerated response to some non-dangerous agent. This is the case, for example, of allergies.

The immune system presents many level of protection for the organism [9]:

- surface barriers;
- innate immune system [2, 27];
- adaptive (or acquired) immune system [2].

Surface barriers represent the first layer of defence. In a nutshell, they essentially avoid that external dangerous agents enter the organism. The simplest example of physical barrier is given by the skin.

The innate immune system [27] is activated when some non-self-molecule manages to enter the body. Its response is very fast, but it is not precise. The idea is that the innate immune system can give a "generic danger alarm" but it cannot recognize exactly what kind of danger it has to face.

The adaptive (or acquired) immune system, on the other hand, is slower than the innate one, but it is *more precise*. Indeed, it has a memory of the previously defeated attacks and it can provide *specific responses* to the dangerous pathogens.

In what follows, we will see these components in more details, clarifying their role in the biological immune system.

Surface Barriers

Surface barriers represent the first defence layer of the organism. Their intervention is *nonspecific* in the sense that they do not recognize what kind of enemy are fighting. They actually fight all potential intruders. This nonspecific defence is very fast. Usually surface barriers activate immediately, or, in any case, very fast. They can be divided into *physical* or *chemical* barriers.

The simplest physical barriers that we can imagine are the "walls" that organisms erect against pathogens. For example, the first barrier of this kind that we can think about is the *skin*. These barriers do not allow the pathogens to enter the organism they protect. Obviously, they may be bypassed in some cases. For example, injuries are as "breaches" for these protective walls and—for example—bacteria may enter the organism. Moreover, we should take into account that the internal organs are not completely protected via these barriers, since non-self and dangerous agents may enter, for example, from the cavities. Indeed, while breathing, both from the mouth and from the nose, bacteria, toxins and other undesired molecules may enter. In the same way, these dangerous pathogens may try to enter via ears or eyes. Therefore, the organs have other ways to protect themselves. As an example, eyelashes' movement is a physical protection such as the presence of hair in nose and ears, trapping undesired agents.

Chemical barriers, instead, are usually produced to kill pathogens. For example, human skin and respiratory system are able to secrete β-*defensins* [16], particular proteins (actually, they are peptides), that defend the body from pathogens. Other similar defensins (α-defensins) are instead generated in the *Paneth cells* [4], in the intestines. Moreover, we recall that also tears, whose function is to wash the eye

and protect it from foreign bodies, contain lysozyme, which naturally kills bacteria. Lysozyme is present in the saliva as well. It is also important to protect newborns, being one component of the mother's milk.

Another different kind of barrier is given by the *commensal flora*, which lives in a mutualistic symbiosis inside a bigger organism, contributing to its well-being. The commensal flora naturally fights against other bacteria for having food and space and so, by protecting itself, also protects the hosting organism.

These are only a minimal part of the possible examples one can exhibit, to say that an organism has a very variegated set of external protection barriers.

The Innate Immune System

The innate immune system [2, 42] activates when non-self-agents enter the organism. Its response is *nonspecific* but *fast*. The innate immune system is able to recognize the occurrence of a danger for the organism, without specifying what kind of danger it is and it is the responsible of inflammations. Moreover, it is able to activate the more specific responses of the adaptive immune system.

Very simple examples of defences activated by the innate immune system are cough and sneezes, to expel non-self-agents from nose and mouth. Important components of the innate immune system are *leukocytes*, commonly known as *white blood cells*, which act as they were independent organisms by themselves. We have also the *phagocytes*, as *macrophages* and *neutrophils*, whose task is to kill the pathogens by simple contact or by phagocytizing them. In particular, macrophages live in the tissues and have two main functions:

- absorb the residues and "clean" the organism;
- secrete the chemical substances that activate the adaptive immune system.

On the other hand, neutrophils live in the blood and look for pathogens to destroy. Both macrophages and neutrophils can be called to a specific part of the body, if needed, using special proteins called *cytokines* [35]. Neutrophils are a special kind of *granulocytes* (special white blood cells containing some granules in their composition) and they are the first responding in case of pathogen intrusion. Some other granulocytes, mainly connected to allergies and infections caused by parasites, are called *basophils* and *eosinophils*. Other granulocytes, the *mast cells*, are located in the skin and in mucosas and their role is to increase blood circulation in the specific zone of the attack from some intruder, creating an inflammation. *Natural killer cells*, instead, are able to attack and destroy cells of the organism that have been infected and compromised. Finally, the *complement proteins*, produced in the liver, attack pathogens by melting their external membrane.

In the final analysis, what we informally call *inflammation* is the cooperation of agents in the innate immune system. When a tissue is damaged and some pathogen manages to enter the organism, complement proteins activate and go to the damaged tissue. Mast cells cause the increase of blood flow in that part,

so that neutrophils reach the damage tissue going out from blood. Macrophages phagocytize the pathogens and activate the adaptive immune system. In this process, flushing, heat, swelling and pain are generated. Sometimes also fever can occur.

The Adaptive (or Acquired) Immune System

Finally, the last and most powerful defence layer is the adaptive (or acquired) immune system. It is slower than the innate immune system, but its response is *specific*. The adaptive immune system, indeed, can *recognize* the pathogens and act in a specific way to defeat the occurring enemy. We have two types of adaptive immunity, namely cell-mediated immunity and humoral immunity. The former does not involve antibodies, the latter is based on their production. The cells involved in the adaptive immune system are some leukocytes called *lymphocytes*. In particular, we have [35]:

- T cells;
- B cells.

Lymphocytes have various receptors and these make them able to recognize many different dangerous agents, by means of their *antigens*, substances that are a danger signal for the immune system. They can be "educated" in the *lymphonodes*, organs of the *lymphatic vessel*, by the *dendritic cells* [24], namely cells living in the tissues, that phagocytize bacteria and present to lymphocytes the corresponding antigens. Generated from the bone marrow, T cells are transferred via the lymphatic vessel to the *thymus* [9], where they mature, specializing in different possible T cells:

- T_H, *helper T cells*: they recognize the pathogen and stimulate the production of antibodies from B cells;
- T_S, *suppressor T cells*: they are involved in the regulation process in the sense that sometimes tolerance is needed and in this case they suppress the immune response;
- T_c, *cytotoxic T cells*: destroy the compromised cells.

Also B cells generate in the bone marrow, but, differently from T cells, they do not migrate to the thymus, but they are directly driven to the blood. In the beginning, they are non-active and they are stimulated by helper T cells. When helper T cells activate B cells, the latter develop as *plasma cells* or *memory B cells*. Plasma cells are the B cells generating the antibodies, proteins that specifically help in the elimination of some pathogens, identifying them via antigenes. Memory B cells, instead, provide rapid response in the case the antigen of the non-self-agent has been already faced by that organism. It is important to remark that the B cells generate antibodies both for diseases already experienced and for new ones. In the case of an already experienced disease, the immune memory is used, so that the B cells produce the specific antibodies very fast and the infection is healed soon. For

the case of newly experienced diseases, B cells have to generate a response from scratch, and so the whole process is slower. Anyway, after the first generation of antibodies for that disease, memory B cells memorize the experience, so that from the next time it occurs, healing will be faster.

Fuzzy Sets

Due to the bounded capabilities of human sensory we cannot expect to conceive every phenomenon accurately. Moreover, in real world not all concepts are defined or exist with sharp boundaries, i.e., there exist concepts or classes of objects for which there are not sharply defined criteria for the class membership. However such blurred concepts and classes play an important role in the human perception process. Such concepts cannot be modelled through the application of set theory whose ability in this regard has been long challenged in philosophy and logic.

Fuzzy sets, proposed by Zadeh in his seminal 1965 paper [54], can be conceived as a generalization of set theory that admits partial membership of elements. Classical set theory is indeed bivalent, i.e., an object is either in a set or not. Fuzzy set theory, unlike classical set theory, defines a set by means of a membership function, whose values can range in the [0, 1] interval of the real numbers; 0 extreme corresponds to no membership at all, whereas 1 corresponds to full membership. In other words, fuzzy set theory adds an infinite number of grey levels to the black and white world of classical set theory. The following example clarifies the concept and essence of fuzzy sets.

Suppose we have two paint containers, one with pure white paint and the other with black one. First, we take a paint brush, dip it in the white paint container and draw line 1 (see Fig. 1). Then, we mix a big amount of white paint with a bit of black and we draw line 2. Next, we mix a big amount of black paint with a bit of white and we draw line 3. Finally, we use the pure black paint, to get line 4.

It is not possible to properly deal with such problems using classical set theory. On the contrary, using fuzzy logic [54–57], we can define a "degree of membership"—grey level. Thus we would be able to assert that, for example, line 2 and 3 are white, respectively, with the degrees of 0.70 and 0.30. Notice that fuzzy set theory is fundamentally different from probability theory [24]. Indeed, probability

Fig. 1 The four lines: line 1, line 2, line 3 and line 4

Line 1 Line 2 Line 3 Line 4

theory deals with random uncertainty, i.e., uncertainty on what event may occur but the nature of the possible events is completely clear, whereas fuzzy set theory concerns ambiguity of an already shown up event.

Fuzzy set A—also known as type-1 fuzzy set—in the universe of discourse U is characterized by the membership function $\mu_A : U \rightarrow [0, 1]$ and would be denoted as $A = \{(u, \mu_A(u)), u \in U, \mu_A(u) \in [0, 1]\}$. It is also common to show the fuzzy set as $A = \sum_{u \in U} \frac{\mu_A(u)}{u}$ or $A = \int_{u \in U} \frac{\mu_A(u)}{u}$ when U is discrete or continuous, respectively. The membership function assigns to each object u in the universe of discourse U a crisp number $\mu_A(u)$ from the unit interval $[0, 1]$ that represents the grade of membership of u in A. In the above formulation, the division line is only a notation to show that the membership value assigned to the object u is $\mu_A(u)$ and does not convey the division operation. Similarly the notions \sum or \int indicates the union rather than summation or integral. If the unit interval $[0, 1]$ reduces to $\{0, 1\}$, then the fuzzy set will be a classical set. In other words, classical sets are a special case of fuzzy sets, in which objects are either a full member of the set or not.

Type-2 Fuzzy Sets

In real applications there are situations that membership functions of a type-1 fuzzy sets are ill defined. Imagine the concept of "tall man" which is intrinsically vague and has different *meanings* to different people. There is no perfect way with type-1 fuzzy sets that enable handling uncertainties an individual has about the membership function of a fuzzy set denoting this concept—that is called *intra-uncertainty*. Moreover type-1 fuzzy set does not support handling the different *meanings* or generally different membership functions that although correctly, but, for example, are derived from different individuals—it is referred to as *inter-uncertainty*.

Type-2 fuzzy sets enable capturing the uncertainty on membership functions of fuzzy sets through blurring the membership function of type-1 fuzzy sets. Simply to say, instead of relating a single crisp number from $[0, 1]$ to any entity as a membership value, one or more crisp numbers in type-2 fuzzy sets may be related to an entity and that with different strengths. This will introduce the third dimension in type-2 fuzzy sets that permeates better handling uncertainties, specially *intra-* and *inter-uncertainties*.

Type-2 fuzzy set, as defined by Zadeh [56] is a fuzzy set with fuzzy membership function. In his own words "a fuzzy set is of type n, $n = 2, 3, \ldots$ if its membership function ranges over fuzzy sets of type $n - 1$. The membership function of a fuzzy set of type 1 ranges over the interval $[0, 1]$" [56]. Type-2 fuzzy set \tilde{A} in the universal set X is the fuzzy set which is characterized by a fuzzy membership function $\mu_{\tilde{A}} : X \rightarrow [0, 1]^J$, $J_x \subseteq [0, 1]$, with $\mu_{\tilde{A}}(x)$ being a fuzzy set in $[0, 1]$ (or in the subset J of $[0, 1]$) denoting the fuzzy grade of membership of x in \tilde{A} [32]. However, we

adopt the notions and term set used in [28], that is,

$$\tilde{A} = \int_{x \in X} \int_{u \in J_x} \mu_{\tilde{A}}(x, u)/(x, u) \text{ where} 0 \le \mu_{\tilde{A}}(x, u) \le 1, u \in J_x \subseteq [0, 1]$$

$$= \int_{x \in X} \left[\int_{u \in J_x} f_x(u)/u \right] / x \text{ where} f_x(u) \in [0, 1] \text{and} u \in J_x \subseteq [0, 1].$$

Here, x is the *primary variable* and J_x represents the *primary membership* of x. In this regard $\mu_{\tilde{A}}(x) \triangleq \int_{u \in J_x} f_x(u)/u$, which is a type-1 fuzzy set that denotes the fuzzy grade of membership of x in \tilde{A}, is referred to as *secondary membership function* or *secondary set*; we simply refer to it as *fuzzy grade* and call $f_x(u)$ the *secondary grade*.

We observe that type-1 fuzzy sets are a special case of type-2 fuzzy sets, where the set of primary membership degrees for all elements of the universe of discourse is a singleton whose secondary grade is unity, i.e., $\forall x \in X$ we have $J_x \in \{u_x\}$ and $f_x(u_x) = 1$. However if $\forall x \in X$ and $\forall u \in J_x$, then $f_x(u_x) = 1$, the type-2 fuzzy set reduces to the so-called *interval type-2 fuzzy set* that can be characterized by

$$\tilde{A} = \int_{x \in X} \left[\int_{u \in J_x} \frac{1}{u} \right] / x \text{ where } u \in J_x \subseteq [0, 1].$$

An IT2FS \tilde{A} can be fully characterized by its so-called Footprint Of Uncertainty (FOU) that would be defined by two type-1 fuzzy sets named Upper Membership Function (UMF) and Lower Membership Function (LMF):

$$\text{UMF}_{\tilde{A}} = \overline{\text{FOU}_{\tilde{A}}} = \left\{ (x, \mu_{\tilde{A}}(x)), x \in X, \mu_{\tilde{A}}(x) = \sup_{u \in J_x}(u) \right\}$$

$$\text{LMF}_{\tilde{A}} = \underline{\text{FOU}_{\tilde{A}}} = \left\{ (x, \mu_{\tilde{A}}(x)), x \in X, \mu_{\tilde{A}}(x) = \inf_{u \in J_x}(u) \right\}.$$

Knowing that (a) the centroid of a type-1 fuzzy set $A = \sum_{x \in X} \mu_A(x)/x$ is

$$C_A = \frac{\sum_{x \in X} x \mu_A(x)}{\sum_{x \in X} \mu_A(x)}$$

and (b) knowing that the secondary grades in interval type-2 fuzzy sets are all equal to 1, we can apply the Zadeh's Extension principle [55] obtaining the following interval:

$$C_{\tilde{A}} = [c_l, c_r] = \sum_{u_1 \in J_{x_1}} \cdots \sum_{u_N \in J_{x_N}} 1 \left/ \frac{\sum_{i=1}^{N} x_i u_i}{\sum_{i=1}^{N} u_i} \right. . \tag{1}$$

The extremes c_l and c_r can be computed using Karnik–Mendel iterative algorithm (KM Algorithm) [21, 22] or the bounds of the end points of the centroid of an interval type-2 fuzzy set [29, 53]—i.e., $\underline{c_l} \leq c_l \leq \overline{c_l}$, and $\underline{c_r} \leq c_r \leq \overline{c_r}$.

Further details on type-2 fuzzy sets and their operations would be found in [28, 30, 43–45].

Designing a Methodology to Identify and Measure the Sublime

In order to identify and measure the aesthetic impact of the sublime, we define a methodology to measure its impact on theatre consumption, and to harness the whole creative process, from page to stage.

Firstly, it is necessary to create and produce a number of short theatrical dramas designed so as to obtain normative ratings of the sublime.

Secondly, it is necessary to collect experimental data using non-invasive tool—electroencephalogram, eye-tracker, skin conductance, heart rate and so on—altering as little as possible the fruition by the spectators.

Thirdly, design and engineering an agent-based software framework able to identify multifactorial processes, as the D-B-M theatrical sublime is conjectured to be.

In the sequel, we focus on the latter, designing an Artificial Immune System for the recognition of the sublime.

AIS Based on T2FS

By monitoring and analysing the physical parameters collected during the live performances in theatre, we would like to identify specific patterns of activation reflecting the "sublime" experience by means of an AIS based T2FS.

To distinguish between sublime/non-sublime patterns in theatre, we have to map the ordinary (isomorphic—self) conformation, without emotional peaks, of the system "theatrical performance/audience behaviour" and to look for its non-ordinary (not isomorphic—not-self—exceptional) conformations when the sublime emotional peak happens, defining the sublime pattern(s) through the so-called AIS antigen signature strategy. To minimize the effect of uncertainties in our data, we engineer an interval type-2 fuzzy set based-algorithm. The AIS requires:

1. a list of characteristics (parameters, i.e., f_i) of the sublime given by the scientific and dramaturgical committee experts;
2. the indication by n experts of the passages of dramas in which the arousal of a sublime reaction in the audience is expected (see Figs. 2, 3, and 4);
3. the construction of an interval type-2 fuzzy map for each system parameter denoting the meanings of the granules (categories) Sublime, Suspicious-Sublime,

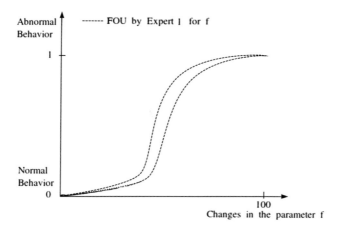

Fig. 2 FOU by expert 1 (parameter f_i)

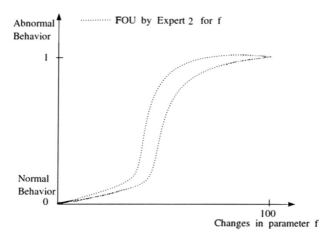

Fig. 3 FOU by expert 2 (parameter f_i)

Non-Decidable, Suspicious-Non-Sublime, Non-Sublime as intervals so as to constitute the frame of reference;

4. the construction of the system's type-2 fuzzy map (see Fig. 5);
5. the computation of the centroid (the centre of aggregation of the membership function) of the map;
6. the identification of the region (Sublime, Suspicious-Sublime, Non-Decidable, Suspicious-Non-Sublime, Non-Sublime) to which the centroid belongs (see Fig. 6).

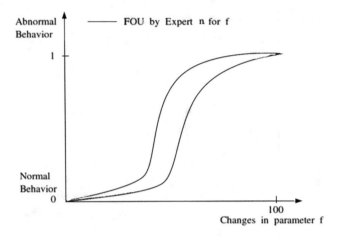

Fig. 4 FOU by expert n (parameter f_i)

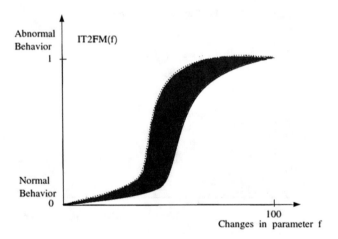

Fig. 5 Interval Type-2 Fuzzy Map (IT2FM) of the system (parameter f_i)

In such a way we are able first to identify what may be called one or more tuned intensity curve(s) of the sublime during the dramatic process, and then to analyse its/their components in detail in order to render pre-describable the emotional curve that should be found in the audience.

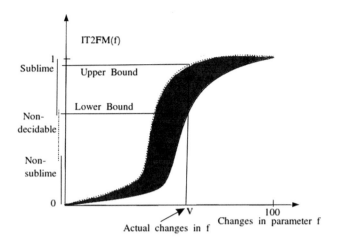

Fig. 6 Region identification: [sublime, ..., non-sublime]

Conclusions

In this paper, we analysed a methodology which places itself in the framework of recognizing and modelling the emotion of sublime, related to theatrical performances.

The idea described in this paper is based on that first one has to obtain normative ratings of the sublime. This operation is performed by collecting information from short theatrical dramas produced on purpose.

The spectators of these short dramas are then examined through non-invasive instruments, e.g., eye-tracker, skin conductance, heart rate, that collect biological data in which we can find the fingerprint of their emotions.

To analyse the collected data, we suggested to use an Artificial Immune System based on fuzzy logic. Mimicking the properties of the biological one, we designed a software agent based on AIS with a T2FS recognition engine. Among the possible logic models we could use to face our problem, type-2 fuzzy logic is the best solution. Indeed, a T2FS approach that enable handling and minimizing the effects of uncertainties and in this context a number of sources of uncertainties can be easily identified. Moreover, we rely on the judgement of different experts that may have different opinions on the same phenomenon. Therefore, T2FS has been suggested exactly to address this kind of problems.

References

1. U. Aickelin, P. Bentley, S. Cayzer, J. Kim, J. McLeod, Danger theory: the link between AIS and IDS, in *Proceedings of the 2nd International Conference on Artificial Immune Systems* (2003)
2. B. Alberts, A. Johnson, J. Lewis, M. Raff, K. Roberts, P. Walter, *Molecular Biology of the Cell*, 5th edn. (Garland Science, New York, 2007)
3. Arist. Poet., 48b, 3–19
4. T. Ayabe, D.P. Satchell, C.L. Wilson, W.C. Parks, M.E. Selsted, A.J. Ouellette, Secretion of microbicidal α-defensins by intestinal Paneth cells in response to bacteria. Nat. Immunol. **2**, 113 (2000)
5. P. Baudains, H.M. Fry, T.P. Davies, A.G. Wilson, S.R. Bishop, A dynamic spatial model of conflict escalation. Eur. J. Appl. Math. **27**, 530–553 (2015). Available on CJO 2015
6. E. Brady, *The Sublime in Modern Philosophy: Aesthetics, Ethics, and Nature* (CUP, Cambridge, 2013)
7. E. Burke, *A Philosophical Enquiry into the Origin of our Ideas of the Sublime and Beautiful* (Blackwell, Oxford, 1990)
8. G. Colombetti, Appraising valence. J. Consciousness Stud. **12**(8–10), 103–126 (2005)
9. P.J. Delves, I.M. Roitt, The immune system. New Engl. J. Med. (2000). https://doi.org/10.1056/NEJM200007063430107
10. R. Doran, *The Theory of the Sublime from Longinus to Kant* (CUP, Cambridge, 2017)
11. M. Drozda, S. Schaust, H. Szczerbicka, AIS for misbehavior detection in wireless sensor networks: performance and design principles, in *Proceedings of IEEE Congress on Evolutionary Computation* (2007)
12. J.B. Du Bos, *Réflexions critiques, sur la poésie et sur la peinture, 1719* (George Conrad Walter, Dresde, 1760)
13. J.B. Du Bos, *Riflessioni critiche sulla poesia e sulla pittura* (Aesthetica, Palermo, 2005)
14. P. Galanter, What is generative art? Complexity theory as a context for art theory, in *Proceedings of the International Conference on Generative Art–Politecnico di Milano* (2003)
15. P. Galanter, Complexity, neuroaesthetics, and computational aesthetic evaluation, in *XII Generative Art Conference – Politecnico di Milano* (2009)
16. R.L. Gallo, K.M. Huttner, Antimicrobial peptides: an emerging concept in cutaneous biology. J. Invest. Dermatol. (1998). https://doi.org/10.1046/j.1523-1747.1998.00361.x
17. J. Gomez, D. Dasgupta, Evolving fuzzy classifiers for intrusion detection, in *Proceedings of the 3rd Annual IEEE Information Assurance Workshop* (2002)
18. J. Gomez, F. Gonzalez, D. Dasgupta, An Immuno-fuzzy approach to anomaly detection, in *Proceedings of the 12th IEEE International Conference on Fuzzy Systems* (2003)
19. J. Greensmith, U. Aickelin, S. Cayzer, Introducing dendritic cells as a novel immune-inspired algorithm for anomaly detection, in *Proceedings of the 4th International Conference on Artificial Immune Systems* (2005)
20. H. Ibata, *The Challenge of the Sublime: From Burke's Philosophical Enquiry to British Romantic Art* (Manchester University Press, Manchester). ebook
21. N.N. Karnik, J.M. Mendel, Centroid of a type-2 fuzzy set. Inf. Sci. **132**, 195–220 (2001)
22. H. Kerr, D. Lemmings, R. Phiddian (eds.), *Passions Sympathy and Print Culture Public Opinion and Emotional Authenticity in Eighteenth-Century Britain* (Palgrave Macmillan, Basingstoke, 2015)
23. J. Kim, J. Greensmith, J. Twycross, U. Aickelin, Malicious code execution detection and response immune system inspired by the danger theory, in *Proceedings of the Adaptive and Resilient Computing Security Workshop* (2005)
24. M.B. Lutz, G. Schuler, Immature, semi-mature and fully mature dendritic cells: which signals induce tolerance or immunity? Trends. Immunol. **23**, 445–449 (2002)
25. T.J. Mayne, G.A. Bonanno, *Emotions Current Issues and Future Directions* (Guilford Press, New York, 2001)

26. M. Mazzocut-Mis, *How Far Can We Go? Pain, Excess and the Obscene* (Cambridge Scholars Publishing, Newcastle upon Tyne, 2012)
27. R. Medzhitov, C.A. Janeway, Innate immunity: the virtues of a nonclonal system of recognition. Cell. (1997). https://doi.org/10.1016/S0092-8674(00)80412-2
28. J.M. Mendel, R.I. John, Type-2 fuzzy sets made simple. IEEE Trans. Fuzzy Syst. (2002). https://doi.org/10.1109/91.995115
29. J.M. Mendel, H. Wu, Centroid uncertainty bounds for interval type-2 fuzzy sets: forward and inverse problems, in *Proceedings of IEEE International Conference on Fuzzy Systems* (2004), pp. 947–952
30. J.M. Mendel, R.I. John, F. Liu, Interval type-2 fuzzy logic systems made simple. IEEE Trans. Fuzzy Syst. **14**(6), 808–821 (2006)
31. M. Mendelssohn, Rhapsody, in *Philosophical Writings* (CUP, Cambridge, 1997)
32. M. Mizamoto, K. Tanaka, Some properties of fuzzy set of type-2. Inform. Control **31**, 312–340 (1976)
33. J.D. Murray, *Mathematical Biology I: An Introduction*. Interdisciplinary Applied Mathematics, vol. 17 (Springer, New York, 2002)
34. W.G. Parrott, *The Positive Side of Negative Emotions* (The Guildford Press, London, 2014)
35. R.R. Rich, D.D. Chaplin, The human immune response. Cell Immunol. (2019). https://doi.org/10.1016/B978-0-7020-6896-6.00001-6s
36. S. Sarafijanovic, J.-Y. Le Boudec, An artificial immune system for misbehavior detection in mobile ad-hoc networks with virtual thymus, clustering, danger signal, and memory detectors, in *Proceedings of the 3rd International Conference on Artificial Immune Systems* (2004)
37. A. Scarantino, The philosophy of emotions and its impact on affective science, in *Handbook of Emotions*, ed. by L.F. Barrett, M. Lewis, J.M. Haviland Jones (Guilford Press, New York, 2016), pp. 3–48
38. R. Shusterman, Somaesthetics and Burke's sublime. Br. J. Aesth. **45**, 4 (2005)
39. R. Shusterman, *Thinking through the Body. Essay in Somaesthetics* (CUP, Cambridge, 2012)
40. A. Smuts, Art and negative affect. Philos. Compass **4**(1), 39–55 (2009)
41. R.C. Solomon, L.D. Stone, On "positive" and "negative" emotions. J. Theor. Soc. Behav. **32**, 417–435 (2002)
42. L.M. Sompayrac, *How the Immune System Works* (Wiley-Blackwell, Oxford, 2019)
43. H. Tahayori, A.G.B. Tettamanzi, G.D. Antoni, Approximated type-2 fuzzy set operations, in *IEEE International Conference on Fuzzy Systems* (2006), pp. 1910–1917
44. H. Tahayori, A.G.B. Tettamanzi, G.D. Antoni, A. Visconti, On the calculation of extended max and min operations between convex fuzzy sets of the real line Fuzzy Sets Syst. **160**(21), 3103–3114 (2009)
45. H. Tahayori, A.G.B. Tettamanzi, G.D. Antoni, A. Visconti, M. Moharrer, Concave type-2 fuzzy sets: properties and operations. Soft Comput. **14**(7), 749–756 (2010)
46. F. Teroni, Emotionally charged: the puzzle of affective valence, in *Shadows of the Souls: Philosophical Perspectives on Negative Emotions*, ed. by F. Teroni, Ch. Tappolet, A. Konzelmann Ziv (Routledge, New York, 2018)
47. J. Timmis, Artificial immune systems, in *Encyclopedia of Machine Learning and Data Mining* (2017), pp. 61–65
48. J. Timmis, A.R. Ismail, J.D. Bjerknes, A.F.T. Winfield, An immune-inspired swarm aggregation algorithm for self-healing swarm robotic systems. Biosystems **146**, 60–76 (2016)
49. K. Vermeir, M. Funk Deckard (eds.), *The Science of Sensibility: Reading Burke's Philosophical Enquiry* (Springer, Berlin, 2012)
50. A. Visconti, H. Tahayori, Detecting misbehaving nodes in MANET with an artificial immune system based on type-2 fuzzy sets, in *IEEE Proceedings of the 4th International Conference for Internet Technology and Secured Transactions, ICITST09* (2009). ISBN 978-1-4244-5647-5
51. A. Visconti, H. Tahayori, Artificial immune system based on interval type-2 fuzzy set paradigm. Appl. Soft. Comput. **11**(6), 4055–4063 (2011). ISSN 1568-4946
52. S. Wongkaew, M. Caponigro, A. Borzí, On the control through leadership of the Hegselmann-Krause opinion formation model. Math. Models Methods Appl. Sci. **25**(03), 565–585 (2015)

53. H. Wu, J.M. Mendel, Uncertainty bounds and their use in the design of interval type-2 fuzzy logic systems. IEEE Trans. Fuzzy Syst. **10**(5), 622–639 (2002)
54. L.A. Zadeh, Fuzzy algorithms. Inform. Control **5**, 94–102 (1965)
55. L.A. Zadeh, The concept of a linguistic variable and its application to approximate reasoning. Memo. No. ERL-M411, University of California (1973)
56. L.A. Zadeh, The concept of a linguistic variable and its application to approximate reasoning–I. Inform Sci. (1975). https://doi.org/10.1016/0020-0255(75)90036-5
57. H.J. Zimmermann, *Fuzzy Set Theory–and its Applications* (Springer Science & Business Media, New York, 2011)

Mathematics in Disney Comics

Alberto Saracco

Mathematics in Comics

Recently, various professional mathematicians started doing popularization of mathematics by being directly involved in the writing of subjects or scripts of comic books.

Marco Abate has been one of the first professional mathematicians both to write scripts for popular comics (as *Lazarus Ledd* [3] or *Martin Mystère* [4]) and to reflect about the role of mathematics in comic books and about the best mean of popularizing mathematics in comics [1, 2].

Marco Abate in [1] distinguishes three different approaches in telling a mathematical story, the biographical, the symbolic, and the structural approach:

- in the biographical approach, the main subject of the story is the life (or some aspects of it) of a mathematician;
- in the symbolic approach, math is used to symbolize something, i.e., it is of not much interest what the used mathematical language itself means (it can actually be some sort of meaningless mumbo jumbo), but rather what it evokes in the reader;
- in the structural approach, the mathematics itself is an important and vivid part of the story.

Most of the appearances of mathematics in comics up to 20 years ago were limited to the symbolic approach, and the lingo used was actually mumbo jumbo, not mathematically correct and sometimes not even mathematics, but simply mathematics-looking to the unknowing reader.

A. Saracco (✉)

Dipartimento di Scienze Matematiche, Fisiche e Informatiche, Università di Parma, Parma, Italy

e-mail: alberto.saracco@unipr.it

© Springer Nature Switzerland AG 2020

M. Emmer, M. Abate (eds.), *Imagine Math 7*,

https://doi.org/10.1007/978-3-030-42653-8_12

In the last 15 years, since Marco Abate gave a speech on *mathematics and comics* in the congress *Matematica e Cultura 2003* and wrote his two papers [1, 2], many things changed. The broader public became more and more interested in mathematics and math started to appear more and more often in movies, books, plays, and comics.

The biographical approach began to be more used, as people became interested in mathematicians and in their lives, and even the structural approach became more and more frequent, with mathematicians actively involved in the realization of the comic.

In 2013 two mathematicians, Roberto Natalini and Andrea Plazzi, founded a society called *Comics&Science* in order to present science (and of course math) in the form of comics. Three years later, a similar (and similarly named) project landed on the Italian weekly comics journal *Topolino*: *Topolino Comic&Science*. Two comics writers, Francesco Artibani and Fausto Vitaliano, started a collaboration with various Italian scientists in order to realize a series of stories presenting an aspect of science (as for mathematics, two stories have been written so far [5, 6]).

There have now been various different kinds of appearances of mathematics in comics: graphic novels devoted to great mathematicians or to areas of mathematics, text-books in comics form, mixed publications with both comics and traditional popularizing papers, popular comics for everyone. Each one has its own expected audience of readers and proper language to be used.

- **Graphic novels** Graphic novels are a suitable place for long and well-reasoned stories, hence giving the possibility to explain in details the history of an idea or the life of an interesting person. In the last 15 years many comic book artists have started interesting collaborations with mathematicians or other scientists, ending up in really admirable works, as e.g., *Logicomix* [11], on the life (and mathematics) of Bertrand Russell.
- **Text-books** The mix of images and text offered by comics is so powerful that even some scientific text-books appeared. A remarkable example is the series *I manga delle scienze* [19], which consists of 12 mangas written by famous Japanese mangakas in collaboration with university professors on different scientific subjects. A manga story is developed and a scientific argument is at the core of it (sometimes the argument fits really well into the story, sometimes less), and the proper comics and pages of deeper explanations written and illustrated are alternated. The result is a really enjoyable comics where the reader can decide how much he or she wants to learn the subject in a deeper way. The difficulty and deepness level is that of an undergrad university course for people not in the subject. The Italian translation was supervised by Comics&Science. To mathematics are dedicated the volumes: 2, mathematical analysis; 5, statistics; 10, linear algebra; 11, regression—statistical analysis of data.
- **Mixed publications** With mixed publications I mean publications where both the traditional form of popularization (written texts) and the one in the form of comics is used. This is the format used in the *Comics&Science* booklets. An example of this is the issue written in occasion of the European Girls'

Mathematical Olympiad taking place in Italy [20]. In that issue you can find two 10-pages comics (by two different artists, Alice Milani and Claudia Flandoli, both daughters of professional mathematicians), one about Sofia Kovalevskaja (being a short biographical novel) and one on the EGMO (featuring also four famous women in math: Hypatia, Ada Lovelace, Sofia Kovalevskaja, and Emmy Noether) and a 2-page story by Davide La Rosa, together with several short popularizing papers by various mathematicians.

- **Popular comics** Math has appeared in popular comics mostly for its symbolic and evocative meaning. In popular comics it is a much bigger challenge to insert some significative mathematics, and even more if we consider comics journals for kids (as those of Disney) and usually it has not a prominent position in the story.

Among others it is worth citing the comic "Lino il Topo e la matematica veneziana," which was drawn by many Disney artists, and whose main character is Lino il Topo, a parody of Mickey Mouse (Topolino in Italian) used in the 30's of the twentieth century by Nerbini to avoid copyright problems with Disney while making profit out of the celebrity of Mickey Mouse. This comic, where math has a deep part, was made explicitly in occasion of the meeting "Matematica e cultura 2011" in Venice, and, while it was printed in only 200 non-commercial copies, a description of the comic and the math behind it is available in the proceedings of the conference [8].

The Mathematics of Disney Comics

The main object of this paper is to consider the mathematics appearing in Disney comics. As of today, July 1st, 2019, there are 150,679 Disney stories, according to inducks[1], the online most comprehensive Disney comics catalogue. Thus it is a really hard, even if fascinating, task to deal with all the appearances of mathematics in Disney stories. We will limit ourselves to show some examples to highlight the phenomena.

We will start with a section on mathematics by non-mathematicians, followed by a section dedicated to Don Rosa—a famous Disney fan who was an engineer and later on in his life became a Disney author, writing and drawing almost a hundred of Disney stories (mostly in the ducks universe)—and a final section dedicated to the Italian project *Topolino Comic&Science*.

[1] http://inducks.org is an almost complete catalogue of Disney publications worldwide. In there, among many other things, it is possible to find the list of publications of any story. In our reference section we cite the first appearance of each story, and refer the reader to inducks for its other appearances.

The main focus will be on the image of mathematics: what image and idea of mathematics do its different uses in Disney comics convey to the reader? And, even more important, what use of this medium should a mathematician do?

Apart from the section dedicated to Don Rosa, the stories we will consider are by Italian authors (and have not appeared in English language), due to the fact that I am Italian and that most of modern Disney production takes place in Italy, while in UK and USA both Disney production and publications are quite limited. Thus I will give my own translations of the cartoons.

Nearly everyone to whom I told I was writing a paper on the mathematics in Disney comics asked me about "Donald in mathmagic land," the famous short movie which has also a comic book version [9]. I actually will not talk about it. It is already well-known, and moreover you can find a nice discussion about it (as well as other math-related Disney comics) in [7].

Mathematics in Disney Non-mathematicians' Comics

Biographical Approach

The biographical approach is a classical approach used by non-mathematicians to talk about math: you take a nice, interesting story about a mathematician and simply tell it. Often you do not even need to have but a very thin and vague idea about his or her mathematics. In some cases the mathematics even stays mostly out of the story and just appears as a mild characterization of the hero of the story. It is not unusual in such a story that the hero loses nothing by being considered a generic scientist instead of a mathematician.

Brigivati Perfect for illustrating this kind of approach is the story *Le lezioni di Pico: la matematica di Brigivati* [17].

Brigivati is a duck version of Lilavati, the daughter of the Indian mathematician, astronomer, and astrologist Bhaskara to whom an arithmetic book is dedicated.

Legend has it that Bhaskara foresights that Lilavati's groom would have died soon after marriage, if the marriage would not have been celebrated in a very precise moment. To prevent such a disgrace, Lilavati's father put a cup with a little hole in a vessel filled with water. The cup would have sinked at the correct time for marriage. Lilavati, led by curiosity, went to see the device and a pearl from her ring fell into the cup partially blocking the hole in the cup. Thus the cup sinked at the wrong time and Lilavati's groom died soon after the marriage. Bhaskara taught math to his daughter to soothe her pain and dedicated her his arithmetic book to make her immortal.

In the story two different versions of the legend of Lilavati are told. Birgitte McBridge, willing to conquer Scrooge McDuck, decides to study economics and

Fig. 1 Brigivati [17], page 9, ©Disney. *A pearl of the necklace fell into the hourglass, **blocking it!***

math. While studying, she stumbles upon the legend of Nenevati, mostly faithful to the original one, with the exception (death being a tabu in Disney comics) that due to the pearl (Fig. 1) the marriage is not celebrated and Nenevati devotes herself to mathematics (Fig. 2).

Fig. 2 Brigivati [17], page 10, ©Disney.
- The stars changed their mind on your destiny, Nenevati!
- But... a pearl is blocking the hourglass!
- That's true! I see it!
- My daughter, your destiny is to devote yourself only to mathematics!
- To soothe her pain, Thaskara dedicated her his treaty... so that she would be remembered by mathematicians!

Fig. 3 Brigivati [17], page 22, ©Disney.
- *Vinegar melts pearls! I need to calculate how much water to remove from the hourglass... and how much vinegar to put in, so that the pearl will melt in time!*
After complicated calculations...
- *Good! I need a jar of vinegar! Math was a **necessary** ally to circumvent Paperon's trick!*

Birgitte is totally unsatisfied with the unhappily ending story, but Ludwig Von Drake, who overheard her cries, tells her the story of another Indian mathematician, Brigivati, who used her knowledge of mathematics to manage to marry Paperon (Scrooge), the rajah's treasurer. In this version of the legend, Paperon puts a pearl in order to block the hourglass and prevent the marriage, but Brigivati calculates the amount of vinegar needed to melt the pearl in time to save the marriage (Fig. 3).

Mathematics has a not much relevant role in the story, and Brigivati is a mathematician mostly because Bhaskara and Lilavati were mathematicians. The computations appearing in the story might as well (or even better) be made by a chemist or a physicist. But in popular culture computations are always related to math, even too much probably. I have been asked many times *what does a mathematician do? Long computations?*, and I believe this is far from being an unlikely question to be asked to mathematicians. Undoubtedly if the use of math in comics is reserved to non-mathematicians, this will be the emerging image of it.

Symbolic Approach

The most common use of math by non-mathematicians is the symbolic one. And usually math is not used to symbolize good things: math is something awful, used to evoke scary feelings in the reader.

L'antipatica matematica Quite representative of this use of mathematics is the story *Paperino e l'antipatica matematica* [12] (Donald Duck and the unpleasant mathematics), where math is presented as something unpleasant or unlikeable right off the title. This is indeed a (fun) story that pictures mathematics in such a way a mathematician would never want to see it: mostly a torture, made of totally meaningless mumbo jumbo.

The story begins with Huey, Dewey, and Louey dealing with their math homeworks: they are completely wrecked by the task of *find[ing] the volume of a polyhedron inscribed into a tetrahedron whose vertexes are the intersections of the tangent bisecant to a sphere that…* (Fig. 4); this is totally mumbo jumbo (what is it a tangent bisecants?) made up to convey the idea of a completely abstruse request.

Uncle Donald, with the help of Daisy, finds a math teacher who can help the three students, and to his joy and stupor miss Milly Metrik turns out to be a beautiful duck! Donald begins to flirt with Milly and tells her he loves much mathematics, but unluckily he was not able to study it when he was young. Milly—in agreement with Daisy—uses her charm to make Donald study all the high school math program. Donald cannot confess he really hates math, and so he engages a 2-weeks tour-de-force in algebra and geometry (Fig. 5).

The story ends when Donald can no longer endure to the pain of studying math and goes to Daisy's home, just to find Milly there and discover he now knows the high school math program and can (try to) teach math himself to Huey, Dewey, and Louey.

As already noted, there is no real math in the story, but a lot of symbols and strange mathematical sounding lingo. The story could have been about any subject of study and would have worked exactly the same way. Or at least, that is what we

Fig. 4 L'antipatica matematica, page 2 © Disney

Fig. 5 L'antipatica matematica, pages 23-27-28 © Disney
After two weeks of study, homework and examinations...
- The measure of a circular semi-sector equal to the semi-product of the lengths of...

would like to believe. Unluckily, mathematics is perceived by a huge percentage of students as the tougher subject, in addition to being meaningless. So the story would have worked with any subject, but being about the *unpleasant mathematics* makes a lot of readers to identify more deeply with poor Donald, tortured by a beautiful but terrible mathematician.

Misteri della matematica Another possible and very frequent use of math in Disney stories is that of making puns or gags. Even if this does not completely classify as a symbolic use of math, I put it in this section.

A nice example of this is the one-pager of Donald and Fethry Duck *Misteri della matematica* [10] (misteries of mathematics, Fig. 6).

In this short story Fethry is puzzled because he always thought that $8 = 4 + 4$, but then Daisy told him that $8 = 5 + 3$ and he heard on the radio that $8 = 6 + 2$, so he no longer knows what to think. Donald smiles at the weird concern of his cousin (and at the reader), given he (and the reader) knows better about basic arithmetic: the story is fun, because Fethry is dumber than we are... should have we got not a clear idea of what addition or a number is, we would not have find it funny.

At a closer look this one-pager enlightens a very important fact about numbers and math in general, and so this short story may be used as a tool in teaching. An object is equal only to itself, but if we consider this extremely strong notion of equality, we go nowhere. To do math we need to consider different things (even

Fig. 6 Misteri della matematica, © Disney

only formally different things) to be equal. 8 is the normal form of the number, while $4+4$, $5+3$, and $6+2$ are other forms of the same number. And from various equalities we can learn things. Using 8 as an example, from $8 = 4+4$ or $8 = 4\cdot2$ we learn that 8 is even; from $8 = 2^3$ that is a cube and that has only one prime divisor, and so on. In more advanced math than basic arithmetic, one can find that a quantity may be expressed as a sum (or integral) of positive terms (and thus is positive), but also as a sum of integers (and thus is an integer). From the two different forms in which we expressed the quantity we learn something (namely, it is a positive integer).

Structural Approach

As for the structural approach, we give two examples of stories by Guido Martina, famous for his greedy and dark Scrooge and his creation of Super Duck. Guido Martina has a M.Sc. in Literature and Philosophy, but actually would have preferred

to study engineering. This probably explains the structure of the following stories whose backbones are a nice mix of literature and mathematical legends.

Paperiade At the base of Martina's parodistic version of Homer's Iliad, *Paperiade* [13], lies the math-related legend of the birth of chess. The Shah of Persia asked to his wizard Sissa to create a new game. Sissa invented chess and was able to ask any reward for such a nice game. Sissa just asked some rice: more precisely, one grain of rice for the first square of the chessboard, two for the second, four for the third, eight for the fourth, and so on doubling the rice on each square, till the 64th square of the board. The reward seemed a small thing to the Shah, but actually the total number of grains of rice asked amounts to

$$\sum_{n=0}^{63} 2^n = 2^{64} - 1 = 18,446,744,073,709,551,615$$

i.e., more than 18 quintillions. When the shah realized it, he put to death the wizard.

In the Paperiade, Scrooge sends his nephew Donald to rescue a magical checkerboard. If you put one grain of rice on the first square, there magically appear 2 on the second square, 4 on the third, and so on doubling (Fig. 7). Donald is tricked into the adventure because he thinks he has to rescue Daisy, since *lady* and *checkers* are both called *dama* in Italian.

After a while Donald discovers the truth about their quest and the uncle explains the magical mathematical properties of the object (Fig. 8). It is worth noticing that the total number of grains calculated by Scrooge and Gyro Gearloose are both wrong: the first by a factor of 10^7, the second by a factor 10.

Fig. 7 Paperiade, © Disney.
Miracle!!

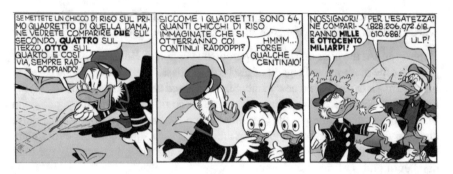

Fig. 8 Paperiade, © Disney.
- *If you put a grain of rice on the first square of that checkerboard, you'll see* **two** *appear on the second,* **four** *on the third,* **eight** *on the fourth, and so on doubling at each square! Since the squares are 64, how many grains of rice do you think there would be in total?*
- *Some hundreds, maybe!*
- *No.* 1 **trillion and** 800 **billion**
- *To be exact:* 1, 828, 206, 072, 618, 610, 688*!*

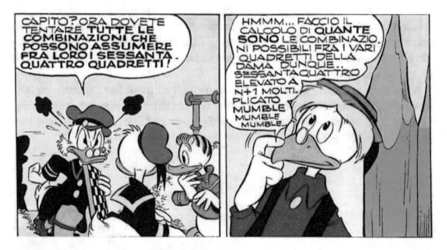

Fig. 9 Paperiade, © Disney
- *Understood? Now you'll have to try* **all the combinations that the sixty-four squares may assume!**
- *Hmmm... Let's calculate* **how many** *are the possible combinations of the squares on the checkerboard. So... sixty-four to the $n + 1$ multiplied by... mumble mumble mumble...*

The story ends with the ducks rescuing the magical checkerboard from the Beagle Boys, but following a fight between Donald Duck and Gladstone Gander, the checkerboards goes in 64 pieces (Fig. 9), Gyro *wrongly* calculates the possible

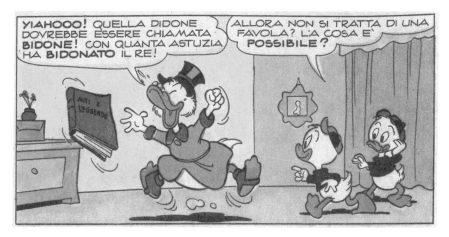

Fig. 10 Il tredicesimo invitato, page 16 © Disney
US - Yahoo! Dido's ox should have been called hoax! For how well she did hoax the king!
HDL - So, it's not a fairy tale? Is that indeed possible?

combinations of the squares of the checkers to be almost 1 quintillion[2] (precisely
914, 103, 486, 309, 305, 344) and uncle Scrooge chases the two nephews in anger.

In the story the mathematical legend and the mathematical concept of powers of
two play a prominent role. The exponential growth is at the core of the story: there is
even a scene in which Gladstone and the Beagle Boys use the magical checkers and
grains of rice to invade all of their house. That said, the numbers used in the story are
wrong and are used just for a symbolic reason: to be examples of very big numbers.
It is quite interesting the fact that all the numbers cited to give an idea of really huge
numbers, are actually smaller (in some cases several orders of magnitude smaller)
than the real figures. This is a spy of the fact that the real behavior of powers and of
combinatorics in general is totally out of reach for our intuition.

Il tredicesimo invitato As in the previous story, math has a very important role in
Zio Paperone e il tredicesimo invitato [14] (Uncle Scrooge and the 13th guest). In
the story the legend of the founding of Carthage (Queen Dido was given the chance
to found a city on the area she would have been able to enclose with a given ox hide:
she cut the hide in thin strips and proceeded to enclose a very large area) is told by
Hewey, Dewey, and Louey to uncle Scrooge (Fig. 10). The legend of Queen Dido
opened a whole area of mathematics, that of isoperimetric problems (i.e., finding
the least perimeter enclosing a given area).

The new billionaire John D. Rockerduck tries to cheat Scrooge into selling him
a useless piece of land called Ox Hide by making him believe it is full of oil, at an
extremely high price. Scrooge McDuck uses the idea of Dido (*the hoax of the ox*,

[2]The actual figure being $(32!)^2 \cdot 4^{63} \cdot 2$ which is roughly 1.18 billion googols, or $1.18 \cdot 10^{109}$.

Fig. 11 Il tredicesimo invitato, pages 37-38-39, © Disney
*US - So! I buy the **two square meters** of land lying in the ox hide! This ox hide!*
HDL -Eh, eh! Dido's trick!

we may say—*il bidone di Didone* in Italian) to deceive his rival: he buys an ox hide
and uses it to surround a big piece of land, nearby Ox Hide, full of oil and proceeds
to take possess of it by paying only the $2\,\mathrm{m}^2$ of the ox hide he used (in Fig. 11 you
can see Scrooge unrolling his ox hide, Huey, Dewey, and Louey cutting the hide and
then delimiting the boundary of the oil-rich Rockerduck's land).

The Math in the Comics of Don Rosa

Keno Don Hugo Rosa was a civil engineer and a huge Disney fan, until when—
36 years old—he managed to publish an Uncle Scrooge story. He thought of it as
a once-in-life occasion, but actually it turned to be the first of almost 100 stories
with Disney characters he wrote. Eventually Don Rosa left his job as an engineer
and dedicated himself fully to the Barks' ducks universe. He is famous for his style
always full of details and for his precision both in historical setting (he wrote the
Lifes and times of Scrooge McDuck, where he imagined all the life of Scrooge since
he was a child till he invited Donald and nephews for a *Christmas on Bear Mountain*,

trying to adhere as much as possible to all the infos you could get in Barks stories) and in scientific infos (being an engineer helped in this).

So, even if technically Don Rosa is not a mathematician, his knowledge of math and his willingness to be precise allowed him a use of math in his stories which is an unicum and needs to be treated in a section on its own. To illustrate it, I will use two stories, one where there is a symbolical use of math and the other with a historical appearance.

Lillehammer In *Donald Duck. From Duckburg to Lillehammer* [15], there is a competition to choose an athlete to represent Duckburg at the Winter Olympics of Lillehammer. Donald Duck tries with all his efforts to succeed, but every time a stroke of luck makes Gladstone Gander win the competition. During the competition of figure skating everything seems to go the usual way: the only thing Gladstone knows about skating is that it takes place on ice, but suddenly a fish with a huge magnet tied to its body makes Gladstone move as a pro skater. He even draws a $\sqrt{81}$ using the skates (Fig. 12) and manages to get a 9.8 out of 10.

Donald on the other hand is really great at skating, and manages to write the fundamental theorem of calculus (Fig. 13)

$$\int_b^a f'(x)\,dx \;=\; f(a) - f(b)$$

and would have won this competition, if not for the magnet-fish which gets Donald out of his skates, destroying the judges' stage.

This is obviously a symbolic use of math, but a very intelligent one indeed. The gag is all on the fact that it is much more complicated to write the formula of the fundamental theorem of calculus rather than the square root of a number, but the

Fig. 12 From Duckburg to Lillehammer, page 7 © Disney

Fig. 13 From Duckburg to Lillehammer, page 8 © Disney. In the first edition the minus in the formula was erroneously replaced with an equality sign; also dx is missing

Fig. 14 The treasure of the ten avatars, page 8 © Disney

really nice part is the fact that alongside with the higher difficulty of drawing there is a completely similar higher complication of the mathematical tool, even more if you consider that in the USA, differently from Italy, calculus is a University subject, while square roots are known to everybody. I quite believe this was a deliberate choice by Don Rosa, even if in his introduction to the story in *The Don Rosa library* he does say nothing about it. Perhaps because he was regretting too much his mistake in the formula.

The Ten Avatars The Uncle Scrooge adventure *The treasure of the ten avatar* [16] takes place in India. Don Rosa uses this to gift the reader with the fact that Arabic numbers and the important symbol for zero actually originated in Hindi culture, as clearly written in the Junior Woodchucks' Guidebook (Fig. 14).

This simply looks like one of the many things Don Rosa usually puts in one of his stories to make them complete and full of crazy details, but it is actually so central to him that he dedicates to it the final gag of the story, when he defines the concept of

Fig. 15 The treasure of the ten avatars, page 28 © Disney

zero *the **most important** legacy from the ancient Hindu culture* (Fig. 15), as indeed it is.

In conclusion, mathematics is not central in Don Rosa's stories, but nevertheless when it appears it has a very good consideration and it really is used in an appropriate way.

Professional Mathematicians and Disney Comics: Topolino Comic&Science

As already said, comics are a powerful means of communication and it would be better to use its power to give to the broad public a nice and correct image of mathematics, together possibly with some useful or interesting piece of knowledge about it. For this, the participation of professional mathematicians in the process of writing the script is necessary. Marco Abate wrote some stories in popular magazines [3, 4] with a deep use of mathematics. As for Disney comics, *Topolino Comic&Science* is a project putting together the technical knowledge of the scientist (the mathematician in the case we are interested to) with the ability of long-time Disney writers as Artibani and Vitaliano. It is indeed necessary to combine the rigorous math theme with a nice-to-read Disney adventure, filled with gags and puns (even math-related ones, Fig. 16). The two stories about math of the cycle so far published were both written by Artibani.

Fig. 16 © Disney. Mathematically themed puns in the Topolino Comic&Science stories. The two puns are not translatable in English: left, Donald says topology is the *study of mice*, since "topo" in Italian means mouse; right, Goofy wants *fare i conti* (meaning either to deal with or to compute) with the mathematician, but Mickey suggests the mathematician is better at that, and they should handle it differently

Quackenberg The first mathematically themed story of the Topolino Comic& Science cycle is *Paperino e i ponti di Quackenberg* [5], to whose subject I collaborated. The bridges of Quackenberg are the duck universe equivalent of those of Koenigsberg. The story takes place in 1736, the year when Euler wrote about Koenigsberg's bridges. In the story Donald Duck is given from his uncle Scrooge, burgmaster of Quackenberg, the (impossible) task to cross all the seven bridges of the city exactly once (Fig. 17).

Fig. 17 Quackenberg, page 7 © Disney
*US - Lazy lad! If I were in your shoes, I would have crossed the seven bridges without using any of them **twice**!*
DD - I would too, if I were traveling for free on a coach with the emperor's coat of arms on it!

Fig. 18 Quackenberg, page 24 © Disney
*EVD - It was a very interesting exercise! I deeply studied the task and... the answer is that the task has **no solution**! Crossing all the bridges without using any of them twice is **impossible**!*

Donald and his three nephews will try to settle the task, and finally will resolve to ask help to Euler Von Drake (Eulero De' Paperis, in Italian). After some thinking, Euler Von Drake first announces the impossibility of the task (Fig. 18) and then proceeds to give a proof of that, similar to the one really given by Euler.

Here the mathematical problem is at the core of the story and a theorem (Euler's theorem on Eulerian graphs) and its complete proof (at least that of the easy implication) are given in three of the last pages of the story (Fig. 19), making this story the first Disney story with a mathematical proof in it. The text of the proof is completely due to Artibani.

I have used this story for some mathematical laboratories for students from second to tenth grade. For details, refer to [18].

I numeri del futuro The latest mathematical story of the cycle, *Topolino e i numeri del futuro* [6] (Mickey Mouse and future's numbers) takes place in Rome in 1955, at the time of the arrival of the first computers in Italy. Mickey, Goofy, and Dr. Spike Marlin, sent to a nearby past, are caught in a fast-paced mystery concerning the mega-computer FINAC, which was really at Rome at the time. Both in reality and in the story, the computer FINAC was brought to Rome by the mathematician Mauro Picone (Fig. 20).

Mickey and friends deal with the concerns and fears of mathematicians about losing their jobs. The story has mainly a biographical (or historical) approach, but devotes space to illustrate many of the applications of math. In the worlds of Dr. Marlin, which end the story, *machines like FINAC changed our world! Thanks to computers there's mathematics everywhere... Radio signals are zipped and unzipped by algorithms which eliminate noise! To know the weather you look at forecasts... which are numerical solutions of complex systems of non-linear equations! A web search engine is actually a sophisticated mathematical algorithm!*

Fig. 19 Quackenberg, pages 26–27 © Disney. The wonderful double page containing part of the proof of the theorem, in form of a dialogue between Euler Von Drake and Donald Duck

Fig. 20 I numeri del futuro, page 11 © Disney
- *. . . it is enough to follow the voice of Professor **Picone**, the Director!*
*Picone - **Did you check everything? Then check again, no matter if you'll need all the night!***
*Sirs, I recall you that tomorrow we will receive **important** guests and not a single digit should be out of place!*
- *Don't worry, Professor!*

Fig. 21 I numeri del futuro, page 29 © Disney

Videogames, music from our cell phones, e-mail… there's applied math beneath all this… from physics to engineering to the smartphone in our pocket! We should remember that more often! (Fig. 21).

The final dialogue of the story, between Mickey and Dr. Spike Marlin focuses on the difficulty of math and points out how all progress in human's history has been tough, at the beginning (Fig. 22).

Fig. 22 I numeri del futuro, page 30 © Disney
Mickey - You are very right, Dr. Marlin! Sometimes we think math to be difficult or, even worse, useless...
*Dr.Marlin - ... but it's not like that! It's not easy, that's for sure... but even building the **first wheel** shouldn't have been a simple task!*

Conclusion: Use of Comics in Teaching and Popularization of Math

Mathematics is becoming an extremely popular subject and it keeps popping up in movies, books, and comics. It is up to the community of mathematicians to keep an eye on the phenomenon and try to bend it in directions which give a good and correct image of mathematics to the viewer or reader. Luckily nowadays many writers are willing to listen to experts in order to produce a better work.

Many appearances of math in comics may be used to teach or popularize math. Of course, comics like *Quackenberg* [5] or *I numeri del futuro* [6] better serve this aim, since they were explicitly written to popularize math. I have experimented using both of them in teaching and students were really happy about it. The graph theory laboratories based on *Quackenberg* are described in [18]. But, as we have, for instance, seen for the short story *Misteri della matematica* [10], any starting point may be a good one, to talk about the beautiful and rich realm of math! It really is up to us, researcher, professors, and teachers of mathematics, to find ways to communicate to everyone the fascinating beauty of this science. Comics can help us.

Acknowledgments All images are © Disney. I thank the editorial team of *Topolino* of *Panini Comics* for the support and for allowing me to use them, in this paper and at conferences and laboratories. Thanks are also due to the Facebook group *Ventenni Paperoni* for the help in finding some images.

References

1. M. Abate, *Narrare matematica nel fumetto*. Int. J. Sci. Commun. **7**, 1–10 (2003)
2. M. Abate, Scrivere Matematica nel fumetto, in *Matematica e cultura 2004*, ed. by M. Emmer (Springer Italia, Milano, 2004), pp. 19–29
3. M. Abate, S. Natali, *Il lemma di Levemberg*. Lazarus Ledd Extra, vol. 3 (Star Comics, Perugia, 1996)
4. M. Abate, P. Ongaro, *La formula di Ramanujan*. Martin Mystère, vol. 230 (Sergio Bonelli Editore, Milano, 2001)
5. F. Artibani, M. Mazzarello, A. Saracco, *Paperino e i ponti di Quackenberg*. Topolino **3232**(3) (2017)
6. F. Artibani, V. Held, R. Natalini, *Topolino e i numeri del futuro*. Topolino **3279**(2) (2018)
7. L. Boschi, Comics and mathmagic: notes on Disney numerology, in *Mathematics and Culture III*, ed. by M. Emmer (Springer, Berlin, 2012), pp. 267–273
8. L. Boschi, M. Emmer, A Venetian comic strip, in *Mathematics and Culture III*, ed. by M. Emmer (Springer, Berlin, 2012), pp. 159–166
9. D.R. Christensen, T. Strobl, *Donald in Mathmagic Land*. Four Color Comics, vol. 1051 (1959)
10. F. Corteggiani, G. Cavazzano, *Misteri della matematica*. Topolino **2439**(01) (2002)
11. A. Doxiadis, C. Papadimitriou, *Logicomix: An Epic Search for Truth* (Bloomsbury USA, New York, 2009)
12. C. Gentina, G. Bordini, *Paperino e l'antipatica matematica*. Topolino **2025**(2) (1994)
13. G. Martina, L. Bottaro, *Paperiade*. Topolino **202**(A), **203**(A), **204**(A) (1959)
14. G. Martina, M. De Vita, *Zio Paperone e il tredicesimo invitato*. Topolino **817**(A) (1971)
15. K. D. H. Rosa, *Donald Duck. From Duckburg to Lillehammer*. Anders And & Co. **1994B07** (1994)
16. K. D. H. Rosa, *Uncle Scrooge. The treasure of the ten avatars*. Anders And & Co. **1996-26** (1996)
17. N. Russo, R. Marini, *Le lezioni di Pico: la matematica di Brigivati*. Topolino **2231**(6) (1998)
18. A. Saracco, *Paperino e i ponti di Quackenberg - La teoria dei grafi a fumetti*. Mathesis Milano **38**, 22–37 (2018)
19. Vv. Aa., I manga delle scienze, vol. 12, Le Scienze (2016)
20. Vv. Aa., Comics&Science – The women in math issue (2018)

Part VI
Mathematics and Applications

The Language of Structures

Tullia Iori

In the mid-1960s, Italian structural engineering suddenly leapt into the international spotlight. In a short period of time, considered the golden age for the entire Western world, Italy shifted from a state of backwardness, in which it had been mired for so many years, to one of fulfilled modernity. The most spectacular signs of this feat include reinforced concrete large structures from the post-war period and the successive years of the economic miracle.

Upon first glance, Italian structures do not reveal particularly innovative scientific or technological characteristics. On the contrary, they fit perfectly into the categories so clearly defined by modern structural typologies. For this reason they are immediately familiar. Yet, they also demonstrate a marked recognisability, introducing their own unmistakable intonation and standing out for their particular architectural physiognomy.

This polarity, balanced between orthodoxy and national identity, is the true characteristic trait of the Italian School of Engineering. Not to mention its hallmark.

Hence, each time we return to investigate the identity of the first-rate engineering expressed by a late arriving nation such as Italy, two opposing curiosities guide us through a labyrinth of events and the tangle of documents: what are the foundations of the conformity of Italian structures within an international framework? But above all, to what internal factors of the country's history does it owe its uniqueness?.[1]

[1] In order not to weigh down the narrative, detailed notes have not been included in the text, which would have been very numerous, because the story, in each step, is based on the often unpublished documentation acquired during the SIXXI research. For all the references, please consult the following books: T. Iori, S. Poretti, *SIXXI 1. Storia dell'Ingegneria strutturale in Italia*, Roma,

T. Iori (✉)
Dipartimento di Ingegneria Civile e Ingegneria Informatica, Università di Roma Tor Vergata, Roma, Italy
e-mail: iori@uniroma2.it

© Springer Nature Switzerland AG 2020 213
M. Emmer, M. Abate (eds.), *Imagine Math 7*,
https://doi.org/10.1007/978-3-030-42653-8_13

This text is dedicated to the 43 victims of the collapse of the bridge over the Polcevera in Genoa, on 14 August 2018. It is not yet possible to know the causes of the collapse, but Riccardo Morandi is certainly not guilty for it. He was the best Italian bridge designer, with few rivals in Europe. Blaming Morandi for the collapse was a way to absolve the real culprits for not being able to save a masterpiece of Italian engineering, an icon of Made in Italy, causing unforgivable mourning.

From Preunitary States to United Italy (1830–1890)

In Italy, modern engineering started before Italy (before 1861, the year of Italian Unification), when the country was still divided into Reigns, Grand Duchies, Duchies, States.

Corps of Engineers were organised in each of them and training was provided by local Schools of engineering. At first, the Italian engineer was a technical bureaucrat, a hydraulic engineer and a land surveyor, not a structural designer. Largest structures were built by foreign engineers and foreign construction firms. This was the period of large wrought iron structures. Like other countries, Italy was invaded by suspension bridges, symbols of the new modernity.

After the unification, things slowly changed. With the development of the railway network, imported bridges were complemented by an increasing number of works by Italian engineers and construction firms. In those years, the most beautiful product of the virtuous combination of science and construction skill was the Paderno arch bridge over the river near Milan, with its span of 150 m (see Fig. 1).

At the end of the century, Italian engineering no longer depended on foreign schools but had not taken on its identity, yet. So, the nineteenth-century structures are "imported structures".

But, they tell us something interesting: the Italian Engineering belongs to the big family of international engineering. Did wrought iron trusses spread all over the world? In Italy, too.

Even if Italy lost the Industrial Revolution, even if Italy was a predominantly agricultural country without iron mines, without coke, without steel industry, Italian engineering was an orthodox engineering.

Gangemi, 2014; T. Iori, S. Poretti, SIXXI 2. Storia dell'Ingegneria strutturale in Italia, Roma, Gangemi, 2015; T. Iori, S. Poretti, Storia dell'Ingegneria strutturale italiana. Ascesa e Declino, in *Rassegna di Architettura e Urbanistica*, vol. LI, n. 148, 2016, pp. 8–52; T. Iori, S. Poretti, *SIXXI 4. Storia dell'Ingegneria strutturale in Italia*, Roma, Gangemi, 2017; T. Iori, S. Poretti, The rise and decline of Italian School of Engineering, in *Construction History: Journal of the Construction History Society*, 2(33), 2018, pp. 85–107.

Fig. 1 Railway bridge over the river Adda, Paderno. Jules Röthlisberger, Officine Savigliano, 1887–1889. Photo: Sergio Poretti

Moreover, Italian scientists gave a substantial contribution to the development of the theory of structures with the "energetic path" for the resolution of statically indeterminate trusses.

But, iron construction was alien to the Italian milieu. The iron trusses looked like spaceships landed in our territory.

Also Alessandro Antonelli's attempt to foster an all-Italian "reinforced masonry" construction method for big structures turned out to be a utopia (as was the Mole Antonelliana in Turin).

The good occasion for the Italian School of Engineering to start was the advent of a new material: the reinforced concrete.

The Advent of Reinforced Concrete (1890–1935)

Reinforced concrete spread in Italy since 1892. There was no evidence showing that it could also be used in large structures, according to the bad results of the conventional elastic theory.

Despite this, the application of the new material in bridges was started by the most prolific agents of the Hennebique system. But other patents also spread, such as the Melan System.

The culmination of the introductory phase of the use of reinforced concrete is represented by the Risorgimento Bridge over the Tiber in Rome, completed in 1911 by Hennebique and his Italian main agent, Giovanni Antonio Porcheddu.

With its 100-m span, the bridge set the world record at that time. With its challenging structural model—uncertain between a thrust-generating arch, two cantilevers joined in the centre and a variable-inertia fixed beam—it marked the transformation of reinforced concrete from a patented commercial product into a "free material" (see Fig. 2).

That was the pioneering stage of reinforced concrete structures worldwide: scientists working side by side with builders, and often practice came before theory. At that time, "the object that does the science" (in Edoardo Benvenuto's words) was the arched bridge.

Fig. 2 Risorgimento bridge over the Tiber, Rome. F. Hennebique, G.A. Porcheddu, 1909–1911. Photo: Sergio Poretti

Fig. 3 Victory Bridge over the river Piave, Belluno. E. Miozzi, 1925–1926. Photo: Sergio Poretti

Meanwhile, World War One broke out. During the post-war reconstruction, numerous "Victory" bridges embodied the experimentation of a new generation of young engineers, using reinforced concrete now freed from patents (see Fig. 3).

In those years, Pier Luigi Nervi appeared in the scene. With the dynamics and exposed structures of the Berta Stadium in Florence (the spiral staircase and the cantilever roof) the news that Italian architecture had finally awakened spread all over the world.

Experimentation Triggered by Autarchy (1936–1944)

But in 1936 the scenario suddenly changed: following the crazy dream of the Italian Empire, Mussolini invaded Ethiopia. Heavy sanctions fell on Italy by Nation's Society. Fascism proclaimed the autarchy regime, a sort of economic self-sufficiency. All the Italian steel was required by the war industry and the use of reinforced concrete was first limited and then, in 1939, banned.

How did the structural engineering answer to these restrictions? In different ways.

In the public construction sites of the Regime, according to the fascist rhetoric, structural engineering reverted to masonry construction (with bricks and stones).

In the Laboratories, instead, it projected forward by experimenting with new steel-saving techniques, following two lines.

Fig. 4 Magliana Warehouse, Roma. P.L. Nervi, 1944–1945. Photo: Sergio Poretti

The first line made the best use of the "resistance through form" principle.

It was led by the scientist Arturo Danusso, who in 1931 established a crucial "Test Laboratory on Scale models" in Milan.

This line was developed by Nervi, who in those years invented a cost-effective method of construction, called "structural prefabbrication", first applied in the Air Force's Hangars of Orvieto.

The structure was decomposed in many small pieces that could be prepared on the ground and then reassembled as in a large mosaic, over a tubular reusable scaffolding.

During the war Nervi also invented a new material, the "ferroconcrete", first applied in a warehouse in Rome in the Magliana neighbourhood, with its corrugated roof and walls just 2.5 cm thick (see Fig. 4).

But there was a second experimental line, fostered by autarchy, which relied on "Volterra distortions" to save steel and at the same time to increase the static efficiency of the structure.

It was led by the scientist Gustavo Colonnetti and was developed by Riccardo Morandi, the father of prestressing in Italy.

So, facing autarchic constraints, the School took on its final look, which included two "souls", two apparently opposite souls.

The first soul, led by Danusso, is an empirical-naturalistic approach, which would produce an original version of thin shell. A thin shell is shape resistant, due to its curvature, double curvature, anticlastic curvature (as in the Tresigallo Hypar by Giorgio Baroni in 1940).

Shape resistance exists in nature: in plants, in seashells, in rocks. According to Danusso, science has to be used to understand nature. Only scale models (and not

mathematical calculations) can reveal the real structural behaviour. The engineer's role is "to try to imitate nature".

The second soul, led by Colonnetti, is an analytical-positivistic approach, that would produce the early development of prestressing. According to Colonnetti, the engineer's role is to modify the natural behaviour of the materials: to "train" materials to resist to "un-natural" stresses (this is prestressing: pretensioned steel wires make the concrete able to resist to tension, which is not its natural skill).

Thin shells and coactions were the two strategies that marked the success of reinforced concrete structures worldwide. That confirmed Italian engineering was part of the great international family of modern engineering.

In the following of the narrative, the elements that have had a direct impact on the languages the School would express in its mature phase, thereby creating its uniqueness will be revealed.

Post-war Reconstruction (1945–1955)

Meanwhile, World War II broke out and in Italy there was a terrible territory war.

Thousands of bridges were destroyed by the retreating German troops and Anglo-American bombings: 2944 railway bridges and 811 road bridges, not including urban bridges.

After the end of the war, there was plenty of work for all engineers.

The reconstruction began with the bridges in the cities: for instance in Florence, where all the bridges on the Arno River had been destroyed on the night of August 3, 1944, to slow down the advance of the allied troops.

In most cases, low cost, reinforced concrete arched bridge, silenced the debate on preserving the historical landscape. It occurred in Pisa, for instance, with the bridge "in the middle" over the river Arno by Giulio Krall (see Fig. 5), a frame that pretends to be an arch.

But there was room for all bridge types, such as the ultra-light version of the deck-stiffened thin arched bridge imported from Switzerland (see Fig. 6).

Meanwhile, the very first prestressed concrete beam bridges were designed and Morandi boldly introduced prestressed concrete in the heart of Florence, with the Vespucci bridge on the Arno river.

Since 1948, the reconstruction was supported by US aid: the Marshall Plan was fundamental. There was a special part of this fund dedicated to restart tourism and it was also invested on highways: in Ligury, between Genoa and Savona, where arch bridges, built thanks to Innocenti tubular scaffoldings, were designed by Morandi, and between Vietri and Salerno, where a beautiful sequence of deck-stiffened thin arched bridges embroiders the Amalfi cost.

Even Nervi played a major role in post-war reconstruction. Combining the two inventions, structural prefabrication and ferroconcrete, proceeded to the final testing of "Nervi System". In 1947 he applied it to the 90 m span roof of the Hall B in Turin.

Fig. 5 Bridge "in the middle" over the river Arno, Pisa. G. Krall, 1947. Photo: Sergio Poretti

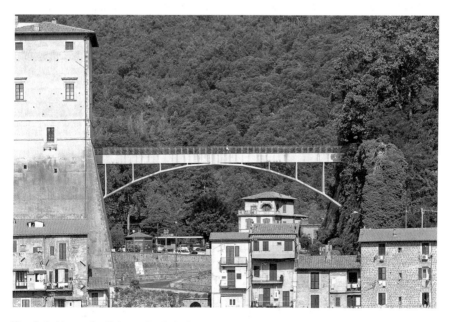

Fig. 6 Bridge at the Colonna Castle in Genazzano, near Rome, 1947. Photo: Sergio Poretti

By silently participating in the post-war reconstruction, Italian Engineering entered its adulthood, acquiring a collective and national dimension and revealing its uniqueness.

While in the Anglo-Saxon world, science and technology took on a central position, in Italy, throughout the twentieth century, modernisation took place under the hegemony of a philosophical current called "Neo-Idealism", led by Benedetto Croce, and under the hegemony of Catholicism, both of which supported the superiority of humanist culture with respect to scientific culture.

So, the Italian School of Engineering was growing up in this unique environment dominated by humanist culture and Catholicism. That supremacy was recognised by engineers. Scientists were the most fervent supporters of the superiority of spiritual vision.

For Danusso, the "naturalist", this was crystal and clear: he also "demonstrated" striking similarities between the plastic adaptation of a bridge beyond the elastic behaviour and the justice in a just and pious society.

Colonnetti, the "positivist", wrote more religious papers then scientific ones: he loved to say that the engineer, in his role of trainer of materials beyond their natural limit, plays as "God's helper".

Designers, being more sensitive to the secular precepts of neo-idealism, preferred the principles of ethics: so, for them, the key word is "correctness". Not related to the correctness of static calculation, of course, but in the sense of moral commitment. It is no coincidence that Nervi's most famous book is titled: "Building correctly".

In the mid-1950s, it was time for success, coinciding with the years of the economic boom.

In that period, everything went in the right way and also Italian structural engineering received international recognition.

From Reconstruction to the Economic Miracle: The Autostrada del Sole (1956–1964)

Eight years—between 1956 and 1964—were sufficient to build the nearly 800 km long Autostrada del Sole, the Highway of the Sun, which included about 400 bridges.

The bridges were designed one by one and built by small construction companies.

Prestressed concrete was used to build the beam viaduct stretching across the great rivers of the northern plains. Over the Apennine valleys, the large arch bridge made its swan song with record spans (see Fig. 7).

The "prima donna" of this daring feat was the Innocenti scaffolding, the "wonderful grid of steel tubes arranged in a fan", jointed by a simple tool patented by Ferdinando Innocenti (the Lambretta inventor, too).

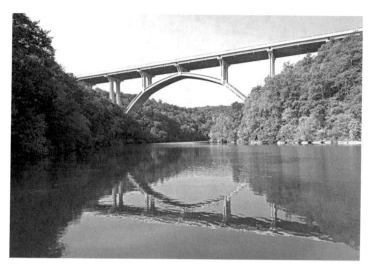

Fig. 7 "G. Romita" bridge over the Arno river, Highway of the Sun, Levane. S. Zorzi, 1962–1964. Photo: Sergio Poretti

To understand the reasons why the motorway expressed the Italian character of the School, we must imagine the construction site, which reflects the economic and productive conditions in the country.

As emerged consistently from the SIXXI research, Italian engineering was to participate in completely anomalous modernisation: a gradual path with no industrial revolutions and entrepreneurial concentrations. Actually, the School operated in a country that was locked in a state of "proto-industrialisation", in which the idea of progress coexisted peacefully with craftsmen's traditions.

Despite its territorial scale, the highway consisted of many handmade pieces: it was a gigantic, collective artisan work. Hence, the workers' skills, low cost of labour, and low mechanisation were preserved. Moreover, one of the most important objectives of construction sites was to defeat unemployment.

Thus, humanism as a result of the cultural milieu adds to the humanism of working practices, in which the engineer was fully involved. And the structural work is permeated of humanism: not a standardised object, but a unique object, unrepeatable, a sculpture.

Hosting of Major International Events: Rome Olympic Games and Italia '61 (1956–1964)

The Highway of the Sun lacked the support of Italy's most important engineer, Pier Luigi Nervi.

Fig. 8 Little Sport Palace, Rome. P.L. Nervi, 1956–1957. Photo: Sergio Poretti

In the same period, the 70-year-old engineer was charged, with his small construction firm, of the construction of the sport palaces and stadium for the Olympic Games in Rome 1960.

First, the Little Sport Palace, the "Palazzetto": a low, spherical dome, 60 m in diameter, smooth on the outside, looked inside like an embroidery of crossed ribs (see Fig. 8).

The construction site was a winning application of the Nervi System: the dome was divided into 1620 rhomboidal pieces in ferroconcrete to be produced on the ground and to be reassembled on site, like a gigantic mosaic supported by an Innocenti scaffolding (see Fig. 9).

And then the other structures: the Flaminio Stadium and the Big Sport Palace in Eur neighbourhood, the largest application of the Nervi system. The image of young Cassius Clay with the light-heavy-weight gold medal around his neck, with the gorgeous dome as a halo, astound the world.

If the international community recognised the boom of an Italian School of Engineering soon, this was because the structural languages that it expressed looked familiar and original at the same time. And the most important language was the one derived from the Nervi System.

This language reveals one consequence of the humanistic dimension of Italian engineering: Historicism. It is a unique case.

Modern engineering has taken the dogma of "breaking with the past" to the letter. History was out. But Italian engineers defended their anthropological diversity. And they look to the past with admiration and nostalgia.

Nervi kept the book by Jean Gimpel, *The Cathedral Builders*, by his bedside and had a true devotion for the manufacturers of great masonry domes.

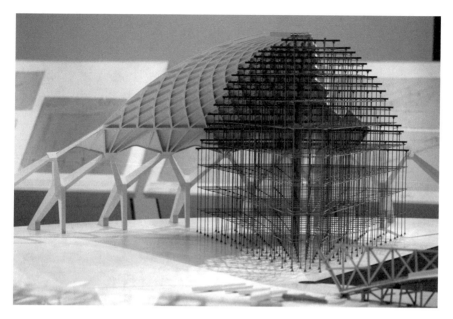

Fig. 9 Little Sport Palace, Rome. P.L. Nervi, 1956–1957. Model built for the monographic exhibition on P.L. Nervi in MAXXI Museum, Roma, 2010. Photo: Sergio Poretti

Looking at Nervi's structure, you can see the tension flow: the image describes in detail the relation between form and static behaviour. Exactly the same as in a gothic cathedral.

At the same time, Nervi's Palazzetto is one of the many versions of the "natural" language, which was very popular among thin shell.

What then makes Nervi's domes so unique? The undulated, corrugated, ribbed shape.

Nervi's complex shapes would be too expensive for anyone. What makes them, paradoxically, economical is the Nervi System. That is an artisanal and handmade system, linked to the backwardness of the production system in Italy.

Therefore, the language originality arises from an X factor, an Italian factor: the ingenuity of crafted workmanship, which goes back to the tradition of great Italian builders (Guarino Guarini, Michelangelo, back to Brunelleschi).

Morandi's Invention (1956–1964)

Also Riccardo Morandi took part in the great achievements of the economic boom, following a very personal path, which led him to define his own structural and architectural style.

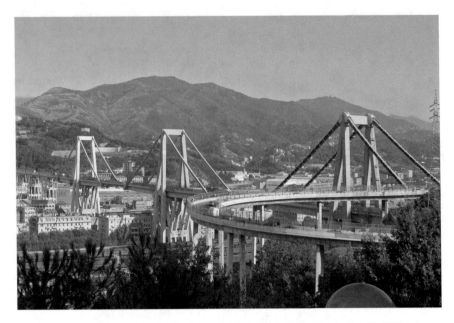

Fig. 10 Polcevera Bridge, Genova. R. Morandi, 1960–1967. Photo: Sergio Poretti, 2012

For Morandi, the key word is to "improve" the natural behaviour of a structure: balancing forces in order to reduce stresses (like in the Fiumarella Bridge: the inclined struts reduce the arch thrust by 10%), or adding lower ties which create moments opposite to that one determined by the load, or taking advantage of the magic of prestressing, like in his structural invention: the cable-stayed "homogenised" structure in which also strands are made with prestressed reinforced concrete.

The dramatically famous bridge over the Polcevera river in Genua, was his masterpiece (see Fig. 10).

The internal steel cables alone carried the weight of the bridge, the permanent loads. However, the travelling loads would make them stretch too much; consequently, the concrete around the cables, prestressed by a second group of cables, protected the steel from corrosion and reduced elongation. Complex but effective.

The invention was repeated several times in his carrier, even for the spectacular roof of the Alitalia Hangars in Fiumicino Airport.

The "homogenised" cable-stayed bridge by Morandi is another "logo" of the Italian School of Engineering. While Nervi's shape resistant forms exhibit the flow of internal tensions, Morandi's figure represents the balance of external forces, the weights and counterweights, thrusts and counter-thrusts.

The artificial scientism of balanced figure opposes the naturalism of shape resistant forms.

Here is another consequence of the humanistic dimension of Italian engineering: being close to an artistic movement as futurism was the driving force, not only for Morandi, to develop a special sensitivity for the figurative aspect of the structure.

In Italy engineering flirted with futurism. Futurism feeds on engineering: dynamicity, technologism, scientism. The Engineering absorbs from Futurism a certain lyricism and a visionary approach (which is pretty heretical, for an applied science).

The Disappearance of the Fireflies (1965)

In the early 1960s, the popularity of Italian engineering spread throughout the world.

Through the new-born television, those structures let the world know the Italian miracle. At the "Twentieth Century Engineering" Exhibition at New York's Museum of Modern Art in 1964, the very restricted selection of world icons included a high number of Italian works.

But in the mid-1960s, at the peak of its success, the School suddenly died out.

And disappeared from the scene. The cultural milieu, in which the multitalented designer had grown up, dispelled. Very low-cost manpower was no longer available, an essential condition for the survival of small-scale work sites. The teaching changed due to the students' revolution and the advent of mass university. With the computer, the way structures were calculated changed.

The shift was certainly not limited to the world of construction.

On a wider scale, engineering was led into a crisis sweeping every sector at that time in Italy. It was a turning point. The famous poet Pier Paolo Pasolini called that "something" that happened in Italy in 1965 "the disappearance of the fireflies".

Posthumous Masterpieces (1965–1980)

The decline of Italian engineering was enhanced by the trails left in the wake of the golden age, from which some memorable, "posthumous" masterpieces were produced.

After the end, the School continued to generate languages. New languages. Languages that still expressed the "Italianness" of the structure, albeit with different accents from those of the golden years.

Among the numerous works made by Italian engineers abroad, those designed by Nervi outlined the figure of the star-architect *ante litteram* up to the late 1970s.

Meantime, in Italy, the arched bridge was replaced everywhere by the girder-span viaduct with very high piers, with extensive use of industrial prefabrication.

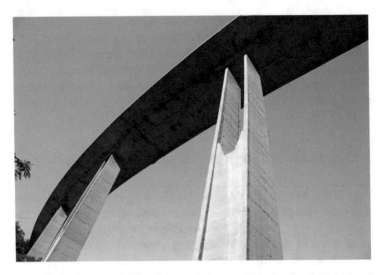

Fig. 11 Viaduct over the river Teccio, Cadibona, Highway Turin-Savona. S. Zorzi, 1976. Photo: Sergio Poretti

However, one of the younger engineers, Silvano Zorzi could not accept that this would necessarily involve depersonalisation of the structural work. And so, in the latest-generation viaducts, he made a desperate attempt to sublimate simplicity of the viaduct with multiple piers (see Fig. 11).

He applied a "structural Industrial design", which was also a constructive design: he replaced the Innocenti scaffolding with proto-industrial machines that preserved casting on site.

The effort to sublimate simplicity of the viaduct through drawing was an attempt to keep the School alive in the post-craft stage. Zorzi's minimalism shed light on yet another characteristic of the School: its close affinity with the industrial design sector.

The elective affinity with this area of the architectural culture is mainly due to an "anthropological" similarity that brings structures closer to industrial design objects than to buildings. After all, a bridge is an item of everyday use, such as table, bicycle, lamp, etc.

Again, this is another consequence of the humanistic character of Italian engineering, a real industrial designer.

Finally, there is a work in which the adventure of the Italian School found its conclusion and its apotheosis: the bridge crossing the Basento River in Potenza by Sergio Musmeci (see Fig. 12).

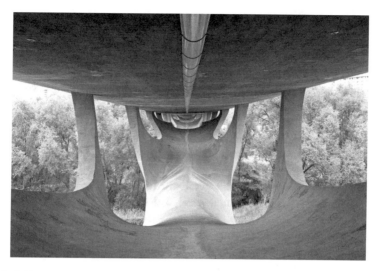

Fig. 12 Bridge over the river Basento, Potenza. S. Musmeci, 1971–1975. Photo: Sergio Poretti

The "unnamed" form of the shell was designed following this idea: once the constraints and loads were set, the unknown factor to be calculated was the form.

In order not to affect the purity of the scientific calculation of the form, it was necessary, however, to be freed from the construction problem.

The difficulty of building on the ground a shape that was even difficult to draw implied increased costs and delays. The solution was found in a complex wooden formwork, put on a last Innocenti scaffolding, that allowed the "unnamed" form to be shaped in a handmade sculpture.

Musmeci's language, the latest development in Italian structural engineering, reveals another exceptional feature: its prophetic character.

In our time, the classical stage of Engineering at international level having concluded, the sobriety and sincerity of the structure are replaced by a "forbidden" character: spectacularity, based on improbable balances, absurd forms, playful effects.

In our world, the world of the "pop structures" and "Instagram engineering", Baroque scenery replaces the reference to the Gothic cathedral, and the "form finding" tendency makes Musmeci appear as a seer to us.

Conclusions

Different features indicate the impact of humanistic culture on Italian engineer's languages. That also reflects the economic and productive conditions in the country.

Avoiding the cliché of Italian creativity, the particular architectural value of the Italian structure is derived from this combination of humanistic factors (see Fig. 13).

Moreover, the Italian Structure became a symbol for the history of the country.

This is peculiar. And it is one of the reasons of the extreme "Italianness" of the School: that is, a special "historical meaningfulness".

Usually, it is Architecture that has the role of reflecting historical context.

Engineering tells us only about technological and scientific progress.

The structures of Nervi, Morandi, Zorzi, Musmeci and others are an exception. Despite their orthodoxy in the international arena, they tell us some interesting vicissitudes of Italian modernisation (especially through the way they were built).

And then, they should occupy a central place in the catalogue of "Italian Style" products, next to the objects of the most celebrated industrial designers. A real monument to the "Made in Italy".

Fig. 13 Sport Palace at Eur, Roma. P.L. Nervi, 1958–1960. Photo: Sergio Poretti

Fig. 14 Mina on the roof of Morandi's Alitalia hangars at Fiumicino, 1966. Courtesy Barilla

So, it is not a surprise for us that in 1966, the costume and set designer Piero Gherardi (winner of two Oscars for "8 e mezzo" and "La dolce vita" films) chose as a set for a commercial, designed to highlight the "Italianness" of Barilla pasta, the roof of Morandi's Alitalia hangars at Fiumicino, on which the most famous Italian singer Mina sang "Mai cosi" (see Fig. 14).

Acknowledgment The author would like to thank the European Research Council for financing the SIXXI research project—ERC Advanced Grant 2011, awarded to Sergio Poretti (1944–2017).

Mathematical Aspects of Leonardo's Production in Milan

Elena Marchetti and Luisa Rossi Costa

Introduction

The cultural background in Milan led us to consider Leonardo traditionally Leonardo da Vinci as one of the most important guests in our town, of all times. This thought is confirmed by Leonardo's works preserved in Lombardy, present not only in museums, but also spread out in the region. Leonardo was not only painter and artist, as it is well known: he planned integrative parts of important historical buildings, he developed the structure of the plan of the city and some urban neighbourhoods, he worked to create a net of canals, for example to connect the river Ticino with the river Adda [1, 2].

The opportunity to talk about this versatile artist-scientist leads us to analyze more closely the period he spent in Milan at the Sforza Court. In particular we refer to the works carried out by him in this context, and as mathematicians, we are attracted by his studies on mathematics and geometry. His activity in these fields became increasingly important, especially after meeting with Luca Pacioli, one of the most influential mathematicians of the Renaissance.

In the first part of this chapter we describe Leonardo's engineering works planned and developed for Milan and for the Lombardy region, also underlining some architectural and urban aspects. We will consider some paintings, frescoes and decorations, mentioning also the rich collection of Leonardo's drawings [3], present and periodically exhibited in the *Veneranda Pinacoteca Ambrosiana*.[1] In the second part we will focus on the relationship, started in 1496, between Leonardo and Luca

[1] Exhibition project of the *Codex Atlanticus* curated by Pietro C. Marani.

E. Marchetti (✉) · L. Rossi Costa
Dipartimento di Matematica, Politecnico di Milano, Milano, Italy
e-mail: elena.marchetti@polimi.it; luisa.rossi@polimi.it

© Springer Nature Switzerland AG 2020
M. Emmer, M. Abate (eds.), *Imagine Math 7*,
https://doi.org/10.1007/978-3-030-42653-8_14

Pacioli, both present at the Sforza Court, when Leonardo developed more and more his studies of mathematics and geometry.

He was very interested in measuring the circle and its parts; he gave special emphasis to the *lunulae*. In January 2014, the *Veneranda Biblioteca Ambrosiana* promoted the exhibition *De Ludo Geometrico,* presenting a rich collection of drawings of *lunulae* on sheets of the *Codex Atlanticus* [4]. Having visited the exhibition, we worked on Leonardo drawings, reproducing some of them with Matlab®. At the same time we investigated the measures and the results proposed by him, giving special emphasis to *lunulae, bisangoli* and *falcate*, decorative portions of the circle.

Leonardo in Milan

Leonardo was in the service of the Duke of Milan between 1482 and 1499 (first period spent in our town). He arrived from the Court of Lorenzo *il Magnifico* in Florence, together with a musician, lyre player. Leonardo presented to the Duke a silver lyre, made by himself; he as well was musician, singer, and composer of madrigals and motets, but probably his main interest was having a job at the Sforza Court. He became *painter and engineer* of the Duke Ludovico *il Moro*. In fact, in this period, he completed paintings and he worked on military matters and fortifications. He realized projects as a mechanical and hydraulic engineer, but thanks to his abilities he was engaged in many other activities. He was organizer and choreographer of events and marriages at the Sforza castle or in other residences of noble families connected to the Duke; he also prepared entertainments for the guests, such as rides, tournaments, games and even puzzles. In Milan, Leonardo also continued to realize drawings of human anatomy, following his great scientific curiosity and leaving a very meaningful and accurate collection of anatomic sheets [5].

The first period of Leonardo in Milan ended in 1499, when Ludovico *il Moro* was defeated by the French armies, that took Milan. He came back to our town in 1506, invited by the French governor, Charles d'Amboise, after having spent time in Mantua, Venice, Cesena, Florence and Urbino. In this second period in Lombardy he worked especially in hydrodynamics, anatomy, mechanics, optics and in mathematics, rather than in painting. In 1513, when the French were removed from Milan, Leonardo went to Rome, where he spent 3 years of unhappiness. At the end, he accepted the invitation of King Francis I and he moved to Amboise, where he died in 1519 [1].

Versatile Artist Devoted to Paintings, Frescoes and Sculptures Just arrived in Milan in 1482 he got a contract to realize the first version of *The Virgin of the Rocks*,[2] to be located in a church nearby *Porta Vercellina*.

He also started painting *The Musician* (part of the painting in Fig. 1) probably a portrait of Franchino Gaffurio or of another musician at the Sforza Court. In the Milanese period Leonardo produced other famous portraits, inspired by the ladies at the Court. All Leonardo's portraits reveal and emphasize his attention to the nuances of the soul, following a working method mentioned in his *Treatise of Painting* [2]. We remember the portraits of Lucrezia Crivelli and of Cecilia Gallerani, the famous *Lady with an Ermine*.[3]

He also painted *S. Gerolamo* and the second version of *The Virgin of the Rocks*. Only *The Musician* is still now in Milan, in the *Veneranda Pinacoteca Ambrosiana*.

The time spent by Leonardo in Lombardy sparked a great interest in landscape, especially related to the views of the alpine mountains. The Po plain, so flat and smooth, certainly favoured in clear days the chance to appreciate the Alps, and in particular the Monte Rosa massif. This attention to the landscape developed interests in Leonardo also for the natural phenomena associated with the alpine environment, as evidenced by some of his drawings. He also inserted mountainous landscapes in the background of many of the paintings and portraits, as can be noted by reviewing his most famous works.

Leonardo also decorated also some rooms in the Sforza Castle. The most important is the *Sala delle Asse,* taking its name from the wood. This room presents part of the walls and the entire ceiling painted by Leonardo and co-workers (1498). It depicts a mock pergola formed by flowered branches, to which a gold rope is tied in a precious game with elegant knots (Fig. 2). A recent important restoration takes back to the original fresco of Leonardo, partly covered in the early twentieth century. The interlacing of cords or tapes, or composite knots, are frequent in Leonardo's works: the great variety of interlacements and decorative forms might suggest a careful mathematical investigation, from the point of view of Topology.

The *Last Supper* (1495–1497), known all over the world, is the fresco painted by Leonardo in the Refectory of the Basilica of *Santa Maria delle Grazie*. Even Bramante had worked in this church, especially in the apsidal area and for the Sacristy. We mention the *Last Supper* without entering in its detailed description, because we believe that it is a well known masterpiece. At the same time we remember the precious collections of drawings [6] related to this fresco, part of which are out of Italy.

Leonardo in Milan worked on some equestrian monuments, one dedicated to Francesco Sforza. For these aims he studied the anatomy of horses, as testified by collections of famous drawings [7]. Leonardo began the project for the Sforza

[2]The first version is now at the Louvre Museum in Paris, the second one is at the National Gallery in London.

[3]Now at the Czartoryski Muzeum in Kracow.

Fig. 1 Il Musico (Pinacoteca Ambrosiana—Milano). https://upload.wikimedia.org/wikipedia/ commons/8/83/Leonardo_da_Vinci_-_Portrait_of_a_Musician.jpg; https://commons.wikimedia. org/w/index.php?search=Musico+Leonardo+da+Vinci&title=Special:Search&go=Go&ns0= 1&ns6=1&ns12=1&ns14=1&ns100=1&ns106=1&searchToken=btis9a2al7yi1bjsnpl4kaxva# %2Fmedia%2FFile%3ARitratto_di_musico_01.jpg

Monument (1483), produced different sketches and models of the statue (1493), but never arrived at its casting because of various difficulties and political events of the period. A bronze horse, realized thanks to the U.S. pilot Charles Dent, based on the original project of Leonardo da Vinci, has been placed in 1999 at the entrance of the racecourse in Milan (Fig. 3).

The life in Milan at the end of the fifteenth century was very lively both in culture and arts and in relationship with other Courts, among them Mantua and Ferrara. At the Sforza Court many events took place, having as guests important

Fig. 2 The mock pergola (Sala Delle Asse). https://commons.wikimedia.org/w/index.php? search=Leonardo+Sala+Delle+Asse&title=Special%3ASearch&go=Go&ns0=1&ns6=1&ns12= 1&ns14=1&ns100=1&ns106=1#/media/File:Leonardo_da_vinci_Intrecci_vegetali_con_frutti_e_ monocromi_di_radici_e_rocce,_sala_delle_asse,_1498,_03.JPG

noble families. Parties and races had Leonardo as organizer and choreographer: among those, *Weddings*, *Giostre* and *Tornei*. In particular during these events he also proposed also games, riddles and rebus, recently collected in a book, dedicated to fans of puzzles [8].

Engineer in Milan and Lombardy As mentioned before, in Milan Leonardo became engineer of the Duke. He was engaged especially to work for the castle, a building that had to be well fortified (Fig. 4) and completed with other parts necessary for everyday life, like warehouses and stalls. He invented many military means, bombards and other kinds of defence, weapons and, also, a sort of tank; in the meantime, he was trying to improve the defence of the walls of the castle. The Sforza family owned other castles and villas; the two most important buildings are located in Pavia and Vigevano. Leonardo worked in both these towns.

In Pavia one of the first Universities in the Italian peninsula was already active, so that Leonardo met some scholars from different disciplines, such as Giorgio Valla and Fazio Cardano, who inspired and enriched his approach to the old Greek and Latin world and to scientific results. In Pavia Leonardo collaborated also with Francesco di Giorgio Martini and with Bramante for the main Church (*Duomo*) and for the castle. He was also impressed by an equestrian medieval statue, called the

Fig. 3 Following the drawings of Leonardo, Milano—1999. https://commons.wikimedia.org/
w/index.php?search=ippodromo+di+milano&title=Special%3ASearch&go=Go&ns0=1&ns6=1
&ns12=1&ns14=1&ns100=1&ns106=1#/media/File:Leonardo's_Horse_by_Nina_Akamu,_
Milano,_Ippodromo_di_San_Siro.jpg

Regisole,[4] probably inspiring him for the suggestions, in view of the monument for
Francesco Sforza. In Vigevano and surroundings Leonardo had planned expansions
of the castle, and stables of the villa called *La Sforzesca* as well as works of
hydraulic irrigation of its lands. He also designed canals to drain an area named
Lomellina.

In the second half of the fifteenth century, the construction of the Cathedral of
Milan had gotten to the point where it was necessary to design a stable dome. To
this goal a competition was organized; it was attended by important artists active
in Lombardy, including Donato Bramante, Leonardo da Vinci, Giovanni Antonio
Amadeo, Antonio Filarete, Francesco di Giorgio Martini. Instead of Leonardo's
projects *(CA 851 r, 719 r)*, inspired by Brunelleschi's dome for Santa Maria del Fiore
in Florence, it was preferred to the dome planned by Amadeo. It appears that the

[4] The original Statue has been destroyed at the end of the eighteenth century. In 1937 a copy,
made by the famous Italian sculptor Francesco Messina (1900–1995), was collocated in front of
the Pavia *Duomo*.

Fig. 4 Fortifications of the
Sforza castle (photo by the
authors)

final project had been then reworked with the collaboration of some competitors and finally the Solari family—builders, artists and architects—was able to successfully complete the dome [9].

From the twelfth century in Lombardy was developed an important net of canals, called *Navigli*, essential for the transport of commodities, goods and other. The *Navigli* were also crucial for the marble of the Duomo, in construction since the end of the fourteenth century. The pink marble from the quarries of Candoglia (Ossola valley), was transported through the river Toce and through the lake Maggiore, then in the river Ticino till Tornavento (not far from today's Malpensa airport), and finally in the *Naviglio Grande* till Milan.

The network of canals, started with the *Naviglio Grande*, was gradually expanded. Leonardo worked as hydraulic engineer and designed new branches of waterways, to connect other parts of Lombardy with its rivers. He improved the *Naviglio Pavese*, connecting Milan to Pavia. In the second period spent in Milan, he worked for the *Naviglio della Martesana*, from Milan to the river Adda and planned the branch called *Naviglio di Paderna*. He also designed locks and their

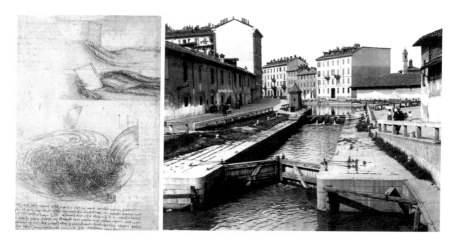

Fig. 5 (Left) Study of water movements by Leonardo. https://commons.wikimedia.org/w/
index.php?title=Special:Search&limit=20&offset=100&profile=default&search=leonardo++da
+Vinci&advancedSearch-current=&ns0=1&ns6=1&ns12=1&ns14=1&ns100=1&ns106=1#/
media/File:Studies_of_Water_passing_Obstacles_and_falling.jpg. (Right) Double lock (end
of the nineteenth century, Cerchia dei Navigli—Milano). https://commons.wikimedia.org/
w/index.php?title=Special:Search&limit=250&offset=0&profile=default&search=Navigli+di+
Milano&advancedSearch-current=&ns0=1&ns6=1&ns12=1&ns14=1&ns100=1&ns106=1#/
media/File:Navigli_Milano_conca_di_Viarenna04.jpg

gates, required for the geophysical configuration of the ground, as evident in some
drawings (Fig. 5).

Leonardo worked also as town planner: the drawings for a new plan of Milan
were very important (1493). He drew an innovative kind of map, representing not
only the profile of the town, but also an overview from the top (Fig. 6). The city was
growing in a circular way, both for the *Navigli* and for some small rivers crossing
the town. He oversaw also the development of several residential areas, in particular
for new quarters around *S. Maria delle Grazie*.

Leonardo and Luca Pacioli

The Scientific Friendship Between Leonardo and Luca The first approach of
Leonardo to mathematics began in Florence when he attended *abacus* school, a
kind of technical school in the Renaissance period [10]. The arithmetic lessons were
inspired by the famous *Liber abaci* of Fibonacci.[5] After having bought in 1494 a

[5]Leonardo Pisano, called *Fibonacci* (1170–1240), is known for the recursive sequence representing
a simple model for the growth of a population of rabbits. This sequence is also related to the *golden
number*.

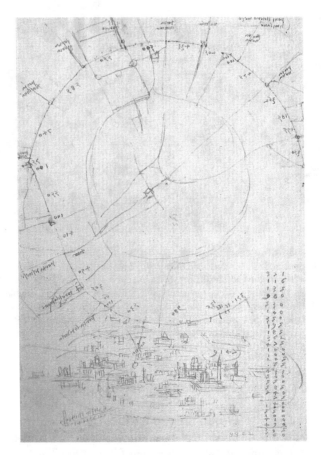

Fig. 6 Overview and profile of Milan (CA 199v). https://commons.wikimedia.org/w/index.php?
search=Codex+Atlanticos&title=Special%3ASearch&go=Go&ns0=1&ns6=1&ns12=1&ns14=
1&ns100=1&ns106=1#/media/File:Leonardo_Milano04.jpg

copy of *Summa de Arithmetica, Geometria, Proportioni e Proportionalità* by Luca
Pacioli, Leonardo in 1496 met personally in Milan the author, entrusted by Ludovico
il Moro as a public teacher of mathematics. From then on, they became friends
and they worked together for instance in editing the *Divina Proportione*, written by
Luca and decorated by Leonardo with the famous *polyhedra* (1509). At the same
time Leonardo, following Pacioli's lessons, became more and more interested in
mathematics, especially in geometry. Both had mathematics and art as topics in
their discussions and they were less interested to the solution of algebraic equations,
studied by many mathematicians of that time.

At Pavia University Leonardo met Giorgio Valla, a famous humanist. With his
help and in reading the book of Valla *De Expetendis et Fugiendis Rebus Opus*,
he became able to learn results of mathematics and physics, which dated back

Fig. 7 The lunula of Hippocrates in the book of G. Valla and our drawing (We realized the drawings in this figure-right, 8, 9, 11, 12, 13, 14, 15, 16 using Matlab®)

to the ancient Greek world. Particularly, he discovered the studies carried out by Hippocrates[6] about the squaring of a *lunula*: the evaluation of the area of a particular finite part of the plane delimited by two circular arcs (Fig. 7). At the time of Leonardo, the problem of the area of plane portions with circular edges (in particular the area of a circle) was still of great interest. The most common approach to reach the solution was the searching of a polygonal figure having area equal to the figure in question. Leonardo also addressed issues of measurement, either by extending the results of Hippocrates or by studying the area of various plane figures with circular edges. It is well known that Leonardo frequently manifested the intention to write a treatise, titled *De Ludo Geometrico*, that never appeared.

Leonardo's most important researches in geometry are present in *Codex Atlanticus* and in *Codex Arundel*. In numerous sheets of the two *Codices*, we can find studies of solids and their transformations, measurements of plane figures delimited by circular arcs and a big collection of *lunulae*, that we intend to illustrate in the following sections.

About the *Lunulae* Leonardo began to be interested in this subject in reading Valla's book, where that mentioned the *Theorem of Hippocrates* about the *lunula*. Starting from an isosceles triangle inscribed in a semicircle of radius r as in Fig. 7-right, the *lunula* is delimited by two arcs of circles, one centred in O and the other in the midpoint of the side PQ. You can verify that the area of the *lunula* is equal to that of the triangle POQ. The area of the *lunula* in fact is easily evaluated:

$$A = \frac{\pi}{2}\left(\frac{r\sqrt{2}}{2}\right)^2 - \left(\frac{\pi}{4}r^2 - \frac{r^2}{2}\right) = \frac{r^2}{2} \ .$$

[6]Hippocrates of Chios (fifth century BC) Greek mathematician, geometer and astronomer.

Fig. 8 Lunulae on right triangles

Fig. 9 Two kinds of bisangolo

Leonardo has proved two other theorems [10], related to the drawings in Fig. 8.

In Fig. 8-left the result comes easily from the theorem of Hippocrates. The real extension of the theorem is illustrated in Fig. 8-right. In any rectangular triangle, where a and b are the lengths of the *catheti*, inscribed in a semicircle of radius $\sqrt{a^2 + b^2}/2$, the sum of the areas of the two *lunulae* is equal to the area of the triangle:

$$A + B = \frac{\pi}{2} \frac{a^2 + b^2}{4} - \left(\frac{\pi}{2} \frac{a^2 + b^2}{4} - \frac{ab}{2} \right) = \frac{ab}{2} \; .$$

A similar result [10], not known at the time of Leonardo, was obtained by the medieval Arabic mathematician Ibn al-Haytham (965–1039). We can say that Leonardo has independently discovered this theorem.

The arcs, binding the *lunula* of Hippocrates (Fig. 9-left), meet with an angle of $\pi/4$. Leonardo also considered the *lunula* in Fig. 9-right where the arcs meet together with a right angle. He named frequently those forms *bisangolo*, instead of *lunula* preferred by Valla [11].

The interest in measuring the *lunulae* led Leonardo to highlight equivalent plane portions. Some results are related to several drawings [4] in the *Codex Atlanticus* (Fig. 10).

We present some of the drawings realized as in Leonardo sheets.

Fig. 10 (Left) Codex Atlanticus (459 r). https://commons.wikimedia.org/wiki/
File:Leonardo_da_Vinci_%E2%80%93_Codex_Atlanticus_folio_459r.jpg#/media/
File:Leonardo_da_Vinci_–_Codex_Atlanticus_folio_459r.jpg. (Right) Flower of life (C.A.
309 v). https://commons.wikimedia.org/wiki/File:Leonardo_da_Vinci_-_Codex_Atlanticus_
folio_309v_detail1.png#/media/File:Leonardo_da_Vinci_-_Codex_Atlanticus_folio_309v_
detail1.png

In Fig. 11-left the white and the coloured parts are equivalent.[7] In Fig. 11-right
the coloured part is equivalent to the double of the internal square. Both results come
from the Theorem of Hippocrates.

In Fig. 12-left the eight *lunulae* of Hippocrates are tangent in the centre of the
circle, where they meet together. The white and the coloured parts have the same
area. In fact supposing that each *lunula* has area $A = r^2/2$, then the length of the
radius of the circle, containing the eight *lunulae*, is $r\sqrt{2}$. Consequently the area of
the coloured part is $4r^2$ and the area of the external square is $8r^2$. In Fig. 12-right it
is immediate to verify that the white part is equivalent to the internal square.

In Fig. 13-left and -central the white parts are equivalent to the respective internal
square; in the *rosette* on the right, white and coloured parts are equivalent.

[7]Leonardo called *dipennato* the coloured part of a figure and *non dipennato* the part not coloured.

Fig. 11 Lunulae in equivalence problems

Fig. 12 Lunulae in equivalence problems

Fig. 13 Bisangoli in equivalence problems

Leonardo focused his attention more and more on the equivalence between plane figures, as evident in the large number of drawings collected in the *Codex* [4]. He studied the *lunula falcata* (coloured part in Fig. 14-left), whose area is equal to that of the isosceles triangle.

Fig. 14 The lunula falcata (left) and bifalcata (right)

Fig. 15 Two variations of lunulae

Leonardo also considered the *lunula bifalcata* (Fig. 14-right), where the coloured part is composed of two different forms, having the same area (one of them is a *bisangolo*). Calling r the radius of the quadrant, the area B of the *bisangolo* is

$$B = \frac{r^2}{4}\left(\frac{\pi}{2} - 1\right).$$

The area A of all the coloured part is equal to

$$A = \frac{r^2}{2}\left(\frac{\pi}{2} - 1\right) = 2B.$$

Leonardo drew different variations coming from the *lunula bifalcata*; two examples are in Fig. 15.

In both drawings, the white part is equivalent to a square of side r (r is equal the radius of the external semicircle).

***Lunulae* and Square Roots** Following Leonardo, we conclude with the relation between another kind of *lunulae* and the square roots of integers [4].

Leonardo, in *CA 596r* [4], considered 11 *lunulae,* reproduced in our drawing (Fig. 16), each of them has the same area of the innermost circle C_0. The ratio of each radius r_n (in increasing order) of the different circles C_n and the radius r_0 of C_0 is equal to $\sqrt{n+1}$, ($n = 1, \ldots, 11$).Taking account that frequently Leonardo has used rule and compass, probably he applied the theorem of Pythagoras to determine the length of each radius. In fact, each radius r_n corresponds to the hypotenuse of a

Fig. 16 Lunulae and square roots problems

right-angled triangle having the orthogonal sides equal to r_0 and $\sqrt{n}\ r_0$ respectively, that is $r_n = \sqrt{n+1}\ r_0$.

Leonardo in this way created a sort of algorithm to obtain the square root of the integers!

Conclusions

On the occasion of the fifth centenary of the death of Leonardo, the famous protagonist of the Renaissance, it seemed right to emphasize the periods he lived in Milan, where he left a remarkable imprint of his artistic and scientific abilities.

With this chapter, we hope to have given the reader a good overview of Leonardo's Milanese period. The long time (over 20 years) that the artist spent in Lombardy is notable especially for the works he has left in the region and for the studies and writings of those years. We think also that the Milanese period was one of the most fertile parts of the life of Leonardo, rich especially in cultural exchanges with many scholars, humanists and artists of that time and with numerous and qualified craftsmen present in Lombardy.

Certainly these relationships influenced Leonardo but at the same time we think that his ability to work in multiple fields, his creativity and inventiveness were a great enrichment to all those who collaborated with him.

For a good knowledge of the life of Leonardo and of his time, the first biography written by Giorgio Vasari [12] is crucial. At the same time, it is interesting a complete description of his production, realized by several authors around the middle of the twentieth century [1].

From our point of view, being mathematicians, we believe that the collaboration with Luca Pacioli was very important for Leonardo.

Pacioli favoured the interest of Leonardo towards geometric studies and mathematics in general. The manuscript *De Divina Proportione*, enriched by drawings of Leonardo, represents the peak of their collaboration.

Leonardo, no more *omo sanza lettere,* already at the end of the first Milanese period is able of interpreting classical texts, having approached the Latin and Greek languages and having closely analyzed many different topics.

References

1. *Leonardo da Vinci*, vols. 1 and 2, ed. by different authors (Istituto Geografico De Agostini, Novara, 1956)
2. P.C. Marani, *Leonardo Da Vinci* (Dizionario biografico degli Italiani, Treccani.it, 2005)
3. A. Marinoni, L. Cogliati Arano, *Leonardo all'Ambrosiana* (Electa Editrice, Milano, 1982)
4. F. Rinaldi, *De Ludo Geometrico - La Matematica e la Geometria di Leonardo*, Codex Atlanticus 18 (Ed. De Agostini, Novara, 2013)
5. L. da Vinci, *Disegni anatomici dalla Biblioteca Reale di Windsor*, Palazzo Vecchio - Firenze (Ed. Giunti Barbera, Firenze, 1979)
6. C. Pedretti, *Studi per il Cenacolo* (Ed. Giunti Barbera, Firenze, 1983)
7. C. Pedretti, *I cavalli di Leonardo* (Ed. Giunti Barbera, Firenze, 1984)
8. L. da Vinci, *Rebus*, ed. by A. Marinoni (Silvana Editoriale, Torino, 1983)
9. C. Pedretti, *Leonardo architetto* (Electa Editrice, Milano, 1978)
10. I.S. Fenyö, Leonardo da Vinci e la Matematica. Rend. Sem. Mat. Fis. Milano **54**(1), 101–125 (1984)
11. R. Marcolongo, *Leonardo da Vinci nella Storia della Matematica e della Meccanica*, ICM Proceedings, Bologna, 3–10 September 1928, vol. 1 (1929), pp. 275–294
12. G. Vasari, *Le vite de' più eccellenti architetti, pittori, et scultori italiani, da Cimabue insino a' tempi nostri*, vol. 2 (G. Einaudi Editore, Firenze)

A Mathematical Improvement of the Skate Curves

Enrico Perano and Marco Codegone

Introduction

Styleslalom consists of performing tricks on skates, called steps, while skating around a line of cups or cones, each one placed at the same distance from the others.

In 1995 only about ten steps had been created and Styleslalom consisted of repeating these steps one after the other from the first to the last cone.

In 1996 one of the authors, E. Perano, introduced a mathematical method to create many more steps from the basic ones that were known in those years and all skaters began to try performing them. Consequently, Styleslalom has expanded exponentially since then, and within a few years it was recognized as a real sporting discipline by all skating federations worldwide.

The method described in this chapter can always be used because it may be applied to any step. It is based on three mathematical concepts: the symmetry of functions, their inversion, and the principle of duality. In the following section we will present the first two concepts and we will give a description of the curves drawn by each skate in parametric form.

E. Perano (✉)
FISR, CONI, Rome, Italy
e-mail: enrico@inlineperano.com; enrico.perano@polito.it

M. Codegone (✉)
Dipartimento di Scienze Matematiche, Dipartimento di Eccellenza 2018-2022, Politecnico di Torino, Torino, Italy
e-mail: marco.codegone@polito.it

© Springer Nature Switzerland AG 2020
M. Emmer, M. Abate (eds.), *Imagine Math 7*,
https://doi.org/10.1007/978-3-030-42653-8_15

Some Preliminary Definitions

There are *elemental steps* that cannot be broken up into simpler steps and *composed steps* that contain two or more connected elemental steps ([1], Chap. 1).

Every step performance is repeated every n cups ($n \geq 2$).

The *period T* of a step is the lowest n that satisfies this condition and it is always equal to 2 for an elemental step [2].

NOTE 1: Before E. Perano introduced his method, composed steps did not exist.

OPPOSITE STEP: Given two steps A and B, B is defined "the A opposite" and we write $B = \overline{(A)}$, if it is obtained performing A in the opposite direction.

SYMMETRIC STEP: a step is defined symmetric when it is equal to its opposite, so that, when performing the opposite, you always obtain the same step.

SWITCHING FIGURE (SWITCH): Trick which is performed with the skates around only one cup and is not repeated when passing the subsequent cups. It is used to change between two different steps.

NOTE 2: as a switch can be executed in a lot of ways, it is possible to perform different switches between two identical steps. The switch used to change from a step A to another step B is also generally different from the one used to switch from step B to step A.

The Mathematical Applications: Symmetry

The features of an elemental step can be described ([1], Chap. III) by a mathematical relation, possibly a function, and its corresponding graph.

A first elemental mathematical approach to Styleslalom consists of associating to a step an elemental graph which describes only the periodicity and possible symmetry of the step, without any reference to the trajectories followed by the skates during their performance.

The space covered with the skates is represented on the horizontal axis, using the number of cones which a skater passes while performing the step as unit of measurement, from the first cone to the last one. The function connected to an elemental step must also be periodic with $T = 2$. It means that its graph must repeat itself equally every section of amplitude 2.

The possible symmetry of each step corresponds to the symmetry with respect to the horizontal axis around which the step develops.

As an example, two elemental steps are shown graphically in Figs. 1 and 2.

The step of the first example (Fig. 1) is symmetric because its graph remains the same after a symmetry about the horizontal axis, whereas the step is not symmetric in the second case (Fig. 2). Consequently, it is possible to draw the graph of its opposite, as shown in Fig. 3.

Overall, the graph of a symmetric step, like the one in Fig. 1, corresponds to a multivalued function, that is not a function according to the standard definition.

Fig. 1 A possible graph of a symmetric step

Fig. 2 Example of graph associated to a not symmetric step

As the opposites of not symmetric elemental steps are different from the original steps, it is possible to add every step to its opposite in order to create new composed steps.

The equation of a function associated to a not symmetric elemental step performed along a line of 20 cups can be written as follows:

$$f(x) = \sum_{k=0}^{9} f_T (x - kT) \quad kT < x < (k+1)\,T \quad k = 0,\dots,9$$

where $f_T(x)$ describes the step in the fundamental period $T = 2$, which is repeated identically every two cones.

Fig. 3 The graph associated to the opposite of the step shown in Fig. 2

Similarly, the equation of the function of its opposite becomes:

$$\overline{f(x)} = \sum_{k=0}^{9} [-f_T(x - kT)] \quad kT < x < (k+1)T \quad k = 0, \ldots, 9$$

We can also write the equation of the j-th among n switches which is defined only around one cone and so covers only half a period:

$$g_j(x) = \begin{cases} 0 & x < 0 \\ f_{sj}(x) & 0 < x < \frac{T}{2} \\ 0 & x > \frac{T}{2} \end{cases}$$

or, more simply:

$$g_j(x) = f_{sj}(x) \left[U(x) - U\left(x - \frac{T}{2}\right) \right]$$

where U indicates the Heaviside step function.

Then it is possible to describe the composed symmetric step using this function:

$$f_c(x) = \begin{cases} f_T(x) & 0 < x < T \\ f_{sj}(x - T) & T < x < \frac{3}{2}T \\ -f_T\left(x - \frac{3}{2}T\right) & \frac{3}{2}T < x < \frac{5}{2}T \\ f_{sj}\left(x - \frac{5}{2}T\right) & \frac{5}{2}T < x < 3T \end{cases}$$

Fig. 4 An example of composition of a not symmetric step with its opposite

For example, consider again the not symmetric step in Fig. 2 (named B), and imagine performing it only in the space corresponding to the first period of two cones. Then, skating around the third cone by a SWITCH, execute the opposite step \overline{B} in the next space of width $T = 2$. In this way you obtain a new step that is no longer elemental but is composed of the original step with its opposite, a symmetric step, having a period equal to $3T = 6$. The result is shown in Fig. 4.

This method allows you to build a symmetric step adding to a not symmetric step its opposite, and it can be summarized in the following RULE 1.

Once a not symmetric step is chosen, alternating it with its opposite a composed symmetric step with a longer period $(T > 2)$ is obtained.

The role of the switching figure that allows a step to alternate with its opposite is fundamental for building the resulting composed step.

As a matter of fact, when you alternate the same step with its opposite, you can obtain different choreographies if the switching figure changes.

Theorem Given a not symmetric elemental step A and n Switching Figures, it is possible to create n^2 composed symmetric steps having a period $T_s = 6$.

Proof Calling $f_A(x)$ the single valued function associated to the elemental step A, $\overline{f_A}(x) = -f_A(x)$ the function defined by \overline{A}, the opposite of A, and $f_{si}(x)$ the function corresponding to the i-th of n Switch Figures, it is possible to

create symmetric compositions described by periodical functions, with a period $T_s = 3T = 3 \cdot 2 = 6$, which, in the first period T_s, are defined as follows:

$$f_c(x) = \begin{cases} f_T(x) & 0 < x < T \\ f_{si}(x - T) & T < x < \frac{3}{2}T \\ -f_T\left(x - \frac{3}{2}T\right) & \frac{3}{2}T < x < \frac{5}{2}T \\ f_{sj}\left(x - \frac{5}{2}T\right) & \frac{5}{2}T < x < 3T \end{cases} \qquad \forall i, j : 1 < i, j < n$$

NOTE 3: In a few cases it is possible to alternate an elemental step with its opposite without needing a switching figure. Consequently, the period of the composed step decreases to $2T = 4$.

The Mathematical Applications: Functions Inversion

The idea of extending a simple step using suitable symmetries in order to build more complex choreographies (step mixtures) can be extended if we use another mathematical tool, the one of inverse function ([1], Chap. IV).

In Styleslalom we introduce the following definition:

INVERSE STEP: given two steps A and B, B is defined "the inverse of A" and it is indicated by A^{-1}, if it is obtained inverting the movements of the skates when step A is performed.

An example of two steps, one the inverse of the other, is skating forward or backward using only one leg and always the same one.

In Mathematical Analysis function inversion is obtained exchanging the variable x with y in the expression of an injective single-valued function; in Styleslalom the inverse of a step is obtained retracing its graph but in the opposite direction, from the point of arrival to the starting point.

For instance, the graph associated to a general step A and the corresponding graph of its inverse, $B = A^{-1}$, are shown in Figs. 5 and 6.

All values assumed by the graph of a step during its performance from the beginning to the end of a period are also assumed by the inverse step but in the reverse order. This means that in a period the inverse step assumes the last position of the original step as its first position and then it goes on taking all intermediate positions in reverse order until it assumes the first position of the original step at the end of the period.

The graph of the inverse step can be traced in a given period reflecting the graph of the original step about the axis of the period (see Fig. 7).

If $f_T(x)$ is the expression of the function associated to an elemental step in the first period $T = 2$, the equation of the function of its inverse in the same period is $f_T(T - x)$.

Fig. 5 A generic graph of an elemental step

Fig. 6 The graph of the inverse step of Fig. 5

So the equation of the function associated to the inverse of an elemental step with a period $T = 2$ performed along a line of 20 cups becomes:

$$f_i(x) = \sum_{k=0}^{9} f_T\left[(k+1)\,T - x\right] \quad kT < x < (k+1)\,T \quad k = 0, \ldots, 9$$

According to this definition of inverse step, steps coinciding with their inverse would be theoretically possible because it may be the case that the graph of a step does not change after its reflection about the axis of the period. This would mean that the step and its inverse are the same step.

Consequently, we give the following definition:

ANTIMETRIC STEP: a step is named antimetric when it is equal to its inverse, that is, when inverting the movement of the skates the same step is still obtained.

Fig. 7 Comparison between the graph of a step and its inverse in a period

The diagram associated to an antimetric step, in each period, is symmetric with respect to the axis of the period.

Actually an elemental step is never antimetric because it cannot coincide with its inverse; however, it is possible to create an antimetric composed steps with longer period adding to an elemental step its inverse.

So the addition of inverse steps allows the introduction of a second rule to make new more complex compositions, from simpler steps.

Alternating a not antimetric step with its inverse, a composed antimetric step with a longer period is obtained

This rule allows you to create an antimetric composed step starting from a simpler step that cannot be antimetric.

NOTE 4: Sometimes it is not possible to perform the inverse of an elemental or not antimetric composed step because it cannot be physically achievable. On the contrary, you can always perform the opposite of a not symmetric step.

NOTE 5: This second rule can also be applied to symmetric compositions resulting from the alternation of an elemental step with its opposite.

Consequently, you can add a symmetric composition to its inverse to obtain a more complex choreography that remains symmetric and, at the same time, has become antimetric.

A More Detailed Mathematical Approach to Styleslalom

A deeper mathematical application consists of describing the curves drawn by each skate considering it as a material point which moves around the cones.

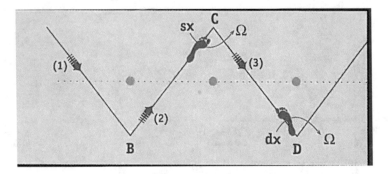

Fig. 8 Example of a triangular wave traced by both skates

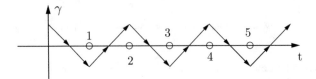

Fig. 9 Triangular wave traced by only one skate

For example [3], a triangular wave can be traced by both skates as shown in Fig. 8.

For each triangle, a skate describes one side sliding forward while simultaneously the second skate slides backward on the other side.

Alternatively, the same trend can be described moving on only one skate (Fig. 9). This movement is shown in the next photo sequence (Fig. 10).

The equation of the triangular wave is the following:

$$\gamma(t) = \sum_{n=1}^{3} \gamma_n(t)$$

with:

$$\gamma_n(t) = \begin{pmatrix} t \\ |t - (2n-1)| - 0.5 \end{pmatrix} \qquad 2(n-1) \leq t \leq 2n$$

In the next example, the curve traced by a skate is a repeated cycloid [4, 5] (Fig. 11):

$$\gamma_1(t) = \begin{pmatrix} \dfrac{r[2\pi t - k\sin(2\pi t)]}{2\pi} \\ \dfrac{r[1 - k\cos(2\pi t)]}{4} \end{pmatrix} \qquad 0 \leq t \leq 2 \ (k=1)$$

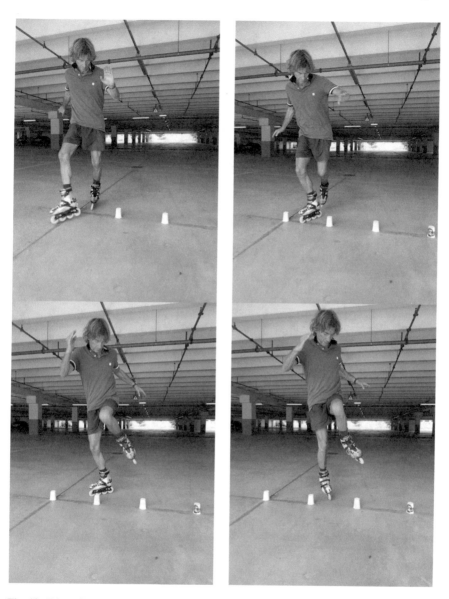

Fig. 10 Triangular wave performed moving only one skate

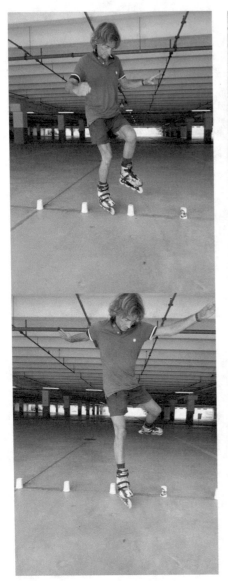
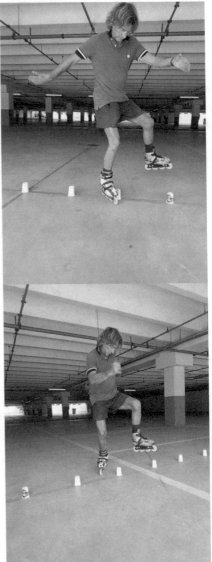

Fig. 10 (continued)

The next photo sequence shows a step where both skates move describing a cycloid, one as in the previous example while the other is a prolate cycloid (Fig. 12).

$$
\gamma_2(t) = \begin{pmatrix} r\left[2\pi t - k\sin\left(2\pi t\right)\right] \\ r\left[1 - k\cos\left(2\pi t\right)\right] \end{pmatrix} \quad 0 \le t \le 2 \;\; (k > 1)
$$

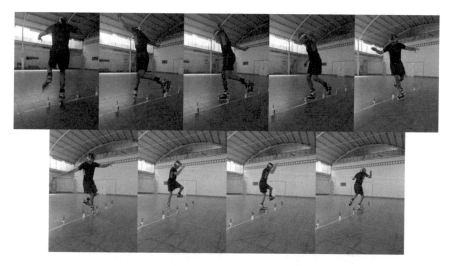

Fig. 11 A repeated cycloid traced moving only one skate

NOTE 6: The step shown in the second example is an elemental step with period $T = 2$ because it describes half a cycloid sliding forward and the other half moving backward on the same skate.

On the contrary, the third example contains a step performed on both skates which describe a cycloid sliding forward, so its period is only $T = 1$. The steps whose period is reduced to one are called **pathological steps**.

Finally, the last example shows the movement of the skates while performing the so-called Ala step around only one cone (Fig. 13).

In Fig. 14 you can see the drawing of the curves γ_l and γ_r [6] described by the left and right skate respectively, and their parametric equations below:

$$\gamma_l(t) = \begin{pmatrix} -\dfrac{3}{2}a + 2a\cos t \\ a\sin t \end{pmatrix} \quad t \in \left[-\dfrac{\pi}{3}, +\dfrac{\pi}{3} \right];$$

$$\gamma_r(t) = \begin{pmatrix} \dfrac{3}{2}a + 2a\cos t \\ a\sin t \end{pmatrix} \quad t \in \left[+\dfrac{2\pi}{3}, +\dfrac{4\pi}{3} \right]$$

letting, for example, $a = 2$.

Fig. 12 Both skates describe a cycloid, one of them is prolate

Fig. 13 The Ala step performed around a cone

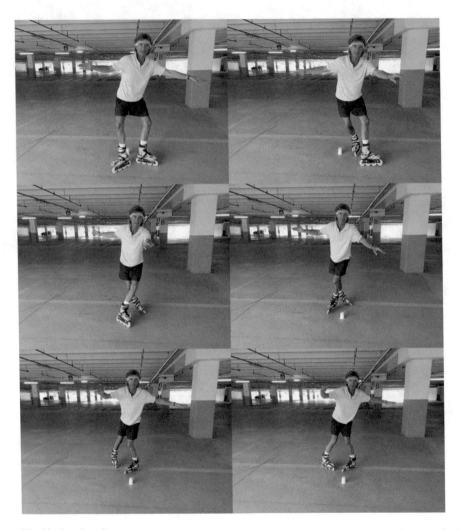

Fig. 13 (continued)

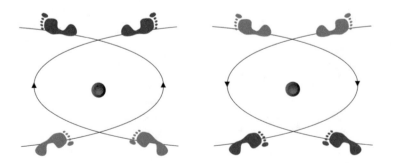

Fig. 14 Curves described by skates performing the Ala step

References

1. E. Perano, *Styleslalom: La matematica applicata al pattinaggio, Teoria ed esempi* (Aurelia edizioni, Asolo, 2010)
2. https://youtu.be/2R05IKyczEI
3. Sport INLINE roller creative magazine, 24 (1998), p. 56
4. M. Abate, F. Tovena, *Curve e superfici* (Springer, Milan, 2006)
5. G. Fano, *Lezioni di Geometria descrittiva date nel Regio Politecnico di Torino* (G.B. Paravia, Torino, 1914)
6. Sport INLINE roller creative magazine, 23 (1998), p. 37

Part VII
Mathematics and Physics

Infinity in Physics

Jean-Marc Lévy-Leblond

Is it necessary, in order to justify a physicist's claim to deal with the infinite—a privilege that might seem reserved to the mathematician and the philosopher—to recall that physical thought has long been linked to the infinite? Archimedes (the first physicist?), and later Galileo, who devoted many pages of the *Discorsi* to it [1] offer two examples among others of a fundamental reflection on the nature of infinity based on the physicist's concerns about material reality, despite the finiteness of its appearances. Nevertheless, it is too often accepted that infinity should not be part of the conceptual arsenal of physics in its own right, since "there is nothing infinite in nature". The appearance of infinity in a physical theory would then signal, if not bankruptcy, at least a risky and perhaps abusive extrapolation of its validity. Here is a recent version of this argument:

> Infinity is a beautiful concept—and it is ruining physics!

> We don't need the infinite to do physics. Our best computer simulations, accurately describing everything from the formation of galaxies to tomorrow's weather to the masses of elementary particles, use only finite computer resources by treating everything as finite. So if we can do without infinity to figure out what happens next, surely nature can, too—in a way that's more deep and elegant than the hacks we use for our computer simulations. Our challenge as physicists is to discover this elegant way and the infinity-free equations describing it—the true laws of physics. To start this search in earnest, we need to question infinity. I'm betting that we also need to let go of it. [2]

This paper is adapted from a chapter in J.-M. Lévy Leblond, *La pierre de touche*, Paris, Gallimard (Folio-Essais), 1996.

J.-M. Lévy-Leblond (✉)
University of Nice-Côte d'Azur, Nice, France
e-mail: jmll@unice.fr

We can start by objecting to the narrow empiricism of this argument that infinity is present in reality, since there is some of it in our heads—integral parts of reality! Without dwelling on showing that this remark is much more than a simple joke, let me propose an elementary but irrefutable syllogism: there is no mathematics without infinity, there is no physics without mathematics—the conclusion is obvious. Indeed, mathematics has a properly constitutive function for physics, far beyond the merely instrumental or formal role to which it is too often reduced: neither tool, nor language, but active though. [3, 4] One therefore hardly sees how physics could, on the false pretext that it deals with reality, escape infinity. It remains to examine the specific forms of its occurrences.

Physics, as a science, builds theories: not simple and sketchy models of reality, but abstract constructions, elaborate approximations. Their concepts do not simply describe the properties of the real that they help us to understand. The more general and abstract they are, the more distant of the concrete situations they relate to.

As aptly remarked by (or attributed to) Spinoza, "the concept of the dog does not bark"—which does not preclude to apply it to a particular canine. Similarly, infinity, while not immediately sensitive or directly measurable, is not a priori disqualified in the eyes of the physicist. Moreover, on reflection, is the infinite, as a number, so much less concrete, so much less physical, than "two", for example? After all, who has ever perceived or measured "two"? I can see two apples, two points, measure two meters, two hours, etc.—but how to apprehend "two"? Despite its familiarity, this is a very abstract concept based on a double idealization: on the one hand, it is necessary to ignore the irreducible singular differences between these two apples, these two points, and on the other hand, the difference in nature between the pairs of apples, points, etc. The concept of the number "two" is therefore based on the assumed identity of the objects in a pair and on a characteristic common to all pairs.

The simple idea of whole number is so elaborate and so rich as compared with to immediate experience that the idea of an infinite number requires only a rather modest additional step. Moreover, despite the naïve epistemological uneasiness that seizes some physicists confronted with the idea of infinity, the most banal primary practice of physics, that of measurement, nevertheless gives it an effective place. There are indeed many measuring devices, of very common use, the graduation of which explicitly displays the sign "∞": such is the case for ohmmetres, rangefinders (see for example the focus scale of any photographic lens). Admittedly, this "numerical" value, when obtained as the result of a concrete experimental measurement of resistance or distance, is interpreted as an approximate value. But is it more, or differently so, than a value of 5 Ω or 2 m?

However, we will be less interested here in a metaphysical reflection on the nature of infinity than in an empirical investigation of its function in physics as it is practiced. For there is indeed some infinity, and even a lot of it, in physics, including the most ordinary one. Two modes of intervention can be distinguished. First, there is a "cardinal" infinite. It occurs when dealing with infinite sets of objects, concepts or quantities. The most common example is the set of points on a line or segment, or, what amounts to the same thing, the set of real numbers. The banal use of these notions should not obscure the strong practical refutation of the

vulgar empirical positions it underlies. If, in fact, the prohibition (formulated by a neopositivist dogma) of introducing into theory any concept that is not "directly measurable" were to be taken seriously, the physicist would perhaps already have to renounce using integer numbers (see above), at least real numbers, because the infinity of their decimal expressions place them outside direct experience. She should only use finite decimals, and not consider $\sqrt{2}$, π, e, etc. as "real numbers"; worse still, even rational numbers with infinite decimal development, such as $1/3 = 0.33333...$ or $1/7 = 0.142857142857142...$ would become suspect. Since any measurement provides only a finite decimal numerical value with a finite decimal range of uncertainty, it is the intervals of finite decimals that alone could claim to be considered as the "numbers" of a physical theory "directly" related to experimental results. As a result, the entire arsenal of the theory of functions of real variable (continuity, differentiability, etc.) would become irrelevant. Would any physicist be willing to make such a sacrifice, and to face the task of a complete theoretical finitist reconstruction of an intuitionist type? It can still be argued that real numbers fill in a very pleasant way, and all in all "natural", the gaps of rationals, that they provide a reasonable extension of them, and that the distance between the empirical use of rationals (with finite decimal development) and the theoretical abstraction of reals (with infinite development) is not so considerable that it cannot in principle be overcome by such reconstruction. But physicists shamelessly use infinite cardinality in much more elaborate situations. Let us think, for example, of analytical functions, which are infinitely derivable, and of the absurdity of any operational approach to such a notion: how to distinguish "experimentally" between a function that is three times derivable and a function that is infinitely derivable?[1]

But it is not this use of the infinite, however massive and ubiquitous it may be, that we want to consider thereafter. It is another mode of intervention of the infinite, of the "ordinal" type, that will be discussed, perhaps raising even more vivid questions. At stake here are no longer the infinity of a set of conceptual entities or physical quantities, but the numerical values themselves of such quantities—energy, velocity, number of particles, etc. To these measurable quantities, experimental practices usually attribute finite numerical values. But the theorist often "makes these quantities tend towards infinity". Sometimes, as we have pointed out, the experimental apparatus itself provides an (approximately) infinite value. So what is the meaning and interest of assigning an infinite value to a physical quantity? Why and how can the physicist affirm, by what right and for what purpose, that this speed, this energy, this resistance is "worth" the infinite? Looking at the concrete situations in which physics uses infinity in this way, three types can be distinguished. The infinite (ordinal) can arise as a problem, as a method, as a solution.

[1] It is amusing to note in this respect that the neopositivist dogma in modern physics, requiring to introduce into theory only "measurable quantities", had as its major lawyer Heisenberg, who was also the initiator of the use of sophisticated theoretical methods based on considerations of analyticity of physical quantities considered as prolonged functions in the complex field.

Infinity as a Problem

The problematic mode is the most well known, if not the most common, under which the infinite arises in physics; it underlies the ordinary conception of the infinite as a disease of theory, to be eliminated as soon as it manifests itself. Indeed, it happens that, seeking to determine the numerical value of a physical quantity, the physicist, at the end of a calculation, obtains, to his great disappointment, an infinite result. Let us give two examples.

The Blackbody Radiation

The somewhat esoteric but agreed terminology of "blackbody radiation" covers what should be more explicitly and more soberly called "electromagnetic radiation at thermal equilibrium". The problem is that of explaining the old and well-known observation that a body heated to a high temperature emits light: why does an iron piece heated up at the smithy or the filament of an incandescent lamp becomes red, then yellow when its temperature increases? The basic mechanism is simple: electromagnetic radiation is emitted when electrically charged particles are accelerated; the temperature rise of a body corresponds to an increase in the agitation of its atomic particles (electrons), which, thus accelerated, emit electromagnetic radiation of an ever higher frequency.

In order to calculate precisely the characteristics of this radiation, i.e. the distribution of radiated energy as a function of frequency (the "spectral density" of energy) at a given temperature, it is necessary to use the concepts of statistical thermodynamics for evaluating the equilibrium conditions between the radiation and the material that permanently emits and reabsorbs it. Classical thermodynamics, at the end of the nineteenth century, provided an answer, the Rayleigh-Jeans' law, for which the spectral density is an ever increasing function of frequency. However, this is an unacceptable answer, since it implies that the total energy radiated at all frequencies, i.e. the integral of the spectral density, represented by the total area between its graph and the frequency axis, is infinite! Of course, in reality, a given body radiates, at each temperature, only a finite quantity of energy, which was already empirically known at the time (Stefan's law) [5]. This paradox represents a major failure of classical theory. It was at the origin of Planck's almost desperate hypothesis, initially quite arbitrary in appearance; assuming that energy could only be exchanged discontinuously between radiation and matter, in well-defined quantities—the "quanta"—it led to the new Planck's distribution law. This formula avoided divergence for high frequencies, gave a total amount of energy now finite, in accordance with Stefan's law and with all experimental data. Here, the unacceptable infinity of the theoretical result was the massive symptom of the failure of classical theory, and triggered the discovery of quantum theory.

Another source of quantum theory has very similar characteristics; it is the problem of atom stability. In classical mechanics, indeed, the energy of a system of charged particles interacting solely by electromagnetic forces has no lower bound. Such a system could therefore indefinitely lose energy by electromagnetic radiation, and emit an infinite amount of it, which is physically absurd. Quantum theory, preventing, thanks to the delocalization of electrons, their fall into the bottomless well of Coulomb potential, ensures the stabilization of atoms and molecules.

Renormalization in Quantum Field Theory

The physics of fundamental particles and their interactions study the very complicated reactions of appearance or disappearance of quantum constituents of matter: the number of particles does not remain constant during such a process, since the kinetic energy of some can be transformed into mass energy for others. The theory that describes these processes, known as "quantum field theory", uses sophisticated and poorly dominated mathematical objects (unbounded operators, non-linear equations, etc.). Developed in detail during the 1930s and 1940s for the simplest case, that of interactions between electrons and photons, this "quantum electrodynamics", led to unpleasant first results: calculating the probability of interaction of two electrons (cross section), or the magnetic moment of the electron, provided infinite values. However, the problem posed by these "divergences" could be solved in an elegant and profound way. In the 1940s, Kramers pointed out that the calculations had been carried out so far by initially introducing into the equations as a parameter the effective mass of the electron; but the same argument showing that the interaction of the electron with its field altered its magnetic moment led to the understanding that its mass was also subject to a change of the same nature. In other words, the mass to be originally introduced into the equations has to be the "bare" mass of an electron hypothetically without interactions; but these interactions, endowing the electron with an electromagnetic field (photons), modify its own energy, i.e. its mass. However, the calculation of this effective "dressed" mass from the bare mass, also gave an infinite result. New problem... and resolution of the previous one! If, in fact, the theory is reformulated so that the final results are expressed in terms of the mass of the "dressed" electron, i.e. its physical mass, the one that is actually observed and measured, the infinities compensate each other; the results are then finite—and in remarkable agreement with experiment. This procedure, called "renormalization", may have appeared for a time as a juggling, an ambiguous and mathematically ill-defined subtraction of infinites. Today, we know how to give it a rigorous formulation. The idea of renormalization has met a considerable fortune, and has extended from quantum field theory to statistical physics, where it underlies the modern theory of phase transitions and critical phenomena. Unlike the previous case, the crisis due to the emergence of the infinite has been resolved here, not by the radical reversal of the theory, but by its reformulation and deepening.

In both the cases mentioned, it is essential to note that the appearance of infinity had the virtue of posing a serious and therefore interesting problem. If, in quantum electrodynamics, for example, the calculation of the dressed mass had resulted in 23.14069 times (or any other finite number) the value of the bare mass, the problem would have shown only limited interest. The infinite, on the contrary, indicates a deep conceptual difficulty. Far from deploring the emergence of this symptom of crisis, the physicist can only rejoice, because this is how the seed of a radical novelty explicitly appears. There is nothing more satisfying than to fault the accepted ideas—and what better flaw than an infinite one, holding the promise of deep subsequent developments! This is a much more interesting case than the one where the limits of validity of a dominant theory are indicated by insidious discrepancies, slight numerical differences. An example of the latter situation is provided by the classical (Newtonian) theory of gravitation, which came up against small disagreements with observation towards the end of the nineteenth century: the perihelion of Mercury's orbit showed a residual movement of about 40 arc seconds per century—once the much more important corrections corresponding to the perturbations due to the other planets had been deduced. Many ad hoc hypotheses and theoretical tampering (a new distant planet? a non-sphericity of the Sun? a slight modification of Newton's law?) could be sufficient to explain this small disagreement. Nothing immediately signalled it as a presage of a real conceptual revolution, namely the replacement of Newtonian gravitational theory by Einstein's "general relativity". It was only after the event that one could recognize in these small differences the surreptitious manifestation of the need for such a revolution. If, therefore, in the cases mentioned above, infinity does appear to be a stumbling block for physics, a symptom of crisis, its very magnitude makes it interesting, and must arouse an enthusiastic welcome rather than a timorous rejection.

Infinity as a Method

But far from always complicating the life of the physicist, the occurrence of the infinite often facilitates it. Infinity is simple, simpler than any finite number, however large it may be and always tainted with arbitrariness (22,026 ? 3,269,017? 485,165,195? etc.): an infinite speed is simpler than a speed of 299,793 km/s (and so many decimals). Infinity in its uniqueness escapes the contingency of the numerical value of a very large number. Thus, the use of infinity sometimes makes the description and analysis of a physical situation more elementary, clearer, and maybe more banal. If it is true that the essence of physical thinking lies in the crucial notion of approximation, then infinity can constitute an excellent approximate value for a physical quantity the true numerical (large and finite) value of which is either unknown or irrelevant. A basic example is provided by the "∞" graduation, already mentioned, to be found on some measuring devices.

Flat Geometries

Another example, hardly less rudimentary, is provided by geometry—in the proper etymological sense, the "measurement of the Earth". Since Greek antiquity, we know that our planet is spherical (approximately), with a radius of about 6400 km. Taking measurements (surveying, mapping, public works) on the ground—let us neglect for the moment the accidents of the relief—thus requires using the geometry of the sphere. Strictly speaking, to measure a field or establish a cadastral survey, one should therefore use the somewhat convoluted formulas of spherical geometry. Of course, surveyors do not; they are rightly satisfied with the formulas of Euclidean plane geometry. This theory constitutes, in fact, an exact formal limit of spherical geometry, in the limit where the radius of curvature of the spherical surface becomes infinite. In practice, it provides an excellent approximation as long as the radius of the Earth is very large with respect to the size of the domains considered (i.e. up to a scale of at least 100 km). Therefore, to consider the radius of the Earth here as infinite enables us to get rid of a physical quantity that is effectively finite but irrelevant, in favour of an abstraction that, although seemingly less realistic, is in fact more in line with the nature of the problem being studied. That the radius of the Earth amounts to 6400 km is both true and of no interest to those who measure a field or record a cadastre. Taking this real value into account would only complicate the problem and mask what is essential at the scale considered. It is therefore convenient, but above all relevant, to approximate by infinity a finite quantity, as long as it is large compared with the numerical magnitudes characteristic of the situation studied. This banal example is very representative of a frequent and fertile procedure in theoretical physics. Thus classical mechanics, that of Galileo and Newton, perfectly adequate to most technical problems, is obtained from Einstein's relativistic theory, more accurate if you will, but less relevant at the speed scale of our trains, planes and even rockets, by considering as infinite the limit speed c, although its value in fact is 299,793 km/s [6]. In the case of the Einsteinian theory of gravitation (usually called "general relativity"), this same process of letting the limit velocity go to infinity offers an even more precise analogy (it is even an homology) with taking the Earth's radius as infinite, since it allows to pass from the Riemannian geometry which characterizes the Einsteinian space-time ("bent" by gravitation) to the Euclidean geometry of the Newtonian space (flat).

Statistical Physics

But let us focus on a less well-known example. A major theme in the physics of collective systems for more than a century has been the study of "phase transitions", or changes of state. It deals with understanding why and how a body changes, for example, from liquid to solid, or to gas. Such changes we consider as radical, showing a qualitative difference in nature and behaviour: a liquid for us is inherently

different from a solid. However, this banal experience poses a difficult problem for the theory. If we try to analyse the transformation of water into ice by considering the elementary components of the system, that is, water molecules, taking into account their interactions (the forces they exert on each other), we are a priori put in difficulty by the gigantic number of these molecules in even the smallest container of our current practice (billions of billions of billions of billions in a drop of water!). One might then be tempted to approach the problem by studying a simplified situation, with a small number of molecules. But the question loses all its meaning: for a system of two molecules, there is obviously neither a liquid nor a solid state. And no more for 3, 4, 10, etc. With what number of molecules, then, can we consider the system large enough that empirical concepts valid on our scale, such as those of liquid or solid, can be applied to it? The rigorous answer of theory (in this case, statistical physics), however surprising it may be, is unambiguous: no finite system is large enough. Even with 10^{25} molecules, qualitative differences in behaviour, reflecting the existence of distinct phases, cannot be demonstrated. More precisely: physical quantities remain continuous functions of temperature. However, it is the sudden jumps, discontinuities, in the variation with temperature of quantities such as the density or calorific capacity of a body, measured experimentally, that reflect these changes of state, these phase transitions. But the theorist is unable to account for these jumps and a fortiori to evaluate the corresponding transition temperature; he can even demonstrate the absence of discontinuities in any system with a finite number of molecules. It is paradoxical to see how a refined theory seems to capitulate to crude phenomena of everyday life. The reason is that we ask for too much precision. Suppose that such a large system (10^{25} molecules and a size much larger than that of intermolecular distances) is approximated by a system of the same density, but infinite both in number of molecules and volume. Then the famous discontinuities appear! The (methodical) introduction of the infinite thus brings us closer to empirical reality, rather than away from it. Indeed, the apparent discontinuities revealed by experimental practice are excellent observational approximations, at our scale, of variations that hypothetical measurements at a finer resolution would reveal as continuous. But this virtual continuity is irrelevant on a scale where the practice effectively differentiates between solids and liquids. It is by abandoning the abusive and misleading claim to account too accurately for the behaviour of a finite system that the essential point is finally understood. The additional abstraction of the infinite transition of the size of the system brings us closer to its concrete reality.

There are many examples of situations where it is both simpler from the point of view of theoretical analysis and more effective from the point of view of empirical reality to consider infinite systems. This is the case for another essential problem in statistical physics, that of irreversibility. It is indeed complicated to explain rigorously why it is very easy to dissolve a lump of sugar in water, but very difficult to separate the sugar from the water afterwards. As with phase transitions, it is clear that the problem does not arise for a rudimentary system composed of a water molecule and a sugar molecule. The irreversibility of the mixture makes little sense if we take two molecules of each, or a thousand, etc. The theoretical analysis, again,

shows that an infinite number of them are needed to theoretically account for the situation. Finally, let us briefly mention the problem of measurement in quantum theory. Much of the persistent epistemological debate on the nature and meaning of quantum theory is related to the difficulty of developing a coherent analysis of measurement processes, i.e. the interactions between a (measured) system and a (measurement) apparatus, within the framework of quantum theory. The latter is described, in accordance with practice, as a macroscopic system, consisting of a very large number of particles. But it seems that we cannot describe it correctly unless this system is supposed to be infinite (and operating for an infinite duration).

These cases show that appealing to infinity may be a sound methodological procedure, leading to relevant and consistent descriptions.

Infinity as a Solution

There are several situations in contemporary physics where a physical quantity comes up against an impassable finite numerical limit. Thus, the speed of a moving object cannot exceed a limiting speed, known as the "speed of light" ($c \sim 300{,}000$ km/s); the temperature of a body cannot fall below "absolute zero" ($T_0 \sim -273$ °C); the evolution of the Universe cannot be traced back before an initial moment ($t_i \sim -13.7$ billion years). What is the significance of such impassable limits?

The Speed Limit

By what right can we impose a limit on speed ("This wall of shame, worse than the Berlin one", wrote an opponent to Einsteinian relativity)? Indeed, there is nothing to prevent us from imagining a speed of, say, 320,000 km/s; why does Nature seem to make no use of it? To clarify the situation, let us proceed in a simple operational way, by measuring the speed of a train (fictional—but this is the archetypal example of relativistic reasoning). The simplest way is to measure the train's transit times at two points on the track whose distance is known. If we assume that clocks are properly synchronized, we deduce the travel time and then the speed—by definition the ratio between the distance travelled and the time taken to travel it. Considering faster and faster trains, we can see that the numerical value of their speeds is increasing, but less and less. Whatever the energy imparted to the train, this value can only tend, without reaching it, towards the speed limit c. It must be noted, however, that this measurement is made using instruments outside the train. Can we set up an intrinsic measure? Yes: it is sufficient to have an accelerometer (for example a simple pendulum) and a clock in the train. The value of the velocity can then be obtained by integrating over time the acceleration thus measured (i.e. the rate of the time variation of the velocity). To the surprise of the unsuspecting experimenter,

this "internal" speed, if it coincides with the "external" speed previously measured for common values (a few hundred kilometres per hour), differs from it for higher values; it is always higher and tends towards infinity without meeting a limit! We must conclude that there are actually two concepts of speed (at least; one could even invent other ones). They coincide in the classical (Galileo–Newtonian) conception of space and time, but differ in the Einsteinian theory. The "internal" speed" is generally called "velocity". Speed (external) and velocity are both equally respectable Einsteinian generalizations of the (unique) concept of Galilean speed. If, therefore, from a certain point of view, the speed of a body admits a finite limit, from another one (that of rapidity), it can grow without limits. This clarifies the nature of this "limit": if it cannot be exceeded, it is because it cannot be reached. It is, in truth, a conceptual infinity, even if it can be disguised under a numerical finiteness.[2] The situation is the same for the "absolute zero" of temperatures. If one cannot cool a body below –273.15 °C, it is because one cannot even get to that temperature— however close to it one can get. Moreover, as in the case of speed, there is a change in the theoretical variable of interest that makes explicit the sending away to infinity of the (finite) limit value.

The Age of the Universe

While it is fairly easy to accept this idea for the limit speed and for the absolute zero, it is less common to apply the same approach to the age of the Universe. However, it is from an old aporia that the question arises: "If the Universe was born 13.7 billion years ago, what was there before?". Many cosmologists avoid the problem by invoking our lack of knowledge of the "first moments" of the Universe and by appealing to exotic effects (quantum, for example) that they hope could dispel the apparent antinomy. Nevertheless, without going beyond the currently accepted framework of classical evolutionary cosmologies of the "Big Bang" type, we can accept both the idea that the Universe is 13.7 billion years old and that there is no "before". The point is to convince ourselves that this original instant, 13.7 billion years ago, is not a moment in the temporal evolution of the Universe— just as 300,000 km/s cannot be the speed of a physical object, nor –273 °C the temperature of a real body. Likewise—let us indulge in a human analogy—neither the moment of our conception nor that of our death is part of our life. The range of ages (ours or the Universe's), as well as that of temperatures and speeds, is open (in the mathematical sense): its limit point does not belong to it. So there is no "before" because there is no beginning. From a conceptual and not purely numerical point

[2]To avoid or dispel a common confusion, it should be pointed out that speed (in the usual sense) is only limited for material bodies or for the transport of a causal influence. Non causal "effects", for example the displacement of a shadow, may well reach supra-luminal speeds (the notion of rapidity is then irrelevant).

of view, this unreachable "origin" is in reality an infinitely remote one. Moreover, the very number that expresses the "age" of the Universe is contingent, if not arbitrary, and of dubious significance. In fact, the year is defined by the Earth's revolution around the Sun. But the Earth is only about 5 billion years old! What are the previous 8.7 billion years if the Earth is not there to count them? In fact, it is a very indirect evaluation, proceeding from a choice which is both natural and conventional, of a current time unit. The same is true for temperatures, where the standard degree (the hundredth part of the temperature interval between freezing and boiling water), defined on our scale, is transferred by a series of connections between different ranges of thermometric measurements, to very low or very high temperatures. It is not difficult to imagine and construct different scales for time, as for temperature, that are both coherent and useful, and that effectively let go to infinity these unattainable boundary points, as does the transition from speed to velocity. Of course, it is not enough to simply redefine arbitrarily a physical magnitude by a mathematical transformation applying the half open line on the entire line, for example via a logarithmic transformation; it is also necessary that the change of variable has a physical meaning [7].

Thus the infinite sometimes disguises itself as a paradoxical and contingent finite. Finding the infinite behind finite appearances then solves the conceptual node. The infinite here is indeed a solution of the problem—in the sense not of a *re*solution, but of a *dis*solution.

The Limits of Physical Infinity

The physicist's game is only one of many, and the Infinite is so large that physics or mathematics can pretend to manage but limited aspects of it. We have not dealt here with THE Infinite, but with certain approaches only—physical and mathematical—to infinity. Neither physicists nor mathematicians have invented the Infinite and cannot claim to appropriate it. It expresses an older need of the human mind, a deeper modality of human experience, than this or that science. Theology, philosophy, poetry, music first took care of it. It would be presumptuous to believe that science today may suffice to answer the query. Let us make sure that one could not say about science what L.-F. Céline wrote about love: "Love is the infinite within the reach of poodles".

References

1. G. Galilei, *Discorsi e dimostrazioni matematiche intorno a due nuove scienze,* 1638, English translation, S. Drake, *Discourse Concerning Two New Sciences* (University of Wisconsin Press, Madison, 1974)
2. M. Tegmark, *This Idea Must Die.* Brockman (2014)

3. J.-M. Lévy-Leblond, Physique et Mathématique, in *Penser les mathématiques*, ed. by M. Loi, (Seuil, Paris, 1982)
4. J.-M. Lévy-Leblond, Why does physics need mathematics, in *The Scientific Enterprise*, ed. by E. Ullmann-Margarit, (Kluwer, Dordrecht, 1992), pp. 145–161
5. A more detailed version of these considerations, detailing certain mathematical formulation, can be found in "La physique et l'infini en pratique", in F. Monnoyeur, ed., *Infini des philosophes*, Belin (1995)
6. For the somewhat subtle relationship between Einstein's theory and classical relativity theory, see "Absolu/Relatif" in J.-M. Lévy-Leblond, *Aux contraires*, Gallimard (1996)
7. A more detailed treatment of this question can be found in the chapter "L'Origine des temps", in J.-M. Lévy-Leblond, *Did the Big Band Begin?*, Am. J. Phys. **58**, 156–159 (1990)

Hyperbolic Honeycomb

Gian Marco Todesco

Honeycombs

A *honeycomb* is a tight packing of polyhedra that allows no gaps. It can be considered the generalization of tessellations in three-dimensional spaces (and more generally in spaces with any number of dimensions).

I will consider a specific tessellation of the three-dimensional hyperbolic space. This space has a non-Euclidean geometry: for example, the volume of balls in this space is not proportional to the cube of the radius, instead, it increases exponentially. In some sense, this space is larger and richer than the familiar Euclidean space, and as we will see, stunning patterns populate it.

Honeycombs are beautiful designs; looking at them sheds light on the space structure. A lovely straightforward example is illustrated in the lithograph *Cubic Space Division* (1952), by the Dutch graphic artist Maurits Cornelis Escher. On this page, it is possible to see a computer rendering inspired by Escher's drawing (Fig. 1). The very nature of the Euclidean space is well represented by the grid of parallel alleys that fade away at infinity.

To make a comparison, I consider a simple tiling of the Hyperbolic plane (Fig. 2). In this tiling, the lines (represented by circle arcs) meet forming right angles (as in the Escher drawing), but the "alleys" continue to branch and move away incapable of keeping the same direction.

G. M. Todesco (✉)
Digital Video, Rome, Italy

© Springer Nature Switzerland AG 2020
M. Emmer, M. Abate (eds.), *Imagine Math 7*,
https://doi.org/10.1007/978-3-030-42653-8_17

Fig. 1 A computer rendering inspired by the Escher's lithography "Cubic Space Division (Cubic Space Filling)"

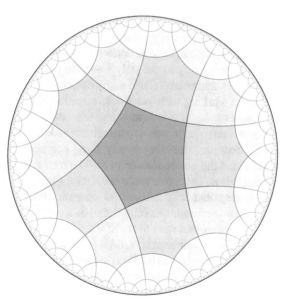

Fig. 2 A regular tessellation of the Hyperbolic plane represented on the Poincaré disk model. The tessellation is named {5,4}: four pentagons meet at each vertex

A Long Digression

I will start with a (Hyperbolic) digression, and for a while will move away from the main subject. The computer program that I will use to explore the Hyperbolic space has been developed for a precise reason that deserves to be narrated. It is a story that involves two errors: the first very creative and engaging, while the second is embarrassing, but led to the creation of beautiful digital images. The title of this article should have been more appropriately:

Tale of two errors
How I lost my way and stumbled upon the Hyperbolic Space

The protagonist of the story is Denis, a 10-year-old boy who went to primary school in a small town near Venice. A secondary school math teacher, Sofia Sabatti, visited Denis's class in the context of the *Progetto continuità:* a programme that allows the students to get to know and be known by future teachers across educational stages.

The teacher handed the pupils some pieces of *Polydron*, a geometric construction toy. The colourful pieces have the shape of regular polygons (squares, equilateral triangles, and many others); all the sides have the same length. The sides are outfitted with ingenious joints that allow snapping together any pair of pieces. With this toy, it is possible to assemble many kinds of polyhedra, with different sizes and complexity.

The exercise assigned to the children was simple: they had to build solids using only one type of face. Despite its simplicity, the task is engaging and leads to many possible discoveries: the five regular convex polyhedra, the surprisingly rich set of deltahedra, the impossibility to use polygons with more than five edges, the difference between convex and concave, and many others.

Our little hero began working with great determination and absolute contempt for the rules. The teacher saw the first results and was smart enough not to blame or interrupt him. The final result was stunning: he had assembled 6 squares, 32 triangles, and 12 decagons, building a very large polyhedron with the same symmetry of the cube and the octahedron (Fig. 3). The model is well built, stable, and robust; rebuilding it is an enjoyable and a satisfactory experience.

It is worth considering that it is unlikely to construct this kind of model by chance. For example, some triangles are connected to a square, but others are not. One must follow a precise mental map to make the correct choice and avoid dead ends. Building the model is a nontrivial task, even for adults; discovering it is much more difficult, requiring imagination in addition to precision. From a didactical point of view, it is interesting that Denis, having decided to disobey the rules, selected a more difficult task compared to the assigned one instead of an easier one.

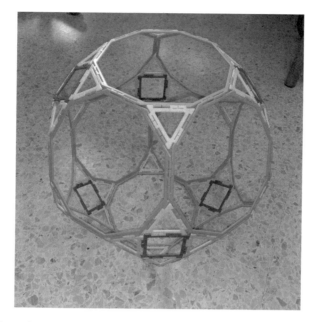

Fig. 3 The "never happening" Denis' polyhedron. Photo courtesy of Sofia Sabatti

Finding the Name

Mathematicians like classifications. While some bad educators may degenerate this attitude into a sterile memorization of names, sorting concepts and inventing groups, it is nevertheless one of the main challenges of math. Names and definitions can contain precious pieces of information. For example, let us consider the concept of *regular polyhedra*. There may seem to be a never-ending variety of solid objects with identical faces; instead, only nine exist (five are convex, and four are star-shaped), which is a fascinating and surprising fact.

Let us consider a negative example and try to find a polyhedron with a different number of sides for each face. We can readily persuade ourselves that such a polyhedron cannot exist. Let us consider the face with the largest number of sides and let us call m this number. This face must have m adjacent faces with the number of sides between three and m. At least two of them must have the same number of sides. So this kind of polyhedron cannot exist. Again an intriguing fact.

The world of polyhedra is so beautiful and exciting that its taxonomy has grown large and complex, and is still growing. A natural question that arises is: what is the name of Denis' polyhedron? It has three types of faces, so it cannot be a regular polyhedron. It has two kinds of vertices (decagon-triangle-square-triangle and decagon-triangle-decagon), so it cannot be a uniform polyhedron. Therefore, it should be a *Johnson solid*: by definition, they are not-uniform, convex polyhedra with regular polygons as faces. In 1966 Norman W. Johnson enumerated 92 Johnson

solids [1], and in 1969 (relatively recently), Victor A. Zalgaller proved that the list is complete.

Surprisingly Denis' polyhedron is not on the list. How is that possible?

Sadly we cannot conclude that Denis discovered a new polyhedron: Zalgaller's demonstration rules this out. We must assume that the polyhedron does not exist or, more precisely, that Denis' model does not represent a polyhedron. It turns out that because the plastic pieces are flexible, their faces are imperceptibly bent (they are not flat polygons) and the hinges along the edges can hide small triangular gaps between adjacent faces. The model is indeed not a polyhedron consisting of regular flat polygons, but this fact does not make it less attractive. It has been used as the logo for "*problemi.xyz*" [2], a website that collects math problems for math teachers.

Near Misses

Beside our model, there are very many entities that are close, but not quite members of the Johnson solids club. Johnson himself found "a number of tantalizingly close misses". The *Johnson solids near-misses* have become an appealing topic. The very definition is not trivial: when exactly a solid can be considered a "near-miss"? Many papers and webpages propose reasonable definitions and compile lists of specimens. Even Wikipedia has a page dedicated to *Near-miss Johnson solids*.

A paper published in 2001 by Craig S. Kaplan and George W. Hart has a section about *Near Misses* and shows three examples. The first one is the Denis model [3].

Evidence of Absence

Maria Dedò, a math professor, wrote the story of the "never happening polyhedron" [4] and challenged herself to prove that the polyhedron does not exist. Of course, we already have a demonstration: the model is not in the Johnson list, and the list is complete (because of Zalgaller's demonstration).

This demonstration is correct, but it is not wholly satisfactory for it says nothing about our model. It would be more helpful to understand exactly where the model failed to be a true polyhedron. To demonstrate that something does not exist is an unusual, stimulating problem.

A possible approach is exploiting the symmetry of our shape.

Figure 4 displays the 12 decagons aligned with a cube. The 12 cube edges split each decagon into two equal parts. For symmetry reasons, we can assume that each decagon forms $45°$ angles with two cube faces. If we assume that edges are one unit long, then the figure is entirely determined by a single parameter D: the distance between the origin and the decagon centres.

Adjacent decagons should share two consecutive vertices. We can compute the distances between the two vertex pairs as functions of parameter D. Equating the

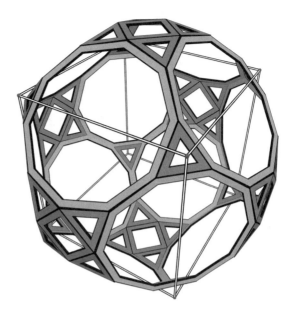

first distance to zero fixes the model and allows us to compute the parameter D and
the distance between the second vertex pair.

The result is small (relative to the length of the edges), but it is not zero: a small
gap separates two adjacent faces. To fill the gap, we must adjust the position of the
second vertex, making the polygon not-planar or not regular.

Another approach considers two adjacent decagons, hinged by a shared segment,
and an equilateral triangle that completes one of the vertices of the Denis model.
The triangle fixes the dihedral angle between the two decagons. Then we add two
more decagons and two more triangles. Figure 5 shows the result. According to
the Denis model, the chain of decagons and triangles should close, and the four
triangles should connect each other, producing the inner square. The figure is
entirely determined (as in the previous case). We can compute the position of all
vertices, and therefore it is possible to compute the distance between the chain ends.
The distance is not nil: it is not even small. The chain does not close, and the gap
is significant. This construction (unlike the previous one) concentrates the defect in
a single point instead of spreading it among the whole model; therefore, the gap is
more substantial.

The Second Error

The "never happening polyhedron" story is a good one. It would be nice to "repair"
the model in order to make it an existing polyhedron. I had the (very wrong) intuition
that the gap between the decagons could change in curved space and could reduce to
zero for a given curvature. This idea, as we will see, is charming, yet utterly wrong.

Fig. 5 Four decagons kept in position by six equilateral triangles. The chain does not close nicely

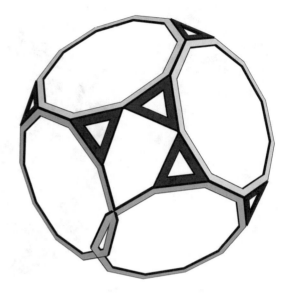

The root of this fake-intuition is a previous edition of this conference. In *Math & Culture, 2009*, I presented a digitally animated representation of another Escher lithography: *Circle Limit III (1959)*. The presentation aimed to show the relations between this drawing and one of the models of Hyperbolic geometry [5].

The Hyperbolic Geometry

The Hyperbolic Geometry is a non-Euclidean geometry.

Two-dimensional Euclidean geometry describes correctly flat surfaces (and surfaces that can be flattened, such as cones and cylinders). Curved surfaces such as spheres or saddles require other geometries. For example, it is easy to see that on the globe, most theorems of Euclidean geometry do not fit: the sum of the angles of a triangle is larger than 180°, and the ratio between the length of a circle and its diameter is less than π. All these geometrical laws are just a good approximation if we consider small parts of the sphere.

An essential difference between the geometry of the flat plane and the geometry of the sphere is the nature of parallel lines (lines that never meet). In Euclidean Geometry, given a line and a point not on it, there is one and only one line parallel to the other. This statement is called *Playfair's axiom* and can be considered equivalent to the *Euclid's fifth postulate*. The statement is not valid on the surface of a sphere: two *lines* (the great circles of the sphere) always cross; therefore, parallel lines do not exist. To describe such a surface we must use a non-Euclidean geometry: the Spherical geometry or the Elliptical geometry (the last one considers a set of antipodal points as a single geometry point; with this smart trick we can say that two

lines intersect in a single point, precisely as the non-parallel line of the Euclidean geometry).

The Hyperbolic geometry goes in the opposite direction: we postulate that there are infinite lines parallel to any given line. Even in this case, the consequences are notable: in the Hyperbolic geometry, the sum of angles in triangles is smaller than 180°, while the ratio between the length of a circle and its diameter is larger than π.

There are many models of Hyperbolic geometry that play the role of the globe for Elliptical geometry, but they are less evident. This fact makes the Hyperbolic geometry slightly less intuitive and more exotic. The model that struck Escher's imagination is the *Poincaré disk model*.

The **points** of the model are inside the unit disk. The **lines** are circle arcs orthogonal to the boundary of the disk or diameters of the disk.

It is possible to demonstrate that two lines meet at most in a single point, and it is clear that for a point not on a line, there are infinite other lines that do not cross the given line.

Angles are measured ordinarily: the Hyperbolic angle between two intersecting lines is equal to the Euclidean angle between the two correspondent curves in the model.

Distance measurement is not straightforward: the scale factor of the model shortens without limit on approaching the disk boundary. If something moves toward the boundary, it appears to shrink more and more. We must consider this effect a sort of perspective deformation: shape and size remain the same despite the alterations of the visual appearance. The Hyperbolic plane and likewise the surface of the sphere, is not flat, but curved: to represent it on a flat surface, it is necessary to accept some deformation. The limiting circle of the Poincaré disk is infinitely far away, and the disk embraces an infinite area.

In Hyperbolic geometry, Euclid's first four postulates are valid; all the theorems and propositions which depend only on them are also correct. Other theorems are entirely different as we have already pointed out.

For instance, similar figures do not exist in the Hyperbolic plane: if two figures have the same shape, they must also have the same size and therefore, they must be congruent. Similarity is an exclusive feature of the Euclidean world. Indeed the mere existence of a pair of similar, non-congruent triangles is equivalent to Euclid's fifth postulate [6].

Two Hyperbolic squares (polygons with four sides with the same length and with equal angles) with different sizes must have different shapes. The interior angles of the two squares must be different (both less than 90°): the biggest square must have the smallest interior angle.

The fact that interior angles depend on the polygon's size is the key feature that makes the Hyperbolic plane so interesting for Escher, the "self-made pattern man", as he defines himself [7]. In Euclidean geometry, interior angles of regular polygons depend only on the number of sides. For instance, each interior angle of a hexagon is always 120°, regardless of the polygon size. Thus it is always possible to put exactly three hexagons around a common vertex so that edges match. This fact constrains the possible tessellations of the plane. We can use only three kinds of

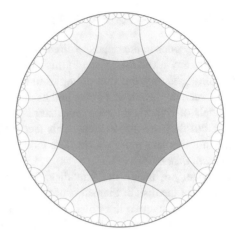

Fig. 6 A regular Hyperbolic tessellation: {8,4}

(a) (b)

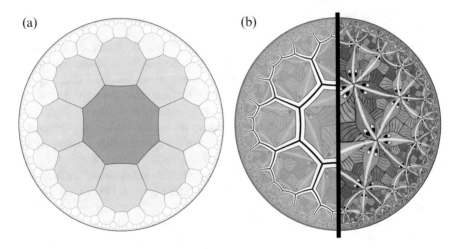

Fig. 7 (**a**) A regular Hyperbolic tessellation: {8,3} (**b**) the structure of Escher's "Circle Limit III"

regular polygons to tessellate the whole plane leaving no gaps: hexagons, squares and triangles.

Conversely, Hyperbolic geometry honours its name by offering a hyperbolical amount of choices. We can adjust the interior angle making it small as we like, just by changing the polygon size. Therefore, we can make tessellation with any polygon (Fig. 6).

Figure 7 shows a tessellation made of octagons in the Poincaré disk and a digital rendering of Escher's masterpiece *Circle Limit III*, built on top of this tessellation. All the octagons (and all the Escher's fishes) are congruent, but the model distortion changes their Euclidean visual appearance in the model.

The computer can animate the rendering translating the whole tessellation in the Hyperbolic plane. Through the animation, small octagons near the boundary grow larger while they approach the centre and then shrink again, moving toward the opposite side.

A Possible Fix for the Denis' Polyhedron?

Figure 8 shows two triples of octagons around a vertex. The Hyperbolic size of the first triplet is too small: the interior angles of the octagons are too large, and the octagons overlap. The computer animation allows to increase the octagons size slowly until the angle is precisely 120° and the three tiles fit nicely together.

There is a tempting analogy with Fig. 5: the assemblage of four pairs of decagons and triangles. Here too, the angles are wrong, and the two decagons at the ends of the chain overlap.

We could consider assembling the model in a curved, Hyperbolic space. Maybe the angles could be different, yielding to a better result. Then we could adjust the angles by changing the model size and trying to find a perfect match.

Sadly, as we will see, the idea is entirely wrong. Nevertheless, it is a very seductive idea that challenges us to explore the Hyperbolic three-dimensional space.

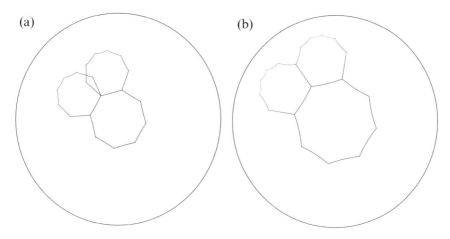

Fig. 8 Two groups of Hyperbolic octagons: (**a**) small size: the octagons overlap as in the Euclidean geometry (**b**) larger size: the octagons fit nicely

The Hyperbolic Space

In the next paragraphs, we will consider a three-dimensional space obeying Hyperbolic geometry. That is a very natural extension of the Hyperbolic plane although it is a somewhat more difficult concept to digest: in the bidimensional case, we can easily imagine curved surfaces (a sphere for Elliptic geometry and a saddle for Hyperbolic geometry) that adequately explain why we need non-Euclidean geometries. This idea also applies to the three-dimensional case, even if it is rather difficult to visualize curved spaces. We could instead measure angles and lengths and verify if the Euclidean theorems are true or false.

If we make the measurements with reasonable precision, we must admit that the space around us appears Euclidean. However, in September 2015, we had stunning evidence that our space can warp, and that therefore it is not flat. The LIGO (Laser Interferometer Gravitational-Wave Observatory) made the first direct observation of gravitational waves: tiny ripples of the spacetime that altered the length of the detector [8]. The deformation was infinitesimal (it is an extraordinary challenge being able to measure it), but its meaning is enormous.

Gravitational waves are minuscule and temporary deformations of the space geometry, but masses create stable deformations. We know that if we were able to measure the sum of the angles of a vast triangle in the Solar System, the result would be noticeably less than 180°. Indeed the Sun's gravity bends the light; we know that light goes straight (it follows the geodesic line of the space) and therefore we must acknowledge that the geometry of our space is authentically not Euclidean.

Of course, the mathematicians like to study even concepts that have no immediate connection with our physical reality, but it is interesting to know that Hyperbolic spaces (both three- and four-dimensional) are helpful mathematical tools to investigate our universe.

The Poincaré Ball

In order to explore Hyperbolic space, we will use a model that is analogous to the Poincaré disk: the Poincaré ball. Hyperbolic **points** are represented by the points inside the unit ball. Ball diameters and specific circle arcs represent the Hyperbolic **lines**. The circle arcs must be contained in the ball, and must be perpendicular to the sphere that bounds the ball. Similarly to the disk model, angles are preserved (Hyperbolic angles are equal to angles in the ball), while distances must be computed with a given formula and appear distorted: Hyperbolic objects closer to the bounding sphere appear smaller when represented in the model, and if a point approaches the sphere, then its distance from the ball centre approaches infinity: from the point of view of the Hyperbolic geometry the bounding sphere is infinitely far.

Our model represents planes as regular planes passing through the origin or spherical surfaces orthogonal to the ball boundary (we consider only the part of the plane or spherical surface inside the ball). We can populate the ball with points, lines, segments, planes and any other geometrical entities we want.

Hyperbolic Transformations

To build and manipulate models in the Poincaré ball, we need some mathematical tools. Moreover, if we want to create a digital representation of the ball and the geometric objects inside it, we must also take care of an efficient implementation of those tools.

Our primary needs are the transformations that move and rotate objects. These belong to the group of transformations that preserve distances: the so-called *isometries* (from two Greek words that mean "equal measure"). Rotation around the ball centre is straightforward; rotation around any other point requires special rules. A possible analogy of Euclidean translation, however, is almost entirely different from the Euclidean case: as we have already noticed, it will change the visual appearance of translated figures; moreover, there is only one translation axis (the line left unchanged by the translation). For comparison, a Euclidean translation leaves a whole family of parallel lines unchanged.

To build the needed transformations, we may start from another isometry, which has a remarkably simple definition in our model: the reflection on a plane. Combining an even number of reflections, we can build direct isometries, that is the analogous of Euclidean rotations and translations. In the Poincaré ball model the reflection on a Hyperbolic plane is represented by the *geometric inversion* in the sphere that contains the plane (if a Hyperbolic plane passes through the origin then it looks like a regular Euclidean plane, and the reflection is straightforward). The inversion is a well-known geometric transformation that fixes points of a sphere and swaps inside and outside points.

Implementation

In computer graphics, it is natural to represent three-dimensional points by homogeneous coordinates: a vector of four numbers represents a point, and two different vectors that are multiples of each other represent the same point.

With this convention, 4×4 matrices can represent many kinds of Euclidean transformations: translations, rotations, perspective projections and many others. The computer graphics boards have dedicated hardware specialized in multiplying 4×4 matrices and 4-vectors very efficiently.

Luckily 4 × 4 matrices can also represent Hyperbolic transformations. Therefore, it is possible to visualize Hyperbolic worlds taking advantage of all the power of modern computers [9].

Building Shapes

Figure 9 visualizes the Hyperbolic ball with some geometric entities inside it. The computer can animate the image in real time while performing Hyperbolic transformations of the visualized objects.

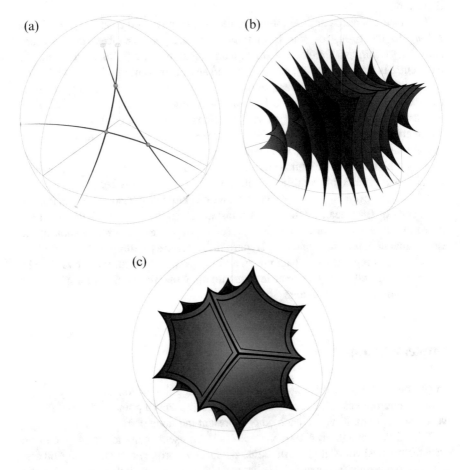

Fig. 9 Geometric objects of the Hyperbolic space represented in the Poincaré ball: (**a**) points and lines (**b**) many squares perpendicular to the same line (**c**) a Hyperbolic regular dodecahedron

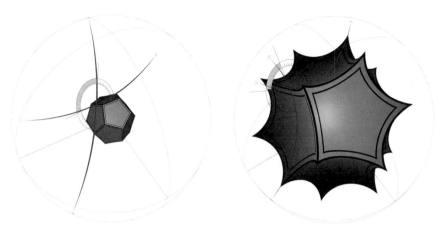

Fig. 10 Two Hyperbolic regular dodecahedra with different size and different dihedral angle

To create a Hyperbolic regular polyhedron, we can exploit the unique role of the origin (the ball centre). We put a small Euclidean polyhedron at the origin and create Hyperbolic points at the polyhedron vertices.

Then we connect these points with Hyperbolic segments and create Hyperbolic faces limited by these segments. The result is a Hyperbolic polyhedron. For symmetry reasons (in the model, Hyperbolic rotations around the origin are represented by Euclidean rotations) we can assume that also the Hyperbolic polyhedron is regular.

The faces appear concave, and the measure of the dihedral angle between two adjacent faces is less than the Euclidean counterpart.

If we change the polyhedron size (changing the size of the seed Euclidean polyhedron), the dihedral angle changes accordingly, as we expected: the bigger the size, the smaller the angle. (Fig. 10).

Denis' Polyhedron

Unfortunately, the dream of being able to correct Denis' polyhedron in the Hyperbolic space stops here. Let us consider the 12 decagons only and recall our previous reasonings: we assumed, for symmetry reasons, that they must be perpendicular to the lines connecting their centres with the centre of the polyhedron. Moreover, we know that such a configuration cannot exist in the Euclidean space: pairs of adjacent decagons can share only a vertex each; a tiny triangular fissure separates the facing edges.

Let suppose that Denis' polyhedron can exist in Hyperbolic space, for a carefully selected edge size. Then we should have a configuration of 12 Hyperbolic decagons

nicely connected, with no gaps. Each pair of adjacent decagons should share two vertices.

If the centre of the Hyperbolic polyhedron was in the ball centre, then (for symmetry reasons) the vertices of any given decagon would lie on the same Euclidean plane and would form a Euclidean regular decagon.

Therefore, we should have had 12 Euclidean regular decagons, with every pair of adjacent decagons sharing an edge, with no gaps.

We know that that is not possible, so we have to admit that even the Hyperbolic version of Denis' polyhedron does not exist.

The Honeycomb

To compensate for the unfortunate discovery, we are going to conclude our quick exploration of Hyperbolic space by building a beautiful model.

We had seen that if we change the size of a regular Hyperbolic polyhedron, the dihedral angles change as well, as we expected. That allows us to create the three-dimensional analogues of the beautiful tessellations on the Poincaré disk. We will build only one of these tessellations, but their number is infinite (as in the bidimensional case).

We start with a regular Hyperbolic dodecahedron and carefully adjust its size so that the dihedral angle is precisely 90°. In the Poincaré ball, we translate the model so that one vertex lies in the origin. The three edges that share that vertex appear to be straight segments in the model; these segments are all perpendicular to each other, and the whole polyhedron fits nicely into an octant. Using the reflection transformation, we can create seven replicas of the dodecahedron, filling the whole space around the origin with no gaps.

The replication process can continue forever: the space occupied by the polyhedra is bounded by pentagonal faces; each one of these pentagonal faces belongs to just one dodecahedron. We select one of these faces and the related dodecahedron; then we create a copy of that dodecahedron by reflecting it on the Hyperbolic plane passing through the face. The symmetry of the model ensures that there are no overlaps or fissures between adjacent dodecahedra.

Figure 11 shows a step of the process. We translated the model again so that a dodecahedron sits in the origin. With such large polyhedra, the visual shrinking effect is substantial: the dodecahedra in adjacent shells are smaller and smaller; already in the third shell they are minuscule. On the other side, their number is immense. The whole set resembles dandelion fluff.

Fig. 11 A Hyperbolic
honeycomb in the Poincaré
ball. Four regular
dodecahedra meet around
each edge. The honeycomb is
named {5,3,4}

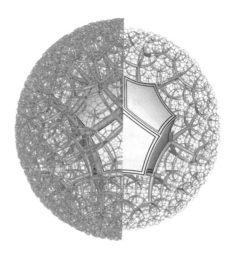

Floating in the Hyperbolic Space

We can change the point of view and look at the pattern from the origin of the
ball. We will see an immense web of curved lines. At each vertex three lines
meet, forming right angles. It is very natural to highlight this feature by visualizing
vertices as large cubes and edges as square-section bars. The resulting visual
representation recalls Escher's *Cubic Space Division,* the image from which we
started (Fig. 12).

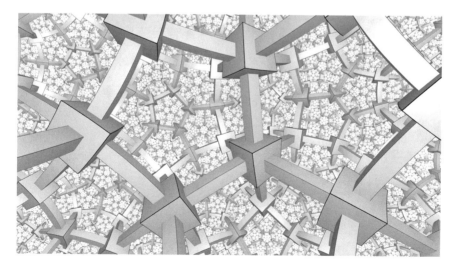

Fig. 12 Inside the Hyperbolic honeycomb

In the computer-generated image, as in Escher's drawing, details fade away into the distance. This visual effect is also a trick to limit the complexity of the drawing. Even using this trick, the amount of objects that the computer has to draw is immense.

Luckily (as we have already noticed) the graphical board helps us and therefore the last computer animation allows us to float in the Hyperbolic space, following one of the lines while the others diverge and branch out to infinity.

References

1. N. Johnson, Convex polyhedra with regular faces. Can. J. Math. **18**, 169–200 (1966). https://doi.org/10.4153/CJM-1966-021-8
2. M. Dedò, S. Sabatti, Problemi per matematici in erba. http://problemi.xyz
3. C.S. Kaplan, G.W. Hart, Symmetrohedra: Polyhedra from symmetric placement of regular polygons, in *Bridges* (2001)
4. M. Dedò, C'è bisogno di 'spirito geometrico': qualche esempio, in *L'insegnamento della matematica e delle scienze integrate*, vol. 41 A–B, n 5 (novembre-dicembre 2018)
5. G.M. Todesco, MC Escher e il piano iperbolico, in *Matematica e cultura 2010* (Springer, Milano, 2010), pp 129–143
6. G.E. Martin, *The Foundations of Geometry and the Non-Euclidean Plane* (Springer, New York, 2012), p. 278
7. H.S.M. Coxeter, The non-Euclidean symmetry of Escher's picture 'Circle Limit III'. Leonardo, 19–25 (1979)
8. C. Zhao, D.G. Blair, First direct detection of gravitational waves. Natl. Sci. Rev. **4**(5), 681–682 (2017)
9. M. Phillips, C. Gunn, Visualizing hyperbolic space: Unusual uses of 4 x 4 matrices. SI3D **92**, 209–214 (1992)

Explaining Cybersecurity
with Films and the Arts

Luca Viganò

Introduction

Inspired by the *Explainable Artificial Intelligence (XAI)* program of the Defense Advanced Research Projects Agency (DARPA) of the United States Department of Defense, Daniele Magazzeni and I proposed a new paradigm in security research: *Explainable Security (XSec)*. In [36], we discussed the "Six Ws" of XSec (Who? What? Where? When? Why? and How? as summarized in Fig. 1) and argued that XSec has unique and complex characteristics: XSec involves several different stakeholders (i.e., the system's developers, analysts, users, and attackers) and is multi-faceted by nature, as it requires reasoning about system model, threat model, and properties of security, privacy, and trust as well as concrete attacks, vulnerabilities, and countermeasures. We defined a road map for XSec that identifies several possible research directions.

In this paper, I address one of these directions. I discuss how a number of basic cybersecurity notions (and even several advanced ones) can be explained with the help of some well-known popular movies and other artworks, and some perhaps less obvious ones. I focus in particular on anonymity, pseudonymity, and authentication, but similar explanations can be given for other security properties, for the algorithms, protocols, and systems that have been developed to achieve such properties, and for the vulnerabilities and attacks that they suffer from.

In [36], we gave a detailed list of who gives the explanations but also who receives them and pointed out that the recipients of the explanations might be varied, ranging from experts to laypersons; in particular, non-expert users will need to receive an explanation of how to interact with a security system, why the system

L. Viganò (✉)
Department of Informatics, King's College London, London, UK
e-mail: luca.vigano@kcl.ac.uk

© Springer Nature Switzerland AG 2020
M. Emmer, M. Abate (eds.), *Imagine Math 7*,
https://doi.org/10.1007/978-3-030-42653-8_18

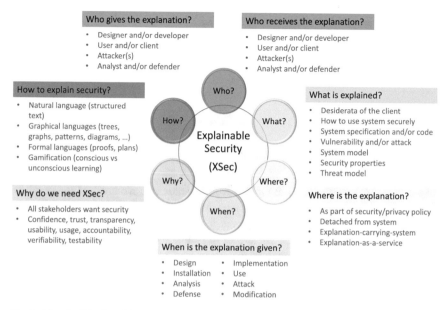

Fig. 1 The six Ws of explainable security (from [36])

is secure, and why it carries out a particular action. To that end, it will be necessary to explain the security notions, properties, and mechanisms in a language, and in a way, that is understandable by the laypersons and does not scare them off. In practice, however, users are rarely given such explanations and thus end up being frustrated and disillusioned by security systems, which might lead them to making mistakes that turn the systems into systems vulnerable to attacks. Clear and simple explanations with popular movies and the arts allow experts to target the laypersons, reducing the mental and temporal effort required of them and increasing their understanding, and ultimately their willingness to engage with security systems.

One way to do that would be to refer to the myriad of movies, TV series, and books about hackers and cybersecurity in general, some of which are quite realistic in their depiction of cyberattacks (e.g., *Sneakers* [28], *Live Free or Die Hard* [40], *The Girl with the Dragon Tattoo* [14, 25], *Mr. Robot* [13]), some are more, let us say, "inventive," giving hackers and code breakers almost superhero-like abilities (e.g., *Fortress* [15], *The Net* [39], *Hackers* [33], *Swordfish* [31] as well as *Independence Day* [12] in which humans are able to log into the network of the alien ships and infect them with a computer virus, as a fairly unrealistic reference to the way in which Martian invaders are killed by an onslaught of earthly germs in the 1898 novel *The War of the Worlds* by H.G. Wells [38], famously adapted for the radio by Orson Wells in 1938 and for the screen by Steven Spielberg and many others).

In future work, I plan to conduct studies and surveys to quantify to what extent such quite technical movies can help in explaining cybersecurity to laypersons. My feeling is that these movies are mainly aiming to stimulate sympathy in a young

and nerdie, tech-savvy audience and at the same time elicit a "wow" response in the non-expert audience. That is, they are trying to impress (and to advance the plot and our recognition of the hero(s) as the special one(s)), rather than trying to make the audience understand. In this paper, I will instead take a different approach and focus on popular movies and artworks, where cybersecurity is not the main theme or plot keyword, and show how even these can be used to explain cybersecurity notions.

Security Properties Explained

Picture this. A battlefield, 71 B.C. The Roman soldiers have crushed the revolt of the gladiators and slaves led by Spartacus. Many of the rebels have been killed in the battle, while Spartacus, his right-hand man Antoninus, and the other surviving rebels have been captured and are sitting in chains on a hillside. There is just one catch: the Romans do not know who Spartacus is. So, the Roman general addresses the prisoners:

> I bring a message from your master, Marcus Licinius Crassus, commander of Italy. By command of his most merciful excellency, your lives are to be spared. Slaves you were and slaves you'll remain, but the terrible penalty of crucifixion has been set aside under single condition that you identify the body or the living person of the slave called Spartacus.

A beat. Spartacus stands up and opens his mouth to speak, but Antoninus (who was aptly sitting at Spartacus' right) leaps to his feet and shouts "I'm Spartacus!", quickly followed by the slave to Spartacus' left. To the bewilderment of the real Spartacus and of the Roman general, soon each of the prisoners around Spartacus is insisting "I'm Spartacus!" (well, actually, everyone except Spartacus himself).

This is probably the most famous scene of the movie *Spartacus* [19] and the original novel by Howard Fast contains a similar narration, but the script by Dalton Trumbo and the mise-en-scène by Stanley Kubrick turned it into a crisper and more powerful scene.[1]

What just happened? In order to protect Spartacus, Antoninus and the other prisoners have created what in technical terms is called an *anonymity set*: given that all the prisoners are claiming to be Spartacus, it is impossible for the Romans to identify who is the real Spartacus. In other words, Spartacus is *anonymous* as he is not identifiable within the set of the prisoners.

[1] So powerful that it has been imitated, referenced, or parodied in several other movies, TV shows, and even advertisements, such as in the "O Captain! My Captain!" scene in *Dead Poets Society* [37] although the reason for which the students climb on their desks is quite different from that of Spartacus' rebels as the students want to salute their English teacher, Professor Keating, who has taught them so much and encouraged them to live their dreams and fight the status quo. As an example of a parody of the scene, in *Monty Python's Life of Brian* [16] the situation is reversed by depicting an entire group undergoing crucifixion all claiming to be Brian after a Roman centurion has announced that Brian is eligible for release: "I'm Brian.", "Eh, I'm Brian!", "I'm Brian! I'm Brian!', and finally "I'm Brian, and so's my wife."

Fig. 2 Find the Panda

One can of course give a formal definition of *anonymity* [26]—and this is what one would do in front of an expert audience, say in a talk at a conference or in a university lecture on cybersecurity—but the point here is that even non-specialists immediately understand what Antoninus and the other prisoners are doing and why. In fact, I dare say that we all more or less intuitively understand that anonymity cannot exist in a vacuum (one cannot be anonymous by oneself) but rather requires a large enough set of similar "things," a large enough set of similar people, actions, messages, etc. so that one's identity, actions, or messages are not distinguishable from those of the others and thus not identifiable. This intuition is so common that there are even games and puzzles that exploit anonymity sets such as the *Find the Panda* puzzle in Fig. 2 (created by reader "ste1" of the "Bored Panda" website, https://www.boredpanda.com/find-the-panda-illustrated-puzzle-star-wars-edition-ste1/).

As another example, consider the climactic scene at the end of *The Thomas Crown Affair* [21], in which the businessman and art collector Thomas Crown returns a painting that he has stolen at the beginning of the movie from a museum in

New York City.[2] Even though he had announced that he would return the painting, Thomas Crown manages not to get caught by being *unobservable* as he walks around in the museum: he has hired a number of "extras" to also pace through the corridors of the museum and up and down its staircases, carrying the same briefcase that he is carrying and dressed exactly him, namely like the man in a bowler hat in René Magritte's paintings *Golconda* and *The Son of Man*; a copy of the latter hangs in Crown's office, hiding a safe storage space, as shown earlier in the movie. The fact that there are plenty of messages circulating in a network and that such messages all look alike is the main idea underlying the way in which *Mix Networks* realize unobservability and untraceability of messages [9], and thus provide a basis for anonymous communication, emailing, and voting.[3]

This has been set up well by the screenwriters: as an anticipation of what is going to happen in the climactic scene, midway through the movie Thomas Crown takes Catherine Banning, an insurance investigator who has been tasked of recovering the stolen painting, to that same museum on their first "date," although they are still quite confrontational with each other and have not yet fallen in love. A copy of *The Son of Man* hangs there too and when they walk by it, Banning says to Crown:

> Hey, I didn't know your portrait was here! The faceless businessman in a bowler hat. Everything but the briefcase.

This is not only a possible inspiration and foreshadowing for Crown's "unobservability trick," but also prepares us, the audience, to accept that the bowler hat businessman with a briefcase is "faceless" and thus indistinguishable from others who look like him. It stimulates our intuitive understanding of indistinguishability, unobservability, and untraceability so that when Crown fools the police by playing his trick in the movie's denouement we, the audience, are not only not fooled by the trick but also ready to accept it and embrace it, and thus rejoice at the hero's escape.

Similar intuitive definitions can be given of other security properties. For instance, since anonymity is difficult to achieve (as it requires building a very large anonymity set) and is often fraught with legal issues, one could be satisfied with being *pseudonymous*, which is a state of disguised identity (whereas anonymity may be defined as a state of non-identifiable, unreachable, untrackable, or unlinkable identity) [26]. The use of *pseudonyms* and the difficulty of carrying out *pseudonym resolution* to reconcile a pseudonym to its true name[4] can also be explained by means of films and the arts. For example, one could ask the question "Who is Batman?" The answer could be "Bruce Wayne," referring to the wealthy industrialist who dons the batsuit to fight crime, or it could be "one of Adam West, Michael

[2]The museum is never mentioned by name, but there are a number of clues that point to the Metropolitan Museum of Art.

[3]Interestingly, that scene of *The Thomas Crown Affair* provides also a very intuitive example for *steganography*, which is the practice of concealing a message, file, image, or video within another message, file, image, or video.

[4]Similarly, *name resolution* is a method of reconciling an IP address to a user-friendly computer name.

Keaton, Val Kilmer, George Clooney, Christian Bale, Ben Affleck, Will Arnett (who voices Lego Batman), or Robert Pattinson," some of the main actors who played Batman in TV shows and movies. Both are correct answers, depending on the context and on the time of the question, much in the same way pseudonym resolution and name resolution work on the Internet.[5]

One could similarly ask "Who is Superman?" and receive as an answer the names of the actors who played Superman ("Kirk Alyn, George Reeves, Christopher Reeve, Brandon Routh, Henry Cavill, or Channing Tatum") or Superman's alter ego "Clark Kent." But, actually, Clark Kent is a mask and Kal-El is the real being, which humans refer to as Superman.[6] Resolving or discovering the identity of an "entity" (a person or a digital entity such as a process, a client, or a server) is a challenging research problem, with applications in cybersecurity that range from discovering who really is the entity behind an email address to forensic attribution of cyberattacks (e.g., [17]).

Several techniques and mechanisms have been designed to provide *entity authentication*, i.e., let one party prove the identity of another party. Cryptographic protocols such as the *Kerberos Protocol* [18] or the *Single Sign-On Protocol* [24] have been developed to that end. However, cryptographic protocols (a.k.a. security protocols) are notoriously difficult to get right and several attacks have been discovered by carrying out a formal analysis using automated tools, e.g., [3, 4]. Films and artworks can help explain such attacks as well.

As a concrete example, consider the man-in-the-middle attack on the SAML-based Single Sign-On for Google Apps described in [3]. The management of multiple usernames and passwords is not only an annoying aspect of the Internet, it is also one of the most serious security weaknesses, since users often use the same password for multiple accounts or choose passwords that are easy to remember, which makes it easy for an attacker to guess them. *Single Sign-On (SSO) protocols* tackle this problem by enabling entities (companies, associations, institutions or universities, etc.) to establish a federated environment in which clients sign in the environment once and are then able to access services offered by different providers in the federation. The *Security Assertion Markup Language 2.0 Web Browser SSO Profile* is one of the standards on which several established software companies have based their SSO implementations. Google, for instance, developed a SAML-based SSO for its Google Applications Premier Edition, a service for using custom domain names with several Google web applications such as Gmail,

[5]This is tightly connected to the *metaphysics of identity*, as exemplified, for instance, by the paradox of the *Ship of Theseus*, which is commonly attributed to the Greek philosopher Plutarch [27], although it had been discussed by other ancient philosophers prior to Plutarch, most notably Heraclitus and Plato, and was addressed more recently by Thomas Hobbes and John Locke.

[6]This holds according to the standard interpretation of Superman's identity, but there is a huge ongoing debate as to which of the identities (Superman/Kal-El or Clark Kent) is the real being and which is the façade. Google "Clark Kent" and be prepared to be fascinated by the philosophical depth of the arguments. I recommend also checking out the brilliant monologue on Superman that Bill delivers at the end of *Kill Bill: Vol. 2* [34].

Fig. 3 SAML 2.0 web browser SSO profile (from [3])

Google Calendar, and Google Docs. The protocol is shown in Fig. 3. In a nutshell, the protocol works as follows: a client C aims at getting access to a service or a resource that is located at the address URI and is provided by the service provider SP, which is one of the service providers in the federated environment; to that end, SP issues an authentication request of the form AuthReq(ID, SP), where ID is a string uniquely identifying the request; the identity provider IdP, who presides over the federated environment as the certification authority able to authenticate the different clients, challenges C to provide valid credentials (this is typically taken care of at the beginning of the session when the client types in its username and password) and, upon successful authentication, IdP builds an authentication assertion AuthAssert(ID, C, IdP, SP) and digitally signs it with its private key K_{IdP}^{-1}, which is denoted symbolically by writing $\{AuthAssert(ID, C, IdP, SP)\}_{K_{IdP}^{-1}}$; SP checks the authentication assertion and, acknowledging the power of the IdP to issue authentication assertions in the federated environment, provides the resource to C.

However, carrying out a digital signature of a long message such as the authentication assertion is computationally expensive and might slow down the interaction between the user and the machine, so, in their original implementation of this protocol, Google's engineers decided to simplify the authentication assertion by removing two of its parameters, ID and SP, as shown in Fig. 4.

Armando et al. [3] formalized a model of this protocol and, by using SATMC, a state-of-the-art model checker for security protocols that is embedded in both the AVANTSSAR Platform [4] and the SPaCIoS Tool [35], they were able to discover the attack that is illustrated in Fig. 5 by considering the following scenario. Let IdP be a hospital, C be a doctor employed by the hospital, and SP a medical insurance company. The doctor C initiates the protocol in order to get access to a resource provided by the insurance company SP, say to update the information about one of the doctor's patients who is insured by SP. However, as is common in the Internet, there is no guarantee that the agents participating in a protocol

Fig. 4 SAML-based SSO for Google Apps (original, flawed, implementation)

are all honest (if that were the case, then we would need no cryptographic protocols but simply send messages in the clear without any cryptography at all) and a dishonest insurance company (as denoted by the orange bandit) might want to acquire confidential information about the patient. Thanks to the simplified signed authentication assertion $\{AuthAssert(C, SP)\}_{K_{IdP}^{-1}}$, which in this scenario is $\{AuthAssert(doc, H)\}_{K_H^{-1}}$, the dishonest insurance company is able to start another session of the protocol in which it engages with another service provider but pretending to be the doctor. For instance, the other service provider could be Google Mail or Docs and the insurance company could log in as the doctor and read confidential information about the patient in the doctor's email or online documents. The dishonest service provider thus acts as a man-in-the-middle that participates in two sessions of the protocols: one in which it acts under its real name (as the service provider SP) and one in which it pretends to be the client (the doctor doc).

Figure 5 illustrates this man-in-the-middle attack succinctly but I frankly doubt that a non-expert has been able to follow all the details of the explanation that I have just provided, even though I omitted several technical details and carried out a number of simplifications. Popular movies and the arts can again come to our rescue in explaining this attack in a simple and intuitive way.

The signed authentication assertion is basically a certificate issued by the Identity Provider IdP with which the client C can authenticate itself to a service provider SP. The attack is due to IdP simply (and wrongly) issuing a simplified certificate $\{AuthAssert(C, IdP)\}_{K_{IdP}^{-1}}$ that intuitively says "I certify that this is the client C. Signed: The Identity Provider IdP," so that when the dishonest service provider is shown the certificate, it can first copy it and then claim to be the client C in another protocol session.

This can be explained by analogy with the "carte blanche" issued to Milady De Winter by Cardinal Richelieu in *The Three Musketeers* by Alexandre Dumas père [11], which has been adapted a large number of times for the screen and

Fig. 5 Attack on the SAML-based SSO for Google applications

television both in live-action and animation. Let us consider the 1948 movie version [32], which merges and slightly rewrites a number of episodes in the novel.

Cardinal Richelieu, who wants war between France and England, plans to expose the tryst between Queen Anne of France and the Duke of Buckingham. To that end, he requests the services of Milady De Winter, who, in addition to proper compensation, also asks for something else:

Richelieu:	What are your terms?
Milady:	I shall need something from you.
Richelieu:	Of course.
Milady:	In writing. A carte blanche.

A carte blanche is literally a blank sheet of paper with a signature at the bottom. In this case, Richelieu gives Milady a signed letter that excuses her actions as under orders from the Cardinal himself. However, Richelieu commits a mistake: not wanting to include the name of Milady in the letter, as that would tie her to him, he issues a letter that states:

> It is by my order and for the benefit of the State that the bearer of this note has done what has been done. Signed: Richelieu.[7]

At the end of the movie, after Richelieu's plot has been subverted and Milady executed, d'Artagnan and the three musketeers stand in front of King Louis XIII and Richelieu, who accuses them of treason and of the murder of Milady. d'Artagnan

[7] Actually, the script of the 1948 movie [32] contains a slight mistake as the text of the letter in that movie is: "It is by my order and for the good of the State that the bearer of this has done what he has done. Signed: Richelieu.", which makes it difficult for a woman to use this letter.

then produces the letter from a pocket and reads it out. The King inspects the letter and hands it to Richelieu:

Richelieu: That's a forgery. This isn't theirs. I gave this paper to...
King: To whom, Richelieu?

Richelieu does not answer but simply laughs nervously, although one can spot a hint of admiration in his laugh for the clever trick that the musketeers played. He knows that he has been tricked and that the fault is his: he did not put the name of the bearer of the letter on the paper he signed so that d'Artagnan can reuse it pretending to be the original bearer, much in the same way as the hospital signed an authentication that only contained the name of the doctor but not that of the service provider the certificate was meant for, so that a dishonest service provider can then use it to claim to be the doctor.[8]

The solution to the man-in-the-middle attack is to restore the deleted information in the authentication assertion (or to write explicitly the name of Milady in the letter), as Google did in the new implementation of their protocol that they produced after Armando et al. notified them about the attack.

Concluding Discussion: Towards Explainable Security

Obviously, such "popular" explanations are not meant to replace the mathematical definitions and explanations. On the contrary, the mathematical definitions that can be given of these security notions are a fundamental technical add on, on top of our intuition. The problem is that sometimes when teaching, or when explaining, cybersecurity, the experts forget (or do not know how) to refer to the intuition and only focus on the technical definition, thereby possibly frustrating and scaring off much of the audience. A clear and simple explanation, with something that they are already familiar with, such as a non-security related movie or novel like Spartacus or The Three Musketeers, would have made audience members less irritated, stressed, and annoyed, and thus more receptive. Explanations with popular films and the arts can reduce the mental effort required of the laypersons and increase their understanding, and ultimately their willingness to engage with security systems.

I have been using films to explain security for the last 15 years or so, both in my lectures and in public engagement talks, and this is the first of a series of papers that I plan to write on using popular films and artworks to explain cybersecurity. I will, in particular, consider other properties and security notions and investigate the links with *usable security*, *security awareness*, and *security economics* (see the

[8] As another example, consider the two letters of transit in the movie *Casablanca* [10], which allow the bearers to leave Vichy France territory and travel freely around German-occupied Europe and to neutral Portugal, and then to freedom, likely in the USA. The letters were invented as a "MacGuffin" by Joan Alison for the original play and never questioned, even though they are an obvious logical flaw.

references in [36]), and with the *NASA-Task Load Index (NASA-TLX)* and other workload models.

It will also be interesting to investigate the relationships between explaining security with films and the arts and the growing body of literature on using film to explain and teach different disciplines such as (to name only a few):

- philosophy [1, 2, 6, 22, 23],
- history [20],
- social sciences [30],
- management and organizational behavior [7, 8], and
- mental illness [29].

There is much to be learned from these approaches, and it might even be possible to adopt or adapt some of these techniques and tools to the case of explaining security. There is also the database recently developed by Blasco and Quaglia [5] to use films for information security teaching: while their motivation and goal are quite different from the ones of this paper, their database is very interesting and useful, and I plan to investigate possible synergies between their approach and mine.

Acknowledgments This work was supported by the King's Together Multi and Interdisciplinary Research Scheme, King's College London, UK.

References

1. T. Ariemma, *Niente resterà intatto (Introduzione non-convenzionale alla filosofia)* (Diogene Edizioni, Rome, 2015)
2. T. Ariemma, *La filosofia spiegata con le serie TV* (Mondadori, Milan, 2017)
3. A. Armando, R. Carbone, L. Compagna, J. Cuéllar, M. Llanos Tobarra, Formal analysis of SAML 2.0 web browser single sign-on: breaking the SAML-based single sign-on for Google Apps, in *Proceedings of the 6th ACM Workshop on Formal Methods in Security Engineering, FMSE 2008, Alexandria, VA, October 27, 2008* (ACM Press, New York, 2008), pp. 1–10
4. A. Armando, W. Arsac, T. Avanesov, M. Barletta, A. Calvi, A. Cappai, R. Carbone, Y. Chevalier, L. Compagna, J. Cuéllar, G. Erzse, S. Frau, M. Minea, S. Mödersheim, D. von Oheimb, G. Pellegrino, S.E. Ponta, M. Rocchetto, M. Rusinowitch, M.T. Dashti, M. Turuani, L. Viganò, The AVANTSSAR platform for the automated validation of trust and security of service-oriented architectures, in *Tools and Algorithms for the Construction and Analysis of Systems – 18th International Conference, TACAS 2012, Held as Part of the European Joint Conferences on Theory and Practice of Software, ETAPS 2012, Tallinn, Estonia, March 24– April 1, 2012. Proceedings*. LNCS, vol. 7214 (Springer, Berlin, 2012), pp. 267–282
5. J. Blasco, E.A. Quaglia, InfoSec Cinema: Using Films for Information Security Teaching, in *2018 USENIX Workshop on Advances in Security Education, ASE 2018* (USENIX Association, Berkeley, 2018)
6. J. Cabrera, *Da Aristotele a Spielberg. Capire la filosofia attraverso i film* (Bruno Mondadori editore, Milan, 2007)
7. J.E. Champoux, *Management: Using Film to Visualize Principles and Practice* (South-Western, Cincinnati, 2000)
8. J.E. Champoux, *Organizational Behavior: Using Film to Visualize Principles and Practices* (South-Western, Cincinnati, 2000)

9. D. Chaum, Untraceable electronic mail, return addresses, and digital pseudonyms. Commun. ACM **24**(2), 84–88 (1981)
10. M. Curtiz (directed by), *Casablanca*. Screenplay by Julius J. Epstein, Philip G. Epstein and Howard Koch based on the play by Murray Burnett and Joan Alison (1942). https://www.imdb.com/title/tt0034583/
11. A. Dumas père (avec la collaboration d'Auguste Maquet), *Les Trois Mousquetaires* (Le Siècle, 1844)
12. R. Emmerich (directed by), *Independence Day*. Screenplay by Dean Devlin and Roland Emmerich (1996). https://www.imdb.com/title/tt0116629/
13. S. Esmail (created by), *Mr. Robot*, 2015–2019. 4 seasons, 45 episodes. https://www.imdb.com/title/tt4158110/
14. D. Fincher (directed by), *The Girl with the Dragon Tattoo*. Screenplay by Steven Zaillian based on the novel by Stieg Larsson (2011). https://www.imdb.com/title/tt1568346/
15. S. Gordon (directed by), *Fortress*. Screenplay by Troy Neighbors, Steven Feinberg, David Venable and Terry Curtis Fox (1992). https://www.imdb.com/title/tt0106950/
16. T. Jones (directed by), *Monty Python's Life of Brian*. Screenplay by Graham Chapman, John Cleese, Terry Gilliam, Eric Idle, Terry Jones, Michael Palin (1979). https://www.imdb.com/title/tt0079470/
17. E. Karafili, M. Cristani, L. Viganò, A formal approach to analyzing cyber-forensics evidence, in *Proceedings of ESORICS 2018, Part I*. LNCS, vol. 11098 (Springer, Cham, 2018), pp. 281–301
18. Kerberos: The Network Authentication Protocol (2015). https://web.mit.edu/kerberos/
19. S. Kubrick (directed by), *Spartacus* Screenplay by Dalton Trumbo based on the novel by Howard Fast (1960). https://www.imdb.com/title/tt0054331/
20. A.S. Marcus, S.A. Metzger, R.J. Paxton, J.D. Stoddard (eds.), *Teaching History With Film: Strategies for Secondary Social Studies*, 2nd edn. (Routledge, New York, 2018)
21. J. McTiernan (directed by), *The Thomas Crown Affair*. Screenplay by Leslie Dixon and Kurt Wimmer, story by Alan R. Trustman (1999). https://www.imdb.com/title/tt0155267/
22. R. Mordacci, *Al cinema con il filosofo (Imparare ad amare i film)* (Mondadori, Milan, 2015)
23. R. Mordacci (ed.), *Come fare filosofia con i film* (Carocci editore, Rome, 2017)
24. OASIS, Security Assertion Markup Language (SAML) v2.0 (2005). https://www.oasis-open.org/committees/tc_home.php?wg_abbrev=security
25. N.A. Oplev (directed by), *The Girl with the Dragon Tattoo*. Screenplay by Nikolaj Arcel and Rasmus Heisterberg based on the novel by Stieg Larsson (2009). https://www.imdb.com/title/tt1132620/
26. A. Pfitzmann, M. Hansen, A terminology for talking about privacy by data minimization: anonymity, unlinkability, undetectability, unobservability, pseudonymity, and identity management (Version v0.34), August 10 (2010). https://dud.inf.tu-dresden.de/literatur/Anon_Terminology_v0.34.pdf
27. Plutarch (Translated by John Dryden), Theseus. The Internet Classics Archive. https://classics.mit.edu/Plutarch/theseus.html
28. P.A. Robinson (directed by), *Sneakers*. Screenplay by Phil Alden Robinson, Lawrence Lasker and Walter F. Parkes (1992). https://www.imdb.com/title/tt0105435/
29. L.C. Rubin (ed.), *Mental Illness in Popular Media: Essays on the Representation of Disorders* (McFarland & Co, Jefferson, 2012)
30. W.B. Russell III, The art of teaching social studies with film. Clearing House: J. Educ. Strategies Issues Ideas **85**(4), 157–164 (2012)
31. D. Sena (directed by), *Swordfish*. Screenplay by Skip Woods (2001). https://www.imdb.com/title/tt0244244/
32. G. Sidney (directed by), *The Three Musketeers*. Screenplay by Robert Ardrey based on the novel by Alexandre Dumas père (and Auguste Maquet) (1948). https://www.imdb.com/title/tt0040876/
33. I. Softley (directed by), *Hackers*. Screenplay by Rafael Moreu (1995). https://www.imdb.com/title/tt0113243/

34. Q. Tarantino (directed by), *Kill Bill: Vol. 2*. Screenplay by Quentin Tarantino (2004). https://www.imdb.com/title/tt0378194/
35. L. Viganò, The SPaCIoS project: secure provision and consumption in the internet of services, in *IEEE Sixth International Conference on Software Testing, Verification and Validation (ICST)* (IEEE, Piscataway, 2013), pp. 497–498
36. L. Viganò, D. Magazzeni, Explainable security, in *Proceedings of the 6th Workshop on Hot Issues in Security Principles and Trust (HotSpot 2020), affiliated with Euro S&P 2020, 7 September 2020, Genova, Italy* (IEEE, Piscataway, 2020)
37. P. Weir (directed by), *Dead Poets Society*. Screenplay by Tom Schulman (1989). https://www.imdb.com/title/tt0097165/
38. H.G. Wells, *The War of the Worlds* (William Heinemann, London, 1898)
39. I. Winkler (directed by), *The Net*. Screenplay by John Brancato and Michael Ferris (1995). https://www.imdb.com/title/tt0113957/
40. L. Wiseman (directed by), *Live Free or Die Hard*. Screenplay by Mark Bomback based on a story by Mark Bomback and David Marconi, on an article by John Carlin and on characters by Roderick Thorp (2007). https://www.imdb.com/title/tt0337978/

Part IX
Mathematicians

A Portrait of the Mathematical Tribe

Marco LiCalzi

Introduction

In 2009, the photographer Marianna Cook published a fascinating collection of 92 photographic portraits of mathematicians [1]; see also [2]. Her single-page preface to the book exudes the same insight and sensibility that animate her pictures. The first sentence, presumably written after having met and photographed so many of them, claims that "mathematicians [. . .] may look like the rest of us, but they are not the same." If the external appearance is the same, the differences must be somewhere else: here we sketch a (verbal) portrait of what makes them a distinct tribe.

There are of course brilliant epigrams that zero in on a single difference at a time. For instance, Godfrey H. Hardy[1] (1877–1947) writes in *A Mathematician's Apology* that "a mathematician, like a painter or a poet, is a maker of patterns. If his patterns are more permanent than theirs, it is because they are made with *ideas*." But an honest portrait should muster more, and pay attention to the culture, the mores, and the activities of the community.

Our canvas begins with the anthropological viewpoint. The online *Encyclopædia Britannica* states that a tribe is "a notional form of human social organization based on a set of smaller groups (known as bands), having temporary or permanent political integration, and defined by traditions of common descent, language, culture, and ideology." Wishing to expand our color palette, we combed a few more dictionaries and crafted our portrait of the mathematical tribe as a group whose members are aware of their common identity and keep track of their ancestry

[1] When the named person is a mathematician, we add life dates.

M. LiCalzi (✉)
Department of Management, Università Ca' Foscari Venezia, Venice, Italy
e-mail: licalzi@unive.it

© Springer Nature Switzerland AG 2020
M. Emmer, M. Abate (eds.), *Imagine Math 7*,
https://doi.org/10.1007/978-3-030-42653-8_19

(section "Identity"), speak the same language (section "Language"), and share the same culture (section "Culture"). This tribe permanently occupies (or traverse) many scientific territories, claiming rights that are recognized by its neighbors and often discovering whole new regions.

Identity

Origins

The most ancient mathematical texts are from Mesopotamia and Egypt. Ancient Babilonia also appears in the Tower of Babel narrative (Genesis 11:1–9) about the confusion of tongues, as well as in the related mythical account of *Enmerkar and the Lord of Aratta* where Enmerkar invents writing on clay tablets.

Babylon (called Shinar in the Bible) was probably the largest city of its times. As the capital of a vast empire, it was visited by many delegations of people who spoke different languages. It is conjectured that the Hebrews might have incorrectly associated the name of the city (in Akkadian: God's Gate) with the Hebraic noun *bālal* (confusion). The association between the linguistic chaos of the capital and the towering size of its (then) unfinished ziggurat might be at the origin of the narrative.

The very same Babylon is widely recognized as the cradle of three important inventions: alphabet, mathematics, and written law. Words, numbers, and law are the hallmark of civilization.

The connection between words and numbers was prominent among the ancient Greeks, who denoted numerals using letters of the alphabet. Even today, many European languages echo this ancient connection across resemblances between their verbs: to count versus to recount (English); compter/conter (French); zahlen/erzhalen (German); or contare/raccontare (Italian). More subtly, the ancient Greek conceived the meaning of *logos* as encompassing the words of the discourse, the reasoning implicit in their use, and the order ruling the cosmos (as opposed to chaos). Nowadays, the word *rational* exemplifies a similar accretion of meanings.

Against this background, the school founded by Pythagoras (sixth century BC) in Croton is usually considered the first community of mathematicians. The Pythagoreans took vows of reciprocal assistance, shared their possessions, and pursued an ascetic lifestyle. They were often religious mystics, and occasionally wielded power as members of an aristocratic political faction in some cities of southern Italy. The school had two groups: the *mathematikoi* ("learners") who would theorize and develop new mathematical work, and the *akousmatikoi* ("listeners") who could only silently listen to Pythagoras' teachings behind a curtain. After Pythagoras' death, the two groups separated and developed different philosophical traditions.

Pythagoras used words and symbols to convey his thoughts. The *Tetractys*, shown in Fig. 1, is a mystical symbol. It represents the decad $10 = 1 + 2 + 3 + 4$, the four

Fig. 1 The Pythagorean
Tetractys

classical elements (fire, air, water, earth), and the organization of space (from the zero-dimensional point to the three-dimensional tetrahedron). It connects with the music of the spheres and the cosmos. As part of their initiation, the disciples took a secret oath mentioning the Tetractys as "nature's eternal fountain and supply."

The Pythagorean school also had a strong dogmatic slant. They are credited with the first known use of *ipse dixit* (autòs épha) as an argument from authority. The school was run as a sect, imposing great demands on the initiates. In *The Open Society and Its Enemies* (1945) the philosopher Karl R. Popper (1902–1994) warns about "tribalism, i.e., the emphasis on the supreme importance of the tribe without which the individual is nothing at all," making a passing reference to the school in the comment that "the institution of tribal priest-kings or medicine-men or shamans [might] have influenced the old Pythagorean sect, with their surprisingly naive tribal taboos."

Differently from the Pythagorean community, the mathematical tribe is not tribal at all. The reason is magisterially explained by Voltaire (1694–1778) in the entry "Sect" from his *Dictionnaire philosophique*: "There are no sects in geometry; nobody is spoken of as a Euclidean or an Archimedean. When the truth is apparent, it is impossible for parties or factions to arise."

In fact, one could argue that the mathematicians are a rare example of a *global tribe*: they feel connected with each other across linguistic, political, geographical, and even temporal barriers. (Perhaps only musicians share something comparable.)

A historical anecdote may be revealing. In 1919, after the First World War, the Allied Powers created the International Research Council (IRC) with the lofty mission to coordinate international scientific cooperation and to foster the formation of international scientific unions. The members of the Council, however, were not scientists or scientific associations but the governments of the Allied Powers, and the real objective was to curtail the primacy of German science.

On January 25, 1919 Magnus G. Mittag-Leffler (1846–1927) wrote a letter to Hardy declaring that "we as mathematicians need to be at the head in 'the task of reestablishment of friendly relations' between the men of science of all countries." Nonetheless, IRC imposed that the mathematicians from the Central Powers (Germany, the Austro-Hungarian Empire, Bulgaria, and Turkey) be kept out of the quadrennial International Congress of Mathematicians held in 1920 and 1924.

The 1928 Congress was organized in Bologna. Salvatore Pincherle (1853–1936), president of the Congress and of the Italian Mathematical Union, maneuvered

skillfully and gained access for mathematicians from all nations. In the August of 1928, David Hilbert (1862–1943) led a delegation of 76 German mathematicians to Bologna. It was the first time since the War that German scientists attended an international meeting. At the opening ceremony, they received a standing ovation and Hilbert firmly declared that "mathematics knows no races or geographic boundaries; for mathematics, the cultural world is one country."

Recognition

In a short note, aptly titled "The mathematics tribe" [3], Dan Kalman shares a little game that he likes to play when attending a large scientific convention: he tries "to guess which of the passersby are mathematicians." Claiming a pretty good average success, he writes that "there is a true feeling of community at the meetings: is it so strange that I can identify other members of my tribe?" Mathematicians know instinctively who their fellow tribespeople are.

Part of this connection originates in mathematics itself: a 2014 semi-anonymous post on the *xckd* forum reckons that "two mathematicians who have never met, who learned from entirely unrelated sources, may explain to one another precisely how they got to a conclusion and then agree upon its validity." The same logical necessity that in Voltaire's dictum dispels sectarianism binds mathematical minds ex post.

Sometimes the connection may mysteriously emerge even ex ante. More than a decade before that 2014 post, with strikingly similar words, Emmer [4] writes about the case of "two mathematicians who have never met [and], coming from different backgrounds and using different methods, reach the same result at the same time." Ennio De Giorgi (1928–1996) and John Nash (1928–2015), born within few months of each other, independently solved Hilbert's XIX problem between 1955 and 1956.

The significance of this coincidence is tersely captured in Nash's own biographical information, prepared on the occasion of his being awarded the Nobel prize in Economics in 1994: "De Giorgi was first actually to achieve the ascent of the summit. [. . .] It seems conceivable that if either De Giorgi or Nash had failed in the attack on this problem [. . .] then that the lone climber reaching the peak would have been recognized with mathematics' Fields medal." (The Fields medal is arguably the highest honor conferred by the mathematical tribe; we return to it later.)

But there is more to mathematicians' meeting of minds than mere logical necessity. The computer scientist Richard W. Hamming (1915–1998), winner of the 1968 Turing Award "for his work on numerical methods, automatic coding systems, and error-detecting and error-correcting codes" famously quipped that "the only generally agreed upon definition of mathematics is *Mathematics is what mathematicians do.*" The activity of doing mathematics connects mathematicians in a way that is difficult to describe or explain to non-mathematicians.

Where do such elusive links come from? Again, the photographer Cook shares her insight [1]: "I have photographed many people: artists, writers, and scientists, among others. In speaking about their work, mathematicians use the words 'ele-

gance,' 'truth,' and 'beauty' more than everyone else combined." Besides truth, mathematicians seek above all elegance and beauty. Many of them have written about beauty and mathematics; for example, Hardy argues that "beauty is the first test: there is no permanent place in the world for ugly mathematics."

Beauty and elegance are often impervious to outsiders. The mathematician Arthur Cayley (1821–1895) soberly reminds us that, "as for everything else, so for a mathematical theory: beauty can be perceived but not explained." Yet, mathematicians share similar mindsets about elegance and beauty in mathematics, producing widespread consensus on their occurrence. Perhaps surprisingly, this bold claim is supported by empirical evidence from the neurosciences.

An interdisciplinary team of four scientists, including Michael F. Atiyah (1929–2019, Fields medalist), used functional magnetic resonance imagining (fMRI) to classify the brain activity of 15 mathematicians engaged in contemplating mathematical formulae which they had individually rated for their beauty [5]. The results show that the experience of mathematical beauty correlates with activity in the same part of the brain as the experience of beauty derived from other sources. Among the 60 items used in the study, the popular Leonhard Euler's (1707–1783) identity

$$e^{i\pi} + 1 = 0$$

was generally rated most beautiful, while Srinivasa Ramanujan's (1887–1920) infinite series

$$\frac{1}{\pi} = \frac{2\sqrt{2}}{9801} \sum_{k=0}^{\infty} \frac{(4k)!(1103 + 26390k)}{(k!)^4 396^{4k}}$$

was generally rated least beautiful.

Mathematicians appreciate elegance especially in theorems' proofs. Paul Erdős (1913–1996), arguably the most prolific author of mathematical papers ever, famously referred to *The Book* where God keeps the most elegant proof for each theorem—it takes a lot of hard work to be granted the honor of a short peek at The Book. Inspired by this evocative benchmark, in 1995 Aigner and Ziegler began to assemble some *Proofs from THE BOOK* with initial assistance from Erdős himself [6]. The result of their efforts, currently in its sixth edition, was awarded the 2018 Steele Prize for Mathematical Exposition because "this book does an invaluable service to mathematics, by illustrating for non-mathematicians what it is that mathematicians mean when they speak about beauty." This collection is a portfolio where curious minds who wish to peek what ticks mathematicians' sense of elegance can find plenty of examples.

Ancestry

Mathematicians are keen about their ancestry. The youngest mathematician photographed by Cook is Maryam Mirzakhani (1977–2017, Fields medalist); see the paper by Strickland in this volume. During her interview, Mirzakhani "picked up a cup on her desk and began to talk about the shape of its handle, how that shape could be changed, and what mathematical questions and answers could be raised in the process." When Cook told her that another mathematician [Dennis Sullivan (1941–)] had explained topology exactly the same way, she exclaimed: "He's my mathematical grandfather!"

Mathematical kinship is not a blood relationship: it is a special link that ties the doctoral advisor (as a parent) with the advisee (as an offspring). Sullivan was the doctoral advisor of Curt McMullen (1958–, Fields medalist), who later became doctoral advisor for Mirzakhani: this makes her Sullivan's grand-niece. Learning to do mathematics often involves a long apprenticeship: mathematicians are very appreciative of the time and effort devoted by their professors, and in turn, they feel an obligation to nurture the next generation. Having a numerous progeny spanning generations is usually a badge of honor for a mathematician.

The matter is so important to mathematicians that they keep an official registry of record. The *Mathematics Genealogy Project* (https://genealogy.math.ndsu.nodak. edu) provides online access to information about doctoral advisors and mathematical descendants for over 200,000 mathematicians. Because a genealogical tree is a directed graph, some mathematicians enjoy analyzing the mathematical structure of the database. In July 2016, for example, the genealogy graph had 200,037 vertices. There were 7639 (3.8%) isolated nodes and the largest component had 180,094 vertices (about 90% of all nodes). See [7] for more information.

The Genealogy Project describes a vertical relationship, usually relating older professors with younger students. Mathematicians are also fond of tracking collaborative relationships. Two or more mathematicians who publish a joint work are coauthors. The network of coauthorships is an undirected graph, where collaboration appears as a direct link; that is, A and B are connected if they are coauthors. Moreover, if a third mathematician has never coauthored with A but is a coauthor of B, we say that their *collaborative distance* is 1. More generally, two mathematicians A_0 and A_{n+1} have a collaborative distance n if there are other n distinct mathematicians A_1, \ldots, A_n who form a chain where A_k and A_{k+1} are coauthors, for $k = 0, 1, \ldots, n$.

This kind of horizontal network originated with reference to Erdős, who had about 500 coauthors over his vast production. When two people (who never worked together) wonder about the shortest collaborative path linking them, they are likely to discover that this path involves Erdős. If the collaborative distance between A_i and Erdős is d_i, then the collaborative distance between A_1 and A_2 cannot be greater than $d_1 + d_2$. This led the mathematicians' tribe to brand each member i with an *Erdős number* d_i, equal to the minimum collaborative distance between Erdős and i. After more than 20 years since Erdős' death, a large number of

living mathematicians has a single-digit Erdős number. The online database for the *Mathematical Reviews*, run by the American Mathematical Society, has a tool to compute the collaborative distance between any two indexed authors, with a special option for the Erdős number.

Incidentally, movie buffs also tracks the collaborative distance between people who star in the same movie. The actor Kevin Bacon (1958–), who has starred in many movies spanning several genres, plays the same role as Erdős. The database https://oracleofbacon.org provides online access to the Bacon number for anyone who is indexed on IMDb, the *Internet Movie Database*. A mathematician who has appeared in a movie (or an actor who has coauthored a mathematical paper) is likely to have strictly positive Erdős and Bacon numbers. Aficionados enjoy exploring questions such as who has the lowest sum for these two numbers.

Language

To outsiders, mathematicians seem people who have a knack for borrowing ordinary words and return them with a meaning of their own making, often unrelated to common usage. Mathematicians' trees may have leaves and roots, but cannot cast any shadow and are not plants. And even their trees cannot grow square roots. A real number is no more real than an imaginary one. The Klein bottle cannot hold any liquid, and so on. Goethe wittily remarked: "Mathematicians are like Frenchmen: whatever you say to them they translate into their own language and forthwith it is something entirely different."

In fact, many insiders strongly believe that mathematics is a language in itself. Galileo Galilei (1564–1642) wrote that the universe "cannot be understood until we have learned the language and become familiar with the characters in which it is written. It is written in mathematical language." Josiah Willard Gibbs (1839–1903) was known as an unassuming scholar who rarely made public pronouncements; but, during a faculty meeting at Yale about replacing mathematics requirements for the bachelor's degree with foreign language courses, he rose and forcefully declared: "Gentlemen, mathematics is a language." R.L.E. Schwarzenberger (1936–1992) is adamant: "My own attitude [. . .] is simply that mathematics is a language. [. . .] It would be as foolish to attempt to write a love poem in the language of mathematics as to prove the Fundamental Theorem of Algebra using the English language" [8].

The power of the mathematical language lies in its precision and in its flexibility. In a conversation between the neuroscientist J.-P. Changeux and Alain Connes (1947–, Fields medalist), the former acknowledges that "mathematical language is plainly an authentic language" and immediately asks "but is it therefore the only authentic language?" Connes seeks precision, and magisterially corrects the question, while answering that "it is unquestionably the only universal language" [9].

Unfazed by the Babel myth, the tribe speaks one language across time and space for exchanging mathematical ideas among its members. Their system of commu-

nication combines natural language (such as English), technical jargon, symbolic notation, and peculiar conventions. The natural language is only a substrate: taking it literally may generate misunderstandings, ranging from the serious to the hilarious; see [10] for a brilliant discussion.

The mathematical language evolves through the introduction of definitions, notation, and new terms (or different meanings for existing words). James J. Sylvester (1814–1897) was a mathematician with a passion for poetry and one of the most prolific contributors of mathematical neologisms, including *matrix* (introduced in 1850), *graph*, *invariant*, and *discriminant*. Charles L. Dodgson (1832–1898), a mathematician better known by his pen name Lewis Carroll, objected to Sylvester's choice for matrix in 1867: "I am aware that the word 'Matrix' is already in use [but] I use the word 'Block': [...] surely the former word means rather the mould, or form, into which algebraic quantities may be introduced, than an actual assemblage of such quantities." Regardless of his literary merits, Carroll's argument did not carry the day. But, as is for natural languages, mathematical words are driven by usage more than by merit: some expressions win, and others die out.

Some mathematical terms are associated with amusing anecdotes. Edward Kasner (1878–1955) was seeking a name for a very large number (1 followed by a hundred zeros, or 10^{100}). During a walk with his two nephews, one of them suggested *googol*. The boy was sure that a googol was not an infinite number, and thus put forward *googolplex* for an even larger number. It was initially proposed that "a googolplex should be 1, followed by writing zeros until you get tired." But eventually the matter was settled by defining a googolplex to be 10^{googol}, or $10^{10^{100}}$ [11].

The term *random variable* competed for some time against *chance variable* and *stochastic variable*. Apparently, the issue was solved by Chance itself. Joseph L. Doob (1910–2004) recalls that he had an argument with William Feller (1906–1970) at the time when they were writing their monographs: "He asserted that everyone said 'random variable' and I asserted that everyone said 'chance variable'. We obviously had to use the same name in our books, so we decided the issue by a stochastic procedure. That is, we tossed for it and he won." [12].

Notation is another important piece of the mathematical language. It can compress information, and thus makes it easier to advance thinking by building on existing knowledge. Pierre-Simon de Laplace (1749–1827) argues that "such is the advantage of a well-constructed language that its simplified notation often becomes the source of profound theories." Alfred N. Whitehead (1861–1947) adds that "by relieving the brain of all unnecessary work, a good notation sets it free to concentrate on more advanced problems, and, in effect, increases the mental power of the race."

The Pythagorean Tetractys in Fig. 1 compresses information in an arcane way. Good notation, instead, feels natural to the mind: mathematicians speak about the elegance and beauty of their notation. But it may be difficult to get things right. For a long time equations were proposed and solved in words, making it difficult to generalize the results. François Viète (1540–1603) initiated a conscious effort to

create powerful notation and began to write simpler structured expressions such as

$$2 \text{ in } A \text{ quad} - 3 \text{ in } A \text{ plano} + 4 \text{ aequatur } 0$$

In less than a century, with important contributions from René Descartes (1596–1650), the mathematicians learned to write

$$2x^2 - 3x + 4 = 0$$

Most outsiders find it hard to believe that most of the mathematical notation we take for granted nowadays did not exist only a few centuries ago. For instance, the ubiquitous π (i.e., the ratio of the circumference of a circle to its diameter) is unostentatiously introduced by William Jones (1675–1749) only in 1706. Until the fifteenth century, the common notation for addition and subtraction in Europe uses P (plus) and M (minus). The modern symbols $+$ and $-$ first appear in print in 1489, with reference to surplus and deficit in business problems. The symbol $\sqrt{\ }$ for square root shows up in 1525; Descartes adds the vinculum in 1637, changing it to $\sqrt{\ }$. The inequality signs ($>$ and $<$) are from the seventeenth century. Union and intersection (\cap and \cup) appear in the nineteenth century, and \emptyset is introduced in the twentieth century.

Because of the variety of symbols, mathematical typesetting used to be considered laborious and highly error-prone. This changed drastically after Donald Knuth (1938–) released TEX in 1978. This typesetting language was designed to generate exactly the same results under any operating system, by keeping distinct the source code prepared by the author and the generated output. The source code describes what the author wants to achieve, leaving the gritty work of delivering it to the computer. Knuth put TEX in the public domain, allowing many other people to expand it and make it into the most sophisticated digital typesetting system currently available.

TEX and its later variants (most notably, LATEX) grant the user full control on the appearance of a document, so that one can produce high-quality output with relatively low effort. TEX-based typesetting is especially popular among mathematicians and many other scientific communities, who strive for accuracy or use technical notation. For a modest example, this article has been typeset by the author in LATEX, using macros designed by the publisher for ensuring consistent results across the whole book. (Incidentally, this makes both the author and the publisher happier: the former has a reasonable amount of control on the final output, and the latter makes huge savings on the typesetting costs.)

One important byproduct of the popularity of TEX is that most mathematicians may write and read the source code: they can use it to communicate their notation in writing—over email or other systems—with the same accuracy that they devote to their definitions and their theorems. The sender may compose the text

```
Dear Colleague, I have just proved that
    x = \frac{-b \pm \sqrt{b^2-4ac}}{2a}
```

and the receiver would read

Dear Colleague, I have just proved that

$$x = \frac{-b \pm \sqrt{b^2 - 4ac}}{2a}$$

A showcase for the amazing typesetting abilities of TEX is at www.tug.org/texshowcase. We are especially fond of `diminuendo.tex`, that generates decimal expansions for a few prominent rational, irrational, and transcendental numbers, making the digits progressively smaller so that the decimal expansion fits a finite area.

Budding mathematicians must learn the language of mathematics to become effective members of the tribe. As for natural languages, this is more frequently done through direct interactions with other mathematicians than by poring over books. These interactions foster a culture and a sense of community to which we return in section "Culture".

An ingenious feature of the mathematical language is that its terms may have different denotations in different contexts, making it possible to unify different phenomena under one roof. The most obvious example is the conflation of numbers (quantities) and geometric figures: for instance, the Pythagorean theorem states at the same time a relationship between three geometric squares and an equation involving three numbers. The same sentence carries both a geometric and an arithmetic interpretation, respectively, shown on the left and on the right in Fig. 2.

Henri Poincaré (1854–1912) explained that "Mathematicians do not study objects, but relations between objects. Thus, they are free to replace some objects by others so long as the relations remain unchanged. Content to them is irrelevant: they are interested in form only." Focusing on relations provides a shortcut to enrich the language with analogies. For example, compare the distributive property for

Fig. 2 The Pythagorean theorem

addition and multiplication

$$a \cdot (b + c) = a \cdot b + a \cdot c$$

and the distributive property for union and intersection

$$A \cap (B \cup C) = (A \cap B) \cup (A \cap C)$$

We may only see \cap replacing \cdot and \cup replacing $+$, but this superficial difference hides a common structure that is apparent to mathematicians. As Poincaré quipped: "Mathematics is the art of giving the same name to different things."

Language alone is not enough for doing mathematics. Richard Feynman (1918–1988) warns us that "Mathematics is not just a language. Mathematics is a language plus reasoning. It is like a language plus logic. Mathematics is a tool for reasoning. It is, in fact, a big collection of the results of some person's careful thought and reasoning."

Mathematical language without an underlying reasoning turns into a parody. In the movie *The Wizard of Oz*, the Scarecrow asks for a brain and, when he finally gets one, he claims that "The sum of the square roots of any two sides of an isosceles triangle is equal to the square root of the remaining side." This is nonsense wrapped into mathematical language. The scene is paraphrased in the opening scene of Episode 10, Season 5 of the animated sitcom *The Simpsons*, with Homer Simpsons uttering the same sentence.

Culture

The mathematical community shares a culture that includes: (a) social organization; (b) traditions, rituals, and folklore; (c) accomplishments that the tribe esteems so highly to give their doers the status of heroes. We offer only vignettes for each of them, because lack of space prevents us from giving a detailed description.

Social Organization

The mathematical tribe is open-minded and cooperative. Social ties are loose, but existent. Our photographer-guide Cook has two insights to contribute. The first is that "Truth is the ultimate authority in mathematics." Most claims can be settled as either true or false, and this reduces the potential for in-fighting or doctrinal clashes.

The second insight is that "Mathematicians are bound by fairness. Anyone who solves an outstanding problem with a pencil and piece of paper [...] can be catapulted into the upper echelons of the mathematical community overnight. [...] Mathematics may well be the most democratic of creative pursuits, as is

the recognition of success by fellow mathematicians. Honesty and conscience are the tools of character required." The unwritten rule is that most mathematicians quarrel like all human beings, but they are expected to concede an argument when it becomes clear what truth demands.

Beyond this common attitude, there are of course different styles. In the language of anthropology, one might speak of *bands* belonging to the same tribe. David Mumford (1937–, Fields medalist) gave an interesting categorization in a blog piece titled "Math & Beauty & Brain Areas," dated 11 October 2015. He classifies mathematicians into four bands, according to what most strongly drives them.

The *explorers* enjoy "discovering what lies in some distant mathematical continent and, by dint of pure thought," shining a light and reporting back. Some of them are *gem collectors* who undig wholly new objects; others are *mappers* who describe the new continents.

The *alchemists* enjoy "finding connections between two areas of math that no one had previously seen as having anything to do with each other."

The *wrestlers* focus "on relative sizes and strengths of this or that object. They thrive [. . .] on inequalities, and on asymptotic estimates of size or rate of growth."

Finally, the *detectives* "doggedly pursue the most difficult, deep questions, seeking clues here and there, [. . .] often searching for years or decades." Some of them are *strip miners* who "are convinced that underneath the visible superficial layer, there is a whole hidden layer and that the superficial layer must be stripped off to solve the problem." Others are *baptizers* "who name something new, making explicit a key object [. . .] whose significance is clearly seen only when it is formally defined and given a name."

Besides Mumford's loose characters, the mathematical tribe also has formal structures in place. The most important one is probably the *2010 Mathematics Subject Classification* (MSC2010) "produced jointly by the editorial staffs of Mathematical Reviews (MR) and Zentralblatt für Mathematik (Zbl) in consultation with the mathematical community." This classification index is used to tag items in the mathematical literature and help "users find the items of present or potential interest to them as readily as possible." The MSC2010 is a hierarchical scheme, with three levels of structure: at the top level only, it already recognizes 64 distinct mathematical disciplines.

Moving to political bodies, the mathematicians' equivalent of the United Nations is the *International Mathematical Union* (IMU). This is an international non-governmental organization that promotes international cooperation in the field of mathematics. Its members are the national mathematics organizations from more than 80 countries.

IMU supports the International Congress of Mathematicians (ICM) and acknowledges outstanding mathematical research through the awarding of scientific prizes. Its history has been affected by the political controversies after World War I mentioned in section "Identity": the IMU was established in 1920, dissolved in September 1932, and finally reinstated in 1951 with the initial membership of ten countries. Since 2011, its permanent offices are located in Berlin [13].

In 2006, the International Mathematical Union (IMU) announced its adoption of a new logo. The logo design is visible at www.mathunion.org/outreach/imu-logo: it is based on the Borromean rings, a famous topological link of three components with the property that, if any one component is removed, the other two fall apart (while all three together remain linked). The designer says that this logo "represents the interconnectedness not only of the various fields of mathematics, but also of the mathematical community around the world."

The *International Congress of Mathematicians* (ICM) predates the IMU. Held every 4 years, this is the most significant meeting in pure and applied mathematics. It is also one of the oldest scientific congresses: the first ICM took place in Zurich in 1897, at a time where several scientists began an effort to make science transcend political boundaries. Mathematicians, who have a keen sense of being a community, were at the forefront of this effort.

Traditions, Rituals, and Folklore

The standard instruction offered in many schools is different from the initiation rituals for budding mathematicians. One enters the mathematical community by co-optation: if "mathematics is what mathematicians do," then a mathematician is likely to be someone who is accepted as such by other mathematicians. A lot of mathematical knowledge is passed during a period of apprenticeship, where the candidate learns by direct experience and oral transmission which implicit knowledge and hidden assumptions populate the conversations of active mathematicians in the field of the candidate. The creation of mathematics may need to access unbridled ideas; meticulous proofs are often written only after a result has already been uncovered. In passing, we note that mathematical knowledge is often ahistorical: Hilbert reportedly quipped that "one can measure the importance of a scientific work by the number of earlier publications rendered superfluous by it" [14].

Contrary to popular belief, mathematics is often a collaborative effort. Mathematical ideas are nurtured by bouncing them between different minds. Whenever possible, mathematicians congregate to facilitate this process. Many countries have international research centers where mathematical scholars from all over the world meet over more than a few days: they pursue research by discussing recent developments with their colleagues, and in so doing often generate new ideas or open new perspectives.

Modern technology, of course, allows effective means of telecommunication, from email to video calls. In the old times, many mathematicians wrote letters. Some of them gave us a window on how the bonds tying the tribe's members were able to overcome time and distance. At a time where many scientists had a sex prejudice, Marie-Sophie Germain (1776–1831) had a correspondence with famous mathematicians such as Joseph-Louis Lagrange (1736–1813), Adrien-Marie Legendre (1752–1833), and Gauss (1777–1855).

Fearing rejection because of her sex, she approached Gauss under the pen name of Monsieur LeBlanc. When Gauss discovered who she really was, he had no hesitation in acknowledging her merits: "when a woman, because of her sex, our customs and prejudices, encounters infinitely more obstacles than men, in familiarizing herself with their knotty problems, yet overcomes these fetters and penetrates that which is most hidden, she doubtless has the most noble courage, extraordinary talent, and superior genius." One year younger than Germain, but far more influential, Gauss pressured the University of Göttingen to grant her a (posthumous) honorary degree in 1837 and is now listed in the Mathematics Genealogy Project as her "father."

The correspondence between Pierre de Fermat (1607–1665) and Blaise Pascal (1623–1662) is often celebrated as the founding moment for the modern theory of probability [15]. The first letter was sent out by Pascal on August 24, 1654; it is a testimony to how much the best mathematicians feel that truth is the ultimate authority: "I wish to lay my whole reasoning before you, and to have you do me the favor to set me straight if I am in error or to endorse me if I am correct."

Coffee is a beverage that mathematicians often associate with collaborative efforts and intense research. The Lviv School of Mathematics, founded by Hugo Steinhaus (1887–1972) and Stefan Banach (1892–1945), enlisted many capable mathematicians who used to meet and work at the Scottish Café. The problems discussed at this (Polish) coffee shop were collected in a thick notebook provided by Banach's wife, that came to be known as the *Scottish Book*. Stanislaw Ulam (1090– 1984) was one of the major contributors. In 1957, he received from Steinhaus a copy of the notebook which had survived the war, and translated it into English [16]. Later on, Erdős, an avid coffee-drinker who used it to sustain prolonged efforts at mathematics, gave this beverage a special status in the tribe's collective memory with his memorable definition: "A mathematician is a machine for turning coffee into theorems."

A disappearing ritual that many mathematicians are still fond of practicing, and sometimes strenuously defend, may be called the *chalkboard dance*. Some mathematicians passionately argue that teaching requires using the whole body, gesturing and pausing, up to becoming one with the board. (This is contrasted with the dull activity of pushing a button to change slides.) Israel M. Gelfand (1913– 2009) conjectures that gesturing may contribute to making frontal teaching more natural: "using chalk on a blackboard, we write by moving the entire arm. [. . .] Wider movements of arms fit naturally in the cycle of breathing and speaking."

In front of a blackboard—more than one is even better—a mathematician can trace and link ideas as quick as they appear to the mind. There seems to be a connection between the agility of a mind and the time necessary to make them visible (and communicate them). It is not by chance, perhaps, that mathematics makes recourse to motion and action metaphors: asymptotes approach, limits converge, variables run, and so on. The chalkboard dance is not popular among teaching innovators and university administrators, but—when sipping their coffee— several mathematicians speak lovingly of it.

Renteln and Dundes [17] bring a joking viewpoint about the traditions of the mathematical tribe by observing that a folk is a group that shares at least one common factor. "Hence, mathematicians constitute a folk. And, like all folk groups, [they] have their own folk speech (slang), proverbs, limericks, and jokes, among other forms of folklore." Some of this folklore is esoteric, because outsiders may not have the requisite knowledge to appreciate it. Their article offers a generous sampling of "both esoteric and exoteric mathematical folklore, concentrating on humorous genres such as jokes."

Another set of traditions brings mathematics closer to a sport, in the sense of an activity involving exertion and skill, in which an individual competes against another or others. Some competitions are lonely races, where one competes against a very difficult problem or a long-standing conjecture: for example, Andrew Wiles (1953–) worked over 6 years in secrecy to prove Fermat's last theorem. He eventually reached his goal at the age of 41, too late to being awarded the Fields medal (restricted to those under 40): but the achievement was so momentous that the International Mathematical Union (1998) recognized it with a silver plaque in 1998.

More traditional competitions take the form of challenges: in the past, these could be public matches like the one opposing Niccolò Fontana Tartaglia (1499/1500–1557) to Ludovico Ferrari (1522–1565) over the solution of cubic equations. Other disputes, often ferocious and sometimes prolonged, take place when people advance conflicting priority claims over mathematical issues. The most famous involved Isaac Newton (1643–1727) and Gottfried Wilhelm Leibniz (1646–1716) over the development of infinitesimal calculus.

Nowadays, challenges are often issued as open problems. The most influential (implicit) example is Hilbert's list of ten problems, originally presented in 1990 at the International Congress of Mathematicians in Paris, and later expanded to a complete list of 23 problems published in 1902. (Some of them are still open.)

A recent popular example are the seven Millennium Prize Problems published in 2000: a correct solution to any of them carries a one million U.S. dollars prize funded by the Clay Mathematics Institute. Until now, only one has been solved: the Poincaré conjecture has been established by Grigori Perelman (1966–), who has successively declined both the prize money and the Fields medal. It is worth reading about his personality and the reasons for this unusual decision; see [18].

A very different kind of competition is the International Mathematical Olympiad (IMO), a world mathematics contest for high school students selected through local and national competitions. It is the oldest of the International Science Olympiads. The first IMO was held in 1959 in Romania, with seven countries participating. Since then, the competition has taken place every year (except 1980) and has grown to include over 100 countries from five continents. Every country can send up to six contestants, who must be under the age of 20 and cannot be registered at any tertiary institution. The logo of the International Mathematical Olympiad is arguably more elegant than the icon of the Olympic games: it weaves zero and infinity, using the same five colors to denote the five continents but making sure that each color is in

touch with all the other four (in the Olympic icon, each color touches at most other two). The IMO logo can be seen at www.imo-official.org.

The International Mathematical Olympiad is a showcase for young talents, encouraging them to pursue mathematics. The selection process is used by many countries to screen and nurture the young talents, who often make rapid and significant advances in the ranks of the tribe. For instance, to date 15 IMO participants have successively been awarded the Fields medal. (Perelman was also a IMO contestant, but he declined the award.)

The participants are ranked individually based on their scores. Medals are awarded to the highest ranked participants but, differently from the Olympic Games, about half of them is awarded a medal. The numbers of gold, silver, and bronze medals are approximately in the ratios 1 : 2 : 3; that is, the first twelfth of the participants receives a gold medal, the next sixth is given a silver medal, and the next fourth is awarded bronze medals. Anyone who scores above a threshold on at least one problem receives an honorable mention. The tribe does not wish to single out one young person above another, because the advancement of mathematics is a collective enterprise.

Mathematicians are probably the scientific group who confer more awards than any other one. However, the real awards never follow an explicit competition that inevitably declares at the same time a winner and at least one loser. The mathematical awards are offered to recognize brilliant minds whose achievements shine light for all. They are meant to celebrate the best, but the choreography tries to encourage everyone to join in. (Notwithstanding this, it is clear that some non-winners experience disappointment.)

Out of the many existing mathematical prizes, we mention only two. Named after the Norwegian mathematician Niels Henrik Abel (1802–1829), the *Abel Prize* is awarded annually by the King of Norway to one or more outstanding mathematicians. It is modeled after the Nobel Prizes and comes with a monetary award of six million Norwegian Kroner. Its history dates back to 1899 when, upon learning that Alfred Nobel's plans would not include a prize in mathematics, Sophus Lie (1842–1899) proposed to establish a dedicated award. In 1902 King Oscar II of Sweden and Norway seemed open to finance a mathematics award to complement the Nobel Prizes, but the matter was sidetracked by the dissolution of the union between Norway and Sweden in 1905. The Abel Prize was finally established in 2001 "to give the mathematicians their own equivalent of a Nobel Prize."

The Abel Prize is awarded by a committee appointed by the Norwegian Academy of Science and Letters. The tribe is not directly involved in the choice. The Fields medal, instead, is conferred at the International Congress of Mathematicians, in front of the convened mathematicians. This circumstance and its longer history—the award was first conferred in 1936—may be the reasons why the Fields medal is generally reputed more prestigious, in spite of carrying a monetary prize of only 15,000 Canadian dollars. Since 1966, the Fields medal is conferred every 4 years to no more than four mathematicians under the age of 40. The youngest winner was 27 years old when he received the award. The obverse of the medal depicts Archimedes (third century BC); the reverse has an inscription in Latin that translates

to "Mathematicians gathered from the entire world have awarded [this prize] for outstanding writings." The community honors its champions.

Heroes

The champions are noted or admired for their outstanding achievements. Sometimes, the tribe elevates a champion to the rank of hero, who transcend ordinary mathematicians in creativity, technical skill, or vision. The feats of a hero fuel narratives that are part of the mathematical culture, similar to the role played by the founding myths in other cultures.

There is a rich pantheon of mathematical heroes, and opinions on who are the most important ones are unlikely to be unanimous. We offer a few representative samples, arranged by birthdate. Three great heroes from the classical age are Pythagoras, Euclid (fourth century BC), and Archimedes. Four giants from the modern age are Newton, Leibniz, Euler, and Gauss. One might of course conceive many other names, especially in connection to specific fields. For instance, a triad of heroes for probability theory are Fermat, Pascal, and Jacob Bernoulli (1655–1705).

Naming contemporary heroes is fraught with causing controversies, so we deflect this issue and mention three heroes whose stories became successful movies making their names known to the general public, outside of the tribe. The feature film *The Man Who Knew Infinity* (2015) portrays the life of Srinivasa Ramanujan (1887–1920), based on the eponymous biography published in 1991. The drama film *The Imitation Game* (2014) introduces Alan Turing (1912–1954), after the biography *Alan Turing: The Enigma* (1983); see [19]. And the biographical drama film *A Beautiful Mind* (2001), adapted from the eponymous biography published in 1998, portrays the life of John Nash; see [20]. He missed the Fields medal but traveled to Scandinavia in at least two occasions, collecting both the Nobel prize in Economics (1994) and the Abel prize (2015). (Besides, the movie won four Academy Awards, popularly known as Oscars, including one for Best Picture.)

One could find many ways to add to our short list. For instance, the protagonist of the political satire film *Dr. Strangelove or: How I Learned to Stop Worrying and Love the Bomb* (1964), loosely inspired by the thriller *Red Alert*, is partly fashioned after by John von Neumann (1903–1957). We choose two cases.

The first choice is meant to honor the contribution of women mathematicians. The biographical drama film *Hidden Figures* (2016), loosely based on the non-fiction eponymous book, dramatizes the story of the black female mathematicians who worked at the National Aeronautics and Space Administration (NASA) during the Space Race. Twice discriminated (by gender and by color), these women were hidden figures in a white male world; see the paper by Emmer in this volume.

The second choice is meant to honor the scholars who over many centuries have opened up whole new territories for the mathematical tribe. For at least two millennia, the philosophers have agonized over the difference between potential vs actual infinity, often negating (for theological reasons) the existence of the latter.

Georg Cantor (1845–1918) discovered that it is possible to compare the size (in technical jargon: the cardinality) of infinite sets, establishing a hierarchy of infinite numbers. If Ramanujan knew infinity, Cantor faced it and found a way to count beyond infinity!

It takes an amazing courage to look across the infinity, where our (finite) intuition no longer supports the mind. When Cantor proved that a segment had the same number of points as a square, he candidly wrote in a letter to J.W. Richard Dedekind (1831–1916): "I can see it, but I don't believe it!" (June 20, 1877). His theory was initially met by opposition from within the tribe, including Poincaré who firmly declared: "There is no actual infinity. The Cantorians forgot this, and so have fallen into contradiction." But in the end truth reaffirmed its authority and his theory was accepted. Another hero, David Hilbert, acknowledged Cantor's unique achievement in 1926 with a lapidary statement: "No one shall expel us from the paradise that Cantor has created."

Acknowledgments Without implications, I owe Gabriele Lolli a debt of gratitude for our conversations about the tribe. I thank Giulia and the editors for their comments.

References

1. M.R. Cook, *Mathematicians: An Outer View of the Inner World* (Princeton University Press, Princeton, 2009)
2. V. Moncorgé, Mathematics, a closer look: a photographer's perspective, in *Imagine Math 6*, ed. by M. Emmer, M. Abate (Springer, Berlin, 2018), pp. 225–248
3. D. Kalman, The mathematics tribe. Math Horiz. **62**, 401–409 (1969)
4. M. Emmer, A beautiful mind, in *Mathematics, Art, Technology and Cinema*, ed. by M. Emmer, M. Manaresi (Springer, Berlin, 2003), pp. 139–144
5. S. Zeki, J.P. Romaya, D.M.T. Benincasa, M.F. Atiyah, The experience of mathematical beauty and its neural correlates. Front. Hum. Neurosci. **8**, Article 68 (2014)
6. M. Aigner, G.M. Ziegler, *Proofs from the Book*, 6th edn. (Springer, Berlin, 2018)
7. C. Mulcahy, The Mathematics Genealogy Project comes of age at twenty-one. Notices Am. Math. Soc. **64**, 466–470 (2017)
8. R.L.E. Schwarzenberger, The language of geometry. Math. Spectrum **4**, 63–68 (1972)
9. J.-P. Changeux, A. Connes, *Conversations on Mind, Matter and Mathematics* (Princeton University Press, Princeton, 1995)
10. R. Hersh, Math lingo vs. plain English: Double entendre. Am. Math. Mon. **104**, 48–51 (1997)
11. E. Kasner, J.R. Newman, *Mathematics and the Imagination* (Tempus Books, Redmond, 1989)
12. L. Snell, A conversation with Joe Doob. Stat. Sci. **12**, 301–311 (1997)
13. G.P. Curbera, *Mathematicians of the World, Unite!: The International Congress of Mathematicians – A Human Endeavor* (A.K. Peters, Wellesley, 2009)
14. H.W. Eves, *Mathematical Circles Revisited* (Prindle, Weber & Schmidt, Boston, 1971)
15. K. Devlin, *The Unfinished Game* (Perseus Books, New York, 2008)
16. R.D. Mauldin (ed.), *The Scottish Book: Mathematics from the Scottish Café* (Birkhäuser, Boston, 1981)
17. P. Renteln, A. Dundes, Foolproof: a sampling of mathematical folk humor. Notices Am. Math. Soc. **52**, 24–34 (2005)

18. M. Gessen, *Perfect Rigor: A Genius and the Mathematical Breakthrough of the Century* (Houghton Mifflin Harcourt, Boston, 2009)
19. M. Emmer, Turing and the Enigma, in *Mathematics and Culture IV*, ed. by M. Emmer (Springer, Berlin, 2007), pp. 63–70
20. M. Emmer, A beautiful mind: a film by Ron Howard, a book by Sylvia Nasar, in *Mathematics and Culture IV*, ed. by M. Emmer (Springer, Berlin, 2007), pp. 115–122

Creation/Representation/Transmission: Culture and/of Mathematicians' Autobiographies

Odile Chatirichvili

Introduction: Against a Certain Image of Mathematics

In many cultural representations, mathematicians are often stereotyped. Studies of books, films, and series featuring characters (real or fictional) of mathematicians show that they are frequently portrayed as obsessive and withdrawn geniuses, unfit for social interaction[11, 27, 36]. In the broad collective imagination, mathematics has a degraded, or at best ambivalent, image; it is not insignificant that several mathematicians explain, in their autobiographies, that they wish to combat the apprehensions raised by mathematics and reveal its beauty to the general audience.

In the words of Edward Frenkel:

> [...] most people are daunted by math. It has become, in the words of poet Hans Magnus Enzensberger, "a blind spot in our culture—alien territory, in which only the elite, the initiated few have managed to entrench themselves." It's rare, he says, that we "encounter a person who asserts vehemently that the mere thought of reading a novel, or looking at a picture, or seeing a movie causes him insufferable torment," but "sensible, educated people" often say "with a remarkable blend of defiance and pride" that math is "pure torture" or a "nightmare" that "turns them off."[13, p. 1]

One function assigned by mathematicians to their autobiographical narrative is therefore to give an adequate image of themselves and their work.

Nowadays, mathematicians tell their stories in many ways: there are popular books on mathematical work and creation[5], exhibitions, conferences for the general public, YouTube channels, websites, apps, festivals, etc. Working on autobiographical narratives in particular, I am convinced that those texts are a very interesting way to think about the social and cultural representations of mathematics within the world.

O. Chatirichvili (✉)
Université Grenoble Alpes, UMR Litt&Arts - ISA, Grenoble, France
e-mail: odile.chatirichvili@univ-grenoble-alpes.fr, personal website: https://odile.chatirichvili.ml

© Springer Nature Switzerland AG 2020
M. Emmer, M. Abate (eds.), *Imagine Math 7*,
https://doi.org/10.1007/978-3-030-42653-8_20

It might seem weird to a lot of people, but there are indeed a relatively large number of autobiographies and Memoirs[1] by mathematicians, that is to say narratives written by mathematicians themselves in order to relate their personal and professional lives and to describe how their relationships to math are linked with their biographical journey.[2] These texts are commonly used as primary documents for historical[28] or sociological[4] research. But, contrary to autobiographies written by scientists of other fields[30, 33, 34], they have almost never been studied as a literary production per se, as a part of the vast field of "self-writing" and as texts contributing to the building of mental and cultural representations.[3]

In this paper, I will present the basis of my work (which is still in progress) on mathematicians' autobiographies from a literary and cultural point of view. I will propose different hypotheses to examine the role of such texts as literary works and cultural objects, likely to help in the building of a "mathematical culture" or a "culture of mathematics." How can tools from literary studies and discourse analysis allow us to establish a deeper understanding of these texts? How can the specific genre that is mathematicians' autobiographies contribute to building a culture of mathematics and help in improving the accuracy or the creativity of what people imagine about math?

Building an Image of the Self: Life, Writing, and *Ethos*

Within the various forms of dissemination of mathematics and mathematical works, the genre of Memoirs broadens the focus from what is generally seen by placing this research work in a temporal and biographical perspective marked by greater depth. It includes stories from childhood, entry into mathematics, evocations of personal and intimate life, passions outside mathematics that are likely to feed research, etc.

Let me develop a very striking example of this diversity: the French mathematician Laurent Schwartz opens the Foreword of *Un mathématicien aux prises avec*

[1] In French literary studies, the term "Memoirs" refers to a particular autobiographical genre, which has been defined by researcher Jean-Louis Jeannelle:

> If autobiography is the story that "someone makes of his own existence, when he emphasizes on his individual life", according to Philippe Lejeune's formula[21], Memoirs, on the other hand, are the story of a life in its historical condition: an individual testifies to his journey as a man carried along in the course of events, both as an actor and a witness, carrying a story that gives meaning to the past. Autobiography reflects what distinguishes a subject, i.e. an identity such that it has gradually been constructed in a given family and social context; Memoirs attest to a life in its public and collective dimension[...][19, p. 13]

[2] I am currently working on establishing a list of those texts on my personal website: https://odile. chatirichvili.ml/automathographies.html.

[3] An interesting exception would be [12] about the autobiography of G.H.Hardy[18].

le siècle [31][4] with the sentence "I am a mathematician. Mathematics have filled my life [...]" [32, p. vii]. A few lines later, he continues: "I have been involved in many activities besides mathematics, sometimes to such a point that my research suffered"[32, p. vii] and then talks about his political commitments and his passion for entomology. On the next page begins a second introductory text, which is entitled "The Garden of Eden": over nearly 30 pages, Schwartz describes the garden of his family home in Autouillet, near Paris. What is apparently a bucolic digression allows him in fact to talk about his parents, brothers, wife, and children, that is to say a family environment which contributes to his intimate identity. The allusions to mathematics are very limited and are mainly used to draw, like in a watermark, a portrait of the mathematician as a gardener in love with nature:

> Mathematical research still procures me my greatest pleasure. But mathematics in Autouillet has more charm than mathematics at my desk in Paris.[32, p. 28]

With this anecdote, mathematical research is shown as a concrete and embodied activity. We are far from the image of the mathematician in his ivory tower; here, the mathematician seems to be an accessible man seeking simple pleasures, someone with whom a non-mathematician reader could, to some extent, identify.

This example is no exception; the texts I study often use narrative and rhetorical processes to make their narrator/character "closer" to the reader, to show a "normal" and simple life, and thus to reverse the cliché of the mathematical genius who breaks away from the real world. Yvonne Choquet-Bruhat gives her children a central role in the prologue and epilogue of her Memoirs: they are at the same time "the essential part of [her] life"[9, p. 9] and the main recipients of the text, written "at their request"[9, p. 9]. Benoit B. Mandelbrot ends his narration with two family photos, one with his wife and grandchildren, the other with his wife[24, p. 301], at the end of a book which contains quite a few visual elements, mainly used to illustrate mathematical concepts (such as fractals).

According to a "rule" of the autobiographical genre, all of this is presented as a way of unveiling oneself: when writing an autobiography, one is supposed to show oneself in the most authentic and sincere way. Schwartz thanks his proofreader:

> She read all the chapters with the competence of a translator, which enabled her to help me polish the style, without losing anything of my thought or my personality, so that everyone who knows me recognizes me in the book and feels, as certain readers have told me, that they can "hear the sound of my voice".[31, p. viii]

The ideal objective of autobiography is expressed here, or at least its claimed objective of building through the written text an honest and trustworthy image of oneself, up to the sound of a voice.

But in reality, a life story is a construction. This is inherent to the narrative form: any story is built by selecting and ordering events in a particular way. This

[4]Published in French in 1997; I will quote the English translation by Leila Schneps published in 2001. Apart a few exceptions which will be notified, other quotes from French texts in this paper are translated by myself.

construction is sometimes deliberately and consciously studied to reflect a certain self-image. In any case, according to researcher Ruth Amossy who articulates rhetorical and sociological analysis, "self-presentation, or what rhetorical tradition calls "ethos," is an integral dimension of discourse"[3, p. 7].

This concept of "ethos" is used in different fields and is very important both in the elaboration of autobiographical and memorial texts, but also in scientific practice. The term comes from ancient rhetoric, where it more specifically refers to a component of argumentation: beyond the arguments (the *logos*) and the emotions created by the discourse (the *pathos*), there is the image (the *ethos*) projected by the speaker, who must inspire confidence and ensure his or her authority over the audience.

In its general definition, "ethos refers to a set of principles and values that shape behaviour. [...] all the ways of being and doing, with an ethical dimension"[2, p. 200]. To be short, it is everything, in a text or speech, that contributes to building a certain image of the person who is writing or speaking, a certain "self-presentation."

Finally, one can speak of "professional ethos," that is to say how you are supposed to act, talk, write in a specific professional context. By extension, there is of course an "ethos of science" (which Robert K. Merton defines as "that affectively toned complex of values and norms which is held to be binding on the man of science"[25]) and more particularly of mathematics as a "profession"[37].

The author of an autobiography works with rhetorical tools to build his or her own image through the text. Let us quickly examine two examples of how a passage explicitly showing the mathematician in a modest light could in fact be stylistically serving his enhancement, his own distinction.

Laurent Schwartz devotes a long chapter to "The Invention of Distributions"[32, pp. 209–254], the mathematical object that earned him the Fields Medal in 1950. Before describing the moment of discovery, he first lists the mathematical research and concepts, which were known or unknown to him at the time, that constitute "preliminaries" to it.

> [...] the enumeration of my many precursors is impressive, and the dates of their inventions are closer and closer to 1944. The discovery was bound to come, and I was merely an "instrument of destiny" (one must obviously have a suitable ability to become such an instrument!). Further on, I will discuss the question of why destiny fixed itself upon me.[32, p. 224]

The expression "to be an instrument of destiny" refers to the idea that there would be a power superior and external to the mathematician (in this case, a kind of fatality of mathematical discovery, an inevitable sequence of events happening in the mathematical community towards a necessary advancement of ideas and knowledge) and that the mathematician would be relatively passive, a simple intermediate figure, a vessel allowing the discovery to come into being. But then there is, in the parentheses and last sentence, a discursive work of distinction through election: "destiny" allows the mathematician to have a life that is not ultimately the mere result of chance. The writer underlines, under a rhetorical claim of modesty (the restrictive word "merely"), the remarkable scope of his work. The fact that

Schwartz places the expression "instrument of destiny" in quotation marks shows that he keeps his distance from this statement: he is indeed aware that he is a brilliant mind, and retrospective writing, by establishing a teleological coherence of life, changes causality: it is easy to see how you were able to reach a peak when you have actually already managed to reach it. Schwartz shows such retrospective explanation in other places in his text: "I always possessed the spirit of research. And it is a fact that I became a researcher. It was predictable from my earliest childhood"[32, p. 29].

This "fake modesty" of the mathematician can even taint the ethos of the writer. In his preface, Norbert Wiener points out that the writing of his Memoirs will not bring him any socio-professional advantage:

> [...] I must wait for the judgment of the public in order to be sure that I have achieved a measure of success. Why did I assume this uninviting labor, which at the best can add little to my stature as a working scientist and at the worst must offer new opportunities for those who may be inclined to criticize me? All in all, I don't know.[35, p. 10]

In this passage which perfectly fits the form and objective of the rhetoric process of *captatio benevolentiae*,[5] Wiener seems to be abandoning the authority that competence is likely to give him in the scientific world. He does this in order to submit himself and his text to the judgment of an audience that he is not used to addressing and with whom he has other types of duties. In the mathematical community, he must be exact and rigorous, whereas with a lay audience he has to be clear and understandable. Writing his autobiography radically changes his very role as a scientist. However, it is precisely this endangering which, under an apparent humility, enhances the author's stature: a failure would be explainable, a success all the more impressive.

A Genre for Whom?

Norbert Wiener's quotation raises an essential question about the public of mathematicians' autobiographies: for whom does a mathematician write his or her autobiography or Memoirs? What objectives and responsibilities does he or she have towards these public(s)? How are the abstraction, rigor, and extreme complexity of twentieth-century mathematics to be articulated in light of a demand for accessibility?

In the case of mathematicians' autobiographies, there are at least two different types of "real readers" (that is to say "empirical readers," as opposed to the "ideal readers" of some part of the reception theories): the "mathematician reader" and the "non-mathematician reader." In fact, each real reader is endowed with a more or less developed mathematical culture, with a polarization between "expert reader" and "lay reader" (a distinction made by several authors in various terms in my

[5]From Latin "seeking benevolence," it is a rhetorical technique aiming at provoking and attracting the benevolent attention of an audience.

corpus). Even a mathematician working in a certain field of math would not be able to understand the research of a colleague working in another field.

Alexandre Grothendieck, for example, begins some technical footnotes of *Récoltes et Semailles*[15] with an address showing different degrees of precision: "the non-mathematician reader," "the mathematician reader," "the geometer reader," "the algebraic geometer reader," etc. These details show that the author is aware of the existence of a "real reader" and integrates it in differentiated ways into his narration.

The first approach to these questions is to study the relationship between the origins of the writing project, the intentions and objectives expressed, and the methods of publishing and disseminating the texts.

Yvonne Choquet-Bruhat, as we have said, writes "at the request" of her children: this is the origin of the autobiographical project, which is very common in family circles. However, these stories and memories are published by Odile Jacob, a French publishing house whose name is "often associated with that of high-level scientific popularization"[23, p. 21]. According to a paper studying the catalogue of publications, the publisher "acts as a symbolic converter for the benefit of authors recognized in their field but unknown to a wider readership"[23, pp. 35–36]. A writing practice that presents itself as an encounter of the private and intimate, with editorial institutionalization, is to be explored.

Laurent Schwartz and Edward Frenkel both mention, in the preface to their book, the difficulties that a potential lay reader might experience in understanding mathematical passages; but Schwartz proposes a fragmented reading program where the reader skips pages, while Frenkel claims he wants to make his "dear reader" understand mathematics. The first one is more of an elitist than the second one, who expressly wants to contribute to scientific popularization.[6]

As one last example of the reader's inclusion in the writing project: Norbert Wiener underlines his "duty of exegesis"[35, p. 10]: with his autobiography, he wants to "explain" and "translate" in order to "make [an] understanding available" to himself and to others, especially future scientists but also "the larger intellectual public." The use of the term "exegesis," which connotes the literary and even religious field, underscores the interpretative work of a hidden reality[7] unveiled by the mathematician, but it is also a term used in reference to popularization.

Of course, there is not a single common goal for all mathematicians' autobiographies. But comparing the opening pages can help us to highlight the objectives each writer claims to follow. This does not mean that he is absolutely honest nor right, nor that he will manage to achieve those goals through the text. Between intentions and real effects, there is often a gap. Online comments about Frenkel's *Love & Math* show that the enthusiastic project of the mathematician—who is very active

[6]In [8], I further analyze this comparison.

[7]Expression from the title of [13].

in popularizing math—is not always successful from the readers' perspective. A "customer review" on the Amazon page of the book says:

> *By Salvatore R. Mangano on January 4, 2014* I love math and really wanted to love this book but... [...] as the book progresses Frenkel drags the reader through murkier and murkier waters until all but the most well schooled mathematician could hope to see but a fraction of what Frankel is trying to show.

Successful or not, the mathematician who writes and publishes his autobiography engages his reputation and his scientific identity in the task. This contract between the author of an autobiography and the reader is called "autobiographical pact" by French theorician Philippe Lejeune:

> The autobiographical pact is the affirmation in the text of this identity, ultimately referring to the author's name on the cover.
> The forms of the autobiographical pact are very diverse: but all of them express the intention to honor his signature. The reader may argue about similarity, but never about identity.[21, p. 26]

This pact, created by the very fact that the name on the cover is the name of the narrator and the main protagonist of the story, is an essential part of the possibility that there could be an autobiography at all. What is specific in the autobiography of a scientist, especially when the author aims at explaining his work which is a constitutive part of his identity, is of double nature:

1. the name has a very strong and complex importance in science because of the articulation between objectivity and subjectivity on the one hand, and between the individual parenthood of a scientific discovery and the process of research in a global community on the other hand;
2. there is generally a gap of technical and cultural competence between a mathematician and the reader. The extreme abstraction of contemporary mathematics makes it almost impossible to explain its content to the layman or to give an image of it.

That is why the questions of the public and of the writing project are linked, to some extent, to the process of popularizing science. Which aspects of mathematics or mathematical research are to be transmitted through autobiographies?

Transmitting a Specific Image of Math

Where "literary" autobiographers seem to follow the purpose of "knowing themselves," mathematicians (but they are not the only ones) aim towards the objective of "making the other understand": with this in mind, autobiography would be part of strategies to popularize or disseminate knowledge and practices by entering inside a "black box."

The possible and/or claimed functions of these works could be very roughly summarized as follows:

1. stating concrete aspects of mathematical work
2. describing the processes of mathematical thought
3. exposing and explaining mathematical content

The first and second points are linked when research is shown as an investigation (as a methodical process) and a quest (as an inner process). As Georges Gusdorf writes:

> Science is an adventure, and the beautiful order of accomplished science must not hide the epic of science in the making, with its trials, errors, failures, and triumphs. Autobiography restores the living movement of the quest for truth, according to the perspective of the man of knowledge, who searches for something other than what he is searching for, and who, in searching, searches for himself.[16, p. 412]

Moments of mathematical discovery[8] are sometimes a key step in a book's structure: as was previously stated, Schwartz devotes a whole chapter to "The Invention of Distributions." This illustrates how texts can more or less discreetly use terms and narrative structures from different textual forms, including investigation, artistic creation, even biblical revelation (through illumination or auditing). But the autobiography is first of all a textual form that enables to shed light on the research processes that are usually hidden: meanders, "zig-zags"[32, p. 256], accidents, blocks, and bifurcations that lead to the theorem, theory, or formula as it was made public in the mathematical community in its "finished" form (scientific publications, courses, conferences, etc.). Some passages also stress the difficulties and pains of research: errors, hurdles, or disappointments[7].

The exposition and explanation of precise mathematical content, however, seem harder to manage, because it is complicated and often boring. Edward Frenkel's book explicitly aims to articulate a life narrative as well as a popularization of mathematics, with the latter being presented and highlighted as an essential and unjustly misunderstood cultural object:

> Mathematics is as much part of our cultural heritage as art, literature, and music. [...] This book is an invitation to this rich and dazzling world. I wrote it for readers without any background in mathematics. [...] My goal is to explain this stuff to you in terms that you will understand. I will also talk about my experience of growing up in the former Soviet Union, where mathematics became an outpost of freedom in the face of an oppressive regime.[13, pp. 5–6]

Frenkel addresses very advanced mathematical concepts in his book, seeking to capture the reader's attention in many ways.

Chapter 15[13, pp. 166–183], "A Delicate Dance," which is devoted to Langlands' program (the subject of Frenkel's PhD thesis) is thus presented in the form of a screenplay. First, there is a dialog between Edward, a doctoral student at Harvard,

[8]The mathematical discovery has been studied in a psychological and sociological perspective in [17].

and his supervisor, Drinfeld. The apparatus of the screenplay is announced as such and visually marked by a change of font reproducing the traditional "typewriter" font of such a document.

To explain what "the group SO(3) of rotations of a sphere" is, the teacher refers to "the cup trick"; the next "scene" is a flashback featuring Edward discovering this "cup trick" during a student evening, before returning to the initial scene in the teacher's office where the technical dialog goes on. This tour is also illustrated by a series of photographs of Frenkel who reenacts himself, with his own body, the story which has just been told as a movie scene[13, p. 171].

At the end of this scenario, the "first" narrative, in the usual font and layout, continues to intertwine mathematical explanations and references to cinema: *The Matrix*,[9] which is explicitly cited, and, more discreetly, *Casablanca*[10] when the mathematician uses, as an example of particular attributes of a rotation, a love story between two fictional characters called Rick and Ilsa, as the protagonists embodied by Humphrey Bogart and Ingrid Bergman. The use of the cinema creates a complicity with the reader by linking mathematics to a more familiar cultural field; cinema does not help to explain mathematical content as such, but it enables what could be a reassuring setup for the understanding of the mathematical concepts.

The mathematician described his state of mind at the time: "It was exciting and also a little scary"[13, p. 176]. This ambivalence between fascination and frustration is an aspect that can be found many times in his book, as well as the attraction of cinema and romantic relationships. These different elements culminate in the last chapter, "Searching for the Formula of Love"[13, pp. 229–241], where Frenkel tells how he came to make an erotic-mathematical short film based on a film by the Japanese writer Yukio Mishima.[11]

Reading *Love & Math*, we cannot help but notice the mathematician's fascination with his research subject, which he seeks to convey to his reader in many ways. This is an essential aspect of the popularization of science:

> [...] the relationship between knowledge, the popularizer and his public is organized as a particular pedagogical relationship where the exercise of popularization is very often associated with an exercise of seduction [...][29, p. 12]

In Frenkel's case, seduction is based on seductive "tools" (references to cinema, use of pictures, omnipresence of the vocabulary of love), but also on rhetorical strategies of self-denial as part of his ethos. I analyze more precisely in an other article[8] how the mathematician shows that he undergoes, just like the reader, moments of misunderstanding and frustration, all the while remaining very insistent on the strength and beauty of the emotions that research provides him. This allows the reader to identify with Frenkel: "I don't understand everything, but maybe the mathematician doesn't either; he likes mathematics, so maybe I do

[9]Movie by The Wachowskis (1999).

[10]Movie by Michael Curtiz (1942).

[11]One can also read Frenkel's own presentation of his film in *Imagine Math 2*[14].

too." Misunderstanding is shown as being simultaneously negative and positive, inevitable and frustrating, inevitable and seductive. This process could prove to be a way to positively formulate the relationship to mathematics by showing it as an emotional, potentially erotic object, at least embodied in the body.

What Would a "Mathematical Culture" of Autobiographies Consist of?

From the perspective of the humanities, the word "culture" is very polysemic. Ruth Amossy distinguishes two main meanings:

> Overall, we can distinguish 1) an elitist meaning of the term (but which is commonly used), where "culture" refers to the body of knowledge that distinguishes the cultured man from the uncultivated, namely a philosophical, artistic and literary heritage; 2) a non-hierarchical conception inherited from ethnology where the term culture refers to all symbolic systems that can be transmitted in and by any community, including primitive societies.[1, p. 129]

As with the concept of "ethos," there is also a "disciplinary" dimension to the concept of "culture" which concerns both meanings. One can speak of the "musical culture," the "scientific culture," or the "mathematical culture": it is a symbolic system one must master to enter a group, to understand and be understood by the others within it.

The expression "mathematical culture" is mainly used in regard to the teaching of mathematics in academia. The OECD (2001) defines "mathematical culture," or "mathematical literacy" as such:

> Mathematical literacy is defined in the Programme for International Student Assessment (PISA) as the capacity to identify, understand and engage in mathematics, and to make well-founded judgements about the role that mathematics plays in an individual's current and future private life, occupational life, social life with peers and relatives, and life as a constructive, concerned and reflective citizen[26, p. 369].

Mathematical culture is not just about knowing how to handle basic competences with numbers, calculus, geometry, etc., i.e. having "technical" skills. It is also about knowing that mathematics is a human construct and placing it within a historical perspective, knowing that mathematics play a role in other disciplines (informatics, economics, etc.) and developing a representation of math that avoids clichés (that many representations of mathematicians in pop-culture transmit).

Ways of representing and transmitting scientific culture to a non-scientific audience are closely linked to the idea of popularizing science. Yves Jeanneret explains that science popularization has had different definitions and objectives, depending on the historical period and its ideological issues. It can be seen as a way to "make public what is hidden"[20, p. 19], to "share one's own culture with others"[20, p. 14], "scientific ideas" being "an element of heritage, in the same way as major works of literature and art or achievements of our history"[20, p. 162].

To this extent, science is part of culture in the first meaning distinguished by Ruth Amossy.

We have seen previously that autobiographies can aim at elucidating concrete aspects of the mathematical work, describing the processes of the mathematical thought and explaining mathematical content. Mathematicians' autobiographies can obviously play a role in transmitting a living and humanized image of the discipline by making effort to enable a process of identification and familiarization; but the main difficulty is to find a proper way to talk about math, by being clear and interesting without over-simplifying or losing rigor. Authors of autobiographies often face this problem, especially when it comes to engaging their "academic self" in an unusual form of writing. Michael Shortland underlines that it is hard to "release [. . .] the subjective voice" in a professional field where objectivity and rationality are essential parts of the ethos[33, p. 171].

Aside from some exceptions, like Frenkel's book, it is hard to say that autobiographies and Memoirs are works of popularization as such. Most of the time, they do not try to make the reader understand math. But Yves Jeanneret evokes a definition of science popularization as

> [. . .] a very particular discourse practice, linked to the history of exegesis, whose components are the transcendence of a text, the plurality of reading levels, the elaboration of a second text addressed in a singular communicational situation to a particular reader.[20, p. 20]

The idea of a "second text," which is close to the tradition of the "second book" written by ethnographers[12], and the importance given to the "communicational situation" are two aspects that also function to describe autobiographies. As we have already said, these "second texts" (parallel to the academic production) are especially oriented towards a public of non-specialists. Even without explicit popularizing intent, autobiographies remain a part of this process in that they contribute to building the narration of a history and a culture of mathematics.

Moreover, autobiographies can be seen as "original contribution[s] to culture," an expression used by Jeanneret to evoke the "poetic character" claimed by some works of popularization[20, p. 163]. How could this idea of "poetic character" be

[12] See [10]:

> [. . .] upon their return from fieldwork, most twentieth-century ethnographers produced, in addition to the expected scholarly monograph, a second book, a book that was often more "literary," or at least freer in its form and intended for a wider audience than specialized publications.[. . .] it may also happen that the second book has no direct relationship to the scholarly work: it is neither a refutation, nor a rectification or a supplement, but a mere testimony. In that case, it simply fulfills the elementary need to recount the fieldwork experience or to make use of the elements that the scholarly work left aside. It is just that the (very badly named) ethnographic "encounter" is tremendously richer, more complex, and more multilayered than a scientific event, and it is much more than the reference it will become in the conversations among experts in which ethnographer engages with his peers.[10, pp. ix and xi, Preface to the English Edition]

pertinent to talk about mathematicians' autobiographies? Their literary dimension is not about the esthetic quality of their style. Erwin Chargaff would write that "[a scientific autobiography] belongs to a most awkward literary genre," among other reasons because scientists "lead monotonous and uneventful lives and [...] besides, often do not know how to write"[6, p. 1448]. The "poeticity" is not linked to how beautiful or creative the text is, but rather to the collective and specific ways to shape one's own life, research, and discovery into a narration. Lejeune says that autobiographies are "language phenomenons"[21, p. 10] and "historical facts"[22, p. 23] that merit study not only one in their singularity but also "through series of texts." This is because they build original images and collective imaginaries both in the broad non-mathematical audience and within the mathematical community.

The role of autobiographies in the building of a narrative culture among the mathematical community is the last form of "culture" I want to evoke in this paper, as a lead for later research. Autobiographies can be marks of a reflexive exercise, in a field where auto-reflexivity is not that frequent. A sociological and ethnographical study of the reception of those texts among mathematicians would be of higher interest to tackle the fact that stories contribute to building communities, be they institutionalized or imagined.

Conclusion

Mathematicians' autobiographies and Memoirs are likely to transmit a historical culture of math, insofar as they are testimonies of individual life journeys through working communities in specific periods of history. By discovering how Schwartz had to hide from the Nazis, how Frenkel could only continue to study math by leaving the USSR, how Choquet-Bruhat had to manage familial issues during her career, the reader can no longer think of math as purely abstract knowledge: it is also a discipline subject to political, historical, and ideological issues.

Mathematicians' Memoirs can also be a way to embody their research and give math a more "human" side. Some authors use strategies to build proximity and identification with the reader. Some create ways to make their research more understandable or relatable. Some, finally (but I cannot elaborate on this particular subject in the present article) insist on the relationships between math and other forms of cultural productions, outlining the imbrication of science and math in the daily and collective human and social life.

They are not always able to achieve their goals, but it seems clear that mathematicians' Memoirs are contributing, in specific ways, to transmitting and creating a culture of mathematics. They are doing so by addressing a public outside the community, by turning research into narration, and by showing themselves, with sincerity or narcissism, as (almost) "normal" people.

Acknowledgments The author would like to thank Lindsey Wainwright, Antoine Julia, and Gabriel Alcaras for their precious help during the making of this paper.

References

1. R. Amossy, Culture, in *Le dictionnaire du littéraire*, ed. by P. Aron, D. Saint-Jacques, A. Viala (Presses universitaires de France, Paris, 2002)
2. R. Amossy, Ethos, in *Le dictionnaire du littéraire*, ed. by P. Aron, D. Saint-Jacques, A. Viala (Presses universitaires de France, Paris, 2002)
3. R. Amossy, *La présentation de soi: ethos et identité verbale* (Presses universitaires de France, Paris, 2010)
4. M.J. Barany, The myth and the medal. Notices Am. Math. Soc. **62**(1), 15–20 (2015)
5. K. Beffa, C. Villani, *Les coulisses de la création* (Flammarion, Paris, 2015)
6. E. Chargaff, A quick climb up Mount Olympus. Science **159**(3822), 1448–1449 (1968)
7. O. Chatirichvili, Désordres de la recherche dans les autobiographies de mathématiciens. Auto/biographie, désordre, entropie - Mnemosyne o la costruzione del senso (12), 69–87 (2019)
8. O. Chatirichvili, Formuler la vie - Entre écriture et image, le dispositif des formules mathématiques dans le récit de soi. Récits en images de soi: dispositifs, Le Conférencier-Textimage (2020). http://revue-textimage.com/conferencier/10_recits_en_images_de_soi_2/chatirichvili1.html
9. Y. Choquet-Bruhat, *Une mathématicienne dans cet étrange univers. Mémoires* (Odile Jacob, Paris, 2016)
10. V. Debaene, *Far Afield. French Anthropology between Science and Literature*, Translated by Justin Izzo (University of Chicago Press, Chicago, 2014)
11. D. Dotson, Portrayal of mathematicians in fictional works. CLCWeb Comp. Lit. Cult. **8**(4), 5 (2006)
12. M. Emmer, Raccontare/raccontarsi: i matematici. Vitesse ou lenteur dans les récits autobiographiques sur la naissance des idées - Mnemosyne o la costruzione del senso (9), 27–46 (2016)
13. E. Frenkel, *Love and Math: the Heart of Hidden Reality* (Basic Books, New York, 2013)
14. E. Frenkel, Mathematics, love, and tattoos, in *Imagine Math 2: Between Culture and Mathematics*, ed. by M. Emmer (Springer, Mailand, 2013)
15. A. Grothendieck, *Récoltes et Semailles. Réflexions et témoignages sur un passé de mathématicien.* non publié (1986)
16. G. Gusdorf, *Lignes de vie - 1. Les Écritures du moi* (Odile Jacob, Paris, 1990)
17. J. Hadamard, *An Essay on the Psychology of Invention in the Mathematical Field* (Dover, New York, 1954)
18. G.H. Hardy, *A Mathematician's Apology* (Cambridge University Press, Cambridge, 1940)
19. J.-L. Jeannelle, *Écrire ses mémoires au XXe siècle: déclin et renouveau* (Gallimard, Paris, 2008)
20. Y. Jeanneret, *Écrire la science. Formes et enjeux de la vulgarisation* (Presses universitaires de France, Paris, 1994)
21. P. Lejeune, *Le Pacte autobiographique* (Seuil, Paris, 1996)
22. P. Lejeune, *Écrire sa vie: du pacte au patrimoine autobiographique* (Éditions du Mauconduit, Paris, 2015)
23. S. Lemerle, Le biologisme comme griffe éditoriale. Sociétés contemporaines **64**(4), 21–40 (2006)
24. B.B. Mandelbrot, *The Fractalist. Memoir of a Scientific Maverick* (Pantheon Books, New York, 2012)
25. R.K. Merton, *The Sociology of Science: Theoretical and Empirical Investigations* (University of Chicago, Chicago, 1973)
26. OECD, Education at a Glance 2002: OECD Indicators. Technical report, OECD (2002)
27. M. Pantsar, The great gibberish—mathematics in western popular culture, in *Mathematical Cultures*, ed. by B. Larvor. Trends in the History of Science (Springer International Publishing, Cham, 2016), pp. 409–437

28. A.-S. Paumier, *Laurent Schwartz (1915–2002) et la vie collective des mathématiques*. Thèse de doctorat en mathématiques, Université Pierre et Marie Curie - Paris VI, June (2014)
29. D. Raichvarg, J. Jacques, *Savants et ignorants* (Seuil, Paris, 2003)
30. N. Robin, G. Wiesenfeldt, Scientific autobiographies as literary genre and historical sources. Jahrbuch für Europäische Wissenschatfskultur (4), 7–11 (2008)
31. L. Schwartz, *Un mathématicien aux prises avec le siècle* (Odile Jacob, Paris, 1997)
32. L. Schwartz, *A Mathematician Grappling with His Century*, Translated by Leila Schneps (Birkäuser, Basel, 2001)
33. M. Shortland, Exemplary lives: a study of scientific autobiographies. Sci. Public Policy **15**(3), 170–179 (1988)
34. M. Shortland, R. Yeo, *Telling Lives in Science: Essays on Scientific Biography* (Cambridge University Press, Cambridge, 1996)
35. N. Wiener, *I Am a Mathematician: The Later Life of a Prodigy* (The M.I.T. Press, Cambridge, 1964)
36. J.L. Wilson, C.M. Latterell, Nerds? Or nuts? Pop culture portrayals of mathematicians. ETC: Rev. Gen. Semant. **58**(2), 172–178 (2001)
37. B. Zarca, *L'univers des mathématiciens: l'ethos professionnel des plus rigoureux des scientifiques* (Presses universitaires de Rennes, Rennes, 2012)

Mathematical Imagination and the Preparation of the Child for Science: Sparks from Mary Everest Boole

Paola Magrone and Ana Millán Gasca

> *How children should get their first notions of number hardly*
> *anybody in this country knows, and, but for the goodly band of*
> *ladies who have now begun to study education scientifically, we*
> *might add hardly anybody in this country seems to care.*
>
> Reverend Robert Herbert Quick (1831–1891), [1]

A Brilliant Woman in the Age of Science

Mary Everest (1832–1901) lived in Britain during the reign of Queen Victoria, at a time when higher education was foreclosed to women, one of the causes for the lack of women scientists. She spent some years of her childhood in France and received her first mathematical education from a French teacher who aroused her interest in science. However, she, like others, managed to train herself, thanks to her great determination and the network of contacts which she had access to during her youth. In 1855 she married George Boole (1815–1864), himself a self-taught mathematician, who completed his younger bride and then wife's mathematical training, also involving her in the writing of his treatise on differential equations.

No doubt Mary considered her life's mission spreading to a wide audience her husband's logical investigations, whose cultural origins can be better understood through the narrative that is found in her works [2, 3]. In some way, her husband's fame [4] had an ambivalent impact on her (in Fig. 1 portraits of Mary and George). She actually remains associated to his name and just for this reason her intellectual figure raises curiosity, at the same time this association prevented her

P. Magrone (✉)
Department of Architecture, Roma Tre University, Rome, Italy
e-mail: paola.magrone@uniroma3.it

A. M. Gasca
Department of Education, Roma Tre University, Rome, Italy
e-mail: anamaria.millangasca@uniroma3.it

© Springer Nature Switzerland AG 2020
M. Emmer, M. Abate (eds.), *Imagine Math 7*,
https://doi.org/10.1007/978-3-030-42653-8_21

Fig. 1 Left, Mary Everest Boole, original drawing by Enza Siciliano, reproduced with permission; right, portrait of George Boole, by Harry Furniss late nineteenth century, pen and ink, © National Portrait Gallery, London, reproduced with permission

fair appreciation: she was original in her research on human thinking, and lucid regarding the impact of science on anthropological views (as we would say today), especially considering rearing young children. Moreover, she was a talented writer on education, trying to convey in her (often concise) books a flavor of how to address the child, to communicate with her/him, supporting the rhythm of thought through activities and reflections put forward by the teacher or educator.

In 1972 a leading and erudite member of innovators in school mathematics Dick (Dikran) G. Tahta (1928–2006) edited an interesting anthology on her views on mathematical education [5, 6], but her husband's fame in the golden years of computer science was enough to befog them. Since then, several authors have vindicated her merit, connecting her to other pioneer women in the age of the suffragettes (even if she was never involved in this political movement) and bringing attention to her "insider's" views on Boole's ideas [3, 7–11].

Mary and George shared an outlook that connected psychology, logic, and mathematics: their investigation of the laws of thought looked finding insights on human search for truth, also in religious thought or in natural science. This investigation lies at the bottom of crucial ideas in the development of the modern digital world. George Boole developed a "calculus of logic", a seminal work in mathematical logics. Mary Everest devoted herself to mathematics and science elementary education, considering it not merely a technical training, but the

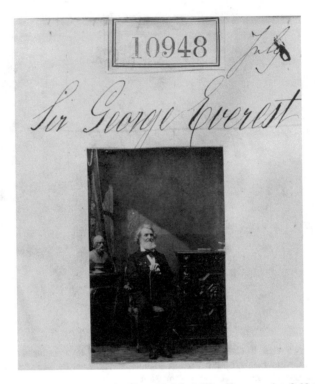

Fig. 2 Sir George Everest by, Camille Silvy, 28 July 1862, albumen print © National Portrait Gallery, London

development of a logical and ethical attitude since childhood, moving away the frontiers of ignorance.

Mary's affectionate uncle (Fig. 2) was George Everest (1790–1866), Surveyor General of India in years 1840–1853, whose family name is used in the Western world for the highest mountain in the world (*Sagarmatha* in Nepali) by decision of the British Royal Geographic Society in 1865. Contacts with Indian thought, the astonishing development of science and a reaction against dogmatism in the Anglican faith and the rigidity of the educational system of the upper classes—based on the classics and aimed at bringing up future worshippers—countered tradition and continuity in Victorian age. Mary had the opportunity to meet gentlemen of science such as John Hershel (1792–1871) and Charles Babbage (1791–1892) at her parent's home and became familiar with the ideas of Augustus De Morgan (1806–1871) and the French (Auguste-Joseph-) Alphonse Gratry (1805–1872) through her husband. Hershel and Babbage were the founders of the Analytical Society, which struggled to change the mathematical atmosphere of competition around the *tripos* in Cambridge University. De Morgan wrote extensively on the teaching of mathematics, and was professor of mathematics for many years at the University College of London, the first non-denominational higher education institution in

London [12]. Gratry was a priest who devoted his life to education, author of educational treatises (among them two treatises on logic), and supported rationalist positions in the Catholic Church such as the opposition to the dogma of the Pope's infallibility. Mary appears in her literary works deeply and sincerely involved in the discussions and battles of her times; a good example are the two letters that she wrote to Charles Darwin—some 2 years after her husband's death—in which she ventured to ask to the author of *The Origin of Species* (1859) the following question:

> Do you consider the holding of your Theory of Natural Selection, in its fullest & most unreserved sense, to be inconsistent,—I do not say with any particular scheme of Theological doctrine,—but with the following belief, viz:
>
> That knowledge is given to man by the direct Inspiration of the Spirit of God.
>
> That God is a personal and Infinitely good Being.
>
> That the effect of the action of the Spirit of God on the brain of man is especially a moral effect.
>
> And that each individual man has, within certain limits, a power of choice as to how far he will yield to his hereditary animal impulses, and how far he will rather follow the guidance of the Spirit Who is educating him into a power of resisting those impulses in obedience to moral motives. [Letter from Mary E. Boole to Charles Darwin, London, December 13th, 1866, Darwin Correspondence Project, "Letter no. 5303," accessed on 29 September 2019, https://www.darwinproject.ac.uk/letter/DCP-LETT-5303.xml]

Her vibrating personality and intense intellectual trajectory are perhaps the explanation of the baffling picture of hers that is traced in the *Dictionary of National Biography* (2004):

>is a remarkable mixture of insight, educational innovation, tedious banality, and an incomprehensible confusion of mathematics, religion, and philosophy...

New scientific discoveries, above all the theory of the evolution of species, joined and strengthened the existing movement that sought to emancipate Anglican Christianity from rigidity and ecclesiastical dogmatism. These ideas had not excessively anticlerical features, and many scientists were interested in spirituality—including spiritism—but it was clear that the moment had arrived for religion to cope with scientific progress. Mary found herself in an environment full of stimuli: her father was an unorthodox reverend interested in debating on spirituality in all its expressions, including Judaism; and her husband was a scholar eager to deepen the study of the human psyche and the comparison between religious visions, including polytheism. Mary grew up surrounded by people of faith and inclined to spirituality, developing a solid religiosity but far from rigid dogmatism and her positions were contrary to the excessive intrusiveness of the ecclesiastical authority: her scientific mind spoke to the spiritual soul.

For a short period after her husband's death she worked as librarian in the recently established Queen's College for girls in London. Since then she was involved with parents—specially mothers—and educators in children's scientific education. In fact, in the final decades of the nineteenth century the need to introduce mathematics and science in education began to spread in liberal circles, both in Great Britain and abroad. It was a mark of modernization, following the extremely influential views of Herbert Spencer (1820–1903) in his essay *Education:*

intellectual, moral, and physical (1861). Spencer's pedagogical views can be summarized in the motto: from the simple to the complex, from the concrete to the abstract, from the known to the unknown [13]. Mary Boole challenged all these three points, and she relied instead on a reflection on human cognition since childhood based on the *unconscious mind*—a crucial idea that she presented to the 1899 congress of the Parent's National Educational Union—and the idea of the *scientific attitude* of unceasing search of *yet unknown* truths.

Mary Boole had tight interest in pedagogical issues with women such as Victoria Welby (1837–1912), a philosopher of language and pioneer of semiotics, and Charlotte Mason (1842–1923), charismatic educator, editor of the *Parent's Review* and collaborated with Edith L. Collett Somervell (1861–1944).

Infancy, Knowledge, and Imagination: Developing the Scientific Attitude

Her first book, *The Message of Psychic Science to Mothers and Nurses*, was published in 1883, but her main essays were all published in the years 1903–1911, when she was in her 70s. In her essay *The Preparation of Child for Science* [14], Mary Everest Boole presented an overview of a path to the early introduction of mathematics and the natural sciences. Those years were in some sense a golden age of mathematics and science for children [15], but the contribution of Mary Boole was outstanding for its pedagogical insights and for being a response to what she foresaw as Science "sweeping on, and swallowing whatever stands in its way", and the immersion of young persons in scientific life.

Parents should not worry in providing up-to-date scientific information to their daughters and sons. Instead, since the preschool age, parents could and should nourish the *unconscious mind* and favor the development of the *scientific attitude* (Fig. 3):

> When a child's attention is attracted by any unfamiliar occurrence, especially by any such sound as that of a singing flame, or by a moving light on the ceiling, do not unnecessarily distract him. As long as he is interested and happy, leave him alone. Let him acquire the habit of quiet and silent observation. [14, p. 58]

The singing flame is a musical instrument presented by its inventor Frédérick Kastner (1852–1882) to the Royal Society in 1875, nicely combining science and music. The flame is produced by hydrogen that vibrates in the tube and generates a sound, which changes according to the size of the tube. When a child can observe such a device, she/he finds himself on the threshold of the *As Yet Unknown*. The child's desire for knowledge is the real propeller of the scientific spirit.

The scientific educator needs an understanding of the child's way of thinking, acting and imagining in contact with the myriad of goads from the external world

Fig. 3 A singing flame (ca. 1860), probably constructed by Mariano Pierucci, one of the best scientific instruments technician in Italy at the time. Source Fondazione Scienza e Tecnica, Firenze (www.fstfirenze.it/apparecchio-per-le-fiamme-cantanti). Reproduced with permission

(including artificial objects, nature, and people). She affirms that knowledge and investigation do not proceed in a continuous and linear way, they go through phases of analysis and then of synthesis, of amazement and intuition; the path to knowledge passes through errors and wrong impressions, which must be embraced with patience. From her own words, the states which the scientific mind should pass through facing a new event or fact should be

Homage, Attention, Observation, Analysis, Antithesis, Synthesis, Contemplation, *Efface-ment, Repose, Judgement or Classification* [14, p. 15]

This cycle can last a few days or an entire life because it restarts relentlessly. This swing, this staying in between the known and the not yet known, driven by the natural curiosity of children, triggers a dynamic, cyclical process. Mary Boole narrates the continuous in-depth dialog between pupil and teacher, regarding phenomena and objects in the environment: flowers, water, tools, machines, stars, and so on (Fig. 4).

Children are capable of performing "a bit of true science work" [14, p. 32] but in school "children's minds are too often left to clutch at straws in an ocean of new ideas" [16, p. 12].

One should keep in mind the rigidities of a period marked by positivism, when scientific dogmatism risked banishing imagination and humanity from science and the knowledge of the natural world. For example, the French author Louis Figuier (1819–1894), a Sorbonne University professor, author of many scientific vulgarization works, wrote in 1862 that young children should be given natural science books instead of fairy tales and fantasy; Hertzel, the editor of Jules Verne wrote him an answer, defending the association of science and imagination, in the

Fig. 4 Left, Two pendulums Harmonograph, by Newton & Co., 1909 © The Board of Trustees of the Science Museum. By—NC—SA/4.0 Right, Lissajous curves, produced by P. Magrone. Lissajous curves are special cases of curves produced with a two pendulum harmonograph, considering the absence of friction and small oscillations (see also http://mathworld.wolfram. com/LissajousCurve.html). "Most children delight in machinery which moves with a slow, steady, rocking motion. Let them waste as much time as they like in watching it [...] get leave to let the little ones see the big, ugly, lumbering monster creating the most fairy-like beauty by simple obedience to rhythmic law. Do not preach or try to explain; let the motion itself lay its spell on their souls and preach a sermon too eloquent to be translated into human speech" [14, p. 60)]

opening pages of the fourth edition of the bestseller *Grand Papa's Arithmetic: A Story of Two Little Apple Merchants,* by the pedagogue Jean Macé (1815–1894), whose editor was Hertzel himself (Fig. 5).

To understand Mary Boole's cultural landmarks in such a context, attention should be paid to two pieces of poetry that she chose to include in the cover of her *Lectures on the logic of arithmetic* (1903). The first one is a verse from William Wordsworth's (1770–1850) ode *Intimations of Immortality from Recollections of Early Childhood* (1798) [17]:

Heaven lies about us in our infancy!

Wordsworth's romantic vision well supported Mary's vision of the strength the child's insight. She opposed the idea that "the young are always eager for a rule or formula which will save them the trouble of thinking for themselves"—as John P. Kirkman and Alfred E. Field, wrote *An Arithmetic for Schools* (1902). Instead, one should be granted knowledge of "what lies at the heart of genuine Mathematical

Fig. 5 From a book by J. Macé. The illustrations were meant to visually and intuitively facilitate the understanding of mathematical concepts; the image was not only a decorative element, but a functional element to the text. Source Jean Macé, *L'Arithmétique de Mademoiselle Lili à l'usage de Monsieur Toto, pour servir de préparation à l'arithmétique du grand-papa*, Hetzel, Paris (1867)

Fig. 6 Bushman wall-painting, source Eduard Clodd, *Primitive man*, 1895, Hodder, London, p. 75. Archive.org

Science" (her words). The key to it was conveyed by a verse from a more recent poem of Romantic echoes, George Eliot (1819–1880) *The Legend of Jubal* (1870),

> Knew that true heaven, the recovered past!

The tale of the past offers to children many clues to understanding; so she started her book with a scene of children being told about Primitive man—the hero of Edward Clodd's (1840–1930) book on prehistoric times as reconstructed from current research—discovering numbers. Narration and imagination were infancy's heaven, and this included mathematical imagination (Fig. 6).

Children, she argues, are not necessarily bounded to reality (the known) and to the immediacy of here and now. But we, adults, have to disclose to them the "mathematical shorthands" that are the reason why often children are "hopelessly puzzled over sums and other things", feeling that there is "a region where grown-ups conduct a self-satisfied mental life in which children cannot share". For example, discussing the reason why, when doing operations with pen and paper, we go artificially from right to the left (and not from left to right, as we do with mind operations!); or explaining that the minus sign indicates "something about the point of view from which the things or numbers are considered", by means of a simple diagram and situation regarding a counter, a customer with her purse and a shopman with his till (see Fig. 7). Also linking the action of "dis-membering and re-collecting" to the early experiences of children of "tearing or breaking things and fitting the bits together again" (it is natural for the human mind to "act disassembling things and then conceive them as united"; this is the process we follow, when we are dealing with very large numbers: we break them down); or "suggesting the feeling of proportion to the imagination of the children" by looking to several lines with the naked eye and then through a magnifying glass. Children being taught arithmetic in unsuitable ways develop what she calls "mental rickets"; instead, she suggests teachers to reserve some minutes at the end of every lesson to create a mind picture shutting eyes, taking long easy breaths, listening to the teachers retelling and meditating all that in silence. Just to make an example, during the lesson about counting by ten, she asks pupils to make the mind picture of a sheep passing through a gate.

Fig. 7 This diagram shows a shop counter, T indicates the money contained in the seller's till, P the money contained in the customer's purse. Arrows are the geometric representation of plus and minus signs of money going from the shopman to the customer and vice-versa. Interpretation of the authors of the original picture appearing in Mary Everest Boole, Lectures on the logic of arithmetic, 1903, Clarendon Press, p. 70

This richness of puzzling ideas fruit of mathematical imagination deserve attention in education. Scientist use them by routine, but when introducing them to the young, one should stop and realize "the grandeur of the idea involved": pupils assimilate it wrapped up in a poetical appreciation. She puts forward the great example of celestial mechanics: the trajectories of celestial bodies and the underlying forces, and the "mathematical lines" such as tangents and axes and so on that help us to understand or explain the surrounding world:

> The tangent to an ellipse is an imaginary straight line, representing the path which would be followed by the body tracing the ellipse if its connexion with the attracting focus were sudden to cease. In its essence, the tangent is a sublime effort of the scientific imagination; it pictures the result of a sudden cessation of the action of gravity. In practice, the tangent is a convenient line for indicating the curvature at any given point. [...] We ought to use tangents, mechanically, as mere measuring-rods. But a good teacher will take care that no pupil goes through a year's work at Analytical geometry without having been, once or twice, aroused to *perceive the wonderful poetic conceptions* represented by the lines he is using" [14, p. 97, our emphasis].

As we will see in the final paragraph, this appreciation is not reserved to teenagers, but also to much younger pupils. As a matter of fact, Mary Boole compares jokingly the axes and tangents to the tailors' fashion books where the pictures of dresses contain straight lines indicating measures: obviously people do not walk around with lines across shoulders ... the images in the books are puzzling in a way math books can be puzzling!

The question of science education should be connected to an overall humanistic vision (an "ethical and logical preparation", as Mary Boole considered it), rather than being only the object proposals regarding learning methods and "tricks" of teaching. According to her, the key idea could be to pursue an "early scientific

Fig. 8 Children at the South Kensington Science Museum, 1934, Credit: Science Museum/SSPL. Mary suggests to bring the children to the South Kensington Science Museum, where there is a selection of machines: "[...] The most attractive to children are those which they can turn on themselves by touching an electric button. [...] The sensation of putting one's finger on a button and seeing a whole army of wheels, cogs, levers, and hammers respond, as if by enchantment, to one's touch, is a tremendous revelation to a child's subconscious mind" [14, p. 62]. Reproduced with permission

attitude" and not an "early teaching" and a scientific education exclusively aimed at up-to-dateness (Fig. 8):

> Up-to-dateness is the cause of disorder; the haste, the greed, to efface rapidly each partial impression, when we have nothing to substitute for it but some other impression equally partial, *is not only unscientific but eminently disorderly.* [14, p. 23]

The work on the child's unconscious mind is developed through a rhythmic, natural, balanced alternation of active moments, mind pictures and sabbatical moments in which the child is free to overthink and ruminate on what has been observed, done and discussed. Puzzlement is a great component of this attitude, but not a puzzlement driving to renouncing understanding; instead, it is the origin of dynamic state of mind, of mental oscillation:

> [...] when a child has formed for himself a clear, undisturbed impression of the earth's unmovableness and the apparent motion of the sun, and then has read that astronomers believe the earth goes round and the sun does not go round the earth, if he then puts together in his mind the two apparently conflicting statements that made by his senses, and that made by his book and lets them combine to create in him an impression which shall embrace both, then the sacrosanct scientific act has taken place within his mind [14, p. 32].

The Impulse of Mathematical Imagination: Curves, Lines, Sewing Cards, and the Story of a Rabbit and a Dog

Mathematical imagination, and in particular geometric imagination, plays a crucial role in the scientific pursuit of a yet unknown truth. We should have in mind that her long experience as educator, especially regarding mathematics and science, was inspired by her views on human thought, which combined logic and psychology. In George Boole's research in this field was a symbolic, algebraic research. Mary Everest explored also the role of form, inspired by the work of a quite weird scholar of her generation, the architect Benjamin Betts (b. 1832), a British civil servant in the Survey Department at Auckland, New Zealand. Betts developed a "geometrical psychology" regarding the evolution of human conscience, which he represented— he was an expert draftsman—by means of beautiful diagrams inspired by natural forms (Fig. 9):

> An analogy used by Fichte in "The science of knowledge" of the correspondence of the line and the circle with modes of consciousness, led to his conception of the idea of developing a Science of Representation. [...] He attempts to represent the successive stages of this evolution [of human] by means of. These [symbolic mathematical] forms represent the course of development of human consciousness from the animal basis, the pure sense-consciousness, to the spiritual or divine consciousness; both which extremes are not man. [18, pp. 6 and 9]

Fig. 9 Betts' diagrams in the edition by Luisa Cook, for the publishing house Redway of London (from left, p. 91, 93, 97), that published many books on occultism. The essence of the evolution of human consciousness was linked, in a holistic point of view, to vegetable morphology and the infinity of the Universe. From a letter from Betts to Mary Boole: The laws of infinite solar systems throughout the universe are telegraphed to us by the flowers at our feet... These laws of the corolla-form we have educed as Laws of Thought, of self-consciousness as revealed in the act of thinking [14, p. 11]. Archive.org

Fig. 10 The curve of pursuit, reproduced by Paola Magrone from the original appearing in [19] p. 32. "The child draws straight lines which represent to the mind the successive desires and thoughts of animals; which express his own understanding of and sympathy with those desires and thoughts. [...] the connection between Laws of thought and Laws of form passes out of the category of things which need to be proved and becomes axiomatic" (from the preface by Mary Boole in [19])

Boole wrote that even if Bett's diagrams are so complex, they were "very helpful in suggesting simpler methods". She developed in fact her own representation of the rhythmic pulsation for educational purposes, using curves and tangents, generated by the motion of some animals in a story instead of by the motion of planets. As she explained, while observing her granddaughters decorating Christmas cards by sewing silk tangents (she had also used this sewing cards as a girl), she had the sudden revelation that she could use the generation of curves as envelopes of tangents for "introducing little children to the conception of a connection between organic thought-sequence and the evolution of harmonious form": she called them the curves of pursuit, because of the story she associated to it. A rabbit escapes from a dog: straight lines (build by means of strands of wool or other materials) represent the dog's thoughts and wishes to catch the rabbit that he could not fulfill; and those of the rabbit that wants to run safe in its burrow (Fig. 10).

The curve of pursuit can be sewed by kids following a short tale, giving life to a sort of game of identification: R is a rabbit who finds herself at some distance from her burrow B; the dog D sees the rabbit and wants to catch her. The line from R to B represents the will of the rabbit to run safe in her burrow. The dog runs toward R from D, and the rabbit hops from R to r_1; so the dog, after arriving in d_1 changes his mind and trajectory, slightly turning toward r_1. In the meantime, the rabbit is jumping to r_2, so as the dog arrives at d_2, he chooses to move to r_2 and so on. The lines from d_1 to r_1, from d_2 to r_2 etc. represent the dog's *wishes*. The curve, which is perceived visually, is the actual *action* of the dog.

This is the most celebrated contribution by Mary Everest Boole: the so called Boole cards and the related activity of curve stitching. Starting from the threads sewn on a card punctured by the needle at fixed points, curves appear under one's fingers, as envelope of the family of lines defined by the thread. The idea of tangent line appears in the background and impacts on the unconscious mind. Thus, a visual, tactile and motor game generates naïf (unconscious, implicit) conceptions (what

Fig. 11 Children at work on Boole's cards. Pictures by Paola Magrone

she calls "natural" or even "wild" teaching and learning); it *prepares* the ground for formal (explicit, aware) study ("artificial" as opposed to "natural", using her terminology) in secondary or higher education. This was Mary's own experience:

> As the practical art of sewing perforated card was already quite familiar to me, my brain was free **to receive as a seed** the discovery I had made, and to let it grow naturally; all the more because no one spoke to me then of tangents [...] Therefore, when I did begin to learn artificially about tangents, the teacher was not obliged to put cuttings into raw soil; he found ready a good strong *wild* stock of *loving interest* in the relation between a curve and the straight lines which generate it, on to which he was able to graft the new knowledge. [14, p. 92, our emphasizes]

This informal, hands-on experience is part of what she calls a "hygienic sequence in development", because it establishes an implicit relation between the child's mind and the abstract concept, which will remain silent for years and reveal itself at the right moment (Fig. 11).

Boole's cards are well known: here for example the curve-stitching activity *Making patterns: Pushing the envelope* sponsored by the AMS in the biennial USA Science & Engineering Festival 2018 (http://www.ams.org/publicoutreach/curve-stitching). What happens when children begin to sew after listening to the rabbit-dog story: they feel as if the dog and rabbit were there (we call this mimesis, a force of understanding already described by Plato and Aristotle, the driving force in poetry and the arts); and their geometrical imagination is working, it is disclosing, revealing the curve that is emerging from straight lines; a rhythmical pulsation is created by "the pressure of opposite forces", by the tension between the alternating desires of animals [8, 20]. A look into heaven, as Shelly Innes put it. The infancy heaven: colors and threads and rabbits and dogs and the power of imagination and of mathematics. Thus, hands-on experience conveys much more the concrete perceptual relationship with real things, disclosing the (often missed) originality and

complexity of the children's mind, the power of their mimesis and fantasy, which is enhanced by narration but also by geometrical suggestions. Notice that Mary Boole ventured to use the adjective "wild" to describe her own childish conception of tangent line. Kieran Egan has written about the "domestication of the savage mind" in primary education, showing that developing the poet in each child is the starting point of literacy and rationality [13]: from Boole works arrive sparkles on the poetics of math and science in childhood.

References

1. R.H. Quick, The first stage in arithmetic. Parent's Rev. **7**, 8–17. See J. Dennis 2009 "Learning arithmetic: textbooks and their users in England 1500–1900", in *The Oxford Handbook of the History of Mathematics*, E. Robson, J. Stedall (Oxford University Press, Oxford, 1896) pp. 448–467
2. I. Grattan-Guinness, Psychology in the foundations of logic and mathematics, in *History and Philosophy of Logic*, vol. 3 (Taylor & Francis, London, 1982), pp. 33–53
3. L.M. Laita, Boolean algebra and its extra-logic sources: the testimony of Mary Everest Boole, in *History and Philosophy of Logic*, vol. 1 (Taylor & Francis, London, 1980), pp. 37–60
4. D. MacHale, *The Life and Work of George Boole: A Prelude to the Digital Age* (Cork University Press, Cork, 2014). (New edition)
5. D.G. Thata, *A Boolean Anthology. Selected Writings of Mary Boole – On Mathematical Education* (Association of Teachers of Mathematics, Nelson, 1972)
6. G. Hoare, E. Love, Dick Tahta. A maths teacher with gusto, he inspired the schoolboy Hawking. *The Guardian*, 5 January 2007
7. S. Innes, Mary Boole and curve stitching: a look into heaven. Endeavour **28**(1), 36–38 (2004)
8. P. Magrone, A. Millán Gasca, *I bambini e il pensiero scientifico. Il lavoro di Mary Everest Boole. With integral translation in Italian of "The Preparation of the Child for Science"* (Carocci, Roma, 2018)
9. K.D. Michailowicz, Mary Everest Boole (1832–1916): an erstwhile pedagogist for contemporary times, in *Vita Mathematica: Historical research and integration with teaching*, ed. by R. Calinger, (Mathematical Association of America, Washington, DC, 1996), pp. 291–296
10. S. Petrilli, Three women in semiotics: Welby, Boole, Langer. Semiotica: J. Int. Assoc. Semiotic Stud. **182**, 327–374 (2010)
11. K.G. Valente, Giving wings to logic: Mary Everest Boole's propagation and fulfilment of a legacy. Br. J. Hist. Sci. **43**(1), 49–74 (2010)
12. A. Rice, Mathematics in the metropolis: a survey of Victorian London. Historia Mathematica **23**, 376–417 (1996)
13. K. Egan, *Primary understanding. Education in early childhood* (Routledge, New York, 2014), (originally published 1988)
14. M. Everest Boole, *The Preparation of the Child for Science* (Clarendon Press, Oxford, 1904)
15. A. Millán Gasca, Mathematics and children's minds: the role of geometry in the European tradition from Pestalozzi to Laisant. Archives internationales d'histoire des sciences **65**(2), 175, 261–277 (2015)
16. M. Everest Boole, *Lectures on the Logic of Arithmetic* (Clarendon Press, Oxford, 1903)

17. T.B. Olsen, *Wordsworth and Evolution in Victorian Literature: Entangled Influence* (Routledge, New York, 2017)
18. L. Cook (ed.), *Geometrical Psychology, or The Science of Representation: An Abstract of the Theories and Diagrams of B. W. Betts* (Redway, London, 1887)
19. E. Somervell, *A Rhythmic Approach to Mathematics* (G. Philip & son, London, 1906)
20. P. Magrone, S. Massenzi, A. Millan Gasca, Rhythmical pulsation: art, mimesis and mathematics in primary school following Mary Everest Boole. J. Math. Arts **13**(1 and 2), (2019). Special Issue in Education

Antanas Mockus and the Civil Role of a Mathematician

Carlo Tognato

Introduction

Over the past decade a growing number of analysts in academia and the media around the world have insistently warned against the decline of support for democratic institutions and the prospect of an authoritarian surge within the West and beyond [1]. Roberto Foa and Yascha Mounk, for example, recently observed that only 30% of Americans born in the 1980s regard democracy as an essential dimension of social life and 1 in 6 support martial rule up from 1 in 16 in 1995 [2].

Some have blamed neoliberalism and the traumatizing dislocations produced by global capitalism for the growing support over the past two decades for authoritarian populist leaders and have occasionally alerted against the coming of a new kind of societal fascism [3]. Others like Pippa Norris, instead, have objected that such leaders have emerged even in "several affluent post-industrial 'knowledge' societies, in cradle-to-grave welfare states with some of the best-educated and most secure populations in the world." [4] And based on that, they have explained the relatively recent surge in authoritarian populism as a backlash against long-term social change which over the past few decades has transformed in many societies the balance between sex roles, public understandings of gender identities and sexuality, social norms on diversity, and that has led to the diffusion of secular values.

C. Tognato (✉)
Center for the Study of Social Change, Institutions, and Policy (SCIP), Schar School of Policy and Government, George Mason University, Arlington, VA, USA

Center for Cultural Sociology, Yale University, New Haven, CT, USA
e-mail: ctognato@gmu.edu

© Springer Nature Switzerland AG 2020
M. Emmer, M. Abate (eds.), *Imagine Math 7*,
https://doi.org/10.1007/978-3-030-42653-8_22

In a number of societies the creep of authoritarian populism has not only resulted into the emergence of institutional practices that appear to be inconsistent with democracy, such as the intimidation of the media, the emergence and consolidation of official or semiofficial media networks spreading populist propaganda, the attempt at politicizing the civil service, the military, and domestic security agencies and of using government surveillance and law enforcement against domestic political opponents, the stacking of the judiciary branch with partisan appointees in an effort at undermining judicial independence, and the delegitimation of the electoral system by recklessly calling it rigged without any solid base to support such a claim [5].

Most importantly, alongside with the demonization of the opposition and the adoption of fearmongering as a pillar of political action, authoritarian populists have sought to undermine the civil values that underpin the functioning of democratic institutions. And in particular, they have steadily eroded crucial normative standards in public discourse such as truth, rationality, reasonableness, self-control, trustworthiness, transparency, good faith, and accountability.

Such a trend at a national level has then been matched by a new form of authoritarian internationalism on a global scale which has leveraged standard institutional resources of democratic societies, such as NGOs, think tanks, election monitors, and media, for the purpose of manipulating audiences and suppressing democratic consent [6]. They have been turned into "zombie" civil institutions—civil on the outside, but devoid of their civil function on the inside.

Practitioners across a variety of disciplinary fields may wonder at this point what role they might play in defense of civil values and, more generally, what relevance their practice may have to cultivate and sustain them. The literature has identified a number of ways mathematics and mathematicians may contribute on that front. After referring to it, I will zoom into the case of Antanas Mockus, former chancellor of the National University of Colombia and a mathematician, who in 1995 became mayor of Bogotá at a time of profound crisis in Colombian society and started out a most ambitious program of urban intervention—the *politica de cultura ciudadana*—geared to induce rapid behavioral and cultural change among his fellow-citizens. His contribution changed the course of history in his city and left a mark in the political and intellectual history of Colombia, which national and international analysts have duly noted on a variety of occasions. In this chapter I will look at how the competences that the literature has identified to be cultivated by a training in, and a practice of, mathematics may have supported his interventions into the civil life of his own community.

The Civil Role of Mathematics and Mathematicians

One way observers in the media and in academia explain the relevance of mathematics and mathematicians in democratic societies is by noting that numerical information permeates all fronts of democratic discourse and civil decision-making

[7]. Numerical thinking has become a fundamental component of "the discourse of public life" [8], particularly in the course of the twentieth century, and participation in civil life crucially relies on the competence of thinking numerically [9]. Quantitative literacy, in other words, "empowers people by giving them tools to think for themselves, to ask intelligent questions of experts, and to confront authority confidently." And by reverse, "an innumerate citizen today is as vulnerable as the illiterate peasant of Gutenberg's time" [10]. There is much more than this, though, to the contribution of mathematical training and practice to civil life.

As John Dewey noted in his celebrated work *On Education*, a well-functioning democracy may be understood as "the political manifestation of the scientific method, with its combination of purposiveness and objectivity, freedom and discipline, individual speculation and public verification" [11]. Based on that, he saw an education for democracy to be necessarily geared to cultivate reflective, creative, and responsible individuals.

For a long time, mathematics has been recognized to be contributing to that on a number of fronts. Its capability of forming citizens by strengthening reason was already acknowledged during the Enlightenment and in post-revolutionary France [12]. During the nineteenth century, in turn, mathematics was pursued in Cambridge as "a way to teach young men to understand and recognize the truth" [13]. During the 1830s, then, Oxford and Cambridge battled on whether logic or mathematics were better suited to cultivate reason in young men, that is, whether it was better to teach the rules of reason via logic or practice it via mathematics [14].

Since then, analysts have noted that such mental habits as neatness, orderliness, accuracy, persistence, and attention to detail, clarity, the orientation to problem-solving and the ability to identify assumptions and gaps in argumentation may actually translate from mathematical practice to good citizenship [15, 16]. And they have also recognized that mathematical reasoning may actually develop an ethos of intellectual honesty that is useful in democratic life: "This trait results from the consideration in problems as to that which is essential and that which is irrelevant. You will find the mathematically trained citizen perhaps annoying you by his persistent 'How do you know?', but you must concede that he will not admit into the discussion any fanciful, irrelevant padding." [17].

Particularly at a time when reason and truth are under siege, falsehoods are laundered into "alternative facts," science is subject to ideological manipulation, moral relativism and partisan politics are undermining the commitment to constitutional principles and fundamental rights, and free speech becomes "somehow contingent on the identity of the speaker," mathematical competence and practice is once again recognized to usefully cultivate an ability and a willingness to reason on both sides of arguments [18].

And yet, others have also insisted on the fact that mathematics is not just about solving problems. It is also about figuring out which techniques we *ought* to use to solve problems, and how much we can really trust the answers that they produce [19]. It trains people to "glimpse the entire structure of a problem, so that you can figure out how best to tackle it, and how reliable your ultimate answers will be" [20]. It is also about problem-finding [21]. It develops an inclination to "jump around" to

get better viewpoints into problems and to insistently ask "what if?" [22]. And it cultivates a tolerance for nuance and uncertainty [20].

Here, I will show how a Colombian mathematician, Antanas Mockus, tapped into some of these competences for the purpose of supporting civil life in his own university and in Colombia's capital city, Bogotá. Before showing how he did, though, I will first present the general contexts of his action and then refer to his biography and career trajectory.

The Contexts of Antanas Mockus

After more than four decades of relative peaceful electoral politics in Colombia, the assassination in 1948 of the leader of the most progressive faction within the Liberal Party opened up a traumatic decade of political violence that resulted in the barbaric elimination of 200 thousand people. In the 1950s, liberals formed self-defense guerrilla groups in rural areas in response to violence, some of which later radicalized and shifted into the communist camp. In 1958 liberals and conservatives decided to establish a National Front and agreed to alternate at the presidency in an effort at reestablishing a republican commitment to peaceful electoral politics. The idea, though, that violence could be used to change the course of politics had entered the horizon of Colombian political life and was there to stay.

Mostly inspired by the Cuban Revolution, between the 1964 and 1970 Colombia's major revolutionary guerrilla movements were established—the *Fuerzas Armadas Revolucionarias de Colombia* (FARC), the *Ejército de Liberación Nacional* (ELN), the *Ejército Popular de Liberación* (EPL) and the M-19 [23, 24]. In the course of the 1980s guerrilla groups grew at an accelerating pace. By 2001, for example, the FARC reached 18,000 combatants up from 2000 [25]. In 1982 the Colombian government opened up a negotiating table with the FARC, the ELN, the EPL and the M19. In 1984 the FARC signed a cease-fire and constituted with other leftist political parties a new political party—the Unión Patriótica. By engaging in legal electoral politics while failing to unambiguously distance itself from the armed struggle of the FARC, though, the Unión Patriótica turned into an easy target of paramilitaries, drug-lords and state agents. In the end, 4000 of its own members were assassinated [26]. The M-19 and the EPL, on the other hand, successfully finalized the peace negotiation with the government and ultimately demobilized in 1990 and 1991, respectively, when a new progressive constitution came into force. The FARC, instead, kept on fighting for another quarter of a century.

The combination of all the forms of struggle by insurgent groups, which coupled the armed struggle with participation in the electoral process and in social mobilization, irremediably poisoned Colombian politics and paved the way to the combination of political struggle with military action all across the political spectrum. As Jorge Orlando Melo put it, "militants of trade unions and legal parties or movements could no longer tell to what extent they might be accomplices of political barbarianism, and on a variety of occasions they could not free themselves

from retaliations against the guerrilla." [27] Thus, since the end of the 1970s the combination of all the forms of struggle on the part of the guerrilla was met by its victims with "a new and more efficient form of combination of all the forms of struggle" [27]. This was the origin of paramilitary groups.

Since the 1980s guerrilla expansion was increasingly met by a surge in paramilitary organizations, the influence of which dramatically increased throughout the 1990s over rural and urban areas, often through terror, till their demobilization between 2003 and 2006. During the 1980s and 1990s Colombian institutions also came under the pressure and influence of drug cartels [28]. The attempt at cracking down on the Medellin cartel, in turn, opened up a period of narcoterrorism between the end of the 1980s and the early 1990s, which deeply affected the life of its major city centers. By the mid-1990s, the impact of guerrillas, paramilitaries, and drug-cartels on the social and institutional life of the country was so overwhelming that Colombia was almost regarded as a failed state [29].

In 1998 the Colombian government opened up a new peace negotiation with the FARC and cleared to that end a part of its territory as big as Switzerland to allow peace talks. The process, though, collapsed as the FARC continued its attacks on military and civilian targets during that time. In 2002 a new president, Álvaro Uribe, was elected with the mandate to unleash an all-out war against guerrillas. The new offensive doctrine, the availability of better armaments, and the improvement in intelligence operations, in part thanks to a substantial increase in US military assistance, led to a progressive debilitation of the FARC and set the stage for a new round of peace talks. This time, they resulted into a peace accord in 2016.

This was the background against which life unfolded in Colombian cities. Up till 1994, according to the US State Department Bogotá was the most dangerous city in Latin America: "The city seemed hopelessly mired in a level of corruption that turned almost any investment against itself, because conventional cures of money or more armed enforcement would have aggravated, not mitigated, the greed and the violence." [30] Jesus Martin-Barbero adds that "a distrust of everyone by everyone" characterized life in the city and the media propagated "the generalized feeling that collective action is impotent, while in turn promoting the individual's retreat to the domestic sphere" [31]. Such erosion of the civil fabric of the city, in turn, ended up legitimizing "the right to fear": "Its inhabitants walk from home to work as if they were in a tunnel," "clutching their handbags, attentive to any indication of danger and responding immediately and aggressively to any minimally undecipherable gesture" [31–33].

The implosion of civil life also reverberated onto Colombian public universities. Since the 1960s the adoption by radicalized groups of antidemocratic practices and intimidation tactics within such settings did not only drive the majority of those communities into apathy, thereby allowing their more extremists members to monopolize the voice and representation of such communities [34]. By the early 1970s the link in Colombian public universities between radicalism and the armed struggle was also naturalized as an inherent component of university radicalism [34]. And as violence got rooted into public university campuses, such settings turned into yet another theater of the war, where revolutionary and anarchist groups confronted

the state, paramilitaries and drug-traffickers, and where they recruited students as well as trained them in clandestine operations [35].

Public universities, in particular, were enrolled into the combination of all the forms of struggle on the part of guerrillas as some of their members actively helped consolidate, almost unopposed, the narrative repertoire that justified the armed struggle well past the time all other Latin-American revolutionary movements, except from Sendero Luminoso, abandoned it. Cayetano Betancur, an important philosopher from the National University of Colombia, called on Colombian intellectuals for their responsibility on violence and blamed them for abusing "their rhetorical and dialectical weapons" [36, 37]. Jorge Orlando Melo, on his part, a famous historian, later director of the largest network of public libraries in Colombia and a member during the 1970s of the Partido Socialista Revolucionario, also insisted that in Colombia "intellectuals played an important role in the creation of a 'common sense' justifying violence by elaborating arguments in favor of it" [38]. In particular, as Jorge Giraldo Ramírez puts it, they justified violence as a mean to address political and social differences. They dismissed democracy as a channel to peacefully resolve political conflicts. They nurtured the distrust in the rule of law and, finally, they fed into the devaluation of human life as a moral foundation of society [39].

All this resulted into a long and gradual process of retreat of civil life within public university campuses, which only slowly started to be reverted since the early 1990s, when the M-19 successfully demobilized and a new progressive constitution was passed. Since then, the return of the civil in such settings has been gradual, highly contested, and still painfully incomplete [40–43].

A Short Biographical Note of Antanas Mockus

The son of Lithuanian immigrants, Antanas Mockus studied at the Lycée Français in Bogotá in the 1960s and graduated in mathematics from the *University of Dijon* in France in 1970. In 1975, he joined the academic staff of the *Department of Mathematics* at the *National University of Colombia* in Bogotá. Early on, his teaching reflected the breadth of his intellectual interests.

In 1978 Mockus taught a course on the representation of science in Colombian mainstream media, which at the time used to support an uncritical admiration on the part of the Colombian public for scientific knowledge as if it belonged to "the realm of inaccessible 'magic'" [44]. Prompted by that course, Mockus joined a research group directed by an Italian mathematician, Carlo Federici, who had migrated to Colombia just after the end of WWII, spent his academic career at the National University of Colombia and upon his retirement became principal of the Italian School in Bogotá. The Federici group, which gathered faculty members from the departments of mathematics and physics at the National University, had been committed to promote the teaching of mathematics and natural sciences in Colombian primary schools as a way to cultivate a genuinely scientific disposition

in children and counter the fetishistic representation of science in Colombian media and public culture [45].

In 1978 the Ministry of Education sought to reform the school curriculum based on an understanding of instructional design that took teaching as a mechanical sequence of planned, repeatable actions, thereby denying the open-ended communicative nature of the teacher–student relationship. As Carlos Augusto Hernandez [46] points out, the Federici Group, which Mockus ended up leading, attacked on such ground the reform at a symposium and later in two publications about the autonomy of the educator [47] and the taylorization of education [48]. That critique was later adopted by the federation of Colombian educators in its battle against the reform and also ended up playing an important role in the shift of emphasis on the part of the federation from traditional union politics to cultural politics in defense of the distinctive professional identity of teachers. As a result of his public engagement with the federation of Colombian educators and as an editorial member of its new magazine, *Educación y Cultura*, which became a point of reference for the Colombian Pedagogic Movement, Mockus turned into a politically significant figure in the field of Colombian education.

In the 1980s, he also played a relevant role in a professorial movement at the *National University* in defense of university autonomy and academic culture, two issues that he later addressed at the end of the 1980s in a widely read lecture about "The Mission of the University" [49]. This platform further broadened his recognition within his university community. In 1989 he was appointed vice-chancellor and in 1990, at the age of 38, he became chancellor.

His term as head of Colombia's largest public university was marked by a series of pedagogic initiatives that tapped into symbolism and performance for the purpose of promoting peaceful coexistence and free debate on the campuses of the *National University* in which over many decades of war intimidation and self-censorship had progressively curtailed free expression in relation to a series of taboo issues [50, 51]. As Carlos Augusto Hernandez remarks, "Mockus was committed to tirelessly promoting rational agreements and transforming physical violence into symbolic violence when consensus was impossible" [52]. And students appeared to go along with it. After all, Mockus could afford to enter the buildings occupied by students on strike without his bodyguards.

In 1993, during a speech before a thousand art students in the majestic *León de Greiff Auditorium* of the *National University*, Mockus mooned his audience to shock a group of protestors into silence. He then pulled up his pants and went on with his speech. He was later forced to resign, but public debate over the incident suddenly turned him into a popular public figure. Although he did not belong to Bogotá's elite, nor was he part of the political machinery of traditional Colombian parties, in 1994, he decided to run for mayor of Bogotá. In spite of running his campaign on what turned out to be the smallest budget in Colombian electoral history, to the dismay of many and the satisfaction of many more, he won. Various analysts regarded that event as a watershed in the political history of Bogotá [53–60].

When Mockus took office as mayor in 1995, Bogotá was plagued by violence and its inhabitants felt they had little in common with one another. Mockus responded

to that fragmentation by seeking to build some common ground among them. In particular, he addressed violence and crime by attempting to bring the legal, moral, and cultural forms of regulating conduct back into line. This orientation constituted the backbone of his cultural policy—*política de cultura ciudadana,*—which resulted into an extensive pedagogization of the everyday life of Bogotá, and touched upon a wide variety of issues, such as recreation, transportation, public utilities, the environment, taxation, and security, to name just a few [61]. Mockus' use of the arts to execute his pedagogic agenda as mayor marked an important element of continuity with his prior engagement with performance as chancellor. As mayor, he continued to tap into creative practices to deliver his pedagogic messages and modify people's conduct. His programs ended up triggering a collective process of self-reflection among his fellow-citizens, thus turning their living-together into a generalized pedagogic exercise. It reignited public deliberation. It brought back the very idea of the public into the life of the Bogotanos and anchored it not only to the value of rationality, but also to a renewed sense of collective identity.

Over the years, Mockus' pedagogic practices have received the praise of many observers both in Colombia and internationally, and his experience earned him a long series of mentions by various respected institutions. For example, in October 2002, the United Nations declared Bogotá to be "an exemplary city for Latin America from which other cities may learn" [62–64]. Since then, Mockus actively participated in Colombian national political life twice as presidential candidate and most recently as senator.

Before turning to the segment of the chapter that addresses how Mockus' practices might reflect three competences that observers have associated with professional training in mathematics and with the practice of that discipline, it may be worth acknowledging, as well, that philosophy and the arts also played an important role in his biography and academic trajectory. I would contend that his civil practices appear to reflect the competences associated with his professional training in mathematics as much as with his broader engagement with the other liberal arts.

Mockus' turn to philosophy was particularly distinctive during the 1980s as his research progressively shifted into the field of education. Over that decade various members of the Federici group with a professional training in mathematics or physics turned to philosophy and social theory and enrolled into the newly established master program in philosophy at the *National University*. As Carlos Augusto Hernandez points out, Husserl, Wittgenstein, Gadamer, Habermas, Bachelard, Kuhn, Bernstein, Bourdieu, and Gouldner became important sources of inspiration for the group [65].

In addition to Mockus the mathematician, Mockus the educator, and Mockus the philosopher, it is necessary to acknowledge, as well, the artistic dimension of his practices. According to Mockus "the artist is someone who, in a prison cell, takes a piece of chalk and draws a border to define his space, a person who has more restrictions than those normally apparent. But upon defining those restrictions himself, he liberates himself" [66, 67]. And indeed, his civil practices reflected just that as they cultivated reflexivity among his fellow-citizens vis a vis the norms

that regulated their behavior. The 2012 Seventh Biennial of Art in Berlin, which explored the intersection between politics and the arts, acknowledged the artistic character of Mockus' civil practices and invited him to participate and exhibit. Harvard humanist Doris Sommer, on her part, shed light on the links between the philosophical and artistic dimensions of Mockus' practices. The free play of imagination that characterizes the arts, she showed, plays a fundamental role in deliberation. And thanks to it, "deliberation can exercise freedom to play out a range of scenarios and their results without the irrevocable, possibly harmful, rush towards habitual or preconceived conclusions" [68]. This, she continued, is what ultimately turns Mockus' civil practices into a work of art.

And the arts were indeed an important dimension of Mockus' life long before his performative stunts as a chancellor of the *National University* and as a mayor of Bogotá. As Carlos Augusto Hernández points out, Mockus was surrounded by art since his childhood, being his mother a sculptor. In addition, since his youth he "learned to love metaphor" and during his undergraduate years he "was enticed by literature and wrote his own plays" [69].

After briefly presenting Mockus' biography and career trajectory, I will now address in the following three sections how his practice as a chancellor of the *National University* and as a mayor of Bogotá may reflect three competences that analysts have recognized to be associated with professional training in mathematics and with the practice of it. It is important to underline, though, that I am not arguing that such competences are exclusive of mathematical training and practice. In the specific case of Mockus, after all, they turned out to be boosted by his engagement with philosophy and the arts.

In the next section I will start by showing how during his tenure as mayor Mockus was capable of bringing certain problems into focus about the obstacles to civil life in Bogotá and how he was able to see the underlying structure of reality he was out to change.

Bringing Problems into Focus and Seeing the Underlying Structure of Reality

Mockus was convinced that the problem of violence and anomie that plagued Bogotá and Colombia crucially depended on the uncoupling among three regulatory systems of people's behavior: law, morals, and social norms. To restore the force of the law, it was necessary to bring all the three into line. The latter, he thought, would be possible by tapping into a series of emotional mechanisms to promote or restrain behavioral and ultimately cultural change.

In particular, he thought that compliance with the law might be spurred by admiration and respect for it or by the fear of sanction. Moral norms, in turn, might be upheld by inspiring conscious self-gratification (that is, peace with one's own conscience) or by fear of guilt. And social norms might be complied with in

response to social admiration and recognition or out of fear of shame and social rejection [70, 71].

To strategically trigger such emotions, Mockus punctuated the civil life of its city with a multiplicity of ritual scenarios and staged public performances for the purpose of triggering such emotional responses among his fellow-citizens. These, in turn, subsequently led to behavioral change and to a change in identities that might ultimately allow behavioral changes to stick over the longer term.

For example, in July 1996 Mockus launched a program called *Knights of the Crosswalk* in response to a clash between taxi drivers that escalated into a shooting and resulted into the death of a baby passenger. Taxi drivers with impeccable credentials of civility would be symbolically recognized as Knights of the Crosswalk and would be allowed to exhibit a sticker on their taxi. 150 model taxi drivers were initially identified by the Mayor's Office and the Institute of Urban Culture for their positive dispositions toward their passengers (such as greeting them) and for their honesty (such as returning the right change on the fares). After that initial phase, another thousand model taxi drivers were identified. By the end of 1997 they rose to 15,000. To this day some taxi drivers in Bogotá still admit that "Mockus educated us" [72].

In 1995–1997 and 2000–2002, in turn, Mockus sought to generalize and decentralize among his fellow-citizens the possibility of publicly expressing disapproval or approval for other people's behavior and distributed 350 thousand thumb-up and thumb-down cards to that end. At all times the Bogotanos would end up pulling out of their pockets such cards just like referees do in soccer matches.

On a different occasion, Mockus resorted to a geometric representation—the Moebius strip—to show his fellow-citizens how difference and commonality may coexist in a community. Society, he maintained, may well feature difference locally and yet live as a unit globally. In spite of all differences, in other words, all may still stand, "on the same side, sharing a context of general agreement over a shared vision of the city, and sharing the same search for solidarity" [73]. That understanding underpinned his development plan during his second term as mayor between 2001 and 2003 and human rights became the pivot of the shared vision of the city that he sought to articulate: "Believing that the universal brings people together and that the idea and co-creation of human rights exposes people to the radical experience of the universal, the administration was convinced that promoting human rights would place all citizens on the same side" [74]. The Moebius strip symbolized that very vision of integration.

Apart from his professional predisposition to see the underlying structure of reality, Mockus also exhibited another competence that analysts have recognized to be spinning off the practice of mathematical reasoning. That is, a distinctive capability of stepping out of routine perspectives on problems by asking "what if" and landing on highly eccentric new solutions.

What if?

In the 1990s Bogotá's streets were a mess and the level of compliance with traffic regulations was minimal. No surprise this issue was first on Mockus' agenda when he took office. After a long night with his team trying to find a solution to the puzzle, he sent everyone home. Once at home, Paul Bromberg, his second-in-command on the front of the *Cultura Ciudadana*, told his family about the deadlock at which point his father-in-law commented: "When there is nothing else to do, you pull out the clowns," meaning that, when there is no solution to a problem, you simply give up. The next day, Bromberg told his father-in-law's reaction to Mockus. who interpreted it, instead, in a totally eccentric way. "What if we actually pulled out the clowns?" And he did. At all critical corners and traffic-lights of the city road network he pulled out hundreds of mimes who started to shame or praise drivers and pedestrians who would respectively infringe or comply with traffic norms. When Mockus announced this program, a journalist asked whether the mimes would have the power to set fines. Since Mockus ruled that out, the journalist trenchantly responded that it would never work. But it did. Mockus distributed 400 hundred mimes across 482 city intersections and, as a result, people started to adjust their behavior as a result of the positive and negative emotions triggered by the mimes [75].

On a different occasion, when Colombian mayors got threatened by the FARC, Mockus started to wear a bullet-proof vest that the US embassy had gifted him. He realized, though, that the vest could be easily pierced through by a knive or scissor, so he decided to carve a heart-shaped hole into it. By resignifying that object in an utterly unobvious way, Mockus was able to transform the wearing of it into an act of civil resistance against terrorism by paradoxically turning vulnerability into moral strength [76].

In yet another occasion, Mockus played with a ritual symbol of the dead to alter drivers' behavior in all city locations where lethal traffic accidents had occurred. In Colombia, people tend to erect altars on the side of inter-city roads where members of their families or friends die as a result of car accidents. Mockus drew on that practice by having 1,500 black stars painted on the roads of Bogotá in correspondence to the locations of deadly accidents and, by sacralizing those spots and bringing them to drivers' attention, the latter would end up mitigating their reckless driving behavior while passing over them.

Mockus even played with the very idea of vaccination to tackle a social issue— violence—that had nothing to do with it. As Jose Falconi points out, in the early 1990s almost 68% of children were mistreated and of these 23% experienced critical circumstances of violence [77]. With his "Days of Inoculation Against Violence," which ended up involving approximately 50,000 Bogotanos, Mockus opened up a controlled space in which his fellow-citizens could release their anger and resentment, start healing their wounds and take a step toward breaking the cycle of violence in their lives. To this end, he punctuated his city with Red Cross-like tents where people would come in. There, they would face a doll made of inflatable balloons. People would be asked to name the person that abused them most in their

life. They would paint his or her face on the balloon and then say or do to him or her what they wished. After popping the balloon, they would then express their wishes in writing on a leaf-shaped piece of paper that they would stick on a Tree of Desires. The leaves would then be knotted together to signify people's unity against violence. After that, people would get a vaccination consisting of few drops of water. And finally, they would receive a card which testified that the vaccination was completed [78]. The program was later replicated within correctional facilities, universities, schools, and companies. In the end, it contributed to de-normalize family violence in Bogotá, raise awareness about the seriousness of it, and ultimately drove more people to report it to public authorities.

Mockus' excentric interpretation of reality was also apparent in another city program that sought to encourage the Bogotanos to voluntarily surrender their arms. Colombia President Samper dismissed the initiative, insisting that the time was not ripe for disarmament. And to make his point, he came up with an awkward wording: "Guns are not meant for spoons." Mockus, however, went along with his idea together with Bishop Rubiano. Drawing inspiration from a passage of the Bible, which referred to the melting of swords into ploughs, Mockus decided to have the surrendered armed melted into baby spoons with the inscription "Arma Fui" (I Was a Weapon), as the ploughs would not resonate with the everyday life of the Bogotanos. In the end, Mockus asked "what if" the arms were actually meant for spoons and made that happen [79–81].

On one further occasion, he prompted his fellow-citizens—over 63,000 in 2002 and almost 46,000 in 2003—to voluntarily pay more city taxes than they actually owed for the purpose of funding additional social programs on social justice, education, and *Cultura Ciudadana*, He also managed to increase tax collection by 32%. His program labelled "Bogotá 110%" turned a routine civic duty into an opportunity for the Bogotanos to express their loyalty to their own city [82].

The practice of mathematics has not only been recognized to cultivate a disposition to ask "what if." It also fosters an openness to reason on both sides of an argument. This was also apparent in Mockus' tenure as a university chancellor and as a mayor.

Openness to Reason on Both Sides

Since the 1960s the campuses of the *National University* turned into a terrain on which hooded militants regularly staged violent clashes with the police, carried out military parades, and interjected in a variety of ways into the normal functioning of the university such as, for example, by occupying universities facilities, at times for weeks on end.

On one occasion, chancellor Mockus went to the Manizales campus to deal with a group of hooded students that had occupied the central administrative building of the university. Instead of having them removed by force by the police, Mockus turned up, requesting that they lift their hoods before engaging in any further negotiation,

but they refused. Instead of walking away, Mockus surprisingly turned his chair giving them his back and started to talk to them. As he was not prepared to speak to people wearing hoods, he told them that the only way he would was by not looking at them, so that he could not tell if they were actually wearing their hoods [83, 84]. He conceded that their demands were reasonable, but their methods were not. "As they spoke, they moved toward each other, always facing in the opposite direction, until one of the *encapuchados* [hooded militants] gave Antanas his hood. Mockus put it on to show his understanding of the protest and left. That night they ended the occupation" [83, 84].

To understand the significance of this performance, it is important to recognize the deep play [85] at stake in the interaction. For many decades the *National University* presented itself to its community as an institutional space in which the state appeared again and again impotent and incapable of enforcing the most basic legal guarantees of order and peaceful coexistence on campus. Such impotence, in turn, was welcomed by violent extremists and their sympathizers as a living proof of the ineffectiveness and illegitimacy of state institutions and of their imminent fall and takeover by revolutionary forces. On the other hand, the state's failure to protect its young citizens on campus from abuses and violence also taught nonmilitants to be "wise" and retreat into silence and apathy. The transformation of the university campus into a ritual scenario in which young citizens would constantly contemplate the face of a subdued state and in which they would learn to put up with, and normalize, the infringement of the rule of law was therefore functional to the reengineering of the university by the militant segment of its community into a formative institution of a new revolutionary order.

Mockus was very much aware of such a deep play. By refusing to enter a conversation with hooded students, he was therefore resisting the deinstitutionalization of the university that was implicit in the interaction. At the same time, though, he also understood that he could not afford to disengage from them. To reaffirm the institutional power of the state, after all, he would need to prove that the university as an institution could still exercise some moral pull over the members of its community. And so he did. By holding a conversation with the hooded students while giving them his back, he struck an unexpected balance between these two imperatives. And by putting the hood on that the student had pulled off at the end of the conversation, Mockus honored the act of courage of the militant student who had dared cross the river that separated the revolutionary camp from the civil camp in that very scenario of interaction. This, in turn, bears witness to Mockus' disposition to reason on both sides.

On a different occasion, in 2001 he launched Ladies' Night in response to violence against women in a variety of urban settings in Bogotá. The idea was to allow women to reclaim and enjoy the city on a night and ask men to stay at home. Any men who for some reason had to go out would be expected to fill a form that the Mayor's office circulated in advance and would state their reasons on such self-certification. If stopped and questioned by women in the streets, their declaration would serve as a permit of circulation.

Quite curiously, this intervention generalized across his fellow-citizens Mockus' openness to reason on both side, which he had shown as a chancellor on the Manizales campus of the *National University*. Lady's Night, after all, prompted men to imagine themselves in the shoes of women, thereby triggering self-reflection about the gendering of social roles as well as of private and public space.

Conclusion

Observers have noted that mathematical reasoning may be put to the service of cultivating a broad spectrum of competences that are useful to adequately discharge citizenship in democratic societies. Here, I referred to a concrete case in which a mathematician—Antanas Mockus—applied them in a variety of situations to tackle some of the puzzles he stumbled upon as a university administrator of the largest and possibly most complex university in Colombia and as a mayor of Bogotá in one of the most challenging phases of its history. In particular, he showed the usefulness in civil life of bringing problems into focus and glimpsing at fundamental structures at play in reality, of insistently asking "what if" to get better viewpoints into problems, and of being willing to reason on both sides of arguments. Such competences were boosted during his life by his sustained engagement with philosophy as well with the arts.

At a time at which democracy and its civil values come under attack, we need to cultivate much more extensively such skills. This may be done by strengthening, among other things, the competence in mathematical reasoning among our younger generations through schooling. To get there, though, we need champions within the community of mathematicians who may step up, go public, and show the general public in the most concrete and transparent manner what the civil benefits of mathematical reasoning are for democratic societies.

When civility in democratic life comes under pressure, universities and scientific communities need to defend a series of civil ideals—openness, criticism, rationality, autonomy, transparency, trustworthiness, among others—that over the past two centuries, at least, have been crucial for the development of democracy as well as of the Humboldtian model of university. Stories like Mockus' may show that the perks of mathematical reasoning and practices may be indeed significant on both fronts.

References

1. G. Rachman, The authoritarian wave reaches the west. *The Financial Times*, 20 February 2017, https://www.ft.com/content/6b57d7ae-f74a-11e6-bd4e-68d53499ed71
2. R.S. Foa, Y. Mounk, The danger of deconsolidation. J. Democr. **27**(3), 5–17 (2016)
3. B. de Souza Santos, *Reinventar la democracia: Reinventar el Estado* (Consejo Latino-americano de Ciencias Sociales, Buenos Aires, 2005)

4. P. Norris, It's not just Trump. Authoritarian populism is rising across the West. Here's why. *The Washington Post*, 11 March 2016, https://www.washingtonpost.com/news/monkey-cage/wp/2016/03/11/its-not-just-trump-authoritarian-populism-is-rising-across-the-west-heres-why/
5. S. Walt, Top 10 signs of creeping authoritarianism, revisited. *Foreign Policy*, 27 July 2017, https://foreignpolicy.com/2017/07/27/top-10-signs-of-creeping-authoritarianism-revisited/
6. C. Walker, The authoritarian threat: the hijacking of 'soft power'. J. Democr. **27**(1), 56 (2016)
7. R. Orrill, Preface: Mathematics, numeracy, and democracy, in *Mathematics and Democracy. The Case for Quantitative Literacy*, ed. by A. Steen (The Woodrow Wilson National Fellowship Foundation, Washington, DC, 2001), p. xvi
8. T. Caplow, H. Louis, B.J. Wattenberg, *The First Measured Century: An Illustrated Guide to Trends in America, 1900–2000* (AEI Press, Washington, DC, 2001)
9. P. Cline Cohen, The emergence of numeracy, in *Mathematics and Democracy. The Case for Quantitative Literacy*, ed. by A. Steen (The Woodrow Wilson National Fellowship Foundation, Washington, DC, 2001), pp. 26–27
10. L. A. Steen (ed.), *Why Numbers Count: Quantitative Literacy for Tomorrow's America* (The College Board, New York, NY, 1997)
11. J. Dewey, *On Education: Selected Writings* (University of Chicago Press, Chicago, 1974), pp. xvii–xviii
12. J.L. Richards, Connecting mathematics with reason, in *Mathematics and Democracy. The Case for Quantitative Literacy*, ed. by A. Steen (The Woodrow Wilson National Fellowship Foundation, Washington, DC, 2001), p. 31
13. J.L. Richards, Connecting mathematics with reason, in *Mathematics and Democracy. The Case for Quantitative Literacy*, ed. by A. Steen (The Woodrow Wilson National Fellowship Foundation, Washington, DC, 2001), p. 33
14. J.L. Richards, Connecting mathematics with reason, in *Mathematics and Democracy. The Case for Quantitative Literacy*, ed. by A. Steen (The Woodrow Wilson National Fellowship Foundation, Washington, DC, 2001), p. 34
15. A.S. Adams, Civic values in the study of mathematics. Math. Teacher **21**(1), 38 (1928)
16. R. Crowell, Mathematicians would make great elected officials. Here's why. *Forbes*, 24 August 2018, https://www.forbes.com/sites/rachelcrowell/2018/08/24/mathematicians-would-make-great-elected-officials-heres-why/#32096ad33a2f
17. A.S. Adams, Civic values in the study of mathematics. Math. Teacher **21**(1), 38–39 (1928)
18. Z. Fan, Why mathematical reasoning should be a part of civic education. *The Phoenix* (2017), https://swarthmorephoenix.com/2017/02/02/why-mathematical-reasoning-should-be-a-part-of-civic-education/
19. J. Ellenberg, *How Not to Be Wrong: The Power of Mathematical Thinking* (Penguin, New York, 2014)
20. C. Mooney, Is Math Liberal? (Math is more than just calculations. Beneath it all lies a nuanced way of thinking.) www.motherjones.com, 20 June 2014, https://www.motherjones.com/environment/2014/06/inquiring-minds-jordan-ellenberg-math-liberalism-nuance-uncertainty/
21. E.L. Mann, Creativity: the essence of mathematics. J. Educ. Gifted **30**(2), 240–241 (2006)
22. A. Whitcombe, Mathematics creativity, imagination, beauty. Math. School **17**(2), 15 (1988)
23. D. Cunningham et al., Brokers and key players in the internationalization of the FARC. Stud. Conflict Terror. **36**, 478–479 (2013)
24. M. Florez-Morris, Joining guerrilla groups in Colombia: motivations and processes for entering a violent organizations. Stud. Conflict Terror. **30**, 616 (2007)
25. D. Cunningham et al., Brokers and key players in the internationalization of the FARC. Stud. Conflict Terror. **36**, 479 (2013)
26. D. Cunningham et al., Brokers and key players in the internationalization of the FARC. Stud. Conflict Terror. **36**, 479–480 (2013)
27. J.O. Melo, La combinación de todas las formas de lucha. *El Tiempo*, 2 September 2007, http://www.jorgeorlandomelo.com/combinacionformas.htm
28. G. Duncan, *Los señores de la guerra: de paramilitares, mafiosos y autodefensas en Colombia* (Planeta, Bogotá, 2006)

29. P. McLean, Colombia: failed, failing or just weak? Washington Quart. **25**(3), 123–134 (2002)
30. D. Sommer, 'Por Amor al Arte': Haber-Mockus plays with the possible, in *Cultural Agents Reloaded: The Legacy of Antanas Mockus*, ed. by C. Tognato, (The President and Fellows of Harvard College, Cambridge, MA, 2017), pp. 249–250
31. J. Martin-Barbero, Bogotá: between the violence of chaos and civic creativity, in *Cultural Agents Reloaded: The Legacy of Antanas Mockus*, ed. by C. Tognato, (The President and Fellows of Harvard College, Cambridge, MA, 2017), pp. 283–284
32. M.T. Uribe, Bogotá en los noventa, un escenario de intervención, in *Pensar la ciudad*, ed. by F. Giraldo, F. Viviescas, (Tercer Mundo Editores, CENAC-FEDEVIVIENDA, Bogotá, 1996), pp. 391–408
33. S. Niño Murcia et al., *Territorios del miedo en Santa Fé de Bogotá* (Tercer Mundo Editores, Bogotá, 1998)
34. J.O. Melo, Consideraciones sobre la situación universitaria. Revista Colombiana de Educación, **2** (1978), www.pedagogica.edu.co/storage/rce/numeros/rce2final.pdf
35. J. Gámez, Relato de un 'capucho' intimidado por querer abandonar la guerrilla. *El Tiempo*, 2 August 2015, www.eltiempo.com/archivo/documento/CMS-16182162
36. C. Betancur, *Sobre Política: artículos y fragmentos escogidos* (Fondo Editorial Universidad EAFIT, Medellín, 2010), p. 275
37. C. Betancur, *Sobre Política: artículos y fragmentos escogidos* (Fondo Editorial Universidad EAFIT, Medellín, 2010), p. 275, in J. Giraldo Ramírez, *Las ideas en la Guerra: Justificación y crítica en la Colombia contemporánea* (Penguin Random House, Bogotá, 2015), p. 180
38. J.O. Melo, Universidad, intelectuales y sociedad: Colombia 1958–2008. Conference paper delivered at the Universidad de los Andes, December 2008
39. J. Giraldo Ramírez, *Las ideas en la Guerra: Justificación y crítica en la Colombia contemporánea* (Penguin Random House, Bogotá, 2015), p. 148
40. C. Tognato, The civil life of the university: enacting dissent and resistance on a Colombian campus, in *The Civil Sphere in Latin America*, ed. by J. C. Alexander, C. Tognato, (Cambridge, Cambridge University Press, 2018), pp. 149–176
41. C. Tognato, Conversaciones de paz en la universidad: performances de la transición en Colombia, in *Sociedad, cultura y esfera civil. Una agenda de sociología cultural*, ed. by N. Arteaga Botelo, C. Tognato, (Editorial FLACSO-Mexico, Mexico City, 2019), pp. 167–197
42. C. Tognato, Countering violent extremism through narrative intervention: for a decentering the local turn in peacebuilding, in *As War Ends: What Colombia Can Tell Us About the Sustainability of Peace and Transitional Justice*, ed. by J. Meernik, J. DeMeritt, M. Uribe-López, (Cambridge, Cambridge University Press, 2019), pp. 347–366
43. C. Tognato, Radical protest on a university campus: performances of civil transition in Colombia, in *Breaching the Civil Order: Radicalism and The Civil Sphere*, ed. by J. C. Alexander, F. Khosrokhavar, T. Stack, (Cambridge, Cambridge University Press, 2019), pp. 42–69
44. C.A. Hernandez, Antanas Mockus, the academic, in *Cultural Agents Reloaded: The Legacy of Antanas Mockus*, ed. by C. Tognato, (The President and Fellows of Harvard College, Cambridge, MA, 2017), p. 383
45. A. Mockus et al., *El problema de la formación de una actitud científica en el niño a través de la enseñanza de las matemáticas y de las ciencias naturales en la escuela primaria*. Universidad Nacional de Colombia, Bogotá
46. C.A. Hernandez, Antanas Mockus, the academic, in *Cultural Agents Reloaded: The Legacy of Antanas Mockus*, ed. by C. Tognato, (The President and Fellows of Harvard College, Cambridge, MA, 2017), pp. 383–385
47. A. Mockus, Autonomía del educador. Revista Naturaleza **1**, 11–16 (1981)
48. A. Mockus, *Tecnología educativa y Taylorización de la educación* (Universidad Nacional de Colombia, Bogotá, 1982)
49. A. Mockus, La misión de la universidad, in *Reforma Académica. Documentos*, ed. by A. Mockus, (Universidad Nacional de Colombia, Bogotá, 1995), pp. 15–61

50. M.T. Ronderos, *Retratos del poder: vidas extremas en la Colombia contemporánea* (Planeta, Bogotá, 2002)
51. P. Vignolo, The dark side of mooning: Antanas Mockus, between norms and transgression, in *Cultural Agents Reloaded: The Legacy of Antanas Mockus*, ed. by C. Tognato, (The President and Fellows of Harvard College, Cambridge, MA, 2017), pp. 463–493
52. C.A. Hernandez, Antanas Mockus, the academic, in *Cultural Agents Reloaded: The Legacy of Antanas Mockus*, ed. by C. Tognato, (The President and Fellows of Harvard College, Cambridge, MA, 2017), p. 391
53. A. Gilbert, J. Dávila, Bogotá: progress within a hostile environment, in *Capital City Politics in Latin America: Democratization and Empowerment*, ed. by D. J. Myers, H. A. Dietz, (Lynne Rienner, Boulder, CO, 2002), pp. 29–64
54. R. Skinner, City profile: Bogotá. Cities **21**(1), 73–81 (2004)
55. G. Martin, *Bogotá: El renacer de una ciudad* (Grupo Editorial Planeta, S.A. Mundo Editores, Bogotá, 2007)
56. G. Martin, M. Ceballos, *Bogotá, anatomía de una transformación: políticas de seguridad ciudadana, 1995–2003* (Pontifica Javeriana University, Bogotá, 2005)
57. E. Passotti, *Political branding in cities* (Cambridge University Press, Cambridge, 2009)
58. F. Pérez Fernández, Laboratorios de reconstrucción urbana: hacia una antropología de la política urbana en Colombia. Antípoda **10**, 51–84 (2010)
59. K. Beckett, A. Godoy, A tale of two cities: a comparative analysis of quality of life initiatives in New York and Bogotá. Urban Stud. **47**(2), 277–301 (2010)
60. A. Kalandides, City marketing for Bogotá: a case study in integrated place branding. J. Place Manag. Dev. **4**(3), 282–291 (2011)
61. J. Sáenz Obregon, Antanas Mockus as pedagogue: communicative action, civility, and freedom, in *Cultural Agents Reloaded: The Legacy of Antanas Mockus*, ed. by C. Tognato, (The President and Fellows of Harvard College, Cambridge, MA, 2017), pp. 421–452
62. R. Abers, From clientelism to cooperation: local government, participatory policy, and civic organizing in Porto Alegre, Brazil. Polit. Soc. **26**, 511–523 (1998)
63. C. Souza, Participatory budgeting in Brazilian cities: limits and possibilities in building democratic institutions. Environ. Urban. **13**, 159–184 (2001)
64. A. Gilbert, Good urban governance: evidence from a model city? Bull. Latin Am. Res. **25**(3), 394 (2006)
65. C.A. Hernandez, Antanas Mockus, the academic, in *Cultural Agents Reloaded: The Legacy of Antanas Mockus*, ed. by C. Tognato, (The President and Fellows of Harvard College, Cambridge, MA, 2017), pp. 387–389
66. A. Mockus, When I am trapped, I do what an artist would do. Antanas Mockus in conversation with Johanna Warsza, in *Forget Fear: 7th Berlin Biennale for Contemporary Art*, ed. by A. Zmijewski, J. Warsza (König, Köln, 2012), p. 167
67. A. Mockus, When I am trapped, I do what an artist would do. Antanas Mockus in conversation with Johanna Warsza, in *Forget Fear: 7th Berlin Biennale for Contemporary Art*, ed. by A. Zmijewski, J. Warsza (König, Köln, 2012), p. 167, in L. Ospina, Lucas, Mockus the Artist, Mockus the Idiot, in *Cultural Agents Reloaded: The Legacy of Antanas Mockus*, ed. by C. Tognato (The President and Fellows of Harvard College, Cambridge, MA, 2017), p. 456
68. D. Sommer, 'Por Amor al Arte': Haber-Mockus plays with the possible, in *Cultural Agents Reloaded: The Legacy of Antanas Mockus*, ed. by C. Tognato, (The President and Fellows of Harvard College, Cambridge, MA, 2017), p. 259
69. C.A. Hernandez, Antanas Mockus, the academic, in *Cultural Agents Reloaded: The Legacy of Antanas Mockus*, ed. by C. Tognato, (The President and Fellows of Harvard College, Cambridge, MA, 2017), p. 392
70. H. Murraín, Transforming expectation through Cultura Ciudadana, in *Cultural Agents Reloaded: The Legacy of Antanas Mockus*, ed. by C. Tognato, (The President and Fellows of Harvard College, Cambridge, MA, 2017), pp. 295–312

71. G. Mackie, Effective rule of law requires construction of a social norm of legal obedience, in *Cultural Agents Reloaded: The Legacy of Antanas Mockus*, ed. by C. Tognato, (The President and Fellows of Harvard College, Cambridge, MA, 2017), pp. 313–334

72. J. Falconi, Visual essay, in *Cultural Agents Reloaded: The Legacy of Antanas Mockus*, ed. by C. Tognato, (The President and Fellows of Harvard College, Cambridge, MA, 2017), pp. 88–93

73. J. Falconi, Visual essay, in *Cultural Agents Reloaded: The Legacy of Antanas Mockus*, ed. by C. Tognato, (The President and Fellows of Harvard College, Cambridge, MA, 2017), p. 215

74. J. Falconi, Visual essay, in *Cultural Agents Reloaded: The Legacy of Antanas Mockus*, ed. by C. Tognato, (The President and Fellows of Harvard College, Cambridge, MA, 2017), p. 215

75. J. Falconi, Visual essay, in *Cultural Agents Reloaded: The Legacy of Antanas Mockus*, ed. by C. Tognato, (The President and Fellows of Harvard College, Cambridge, MA, 2017), pp. 82–87

76. J. Falconi, Visual essay, in *Cultural Agents Reloaded: The Legacy of Antanas Mockus*, ed. by C. Tognato, (The President and Fellows of Harvard College, Cambridge, MA, 2017), pp. 222–225

77. J. Falconi, Visual essay, in *Cultural Agents Reloaded: The Legacy of Antanas Mockus*, ed. by C. Tognato, (The President and Fellows of Harvard College, Cambridge, MA, 2017), p. 181

78. J. Falconi, Visual essay, in *Cultural Agents Reloaded: The Legacy of Antanas Mockus*, ed. by C. Tognato, (The President and Fellows of Harvard College, Cambridge, MA, 2017), pp. 180–187

79. J. Falconi, Visual essay, in *Cultural Agents Reloaded: The Legacy of Antanas Mockus*, ed. by C. Tognato, (The President and Fellows of Harvard College, Cambridge, MA, 2017), pp. 160–161

80. M. Nogueira de Oliveira, Ethics and citizenship culture in Bogotá's urban administration. Univ. Miami Inter-Am. Law Rev. **41**(1), 1–17 (2009)

81. P. Bromberg Zilberstein, Ingenieros y profetas, transformaciones dirigidas de comportamientos colectivos, in *Reflexiones sobre Cultura Ciudadana en Bogotá*, ed. by P. Bromberg Zilberstein, (Instituto Distrital de Cultura y Turismo, Bogotá, 2003), pp. 67–104

82. J. Falconi, Visual essay, in *Cultural Agents Reloaded: The Legacy of Antanas Mockus*, ed. by C. Tognato, (The President and Fellows of Harvard College, Cambridge, MA, 2017), p. 212

83. M.T. Ronderos, *Retratos del poder: vidas extremas en la Colombia contemporánea* (Planeta, Bogotá, 2002), p. 167

84. M.T. Ronderos, *Retratos del poder: vidas extremas en la Colombia contemporánea* (Planeta, Bogotá, 2002), p. 167, in P. Vignolo, The dark side of mooning: Antanas Mockus, between norms and transgression, in *Cultural Agents Reloaded: The Legacy of Antanas Mockus*, ed. by C. Tognato (The President and Fellows of Harvard College, Cambridge, MA, 2017), p. 465

85. C. Geertz, Deep play: notes on the Balinese cockfight, in *The Interpretation of Cultures*, ed. by C. Geertz, (New York, Basic Books, 1973)

Part X
Mathematics and Literature

François Le Lionnais and the Oulipo

The Unexpected Role of Mathematics in Literature

Elena Toscano and Maria Alessandra Vaccaro

Introduction

"The true spirit of delight, the exaltation, the sense of being more than Man, which is the touchstone of the highest excellence, is to be found in mathematics as surely as poetry" (Bertrand Russel, *Mysticism and Logic*, 1910). This sentence, quoted by François Le Lionnais in his work *La Beauté en Mathématiques* in [1], reflects his conception of a deep bond between mathematics and literature. He had a multifaceted education and was an erudite and founder of the Oulipo with Raymond Queneau. Even though he was neither a 'professional' mathematician nor a 'professional' man of letters but only an *épicurien passionné* as he defined himself [2],[1] while alive, he channelled his interests in the theorisation of the so-called *littérature potentielle* (potential literature) "pour exciter les curieux d'insolite et faire réfléchir les passionnés de littérature aussi bien que le fanatiques de mathématiques" [3]. The purpose of this chapter is outline the figure of François Le Lionnais (who we will refer to from here on as FLL as he himself liked to do [4])

[1] Heartfelt thanks go to Professor Jean-Marc Levy-Leblond, who pointed out this interview to us as a source of valuable information in order better to outline the personality and the career of FLL.

E. Toscano (✉) · M. A. Vaccaro
Università di Palermo, Palermo, Italy
e-mail: elena.toscano@community.unipa.it; marialessandra.vaccaro@unipa.it

© Springer Nature Switzerland AG 2020
M. Emmer, M. Abate (eds.), *Imagine Math 7*,
https://doi.org/10.1007/978-3-030-42653-8_23

through the analysis of his most meaningful works,[2] which, in the current literature, appear as subordinated to the works of the more famous and researched Queneau.[3]

Biography

François Le Lionnais is an 'isolated point' in twentieth-century cultural life. It is impossible to label him or bridle him in a single category: each of his initiatives bears witness to his pedagogic approach to life, his universal erudition, his eclectic education, his indomitable commitment to intellectual experimentation, popularisation, and circulation of ideas. Among the various testimonies to his eclecticism it suffices to mention some of the numerous positions that he held and functions that he performed: head of the *Enseignement et popularisation des sciences* division of UNESCO, member of the advisory committee on scientific language of the *Académie des Sciences*, member of the *Association française pour l'avancement des sciences*, scientific advisor of the *Musées Nationaux*, co-founder (with Louis De Broglie and Jacques Bergier) of the *Association des Écrivains Scientifiques de France*, as well as member of the *Académie internationale du Rat*.

He was born in Paris on 3 October 1901 and, as he himself said in the interview *Un certain disparate* [2], he was an extremely curious child endowed with a prodigious memory, and an avid reader. He cultivated various interests, including music (thanks to his mother, a piano teacher) and mathematics, and soon discovered politics and literature, and above all detective stories, which he was always to appreciate. Another great passion that was to accompany him throughout his life was chess: it seems that "in the 1960s, his library contained around 25,000 volumes, 2000 on mathematics and 2500 on chess" [5]. Trained as a chemical engineer, in the years 1928–1929 he had one of his first professional experiences as head of the *Acquigny Forges*, a foundry in serious financial difficulties that he had the merit of saving thanks to the knowledge that derived from his disparate interests. During his youthful years he drew close to Dadaism and became a friend of Marcel Duchamp, with whom he shared a passion for chess. In 1930 he joined the Communist Party and during the Nazi occupation he became an active member of the Resistance. In April 1944 he was arrested, questioned and tortured by the Gestapo and in November 1944 he was deported to the Mittelbau-Dora concentration camp in Germany. This experience, about which he did not speak gladly, did not see him inactive. Indeed, during the exhausting waits forced on the over 20,000 deportees twice a day for the roll-call, ignoring the absolute

[2]A bibliography consisting of Le Lionnais' works is available at the link: http://oulipo.net/fr/bibliographie-de-fll (accessed 23 November 2018).

[3]A bibliography including some of the Oulipo's works edited by *Bibliothèque nationale de France – Département Littérature et Art* is available at the link: http://www.bnf.fr/documents/biblio_oulipo.pdf (accessed 23 November 2018).

prohibition to speak, FFL organised 'university courses' for his fellow-prisoners in philosophy, sciences, art and particularly painting [6]. The period of detention was also fruitful for the gestation of his best-known work, *Les grands courants de la pensée mathématique* [1]: FLL conceived the plan of the work and made up a list of possible intellectuals—mathematicians and others—to ask for contributions. With the Allied landing in April 1945, the Dora camp was evacuated and the deportees were forced to make what is sadly known as "the death march". FLL succeeded in escaping with some fellow-prisoners and, after walking for days in inhuman conditions, he arrived, very weak, at the German village of Seesen. Here, for 3 weeks, he spent great energy organising help for ex-deportees and assisting them in repatriating. But this is not all: giving yet further proof of his tireless intellectual industriousness, on 5 May 1945 he had *Revivre! Journal des Français séjournant à Seesen libérés du joug nazi* published. This was a journal that essentially put together testimonies and anecdotes on life in the concentration camp and described the atrocities committed there, but also contained jokes and crosswords, probably attributable to FLL himself.

Presumably also by him, as hypothesised in [4], are the two articles *Le tunnel de la mort*, in which he recounts his experiences at Dora, and *Mathématiques à la sauce nazie*, in which he analyses a book of mathematics[4] for university students observing how young Germans in the 1930s were also plagiarised unintentionally by the Nazi ideology through mathematics.

At the end of the war, returning to France, he was to publish *Les grands courants de la pensée mathématique* and bring out the *Ouvroir de littérature potentielle*, known as Oulipo, another cultural project he had been thinking about for a long time. FLL died on 13 March 1984 at his house at Boulogne-Billancourt, leaving the world an intellectual heritage, of which so far only a very small part has been discovered and understood. A recent lengthy biography by Olivier Salon [7], rich in unpublished documents, photos, references and original quotations testifies to his being a *disparate*.

Les grands courants de la pensée mathématique

In 1942 FLL met Jean Ballard in Marseille, at that time the cultural centre of unoccupied France. Ballard, the editor of the literary journal *Cahiers du Sud,* was so impressed by the enthusiasm shown for mathematics by our author as to propose him to be the editor of *Les grands courants de la pensée mathématique.* A work on the state of the art, on the developments in mathematics research and on the influences on other knowledge areas. Ballard himself writes in the preface to the book as follows: "seduced by the vastness and above all by the clarity of

[4]O. Zoll, *Mathematisches Arbeits-und Lehrbuch für höhere Lehranstalten* (Friedr. Vieweg & Sohn, Braunschweig, 1941).

his knowledge, I suggested he have essays written by the best mathematicians of the time and collect the texts in a book giving a picture of the researches and the spirit of present-day mathematics".[5] The idea was to create a book of a fairly elementary level constituted by about 50 articles, three-quarters of which were to be written by great mathematicians and the remaining ones by people who were not mathematicians. In [2] FLL declares that before the outbreak of the war he collected various letters, promises of collaboration with mathematicians of the calibre of Bartel Leendert van der Waerden, Godfrey Harold Hardy, Waclaw Franciszek Sierpiński, David Hilbert and George David Birkhoff. Because of the war most of the international collaborations and some French contributions did not materialise, like those of Jean Cavaillès, a philosopher of mathematics, shot by the Nazis in 1944 for actively participating in the Resistance, and Paul Valéry, a poet and philosopher with a passion for mathematics [8], who died immediately after the end of the war. Valéry was supposed to write the preface to the work. He is at any rate present through an unpublished letter of 1932 that shows his interest in and admiration for what he himself defines the most beautiful of sciences. The only articles by non-French authors are those of the Belgian Lucien Godeaux, an expert on algebraic geometry, the Swiss Le Corbusier, Rolin Wavre, who presents a brief chronicle of mathematical international congresses, and Andréas Speiser, who writes on the notion of group and the arts. In [2] FLL also reveals that he deliberately gave space in *Les grands courants* to some young people, among them Jean Desanti, a philosopher of mathematics and an alumnus of Cavaillès, the young Bourbakist Roger Godement, and Paul Germain, who later became the life honorary secretary of the Academy of Sciences. Despite the loss of the collaborations of illustrious foreign mathematicians mentioned above, FLL succeeded in the intent, and this was no mean feat, of involving and coordinating some of the most important French mathematicians of that period, including Émile Borel, great friend of Valéry and author of the first article in the book on the concept of definition in mathematics, Élie Cartan, who contributed a note devoted to the life and the work of Sophus Lie, and his friend Maurice Fréchet, who contributed two papers, one on natural numbers and their generalisation and another entitled *De l'espace à trois dimensions aux espaces abstraits*.

In the Introduction of [1] FLL states: "if we chose to begin our overview with an examination of *Les grands courants de la pensée mathématique*, it is not only because it is generally appropriate to set mathematics at the origin of the chain of sciences—it is a simplistic but not a wrong vision—but also because mathematics constitutes one of the most original, most amazing and above all most revealing forms of human thought".[6] Clearly the purpose of the work is not, according to

[5]"Séduit par l'étendue et surtout la clarté de son savoir, je lui suggérai de provoquer les explications des meilleurs mathématiciens de ce temps, et de les rassembler en un livre qui présenterait un tableau des recherches et de l'esprit des mathématiques actuelles", [1, p. 7].

[6]"Si nous avons tenu à commencer notre tour d'horizon par un examen des Grands Courants de la Pensée Mathématique, c'est, non seulement parce que l'on convient généralement de placer les mathématiques à l'origine de la chaîne des sciences – c'est là une vue qui n'est point fausse,

the author, to cover all the vast field of mathematics, but to delineate the directions (currents) that run through it, allowing people to get a first idea, clear and distinct, to be defined after the publication of a second volume, to which reference is often made in the text but which in reality was never published. The volume is structured in three big chapters and an appendix: *Le temple mathématique*, constituted by 19 articles, *L'épopée mathématique,* formed by 10 essays lying between the past, the present and the future, and *Influences*, formed by 18 notes. To the realisation of this last part there contributed, Queneau with the paper *La place des Mathématiques dans la classification des Sciences*, FLL himself, with an article entitled *La Beauté en Mathématiques*, in the section *Les Mathématiques, la beauté, l'esthétique et les beaux-arts*. In the introductory note of this section he makes the point that the aesthetics of mathematics is not to be confused with the application of mathematics in the beauty of artworks. Through beauty in mathematics the aim is to oppose the common prejudice that harms the reputation of the latter with the wide public of literarians and, in general, of artists. FLL introduces the distinction between *classical beauty* and *romantic beauty,* justifying it as a practical instrument able to examine and comprehend the aesthetics of mathematics. According to the proposed definition, a mathematical proposition has a classical beauty when it strikes with its simplicity and sober variety, while, at the same time, it blends these features in a harmonious construction. An example of classical beauty is constituted by the nine-point circle (Fig. 1), also known as Euler circle or Feuerbach circle: it is constructed from an arbitrary triangle *ABC* and passes through nine special points of it, the midpoints of the sides, *D, E, F,* the feet of the altitudes, *H, I, J,* and the midpoints *K, L, M* of the segments that connect the vertices of the triangle to the orthocentre *O*.

Fig. 1 The nine-point circle of a triangle

Considering that a circumference is identified by three unaligned points, FLL writes the following: "The surprise is also very great when we realise that points, in numbers greater than 3 (especially if they come from different definitions), are located on the same circumference, three points being enough to define this

quoique simpliste – mais aussi parce que les mathématiques constituent l'une des formes les plus originales, les plus surprenantes, et surtout les plus révélatrices, de la pensée humaine", [1, p. 15].

circumference, and a fourth risking to be foreign to it. [...] So 9 points, coming from 3 different definitions, take their places on the same circumference, like opera ballet dancers in a choreographic figure. Euler's acrobatic genius surely savoured this decorative miracle. How amazed he would have been if he had known what *étoiles* would be added in two centuries to his initial corps de ballet. Now 31, and perhaps 43, different points bloom on this mathematical garland".[7]

FLL describes the beauty that springs from analytical geometry, that is to say that close link between Algebra and Geometry that makes it possible to associate a figure with every equation: "this amazing duplication that with every equation associates a figure and vice versa, each holding out the mirror in which its opposite is reflected, is one of the most characteristic of mathematics: truth, utility and beauty are intimately married to produce the most admirable and most vivid perfection".[8] We observe that, even though the paper has a character of mathematical popularisation, FLL's interest in literary culture also emerges in associating with some representations of curves or mathematical functions, and some of the verses and the passages by authors such as Charles Baudelaire, Eugène Delacroix, Henri Michaux, Lewis Carroll and Stéphane Mallarmé (Fig. 2). He communicates sensations but does not explain why he associates certain verses with specific images of curves or functions.

In contrast, the romantic beauty is based on the "cult of violent emotions, non-conformism and oddness". Among the various mathematical examples described by FLL, which rather than fruits of logical activity seem like real devilries, there is the one related to the generalisation of the circle in n-dimensional geometry. The definition is always the same: a *hypercircle* in a space of dimension n is constituted by the locus of the equidistant points from a point, called *centre*. If for every hypercircle one calculates its measure, for example, the area of the circle, the volume of the sphere, the hypervolume of the hypersphere and so forth, one realises that this measure increases with a rise in n, attains a maximum and decreases tending towards zero. But the most "disturbing" thing is that the maximum value is attained in a space whose dimension is not an integer but a value of n between 7 and 8.[9]

The difference between classicism and romanticism necessarily has an effect on the beauty of mathematics' methods "being essentially limited to the opposition

[7]"La surprise est également très grande lorsqu'on s'aperçoit que des points, en nombre supérieur à 3 (surtout s'ils proviennent de définitions différentes), se trouvent situés sur une même circonférence, trois points étant suffisants pour définir cette circonférence, et un quatrième risquant de lui être étranger. [...] Ainsi 9 points, provenant de 3 définitions différentes, viennent prendre place sur une même circonférence, comme des danseuses d'opéra dans une figure chorégraphique. L'acrobatique génie d'Euler a certainement savouré ce miracle décoratif. Comme il aurait été émerveillé s'il avait appris de quelles étoiles son corps de ballet initial devait s'augmenter en deux siècles. Ce sont maintenant 31, et peut-être 43, points différents qui fleurissent sur cette guirlande mathématique", [1, p. 440].

[8]"Ce saisissant dédoublement qui, à toute équation, associe une figure et réciproquement, chacune tendant le miroir où se reflète son vis-à-vis, est un des plus caractéristiques des mathématiques: la vérité, l'utilité et la beauté s'y marient intimement pour engendrer la plus admirable et la plus vivante perfection", [1, p. 444].

[9]Spaces or objects of fractional size have been defined as *fractal varieties*, or simply *fractals*, by Benoît Mandelbrot.

CLASSICISME

Là, tout n'est qu'ordre et beauté,
Luxe, calme et volupté.
 C. BAUDELAIRE.

Courbe obtenue en appliquant à une astroïde (= hypocycloïde à 4 rebroussements) une transformation de Joukowsky.

... le pays des merveilles si doucement rêvé.
 Lewis CARROLL.

Équation différentielle :

$$\rho \frac{d\theta}{d\rho} = \mathrm{tg}\left(4 \ \mathrm{arc} \ \mathrm{tg} \ \sin 4\theta + \frac{\pi}{4}\right)$$

ROMANTISME

Il y a des lignes qui sont des monstres.
 E. DELACROIX.

Quelques courbes vérifiant l'équation différentielle :

$$y' = \frac{x\left[(x-a)^2 + y^2\right] - y\ (x^2 + y^2)}{(x-a)(x^2 + y^2) - y\left[(x-a)^2 + y^2\right]}$$

Luxe, o salle d'ébène où, pour séduire un
 [roi
Se tordent dans leur mort des guirlandes
 [célèbres.
 Stéphane MALLARMÉ.

Limaçon de Pascal transformé par des fonctions elliptiques.

De monstre en monstres, de chenilles
en larves géantes, j'allais me raccrochant.
 Henri MICHAUX.

Équation algébrique :

$$20\,y = \left(8 + x \pm \sqrt{16 - x}\right)$$
$$\left(8 - x \pm \sqrt{16 + x}\right)$$

C'était un palais infini
Plein de bassins et de cascades
Tombant dans l'or mat et bruni.
 Charles BAUDELAIRE.

Rhodanée : $\rho = \dfrac{3}{10}\,\theta + \dfrac{1}{5}$

Fig. 2 Some examples of the association between some representations of curves or mathematical functions, and some of the verses or passages by Charles Baudelaire, Eugène Delacroix, Herni Michaux, Lewis Carrol and Stéphane Mallarmé [1, pp. 439, 443, 445]. Image reproduced with the kind permission of the owner Miss Elisabeth Schmidt

between the will of equilibrium and the nostalgia of vertigo". FLL defines as *classical* those mathematical methods that juxtapose and unify some discoveries that at first sight seem totally distant from one another. An example of this is constituted by conics (Fig. 3): ellipse, hyperbola and parabola, apparently different curves, are made similar by being the geometric locus of the points for which the ratio is constant between the distances from a fixed point and from a fixed straight line (respectively smaller, greater or equal to one). Moreover, projective geometry, clarifying the relationships among their properties, takes a further step towards unity, and analytical geometry blends them in a whole, showing that every complete second-degree algebraic equation is a conic.

We can consider romantic those mathematical procedures that are constituted by unexpected inventions and endowed with amazing potentiality, like for instance the one that in 1859 allowed Bernhard Riemann to produce the amazing zeta

Fig. 3 The conics: an example of classical beauty method [1, p. 451]. Image reproduced with the kind permission of the owner Miss Elisabeth Schmidt

function. Beauty in mathematics is easily explained if one makes reference to fusion of separate disciplines,[10] each of which maintains its own individuality, like for instance that between the theory of functions and the theory of surfaces operated by

[10]In 1940 André Weil presented the same concept in a letter sent to his sister Simone: "it is essential [. . .] to provide a unification, which absorbs in some simple and general theories all the common substrata of the diverse branches of the science, suppressing what is not so useful and necessary, and leaving intact what is truly the specific detail of each big problem", [9, p. 254].

Gaspard Monge or Sophus Lie's theory of abstract groups, which contains in itself the theories of substitution groups and transformations groups.

Our author concludes his essay examining the evolution of the aesthetics of mathematics: "The beauty of mathematics obviously does not guarantee either its truth or its utility. But it furnishes the former with the power to live unprecedented hours, and the latter with the certainty that mathematics will continue to be cultivated for the greater benefit of everybody and the greater glory of the human adventure by men that do not hope for any material profit for themselves".[11]

FLL and the Connection with Bourbaki

In the area of popularisation of mathematics for FLL it was surely a big success, "almost a triumph" as he himself was to say, to succeed in involving in the project de *Les grands courants* some exponents of the Bourbaki group [10], such as André Weil and Jean Dieudonné, in addition to Godement, already mentioned. FLL introduces Dieudonné's contribution, dedicated to Hilbert, attributing to him the merit of revealing through a simple exposition the incredible innovating power of Hilbert's thought. The article by Weil[12] *L'avenir des mathématiques*, in FLL's opinion is the most difficult from the mathematical point of view in the whole text: "this article contained some affirmations that had to be supported by technical arguments that the author furnished in the most concise and briefest way possible".[13] In [2] our author says he got to know Bourbaki's ideas through Enrique Freymann, the director of Hermann, the Bourbaki publisher, and he declares he only became a hyper-Bourbakist after overcoming some initial reticence. Nevertheless, he reproaches the Bourbakists with evident contempt for elementary teaching and, more importantly, disdain for popularisation, while he is aligned with their school of thought as regards aversion for applied mathematics. Quoting FLL: "Hence I converted to Bourbaki and I wanted, for my book (*Les grands courants de la pensée mathématique*), to have an article by Bourbaki on Bourbaki".[14] FLL affirms he was put in contact with some members of Bourbaki, among them Dieudonné, by Charles Ehresmann, one of the founders of the Bourbakist school, and laboured quite a lot to

[11]"La beauté des mathématiques ne garantit, certes, ni leur vérité ni leur utilité. Mais elle apporte aux uns le pouvoir de vivre des heures incomparables, aux autres, la certitude que les mathématiques continueront à être cultivées pour le plus grand profit de tous et la plus grande gloire de l'aventure humaine par des hommes qui n'en espèrent pour eux-mêmes aucun profit matériel", [1, p. 458].

[12]In [2] FLL claims he received this work after the war from Élie Cartan who most likely had acted as an intermediary with André Weil; the latter in those years was a professor in São Paulo in Brazil.

[13]"Cet article comportait des affirmations qui avaient besoin d'être étayées d'une argumentation technique que l'auteur a donnée, aussi brève et aussi serrée que possible", [1, pp. 305–306].

[14]"Je suis donc converti à Bourbaki et je voulais, pour mon livre (*Les grands courants de la pensée mathématique*), avoir un article de Bourbaki sur Bourbaki", [2].

convince them to write an article for scientific diffusion. This contribution, entitled *L'architecture des Mathématiques,* translated into English and published in 1950 in the *American mathematical monthly* [10],[15] can be considered the ideological manifesto of Bourbaki and surely helped to augment overseas its international fame. FLL reports he had discussions with the Bourbakists on the definition that they give of mathematics, that is to say whether "mathematics is the study of structures that necessarily operate on sets or whether, doing without the sets, mathematics is the study of structures". In [12] FLL clarifies: "the style of thought of Bourbaki is thus set in the great modern effort at formalisation of mathematics. It imposes on its followers a desire for almost ascetic purification. Forcing itself to reconstruct mathematics only step by step, it guarantees it extraordinary solidity, but it is evidently condemned to losing the benefits of the risk. One recognises the characteristic formulation of logicians; it is not always that of inventors".[16]

In an analysis of the Bourbaki article in [1], the first question that is addressed concerns the existence of *a mathematics* or *some mathematics.* Does one tend towards a unitary spirit or do autonomous disciplines exist, isolated from one another, both in their purposes and in their methods and even in their language? According to Bourbaki "the internal evolution of mathematics, despite appearances, has more than ever strengthened the unity of its different parts and has created a sort of central nucleus that is more coherent than it has ever been. The main point of this evolution has consisted in a systematisation of the relationships existing among the different mathematical theories and is summed up in a tendency that is generally known by the name of *axiomatic method*". According to this method, mathematics is not a concatenation of syllogisms that develop by chance, nor a collection of more or less astute artifices. Axiomatics teaches us to seek the deep reasons for a discovery, to find the common ideas buried under the external apparatus of the details proper to each of the theories considered, to bring out these ideas and to highlight them. The axiomatic method works through the concept of structures, which are the tools of the mathematician. However, these, by themselves, are not enough. A particular intuition is necessary, a sort of "direct divination", preceding all reasoning, in the genesis of every discovery: "but it (the intuition) by now has available the powerful levers furnished by the theory of the principal types of structures and dominates at a glance the immense dominoes unified by axiomatics, where once the most shapeless chaos seemed to reign".[17]

[15]In [2] Michèle Audin hypothesises that the Bourbaki article published in *Les grands courants* was written by Dieudonné alone.

[16]"Le style de pensée de Bourbaki se situe ainsi dans le grand effort moderne de formalisation des mathématiques. Il impose à ses partisans une volonté de purification presque ascétique. En s'obligeant à ne reconstruire les mathématiques que pas à pas, il s'assure une extraordinaire solidité, mais il se condamne évidemment à perdre les bénéfices du risque. On reconnaît la démarche caractéristique des logiciens; elle n'est pas toujours celle des inventeurs", [12, p. 9].

[17]"Mais elle (intuition) dispose désormais des puissants leviers que lui fournit la théorie des grands types de structures, et elle domine d'un seul coup d'œil d'immenses domaines unifiés par l'axiomatique, où jadis semblait régner le plus informe chaos", [1, p. 43].

In the axiomatic conception mathematics appears as a sort of container of abstract forms, mathematical structures, and it turns out that certain aspects of experimental reality are modelled in some of these forms. "It is only with this sense of the word 'form' that it can be said that the axiomatic method is a 'formalism'; the unity that it confers on mathematics is not the armour of formal logic, the unity of a lifeless skeleton; it is the lymph that nourishes an organism in full development, the ductile and fruitful instrument of researches on which there have consciously worked, after Gauss, all the great thinkers of mathematics, all those people that, using the expression of Lejeune-Dirichlet, have always tried 'to replace calculations with ideas'".[18]

As we will see in the next sections, in literature Oulipo was undoubtedly to adopt some aspects typical of the Bourbaki approach [13], like the method of collective work and systematic use of structures for literary creation.[19] By contrast, the Oulipians broke away from the Bourbakist school of thought as concerns the predilection for combinatorics and, more in general, for applied mathematics.

In general terms, surely the work of Oulipo was to develop in the direction of reducing the distance,[20] or even the hostility, between writers and mathematicians [14] with a view to the creation of a perfect fusion between science and humanism.[21]

[18]"C'est seulement avec ce sens du mot 'forme' qu'on peut dire que la méthode axiomatique est un 'formalisme'; l'unité qu'elle confère à la mathématique, ce n'est pas l'armature de la logique formelle, unité de squelette sans vie; c'est la sève nourricière d'un organisme en plein développement, le souple et fécond instrument de recherches auquel ont consciemment travaillé, depuis Gauss, tous les grands penseurs des mathématiques, tous ceux qui, suivant la formule de Lejeune-Dirichlet, ont toujours tendu à 'substituer les idées au calcul'", [1, p. 47].

[19]It is to be noted that both Queneau [15] and Roubaud were greatly inspired by Bourbaki in their literary production.

[20][3, p. 26].

[21]In the essay *La place des mathématiques dans la classification des sciences*, which constitutes Queneau's contribution in [1], he identifies the common denominator between Science and Art with the game: "The ideal that scientists created for themselves all through the first part of this century was a conception of science not as knowledge, but as rule and method. They offer (indefinable) notions, axioms, and the proper way to use them: in short, a system of conventions. But what is that if not a game, in no way different from chess or bridge? Before further examining that side of science, we must consider this point: is science a knowledge? Does it allow us to know? And since (in this article) our subject is mathematics, what do we know in mathematics? Precisely nothing. And there's nothing to know. We no more know the point, the number, the group, the set, the function than we know the electron, life, human behavior. We no more know the world of functions and differential equations than we 'know' Concrete Everyday Earthly Reality. All that we know is a method considered (accepted) as true by the community of scientists, a method that also has the advantage of rejoining the fabricative techniques. But this method is also a game; it is, in the most precise terms, what's known as a jeu d'esprit. Thus, all of science, in its fully realised form, will present itself as a Technique and as a Game, which is to say precisely as that other human activity—Art—presents itself".

Fig. 4 FLL and his cat *Sire pensif*. © Elisabeth Schmidt's personal archives, 1967 (left). Raymond Queneau decorating FLL of the *Ordre de la Grande Gidouille* with Ursula Vian in the background. © Elisabeth Schmidt's personal archives, 1961 (middle). The *oulipiens* gathered at FLL's house in 1975. Among the others FLL, Raymond Queneau, Italo Calvino, Georges Perec and Claude Berge are in the picture. © Oulipo's archives, 1975 (right). All photos are reproduced with kind permission of the owners

FLL and the Oulipo

The preparation of *Les grands courants de la pensée mathématique* was an opportunity to meet Queneau, with whom a friendship and an intellectual association were to develop and would last a lifetime and, in 1960, were to have their maximum expression in the foundation of Oulipo. FLL conceives the idea of a possible mathematical experimentation in the literary creative process during his university studies. After being fascinated by this idea for years, it was realised thanks to the conversations with Queneau, particularly during the one that took place at Cerisy-la-Salle in September 1960. On Thursday, 24 November 1960, in the wine cellar of the restaurant *Au Vrai Gascon* in Paris, FLL and Queneau founded the *Seminaire de Littérature Expérimentale* (Selitex)[22]: this was a small group of literarians-mathematicians, mathematicians-literati and, in general, scholars united by the desire to investigate the application of some mathematical structures to different levels of literature thanks to the imposition of some obligations and rules (*contraintes*). A month later, on 19 December 1960, what Calvino defines as "a kind of secret society",[23] took the name Oulipo thanks to an intuition by Albert-Marie Schmidt, one of the founding members.

FLL was first of all the 'thinker' of Oulipo (playfully called the *Frésident-Pondateur*) and especially gives his specific contribution on the writing of *Le premier Manifeste* and *Le second Manifeste* and along with other works that were published in the collective work *La littérature potentielle* [16]. Together with Queneau, he also played an important role as a 'recruiter' of the so-called *oulipiens* (Fig. 4).

[22]In actual fact, a subcommittee of the College of Pataphysics created in Paris on 11 May 1948.

[23]Italo Calvino, *Perec, gnomo e cabalista*, La Repubblica, 6 marzo 1982, p. 18.

The first nucleus of ten founder members, in addition to the previously mentioned FLL, Raymond Queneau (1903–1976) and Albert-Marie Schmidt (1901–1966) involved Noël Arnaud (1919–2003), Jacques Bens (1931–2001), Claude Berge (1926–2002), Jacques Duchateau (1929–2017), Latis *alias* Emmanuel Peillet (1914–1973), Jean Lescure (1912–2005) and Jean Queval (1913–1990). In addition, in the following years, writers such as Georges Perec and Italo Calvino, and the mathematician Jacques Roubaud joined the group along with other important persons.

Among today's members it is worth mentioning that the mathematicians Pierre Rosenstiehl, Olivier Salon and Michèle Audin[24] have been co-opted.

But what is Oulipo? This question is answered in a spirited way by the *oulipiens* Marcel Bénabou and Jacques Roubaud:

> *Qu'est-ce que l'Oulipo?*
> *OULIPO? Qu'est ceci? Qu'est cela? Qu'est-ce que OU? Qu'est-ce que LI? Qu'est-ce que PO?*
> *OU c'est OUVROIR, un atelier. Pour fabriquer quoi? De la LI.*
> *LI c'est la littérature, ce qu'on lit et ce qu'on rature. Quelle sorte de LI? La LIPO.*
> *PO signifie potentiel. De la littérature en quantité illimitée, potentiellement productible jusqu'à la fin des temps, en quantités énormes, infinies pour toutes fins pratiques. [...]*

In a 1964 lecture at the Henri Poincaré Institute, Queneau made a point first of all to specify what Oulipo is not [12, publisher's note]:

1. It is not a literary movement.
2. It is not a scientific seminar.
3. It is not aleatory literature.[25]

Above all it is not an avant-garde movement. Indeed, in relation to the artistic-literary currents that preceded it—one thinks of Futurism, Dadaism, Surrealism—the Oulipian programme appears like a return to order insofar as, as Queneau put it, there is no opposition between inspiration, intuition and imposition of *contraintes*,[26] which, far from bridling writers' creative fancy, make it possible to give rise to new expressive forms with full respect for—and/or recovery of—the rules of composition and formal structures in disuse.[27]

[24]Some contributions of Michèle Audin are in [17–19].

[25]Queneau refers to the literature promoted by Max Bense and his group in Stuttgart [20].

[26][21, p. 343].

[27]"Every literary work is constructed starting from an inspiration (or at least the author suggests it) that more or less has to adapt to a series of restrictions and procedures, inserted into one another like Russian dolls. Restrictions on vocabulary and grammar, restrictions on the rules of the novel (division into chapters, etc.) or classical tragedy (rules of the three units), restrictions on general versification, restrictions on fixed forms (as in the rondo and in the sonnet), etc. [...] Mathematics (more particularly the abstract structures of contemporary mathematics) afford a thousand directions of exploration, starting from both Algebra (resorting to new laws of composition), and Topology (considering the proximity, opening or closing of texts)", *Le premier Manifeste* in [12].

The constraints and rules proposed by Oulipo vary: some refer to the microstructure of poetry or prose ("alphabetical, phonetic, vocalic, consonantal and syllabic *contraintes*; [...] metric, prosodic, rhyming and rhythmical ones"[28]), while others concern the macrostructure (for example division into chapters and/or paragraphs or the graphic layout of letters). Accordingly, the typologies of the 'results' are ample and potentially endless.

In the researches that Oulipo proposed to undertake, two main tendencies, two *Lipos*, coexist (Lescure in [12, p. 33]). One, oriented towards analysis, *Anoulipisme*, is dedicated to discovering or rather tracking down in the study of works of the past the use of *contraintes* existing before their theorisation by Oulipo, jokingly called "plagiarisms by anticipation". The other, oriented towards synthesis, *Sintoulipisme*, is dedicated to the invention of new mathematical–literary constraints. From the one to the other, writes FLL, "many subtle passages exist"[29] the defining line between the two *Lipos* not being well marked out.

The potential literature, as declared by FLL in [23], falls within the scope of the usage of the mathematics that dated back to medieval Provençal poetry.[30] An example of "literary mathematical structure" that catalysed the interest of the Oulipo members—so much so as to be defined by Queneau "particulièrment potentielle"— is the lyric sestet, which was introduced in the twelfth century by the Occitan troubadour Arnaut Daniel. The main characteristic of this sestet is that every word of the first stanza, formed by six verses, comes back later on in the other stanzas by following a fixed circular permutation of order 6 [24].[31] This gives rise to the idea of creating the "n-ets" (also called *quenets*, in honour of Queneau) with n other than 6, by using the peculiar methods to the group theory [26]. Of course, the research on the generalisation of the sestet was not the only example of mathematisation of poetry on which the Oulipo focused on: for an overview of the themes dealt with and of the attempts made one just has to browse through [12] or chapter *III. Travaux et recherches* in [27] or again Roubaud [28].

The lipogram, like the sestet, is a classic case of plagiarism by anticipation [29]. Some lipograms were already composed, for example, by the ancient Greek poet Lucius Septimius Nestor of Laranda (who lived in the first half of the third century) and by the French bibliographer Étienne-Gabriel Peignot (1767–1849) [3, 22]. Among the *oulipiens* the most famous composer of lipograms is certainly Perec, the author of the thriller *La disparition* (1969): 312 pages in which only words that do not contain the letter *e*, the most frequent vowel in the French language, appear. By the same author one cannot mention *La vie mode d'emploi* (1978)—dedicated

[28][22, p. 60].

[29]*Le premier Manifeste* in [12].

[30]"I decided to propose to Raymond the creation of an experimental literature workshop or seminar to scientifically address what the troubadours, rhetoricians, Raymond Roussel, the Russian formalists and some others had only predicted", in [23, p. 77].

[31]Moreover, in a sestet, the basic idea of the combinatorics between the verses is founded on the sum of the opposite faces of a dice: $6 + 1, 5 + 2, 4 + 3$, [25, p. 61].

Fig. 5 Map of the building described by Georges Perec in *La vie mode d'emploi*

to the memory of Queneau—in which he methodically describes the life of the different inhabitants of a Parisian building following a circular scheme similar to the movement of the knight in the game of chess to visit the 99 apartments of the building (Fig. 5). We are talking more precisely about a *Hamiltonian path* on a graph (directed or not) or a pathway that touches all the graph vertices once and once only [30]. In [31, 32] Perec himself describes the complex mechanism of composition of the work based on the use of a Graeco-Latin orthogonal square of dimension 10 (of whose existence, shown in [33], it seems he heard from Berge, an expert on graph theory, [24, p. 4] and of an *ad-hoc* permutation, that is to say a *pseudo-quenet* of order 10. In this case Perec introduces what in Oulipian language is called *clínamen*, that is to say a local variation of the *contrainte*, the exception to the rule that becomes a rule itself.

If we analyse Oulipian production we notice that different uses were made of group theory and particularly of matrices, graphs and trees. FLL himself in [3] emphasises that the very famous *Relation x takes y for z* due to Queneau can be visualised thanks to a directed graph as well as with tables that represent the laws of composition of a group as in [12, p. 58]. In brief, x is a character that, in a certain situation, exchanges a second character y for a third one z. Generalising, given a statement that involves x, y and z, these can also be people, feelings, abstract ideas, etc., so the relationship produces very varied though finite situations. For example, the statement *Three mad people (a, b, c) believe they are Napoleon (n) and each of them takes the other two for what they are* can be schematised with the following multiplication table [12, p. 60]:

	a	b	c	n
a	n	b	c	a
b	a	n	c	b
c	a	b	n	c
n	0	0	0	0

Finally, a process much investigated by the Oulipians is the so-called $M \pm n$ *Method*, especially in its variant $S+7$ [12, p. 139]. It consists of replacing, in an existing text, the nouns (S) or the words (M, *mots* in French), with other nouns (or words) that follow them ($+$) or precede them ($-$) by 7 (or n) positions in a selected dictionary. An interesting example is due to Lescure and is furnished precisely by the very famous *Fifth Postulate* of Euclid [12, p. 143–144]:

> *Si deux droites situées dans un plan font avec une même sécante des angles intérieurs du même côté dont la somme soit plus petite que deux droits, ces deux droites se rencontrent de ce côté.*
>
> *Licence*: *On remplacera la préposition "de" dans l'expression "de ce côté" par la préposition "dans" si le sens l'exige.*
>
> *S+7 (Dictionnaire philosophique de André Lalande):*
> *Si deux dynamismes situés dans une polémique font avec une même sémiologie des antécédents intérieurs de la même cristallisation dont le souvenir soit plus petit que deux dynamiques, ces deux dynamismes se rencontrent dans cette cristallisation.*

The Ou-*x*-po

On the model of Oulipo FLL imagines other *Ouvroirs* [34], Ou-*x*-po,[32] for music ($x=mu$), painting ($x=pein$), cinema ($x=ciné$), tragicomic theatre ($x=tra$) and cuisine ($x=cui$), and on 23 August 1973 personally founds the *Ouvroir de Littérature*

[32]For a list of Ou-*x*-Po activities see the website http://www.fatrazie.com/jeux-de-mots/ouxpo (accessed 13 June 2019).

Policière Potentielle, known as Oulipopo, with the objective of "listing in the most exhaustive way possible and rationally classifying the situations, the mechanisms and their combinations exploited by the detective novel (analytical Oulipopo), and more in general—this ambition was his main vocation—all the situations and potential mechanisms not used or even unusable (synthetic Oulipopo)".[33] To do this he involved different writers, critics and literarians who were experts on the genre of the crime novel: Jacques Baudou, Jacques Bens, Jacques Bergier, Paul Gayot, François Guérif, Michel Lebrun, Yves Olivier-Martin, François Raymond, François Rivière and Évelyne Diebolt.

The natural places of publication of *Oulipopiens'* works were two: the bulletin *Enigmatika*[34] with its criticism and filmography columns, and *La bibliothèque énigmatique* founded for texts that could not find a place in the journal, like novels, collections, etc. FLL himself dedicated some works of his [31–37] to analysis of the detective story. In particular, he examined the possible answers to the question, "who is the culprit?". To do this he resorts to graph theory in order to propose a tree structure that completes the possible identities (Fig. 6).

The reader is, therefore, surprised to be included in the list of the probable suspects, hypothesis that, in FLL's opinion, had not been contemplated in any of the crime literature works yet (writing on 12 January 1969). The reader is also actively engaged, being called to structure the story basing it on a decisional tree, and, hence, creating a hyper-linkable work, some sort of *ante litteram* e-book. Our author stresses that, considering a five-level tree, each level having from two to four bifurcations, a detective story can easily fill from 200 to 300 pages!

FLL, the Poetry and the Theatre

Proposing mathematical literary structures, as specified by FLL, does not guarantee quality works but it allows the writers to better express themselves as compared to more traditional ways [3]. In effect, we find the best results precisely in potential poetry. An admirable example of the use of Combinatorics in poetic composition is *Cent Mille Milliards de Poèmes* by Queneau, published in 1961. This is a set of ten sonnets printed on paper, each verse on a different horizontal strip (Fig. 7): in this way any line of a sonnet can be combined with any of the other nine, producing 10^{14} (a hundred thousand million, precisely) different sonnets.

[33]"Recenser aussi exhaustivement que possible et de classer rationnellement les situations, les mécanismes et leurs combinaisons exploités par le roman policier d'énigme (Oulipopo analytique), plus largement – cette ambition étant sa vocation première – toutes les situations et les mécanismes potentiels inutilisés, voire inutilisables (Oulipopo synthétique)" in Subsidia Pataphysica 24–25, (1974).

[34]The first issue comes out in February 1976 and it is followed by 40 issues.

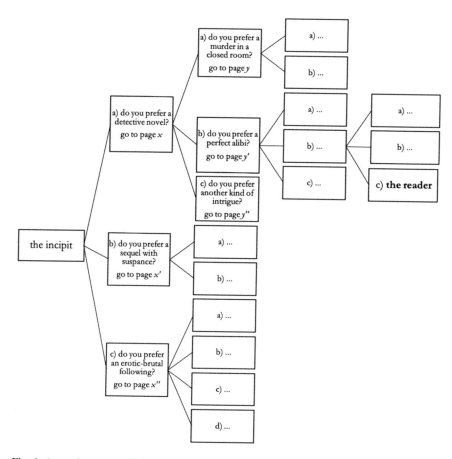

Fig. 6 A tree that covers all the possible identities of the culprit in a detective story

In addition to *n*-ets, generalisations of sestets, already discussed previously among the poetic experimentations we can list, by way of example, *boules de neige*, irrational sonnets, Algol poems and Boolean ones.

A *boule de neige* is a composition in rhopalic verses (from the Greek ῥόπαλον, cudgel). The fact is the poem takes the form of a cudgel, each verse being constituted by a single word and each word having one letter more than the preceding one, as shown in this example by Lescure [12, p. 104]:

> *L'*
> *os*
> *dur*
> *rêve*
> *parmi*
> *trente*
> *pierres*
> *blanches*

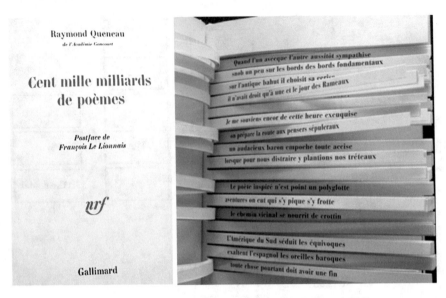

Fig. 7 *Cent Mille Milliards de Poèmes* by Raymond Queneau, © Gallimard, 1961

> furieuses
> métaphores
> réalisables
> mortellement.

Irrational sonnets are called this way because the stanzas are composed by a number of verses equal to the approximate development of the irrational number π: 3, 1, 4, 1, 5, ... as Bens shows [12, p. 252]:

> Le presbytère n'a rien perdu de son charme,
> Ni le jardin de cet éclat qui vous désarme
> Rendant la main aux chiens, la bride à l'étalon:
>
> Mais cette explication ne vaut pas ce mystère.
>
> Foin des lumières qui vous brisent le talon,
> Des raisonnements qui, dissipant votre alarme,
> Se coiffent bêtement d'un chapeau de gendarme,
> Désignant là le juste, et ici, le félon.
>
> Aucune explication ne rachète un mystère.
>
> J'aime mieux les charmes passés du presbytère
> Et l'éclat emprunté d'un célèbre jardin;
> J'aime mieux les frissons (c'est dans mon caractère)
> De tel petit larron que la crainte oblitère,
> Qu'évidentes et sues les lampes d'Aladin.

Algol poems owe their name and their characteristics to the *ALGOrithmic Language*, one of the first programming languages to use the words of current languages. Some compositions are founded on a small dictionary created with

the translation from English of 24 key Algol words: *Tableau, Début, Booléen, Commentaire, Faire, Sinon, Fin, Faux, Pour, Aller à, Sì, Entier, Étiquette, Rémanent, Procédure, Réel, Pas, Chaîne, Aiguillage, Alors, Vrai, Jusqu'à, Valeur* and *Tant que*. Using some of them, Arnaud wrote the following Algol poem [12, p. 219]:

<div align="center">

DÉBUT
Pour aller à chaîne
faire étiquette
alors vrai tableau
sinon valeur.

</div>

Lastly, Boolean poems are written making reference to notions of set theory and Boolean algebra. As other *oulipiens*, FLL delighted in the composition of some poems among which the five *tentatives à le limite* published in the Italian magazine *Il Caffè* [38]: *La rien que la toute la,*[35] *Sur le bout de la langue, La poésie à l'état de traces, Réduction d'un poème à une seule lettre, Poème composé d'un seul mot.*

The Boolean algebraic operations guide FLL in the composition of two brief poems, *Épitaphe* and *Damoiselle* (better known as *Corbeuf* [39]):

<div align="center">

ÉPITAPHE *DAMOISELLE*
Un beau feu d'amour *Chercher la vertu*
Un soupir perdu *Au-delà de ses yeux*
La cendre du cœur *Est la seule*
 Peine
 Corbeuf

</div>

obtained by intersection and symmetrical difference of two sonnets respectively by Pierre Corneille and Georges de Brébeuf.

In Table 1 the algebraic operations are illustrated: the words belonging to the intersection of the two sonnets are written in capital letters, while the remaining words are, evidently, those that belong to the symmetrical difference, i.e. to the difference between the union and the intersection. *Corbeuf* therefore proves to be a *haiku* formed by some words that exclusively belong to the symmetrical difference and are bolded. *Épitaphe* likewise turns out to be a *haiku* formed with some words that exclusively belong to the intersection and are underlined.

Boolean algebra as FLL maintains "offers countless possibilities" in the context of works destined for theatre [40]. An example is *Théâtre à intersection* in which the scene is divided into three sectors, A (left), B (centre) and C (right). Two different *pièces* are performed in A and in C which can be two scenes of interiors, while B is an exterior. Characters in A can go to B but not to C and the same holds for the characters in C, who can go to B but not to A. In this way characters in A and C can meet in B and give life to a third completely different *pièce* from the other two. Likewise, looking to the operation of union of sets, FLL conceives *Théâtre à*

[35]Poem without verbs, nouns and adjectives dedicated to his friend Raymond Queneau.

Table 1 Genesis of *Corbeuf*

P. Corneille (1655)	G. de Brébeuf (1638)
ÉPITAPHE Sur la mort de **Damoiselle** Élisabeth Ranquet	ÉPITAPHE
NE VERSE POINT DE PLEURS SUR CETTE SÉPULTURE, passant ce lit funèbre **est** un lit PRÉCIEUX, OÙ GÎT D'UN CORPS TOUT PUR LA CENDRE TOUTE PURE MAIS le zèle DU CŒUR VIT ENCORE EN CES LIEUX.	NE VERSE POINT DE PLEURS SUR CETTE SÉPULTURE tu vois de Léonor le tombeau PRÉCIEUX OÙ GÎT D'UN CORPS TOUT PUR LA CENDRE TOUTE PURE MAIS **la vertu**DU CŒUR VIT ENCORE EN CES LIEUX.
AVANT QUE DE PAYER le droit À LA NATURE, SON âme s'ÉLEVANT **au-delà de ses yeux** avait AU CRÉATEUR uni LA CRÉATURE ET MARCHANT SUR LA TERRE ELLE ÉTAIT DANS LES CIEUX.	AVANT QUE DE PAYER les droits À LA NATURE SON esprit S'ÉLEVANT d'un vol audacieux allait AU CRÉATEUR unir LA CRÉATURE ET MARCHANT SUR LA TERRE ELLE ÉTAIT DANS LES CIEUX.
LES PAUVRES BIEN MIEUX QU'ELLE ONT SENTI SA RICHESSE l'humilité, **la peine** étaient son ALLÉGRESSE ET SON DERNIER SOUPIR FUT UN SOUPIR D'AMOUR.	LES PAUVRES BIEN MIEUX QU'ELLE ONT SENTI SA RICHESSE ne **chercher** que dieu seul fut sa **seule** ALLÉGRESSE ET SON DERNIER SOUPIR FUT UN SOUPIR D'AMOUR.
PASSANT, QU'À SON EXEMPLE UN BEAU FEU TE TRANSPORTE, ET LOIN DE LA PLEURER D'AVOIR PERDU LE JOUR, CROIS QU'ON ne meurt jamais quand on meurt DE LA SORTE.	PASSANT, QU'À SON EXEMPLE UN BEAU FEU TE TRANSPORTE ET LOIN DE LA PLEURER D'AVOIR PERDU LE JOUR CROIS QU'ON commence à vivre en mourant DE LA SORTE.

reunion and "on this basis it is possible to imagine a big number of combinations: a comic *pièce* and at once a tragic one, complementary or parallel *pièces*, etc."[36] [40].

Other *oulipiens* also dealt with theatre. For example, Paul Fournel and Jean-Pierre Énard in *L'arbre à théâtre-Comédie combinatoire* [12, p. 277] propose to furnish a tree scheme for writing a comedy. But "the problems raised by an operation like this are particularly numerous and some [. . .] seemed practically insuperable" like asking the actors for a superhuman effort of memory; therefore, the two authors "worked out an original graph showing the spectator all the characteristics of the tree but involving no drawback for the actors". Once more a *clínamen* was the solution.

[36]"Sur cette base on peut imaginer un grand nombre de combinaisons: une pièce comique en même temps qu'une pièce tragique, des pièces complémentaires ou parallèles, etc."

Les nombres remarquables

In 1983 FLL, aged 82, published his last work: *Les nombres remarquables* [41]. A sort of autobiography in which he was engaged since the age of five, when he started collecting and classifying, according to some "subjective criteria of 'remarkability'" about 400 numbers that fascinated him most: "I was not five years old yet when, observing the tables of multiples of integers, on the covers of my school notebooks, I realised that the population of numbers presented a certain regularity. The revelation happened with the number 5. [...] Later at the college at Melun, the intersection of the heights, of the medians, of the bisectors and the perpendiculars to the midpoints of the sides of a triangle led me to extend mathematics from arithmetic to geometry. [...] Ten years later, at the Faculty of Sciences, I realised, passing from one class to the other, my interest in certain numbers. To the integers of my infancy there were added other numbers, prime numbers and those, for instance, that you meet in mathematical games. Rational numbers, which at that time I called fractional numbers, were added for me to integers, but they did not interest me much; irrational numbers like the square root of 2 or π appeared more seductive to me. But nobody at high school had taught me the difference between algebraic numbers and transcendent numbers. I began to write in a notebook all the numbers that I found and that seemed worthy of interest to me. This list became richer and improved further after university. Before the beginning of the Second World War, my collection had taken the form of a card index in which, for some numbers, the same card presented different properties. Mathematics does not have the monopoly on numbers. We also meet them elsewhere, particularly in other sciences and practically in most human activities. But it was only the particular numbers of mathematics that interested me and seemed worthy of being collected in my anthology. I therefore discarded the important numbers of the experimental, physical, chemical, natural and biological, psychological or sociological sciences, as Planck's constant, the gravitational constant, the fine structure constant, Avogadro's number, the 'magic' nuclear numbers, etc. [...] I thought it was not appropriate, in April 1944, to take my cards with me to the Fresnes prison or the Dora concentration camp, where I was confined. But my memory was intact and my dear numbers visited me every day, together with other comforts like music, poetry, history and science. On my return in May 1945, my file had disappeared. I did a new one, modifying my terminology, and I baptised the cards in my herbarium *Nombres remarquables*".[37]

[37]"Je n'avais pas cinq ans que, regardant les tables de multiples des entiers proposées par les couvertures de mes cahiers d'écolier, je m'aperçus que la population des nombres présentait une certaine régularité. La révélation commença à l'occasion de 5. [...] Plus tard au collège de Melun, la rencontre des points d'intersection des hauteurs, des médians, des bissectrices et des médiatrices du triangle m'apprit l'extension des mathématiques dfe l'arithmétique à la géométrie. [...] Dix ans après, en Faculté des sciences, j'avais pris conscience, d'une classe à l'autre, de l'intérêt de certains nombres. Aux entiers de mon enfance s'ajoutaient d'autres nombres, les nombres premiers, et ceux, par exemple, que l'on rencontrait dans les jeux mathématiques. Les nombres

FLL took advantage of the precious collaboration with Jean Brette to complete his collection of numbers. In FLL's opinion, this activity would have been supposed to take a few weeks, instead, it occupied them for 4 years. Throughout those years, "every time a mathematician knew of a number with particular properties, that number was offered to François",[38] Brette stated.

In this book the numbers with most remarkable properties are marked with one to three stars. For example, 0.5 being tied to *Riemann's Hypothesis*, deserves three stars, as does 6, the smallest *perfect* even number, i.e. one equal to the sum of its divisors: $6 = 1 + 2 + 3$ [41, p. 60]:

6	
***	*Il n'existe pas de carré gréco-latin d'ordre 6. C'est le célèbre problème des trente-six officiers posé par Euler: peut-on former un carré à l'aide de trente-six officiers de six grades distincts et appartenant à six corps d'armée distincts (un seul officier de chaque grade et de chaque armée), de telle façon qu'on ne trouve jamais deux fois le même grade ou le même corps d'armée dans une ligne ou une colonne? Tarry, en 1901, a démontré par exploration systématique, que le problème est insoluble. De plus, sur l'exemple de 2 et de 6, Euler avait conjecturé qu'il n'existait pas de carré gréco-latin d'ordre 4n+2. Bose, Parker et Shrikande ont montré en 1959 que cette conjecture était fausse en construisant un tel carré d'ordre 10 (n=2). On sait depuis qu'il existe des carrés gréco-latins de tout ordre sauf 2 et 6. Apparus en mathématique comme des récréations mathématiques, les carrés gréco-latins se sont révélés d'un intérêt considérable en statistique pour la constituition de plans d'expérience. [...]*

rationnels, qui j'appelais alors nombres fractionnaires, s'ajoutaient pour moi aux entiers, mais ils ne m'intéressaient guère; plus séduisants m'apparaîssaient les nombres irrationnels, comme $\sqrt{2}$ ou π. Mais on ne m'avait pas appris au lycée la distinction entre les nombres algébriques et les nombres transcendants. Je commençais à inscrire sur un carnet tous les nombres que je rencontrais et qui me semblaient dignes d'intérêt. Cette liste s'enrichit et s'affina après l'univerisité. Elle finit bientôt par contenir plus d'une centaine d'éléments. Avant la deuxième guerre mondiale, ma collection avait pris la forme d'un fichier où, pour certains nombres, la même fiche présentait plusieurs propriétés différentes. Les mathématiques n'ont pas le monopole des nombres. Ceux-ci se rencontrent ailleurs Notamment dans les autres sciences et pratiquement dans la plupart des activités humaines. Mais seuls les nombres distingués par les mathématiques m'intéressaient et me paraissaient dignes d'être recueillis dans mon florilège. J'écartais donc les nombres relevant des sciences expérimentales, physiques, chimiques, naturelles, biologiques, voire psychologiques ou sociologiques, comme la constante de Planck, la constante de gravitation, la constante de structure fine, le nombre d'Avogadro, les nombres nucléaires 'magiques', etc. [. . .] Il n'était pas question, en avril 1944, d'emporter mon fichier à la prison de Fresnes ou en déportation au camp de Dora. Mais ma mémoire restait intacte et mes chers nombres me rendaient visite chaque jour en compagnie d'autres consolateurs comme la musique, la poésie, l'histoire et les sciences. A mon retour en mai 1945, mon fichier avait disparu. J'en reconstituai un autre en modifiant ma terminologie et baptisai les pièces de mon herbier *Nombres remarquables*".

[38]"Quand un mathématicien avait connaissance d'un nombre aux propriétés particulières, il l'offrait à François", [7, p. 216].

The leitmotif of the work, once again, is the surprise caused by discovering the existence of properties and structures ruling the "well organised society [...] of numbers". Within his life, he played with these numbers and, in parallel, he experimented in the field of potential literature.

Conclusion

As stated in the Introduction, an analysis of the most significant contributions of François Le Lionnais shows not only his polyhedral culture, but above all his being an eclectic man and a passionate Epicurean. Further, the interview *Un certain disparate* unequivocally reveals his personality, showing the taste for intellectual experimentation that accompanied him all his life. Regarding this aspect, few would have wagered on the success and longevity of his best-known 'creation', Oulipo [42, *preface*]. Born thanks to a group of intellectuals "in the dual sign of great fantasy and as great scrupulousness" it developed and expanded into various fields of the artistic research with the desire of amusing and surprising by playing with mathematics. After all, *le jeu d'esprit* that enlivened the Oulipo exactly reflects Le Lionnais' conception of mathematics as a 'game', since, by stimulating human intelligence, it reaches the deepest and most mysterious roots of nature [43].

References

1. F. Le Lionnais (ed.), *Les Grands Courants de la pensée mathématique* (Cahiers du Sud, Marseilles, 1948)
2. *Un Certain Disparate* interview with François Le Lionnais, ed. by J.-M. Levy-Leblond, J.-B. Grasset. Complete edition by M. Audin, A.F. Garréta, O. Salon (1976), https://blogs.oulipo.net/fll/. Accessed 14 July 2019
3. *Qu'est-ce que l'Oulipo?* interview with François Le Lionnais and Raymond Queneau. L'Éducation **209**, 24–28 (1974)
4. O. Salon, François Le Lionnais, visionnaire et pédagogue discret. Les Nouvelles d'Archimède **50**, 35–39 (2009)
5. O. Salon, François Le Lionnais – Un érudit universel (2009), http://images.math.cnrs.fr/Francois-Le-Lionnais-un-erudit?lang=fr. Accessed 14 July 2019
6. F. Le Lionnais, La peinture a Dora. Confluence **10** (1946)
7. O. Salon, *Le Disparate, François Le Lionnais. Tentative de recollement d'un puzzle biographique* (Othello, Paris, 2016)
8. N. Schappacher, Paul Valéry et la potentialité des mathématiques, in *Paul Valéry: Für eine Epistemologie der Potentialität*, ed. by P. Valdivia Orozco, A. Allerkamp (Winterverlag, Heidelberg). Germanisch-Romanische Monatsschrift, Beihefte Band 74, 173–194 (2016)
9. A. Weil, *Oeuvres Scientifiques, Collected Papers*, vol 1 (Springer, New York, 1979), pp. 244–255
10. J. Borowczyk, Bourbaki et la Touraine. Sciences et Techniques (Publication de l'Académie de Touraine) **20**, 139–160 (2007)
11. N. Bourbaki, The architecture of mathematics. Am. Math. Monthly **57**(4), 221–232 (1950)

12. F. Le Lionnais, Les éléments de mathématique de Bourbaki. L'Éducation Nationale **17**, 9–10 (1950)
13. D. Aubin, The withering immortality of Nicolas Bourbaki: a cultural connector at the confluence of mathematics, structuralism, and the Oulipo in France. Sci. Context **10**(2), 297–342 (1997)
14. C. Bartocci, Raccontare mondi possibili: letteratura e matematica, in *Cavalcare la luce. Scienza e letteratura*, Atti del convegno internazionale, Alessandria-San Salvatore Monferrato, 23–25 May 2007 (Interlinea, Novara, 2009), pp. 141–146
15. R. Queneau, Bourbaki et les mathématiques de demain. Critique **18**(176), 3–18 (1962)
16. Oulipo, *La littérature potentielle: créations, re-créations, récréations* (Gallimard, Paris, 1973)
17. M. Audin, Brief lives, Une vie brève, in *Imagine Maths 4: Between Culture and Mathematics*, ed. by M. Emmer, M. Abate, M. Villarreal (Unione matematica italiana, Bologna; Istituto Veneto di Scienze, Lettere e Arti, Venezia, 2015), pp. 45–52
18. M. Audin, How to tell mathematics (remembering Sofya Kovalevskaya), in *Imagine Maths 4: Between Culture and Mathematics*, ed. by M. Emmer, M. Abate, M. Villarreal (Unione matematica italiana, Bologna; Istituto Veneto di Scienze, Lettere e Arti, Venezia, 2015), pp. 315–321
19. M. Audin, One hundred twenty-one days choosing to write fiction, in *Imagine Maths 4: Between Culture and Mathematics*, ed. by M. Emmer, M. Abate, M. Villarreal (Unione matematica italiana, Bologna; Istituto Veneto di Scienze, Lettere e Arti, Venezia, 2016), pp. 49–55
20. P. Albani, La letteratura potenziale – alcune note sparse, http://www.paoloalbani.it/Letteraturapotenziale.html. Accessed 11 June 2019
21. M. Emmer, Mathematics and Raymond Queneau, in *Mathematics and Culture II*, ed. by M. Emmer, (Springer, Berlin, 2005), pp. 195–200
22. P.P. Argiolas, La potenzialità delle strutture fisse: l'OuLiPo e la scrittura sotto "contrainte". Portales **8**(2), 59–70 (2006)
23. F. Le Lionnais, Raymond Queneau et l'amalgame des mathématiques et de la littérature. La Nouvelle Revue Française **290**, 71–79 (1977)
24. M. Audin, L'Oulipo et les mathématiques. Une description, http://irma.math.unistra.fr/~maudin/ExposeRennes.pdf. Accessed 23 Nov 2018
25. C. Bologna, La "contrainte" e la poetica medievale, in *Raymond Queneau. La scrittura e i suoi multipli. I libri dell'Associazione Sigismondo Malatesta*, ed. by D. Gambelli, C. De Carolis (Bulzoni, Rome, 2009), pp. 45–68
26. M.P. Saclolo, How a medieval troubadour became a mathematical figure. Notices Am. Math. Soc. **58**, 682–687 (2011)
27. Oulipo, *Atlas de littérature potentielle* (Gallimard, Paris, 1981)
28. J. Roubaud, La mathématique dans la méthode de Raymond Queneau. Critique **33**(359), 392–413 (1977)
29. G. Perec, Histoire du lipogramme, in Oulipo, *La littérature potentielle: créations, re-créations, récréations* (Gallimard, Paris, 1973), pp. 73–89
30. M. Macho Stadler, La vita istruzioni per l'uso di Georges Perec (Italian translation by Anna Betti), Xlatangente, http://www.xlatangente.it/upload/files/La_vita_istruzioni_per_l_uso.pdf. Accessed 11 June 2019
31. G. Perec, Quatre figures pour "La Vie mode d'emploi". L'Arc **76**, 50–53 (1979)
32. G. Perec, Le Cahier des charges de "La Vie mode d'emploi" (La librairie du XX siècle, C.N.R.S. et Zulma, Paris, 1993)
33. R.C. Bose, S.S. Shrikhande, E.T. Parker, Further results on the construction of mutually orthogonal Latin squares and the falsity of Euler's conjecture. Can. J. Maths **12**, 189–203 (1960)
34. F. Le Lionnais, Quelques structures et notions mathématiques, in Oulipo, *La littérature potentielle: créations, re-créations, récréations* (Gallimard, Paris, 1973), pp. 291–294
35. F. Le Lionnais, Qui est le coupable? Subsidia Pataphysica **15** (1971)

36. F. Le Lionnais, Les structures du roman policier: qui est le coupable?, in Oulipo, *La littérature potentielle: créations, re-créations, récréations* (Gallimard, Paris, 1973), pp. 66–69. A recent translation in G. Massignan: Oplepo: scrittura à contrainte e letteratura potenziale. Dissertation, Università Ca' Foscari Venezia (a.a. 2010/2011)
37. F. Le Lionnais, Une nouvelle policière en arbre, in Oulipo, *La littérature potentielle: créations, re-créations, récréations* (Gallimard, Paris, 1973), p. 276
38. F. Le Lionnais, La recherche. Il Caffè (1960)
39. F. Le Lionnais, Poèmes booléens, in Oulipo, *La littérature potentielle: créations, re-créations, récréations* (Gallimard, Paris, 1973), pp. 258–262
40. F. Le Lionnais, Théâtre booléen, in Oulipo, *La littérature potentielle: créations, re-créations, récréations* (Gallimard, Paris, 1973), pp. 263–264
41. F. Le Lionnais, *Les nombres remarquables* (Hermann, Paris, 1983)
42. R. Campagnoli (ed.), *Oulipiana* (Guida editori, Naples, 1995)
43. F. Le Lionnais, Les mathématiques modernes sont-elles un jeu? Science Progrès Découverte **3427** (1970)

Part XI
Visual Mathematics

Local Estimates for Minimizers, Embodied Techniques and (Self) Re-presentations Within Performance Art

Telma João Santos

Calculus of Variations and Performance Art: An Improbable Duo

Connections between art and science are not a new landscape within contemporary research, especially in applications. In particular, connections between mathematics and art have been explored, settled, shared and developed by many authors in journals as *Leonardo, Mathematics and the Arts*, and conference books as *Imagine Maths*, among others. It is fascinating to witness the proliferation of intersectional works, where boundaries between artistic work and scientific research are blurred. It is in this blurring boundaries' landscape that I enclose the work presented here, where autobiography is an important intersectional tool.

I started my academic journey as a mathematician with a special interest in qualitative properties of solutions to minimization problems in calculus of variations, inspired in known results from partial differential equations' context. I have been dedicated to functionals depending on the gradient, with linear or nonlinear perturbations, generalizing Arrigo Cellina's results on the validity of the Strong Maximum Principle and searching for local estimates for solutions. I search for the recontextualization in calculus of variations context of known results from partial differential equations, which are connected through the Euler–Lagrange equation, a second-order partial differential equation whose solutions are functions for which the functional involved in a minimization problem is stationary.

T. J. Santos (✉)
Lisboa, Portugal
e-mail: tjfs@uevora.pt

© Springer Nature Switzerland AG 2020
M. Emmer, M. Abate (eds.), *Imagine Math 7*,
https://doi.org/10.1007/978-3-030-42653-8_24

411

The Strong Maximum Principle was first settled in variational setting by Arrigo Cellina, searching for its validity concerning solutions for minimizations problems of the type

$$(P) \qquad \int_{\Omega} f\left(\|\nabla u(x)\|\right) dx \qquad u \in u_0 + W_0^{1,1}(\Omega),$$

where $\Omega \subseteq R^n$ is an open connected set, the extended valued function $F(\gamma) = f(\|\nabla \gamma\|)$ is convex, lower semicontinuous, rotationally invariant and such that $F(0) = 0$. Following Arrigo Cellina in [1], we say that *f has the Strong Maximum Principle if for any Ω open connected, for every continuous nonnegative solution \bar{u} to (P), $\bar{u}(x_0) = 0$ for some $x_0 \in \Omega$, then $\bar{u} \equiv 0$ on Ω*. For minimization problems of this type, Arrigo Cellina proved that smoothness and strict convexity of f at the origin were sufficient and necessary conditions for the *Strong Maximum Principle* to hold. This property can also be seen as an uniqueness result: if we have a nonnegative solution "touching" zero in the interior of an open connected set, then it has to be the trivial null solution.

Along the specific research myself and Vladimir Goncharov were involved on generalizing the validity of *Strong Maximum Principle*, under the same conditions, for the case where F is invariant with respect to a convex compact set $G \subseteq R^n$ instead of being rotationally invariant; that is, $F(\gamma) = f(\rho_G(\nabla \gamma))$, where ρ_G stands for the Minkowski functional (for more insights see [2]). I was simultaneously developing a movement research within performance art setting, searching for ways of identifying specific moments of discontinuity and studying their neighborhoods, comparing possible different outcomes. At some point, I accepted that I was generating movement vocabulary associated with the idea of uniqueness, interconnected with points of discontinuity. I realized that something about being a mathematician and a performer with specific concerns on scientific and artistic research and practice was a new landscape to consider.

Performance is not a strange word for most of us, despite its different meanings, depending on the context. It is, in fact, a paradoxical word, since it can be seen as some action, or set of actions, to be judged; or as some action, or set of actions, to be shared as an artistic object. So, on one side, it can be seen as the outcome of a rigorous set of rules as a way of excelling some technique or some behavior in a normative setting. On the other side, performance (art) is an artistic and nonnormative way of questioning the establishment and its politics.

Performance Art. What is performance art? The eternal desire of defining what cannot be defined in classical ways is an interesting point to depart from. Following Erving Goffman, the word *performance* means "all the activity of an individual which occurs during a period marked by his continuous presence before a particular set of observers and which has some influence on observers" ([3], p. 13). Our daily actions are performative and most of the times we are conscious of their performativity: "While in the presence of others, the individual typically infuses

his activity with signs which dramatically highlight and portray confirmatory facts which might otherwise remain inapparent or obscure" ([3], p. 19).

Performance art arouse from established artistic practices, where known tools associated to those practices are used to question borders through discourses and individual or collaborative proposals. These discourses are characterized by the dynamics of possibilities of artistic thought, turning performance art into a complex and disperse field, not allowing static or fixed definitions and contextualization. It is necessary to reformulate them continuously. Performance art is also an artistic practice that generates new objects, where established artistic practices intersect with new approaches. Performance art opens the possibility of these established practices to communicate with everyday life actions, exhibiting their performativity and discursive force.

In a performance art piece, it is possible to find a personal perspective on the actual world surrounding the performer(s) and, so, a contextual perspective. However, not only the languages used are universal, but also some contextual elements, as questioning society, ways of organizing it and, in particular, gender, race and personal traumas, are universal. The integration of ideas, the perceptive work, communication tools, the "here and now," are part of this artistic practice that, in this way, can be seen as a barometer of the way are mapped social, economic, political, anthropological, cultural, technologic continuous transformations, and their subjective interconnections. As this artistic practice is anchored in the use of diverse tools from diverse practices and fields of study, it can also be shared in less conventional places to connect with, or to reinforce the idea of multiplicity. As Roselee Goldberg writes in [4],

> The work may be presented solo or with a group, with lighting, music or visuals made by the performance artist himself or in collaboration, and performed in places ranging from an art gallery or museum to an "alternative" space, a theater, café, bar, or street corner (p. 9).

Also, as Marvin Carlson writes in [5],

> its practitioners do not base their work on characters previously created by other artists but on their own bodies, on their autobiographies, on their specific experiences in a given culture or in the world, that become performative in that practitioners are aware of them and exhibit them before an audience. (pp. 4–5)

It is also through the audience that performance takes place. Or, as Peggy Phelan notes in [6],

> Performance approaches the real through resisting the metaphorical reduction of the two [representation and real] into the one. But in moving from the aims of metaphor, reproduction, and pleasure to those metonymy, displacement, and pain, performance marks the body itself as loss. Performance is the attempt to value that which is nonreproductive, non-metaphorical. This is enacted through the staging of the drama of misrecognition (twins, actors within characters enacting other characters, doubles, crimes, secrets, etc) which sometimes produces the recognition of the desire to be seen by (and within) the other. Thus, for the spectator the performance spectacle is itself a projection of the scenario in which her own desire takes place. (p. 152)

Performances and their several characterizations are theoretically established and/or questioned in performance studies, a complex, subjective field of study, in constant redefinition. Following Richard Schechner in [7],

> Performance Studies is 'inter—in between. It is ingeneric, interdisciplinary, intercultural— and therefore inherently unstable. Performance studies resists or rejects definitions. As a discipline, PS cannot be mapped effectively because it transgresses boundaries, it goes where it is not expected to be. It is inherently <in between> and therefore cannot be pinned down or located exactly." (p. 360)

Also, John MacKenzie introduces the concept of "Liminality" in [8]:

> What is performance? What is performance studies? "Liminality" is perhaps the most concise and accurate response to both of these questions. Paradoxically, the persistent use of this concept within the field has made liminality into something of a norm. That is, we have come to define the efficacy of performance and of our own research, if not exclusively, then very inclusively, in terms of liminality—that is, a mode of activity whose spatial, temporal, and symbolic "in betweenness" allows for social norms to be suspended, challenged, played with, and perhaps even transformed. (p. 27)

As a mathematician and also as a *performer* with a background in contemporary dance—I studied in Évora's Contemporary Dance Company, Superior Dance School of Lisbon and attended laboratories and intensives by La Pocha Nostra,[1] Nicole Peisl and Alva Noe (dancer and philosopher in residence by Forsythe Company), among others—I started to advance some *in-between* questions: "In which ways I can connect artistic creation and scientific research, at least using an autobiographical approach?," "Is there any methodological approach to propose within artistic creation?," and "In which direction it can be used?"

A Relational Model

One of my main goals within artistic creation and scientific research, and especially as a performance artist and a researcher in calculus of variations, is to draw connections between theses landscapes in order to search for and to propose new meanings in between artistic creation and scientific research. Along time, I have been increasingly interested in scientific research as a conceptual, critical and concrete tool within performance art. In 2014, I proposed a first approach of a relational model in artistic creation, in [9], composed by three main notions: *axiomatic image, sub-images and dynamics.*

This relational model became a tool to create performance art pieces, but also to relate with other performance artists and dancers' works. As a performance artist, I start any project with an idea—*axiomatic image*—that I cannot drop, since it slowly permeates the several universes I am involved in, from research to practice, to

[1]See www.pochanostra.com for more insights on the work by Guillermo Goméz-Peña, Roberto Sifuentes and others.

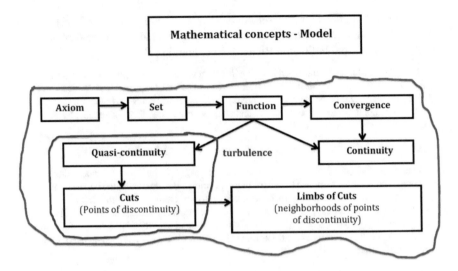

Fig. 1 Mathematical concepts within the relational model presented above

personal ways of perceiving the world and what surrounds my life. It turns itself into a central landscape from which I develop tri-dimensional images—*sub-images*— and their dramaturgic movement—*dynamics*—giving rise to a performance art piece. There is no imposed chronological order, but I start with an *axiomatic image* and both *sub-images* and *dynamics* are constructed from the definition and characterization of *quasi-continuous functions*, the study of neighborhoods, or *limbs*, of points of discontinuity, or *cuts*, looking at these neighborhoods as central landscapes, the micro into the macro, as in Fig. 1 (see [9] for more details).

In [10], the mathematical approach to the concept of turbulence is studied in performance art context, which brings new tools to work with or to relate with: discontinuity points, or *cuts*, are, roughly, limit points of turbulent flows. In this paper [10], I used as case study the performance art piece *On a Multiplicity*, where I searched for different approaches to self-presentations and self-representations through movement and research improvisation tools within research as it is shown in Figs. 2 and 3.

In [11, 12] I reconnect with the model as a relational one and not only as a creation methodological tool, using as case study the performance dance pieces *G.O.D.*, by Flávio Rodrigues.[2] This piece was an important tool to question the model's implicit chronology, since I realized that Flávio had a different approach to creation: he starts with an initial desire to connect many different tools, ideas and sound landscapes and he discovers the *axiomatic image* and *sub-images* later along

[2]See http://www.flaviorodrigues.info/2014/09/god-godess-of-desire.html for more insights on the performance art piece *G.O.D.*

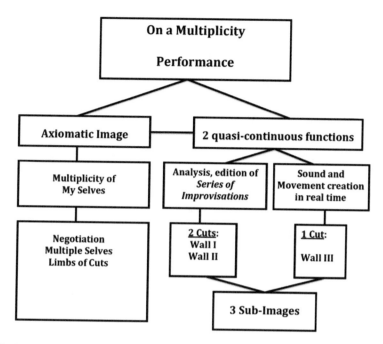

Fig. 2 *Axiomatic image* and *sub-images* of the performance piece "On a Multiplicity"

Fig. 3 *Sub-images* and *dynamics* of the performance art piece "On a Multiplicity"

the creation process—the *axiomatic image* can be even settled only at the end of the process.

At this point, the question of how the Strong Maximum Principle is related with the model arises, since it seems that it is not used in performance art more than a tool—I use in some performance art pieces material from communication strategies used in conferences or material developed from making audible the reasoning behind solitary research. A first approach to possible connections between the Strong Maximum Principle and performance art was first introduced in [13]:

> there are three directions of composing body narratives in this setting: to be introspectively passive, or null ground, to be constantly moving above the null ground, or ricocheting in between, with one important rule: each time the narrative in the performance touches the ground—it can be the literal floor, the zero energy, or a state of the body defined hierarchically as the lowest one—it stays on the ground inside the specific set defined initially. The only possibility is then, to stay on the ground until the environment metamorphoses itself into another equation defined on another set. (p. 33)

LOOP, a Performance Dance Piece by Sérgio Diogo Matias

Sérgio Diogo Matias is a young performer and choreographer, which artistic work is connected with fine arts, especially painting, sculpture, and design. He has been creating dance and performance pieces based on images, sculptures, and researching on ways to choreograph body metamorphosis through physical-emotional states in complex, specific and yet, open formats.

Between November 2018 and May 2019, Sérgio Diogo Matias developed the dance piece LOOP, with contemporary dancer Teresa Alves da Silva and batterist and performer Bruna Carvalho, inspired in what could be a dance piece as a failed rock music concert. The focus was, since the beginning, in defining esthetic features of rock music concerts, searching for analogies in contemporary dance and performance and creating different levels of impermanence and landscapes of failure from different perspectives: time, chronology, connection with the audience, expectation versus real time experience.

I collaborate regularly with Sérgio Diogo Matias since his dance piece MASS|MESS (2017) as a writer and a researcher, which I usually name as "documentation." I collaborated in the past with dance performers in their performance art pieces, where classical contemporary dance codes where put aside, and performance art codes were considered as a motto.[3] This circumstance turns out to be comfortable for me, since I am also a performance artist, even if I am closer to the underground scene and they are closer to institutional places. I chose Sérgio Diogo Matias and his new dance piece LOOP as a case study at this point,

[3]I worked with Flávio Rodrigues (http://www.flaviorodrigues.info/), Bruno Senune (http://brunosenunecontact.blogspot.com/), Joana Castro (https://joanacastroarte.blogspot.com/), among others.

since he is a mainly a dancer and choreographer, and his interest in performance art is related to his interest in developing the multidimensional nature of his work: choreographing a complex landscape of movement interconnected with emotional intended, but altered, states.

LOOP started with two different questions, but I have referred above to only one: how to choreograph a dance piece as a failed rock concert, constructing meaning through analogies and interferences? This first question can be seen as the *axiomatic image* of this piece, if we consider the relational model.

The other question that originated this piece was how to attain an emotional and physical limbo, which can also be seen as Sérgio Diogo's *plane of immanence*, a concept from Deleuze, described in [14] in the following way:

> The plane of immanence includes both the virtual and its actualization simultaneously, without there being any assignable limit between the two. The actual is the complement or the product, the object of actualization, which has nothing but virtual as its subject. Actualization belongs to the virtual. The actualization of the virtual is singularity whereas the actual itself is individuality constituted. The actual falls from the plane like a fruit, whist the actualization relates it back to the plane as if to that which turns the object back into a subject. (pp. 149, 150)

This plan is constructed through the concept of *Body without Organs* (BwO), coined by Artaud in [15]: "when you will have made him a body without organs, then you will have delivered him from all his automatic reactions and restored him to his true freedom." (p. 571) and developed by Deleuze and Guattari in [16]:

> This is how it should be done. Lodge yourself on a stratum, experiment with the opportunities it offers, find an advantageous place on it, find potential movements of deterritorialization, possible lines of flight, experience them, produce flow conjunctions here and there, try out continua of intensities segment by segment, have a small plot of new land at all times. It is through a meticulous relation with the strata that one succeeds in freeing lines of flight, causing conjugated flows to pass and escape and bringing forth continuous intensities for a BwO. (p. 161)

In LOOP, Sérgio Diogo Matias decided to create movement inspired in rock stars, to turn it minimal and to repeat it until a limit to be defined—the BwO. The dance piece as a failed rock music concert, and also as a possible landscape—plane—of immanence. Each set of movements are part of a *sub-image*, and inside each *sub-image*, the *dynamics* is generated through choreographic decisions inside repetitions, and in connection with music and light. Drugs, alcohol, and other addictions can be seen, as referred by Ian Buchanan in [17], as being direct ways to the never attained limit that the BwO is.

There are mainly three *sub-images* in this piece; the first one, *presentation*, is inspired in fashion runaways, but contextualized on stage within an apparent concert, failing in the direct connection that was supposed to happen with the audience, and also on how a rock concert goes on stage, as we can see in Fig. 4.

The second *sub-image* is present in Fig. 5 and we name it *mapping*, which is the process of territorialization, mapping the stage, the conquest, failing the live music concert that was supposed to be happening and the connection with the audience.

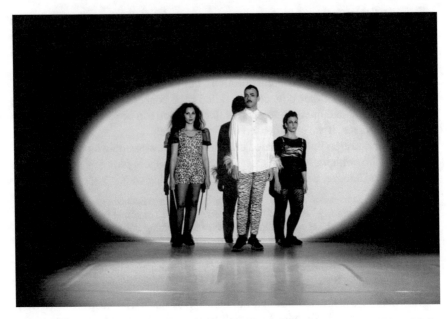

Fig. 4 The first *sub-image*: *presentation*. From left to right: Bruna Carvalho, Sérgio Diogo Matias and Teresa Alves da Silva. Light design by Zeca Iglésias. Photo by Alípio Padilha

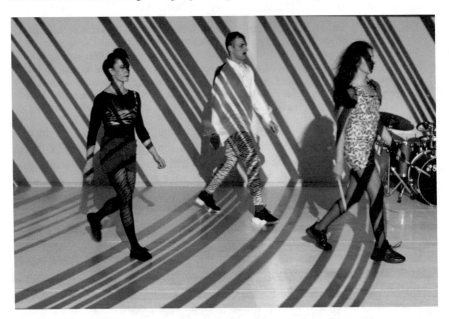

Fig. 5 The second sub-image, the process of territorialization, mapping the stage, the conquest, failing the live music concert that was supposed to be happening and the connection with the audience

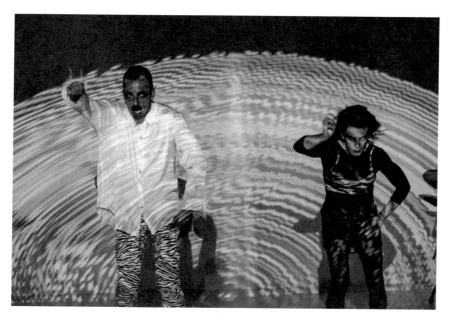

Fig. 6 *Immanence*, the third *sub-image*. From left to right: Sérgio Diogo Matias and Teresa Alves da Silva. Photo credits: Alípio Padilha

The third one is *immanence*, the part of the piece where the plane of immanence is established through the BwO. We can have a glimpse of this part in Figs. 6 and 7.

The final *sub-image*, named *final song*, is the final part of the piece, the final song of the concert, after the encore. It fails, there is no song, only the desire of the song remains. The song in the context of the body without organs as we can perceive in Fig. 8.[4]

Finally, let us approach the *Strong Maximum Principle* in the context of this piece. First, I would like to refer that artists with whom I work are familiar with the relational model, but not with the *Strong Maximum Principle*. This property remains a "personal thing," since it was introduced first in the context of my own work. It is introduced here as a possibility to research on others' pieces, with the respective reformulations. This leaves room to open an interesting universe of possibilities to reformulate properties of solutions in calculus of variations and movement based performance pieces.

It is important to define first what does the trivial null solution means in LOOP's context, and then to search for a possibility of reconfigure how the *Strong Maximum Principle* can be perceived in this piece's context, since it never stops; instead, movement metamorphosis itself, continuously becoming something else. Movement

[4]The dance performance piece LOOP was video recorded and can be seen in https://www.youtube.com/watch?v=5bXDL-6fG4c

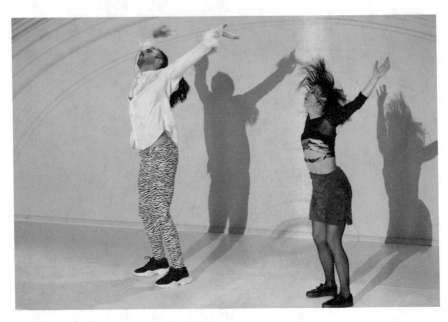

Fig. 7 *Immanence*, the third *sub-image*. From left to right: Sérgio Diogo Matias and Teresa Alves da Silva. Light design by Zeca Iglésias. Photo credits: Bruno Simão

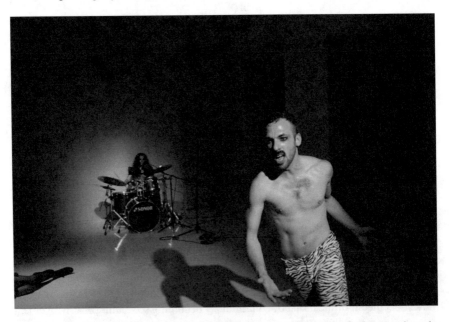

Fig. 8 The fourth *sub*-image, *final song*. The final part of the concert, the final song, where the rock singer is connecting with the audience as it should have happened in the beginning—or as it is usually to happen—and he does not sing, just promises and shares vulnerable tiredness. From behind to the front: Bruna Carvalho and Sérgio Diogo Matias. Photo credits: Bruno Simão

metamorphosis is based on rituals of repetition that allows the rise of a limbo between sobriety and focus, and altered states of perception, giving the audience a sense of vulnerability, as if this rock band was almost giving up this concert, or even the career, the ultimate step of failure.

The *Strong Maximum Principle* is reformulated in LOOP in the following way: giving up leads us to the null solution which, if is attained along the piece, becomes the end of it and the only one possible, taking away the presence of what was already presented. This is because an abrupt end clarifies the presence of absence and does not allow what was presented before, to be inscribed and considered as valid.

References

1. A. Cellina, On the strong maximum principle. Proc. Am. Math. Soc. **130**(2), 413–418 (2002)
2. V.V. Goncharov, T.J. Santos, Local estimates for minimizers of some convex integral functional of the gradient and the strong maximum principle. Set-Valued Variational Anal. **19**(2), 179–202 (2011)
3. E. Goffman, *The Presentation of Self in Everyday Life* (University of Edinburgh Social Sciences Research Center, Edinburgh, 1956)
4. R. Goldberg, *Performance Art: From Futurism to the Present* (Thames & Hudson, New York, 2011)
5. M. Carlson, *Performance: A Critical Introduction* (Routledge, New York, 2004)
6. P. Phelan, *Unmarked: The Politics of Performance* (Routledge, New York, 1993)
7. R. Schechner, What is performance studies anyway? in *The Ends of Performance*, ed. by P. Phelan, J. Lane, (New York University Press, New York, 1998), pp. 357–362
8. J. MacKenzie, The liminal norm, in *The Performance Studies Reader*, ed. by H. Bial, 2nd edn., (Routledge, New York, 2007)
9. T.J. Santos, On a multiplicity: deconstructing Cartesian dualism using mathematical tools in performance. Liminalities J. Perform. Stud. **10**(3), 1–28 (2014)
10. T.J. Santos, On turbulence: in between mathematics and performance. Perform. Res. **19**(5), 7–12 (2014)
11. T.J. Santos, *Entre o pensamento matemático e a arte da performance: questões, analogias e paradigmas*. Ph.D. Thesis, Universidade de Lisboa, 2016
12. T.J. Santos, Mathematics and performance art: first steps on an open road. Leonardo J., (JustAccepted publication, 2017), https://doi.org/10.1162/LEON_a_01546
13. T.J. Santos, On self codes, a case study within mathematics and performance art. J. Sci. Technol. Arts **9**(1), 29–37 (2017)
14. G. Deleuze, C. Parnet, *Dialogues II* (Columbia University Press, New York, 2007)
15. A. Artaud, To have done with the judgment of god, in *Selected Writings*, ed. by S. Sontag, (University of California Press, Berkeley, CA, 1976)
16. G. Deleuze, F. Guattari, *A Thousand Plateaus* (University of Minnesota Press, Minneapolis, MN, 1987)
17. I. Buchanan, The problem of the body in Deleuze and Guattari, or, what can a body do? Body Soc. **3**(3), 73–91 (1997)

Acqua Alta

Claire Bardainne and Adrien Mondot

Something is happening. A new insistence of certain experiences. The derailing of what is referred to as our "modern naturalism", our way of experiencing the world, the beings and things that populate it. Perhaps, this much is happening already: a re-animation of sorts; fragile, ephemeral, clumsy resurgences of animism. Certain things, certain beings, certain forces are speaking to us, are waving at us. The need for a world to reanimate, this is where we stand. It seems about time to accept the fact that we have never ceased to sustain, through some of our practices, a world perhaps not enchanted, but far more dense with presences than we have believe so far. Time to rethink the distribution map of forces, aptitudes and capacities between the living, the invisible, things, cosmic forces... and to nurture the possibility of a new cosmogram.

Jérémy Damian, Weird Animisms, Corps-Objet-Image#3,
(2017–2018)
(http://www.corps-objet-image.com/revue-coi-03)

Acqua Alta is a story.

That of a woman, a man, a house. A daily routine, absurd and filled with discrepancies. But one wet rainy day, their life is turned upside down: the rising waters drown their home in an ink-coloured sea. The woman slips and disappears. Only her hair remains, and it is alive.

It tells the tale of a disaster, unique and universal.

It tells of losing and searching.

It tells of the fear of the bizarre and otherness, and how to tame it.

We created three variations on the same story, using three different formats:

Acqua Alta—Ink black: a visual theatre performance that blends movement and living digital images

C. Bardainne (✉) · A. Mondot
Adrien M & Claire B, Lyon, France
e-mail: claire@am-cb.net; adrien@am-cb.net

© Springer Nature Switzerland AG 2020
M. Emmer, M. Abate (eds.), *Imagine Math 7*,
https://doi.org/10.1007/978-3-030-42653-8_25

Acqua Alta—Crossing the mirror: a book whose drawings and paper volumes become the décor of the story, only visible in augmented reality

Acqua Alta—Tête-à-tête: an immersive experience in a virtual reality headset to live one scene of the performance in immediate proximity

The suggested itinerary for the spectator is made up of the three experiences above, they resonate with one another.

In line with our love for the movement of elements and in the wake of our projects exploring the imaginary of air and of vapour, *Acqua Alta* is a voyage into water.

Acqua alta refers to a phenomenon in Venice when the waters of the Laguna submerge the city during exceptionally high tides. These two words, literally translated as high water, take us on a journey through rain and wave, against currents. They submerge us in an ever-changing, living water, a flood that speaks.

Tiny dancing dots—in virtual and augmented reality as well as projected—reveal the infinite variations in the world of water. The water that drowns along with the water that brings life. And, beyond realism, these images conjure up living spaces, changing landscapes imbued with presence, singular spirits, mischievous and polymorphous phantoms.

A simple graphic stroke and the simple use of black and white ties the three experiences together. But the story, as if told by multiple voices, unfolds playfully in these facets that complete and shed light on one another to create a sensitive experience. The hand-drawn lines traced across the pages of the book thrum and intertwine like long strands of hair. The folded papers are made strong by their geometry but fragile by their substance, sensitive to water and wrinkles.

The tiny beings sheltered within this paper world are reminiscent of the performers on stage. But, whereas the first have no substance, the latter are striking for their flesh and sweat. Man and woman as an irreducible sample of humanity. Satchie Noro and Dimitri Hatton, the creators and performers of the choreography, embody the meeting of finesse and chance, fragility and balance. The non-human world that surrounds them highlights the essence of their human condition and contours.

The original music, composed by Olivier Mellano, transports spectators to a dreamy and suggestive realm in which water sings.

And, although hidden in the sound booth, the live manipulation of images during the show, which we call "digital interpretation", is a performance akin to juggling or puppeteering.

With this project, we continue our research around the recording of dance and body movement (using motion capture equipment). It allows for unusual forms of play and new ways of perceiving movement, as can be experienced in the virtual reality headset. With these living images, computer generated and animated, *Acqua Alta* also furthers our research into digital animism, our desire to digitally create from scratch an imaginary bestiary which sparks a fabulous and improbable feeling, and in which humans and non-humans exist on equal footing. Finally, we strive, at our own modest level, to participate in the creation of an imaginary of the future in which a life can reinvent itself after a catastrophe.

Stage Performance

Acqua Alta—Ink black

On a bare stage, an arrangement of three video projections: one on a gauze at the front of the stage, the second on a gauze at the back of the stage (both on frame and suspended), and the third on a white dance floor in between.

There will also be some projections on the walls of the theatre to wrap the spectators in a continuum of images.

Images are generated and animated live.

This "living" digital space becomes the playing field of Satchie Noro and Dimitri Hatton. One a dancer, the other a circus artist, they are the authors and performers of the choreographic score.

The chiselled lights that accompany the video reveal the bodies and enable a troubling co-existence: the real and the imaginary occupy the same space, the stage. The minimalist set design contains several everyday objects: a vacuum cleaner, a step-ladder, a broom, which are essential companions to this odyssey.

Original music is composed by Olivier Mellano.

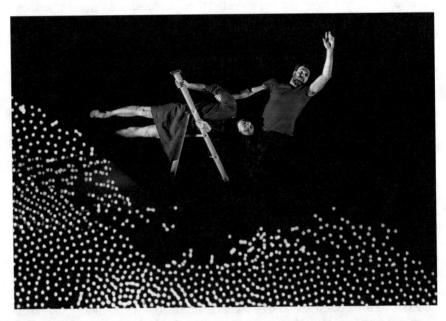

Fig. 1 Image from the stage performance *Acqua Alta—Black Ink* by Adrien M & Claire B. Photo © Romain Etienne

Fig. 2 Stage design of the performance *Acqua Alta—Black Ink.* © Adrien M & Claire B

Pop-Up Book and Augmented Reality

Acqua Alta—Crossing the Mirror

Looking through a tablet, each volume becomes, thanks to a custom-made augmented reality application, the real space for a short virtual dance performance. The augmented reality enables the spectator to look at the book from higher above and understand the movement and space, as well as play with perspective.

The drawings in black ink are landscapes, the folded papers rising from the pages are playgrounds.

The choreography is recorded using a motion capture device, and virtual images (wind, sea, rain) bring these dreamlike realms to life. Through this digital window, the ten double-pages of the book become small theatre stages, where the storyline of the stage performance will unfold with slight adjustments.

The book prototype is laid out on eight tables, in a dedicated space, its ten double-pages shown side by side. Ten tablets with the application are provided and managed by a mediator on-site. The book is a stand-alone object in which the story unfolds in a unique way. But, when presented jointly in a theatre with the book and performance, they resonate with one another.

The retail version of the book and its application will be available in the Autumn 2019 or the Spring 2020.

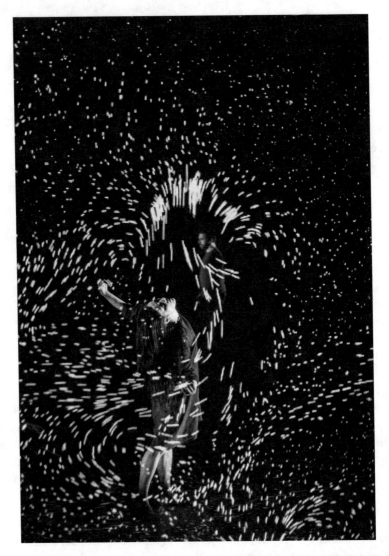

Fig. 3 Images from the stage performance *Acqua Alta—Black Ink* by Adrien M & Claire B. Photo © Romain Etienne

Virtual Reality

Acqua Alta—Tête-à-tête

It is a short performance for a single spectator in which the choreography unfolds around the spectator. It is created using a motion capture (MoCap) device which can record and retransmit movement in a novel way. The spectator shares the stage

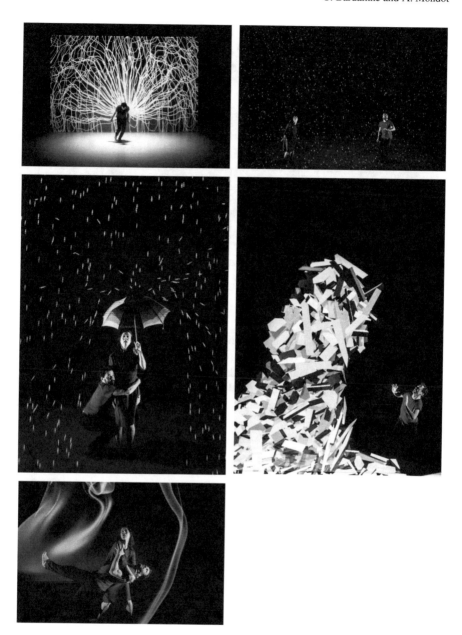

Fig. 4 Images from the stage performance *Acqua Alta—Black Ink* by Adrien M & Claire B.
© Adrien M & Claire B and Romain Etienne

with the dancers and is placed at the centre of the drama. This is a radical shift in
perspective compared to the stage performance. The spectator is the sole recipient
of the unfolding movements. Virtual reality creates proximity and a strong sense of

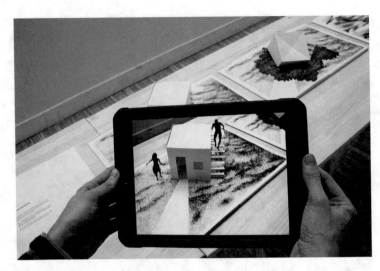

Fig. 5 The pop-up book in augmented reality *Acqua Alta—Crossing the mirror* by Adrien M & Claire B. Photo: Adrien M & Claire B

empathy, and along with a specific writing style, it plays with the limits of reality through the combination of motion capture and computer-generated imagery.

Five to ten individual Oculus Go headsets are provided and managed by an on-site mediator. Each is paired with a stool. Before or after the show, in the theatre foyer or vicinity, it allows the spectator to experience a scene from the story in an immersive way.

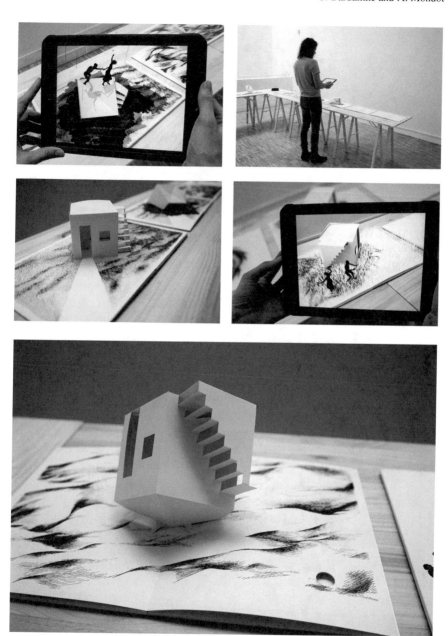

Fig. 6 The pop-up book in augmented reality Book *Acqua Alta—Crossing the mirror*. Photo:
Adrien M & Claire B

Fig. 7 The Virtual Reality experience *Acqua Alta—Tête-à-tête.* Photomontage: Adrien M & Claire B

Fig. 8 The Virtual Reality experience Book *Acqua Alta—Tête-à-tête.* Photomontage: Adrien M & Claire B

Acqua Alta
Adrien M & Claire B
Creation 2019
www.adrienm-claireb.net

Team
Concept and artistic direction Claire Bardainne and Adrien Mondot
Drawings and paper design Claire Bardainne
Computer design Adrien Mondot
Choreography and performance Dimitri Hatton and Satchie Noro
Original music: Olivier Mellano
Additional music: Jean-Sébastien Bach, Ludwig van Beethoven and Jon Brion
Computer development Rémi Engel
Paper engineering Eric Singelin
Script doctor Marietta Ren
Digital interpretation Adrien Mondot, Jérémy Chartier, Yan Godat, alternating
Light engineering Jérémy Chartier, Yan Godat, Benoit Fenayon alternating
Sound engineering Régis Estreich, Christophe Sartori, Romain Sicard alternating
Construction Jérémy Chartier, Yan Godat, Arnaud Gonzalez, Claire Gringore, Yannick Moréteau
Screen print Olivier Bral
Technical management Romain Sicard
Administration Marek Vuiton
Technical direction Alexis Bergeron
Production and booking Joanna Rieussec
Production Margaux Fritsch, Delphine Teypaz

Production
Adrien M & Claire B

Co-productions
LUX, Scène Nationale de Valence. The compagny is associated to LUX en 2018–2019
Hexagone Scène Nationale Arts Sciences—Meylan
Maison de la Danse—Lyon/Pôle européen de création—DRAC Auvergne Rhône-Alpes/Ministère de la Culture
Chaillot—Théâtre National de la Danse
Espace Jéliote, Scène Conventionnée arts de la marionnette, Communauté de Communes du Haut-Béarn, Oloron-Sainte-Marie
Théâtre Paul Éluard, Scène Conventionnée Bezons
Theater Freiburg

Supports
Exceptional support, Adami
Accueil studio, Les Subsistances, Lyon, 2018–2019

The Adrien M & Claire B Company is accredited by DRAC Auvergne-Rhône-Alpes, Auvergne-Rhône-Alpes Region and is supported by the City of Lyon.

Established in 2011 by Claire Bardainne and Adrien Mondot, the company Adrien M & Claire B creates work that brings together the visual arts and the performing arts. Their shows and installations immerse the body in images, they blend sensitive and handcrafted art with digital devices.

A Supposedly Fun Thing We Would Do Again[1]

By Rudi Mathematici (www.rudimathematici.it)

Rodolfo Clerico • Piero Fabbri • Francesca Ortenzio
Torino, Italy
e-mail: piero.fabbri.314@gmail.com; info@rudimathematici.com

The *Parigina III*[rd2] is quite different from the *Nadir*, but to see it floating, ready to welcome us and presumably really able to carry us by sea to San Giorgio Island (as the Conference Program predicts) is more than enough to let us recall the majestic cruise ship sung by DFW,[3] and therefore to make us relive the ultimate reason where it all began. Or, at least, where the process that led us here today began, pressing the keys of this keyboard in order to write about mathematics without being mathematicians, in order to attempt chronicles without being reporters. But this is

[1] If the title sounds familiar and far from being original—in short, almost copied from a famous story/reportage by a great writer—know that it is not a coincidence at all, but a premeditated joke. But it's not only our fault. To make this modest attempt at literary theft even more obvious, we will characterize the "jumpable" footnotes with the initials "IYI," to be read "If You're Interested," perhaps with some variation on the theme. And yes, of course, also this acronym has been stolen.

[2] IYIBWDI (to read: If You're Interested, But We Doubt It)—Ancient reminiscences of high school cause us a certain reluctance to put the apical "st" (in this case "rd") to numbers written in Roman numerals because these, according to our teachers, already define as *ordinal* the number expressed. But this is a report, we have photographic evidence that proves the accuracy of the name of the vessel (well, let's neglect that the original Italian necessarily got an apical "a" instead of an international "rd"), and the reporters deontological mission forces us to remain loyal to reality.

[3] David Foster Wallace, obviously: the author of the short novel (or long story, or commissioned report, call it as you want) entitled "*A Supposedly Fun Thing I'll Never Do Again,*" in which he tells about a cruise in the Caribbean Sea on the luxurious ship "Zenith," which DFW immediately renamed "Nadir."

Fig. 1 The Parigina IIIrd

not the right *incipit*, if we want to respect the rules: so let's pretend that these lines haven't been really typed, virtually cancel every word, and start again.

We saw the trailers of the best mathematical films of recent years, rushing to take note of the titles of those (few) that we have not yet enjoyed. We restrained a sigh of despair looking at the labyrinth named and formed after Borges, cruelly locked and inaccessible for everyone except maybe Spider-Man, and so we also envied a bit that red-and-blue wall-crawler who would take a second to jump over the safety net. We heard the brunette and curly-haired academic sing like a nightingale while explaining the statics and the esthetics of Nervi's buildings, giving voice to a mute and black-and-white Mina (a famous Italian singer), but on the other hand we heard no notes at all from the soprano sitting close to us at the final lunch, because she had to run away and dress the crinolines of Rosina, starring in *Il Barbiere di Siviglia*. We recognized the old and beautiful photo of Maryam as a small child, so proud of her Red Cross nursing gown, and we have seen on the very same screen the gladiator and Hollywood faces of Kirk Douglas and Tony Curtis helping the lecturer at King's College in London to explain the basic rules of computer security.

We walked along Piazza San Marco while two processions were crossing, perpendicular and mathematically independent; one of the sailors in high uniform celebrating the centenary of the *San Marco Battalion* and one of 20-year-old young women and men from Shanghai celebrating the marriage, exotic, and revolutionary, of a couple of friends. We left our eyes on posters of an artist called to celebrate mathematics with brushes and colors; we stalked thousands of flat curves inside the paper laces of the "geometric origami," laces that the French queens would have liked for themselves, and the Dutch lacemakers would have liked to sell to them; and we have admired the thick, hard, luminous, and strong glass carved by acid a century ago. We followed The Geometrician with his rapid and confident steps into endless

Fig. 2 Venezia, no doubt

and unmapped *calli*, the Venetian alleys, looking in vain for the Phantom Bridge (so curious that this should happen to him, the man in charge of bridge crossing during The Conference, bridge talker and ready to feature in his slides even mice, ducks, and a comic avatar of Euler), only to discover that the coveted dish had disappeared from the menu, when the destination was finally reached.

We challenged the laws of probability, starting in private The Conference 7 hours before it was due, thanks to Trenitalia (the Italian railway network), a mathematical mayor and superhero, and the unexpected meeting point in Venice between two geodesics starting one from Turin and the other from Bogotá. And, far more unlikely, in the chiaroscuro of the neo-gothic classroom where the learned speakers alternated their talks, we were even recognized (we, who thought we were in disguise) and flattered by a request for dedication in our booklet, and soon we celebrated the event with 1 of the 57 coffees drunk (between the two of us) in 3 days. And even now, here, despite being very far from the bar of Fort Lauderdale airport but still close, at least in spirit, at the bar of Venezia Santa Lucia station, the usual identity crisis returns: the usual "What Are We Doing Here" (WAWDH); in short, the eternal and unresolved question that starts and closes every mathematical journey of ours. With the consolation (perhaps; with the impression, at least) that this time the fatal question could bring to us even less torment than usual, because the Conference itself yet posed and proposed to everyone, for at least 20 years, a completely similar one.

The Conference is actually a conference and not a "convegno" because it will be in English, and its full name is *Imagine Math 7*, last born of the *Venice Conference Mathematics and Culture* series. It's the umpteenth daughter of the organizational will and voluptuousness of Michele Emmer, mathematician, painter, and filmmaker

heir of a great filmmaker; he's son of Milan, citizen of Rome, and fiancé of Venice, that since 1997 has been the unique location of the Emmerian conferences (and that's the reason why "Venezia" is also the written destination on our *Frecciarossa* tickets, printed above the date March 29, 2019, and the hour 8:15). The same date is written on *The Program*, but the scheduling of the opening speech is only at 15:00, and we well know that in between 400 km of railways wait for us. We do not yet know that also 23,641 steps wait for us (according to the counting of a late-night pedometer) before seeing a hotel bed, but this is only the fault of our inability to find the optimal routes that laureated in Rio de Janeiro Alessio Figalli, and above all of the hypnotic charm of Venetian streets.

But we have already said it: we don't need to wait until 3 PM to see the first slides of the *Imagine Math 7* talks: even if the train is long and there are plenty of free seats, to reach the two we reserved (both window places) we have to trouble a man already seated (aisle place), deeply concentrated on his laptop already attached to the electrical socket under the seat, but (although we will only find out later) not yet attached to the Wi-Fi that Trenitalia guarantees to its travellers. One of us sitting next to the traveller with the laptop peeks at a screen that shows a picture of a strange subject in yellow and red tights, a sort of superhero far from the sculpted look of a Batman: we'll be surprised to find out, later, that the superhero is Antanas Mockus, mayor of Bogotá; we will be much less surprised to learn that he is also a mathematician, because mathematicians don't surprise us anymore, whatever they do. The rude peek at another's computer also reveals a *"Venice Math"* on the header above, and unleashes an immediate exchange of astonished and silent glances between the two Rudi Mathematici. Thanks to the desperation of those who cannot connect to the Internet when to connect is necessary, we discover that our traveling companion is an economist who has moved on to sociology and is practicing in Colombia, and also that Trenitalia refuses to exchange the crucial authorization SMS for Wi-Fi with South American phones. We seize the opportunity and immediately offer an Italian phone for the immediate need: and so Professor Tognato finally lands on the web, and we—pleased to have finally really done something for The Conference's sake—forget for a while the eternal question WAWDH. The fourth place of the quadrilateral drawn by the seats is occupied by a tired psychiatrist, who probably has scented a large amount of possible professional commitment in that polygon, and therefore decides to arrive in the lagoon sleeping.

Then there is Venice, the official start. But the eternal and repeated question, as philosophical and private as it may be, requires at least a partial and logistical response. Otherwise, the mystery of two non-mathematicians, non-chroniclers, directed toward the *Serenissima* to do god-knows-what, would remain unknown. And so here is the flashback, the conglomerate of justifications (only the technical ones, because the metaphysical ones are still missing): more than 10 years ago, in the last months of 2007, when we were already far from being young, but still well provided with a late-adolescent foolishness, we asked Michele Emmer to write the foreword of our second book, "*Rudi Ludi*." We had the good fortune to attend a

Fig. 3 Michele Emmer

lunch with him and Ian Stewart,[4] and the situation was so extraordinary to push us to the point of asking such a thing from the master. The incredible thing is that Michele accepted, and did so with the serenity and ease of those who respond "good morning" to those who greet him in the forenoon; he read the whole book (and it is not at all obvious), and wrote us the preface. Over time, instead of becoming familiar with the idea, the astonishment that we were able to exhibit on that occasion grew. Amazement that, although to a lesser extent, was repeated this autumn, when

[4]IYIBAYR (to read: If You're Interested, But Are You Really?)—Each explanation opens the way to further requests for explanations, and that's an easy way toward infinite. However, given that this text is already full of names, surnames and even images of people who could easily sue us for violation of their privacy, we might as well continue. The cited lunch was offered by Filippo Demonte Barbera, who translated the book "*Flatterland*" by Ian Stewart for Aragno Editions. Michele Emmer was invited because he wrote the afterword of the book, and certainly because it is difficult to forget his documentary dedicated to "*Flatland*" by Edwin Abbott Abbott (www.youtube.com/watch?v=tNDhjYQKWt4). Instead we were there because we had helped Filippo during the editing of his translation: he is a fond reader of our e-zine and a ruthless solver of our geometry problems, so we were happy to help him. As a reward, we found ourselves sitting in a Turin restaurant next to two real and famous mathematicians.

Michele asked us in an unexpected mail: *"Why don't you come to Venice in March as accredited journalists?"*—Well, just because we are not journalists: obvious, isn't it? We've never seen the Professional Order of Journalists, we answer naively, and soon we are teased in subsequent emails, in which Michele explains to us how crucial our formal affiliation with the Order is for him.

But now we were excited at the idea of pretending to be journalists, because in this way we would have been able to give a sort of official flavor to the Venetian mission. We examined the long list of editors-in-chief of the countless publications we work with and, if you are really reading this sentence on paper, it means that Roberto Natalini, editor of the mathematical magazine *Archimede*, was finally moved, or perhaps he didn't have the courage to tell us *"But I was just joking ..."* when we answered *"Sure!"* to his constraint: *"...but only if you write it in a David Foster Wallace style."* Or maybe he was fascinated by the lure implicit in that fedora that the one of us who smokes the pipe prepared with a *"Press–Archimede"* card inserted in the hatband. All this would have been much better in an IYI, and it is only to avoid nesting sublevels of notes[5] that is written here, where instead there should be room only for a report of how in Venice smart people tried, once more, to mix mathematics and culture. Better: to bring into focus and under the spotlight that this mixture already exists, it has always existed: widespread, profound, necessary, and inevitable.

If it were located in any other city in the world, Franchetti Palace would shine on the covers of the glossy tourist guides; it would have greater fame and probably even retain the double name, Cavalli-Franchetti, showing its unquestionable nobility. But Venice is entirely an excess of art and wonder, and therefore the neo-Gothic explosion that attracts tourists intrigued by its pentafore[6] (perhaps glimpsed from the *vaporetto* running along the *Canal Grande* or going down the wide wooden steps of the *Ponte dell'Accademia*) remains almost unknown, and surely not sufficiently narrated and explained by the brochures. Moreover, this is the building chosen by the *Istituto Veneto di Scienze, Lettere e Arti* as its official and definitive headquarters, and if such an institution elected it as its own home, it cannot be doubted that it is a building exuding history and beauty.

When we climb—quite too early—the few steps that could lead us first to the court, then to the garden and finally to the *Sala del Portego*, there are many other people's glances that sinusoidally oscillate between the thick meshes of the grids protecting the large windows of the palace and the yellow–white alternation of the facade. Our lost eyes, on the other hand, sweep along the axis of the abscissas, omit those of the ordinates, and try to intercept familiar or at least known faces; they linger even trying to figure out from the features and outfits if the owners of those

[5]Caution that (we have verified) was not even strictly necessary, because DFW freely nests sublevels of notes in the notes (see note 115a in note 115, page 126 of the Italian edition of the quoted sacred text ASFTINDA, but it isn't the only one). But well . . . DFW was DFW and we are only RM, and a minimum of respect is necessary even in mocking.

[6]IYI—Mullioned windows with five lights.

Fig. 4 Cavalli-Franchetti Palace, also known as Franchetti Palace

faces and clothes are genuine mathematicians or mere travellers who came there by chance, from Wisconsin or Nagoya. Finally, they (our eyes) intercept the educated cordon still stretched on the path that would lead us to our destination, and so we agree between us that it is not polite to bypass it: better to go back to Campo Santo Stefano and drink the eighth coffee[7] of the day (only second, however, among those taken while seated).

At the bar table, perhaps 12 meters away from the steps mentioned above, we continue to watch the passage and passersby: the heavy backpacks we carry on our shoulders from Turin do not seem lighter even now that we have placed them on the two unused out of four chairs surrounding the table, but obviously it must

[7]IYI—For a long time we believed (and we still believe, after all) in Paul Erdős' famous aphorism, *"a mathematician is a device for turning coffee into theorems,"* so we consumed cubic meters of *"arabica"* and *"robusta"* hoping to give birth to at least a tiny little corollary. Only recently we have discovered that the aphorism conceals a cruel wordplay in German (perhaps also in Hungarian, who knows) because the main word—*Satz*—in Teutonic means both "theorem" and "coffee ground." We are sadly resigning ourselves to the idea that the sentence of Erdős, in our case, concerns only the second meaning of "Satz."

Fig. 5 A poster by Mimmo
Paladino for The Conference

be just an impression; and in fact our backs behind us are silently thanking us. As it always happens at the beginning of this millennium in moments of pause and waiting, mobile phones also suddenly appear in our hands. A quick glance at the news, then some quick message to Alice[8] via WhatsApp, burning gigabytes in sending the first tranche of photographs. And we believe we are still in anticipation, when finally we cover the 12-meters again, discovering that the cordon is still there but only halfway, and maybe it was halfway even before, and so we pass it, we turn two corners until we face the *Canal Grande* and—alas!—we're facing also the open door of the Reception, where all the badges of the participants of the Congress are clearly shown on a white table; and there are already a lot of holes in what, in the beginning, was certainly a perfectly rectangular matrix made of rectangular tiles.

The non-pipe-smoker of us feels the reproachful look from the pipe-smoker who, constantly fearful to be late, usually arrives with an advance from 90 to 120 min[9] at every single appointment. In a hurry, we smile at the young ladies who give us the badges and a pale blue plastic bag in which we found The Program, Program Variations, bloc-notes, pen, and Catalogue of the Mimmo Paladino exhibition. A badge has an unnecessary "t" in the first name, but this is such a natural and frequent mistake that it is no longer considered an error by the bearer: probably there must be a quantum wave function that overlaps the one with the right spelling, and they finally collapse in one state or another, a bit like Schrödinger's Cat who no longer even cares being alive or dead, because what really matters is the fascinating indecision before the mere collapse.

[8]IYI—Alice is the best third of Rudi Mathematici little group.

[9]Yes, we know: it sounds like a joke, but it's not at all.

Just enough time to fit the backpacks in the wardrobe lockers,[10] enter the salon, and find out we're almost late: not late for the first speech, but late anyway, because Michele Emmer is already enumerating the instructions about the Conference, Schedule-Program-Movements, and the free chairs closest to the speaker table are already much closer to the back wall than to the speakers themselves. Our chairman is modulating his baritone voice in English, and that is—at least to one of us— the second biggest problem in the ranking of the "Conference Problems." Albion's language is the universal "lingua franca" of science, therefore it is good, just and right that it has to be the official vehicle of the talks of the Conference; but if you arrive late, if you are forced on a distant chair and—that's the main point—if you are still fighting against a seven-lustra-old catarrhal otitis, the risk of losing some crucial passage of the Conference is quite high. But "who causes his own issues can only complain to himself," says a proverbial Italian hendecasyllable, and the only remedy is to increase concentration with sharp attention and amplify the reach of the auricle with the traditional hand arranged like a parabolic antenna stuck to the ear.

The Program (a traditionally tripartite and folded A4 cardboard) officially proposes the wedding *fil-rouge* of mathematics and culture convened in this Venetian room: *"Homage to Bauhaus," "Fields Medals," "Mathematics and Origami," "Mathematics and Cinema," "Mathematics and Physics,"* and *"Mathematics and Art"*; and that's just for the opening half-day on Friday afternoon. The Programmatic promises for tomorrow morning are instead classified as *"Mathematics and Arts," "Mathematics and Bridges,"* and mysterious *"Mathematics and ..."*: then, in the early Saturday afternoon, *Imagine Math 7* will become bifid with the *"Accepted Papers"* that will occupy two rooms and force the audience to an arduous selection. The plenary reunion will run with *"Mathematics, Images, Philosophy," "Mathematicians," "Mathematics and Cinema," "Mathematics and Cancer," "Mathematics and Performance Art,"* and finally *"Visual Mathematics and Theater."* Many sections have more than one talk, each one strictly limited to 30 min; but the strength of a program is revealed in its Darwinian capacity for adaptation, and so the dances open with the apologists of the Centenary of the Bauhaus chivalrously giving way to the Fields Medals and, above all, to the ladies.

Elisabetta Strickland[11] has always cared about the role of women in mathematics, and has an easy game of moving the audience by remembering Maryam Mirzakhani, so smart and young[12] to deserve the Fields Medal, so unfortunate (and quite too young) to have already prematurely left this world. We found and published her

[10]Not a really short time, to tell the truth, because the backpacks were voluminous and far to be polyhedral, while the lockers' boxes were almost perfectly equivalent in volume, but strictly cubic and made of rigid metal.

[11]Dipartimento di Matematica, Università di Roma Tor Vergata.

[12]As you probably know, no Fields Medal is awarded over the age of 40 years, even if you are better than Riemann or Gauss.

Fig. 6 Amazing origami

picture as a child proud of her Red Cross uniform already in 2014,[13] but seeing it again on the screen leaves a new pang in our heart: almost as much as to hear Professor Strickland remember how the daughter of the Iranian mathematician believed that her mother was a painter, due to the habit Mirzakhani had of painting her mathematics on large, enormous sheets of paper, often lying directly on the ground.

The second half of the section dedicated to the highest mathematical prize is presented by Emmer himself starting from a video that, being an extract from the film "*Girl with a Pearl Earring*," makes us imagine something about the Flemish perspective of the Vermeer paintings; but instead it stops with the image stuck on a little Dutch girl who already plays (in the fictional seventeenth century) with soap bubbles. Slipping on the shiny and almost immaterial surface of those bubbles, the slides ride centuries up to the smiling face of Alessio Figalli. His most famous picture, before the one taken last year in Rio de Janeiro together with the other three Fields laureates, was a photo portraying him with some iridescent globes built by the surface tension. Michael Rottam[14] is then invited to talk about the relationship between Paul Klee and mathematics, recovering half of the section programmatically planned as initial. After him, The Program lists the section for which we decided that yes, we would spend two nights in Veneto, not just one; yes, we would have filled out the company forms and asked for an extra day off; yes, we would have left our families to their fate for a long, very long weekend: the Geometric Origami.

[13]IYI—We're talking about issue #189 of "*Rudi Mathematici*" e-zine, October 2014. The opening piece is always a "birthday article" dedicated a famous mathematician. That was actually dedicated to Laura Bassi but entitled "*Unveiled math*," with easy reference to Mirzakhani's Iranian hijab. But we talked about her also in RM236 and other issues.

[14]Academy of Art and Design, Institute of Experimental Design and Media Cultures, Basilea (CH).

Last October, under the still hot sun of Cagliari, we had received the invitation to organize a laboratory for the *XXX Conference of the UMI-CIIM*[15] and, strengthened by the venerable passion of the one among us who smokes a pipe, we applied with the proposal entitled *"La Geometria prende tutta un'altra piega"*[16] that, *ça va sans dire*, was about origami and geometry. So we squeeze our eyes, open our ears, sharpen nails, and grind our teeth, waiting to find out what these incautious professors have to teach us here; do they hope to make something more beautiful and pure than our laboratory, the petty ones? Will we be forced to raise eyebrows and hands, claim primogeniture, contest Japanese accents, and folding techniques? Do the *poareti* (to put it in the local vernacular) know what kind of risk they are facing? No, they don't know, and they don't need to know. Right in the next room[17] there is the exhibition *"Origami Tessellations"* astonishingly built by Alessandro Beber, an artist from Trentino, who later will take place on the stage to talk about those tessellations, their story and their technique (not their massive beauty, which speaks for itself); but before him Marco Abate[18] takes the speaker's chair, microphone, and webcam and starts showing marvels apparently impossible to create with any machinery and material, not to mention just hands and paper. His speech is simply titled *"Geometric Origami"* and, relying on our performances in Cagliari, we're expecting Huzita's Axioms and Haga's Theorems. Instead, we hold our breath, hardly recognizing some Fusé's Constructions, but it is not our fault: it's because Abate leads the oratory more upon esthetic wonder than on the underlying mathematical secrets, and like a wizard pulls out (from who-knows-where, probably from an actual magician's top hat) colored shapes that it is hard to believe are just folded paper: not to mention those, absent from his magical luggage, are projected and narrated on the screen. The Pisan professor certainly knows who's dealing with, knows his audience, and so he does not dwell on formulas—maybe because the etymology recalls that "formulas" means simply "small forms"—while he wants to fly directly upon the wonderful great forms, upon the esthetic astonishment rather than the mere technique. Perhaps he takes for granted the high mathematical literacy of the public, but more probably he wisely goes along the path of wonder, of beauty, which is still the ultimate driving force of curiosity, and therefore of research, and in other words of knowledge as a whole. And then we finally look not only at the screen, but also at the audience, captured

[15] UMI-CIIM stands for *Unione Matematica Italiana—Commissione Italiana per l'Insegnamento della Matematica* (Italian Mathematical Union—Mathematics Teaching Italian Committee). But we know, you already know that...

[16] IYI—Literally: "Geometry takes a different fold"; with a silly pun in Italian, because the "fold" recalls obviously the Origami, while "to take a different fold" in Italian sounds like "to take another turn", less or more.

[17] ...and right now the doubt catches us suddenly and badly, because we have always called "*Sala del Portego*" the main one of The Conference, but perhaps (probably, indeed) this little showroom is the actual holder of the name, and in this case our chronicler incapacity will beautifully stand out, since we absolutely do not remember the name of the main room.

[18] Dipartimento di Matematica, Università di Pisa.

and ecstatic just like us, and the faces of the students, and of the curious people, professional and amateur together, and we are now seriously tempted to concentrate our attention to them, to extract from those glances our chronicle and perhaps even a bit of mathematical poetry, but unfortunately The Monster is now strong and urgent: the First Problem in the aforementioned classification of the "Conference Problems" is dramatically pressing us. Because the first duty of the reporters is the faithful and punctual information, and not the apologetic enthusiasm, however sincere. And so the moment is right now: after having recorded the pyrotechnics and the prestidigitation of Abate's speech, exactly at 17:32 o'clock, Venice time zone, as the digital chronometers on our left wrists and a hundred smartphones are showing. And The Monster is entirely summarized in the fatal question: "Whatever happened to the coffee-break?". The Program is an atheist, it denies its existence. Terrified by the unforeseen denial, faces are scanning each other while, after the origami's glory, the speaker's table is already agitated by the change of scene and protagonist. It will take a little, half a day at least, before understanding the logic— not too complicated, to say the truth—underlying the agnostic Program. The fact is that this is an adult, professional, and therefore libertarian Conference: breaks are free, coffee is available at every Venetian bar, and, if someone really needs it, he has only to pay the price of the Erdősian dependence with the ECB coins and—that's the higher price—with the loss of the chrysostom words of the occurring speaker. "Never!", we swear to ourselves, also because it's movie time.

Alessandro Rizzi and Alice Plutino[19] are young people who take care of the old. Old films (because they lead us through new algorithms to renew old documentaries) but also old hearts of graying nerds, because the logo that accompanies their presentation reads "*I've seen things*"[20] above the stylized silhouette of a paper unicorn (origami, again!). So, immediately the memory brings us back to Gaff's

[19] Both from Dipartimento di Informatica, Università di Milano.

[20] Not to mention their brand: *Nexo*. At least one of the spectators once fell in love with a Nexus 6: Pris.

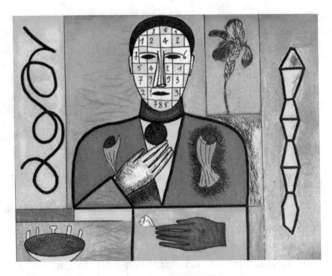

Fig. 8 "*Sulla Mathematica*", Mimmo Paladino, 2001 © M. Paladino

grin and to Harrison Ford/Rick Deckard's hallucinated gaze, while the rest of our brains wonders thinking that the two learned youngsters, below the screen, certainly weren't even born in 1982 when instead we already sank in a movie theater seat, absorbed in our first vision of *Blade Runner*. But they handle powerful algorithms, which give back light to celluloid in 35 mm with incredibly reduced costs and times, compared to established techniques. So they force us to envy their skill, as well as their age. If a mistake is made by them, it is to choose as sample documentary "*Isole nella laguna*,"[21] by Luciano Emmer, because if the 13 min of the duration are certainly perfect to test an algorithm, they as well easily allow Michele to show everyone, in full, one of his father's masterpieces. Thus, the restored documentary can be enjoyed right here, in the capital of the lagoon, and immediately takes us 70 years back in time and a few kilometers to the east in space, on the foggy black and white of the film. And in short, the movie forces us into a strange rhythm, slow, and powerful, full of the wonder of a story that can be already told as a piece of history, but reveals the deep sense of continuity with our days. And even if we find ourselves grateful to the restorative technique that gives the short film pure to our eyes, rapidly the sense of gratitude gives way to the atmosphere of the humid mists of Burano, and we soon forget everything that is not the film itself, in the usual catharsis which, since ancient Greeks times, projects the soul toward a small piece of infinity.

Look, the infinity! That infinity that is "half mathematics," according to the non-pipe-smoker of us who always proposes himself as a great misunderstood producer of epigrams; or maybe the mystical infinity of almost all religions, which seem to abhor spatial and temporal limits and combine the adjectives "perfect"

[21] Italian for "Islands in the lagoon."

and "infinite" so often together, although etymology ruthlessly states them so opposed, and not only on the tables of verbs. That infinity so avoided by physicists, saddened by the collapse (precisely infinite) of the divergent series that mock the measurements; yet it is indeed a physicist—or at least we believe him to be—Jean-Marie Levy Leblond,[22] who now challenges the public with the question "*Is infinity a physical concept?*", and is preparing to defend this thesis. Prof. Levy-Leblond is now showing how often a numerical threshold is actually an unreachable passage, a bragger, and masked infinity, so often called into play together with the word "eternal" as well as "absolute," another term both mathematical and mystical, and ultimately completely impossible to find on this small planet and in this small floating city, which now calls us aloud outside the walls of Palazzo Franchetti.

It is The Program itself that invites us out, to stroll on the few steps that lead us to another building,[23] another seat of the Veneto Institute of Sciences, Letters and Arts, where Mimmo Paladino's works await us. Well organized like the molecules of a perfect gas, we arrive at the show, we listen to Michele Emmer, who tells how the works on display were born, and again we try to make ourselves visible, in order to join Michele, moving our hands and eyes to say "*Here we are, we really came!*", but we succeed only at the end, because the Host of the Conference is like the Captain of the Nadir, sought and demanded by all, and only at last we managed to greet, deliver, and receive a smile, but unfortunately just on the run, because among the hundred organizational urgencies Professor Emmer has also the need to find his telephone, lost who knows where, probably on the main desk of the *Sala del Portego* (or whatever its name was).

Dinner calls, and calls with all the mysteries connected with it: where to eat? In Venice, which promises a memorable spring evening, or in Padua, Galileo's shelter, where incidentally stands the hotel we booked and a hotelier not yet informed of

[22] Université Nice Sophia Antipolis. Director of the newspaper "*Alliage*" which deserves respect and admiration, because the "fusion" that its title promises is that between Culture, Science and Technology.

[23] IYI—Palazzo Loredan, to be precise: address San Marco 2945. The palace is home to a museum, and among other things it also hosts the "*Panteon Veneto*", a series of busts of the great men of the region. We specified the address because it is impossible not to mention, talking about mathematics (which most people still believe to be the science of numbers) the original and labyrinthine Venetian house numbering. The pipe-smoker among us, who lived in his childhood in Venice, remembered that the numbering proceeds by concentric circles, or rather by spiral, from centre to periphery: and to reinforce his thesis pointed out that the Basilica of San Marco bears the notable number 1. This made The Geometrician (who is about to enter dramatically on stage) puzzled, because he recalled to have seen, in his own walks, a "last number of the *sestiere*". As often happens in disputes between mathematicians, the truth blessed both, because it is true that the Venetian numeration proceeds "*by spire, from the centre to the periphery . . .*", but it is equally true that the parochialism requires the additional specification "*. . . of the district*". It's an Austrian method called "*insulario* numbering", introduced in the few years between the eighteenth and nineteenth centuries, after the Treaty of Campoformio, when Venice came under Vienna's rule. We could also talk about the numerical implications of the six districts (*sestieri*), alternative to the usual four districts (*quartieri*), and other Italian cities with three (*terzieri*) or eight (*ottieri*) districts, but maybe it is better to let it go.

our arrival in Veneto and perhaps already inclined to reallocate our rooms? What to eat, pizza or dinner worthy of so much name? Meat or fish? All problems will be solved (or at least they will change shape and nature), when among Paladino's paintings we see the familiar face of our friend Nicola, the one that persists in the strange habit of being called Alberto Saracco. We met Alberto in Naples, in that perfumed May of 2018, at the "First[24] Carnival of Mathematics Live" organized by *MaddMaths!* and propelled by Roberto Natalini's organizational skill with the approval of almost all the mathematical institutions that count. It is the place where we met more mathematicians, and if we were to tell about it now, this chapter would lose (ahem) slenderness. We, therefore, invite the audacious readers who have come this far, if still unaware of such an event, to make a quick and fruitful research on the net both on the specific "*live*" and on the *Carnivals of Mathematics* in general; then we delegate to this IYI[25] the dissolution of the onomastic mystery Nicola/Alberto, and happily we jump toward the dinner, because The just discovered Geometrician agrees to eat with us, and reveals that he has precious tips on inns looking perfect for the very capacious bellies and the very poky pockets of the mathematicians, professionals, or amateurs may they be.

Almost every intersection in Venice is marked by yellow signs that have become so typical that souvenir shops sell miniatures; they usually travel in alternative pairs, and the most common is undoubtedly "to S. Marco (this way)—to Rialto (this other

[24] The ordinal "First" is optional and only a wish in any series, including that of the popes, if the "second" element of the succession has not yet come to life. As example and warning, a famous photographic riddle showed the first page of a 1914 newspaper shouting "*WWI broke out*" inviting readers to demonstrate that it was fake news. Nevertheless, we remain stubbornly wishful and hopeful that the ordinal close to the Neapolitan Carnival may soon lose its optional nature.

[25] In the marvellous cloister of the Complex of Saints Marcellino and Festo, where all the participants and speakers of the Live-Mathematics Carnival conferences roamed, a guy introduced himself to us. He had just illustrated to the audience a spectacular comic story based on the famous topological problem of the seven Königsberg bridges. Now he's holding a pen and a copy of "*Storie che contano*" (our latest book: the title sounds, more or less, "*Stories that Count*," with the usual pun about the two main meanings of the verb "to count"), among the two most flattering actions to perform in front of vain people like us. The problem, in part already sketched also in this chapter, is that the one among us that is delegated to compile the dedications on the books is also the one with bad hearing ability, and so, even if surely the young man presented himself urbanely and declaimed clearly his name, the autographer did not intercept it. However, mindful of the fact that on that day among the three scheduled speakers there were both Nicola Parolini and Nicola Ciccoli, he relied on the obvious possibility of catching the most probable name, and confidently began to write "*To Nicola...*". A sort of cloud passed upon the face of The Geometrician, and soon turned into black cumulonimbus of shame on us. We cancelled the wrong name, we even thought of seizing the book now infected by the error, replacing it with a new one; then we could even give the impure copy to Ciccoli or Parolini, even remedying the scar, but we had no copy suitable for the replacement need. We promised that we would make up for it on a bright future day, but it was a sailor's promise. To survive the disgrace, now we just have to reiterate, even double the infamy: for this reason, in meeting him here in Venice wickedly we persevere, widening the smile and exclaiming: "*Nicola! Nice to see you again!*". The god of mathematics, if it exists, will never forgive us.

Fig. 9 Venetian Interlude

way)." They are of undoubted utility and wise positioning[26] because, as we know, the map of Venice is summarily similar to a plump fish, with the head that looks at the Italian peninsula, the tail swimming in the lagoon, and the *Canal Grande* dissecting it with a long and twisted "S" upside down, to the delight of tourists who want to admire the *Serenissima* from the *vaporetti*. Piazza San Marco, historical and artistic gravity center of the city, is located near the ... er, let's say it is close to the tail, and—unless you want to stay in the northern part (*Cannaregio*, dorsal fin of the fish), or venture into that southern (*Dorsoduro*, that even if it is called "dorso," i.e., "back," is the belly of the fish) thus losing the central districts of San Polo and Santa Croce—for the walkers who leave San Marco it's almost mandatory to have Rialto as a general hub toward the rest of the city, because the *Canal Grande* is very poor of bridges.

[26]The positioning is wise even when it is clearly puzzling, as in the not-so-rare case "*to S.Marco* (this way)—*to S.Marco* (this other way)": once the inevitable initial perplexity is overcome, it is realized that we are in a corner of a block and that the direction to San Marco is toward the diagonally opposite corner.

On the west side of the city, the pair of equal and opposite directions registered by the signs is usually "to Rialto (this way)—to the Railway (this other way)[27]"; but on this warm and dark evening The Geometrician follows the precious indications of his accomplice hotelier, and we head toward a pumpkin-based meal *trattoria*. It must be recognized to both (Geometrician and Hotelier) that the destination is reached without too much anguish, certainly throughout a path not figallically optimal, but more than acceptable in terms of time and steps; but—alas—the inn specializing in large cucurbits is unfortunately closed. Alberto is not a geometrician for nothing, he always has an alternative path at his disposal, whatever the size of the vector space he is confronted with: and another Venetian tavern is soon identified, indeed not very close, but attractive anyway because it seems universally celebrated by carnivores (and abhorred by vegetarians, probably), and among the faults of us three travellers—we confess—there is also that of giving work to canines.

And here there was the real highlight of the evening, the moment that we don't hesitate to call poetic, because we three found ourselves at the end of a street, to gaze at the soft reflections of the waves of the Canal Grande where we were about to cross a bridge. A magical place, on the Venetian Friday night, far from the shouting and footsteps of tourists, with only a faint lapping that rose from the water, and the even weaker breaths of the three of us, speechless by the absence of the expected bridge and by the immanence of the Phantom Bridge. Almost immediately we rationalize, we analyze maps and maps, especially that of the intrusive *Google Maps* which, stubborn, continues to ensure the existence of a path (according to it plausible) right in front of us; and so like three Hercule Poirots we scour the place, we note the presence of fatuous moorings, and finally we deduce that the geographical resident of our smartphones is convinced that we can take a ferry, or maybe good-hearted gondoliers. The inn—if it really exists—must be there, less than 100 meters for a crow, a couple of kilometers for three bridgeless mathematicians. But it was worth it; perhaps every corner of Venice is worth the time, if the occasion and company are good. And those few seconds of shared and amazed loss, somehow, quickly climbed our brains and fixed themselves in the category of long-lasting memories.

Alberto would then return to talk about the urgent need for additional bridges the next day, in front of a wiser and more numerous public: for the moment, all that remained for us was to entrust ourselves to the legs, reach the restaurant, find it open and even with a free table; then search the menu for the praised meat delicacies, and discover that there were only fish ones; drown the disappointment in a capable plate of pasta, and talk in three by three of all that is spoken at dinner, and above all of the two things in common to all the guests: the Piedmont's region of Canavese—where one of us was born, another works, and the third resides—and mathematics. Then other steps, toward hotels and stations, and for two of us also a slow and late train, and then a couple of kilometers from Padua to the hotel room where backpacks,

[27]Only after 24 good hours in which we got lost at least half a dozen times, we finally intercepted the rare and very precious signs "to the Academy (This or this other way)" which were the true route to The Conference.

Fig. 10 Ancient and modern sighs generators

clothes, shoes, and reporters collapse together, and finally even the phone, last object operated to recommend an alarm clock, and that perfidiously shows with its dim light that twenty-three thousand-and-more steps in that pedometer app. No one yet knows that that same app, tomorrow night, will stop only after announcing a cruellest 28,782.

"Good," thinks the no-pipe-smoker, and is a well-deserved concession due to the pipe-smoker who is obviously a connoisseur not only of English tobaccos, but also of Venetian bars and their brioche selection. We are not late: the early morning Padua-Venice train was faster than the night one, and to us the half-hour-walk from our hotel to Central Padua Station served to reactivate the blood circulation. We're now doing a coffee and brioche stop not too much far from The Conference: we are on the correct side of the Canal Grande and we still have an hour and a quarter before Palazzo Franchetti opens its mathematical doors again.

Then, well, we got lost. Our intention was to go through Piazza San Marco but instead we passed it, and now the yellow signs speak about strange toponyms such as "*Fondamenta Nuove*"; the *calli* and *campi* widen, and so we sail almost upwind in this sea city, until we cross red-coated choristers entering the Basilica (hey, here it is!) from a side door. Then there are soldiers and sailors who seem to siege the basilica and almost occupy it, also spreading over the square, the only Venice's

proper square. The anticipation in which we basked is spent almost entirely, but only almost, fortunately: from here we know how to reach the coveted goal, and when we enter the (perhaps) *Sala del Portego* there is already some activity, but the places that we manage to occupy are better of a whole chairs section than those of the previous day.

Strange is the mind of mathematicians, or perhaps and even more simply, strange is the human one. But the fact is that it took just half a day to soften our eternal WAWDH syndrome: we already feel a little less as foreigners in a foreign land, and the faces that only yesterday were completely unknown, this morning look already a little less unfamiliar. Maybe because of Michele Emmer, who is already organizing; maybe because we already recognize the Disneyesque shirt of The Geometrician, but without doubt the greater merit is deserved to Claudia (may Heaven help our memory) who is approaching us and, smiling, asks confirmation that indeed we are the Rudi Mathematici, and to our flattered affirmative answer she hands us a copy of "*Storie che contano*" and a pen. We improvise two lines of blue ink on the white and very first page—probably too banal, but we were excited to manage a smart dedication—and, even if Claudia will never know, we keep for her in the deep of our hearts an ounce of everlasting affection for having given us a bit of sense and role.[28] So the few minutes before the official beginning of The Conference are spent with the pipe-smoker dialoguing with The Geometrician, thanks to a little problem of recreational mathematics that the Great Procurer of Puzzles[29] decided to submit to him. But there is almost not enough time to dissect the puzzle properly that, *voila*, The Program and Its Variations return to be protagonist again.

In Italian dictionaries, at the lemma "*pedata*" (tread) it is necessary to go down to the third or fourth meaning, before finding the one that is in happy symbiosis with "*alzata*" (riser). The first is—we could say—the indivisible and quantized unit Δx, while the riser is the homologue and corresponding unit Δy, when we speak

[28] Shortly after, anxiety came back with vengeance: what if we misunderstood? What if we had written "To Carla" instead of "To Claudia"? Or even if Claudia was actually Claudia, but if she had now a booklet of use dedicated to Marta, or Clara, or Chiara, or Laura? Could we ever survive, when we well know that making mistakes is human, but doubling them is diabolic?

[29] IYI—The Great Procurer of Puzzles, by dint of procuring problems for "the Prestigious" (as we modestly call our e-zine) for a whole 20 years, is by now in possession of problems suitable for any occasion, a bit like the comedian always has a joke on any event ("So, are you really going to Melbourne for a meeting on extrasolar planets? And do you know the story about the two astronaut kangaroos?"). In this specific case, since almost everybody arrives to Venice by train, the question was about an hypothetical carriage with a hundred seats all booked, but with the first passenger that goes up a little distracted, and therefore sits on a random place, regardless of what is stamped on his ticket. The other 99 passengers are polite people who sit on their assigned sites; but if they find it occupied—alas—they just sit in a random free one. The final question concerns the probability that the 100th and last passenger sits on his right assigned seat or another. Furthermore, some final comments on the nature of the last place would be appreciated. The question is undoubtedly intriguing and surprising once resolved (something that The Geometrician, alumnus of the *Normale di Pisa*, did in shamefully short time), and who's writing this footnote hopes to be forgiven by the other two thirds of the RM Editorial Board for having put the puzzle here; believe it, the penalties reserved to spoiler-makers are frightenly high.

Fig. 11 Daises at dawn

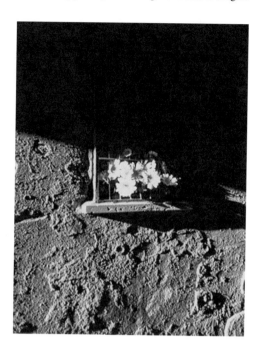

of stairs. Simple, isn't it? Too simple, to say the truth, tells Cornelie Leopold[30] from the stage, and she almost seems to scold the audience of mathematicians who has always trodden a tedious linear path with treads and risers without variations, when changing altitude from one floor to the other. And she shows with graphics and words how reasonable could be, sometimes, to modulate those Δxs and Δys in order to make the profile of the stairs, for example, sinusoidal, with softer approaches and conclusions than the central part: and she joyously ends showing videos crammed full of students going up and down on experimental stairs built at their university in the Palatinate.

And then there is this strange thing, that in order to discover the ultimate meaning of words one must come to mathematics conferences. No, not for the fact that mathematics is also, perhaps above all, a language; or to remember how Peano decided, at a certain point of his life, that in order to continue doing mathematics it was necessary first of all to create a universal language; but because the words just apparently speak clearly, but actually they hide their own meaning inside themselves. And we were still, we, to the "*sublime*" just as superlative: exalted, very high, very beautiful; and we did not hesitate to mention Kant and his "mathematical sublime" only to boast in the name of the beloved discipline, also preening ourselves with the easy etymology coming from *sub* and *limen*, just *below* the *threshold* of infinity, and who knows how much we thought we were wise.

[30]FATUK, Fachbereich Architektur, Technische Universität Kaiserlautern.

Fig. 12 Gian Marco Todesco

But now came to the stage Maddalena Mazzocut-Mis[31] and Andrea Visconti,[32] who both profess esthetics and philosophy, and reveal us the unknown aspect, the horrible component of the sublime: the umpteenth unresolved dialectic between boundless admiration and unspeakable horror. Shocking surprise: is, therefore, the *limen* the boundary between the Terrible and the Magnificent, instead of the Human and Divine threshold? Is it distinguishing and bringing together Good and Evil, and—who knows?—maybe even Jedi Knights and Sith Lords? May The Force Be With Us, and save us from the Dark Side.

I still wonder if it was really true, then. But it is difficult not to recall Tom, a fraternal friend and architect who adored construction sites, when he said that Ferdinando Innocenti's brilliant and fertile idea of his scaffolding pipes was born seeing the scaffolding made of bamboo canes somewhere in China or Japan. Whoever the first genius, certainly the idea of combining steel tubes and special joints so that they could quickly be assembled to build the exoskeleton of mammoth engineering works has been at least as revolutionary as the invention of the centering, that falsework that gave to the great ancient monuments the round arches, and with it they share the silent modesty of those things and people who make every construction possible and then withdraw in silence without the ambition to be part of it.

[31] Department of Cultural and Environmental Heritage, Università di Milano.

[32] IT Department, Università di Milano.

The invisible and lasting force of transience comes to mind, while Tullia Iori[33] modulates her caressing voice to illustrate old photos of large buildings and bridges. One of these, for instance, enchants because the Innocenti tubes initially rise straight from the three pylons at the bottom of the valley, then spread out fan like, just as three parallel rivers that together burst out from the banks, join and grow together to draw a gigantic three-dimensional spider web whose last front supports the perfect arch destined to support a large highway bridge. And indeed of great bridges and large structures that arose in Italy in the 1960s speaks Tullia-the-professor, who will be rewarded in the end by the canonical and well-deserved applause. But it is Tullia-the-singer who delights the audience with a showstopper performance. The final *coup de théâtre* of her talk should be a short 1966 video of the most famous TV show of those years, (*Carosello*), in which the most famous Italian singer (*Mina*) sings a song ("*Mai così*") doing the advertising for the most famous pasta in Italy (you can guess the name). The singer is filmed by Piero Gherardi on the roof of a futuristic building next to the Central Station of Naples, work of the engineer Riccardo Morandi, and it is undoubtedly curious to see how that "Italy of the economic boom" managed to merge together, in presenting itself to the media, so many elements of technical and esthetic strength: the greatest pop-singer, dressed by the best designers, located on the roof[34] of an engineering masterpiece, all just to convince people to buy a certain type of pasta. But here comes the trouble: on the screen Mina can be seen, but not heard: a perfect example of those accidents that in technical jargon are called "Presentation Effect": in short, a corollary of Murphy's Law explicitly reserved for technical equipment for conferences, which diligently crashes only and exactly at the crucial public moment and never during rehearsals. But black-dressed Tullia is not discouraged, on the contrary: she elects herself as a dubbing singer of the mute Mina, and does it so well that the *Sala del Portego* gives her a standing ovation.

Coffee-break? No, no coffee breaks. Do we go out to have one free and independent espresso? No, we don't, at least for now. And we do well, because now Gian Marco Todesco[35] arrives, and we will not be able to talk about his speech without using hyperboles. It will be quickly understood that Todesco is one of those lecturers who travel with full suitcases, who needs a table or a

[33]Department of Civil Engineering and Computer Engineering, Università di Roma Tor Vergata, and also Principal Investigator of SIXXI (Twentieth Century Structural Engineering, the Italian Contribution).

[34]One almost wonders if those four guys from Liverpool who organized that little sonata on the roof of their recording house have stolen the idea to Mina and Gherardi, since the spot was in 1966 and that London concert was only in 1969.

[35]In the leaflet that summarizes the Program, under his name there is written only "Digital Video," but we know that Todesco is a physicist like us, and like us came to work with computers. Of course, then he dedicated himself to silly visual games, not like us who were taken into serious things like management and administrative software. Therefore, we have pushed forward the national GDP and the global economy, while he simply managed to sell his toy programs to Steven Spielberg, Hayao Miyazaki, and a few others of the same kind.

Fig. 13 Net of the augmented truncated dodecahedron, Johnson's most resembling solid (IOHO) to the mysterious polyhedron

wardrobe of wonders from which to extract, from time to time, unexpected and unpredictable objects. He will do it again this time, but not before declaring that all his contribution to The Conference stems not from one, but from two errors. Thus, the sympathy of the public is gained immediately and in particular of two non-mathematicians and non-reporters who are assiduous supporters and frequenters of the Mistake, especially if endowed with high educational value. Mistake Number One is childish and beautiful: childish because it was actually produced by a 10-year-old boy, beautiful simply because it is really beautiful. We do not guarantee to remember the details well, but here's the core of the story: in the school of the little genius, in a sort of didactic experiment of geometry, the pupils were given plastic triangles, squares, decagons, and pentagons that could be assembled. They could be assembled in many ways—obviously also to compose the Platonic solids—and the objects constructed by the juvenile geometric instinct were always inevitably instructive. Except that the boy took out a really unusual one, with deep symmetry and even more surprising esthetics. Since the mathematicians are precise people who catalogue with shrewdness and passion, it spread a little panic in discovering that the boy's solid didn't seem to be catalogued anywhere. Was it a new, unexpected solid? Hell, it seemed really impossible![36].

[36]The solids that can be composed with regular polygons but which are not *Platonic* (i.e., composed by all equal faces), nor *Archimedean* (i.e., composed even by different regular polygons, but with all homogeneous vertices), nor *Prisms* (with bases made by congruent polygons connected by a cycle of parallelograms), or *anti-Prisms* (like Prisms, but with the bases connected by a cycle of triangles), are called *Johnson's Solids*. They have phantasmagorical names like Elongated Triangular Bipyramid, Metagyrate Diminished Rhombicosidodecahedron, Elongated Pentagonal Orthocupolarotunda, and others of equal denominative simplicity; the collective name comes from Norman Johnson who classified 92 of them in 1966, even assuming that there were no others: something that Victor Zalgaller proved 3 years later. And no, the youthful creation of the unknown little boy was not 1 of the 92.

And, in fact, it was impossible: the construction with the regular plastic polygons seemed perfect, but in reality it was not: there were small misalignments, well distributed in the construction, practically invisible but mathematically incontrovertible. "Alas!" we cried: but this was the first mistake. Mistake Number Two is more adult, but even more romantic: it is Todesco himself who, fascinated by the mystery polyhedron, even after having ascertained that it violated the constructive rules of the Euclidean three-dimensional space, still attempts a rescue by renouncing precisely to Euclid, in the hope that a less rigid space (i.e., a hyperbolic one) could still justify it: "*... and so my hyperbolic odyssey began,*" confesses from the stage Gian Marco, who's now speaking about his long days gone by among geodesics that were everything but straight lines, in cobwebs of curves with no constant curvature at all, just to finally intercept the cruel revelation that a previously unknown theorem was there, ready to reveal to him the inanity of his attempts. And we are very grateful to the twin errors: GMT's first slide showed the "*Cubic Space Division*" of M.C. Escher,[37] and so does the last one of the Todeschian hyperbolic odyssey. This comes to life and becomes a video: like in the voyage of Ulysses, the final destination coincides with the place of departure; but as the 20 years spent by Ulysses between sorceresses and cyclops gives new light and look to Ithaca, so the first image of the talk (the rigid and hypnotic repetitiveness of the Escherian and Euclidean grid) now changes. In the video, it becomes dynamic, with the hyperbolic columns that bent only slightly at the center of the picture, but quickly curve to the peripheries, forced by the nearby hyperbolic horizon; and so they move in a curious dance that perhaps only old people may know, when they change glasses and pass from the normal to the progressive, multifocal lenses: these hypnotically lead their eyes and minds into a mobile dance on scenarios that—for their entire previous life—they imagined Euclidean and still, absolutely immobile.

What a coincidence: it is at this point that The Conference itself becomes anything but Euclidean, firm and immobile. No, not for an immanent coffee break nor for lunch, which is now barely a round of analogue clock hands, but because it is the moment of mitosis (or was it meiosis?) in which the classroom is mercilessly duplicated, and the public is called to a dramatic choice: in the Room-A, the Accepted Papers list "*Mathematically-based Algorithms for Film Digital Restoration,*" "*Kubrick: the Golden Perfection,*" and "*Mathematical Aspects of Leonardo's Production in Milan,*" while in Room-B the APs will be "*Mathematics and Comics,*" "*The role of Imagination in the Preparation of the Children for Science: the work of Mary Everest Boole,*" and "*François Le Lionnais and the Oulipo.*" To give up on Cinema, Leonardo and Kubrick is a sad thing, but our choice remains obligatory: we are people who would sell their soul to Mephistopheles, in order to attend a meeting of the Oulipo; people intrigued by Mrs. Boole who we ruthlessly believed to be only a cruel and dangerous homeopathy fan, and above all we are people who have been reading comics for a long time before we learned to

[37] IYI—Maximum initiator among those authors who inoculated to us, adolescent editors of RM, the first viral germs of passion for the strange and multipurpose aspects of mathematics.

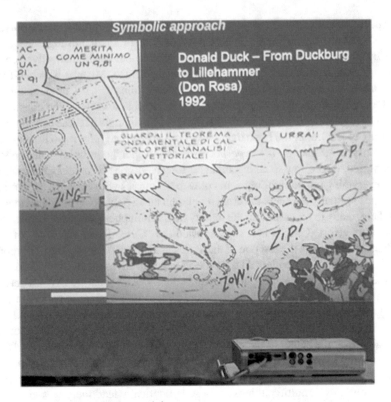

Fig. 14 Skiing ducks and fundamental theorems

read. And then, come on ... The Geometrician will talk about comics, can we leave him alone?

Alberto is already there (because the B-Room is not the Sala del Portego, or at least it is not what we have so far called the Sala del Portego, and you know what a laugh if in the end, we discovered that the Sala del Portego is actually Room-B, instead). He's already there before Michele Emmer arrives to introduce the themes of the "B-Accepted Papers" to half of the original audience, before the lights go down to highlight his slides, and then he finally begins. We already know everything, we think, because we already saw the Disney map of Quackenberg-Königsberg-Kaliningrad both on paper and live in Naples, but the Prof. Saracco's 20 min flow away happily and thoughtfully at the same time; a little because in the past 10 months The Geometrician has enriched the presentation, a bit because a second revision—as the profs always say—never hurts. Did he already mention that beautiful aphorism *"Geometry is the art of making beautiful reasonings on ugly drawings,"* for example? Did he already talk about all these scientific comics he's listing here? No, of course not, also because—we are quite certain—*"Mickey Mouse and the Numbers of the Future,"* for example, was christened by its fathers Artibani

and Natalini[38] in Lucca, in November; and in short Professor Saracco illustrates, explains, recounts, and we will not praise it further because you might think we are biased judges. But we are sure that he too, while illustrating the topological problem of Euler; when he tells us, rightly proud, that the story he helped create is the first and perhaps still the only comic tale that contains a complete demonstration of a mathematical theorem; in short, that he too, The Geometrician, having reached the point where De Paperis/Euler concludes with solid logic that another bridge would be absolutely necessary on the river Pregel, thinks like us about the parallel and undisputed necessity, here in Venice, of a midway bridge between those of *Scalzi* and *Rialto*: in short, of the Phantom Bridge that deluded us last night.

But now we have to go back and eat humble pie, to confirm once more that judgment is the hardest and most difficult part, and that things are always more complicated than they seem at first. About Mary Everest Boole we talked a little in one of our (roughly) biographical articles opening our prestigious e-zine, and in particular in the one dedicated to George Boole. We talked about her just a little, quickly, and without much esteem: in short, we cited her almost only because the English father of logic died after getting sick—cold, flu, pneumonia, who knows— having strolled from the university to his home under heavy rain. The illness that was cured by the spouse, indeed Mary Everest Boole, with homeopathic methods: *Similia similibus curantur*: like cures like, firmly believed Mary; and the fever generated by the rain had to be cured by wetting the sheets of George's bed. Now, instead, Paola Magrone,[39] who wrote a book about Mary Everest Boole's work[40] with Ana Millán Gasca, reveals us many what we didn't suspect at all: things that certainly do not change our profound contempt for homeopathic principles, but able to remind us once more how dangerous it is to judge an entire existence on the basis of a few elements. M.E. Boole was a woman devoted to science, concerned to direct children to scientific methods as soon as possible, and she did so at the cost of sacrifices, dedication, commitment; and she did it in a world in which women were always regarded as unsuitable, almost incomplete, certainly minor and infallibly part of a minority. And in seeing her silhouettes cut and sewn to let the children "touch" the mathematical forms, we must once again remind ourselves to strictly avoid summary judgments. A person is always a universe, contains multitudes, as Walt Whitman said; and now we are here, remembering this advice, and fixing it in mind once again.

[38] IYI—Artibani is Francesco Artibani, the top Disney cartoonist, who has already written several scientific scenes for "*Topolino*" (Italian name of Mickey Mouse and related comic magazine); Natalini is obviously the same Natalini who is partly responsible for the existence of this chapter, but above all he is culpable, with his accomplice Andrea Plazzi, for the foundation of the project "*Comics & Science*," which is revolutionizing the previously weak relations between comics and science popularization. Rumor has it that Marvel and DC are very worried about the new competitor.

[39] Università di Roma Tre, just like Ana Millán Gasca.

[40] Particularly on the text of M.E. Boole "*The Preparation of the Child for Science*."

Fig. 15 Poster for the
Conference, Mimmo
Paladino, 2018

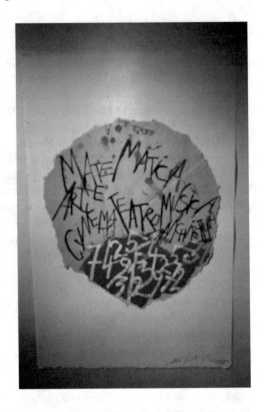

Maria Alessandra Vaccaro[41] has the dual task of closing the morning proceedings of The Conference and making us take a healthy dive into the (somewhat borderline) heads of the founders of the Oulipo.[42] Her talk focuses on the figure of François Le Lionnais, who shares with the perhaps most famous Raymond Queneau the parenting of the Potential Literature Workshop, and is titled *"The unexpected role of mathematics in literature."* While Maria Alessandra summarizes the strange life of a man who mixed science and narration with the same courage with which he sabotaged the V2 he was forced to build during his imprisonment in the concentration camp; while she tells of the continuous mélange between numerical, linguistic, even esthetic self-constraints to which Perec and his companions were subjected; while all this is happening, it is up to us to be once again hypnotized by that famous adjective, "unexpected," which so often accompanies mathematics. The unexpected role in literature, the unexpected efficacy in the natural sciences, as Wigner tells

[41] Università di Palermo; talk prepared together with Elena Toscano, from the same university, but which does not seem to be present. We could also be wrong, though.

[42] OuLiPo, or *Ouvroir de Littérature Potentielle*, which we assumed as known by the reader, because it is a too vast and visionary jungle to try to be explained here, especially in a footnote.

in his famous article,[43] its unexpected presence everywhere. And we wonder why this is so—although it is undoubtedly so—given that in the thousands of possible definitions of "mathematics" we adore that of Jordan Ellenberg who paraphrases von Clausewitz and states that mathematics is nothing but *"the continuation of common sense by other means."* How can common sense be unreasonable and unexpected? Is there perhaps a sort of ontological or gnoseological problem? Something that prevents human beings from rationalizing to the end, if we always end up with wonder and surprise, when we explore with method and reason? We will never know, perhaps, and we will certainly not know here and now, because lower and primordial instincts take over and sweep away Ellenberg, von Clausewitz, Wigner, and all the Oulipo in less than a second: lunch is served, everybody for himself!

Scholars, professors, students! If there is one thing in which we are more skilled than you, this is the ability to squirm athletically out in parties and feasts, you poor amateurs. We do not need the official announcement from the catering staff, less than ever the organizers' one: like domestic cats that detect the faintest click of the box of biscuits and magically arrive in the kitchen with a virtual napkin knotted on their neck more or less in simultaneous with the still incomplete thought of the poor human who feeds them, we are already there, first and feral, while the queue at the tables is still slow to form. Fast, but not famished, on the contrary: the lunch of the Venetian Saturday is almost a bullet to quickly wipe out in our list, because after two half days of mathematical listening we need to get into action: different actions, though. Thus, having Michele Emmer announced, just before the go-ahead for lunch, that the next piece of the great puzzle of The Conference will be an outdoor demonstration of how mathematics can also contaminate the creativity of roller skaters, we agree to give, until then, free and independent vent to our personal perversions. The pipe-smoker needs to put some numerically factual ruminations on paper or mass memory, the other needs to verify if the Saturday of the Venetian village is really Leopardian as it seems.

And it is, no doubt about that. Compared to the previous day, thanks to the blue sky, the optimal temperature and the almost holiday day, Venice is colored even more than usual by tourists, gondoliers, posters, and shows. It is undeniable that this city lives more and more of self-celebration, and therefore is paying with pieces of its own identity the price of the wealth that foreign people, smiling, offers to celebrate it. Undeniably, perhaps inevitable: *calli* and *campi* and *ponti* leave traces of themselves on myriad telephones, and there's no doubt that the Doges, Marco Polo, and all the ancient Venetians could hardly recognize their city. But even so, the Venetian identity remains strong, constant, and continuous. The bell tower of San Marco is reflected on the bright white smiles produced for the selfie of the Texan tourist or for the Nikon of the Japanese girl (and who would have ever imagined

[43] Eugene Wigner, *"The Unreasonable Effectiveness of Mathematics in the Natural Sciences"* (Richard Courant lecture in mathematical sciences delivered at New York University, May 11, 1959). By the way, let's also note that, in Italian even more than in English, the words "unreasonable" and "irrational" sound very similar, and are often used as synonyms.

Fig. 16 Venetian Interlude #2

these scenes, only a century ago...), but it, the tower bell, still stands for its ritual job, guardian, and sentinel of an impossible city, founded to escape from the mainland, grown to regain it, and nowhere, almost suspended between sky and sea and land, like a triple point of liquid, solid, and gaseous states; and like all the triple points temporary and fragile, but of that fragility that builds identity and eternity. But eternity, like infinity, is not of this world, as the battery of the smartphone hastens to remind. By dint of photographing gondolas and tourists, the lithium ions signal first the union's claim, then the state of agitation and finally herald the imminent general strike. We will pay the price, The Conference will suffer from lack of photographic documentation, and who knows if those who were destined to be immortalized will be more disappointed or more satisfied. The second, we fear. Thus, you will not see original photos portraying Enrico Perano[44] while he explains in the court of Palazzo Franchetti how mathematics can be applied to the "style slalom," drawing complex and very analytical graphics on eight wheels placed in two lines of four; nor later,

[44] Federazione Italiana Sport Rotellistici, CONI. But also engineer, writer, and many world records holder.

when with Marco Codegone,[45] at the speakers' table, he will transform and explain his evolutions on the skates with parametric and cyclical functions, arabesques that it is hard to follow when they are drawn on the screen; not to mention what should be to draw them with body and skates on an asphalt dotted with gobelets.[46] The truth is that the non-reporters are now revealing themselves for what they are: in short, more "not" than "reporters." It will be due to the fact that media coverage may not by now be 100% exhaustive, having necessarily already lost the Room-A Accepted Papers,[47] or more likely to the discomfort of the announced death of the telephone, or even more simply from the springy recall to laziness; the fact is that we will not be able to testify with sufficient solicitude the promising lecture by Odile Chatirichvili[48] on mathematical autobiographies, nor even the conclusive (and presumably performing) of Telma João Santos[49] and Claire Bardainne and Adrien Mondot.[50]

We cannot, on the other hand, deny having fallibly fallen into the trap set by Luca Viganò[51] when, after answering together with almost all the rest of the audience *"Peter Parker!"* and then *"Bruce Wayne!!"* to his easy questions about the secret identities of Spider-Man and Batman, with growing arrogance we also shouted *"Clark Kent!!!"* to the ridiculously similar question about Superman. *"To tell the truth, the real identity of Superman is Kal-El"* chuckles the professor, happy to have easily introduced the obvious advantages of anonymous usernames when venturing on the Net.[52] To this end, he had already shown the piece of the film "Spartacus" by Stanley Kubrick, released in 1960, in which Crassus, defeated the army of rebel slaves, promises to save their lives if they indicate who Spartacus is. The faithful Antoninus, played by Tony Curtis, to save the life of Spartacus/Kirk Douglas loudly screams *"I'm Spartacus!,"* immediately imitated by all the prisoners, and thus saving

[45]Engineering Department, Politecnico di Torino.

[46]IYI—Some call them "gobelettes," and we remain uncertain about the correct spelling: shortly, they are plastic glasses that the skaters use as "cones" to trace a path that, although being Euclidean and straight, they will travel instead in very, very complicated curvilinear forms.

[47]Where have promptly spoken—at least we believe so—Giulia Bottaro, Serena Bellotti, Michele Valsesia, Matteo Rebuzzini, Chiara Arpiani, and the aforementioned Alice Plutino, all from Università di Milano; Franca Caliò and Samuele Picarelli Perrotta, of the Politecnico di Milano; Elena Marchetti and Luisa Rossi Carta, also from the same Politecnico.

[48]Université Grenoble Alpes.

[49]Mathematics Department and Theatre Department, Universidade de Évora, Portugal. Their talk was titled *"Local Estimates for Minimizers, embodied techniques and Self Representations within Performance Art."*

[50]Artists of the company *"Adrien M. & Claire B."*, daughter and namesake of themselves. Their performance was *"Animisme numérique."*

[51]Computer Science Department, King's College London.

[52]In case you were so shamefully inexperienced (or maybe so young, which is even worse) not to know, be informed that Clark Kent is indeed the secret identity of Superman has on Earth, but he is still an alien from Krypton, and on his homeworld he was called Kal-El.

the privacy of the leader.[53] Like the rebels, we too are captured by prof Viganò who is showing the most technical slides on security mechanisms in a so clear way that one even forgets that he is describing them in English, and as a *coup de grace*—at least for us—also brings up that old film about the Musketeers and famous and mysterious message of Milady, and we wonder because he certainly does not know that we stole a frame just from that movie a few days ago to change the header of our Facebook page, pompously celebrating our 20 years of mathematics, with a painstaking copy and paste job. And perhaps the fault is of the magic of cinema (which the professor largely uses, as foreseen by The Program itself, given that his talk is titled *"Explaining Cybersecurity with Films and Arts"*), but certainly also of the consummate skill of the Italian Londoner, if we feel obliged—the next day, near the port of the Island of San Giorgio—to intercept and compliment him. He welcomes us with a smile, but almost surprised; they are strange, these academics here: even modest, and they could afford not to be.

Also for this reason it will be useful follow what Marco Li Calzi[54] tells, because he chooses the theme *"The cultural community of mathematicians"*; even if such a subject, as we already know, will brutally awaken the ferocity of the WAWDH. But at least we are consoled by the fact that Professor Li Calzi himself, although endowed with academic nobility, arrives at mathematics from a godchild and restless discipline: Economics. So, there is a sort of fair impartiality, if The Conference calls to speak about the vices and virtues of mathematicians who mathematician is not, at least of formative birth, and will know how to tell with objectivity. And he does so, in fact, also playing on the inevitable little foolishness that make a mathematician be a real mathematician, like the innocent maniacal desire to lower his own Erdős Number or the wide indulgence toward every kind of game. But the real theme arrives early, inevitable and direct, and it is again that of identity: to define what the mathematicians are, it must first define what mathematics is, only to be forced to conclude that mathematics is almost surely nothing but what the mathematicians do, in a circular reasoning. But, perhaps, this circularity is not so aberrant as both some ancient scholars and the modern spreadsheets declare; but, perhaps, it actually preserves the mysterious immanence of the circle, first among all the curves, that is regulated by the irrationality of pi; indeed, more than irrationality, by pure transcendence, which is—perhaps again—not only the one we find in the mathematical dictionaries.

It is up to Carlo, our traveling companion, whose intervention we have already peeked while flanking the whole course of the Po on rails and, curiously, seeing him using computer and slides announces to us a sort of closing notice with credits and so on, because we know that he won't be here tomorrow, and we have to remember to greet him; and—gosh—we should also greet Saracco prof. Alberto,

[53]Privacy only, because—as History teaches—Crassus did not get too demoralized by the purely fictional subterfuge and crucified all the surviving rebels along the Via Appia (and this is no fiction at all, alas).

[54]Università di Venezia and Istituto Veneto di Scienze, Lettere e Arti.

The Geometrician, who like Carlo prof. Tognato will leave the Lagoon before the sun sets. Instead, we still don't know that we have already lost him, already given back to the real world without a goodbye. But as much as he escapes, we'll certainly find him again somewhere.

And so, time seems to start running faster. With all due respect to Newton, who believed it to be regular and absolute, but also with analogous respect to Lorentz and Einstein, who thought they had at least clarified the precise rules of acceleration or slowing down, the time perceived by human beings continues to be that recalcitrant horse that alternates at will long pauses of immobility with furious and wild runs. So we follow Simon Tavaré[55] almost frozen in time as he brings the spectators and maths itself back into the fragility of mankind, and mixes wonder and hope in the audience, teaching how the algorithms powered by computers are now capable of processing bazillions of data applying investigative statistics on metastasis cells, going back, cell generation after cell generation, up to the first source of cancer. What good is math, what is science for? Well, it serves, heck, and it serves almost without having intention, without publicity and proclamations, and does need everything but to have to defend itself from the criticisms of the arrogant.

Michele Emmer, mathematician and filmmaker, plunges straight into the boundary between his passions, and tell us about the unusually proliferous period for mathematical subjects on the silver screen. This definitively transforms the *Sala del Portego* (as long as it is) into a cinema hall, just like these current were the 20 min before the beginning of the movie for which the ticket was paid, and it updates the public—if ever needed—on films with a mathematical theme. We recognize and anticipate *"Morte di un matematico napoletano"* with a great Carlo Cecchi directed by newcomer Martone, *"Hidden Figures"* which reminded half the world that the first "computers" were not of iron and plastic, but of flesh and bone, and often of black and female flesh. Film so unusual and surprising that even Kevin Costner seems almost a decent actor, we say, laughing in a whisper to The Geometrician who—have you seen?—he had not already disappeared toward the lush Emilia. And then *"Gifted,"* by Marc Webb, probably the only film in the world that shows a photograph of Grigorij Perel'man, and which tells how math can be a curse. And others, that we mentally check with *"seen, seen, seen ..."* just as the kids once did with the *"got-it, got-it, need-it!"* while leafing through the soccer players stickers. And get lost, we have to write down that *"X + Y"* by Morgan Matthews, the only figurine we need to complete the collection.

And then it is evening, at least in our personal chronotope, and after a brief private meeting, we establish that we must leave Venice at its sunset, reach the *Ferrovia*, a train, Padua, a *trattoria*, then a specific hotel and finally some even more specific beds and pillows. And so be it.[56]

[55]Department of Statistics and Biological Science, Columbia University, New York. Furthermore, Director of Irving Institute for Cancer Dynamics.

[56]IYIBWDI—Yep, said in this way it seems an easy going walk, both metaphorical and literal. The hard truth is that between the leaving of The Conference and the attainment of the beds there are

Fig. 17 Movie Maths posters

Some claim that it may have been the last to which the whole nation was called, but the fact remains that what happened at three (or two) of the morning of Sunday

five good hours and a number—unspecified but very high—of steps. This is because (1) Arriving at the railway station has already been a feat: imagine how high the number of pedestrians in Venice could be in a warm, thriving, magnificent pre-evening sunset; the inevitable hyper-compressed zooms in American films on Fifth Avenue in New York at rush hour pales in comparison; (2) The meditated reasoning that made us think that it would have been easier to find a cozy table in Padua than in the very busy Venice has turned out to be very fallacious, for various reasons: a little because in Padua we arrived when all those who looked for a place in a restaurant were already sitting in it, a little because (3) Venice is Venice, but also Padua as a tourist attraction is not an amateur, and (4) it is full of Paduans who maybe, on Saturday night, do not disdain the idea of eating out to avoid the daily ritual of washing dishes. The result was that we toured half the city without finding a Paduan inn willing to sell us a plate of lentils, and just before deciding if we should throw the desperate ourselves in a canal (which we have not yet understood if it was the Brenta, the Bacchiglione, or some other river), or to fall back toward the distant hotel's restaurant, we saw a sign that turned out to be a favorable one, resolving in extremis our food problem. And then yes, at that point just a couple of kilometers on foot were missing, before hearing the beep of the electronic key that opened the hotel room.

March 31, 2019, was a passage from standard hour to summertime among the most dramatic ever experienced by your heroes. Under normal conditions, we would have lived with the double anxiety of missing the train to Venice and the one (not linearly independent of the first) of missing the ferry to San Giorgio Island with ordinary anguish, although double; but the hour of sleepless, the lack of confidence in the automatic setting of mobile phone alarms, and the enduring fatigue of the half-marathon (although walked, not run) of the day before have conspired in a way that the appointment in the lobby of the Padua hotel was honored when it was still pitch dark outside. As always happens in these cases, each successive hourly deadline was right on schedule and often in brutal anticipation, with the result that we travel along the *Dorsoduro* route between the Santa Lucia station and the *Zattere* boarding, near The Conference site, in a very early morning, among silent streets and deserted bridges, in a probably very rare atmosphere for this city. We almost expect to see photographers or filmmakers chasing mist vapors from the thin fog that is already rising from the gondolaless canals, and instead Venice gives us a strange painted stone, resting on the handrail of a bridge, not forgotten but explicitly positioned by someone for someone else to take it, to keep it or to make it travel again. It is a game, or at worst an advertisement, but we opt for the first hypothesis: one of those global entertainments that social networks make possible, or at least easier, for a few years now. We keep it, we will take it westward, then we'll see what to do with it.

"The Conference is dead, long live The Conference!" one almost says, on this Sunday that is almost April and lacks conferences: but the flock of mathematicians, although reduced, still comes together like a Holiday Group with luggage in tow, to celebrate the social ritual of the communities that recognize themselves as such. Weighted down with backpacks but lighted up with sunglasses, with some badges still in sight but with the hats of well-trodden tourists on their heads, the eyes meet a little less skeptical than they could do just 2 days ago; good morning professor, hello professor, it's still cold, shall we climb the bell tower? And the young students who still attend today, and maybe they already have two PhDs and we don't know it; and the shifts for the exhibition *"Le Stanze del Vetro"* by Maurice Maginot; and the wall of colored glass bricks; and the labyrinth that only at home we will discover is dedicated to Jorge Luis Borges; and lunch on tables with ten seats, with diners still unknown but with whom it is now possible and normal to speak without asking to ourselves which kind of academics they may be; nor where we are, and above all neither why we are here, as it says the now almost completely domesticated beast of the WAWDH, because what are we doing here is a universal question, replicable even on the doorstep and even sitting in the armchair, that one always shared with the cat who wisely does not ask such silly questions.

And in fact it returns, and returns almost immediately, already on the square in front of *Venezia Santa Lucia* station when, now alone and distant from the participants of The Conference, we reshape the different conjugations of historical questions. Is it then mathematics or is it not mathematics, that we have been doing for 20 years? Is it mathematical or is not, to bombard innocent and unknown readers with little problems, stories that mix anecdotes and biographies, perfect solutions coupled with wrong attempts? Questions to be answered in an easy or an impossible

way, depending on mood and context. Mathematics is everywhere, we always say, and if it is true—and all The Conference seemed to want to strongly reiterate precisely this concept—then it is certain that we do mathematics, because everyone does it, willingly or not. If by "mathematics" we mean "progress in mathematics," then it is really better to go back to the synthesis mentioned by Li Calzi, to recognize that only mathematicians do mathematics, and to confess to the Lagoon that we are not mathematicians, and that despite the hundreds of coffees we will never produce a theorem.

Yet already before, as we celebrated the farewell to Venice in front of a *spritz*; and even more so now, with the Frecciarossa moving, still slow, but already moving westward over the *Ponte della Libertà*, the Liberty Bridge, on this artificial strip suspended between sky and water; now that we still have the entire Po valley in front of us, to go up from the sea to the mountains; now that we still don't know that in Turin we will find two scientific themed mugs left by Alice and tenderly taken to the arrival station by the pipe-smoker's wife; now as always, after all, with the future still uncertain and suspended and the past already a bit forgotten, revised, corrected by memory and feelings; now we just have to cling to that Almost Nothing that gives a bit of sense to our time and actions. If the 20 years spent playing with mathematics had convinced even just a couple of kids that maths can be fun, and maybe even make them laugh, or at least that maths can look a little less gruff, our goal is reached. Reached, dear Liberty Bridge just slipped away, and maybe you've already returned to keep the Ghost Bridge company, for all we know.

And may David Foster Wallace forgive us.

Imagine Math[1]

M. Emmer (ed.), *Imagine Math, Between Culture and Mathematics*, Springer-Verlag, Milan, 2012.

M. Emmer (ed.), *Imagine Math 2, Between Culture and Mathematics*, Springer-Verlag, Milan, 2013.

M. Emmer (ed.), *Imagine Math 3, Between Culture and Mathematics*, Springer International Publishing, Switzerland, 2015.

M. Emmer, M. Abate and M. Villarreal (eds.), *Imagine Maths 4, Between Culture and Mathematics*, UMI & IVSLA, Bologna & Venice, 2015.

M. Emmer, M. Abate, M. Falcone and M. Villarreal (eds.), *Imagine Maths 5, Between Culture and Mathematics*, UMI & IVSLA, Bologna & Venice, 2016.

M. Emmer and M. Abate, *Imagine Math 6, Between Culture and Mathematics*, Springer International Publishing, Switzerland, 2018.

M. Emmer and M. Abate, *Imagine Math 7, Between Culture and Mathematics*, Springer Nature Switzerland, 2020.

[1]List of published books (all volumes are available on Amazon) as of 2012.

© Springer Nature Switzerland AG 2020
M. Emmer, M. Abate (eds.), *Imagine Math 7*,
https://doi.org/10.1007/978-3-030-42653-8